陛下為心者必致其主於盛隆合
君臣同符斯大業定矣于斯
千載一遇也亦將行千載一隆
當時止於兼并而已哉夫非樂
樂生之所屑彊燕而癈道又非樂
苟得則心無近事榮求所以
也不屑則舉齊之事所以運道

The Embodied Image

Christmas, 2000

For Bob,
who loves all art
and
Relishes all cultures.

All my love,

John

The Embodied Image

Chinese Calligraphy from the John B. Elliott Collection

ROBERT E. HARRIST, JR.
WEN C. FONG

With contributions by Qianshen Bai, Dora C. Y. Ching, Chuan-hsing Ho, Cary Y. Liu, Amy McNair, Zhixin Sun, and Jay Xu

The Art Museum, Princeton University

in association with Harry N. Abrams, Inc.

This book was published on the occasion of the exhibition
"The Embodied Image: Chinese Calligraphy from the
John B. Elliott Collection," organized by The Art Museum,
Princeton University

The Art Museum, Princeton University
March 27, 1999–June 27, 1999

The Seattle Art Museum
February 10–May 7, 2000

The Metropolitan Museum of Art
September 15, 2000–January 7, 2001

The exhibition and catalogue were made possible by grants from the
Publications Committee of the Department of Art and Archaeology,
Princeton University; the National Endowment for the Arts; The
Henry Luce Foundation, Inc.; The Andrew W. Mellon Foundation;
the Joint Committee on Chinese Studies of the American Council
of Learned Societies and the Social Science Research Council; and
anonymous donors. The symposium "Character and Context in
Chinese Calligraphy," held at Princeton in conjunction with the
exhibition, and the accompanying publication were made possible
by Martha Sutherland Cheng, Class of 1977.

Paper and cloth editions published by The Art Museum,
Princeton University, Princeton, New Jersey 08544–1018

Cloth edition distributed in 1999 by Harry N. Abrams, Incorporated,
100 Fifth Avenue, New York, N.Y. 10011

Managing Editor: Jill Guthrie
Editors: Dora C. Y. Ching, Robert E. Harrist, Jr., Cary Y. Liu
Copy Editor: Lorri Hagman
Designer: Bruce Campbell
Photographer: Bruce M. White
Indexer: Robert Palmer
Typesetter: Paul Baker Typography, Inc., Chicago, Illinois
Glossary-Index: Birdtrack Press, New Haven, Connecticut
Printer: Arnoldo Mondadori Editore, Verona, Italy

Library of Congress Catalog Card Number: 98–88465
ISBN 0–943012–28–7 (paper); 0–8109–6377–9 (cloth)

The book was typeset in Diotima and Dante and printed on
Gardamatte Brilliante, 135 gsm.

Cover illustration: Huang T'ing-chien (1045–1105), *Scroll for Chang
Ta-t'ung,* 1100 (cat. no. 6, detail).

Frontispiece: Wang Hsi-chih (303–361), *Ritual to Pray for Good Harvest*
(cat. no. 2, detail).

PRINTED AND BOUND IN ITALY

JOHN B. ELLIOTT
1928-1997

Contents

Foreword

The remarkable collection of Chinese art at Princeton is due to the meeting of the minds and hearts of seminal teachers and enlightened and generous collectors who believed in the primacy of the actual work of art for the study of any great artistic tradition and civilization. That article of faith was given practical reality by Professor George Rowley, Graduate School Class of 1926, who taught at Princeton from 1925 to 1962, and Dubois S. Morris, Class of 1893, who gave his extensive collection of Chinese painting to Princeton in 1947. Wen C. Fong, Class of 1951 and Graduate School Class of 1958, a student of Rowley's and now Edwards S. Sanford Professor of Art History and faculty curator of Asian art, has built brilliantly on the foundation established by Rowley and Morris and brought further distinction to Princeton through his teaching and the growth and present stature of the collection. For Wen Fong, who teaches almost exclusively with original works of art, collecting is never an end in itself, but an imperative for the training of students. It is perhaps this quality and a sense of the field, of a larger responsibility to scholarship, that inspires in donors a sense of privileged participation in an enterprise larger than themselves. Because of Wen Fong the Museum has enjoyed the patronage of many collectors, but if his name is to be paired with one collector at Princeton, as Rowley's was with Morris, it is that of his classmate John B. Elliott. John sought Wen's advice when seeking an area in which he could collect effectively and which ultimately would benefit the program in East Asian studies at Princeton. Frederick W. Mote, professor emeritus, was another impressive mentor at Princeton who, with Wen Fong, guided and set a standard for John. While their counsel and direction were important, the collection of Chinese calligraphy was John's achievement. Few collectors would have ventured into the world of calligraphy or been so motivated to form a collection for teaching, for the training of young scholars and the advancement of the understanding of a civilization and culture that meant so much to him.

He was a person of high and noble purpose, and we can only hope that this exhibition and book reflect the measure of his achievement and our appreciation for his great generosity.

As John Elliott's health declined, it became painfully clear that he would most likely not live to see this exhibition of his calligraphy collection. While the exhibition was always a labor of love, after his death it became even more incumbent upon the Museum to ensure that the exhibition and the catalogue be worthy not only of the extraordinary collection John had formed and bequeathed to the Museum but also as fitting a tribute as possible to the man himself.

John was more than a collector; he was, above all, a good and generous friend. There was the inevitable etiquette between us—the director of a museum, never disinterested or completely at ease, and a major donor—but a shared ambition for the Museum was our strongest bond. John never wished to be identified for his gifts and other means of support, and was referred to in the Museum as Mr. Anonymous. His generosity as a collector and donor, which can now be made known, extended well beyond his gifts of Chinese art and included superb pre-Columbian objects and a great many of the finest works in the collection of African tribal art. The collection of Japanese art also was enriched, particularly in examples of *mingei,* Japanese folk art. The collection on which he had the greatest impact, however, after that of Chinese painting and calligraphy, was Greek and Roman antiquities. As a vote of confidence in Robert Guy, then curator of antiquities, John provided the funds for a number of Greek vases and Roman sculptures that dramatically changed that collection. This combination of support for an individual and an institution was John at his best and was exemplified by the aid he provided for students in the Department of Art and Archaeology and for exhibitions and projects in the Museum. John also was generous in his support of Gest Oriental Library, whose journal he funded. He was particularly happy when so many of his interests—

the Museum, Library, and calligraphy—came together in the exhibition "Calligraphy and the East Asian Book," organized by Gest Library and held in The Art Museum in 1989.

One cannot think of John Elliott without mentioning his mother, Ellen, a diminutive and kind but formidable woman who joined and supported him in his passion for Chinese art. She was among the most respected and loved of the Museum docents and gave so much of herself guiding visitors on tours or at the sales and information desk, and was herself a generous donor to the Museum.

John and Ellen would have been pleased that the exhibition was proposed and organized by Robert E. Harrist, Jr., Graduate School Class 1989, with Wen Fong, and that the catalogue contains essays by both student and teacher. Other former and current students who have contributed essays to the catalogue are Dora C.Y. Ching, Ph.D. candidate; Cary Y. Liu, Class of 1978 and Graduate School Class of 1997; Zhixin Sun, Graduate School Class of 1996; and Jay Xu, Ph.D. candidate. Graduate students Ping Foong, Emily A. Hoover, Huiwen Lu, and Shane McCausland have contributed catalogue entries. We are also grateful for the participation of Qianshen Bai, assistant professor, Boston University; Chuan-hsing Ho, curator, National Palace Museum, Taipei; and Amy McNair, associate professor, University of Kansas.

For all exhibitions someone must be in the trenches, and for "The Embodied Image" it was Cary Liu, associate curator of Asian art, and Dora Ching, who is completing her dissertation in Chinese art and archaeology. They have been the principal coordinators with the designer Dan Kershaw for the elegant installation and have given long hours to fine tuning the catalogue, editing, translation, and illustrations, all of which required both diligence and scholarly sophistication. They also must be thanked for their work on the symposium organized in conjunction with the exhibition. They have been nothing less than heroic and have made all the difference in the realization and quality of the exhibition, publication, and symposium.

Once again, the production of the catalogue is the result of the superb team of Jill Guthrie, managing editor; Bruce Campbell, designer; and the printer Arnoldo Mondadori Editore, with special thanks there to Peter Garlid and Sergio Brunelli. They were joined by Lorri Hagman for the specialized editing required for *The Embodied Image.* Maureen McCormick, registrar, dealt with the enormous task and myriad details of John Elliott's estate. We are most grateful to the executors—David Elliott, John's brother; and Michael L. K. Huang, his friend and business partner—for their cooperation and support. Charles K. Steiner, associate director, did a yeoman's job of fundraising, and Wen Fong must also be thanked for his extraordinary efforts to secure financial support for the catalogue, as should Jill Guthrie, who also found herself pressed into service as a fundraiser.

Support was found from a number of sources. The Department of Art and Archaeology made an exceptional grant through the Publications Committee in support of the catalogue, in recognition of the exceptional contribution John Elliott made to Princeton and to the Department of Art and Archaeology. We are also greatly indebted to The Henry Luce Foundation, Inc., for its very generous grant and to The Andrew W. Mellon Foundation for its support through an endowment established in 1985. We are extremely grateful to the National Endowment for the Arts both for a grant made in 1998 specifically for the exhibition and for the Challenge Grant awarded in 1984 to support projects of the caliber of "The Embodied Image." The symposium held in conjunction with the exhibition and the symposium volume were made possible by a generous grant from Martha Sutherland Cheng, Class of 1977; and a planning workshop for the exhibition and catalogue was supported through the good offices of the Joint Committee on Chinese Studies of the American Council of Learned Societies and the Social Science Research Council.

This is the last catalogue to which I will contribute a foreword, and fittingly so, as it is the last exhibition to which I have an emotional attachment. I am grateful for this opportunity to thank John Elliott for his friendship and for so enriching the Museum—and therefore my life, which the Museum was for more than twenty-four years—with his gifts and spirit.

Allen Rosenbaum
Director Emeritus

Foreword

Princeton University lost a loyal alumnus and valued mentor, and the world an unusually courageous and dedicated art collector, with the death of John B. Elliott, Class of 1951, on July 25, 1997. John had an exceptional gift for appreciating the best both in art and in people. In pursuing what he loved with passion and generosity of spirit, he made a lasting contribution to Princeton and to the world of art and learning at large.

John's interests were richly varied. In addition to Chinese calligraphy and painting, a field in which his activities were well known, he also collected photographs, books, drawings, Japanese ceramics, African artifacts, Indonesian textiles, Polynesian effigies, Mesoamerican ritual objects, Native American weavings and pottery, and, during the past two decades, utilitarian art from many cultures both ancient and contemporary. Once he was caught up in his determination to collect the best in Chinese calligraphy and painting, he enlisted the help of his mother, Ellen, and his brother, David. Seventy of the Chinese paintings in the Elliott Family Collection at Princeton were seen in the 1984 exhibition "Images of the Mind: Selections from the Edward L. Elliott Family and John B. Elliott Collections of Chinese Calligraphy and Painting at The Art Museum, Princeton University" and published in the catalogue of the same title. The heart of John's own collection, however, is the calligraphy. It is the only collection outside China and Japan that properly represents the sixteen-hundred-year history of this highly prized and most widely practiced art form, with masterpieces by most of the leading calligraphers from the eleventh century onward. Fifty-five of these works are included in this publication, which accompanies an exhibition of the collection organized by The Art Museum, Princeton University.

I made the acquaintance of John Elliott, a classmate and fellow history major, as an undergraduate at Princeton. We attended several courses together, including that of Professor Albert M. Friend, Jr., on Northern Renaissance art and Professor George Rowley's popular survey on the history of Chinese painting. In 1967 John wondered, while visiting with my wife, Constance, and me, when I was preparing the Princeton exhibition "In Pursuit of Antiquity: Chinese Paintings of the Ming and Ch'ing Dynasties from the Collection of Mr. and Mrs. Earl Morse," if opportunities existed in the collecting of Chinese art. Our discussion turned to John M. Crawford, Jr., the New York collector who had recently acquired his great collection from the renowned painter and collector Chang Ta-ch'ien. I mentioned that Chang would be visiting Princeton the following weekend. The upshot was that John bought two major scrolls, *Scroll for Chang Ta-t'ung* by Huang T'ing-chien (cat. no. 6) and *Admonitions to the Imperial Censors* by Hsien-yü Shu (cat. no. 13). And thus was the Princeton Chinese calligraphy project launched.

In 1969–70, while I was in Hong Kong with my family, on sabbatical leave from Princeton, John paid us a visit. The timing was perfect, as opportunities abounded for acquiring the best in Chinese calligraphy and painting. The collecting of Chinese art in Asia had been prohibited by the Trading with the Enemy Act, passed during the Korean War, but following Henry Kissinger's secret mission to Peking, the restriction was lifted. John and I scoured the art markets in Japan, Hong Kong, and Taiwan, quickly adding some two hundred works to John's collection, and in the process forming one of the most important assemblages of Chinese calligraphy and painting outside Asia.

For the next thirty years, John and I pursued the dual objectives of building a significant body of Chinese art and creating a teaching and research program in East Asian art in Princeton. Our long friendship with another Princeton faculty member, Frederick W. Mote, evolved into an extraordinary collaboration born of the shared vision that together with Princeton's eminence in the discipline of Western humanism, East Asian Studies should have a permanent and honored place. As a member of the Advisory Councils of the Departments of Art and Archaeology and East Asian

Studies, John supported publications, graduate student fellowships, scholarly research, and library acquisitions for both programs. He became a major benefactor of Gest Oriental Library, where he helped to launch *Gest Library Journal,* now in its twelfth year. In 1989, he sponsored the exhibition "Calligraphy and the East Asian Book" and its accompanying catalogue co-edited by Professor Mote, one of several joint projects organized by The Art Museum and Gest Library. In all these enterprises, John's initiatives were warmly supported by his mother, who, until her death in 1990, was one of the most valued and admired volunteer docents of The Art Museum. Over the years, Ellen, John, and David made many major gifts to the Museum. After John's death, his wish to donate the remainder of his Chinese calligraphy collection to Princeton University was warmly supported and implemented by David and his wife, Elaine.

The preparation of this volume has been a continual reminder of John Elliott's contribution not only to the field of Chinese art but to generations of scholars and museum curators around the world.

Wen C. Fong

Acknowledgments

One of the chief pleasures of completing this volume and launching the exhibition it accompanies lies in thanking the many people whose generosity and talents have made both possible.

Major support for the exhibition, "The Embodied Image: Chinese Calligraphy from the John B. Elliott Collection," and for the accompanying catalogue came in the form of major grants from the Publications Committee of the Department of Art and Archaeology, Princeton University; the National Endowment for the Arts; The Henry Luce Foundation, Inc.; and The Andrew W. Mellon Foundation. Additional support was provided by the Spears Fund, Department of Art and Archaeology, Princeton University. Support for a workshop on November 2, 1996, that brought together authors of the catalogue essays to discuss their work came from the Joint Committee on Chinese Studies of the American Council of Learned Societies and the Social Science Research Council, with funds provided by The Henry Luce Foundation, Inc. A grant from Martha Sutherland Cheng, Class of 1977, made possible the international symposium that accompanied the exhibition at Princeton and the publication of the collection of scholarly papers.

Generous lenders to the exhibition have allowed us to illustrate aspects of calligraphy and Chinese material culture not represented in the Elliott Collection. We are especially grateful to Maxwell K. Hearn, curator of Chinese art at The Metropolitan Museum of Art, who arranged for works from The Metropolitan to be included in the exhibition. Our thanks go also to Martin Heijdra, Chinese bibliographer, Gest Oriental Library, Princeton University, for his help in securing loans from the collection of the library. The exhibition has been enriched also by Robert H. Ellsworth, whose friendship with John Elliott is honored by several works on loan from his collection, and by Richard Rosenblum, whose generous loan from his singular collection of Chinese scholars' rocks is deeply appreciated.

To our co-authors, Qianshen Bai, Dora C. Y. Ching, Chuan-hsing Ho, Cary Y. Liu, Amy McNair, Zhixin Sun, and Jay Xu, we would like to express our deep gratitude for their scholarly contributions and years of commitment. The exhibition and catalogue are the culmination of decades of research conducted by students in the Department of Art and Archaeology, Princeton University, and by visiting scholars who have worked closely with the Elliott Collection. We are pleased to acknowledge the Princeton graduate students who contributed catalogue entries: Ping Foong, Emily A. Hoover, Huiwen Lu, and Shane McCausland. Portions of the text were translated by Donald E. Brix and Liu I-wei, with assistance from David Kamen.

At The Art Museum, Princeton University, Cary Y. Liu, associate curator of Asian art, working with Dora C. Y. Ching, project coordinator, took on the enormous tasks of planning the exhibition, supervising the content of the book, and organizing the symposium. Special recognition must go to Mr. Liu, who prepared meticulous research files on works in the Elliott Collection, which served as the foundation for much of our research. His vision has shaped the final design of the exhibition. Ms. Ching's expertise in the field of Chinese calligraphy and her exceptional editorial and administrative skills overcame many crises and averted others. Ms. Ching was assisted by student interns David T. Liu and Jeffrey D. Leven, and by graduate students Sinead Kehoe, Anthony Barbieri-Low, Ray Smith, and Christine Tan.

Jill Guthrie, managing editor at The Art Museum, supervised the complicated production of this volume and offered valuable advice and encouragement to the authors. Lorri Hagman, copy editor, coordinated the work of the multiple authors, smoothing out endless complications and inconsistencies with a keen eye, good sense, and good will. Emily Walter, expert editor of texts on Chinese art and many other subjects, edited Wen Fong's essay with her usual sensibility and skill. The book's handsome design is the work of Bruce Campbell, veteran of many projects in Chinese art, who deserves an honorary degree in this field.

Our thanks go also to Paul Baker and Sandy Snyder of Paul Baker Typography; David W. Goodrich of Birdtrack Press; Kathleen Pike, typist; Robert Palmer, who prepared the index; Daniel Kershaw, exhibition designer; and Paul Didonato, Walt Haupt, Joe Mangone, and Russell Rosie of the Carpenters Shop at Princeton University.

The photographs of works from the Elliott Collection reproduced here were made by Bruce M. White. Photographs of comparative illustrations were provided by H. David Connelly, Slides and Photographs, Department of Art and Archaeology, Princeton University, with the assistance of Xia Wei, curator, and support of Benjamin R. Kessler, director. Additional photographs were made by John Blazejewski and printed by Alison Speckman. Special thanks go to Dimitry Vessensky, collections management associate, The Metropolitan Museum of Art, for his assistance in providing reproductions of works from the museum's collection. Coordination for all photography was arranged by Dora Ching with the assistance of Karen Richter.

Like so many projects that have originated at The Art Museum, Princeton University, "The Embodied Image" benefited from the enthusiasm, imagination, and good judgment of Allen Rosenbaum, director emeritus. His unerring instinct for combining aesthetic quality and intellectual rigor in museum practice has set a high standard for his profession and has guided many aspects of our work. The Museum's acting director, Peter C. Bunnell, has energetically overseen the final stages of the installation of the exhibition. We owe a special debt to Associate Director Charles K. Steiner, who devoted countless hours to planning the exhibition, workshop, and symposium, and helping to ensure funding for the entire project.

Other members of the staff of The Art Museum to whom we would like to express our thanks are Calvin Brown and Gerrit Meaker, preparators; James Cryan, business manager; Jessica Davis, registration assistant; Eliza Frecon, assistant registrar; Dottie Hannigan, secretary; Nicola Knipe, editorial assistant; Patti Lang, coordinator of volunteers; Cheryl Marro, office assistant; Norman Muller, conservator; Karen Richter, assistant registrar, photo services; Ruta Smithson, public information officer; Albert Wise, security manager, and the entire security staff; and Carla Zimowsk,

office assistant. The entire project depended on the herculean efforts of Craig Hoppock, building superintendent, and Maureen McCormick, registrar.

Acknowledgment should be made also to the professional staff at Gest Oriental Library, one of the world's outstanding libraries of Chinese books and periodicals. Throughout the planning of the exhibition and the preparation of the catalogue, we have received support from the Princeton University Development Office, and gratefully acknowledge the help of Sue Hartshorn, Kirsten J. Hund, Douglas C. Lovejoy, Jr., Norman H. McNatt, and Charles Rippin. We are grateful also for the encouragement of Georgia Nugent, associate provost of Princeton University.

Support and encouragement have come also from our colleagues at Princeton: Professors Robert Bagley, Yoshiaki Shimizu, and John Wilmerding. Several friends and colleagues have read drafts of sections of this book and have offered insightful comments and corrections. For this help we are grateful to Virginia Bower, JoAnn Connell, Michael Nylan, Peter C. Sturman, and Marilyn Wong-Gleysteen. Ch'en Pao-chen, John Curtis, Sören Edgren, Lucy L. Lo, H. Christopher Luce, Frederick W. Mote, and Howard Rogers and the Kaikodo Gallery also offered advice, support, and invaluable services for which we are most grateful.

The international symposium "Character and Context in Chinese Calligraphy," held at Princeton in conjunction with the opening of the exhibition on March 27, 1999, included papers by Hua Rende, Suzhou University; Uta Lauer, University of Heidelberg; Huiwen Lu, Princeton University; Harold Mok, Chinese University of Hong Kong; Michael Nylan, Bryn Mawr College; Shih Shou-ch'ien, Academia Sinica; Peter C. Sturman, University of California, Santa Barbara; and Eugene Y. Wang, Harvard University. The publication of the symposium papers relied on the professionalism and expertise of Judith G. Smith, Cary Liu, and Dora Ching, editors; the design firm Binocular, with Stefanie Lew and Joseph Cho; and Daniel M. Youd, translator.

The entire project was made possible through the vision and inspiration of John B. Elliott. Our sincere hope is that we have done justice to the works of art that John so lovingly assembled and so generously shared with the world.

Robert E. Harrist, Jr. Wen C. Fong

New York City *Princeton, New Jersey*

Chronology

SHANG DYNASTY	**ca. 1600–ca. 1100 B.C.**
CHOU DYNASTY	**ca. 1100–256 B.C.**
Western Chou	ca. 1100–771 B.C.
Eastern Chou	770–256 B.C.
Spring and Autumn	770–ca. 470 B.C.
Warring States	ca. 470–221 B.C.
CH'IN DYNASTY	**221–206 B.C.**
HAN DYNASTY	**206 B.C. – A.D. 220**
Western (Early) Han	206 B.C. – A.D. 9
Hsin	A.D. 9–24
Eastern (Later) Han	25–220
THREE KINGDOMS	**220–280**
Wei	220–265
Shu	220–265
Wu	222–280
SIX DYNASTIES*	**222–589**
WESTERN CHIN	**265–317**
SOUTHERN DYNASTIES	**317–589**
Eastern Chin	317–420
Liu Sung	420–479
Southern Ch'i	479–502
Liang	502–557
Ch'en	557–589
NORTHERN DYNASTIES	**386–581**
Northern Wei	386–534
Eastern Wei	534–550
Western Wei	535–556
Northern Ch'i	550–577
Northern Chou	557–581

SUI DYNASTY	**581–618**
T'ANG DYNASTY	**618–907**
LIAO DYNASTY	**907–1125**
FIVE DYNASTIES	**907–960**
Later Liang	907–923
Later T'ang	923–936
Later Chin	936–946
Later Han	946–950
Later Chou	950–960
SUNG DYNASTY	**960–1279**
Northern Sung	960–1127
Southern Sung	1127–1279
CHIN DYNASTY	**1115–1234**
YÜAN DYNASTY	**1260–1368**
MING DYNASTY	**1368–1644**
CH'ING DYNASTY	**1644–1912**
REPUBLIC	**1912–1949**
PEOPLE'S REPUBLIC	**1949–**

*The Six Dynasties whose capital was Nanking, are Wu, Eastern Chin, Liu Sung, Southern Ch'i, Liang, and Ch'en.

Calligraphy Script Styles

As embodied images of ideas and things, Chinese writing developed on media ranging from pottery, bone, bronze, bamboo, and silk to paper. Technical differences aside, the purpose, propriety, and decorum appropriate for particular writings necessitated the evolution of numerous script styles (*tzu-t'i*), and this in turn led to an art of writing: calligraphy. A reciprocating reaction emerged between public monumental scripts concerned with didactic legibility and orthodoxy, and private self-expressive styles believed to capture the spirit and character of the individual. In the development of Chinese calligraphy, the mutual influence among script styles, changing rules of decorum, and archaic revivalism have blurred the distinctions among script forms. Moreover, each style has evolved through the ages, some passing into obsolescence and some being reinvented and transformed. The following descriptions of the major script styles are illustrated through examples of the character *hu*, "tiger."

ORACLE-BONE WRITING (*chia-ku-wen*)

Incised on animal bones and tortoise shells dating from the fourteenth to the eleventh centuries B.C., oracle-bone writing served mostly as a record of divination between a human ruler and the supernatural world. Much speculation surrounds the origin of this writing system, and some scholars have attempted to link it to even older markings suggestive of writing found on pottery from as early as 5000 B.C., although such interpretations are controversial. Oracle-bone writing does, however, demonstrate the pictographic and sacred origins of Chinese writing, and modern Chinese characters have inherited some features of the ancient script.

Oracle-Bone Writing

SEAL SCRIPT (*chuan-shu* or *chou-wen*)

Derived from oracle-bone writing and emblematic designs, seal script is also known as bronze writing (*chin-wen*) because it was used primarily for inscriptions cast on bronze ritual vessels. Showing greater regularity and abstract linear forms, seal-script inscriptions were used increasingly for commemorative documents and narratives that reflect a growing awareness of human history. Traditionally, seal script can be divided into great-seal (*ta-chuan*) and small-seal (*hsiao-chuan*) scripts. The former is identified with bronze inscriptions of the Shang and Chou dynasties (ca.1600–256 B.C.). Small-seal script—characterized by thin wiry lines, regulated spacing, and stylized abstract forms—represents an effort by the First Emperor to standardize writing upon national unification under the Ch'in dynasty (221–206 B.C.).

Seal Script

CLERICAL SCRIPT (*li-shu*)

In the Ch'in and Han dynasties (221 B.C.–A.D. 220), clerical-script writing developed from growing state demands for official records and histories. It first evolved as a draft form of seal script written quickly with brush and ink, originally on wood and bamboo slips, and later on silk and paper. Refined as an official script, it came to mark orthodoxy for imperially sanctioned texts, which were often engraved on monumental stone stelae. In its developed form, clerical script features modulated brush lines with sweeping horizontal strokes ending in sharp tips, and distinctive down-sweep strokes to the right. The transition to brush and ink opened new modes of artistic expression explored in later periods.

Clerical Script

CURSIVE SCRIPT (*ts'ao-shu*)

Originating in the second century B.C. as an abbreviated form of clerical script known as draft clerical (*ts'ao-li*) or draft cursive (*chang-ts'ao*), cursive script matured in the third and fourth centuries A.D., culminating in the

calligraphy of Wang Hsi-chih (303–361; cat. no 2). Begun as a shorthand form used for personal notes and letters, cursive script, with its own stroke order and abbreviated forms, was by nature private and often legible only to the calligrapher or his friends. Taking full advantage of the artistic qualities afforded by the freedom of brush and ink, personal autographic styles developed as modes of individual expression that sometimes even transcended the contents of the text. An extreme form of

Cursive Script

cursive script known as wild cursive (*k'uang-ts'ao*) gained popularity in the T'ang dynasty (618–907). Commonly performed while the writer was inebriated, wild-cursive calligraphy was brushed in spontaneous, fluid strokes in what might be described as a mad dance of joyous delirium.

STANDARD SCRIPT (*k'ai-shu*)

Maturing between the second and fourth centuries, standard script began in the Han period as a refinement of clerical script, without the modulated sweeping strokes or the uniform, wirelike corners of seal script. Instead, the inner brushwork and architectonic structure of the characters were

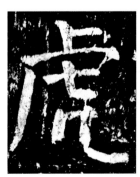

Standard Script

developed in order to produce legible characters that replaced clerical script as the formal script used for official writing and monumental stelae. With imperial sponsorship, calligrapher-officials of the T'ang dynasty adapted Six Dynasties (222–589) models to create a bold yet elegant standard-script style, whose stable construction and inner brush movement can be said to capture a sense of dynamic equilibrium. Becoming the dominant formal script style in

later periods and the model for printing type, standard script can be distinguished by size and technique: large-standard (*ta-k'ai*) using the arm, medium-standard (*chung-k'ai*) using the wrist, and small-standard (*hsiao-k'ai*) using the fingers.

RUNNING SCRIPT (*hsing-shu*)

Essentially a freehand or daily writing style, running script is believed to be a simplification of early standard script, but reached maturity before its model, combining the legibility of standard script with the speed and informal freedom of

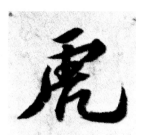

Running Script

cursive script. Unlike cursive script, however, running script only condensed but did not eliminate strokes within characters. In the T'ang dynasty, strict standard and wild-cursive calligraphy represented the extremes of public monumentality versus private expression. In the Sung dynasty (960–1279) running script became the preferred mode of individual self-expression and artistic freedom, as exemplifed in the calligraphy of the Four Great Sung Masters, including Huang T'ing-chien (1045–1105; cat. no. 6) and Mi Fu (1062–1107; cat. no. 7).

ORACLE BONE: from Lo Chen-yü *Yin-hsü shu-ch'i ch'ien-pien* (1913; reprint, Taipei: I-wen yin-shu-kuan, 1970), *chüan* 4: 44/6. SEAL: Inscription on a bronze wine vessel (*chüeh*), ca. 1200 B.C.; from Jung Keng, *Hai-wai chi-chin t'u-lu* (Peiping: Pei-p'ing Yen-ching ta-hsüeh k'ao-ku hsüeh-she, 1935), 2: pl. 91b. CLERICAL: *Stele for Ching-chün, the Minister of Pei-hai (Pei-hai hsiang Ching-chün pei)*, dated 143; from *Shoseki meihin sōkan* (Tokyo: Nigensha, 1964), vol. 2, no. 20. CURSIVE: Chu Yün-ming (1461–1527), *Prose Poem on the Red Cliff (Ch'ih-pi fu)*; from *Shoseki meihin sōkan* (1970), no. 160: 47. STANDARD: Yen Chen-ch'ing (709–785), *Record of the Altar of the Immortal of Mount Ma-ku (Ta-tzu Ma-ku hsien t'an chi)*, dated 771; from *Shoseki meihin sōkan* (1964), vol. 8, no. 88. RUNNING: Su Shih (1037–1101), *A Poem after the Rhyme of the Monk Pien-ts'ai (Tz'u Pien ts'ai yün shih)*, dated 1090, ink on paper, 29.0 x 47.9 cm, Palace Museum, Peking; from *Shodō geijutsu* (Tokyo: Chūōkōron-sha, 1971), 6: pl. 14.

Preface

In China the art of calligraphy has never been interpreted as simply a means of giving tangible form to spoken words. The graphic patterns that make up written characters are seen as images of the human mind at work, striving to discern order in the phenomenal world and to impose meaning on a chaotic flow of perceptions and feelings. Brushed on paper or silk, cast on bronze, or engraved on stone, calligraphy, known in Chinese as *shu-fa*, or "the way of writing," possesses the power to evoke the forces of nature, to promote social and ideological values, and to assert the creativity of individual artists.

Chinese myths explaining the origins of writing attribute to the ancient sage Ts'ang Chieh superhuman powers of discernment that enabled him to perceive in natural phenomena—bird tracks, markings on tortoise shells, and heavenly constellations—the patterns on which he based the earliest forms of written characters. However fanciful these myths may be, they echo fundamental truths borne out by archaeological evidence. The earliest-known writing in China appears on oracle bones—tortoise plastrons and ox scapulae used by Shang dynasty (ca. 1600–1100 B.C.) kings in divinatory rituals through which they communicated with an unseen world of spirits. In the characters carved on oracle bones, the bond between religious or magical power and early forms of writing by mythic accounts was made concrete.

In addition to the oracle bones, inscriptions cast on ritual bronze vessels show that Chinese writing began as pictographic representations of forms in nature as well as of manmade objects. As the script evolved, however, characters became more schematic and abstract. By the Han dynasty (206 B.C.–A.D. 220), the pictographic origins of Chinese writing remained detectable in only a small number of characters, and even these are almost completely unrecognizable without special study. The limited capacity of pictographic writing to represent words for complex ideas or abstract concepts also demanded the invention of other types of characters. The most common combine elements known as radicals, which signify broad categories of meaning, and phonetic elements, which indicate pronunciation. For example, all words having to do with trees or with objects commonly made of wood—such as "pine" (*sung* 松), "forest" (*sen* 森), and "table" (*chuo* 桌)—include the radical derived from the pictographic representation of a tree 木. Characters that have similar pronunciations, such as "sympathy" (*t'ung* 恫), "tube" (*t'ung* 筒), and "copper" (*t'ung* 銅), share the same phonetic element but have different radicals that point to their various meanings. Graphs of this type constitute about 90 percent of all extant characters.

The early representational forms of characters were transformed beyond recognition into schematic designs, but the bond between phenomena in nature and Chinese writing endured in the panoply of metaphor through which critics and theorists have described calligraphy. Written with the flexible animal-hair brush, the principal tool of both Chinese calligraphy and painting, brushstrokes do not represent forms in nature directly, but they evoke kinetic forces, capable of myriad transformations, that animate nature itself. In a classic example of this vision of calligraphy, Sun Kuo-t'ing (ca. 648?–703?) writes of brushstrokes that recall "a shower of rock hailing down in a raging thunder, a flock of geese gliding [in the sky], frantic beasts stampeding in terror, a phoenix dancing, a snake slithering away in fright." For viewers who shared vSun Kuo-t'ing's understanding of calligraphy, observing the effects of brushwork was tantamount to observing, or seeing in imagination, the real and the fantastic phenomena described in his colorful phrases.

Although calligraphy originated in observation of the phenomenal world and achieves thrilling aesthetic effects by calling to mind the forces of nature, writing calligraphy, like rituals or other highly conventionalized human acts, is governed by and perpetuates hierarchical rules and traditions. Submission to these rules begins as soon as a young calligrapher takes up the brush, undergoing rigorous training and mastering the received forms of characters in order to produce legible

written communication. And just as rules of syntax and grammar govern the production of texts, rules of composition and stroke order govern the writing of individual characters. In each act of writing, these age-old conventions reassert their power. The decision to write in one of the historical script types—seal, clerical, standard, running, or cursive—further ensures the continuity of earlier traditions. Selecting as a model the style of a particular calligrapher, such as Wang Hsi-chih (303–361) or Yen Chen-ch'ing (709–785), two masters who have dominated the history of calligraphy, also perpetuates authoritative artistic lineages and parallels the transmission of normative political and social values that have shaped life in China.

Paradoxically, while calligraphy is an art governed by rules that assure its continuity as a cultural practice, it is also the art thought to embody more directly and more vividly than any other the unique physical presence and the creative personality of the individual writer. The prevalence in calligraphy criticism of language drawn from human physiology and medicine points to the essential link between writing and the human body. Good calligraphy has "bone," "muscle," and "flesh." Concentrated in the strokes of calligraphy are the impulses that animate the writer's body, arm, hand, wrist, and fingers, transmitted by the brush to the writing surface. This physical manifestation of the writer's presence parallels the revelation of character, temperament, and mood, as well as the scholarly and artistic cultivation that calligraphy is thought to embody. At the same time that calligraphy preserves and continues ancient protocols of writing, it is also an expressive vehicle of nearly unlimited flexibility that challenges calligraphers to invent distinctive new styles of their own.

All calligraphy, as written communication, consists of words, phrases, and sentences, and each act of writing fixes a text in a visual form that determines the way it is perceived by a reader. The visual effect of a poem transcribed in the tangled strokes of cursive script differs greatly from a version of the same text written in the carefully spaced, orderly characters of standard script. Traditional Chinese criticism and theory provide little guidance for describing these differences or for articulating how different script types and styles affect the meaning a text conveys. Rules governing the relationship between texts and calligraphic styles are generally tacit and unacknowledged, but they are real, ensuring that a stele inscription set up in front of a Confucian temple would not be inscribed in the form of wild-cursive script favored by tipsy calligraphers for transcriptions of their poems on whitewashed walls or large-scale scrolls.

The Embodied Image accompanies an exhibition of Chinese calligraphy from the John B. Elliott Collection at The Art Museum, Princeton University. Although no single exhibition or scholarly volume can address comprehensively the aesthetic and cultural significance of calligraphy in China, the diversity and quality of the collection have allowed us to introduce almost all of the major traditions of calligraphy and to study works by many of the artists who most profoundly shaped the history of this art.

Part 1 includes two introductory essays that map out fundamental problems in the art historical study of calligraphy. In "Reading Chinese Calligraphy," Robert E. Harrist, Jr. argues for a view of calligraphy that accounts for its place in the history of producing and reading texts in China. By questioning the idea, advanced in both China and the West, that a work of calligraphy transcends its linguistic meaning, Harrist attempts to illuminate the intellectual and social processes through which calligraphy originally came to be understood as a form of art.

In "Chinese Calligraphy: Theory and History," Wen C. Fong traces a dialectic relationship between the creativity of individual calligraphers and the controlling power of state and society. This dynamic interaction yielded four revolutions or epochal transformations in the history of calligraphy between the fourth and fourteenth centuries. Fong's account of these transformations stresses the status of calligraphy as a paradigmatic art

that gave expression to the intellectual and political concerns of China's scholarly elite.

Part 2 consists of a catalogue of the exhibition in which individual entries, arranged chronologically, are framed by brief linking narratives. Although not intended as a summary of the history of calligraphy, the entries and narrative text provide a general introduction to the periods and major developments represented by works in the Elliott Collection.

Part 3 comprises nine topical essays that deal with a wide range of issues in the history of calligraphy. These essays are by scholars and curators who approach calligraphy in very different ways, and their views are not always in agreement. They share, however, a strong interest in integrating the history of calligraphy with that of religious, political, literary, and social change in China. Although the arrangement of the essays is not strictly chronological, and they can be read in any order, the topics they cover progress from early religious texts to couplets and letters produced in the late nineteenth and early twentieth centuries.

Calligraphy continues to flourish in China today, promoted by both scholarly and popular publications, calligraphy clubs, local and national competitions, and exhibitions. Although many contemporary scholars correctly warn against seeing unity and continuity in the history of Chinese art, where in fact diversity and transformation are equally apparent, the modern florescence of calligraphy depends on the same bonds between those who write and those who read, between tradition and innovation, between past and present manifest in the works of the Elliott Collection. The knowledge that studying these works can help to illuminate not only the art of the past but of our own time as well has increased the pleasure of writing this book.

Robert E. Harrist, Jr.

The Embodied Image

歸來書屋適菁有

Reading Chinese Calligraphy

ROBERT E. HARRIST, JR.

All writing depends on the generosity of the reader.
—ALBERTO MANGUEL

In recent years historians have produced a flood of studies that illuminate the role of writing, printing, and reading in Western culture, even as the proliferation of computer-generated hypertext challenges all earlier assumptions about these essential practices. Many of these studies share a commitment to the idea, articulated by Roger Chartier, that in order to understand a text, it is necessary "to identify the effect, in terms of meaning, that its material forms produced."[1] The approach Chartier describes marks a radical departure from methods of analysis such as the New Criticism that locate the production of literary meaning solely in language itself. Although this increased attentiveness to materiality and visual effects marks a new trend in the study of written communication in the West, the historiography of Chinese calligraphy has long been focused almost exclusively on these issues.[2] Summarizing this phenomenon in traditional responses to calligraphy, Yu-kung Kao has noted that "the physical presence of the words, not their content, is the object of appreciation."[3]

Whatever its format and whatever the script type or style in which it is written, calligraphy records words that convey specific meanings. Nevertheless, historical and theoretical studies produced over many centuries in China and, more recently, in the West devote little attention to this seemingly self-evident fact. Although it may seem an unproblematic phenomenon, this apparent indifference to both the textual content of calligraphy and the experience of reading it originates in fundamental, and usually unexamined, assumptions about the status of calligraphy as an art. It would be futile and, indeed, very boring to study works of calligraphy by treating them simply as texts, to be read in the way one reads a printed book or newspaper. This essay argues, however, that by thinking about the history of calligraphy not only as a progression of period styles and individual masters but as a history of pro-

ducing and reading texts, we can discern patterns and cultural conventions easily overlooked in most available accounts of this complex art.[4]

CALLIGRAPHY AS WRITING AND AS ART

Among the achievements that have shaped Chinese civilization, none has played a greater role as an agent of cultural unification than the writing system developed over three thousand years ago and still in use today.[5] Ideographic forms legible to speakers of mutually unintelligible regional dialects, Chinese characters facilitated communication essential to statecraft and trade and disseminated religious, mythic, and literary traditions that bind the people of the geographically vast domain of China. But it was far more than the usefulness of writing that led to its elevation as an art among people who first practiced, collected, and wrote about calligraphy as an aesthetic phenomenon.

Most scholars agree that by the early Six Dynasties period (222–589), among aristocrats of southern China, calligraphy had come to be thought of as an art, more or less as that concept is understood today. This period witnessed the burgeoning of critical and theoretical texts on calligraphy, the emergence of an art market, and the formation of collections of works by Wang Hsi-chih (303–361), the most famous of all calligraphers, and other masters.[6] Treatises categorizing script types, discussions of connoisseurship, notes on calligraphic technique, and rankings of calligraphers that proliferated in the fifth and sixth centuries laid the foundations for all later writings on this art. The Six Dynasties period also witnessed the development of a specialized language of appreciation and assessment that metaphorically equated effects of brushwork with forms in nature or the physiology of the human body.[7] During the Six Dynasties it also became common to

Opposite: Huang T'ing-chien (1045-1105), *Scroll for Chang Ta-t'ung* (cat. no. 6, detail).

READING CHINESE CALLIGRAPHY 3

speak of a person's calligraphy as an externalization of the writer's mind and personality open to interpretation by an informed observer—a view of calligraphy that still endures in China today.

Missing in the early discourse of this art is any systematic discussion of the relationship between the textual content of a work of calligraphy and the script type or style in which it appears.[8] A manifestation of this disregard for the literary content of calligraphy as a subject of theoretical discussion is the practice of categorizing works solely on the basis of the script type in which they were written. The careful definition and classification of scripts had begun in the Han dynasty (206 B.C.–A.D. 220) and was a well-established field of study by the third century, as evidenced by texts such as *Forces of the Four Script Types (Ssu-t'i shu-shih)* by Wei Heng (259–291).[9] In discussions of the calligraphy of Wang Hsi-chih, his son Wang Hsien-chih (344–388), and other calligraphers, it was common to sum up their achievements by noting the script types in which they excelled. In the earliest extant survey of calligraphers, *Capable Calligraphers from Antiquity Onward (Ku-lai neng-shu jen-ming)* by Yang Hsin (370–442), entries on individual artists provide terse biographical information along with comments such as "good at cursive script."[10] By the T'ang dynasty, categories of script types came to be used to organize catalogues of calligraphy, including the list of Wang Hsi-chih's works compiled by Ch'u Sui-liang (596–658), in which entries are divided into fourteen items in standard script (*k'ai-shu*) followed by 360 works in running script (*hsing-shu*).[11] When Chang Huai-kuan (fl. ca. 714–760), the author of many texts on calligraphy, inspected a scroll in which works by Wang Hsi-chih and Wang Hsien-chih were mounted, he complained that they were not properly arranged "according to the style of the script."[12]

The habit of organizing collections of calligraphy according to script types was handed down to later periods and accounts for the contrast between two imperial catalogues compiled in the early twelfth century under Emperor Hui-tsung (r. 1100–1126). In *The Hsüan-ho Painting Catalogue (Hsüan-ho hua-p'u)*, paintings are divided by subject matter into ten divisions that include "Buddhist and Taoist Figures," "Landscapes," "Birds and Flowers," and so on; formats and pictorial styles play no role in classification. In *The Hsüan-ho Calligraphy Catalogue (Hsüan-ho shu-p'u)* works of calligraphy are organized by script type, not by cate-

gories reflecting contents, such as "Poems," "Essays," or "Letters." The system used at Hui-tsung's court remained the norm for cataloging calligraphy in later centuries and seems perfectly natural now. It was contingent, however, on cultural and intellectual assumptions about calligraphy that have complex histories of their own.[13]

DISAPPEARING TEXTS
AND THE EARLY DISCOURSE OF CALLIGRAPHY

Implicit in early writings on calligraphy and in the ways collections were organized is the idea that the visual forms of this art—the graphic patterns left on the writing surface by the brush—were open to categorization and analysis without reference to the literary content of calligraphic texts. According to the modern scholar Hsiung Ping-ming, "As authors separated the significance of the beauty of calligraphy from its function, they determined the independent artistic value of calligraphy."[14] Wen C. Fong suggests that this attempt to separate form from content was a step that had to be taken before calligraphy could be perceived as a purely aesthetic phenomenon.[15] But why was this so?

The rise of calligraphy as a major art occurred during an era of turbulent political and social change set off by the fall of the Han dynasty. The establishment of the Eastern Chin dynasty (317–420) south of the Yangtze River marked the beginning of a long period of disunion during which northern China was controlled by foreign conquerors and the south was ruled by a succession of short-lived kingdoms that had their capital in the city of Chien-k'ang (modern Nanking). In spite of near-constant warfare and political coups, this era witnessed what has been called "the discovery of the individual."[16] According to the historian Charles Holcombe, it was the relative weakness of the state during the Six Dynasties that encouraged members of elite social classes "to pursue individual self-realization through religion, art, music, poetry, and social activities."[17] Private enthusiasms and passions, eccentric behavior, eremitism, absorption in literature, and displays of wit in "pure conversation" that enliven biographies from the Six Dynasties shaped ideals of literati culture for centuries to come. Although Wang Hsi-chih, Hsieh An (320–385), and

other members of the Eastern Chin elite who gained fame for their calligraphy held various government offices, many, including Wang, were noted more for their indifference to official life than for their achievements as public figures. In the eyes of later historians, officials of the Six Dynasties were shockingly casual about their duties.[18] Wang himself retired early and devoted his final years to enjoyment of landscape scenery and full-time cultivation of the arts.

In addition to their other enthusiasms, calligraphy became one of the obsessions of early Six Dynasties literati; this prominent role of calligraphy in their lives and the ideas about it they shared were new in the history of writing in China. Beginning in the Shang dynasty (ca. 1600 B.C.–ca. 1100 B.C.), when it was used to record divinatory communications between kings and their departed ancestors, writing had functioned as a tool of rulership—as a means of recording knowledge imbued with magical efficacy to which only the most powerful members of society had access.[19] In the Chou dynasty (ca. 1100–256 B.C.) inscriptions cast on bronze vessels as a deluxe form of publication documented enfeoffments, marriage alliances, transfers of land, and other important events in the lives of powerful clans. During this same era, writing on bamboo and silk preserved historical and philosophical texts that could legitimize political power and maintain social norms. Calligraphy engraved on stelae erected by the state for public viewing during the Han dynasty asserted Confucian ideology, while stone engravings commissioned by local elites to honor their ancestors displayed their filial piety and their commitment to widely shared public values.[20] Although early works of literature circulated as handwritten texts, there is no evidence that they were evaluated on the basis of the calligraphy in which they were done.

In a discussion of the function of writing in early China, Chang Huai-kuan argued that it was a means through which to "summarize morality, illuminate forms of government, and establish solemn respect among lords and fathers and loving fulfillment of ritual. . . . As a means of elucidating ordinances and canons and of establishing the florescence of the nation, nothing approached writing."[21] The works of calligraphy of the Eastern Chin that were most central to the history of writing as an art had little to do, however, with the lofty goals with which Chang Huai-kuan associated the written word. Although Wang Hsi-chih

and members of his circle produced many types of texts, including transcriptions of sacred tracts believed to have been dictated from the spirit world, the most influential format for their calligraphy was the personal letter.[22]

The contents of these letters often consisted of thank-you notes, polite inquiries about health, and discussions of mundane family matters of concern primarily to the authors of the letters and their correspondents. Who else, after all, would care to know that Wang Hsi-chih was sending a friend a gift of oranges or that he felt distress over not being able to properly tend his ancestors' graves—matters discussed in what became two of his most revered works?[23] Written in running and cursive (ts'ao) script, Wang's letters and those of other elite calligraphers of the Eastern Chin displayed sudden changes of speed and brush direction that vividly recorded the impulses of the writer's hand—effects that would have been unacceptable in more formal types of writing or in the work of professional scribes.[24] Although Wang Hsi-chih and his correspondents apparently realized that their letters would circulate among aristocratic circles and no doubt took care to word them carefully, in the early connoisseurship of calligraphy, it was the visual effects of these letters, not their contents, that were subjected to aesthetic evaluation.[25]

THE PERSISTENCE OF TEXTS

The attention lavished on the visual effects of calligraphy rather than its literary content during the Six Dynasties presages both the concept of "art for art's sake" that emerged in nineteenth-century Europe and the claims for the autonomy of visual experience made by advocates of modernist art during the twentieth century.[26] According to the sociologist Pierre Bourdieu, when artists asserted the independence of their works from traditional canons of subject matter, they were able "to affirm their mastery over that which defines them and which properly belongs to them, that is, the form, the technique, in a word, the art, thus instituted as the exclusive aim of art."[27] This assertion of the autonomy of form in relation to subject matter, Bourdieu argues, established a new model of informed perception, the acceptance of which became a defining characteristic of membership in

elite social classes. The dangers of equating the cultural politics of modern Europe with those of fourth- and fifth-century China are all too apparent, but it does appear that by insisting on an aestheticized appreciation of calligraphy, artists, critics, and collectors of the Six Dynasties had invented a set of attitudes and practices through which they could assert their intellectual and social distinction.

Whatever the sociological forces that promoted the separation of visual impact from literary content in the appreciation of calligraphy, this dichotomy became a given in Chinese critical writing. Referring to the origins of calligraphy, Sun Kuo-t'ing (648?–703?) argued that originally, before it could be considered an art, "writing was fit just to record language."[28] In the eighth century Chang Huai-kuan summarized the way in which a superior mind responds to calligraphy: "Those who know calligraphy profoundly observe only its spiritual brilliance and do not see the forms of characters."[29]

If the connoisseurs Chang Huai-kuan credits with achieving the very highest levels of appreciation did ignore the forms of characters in calligraphy, their feat would surprise modern researchers in the field of cognitive psychology who have shown that once literacy achieves a secure hold in the mind, its demands are nearly impossible to suppress. This phenomenon, known as the Stroop effect, named for the researcher who first documented it, is familiar to students in introductory psychology courses. In an experiment that demonstrates this effect, subjects shown a set of cards bearing the names of colors are asked to ignore the semantic meanings of the names and to identify only the colors of ink in which they are printed. Inevitably, the printed words interfere with this task. For example, confronted by the word "red" printed in green, the subject hesitates before being able to name the color of the ink. One study of the Stroop effect on readers of Chinese indicated that they find it even more difficult to ignore the meanings of Chinese characters than do readers of English words. The psychologist Rumjahn Hoosain suggests that these findings may show that "the perception of the meanings of Chinese names is more unavoidable, that is, that the meanings of Chinese characters are more manifest than the meanings of words in English."[30]

Anecdotal evidence of the Stroop effect turns up also in Chinese writings on calligraphy. In the eleventh century the great scholar and epigrapher Ou-yang Hsiu (1007–1072) experienced a learned version of this phenomenon in his encounters with rubbings of Buddhist and Taoist inscriptions in his collection. Although he admired the calligraphy of these works, Ou-yang, a staunch Confucian, was uncomfortable with their religious content and reports that he had to struggle to overlook what the calligraphy said in order to appreciate its aesthetic beauty.[31]

Other traces of how the text of a work of calligraphy interfered with its enjoyment can be found in the Elliott Collection. *Epitaph for Madam Han (Han shih mu-chih ming)* by Chu Yün-ming (1461–1527) was originally a hanging scroll, but a later collector, who felt uncomfortable displaying a mortuary text from a family he did not know, tactfully cut up the scroll and remounted it as a small album that could be taken out and viewed from time to time (fig. 1).[32] In this case, the content of a work of calligraphy ultimately led to its physical transformation.

This evidence for the compulsion to read calligraphic texts documented by psychological experiments and by historical anecdotes comes as no surprise to anyone who has visited a museum gallery in China in which museum-goers are viewing calligraphy. Inevitably, the gallery echoes with voices reading aloud. These sounds recall advice given by the philosopher Chu Hsi (1130–1200), who proposed that one should "read character by character, in a loud voice, without making mistakes in the characters, without jumping over them or adding to them, without reversing them, and without forcing oneself to retain them."[33] In addition to reading aloud, Chinese viewers standing in front of works of calligraphy, especially large hanging scrolls or works in cursive script, can often be seen gesturing with pointing fingers, as if punctuating texts in mid-air.

CALLIGRAPHY, TEXTS, AND ART HISTORY

Throughout the history of calligraphy, reading texts has been as much a part of the experience of this art as has savoring fine brushwork. But because of certain underlying assumptions that took shape as calligraphy came to be regarded as an art form, the experience of reading and the significance of texts never received the type of exhaustive analysis accorded to topics such as

都察院右副都御史毛公妻前封孺
人韓氏墓誌銘

資　　　　　大夫南
詔京禮部尚書
理前許有疾部左調
部戶

侍右總中隸
郎都副中總督漕府
順順運無錫邵
御察院實撰蘇前
史督漕運無錫邵州
府知南

其子錫朋以公命介其姊之夫太學
生秦銳奉京兆祝君希哲狀來徵銘
寶久辱公知公之外孫秦汝季女
垆也公屬我我其甦不諾諸
孺人姓韓氏世為吳人父瑄母王
人生有淑寶公考贈給事中桂

軒府君知其賢也為公聘焉笄而來
歸事府君暨何太孺人婦道飭脩期
年舅沒獨奉姑者十年時公游宦
犀志遠功勤何日綜生業外裁製
庖饋皆必手出一不以關白日無擾
公學公得窮研經史博討世用以學

Figure 1. Chu Yün-ming (1461–1527), *Epitaph for Madam Han*, 1526, album, ink on paper, 26.0 x 12.9 cm. The Art Museum, Princeton University, bequest of John B. Elliott.

Figure 2. Mi Fu (1052–1107), *Poem Written in a Boat on the Wu River* (detail), ca. 1100, handscroll, ink on paper, 31.3 x 559.8 cm. The Metropolitan Museum of Art, New York.

script types and brushwork in the vast and sophisticated body of traditional writings on calligraphy. For the modern art historian, calligraphy presents an unusually complex object of study since, as Johanna Drucker has noted of typography, it "refuses to resolve into either a visual or a verbal mode."[34]

In China today, traditions of connoisseurship and aesthetic appreciation still exercise a powerful hold over the way calligraphy is studied. Although many scholars are exploring the wider cultural significance of this art, problems raised by the textual content of calligraphy and the experience of reading still await systematic study.[35] This may be in part because scholars who grow up with the Chinese language and receive rigorous training in literature and philology find the texts of works of calligraphy—which often are well-known poems, essays, and aphorisms—so familiar as to require little comment.

In Western scholarship on Chinese calligraphy, texts are often translated to make them accessible to a wide readership, but this labor of translation has not yet become part of a larger history of the interaction of literature and calligraphy.[36] Western publications also have called attention to the relationship between the meanings of individual characters and the forms in which they are written. A favorite example is the character *chan,* or "battle," in *Poem Written in a Boat on the Wu River (Wu-chiang chou-chung shih;* fig. 2) by Mi Fu (1052–1107).[37] Here Mi Fu enlarges the character and writes it with a gestural force that complements his use of the word to describe the efforts of boatmen struggling to dislodge a craft stuck on the river bottom. Although this passage in Mi Fu's scroll vividly demonstrates how the meaning of a character and its visual presentation can be closely interrelated, such effects are actually rare in Chinese calligraphy.[38]

Western scholarship has also been shaped in subtle ways by phenomena unique to the historical moment at which the study and collecting of Chinese calligraphy began seriously, especially in the United States, in the decades following World War II. During this period the discipline of art history was dominated by formalist methodologies well suited for analysis of the endlessly varied but controlled shapes of brush-written Chinese characters. At the same time, abstract expressionism emerged as the dominant form of contemporary art. With eyes prepared by the experience of this new art, scholars, collectors, and members of the museum-going public found in Chinese calligraphy (and in the calligraphic brushwork of literati painting) new sources of visual excitement that now looked strikingly familiar.[39] Effects of speed, energy, and force, as well as the sense of physical movement and gestural expression in calligraphy seemed remarkably similar to phenomena in abstract paintings by Jackson Pollock, Willem de Kooning, Franz Joseph Kline, and others. John Crawford, Jr., a pioneering Western collector of Chinese calligraphy, was well aware of how knowledge of abstract painting informed responses to his collection. He once pointed out that "young people often appreciate the calligraphy more than the painting because they were brought up with abstraction in art. They're used to it and can follow its rhythms and pulse."[40]

For scholars and curators hoping to introduce Chinese calligraphy to Western audiences, the torrent of critical writing on abstract expressionism provided, even long after the heyday of this movement had passed, a discourse through which people who could not read calligraphy could discuss it intelligently. Responding to a large exhibition of calligraphy presented at the Yale University Art Gallery in 1977, one critic proposed looking at calligraphy as one would look at a modern Western painting—as a "building up of form complexes." This same critic pointed out that the exhibition helped Western viewers "see Chinese calligraphy as one of the most advanced manifestations of pure visual abstraction."[41] A few years earlier, at the time of the first major exhibition of calligraphy at the Metropolitan Museum of Art, a scholar writing in the museum's bulletin pointed out that insofar as calligraphy is an art, "it exists as such outside the realm of verbal content."[42] It is perhaps ironic that one of the Western commentators to voice doubts about such assertions was the abstract artist whose work was most closely associated with East Asian calligraphy—Mark Tobey. He once remarked to a critic that "without knowing the language or at least having a reading knowledge, our understanding of Chinese calligraphy, to say the least, is limited."[43]

The works of calligraphy in the Elliott Collection, dating from the fourth through the twentieth century, include Buddhist sutras copied by anonymous scribes, transcriptions of literary masterpieces, original compositions by poets and scholars, and personal letters. Written in many different script types and in a wide

array of calligraphic styles, these scrolls and albums served as signifiers of imperial power, tokens of private friendship, and displays of erudition and skill. But as Tobey's statement reminds us, what they and all works of calligraphy share is their status as written communication: all were intended to be read. Organized around examples from the Elliott Collection, the remainder of this essay explores some of the ways through which the dynamic relationship between the processes of writing and reading calligraphy have shaped the history of this art.

PROBLEMS OF CONTENT, FORMAT, AND SCRIPT IN THE STELE AND SUTRA

In a painting attributed to Kuo Hsi (ca. 1000–ca. 1090), two men stand in front of a stele sheltered by ancient pines and framed by other weathered and contorted trees (fig. 3). While one man gazes at the stele, the other points toward it, as if commenting on the text of the monument. These figures are depicted in the act of responding to calligraphy in a format that for nearly two thousand years signified authority, permanence, and orthodoxy.

Although stone monuments bearing engraved characters appeared during the Eastern Chou period (770–256 B.C.), the stele assumed its classic form in the Han dynasty: a large rectangular monolith, often capped by a decorative carved top and resting on a stone base carved in the form of a gigantic tortoise.[44] Stone slabs buried in tombs, plaques or walls at the sites of Buddhist cave chapels, and cliffs or boulders were other important formats for epigraphy, but the stele, through its imposing physical form and its close association with the power of the state, religious institutions, and illustrious families, acquired a unique importance in China as a bearer of engraved writing.

The physical dimensions and orientation of the stele impose protocols of reading on those who approach its polished and engraved surface. Looming vertically, the stone echoes but dwarfs the body of the reader, who normally is standing up, with head raised, to decipher the writing. Although the stele is a type of monument, not a genre of writing, it has generally been reserved for certain types of texts, the contents of which are suggested by the titles of famous examples: *Ritual Vessels Stele at the Temple of Confucius (K'ung-miao*

Figure 3. Attributed to Kuo Hsi (ca . 1000–1090), *Reading a Stele,* hanging scroll, ink on silk, 164.4 x 119.0 cm. National Palace Museum, Taipei, Taiwan, Republic of China.

li-ch'i pei), The Stone Classics (Shih ching), Stele of the To-pao Pagoda (To-pao-t'a pei), and *Stele of the Yen Family (Yen-shih chia-miao pei).* These texts intended for public readership asserted orthodox visions of history, religious doctrine, and self-generated records of genealogy and ancestral achievement.

Inscriptions on stelae demonstrate some of the ways through which the formal, nonsemantic properties of calligraphy structure the way a text is read. The most basic of these include the scale of writing and the organization of the characters on the stone surface. These are apparent in *Stele for the Hsüan-mi Pagoda (Hsüan-mi-t'a pei;* fig. 4), written in 841 by the eminent T'ang calligrapher Liu Kung-ch'üan (778–865). The heading of the stele (*pei-o*) is in larger characters than the text

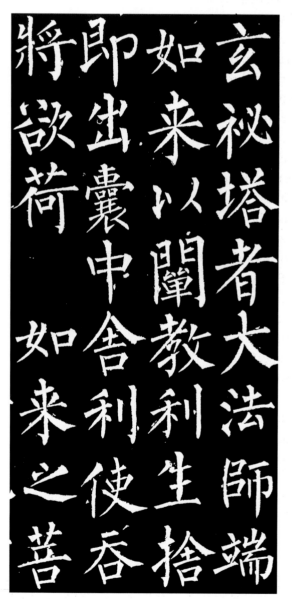

below and attracts the eye first.[45] The use of seal script (*chuan-shu*) for the heading also sets off this part of the inscription from the body of the text: out of use for everyday writing at least since the Han dynasty, this script type was reserved, as its names suggests, for seals or for other contexts in which a deliberately archaizing effect was desired to confer on a piece of writing an air of authority and formality, rather like the effect created by archaic scripts used for the mastheads of newspapers today. In his transcription of *Record of the Miao-yen Monastery* (cat. 11), intended to be engraved on a stele, Chao Meng-fu (1254–1322) also wrote the title in large seal-script characters, which would appear at the top of the stone.

Figure 4. Liu Kung-ch'üan (778–865), *Stele for the Hsüan-mi Pagoda*, 841, rubbing. From *Seian hirin shodō geijutsu* (Tokyo: Kodansha, 1979), pl. 158.

Figure 5. Detail of figure 4. From *Seian hirin shodō geijutsu*, pl. 159.

The body of the stele text written out by Liu Kung-ch'üan and transferred to the surface of the stele appears in highly ordered columns and rows of characters. Visually, this arrangement encourages a steady, even pace of reading. Although stele inscriptions generally did not include punctuation, conventions such as leaving blank spaces before a proper name to indicate respect guide the reader's eye and convey meaning through layout alone.

The overall design of a stele inscription is orderly and balanced, and the script types normally used for these texts create complementary effects. Although earlier stone engravings, such as the inscriptions on Mount T'ai erected by Ch'in Shih-huang-ti (r. 221–210 B.C.), were done in seal script, stone inscriptions of the Han dynasty were written almost exclusively in clerical script (li-shu), which features blocky characters accented by flaring diagonal strokes. The gradual transformation of this script type into standard script can be traced through monumental inscriptions that were transferred from brushwritten originals on silk or paper and engraved on the surfaces of stelae. In the classic stele inscriptions of the T'ang dynasty (618–907), such as those by Liu Kung-ch'üan, which still serve as models of standard script (fig. 5), each character is a stable, architectonic unit. Within individual characters the rhythmic alternations of thick and thin strokes and the carefully articulated turns and hooks create forms imbued with a sense of discipline and energy. From the T'ang dynasty down to the present day, when commemorative stelae continue to be erected, standard script has remained the form of writing used almost exclusively for these texts.[46]

The expectation that a stele inscription should be in standard script was fostered not only through encounters with actual monuments, but even more through the production, collection, and study of rubbings.[47] Through the dissemination of rubbings, stele inscriptions became an essential part of the pedagogy of calligraphy, serving as models emulated by beginning calligraphers who not only mastered the carefully balanced forms of the characters but also learned the texts by heart, often before they were old enough to fully comprehend the meanings of the characters. Although the easy legibility of standard script made it popular for use in many other contexts—such as shop signs, insignia on clothing, printed books, and, today, subtitles on film and television screens (for which the style of Liu Kung-ch'üan is especially popular)—the intimate connection between the stele and standard-script calligraphy greatly enhanced the prestige of this form for writing, preferred for almost all formal contexts.

Buddhist sutras imposed conventions of writing and reading even more rigorous than those that governed the production of stelae.[48] The act of personally writing out or commissioning the transcription of a sutra, like the act of reciting it, was a means of acquiring Buddhist merit, and the religious efficacy of a scripture was believed to reside in the physical artifact of the transcription itself. In many cases the person carrying out the work of transcribing a sutra performed rituals of purification and observed days of fasting and abstinence before sitting down to write.

By the seventh century a form of small standard script loosely called "sutra writing style" (hsieh-ching t'i) became all but universal for the transcription of sutras in China. A section of the Mahāprajñāpāramitā Sūtra, dated 674, in the Elliott Collection (cat. no. 4) provides a classic example of sutra transcription from a golden age of Buddhism in China. Divided into neat columns, most of seventeen characters each, the layout of the text, like that of a stele inscription, promotes orderly, regularly paced reading. Examples of sutras transcribed in other script types are not unknown, however. Among these are two examples in running-cursive script discovered at Tun-huang.[49] The famous Yüan dynasty artist Wu Chen (1280–1354) also once transcribed the Heart Sutra in cursive script.[50] Although no Buddhist doctrine prescribes the use of specific scripts, readers were uneasy with experiments such as Wu Chen's. Commenting on another sutra transcribed in cursive script, Yu T'ung (1618–1704), argued that "the various styles of calligraphy [other than standard] should not be used for writing out sutras."[51]

The vast majority of Buddhist texts that circulated in China during the T'ang and later dynasties were from the brushes of professional scribes; although their names sometimes appear on the sutras they transcribed, most of these calligraphers were low-ranking government employees, free-lance professional calligraphers, or long-forgotten Buddhist monks. But laymen who were also distinguished calligraphers transcribed sutras as acts of piety, which Jean-Pierre Drège terms "votive copying."[52] Although they were

not subject to the same institutional constraints, these writers generally abided by the tacit rules that professional scribes were expected to observe. The copy of the *Diamond Sutra* (cat. no. 10) transcribed by the scholar and lay Buddhist Chang Chi-chih (1186–1266) in memory of his father is an example of this type of private devotional writing. Chang's transcription of the sutra displays strong contrasts of thick and thin strokes that are characteristic subtleties of his personal style, but the neat precision of the writing and the orderly arrangement of columns reflect the centuries-old decorum of sutra transcription.[53] Later transcriptions of sutras made by laymen continued to use the same script type and layout codified, like the conventions governing stele inscriptions, during the T'ang dynasty.

CLASSICAL LITERATURE AND REPRESENTATIONS OF TEXTS

The texts of stele inscriptions and Buddhist sutras imposed on calligraphers and readers expectations shaped by religious, political, and social conventions, and the variations of script within these genres were relatively limited and predictable. But the vast corpus of classical poems and essays that a well-educated reader could recite by heart seems to have freed calligraphers to write as they pleased. Encountering transcriptions of these texts, a reader not so much discovers as recalls the words—reflecting the central role of memorization in traditional Chinese education.[54] Although most of this literature was readily available in printed editions by the Ming dynasty (1368–1644), calligraphers continued to transcribe literary classics in a seemingly limitless range of styles, producing what Drège calls "calligraphic copies" intended to display the skill of the calligrapher. Transcriptions of old favorites such as the two "Prose Poems on the Red Cliff" (*Ch'ih-pi fu*) by Su Shih (1037–1101) appear in everything from neat, trim, small standard script, seen in a transcription by Wen Cheng-ming (1470–1559; fig. 6), to wildly cursive versions, such as Chu Yün-ming's exuberant scroll (fig. 7).

The text of *The Red Cliff* in standard script consists of small characters of uniform size arranged in orderly columns. Within the individual characters most of the strokes are horizontal or vertical lines that vary little in

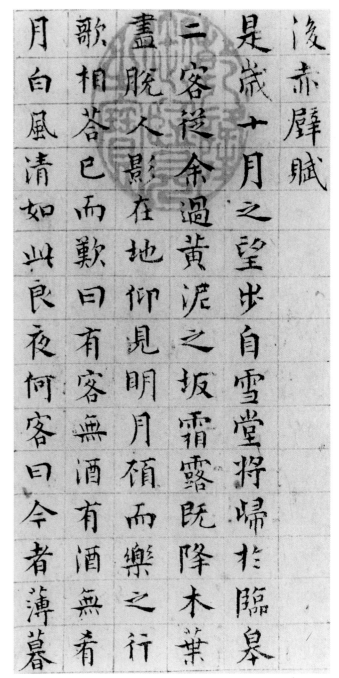

Figure 6. Wen Cheng-ming (1470–1559), *Second Prose Poem on the Red Cliff by Su Shih* (detail), 1556, album leaf, ink on paper, 16.0 x 7.6 cm. National Palace Museum, Taipei, Taiwan, Republic of China.

thickness. In the cursive-script transcription the characters vary greatly in size, expanding and contracting freely. There is also little sense of horizontal and vertical axes governing the placement of the strokes, which are dominated by rounded forms. In some passages the characters seem to fuse into continuous patterns moving both down and across the surface of the scroll. The difficulty that even a seasoned reader of cursive script may have in deciphering the characters is lessened by the fact that such a person would almost certainly know the text of Su Shih's prose poem by heart.

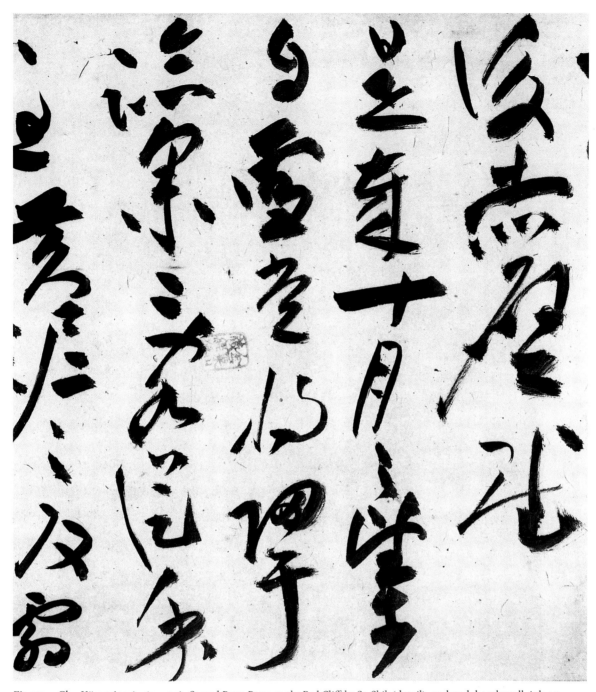

Figure 7. Chu Yün-ming (1461–1527), *Second Prose Poem on the Red Cliff by Su Shih* (detail), undated, handscroll, ink on paper, 31.3 x 1001.7 cm. Shanghai Museum.

The two transcriptions confront the reader with what Chartier calls different "representations" of the same text.[55] They comprise the same lexical items, but visually they are very different. The contrast between these two versions of "The Red Cliff" could be used to illustrate a challenging statement made by the Russian poets Velmir Khlebnikov and Alexei Kruchenyk: "A word written in one particular handwriting or set in a particular typeface is totally distinct from the same word in different lettering."[56] A reader may intuitively sense the correctness of this claim, but arriving at a

way to characterize the role of contrasting script types in producing meaning is extraordinarily difficult, above all because there is no sound theoretical basis for such discussion.

An approach grounded in the psychology of art might use the two transcriptions to demonstrate how contrasting abstract forms produce contrasting impressions in a reader's mind—calm detachment, perhaps, for the standard script version versus restless agitation for the cursive script. Although this approach to analyzing the differences between the two transcrip-

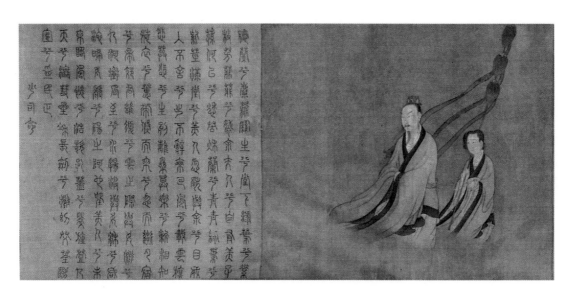

Figure 8. Anonymous (formerly attributed to Chang Tun-li, fl. late 12th century), *"The Nine Songs" of Ch'ü Yüan* (detail), 13th century, handscroll, ink and color on silk, 24.7 x 608.5 cm. Archibald Cary Coolidge Fund, courtesy of Museum of Fine Arts, Boston.

Figure 9. Chu Yün-ming, *First Memorial on Sending Forth the Army* (detail), 1514, handscroll, ink on paper, 22.0 x 102.5 cm. Tokyo National Museum.

Figure 10. Chung Yu (151–230), *Memorial on an Announcement to Sun Ch'üan* (detail), 221, rubbing. From *Shodō zenshū*, n.s. (Tokyo: Heibonsha, 1965), 3: pl. 107.

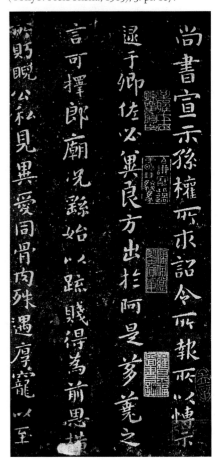

tions revives the problematic notion that calligraphy is an abstract art perceived without the interference of language, evidence from psychological experiments does reveal striking consistency among subjects asked to associate abstract patterns of lines with moods or affective qualities indicated by words such as "sad," "merry," "furious," or "gentle."[57] Studies of this type also display considerable homogeneity of responses among subjects from different cultures.[58]

An interpretation shaped by traditional Chinese theories that view art as a means of self-expression might point to differences of mood or personality reflected in the two transcriptions of "The Red Cliff." Chu Yün-ming's friend Wang Ch'ung (1494–1533), for example, attributed Chu's penchant for writing in "wild-cursive" (k'uang-ts'ao) script to the freedom it gave him to express his personality, which was "bold and direct, impatient of strictness and reserve."[59] From this point of view, in his cursive-script version of "The Red Cliff," Chu Yün-ming was simply being himself, and reading Su Shih's words in Chu's most characteristic calligraphy allows the reader to experience the text through the calligrapher's own sensibility. By the same token, Wen Cheng-ming's prim small-standard script might be thought to reflect what is known to be his fastidious and rather straight-laced personality, though from time to time Wen also wrote in more cursive styles.

One difficulty with these approaches is that they do not acknowledge how a reader's awareness of the history of calligraphy shapes perceptions of the two versions of "The Red Cliff." Confronted by Chu Yün-ming's transcription, a reader familiar with the history and aesthetics of Chinese calligraphy brings to the experience of reading the text awareness of enduring cultural, artistic, and psychological associations that are part of the lore of cursive script. For such a reader, the cursive script "Red Cliff" takes its place in a lineage of calligraphy notable for feats of improvisatory brilliance, wine-inspired spontaneity, and direct externalization of powerful psychic states. The term "wild-cursive" used to describe the form of script Chu Yün-ming uses in his transcription is itself an aesthetic construct that shapes perception of the text.[60] In contrast, the small-standard-script version by Wen Cheng-ming carries with it memories of the long tradition of formal, orderly calligraphy used for texts such as sutras or stele inscriptions.

In some cases the format in which a text appeared governed the selection of scripts or styles that evoked quite specific historically informed responses in the reader. One literary classic that generally imposed few restraints on calligraphers who copied it out was "The Nine Songs" (Chiu ko), a collection of shamanistic chants attributed to Ch'ü Yüan (343–278 B.C.). In a handscroll from the Elliott Collection (cat. no. 29), Wang Ch'ung wrote out these ancient poems in a mixture of standard and draft-cursive (chang-ts'ao) script that he also used for many other texts during his busy career as a leading calligrapher in sixteenth-century Soochow. But when calligraphers transcribed the text of "The Nine Songs" to accompany painted illustrations of these poems, they often selected archaic script types. In a scroll datable to the thirteenth century (fig. 8), the anonymous calligrapher transcribed the text in carefully rendered seal-script characters, clearly expecting that this form of writing would enhance the sense of antiquity evoked by the pictorial images of gods and spirits mentioned in the text.

In his analysis of Chu Yün-ming's transcription of "Memorial on Sending Forth the Army" (Ch'u-shih piao), Christian Murck has called attention to the use of an archaic calligraphic form to evoke a historical period in which a text originated (fig. 9). When Chu Yün-ming transcribed the text of this memorial by Chu-ko Liang (181–234) to accompany a portrait of this great strategist, he used the squat characters and blunt brushstrokes associated with the small-standard-script style of Chu-ko's contemporary, the calligrapher Chung Yu (151–230; fig. 10). Murck argues that Chu Yün-ming made this stylistic choice to evoke memories of the Three Kingdoms period (220–80), famous for its boldly outspoken ministers and larger-than-life heroes, and to subtly suggest a contrast between that era and his own day, "a period of superficial order increasingly disturbed by social and intellectual change and the gradual corruption of political life at its center, the imperial court."[61]

Every act of writing demands that the calligrapher choose one script type or style rather than another, and, as the examples introduced thus far show, the content of a text, as well as the format or setting in which it was to appear, could shape these choices. A text that seems to have been open to transcription in the widest range of visual forms was "The Thousand Character Essay" (Ch'ien-tzu wen). Composed in the

Figure 11. Yü Ho (1307–1382), *Essay on Yüeh I* 1360 (cat. no 16, detail).

Figure 12. Wang Hsi-chih (303–361), *Essay on Yüeh I* (detail), 348, rubbing. From *Shodō zenshū*, n.s,. 4: pl. 1.

sixth century by Chou Hsing-ssu (d. 520), this text originated as a tour de force of literary cleverness using one thousand different characters selected from works of calligraphy by Wang Hsi-chih. It served for many centuries as a reading primer that introduced useful information and moral precepts in easily memorized, four-character phrases. The "Essay" was so well known that the characters composing it were used as an easily remembered numbering system. Examples of this practice appear on objects from Ming dynasty collections, including paintings and calligraphy owned by Hsiang Yüan-pien (1525–1590). In the Ch'ing dynasty (1644–1912), characters from "The Thousand Character Essay" were used to identify cubicles in examination halls.[62]

There are versions of "The Thousand Character Essay" from the T'ang dynasty onward in every known script type. Chao Meng-fu alone produced transcriptions in seal, clerical, draft-cursive, modern cursive, and standard script.[63] Wen Cheng-ming may have

been the all-time champion of writing out this text. He claimed that during his youth he copied two printed editions of the work every day, concentrating especially on clerical script. His friend Chou T'ien-ch'iu (1514–1595) noted that Wen had made several hundred copies of the text.[64] A transcription of the "Essay" in the Elliott Collection by Wen's younger contemporary Wang Ku-hsiang (1501–1568) displays the strong influence of Wen's running-script calligraphy (cat. no. 30).

The freedom of selecting writing styles that "The Thousand Character Essay" encouraged placed it at the opposite end of the spectrum from stele inscriptions and Buddhist sutras, for which only a narrow range of calligraphic forms were acceptable. The "Essay" was transcribed so often as a writing exercise that the text itself may be thought to have disappeared into the calligraphy: that is, the text was so well known that it is doubtful that anybody paid much attention to what it said, accepting it simply as a format for the display of calligraphic skill. Nevertheless,

a *mistake* in the transcription would disturb a Chinese reader just as much as a garbled transcription of the alphabet by a schoolchild might disturb a reader in the West. Even in the case of this familiar writing exercise, the text never goes away.

PRIME OBJECTS: TEXTS AND STYLES

A second type of transcription common in the history of calligraphy involves not only writing out a pre-existing text but also reproducing what can be called a "prime object," a unique embodiment of a text accorded canonical status in the history of calligraphy. The process of copying is, of course, the very foundation of learning how to write: all calligraphers begin their training by faithfully reproducing earlier works, and these models, like all calligraphy, can only be representations of a text. But the labor of copying did

not end even when a mature calligrapher developed a personal style. Produced by expert calligraphers, transcriptions were far more than simply writing exercises: they disseminated canonical masterpieces through the process of reproduction and also displayed the calligraphers' technical skill and insight into the history of calligraphy. But even within this process of reproducing prime objects, the contents of texts could assert their own tacit rules.

Consider Yü Ho's (1307–1382) copy of *Essay on Yüeh I* in the Elliott Collection (fig. 11; cat. no. 16). Written in 1360, this short handscroll reproduces the calligraphy of Wang Hsi-chih's own transcription in small standard script of an essay by Hsia-hou Hsüan (209–254; fig. 12). The text discusses the virtuous conduct of Yüeh I, a general of the Warring States period who defected from the state of Yen, which he had served loyally, after losing the confidence of his ruler. Yü Ho titled his scroll *Copying the Essay on Yüeh I* (*Lin Yüeh I lun*),

Figure 13. Tung Ch'i-ch'ang (1555–1636), *Essay on Yüeh I* (detail), 1620, handscroll, ink on paper, 26.0 x 22.5 cm. Kwangtung Provincial Museum. From Hsieh Chih-liu and Liu Chiu-an, eds., *Chung-kuo mei-shu ch'üan-chi, Shu-fa chuan-k'o pien* (Shanghai: Shang-hai shu-hua ch'u-pan-she, 1989), 5: pl. 119.

Figure 14. The Ch'ien-lung emperor (r. 1736–95), *Essay on Yüeh I* (detail), inscription dated 1751, handscroll, ink on paper, 74.0 x 146.0 cm. Kwangtung Provincial Museum. From *Chung-kuo mei-shu ch'üan-chi, Shu-fa chuan-k'o pien*, 6: pl. 100.

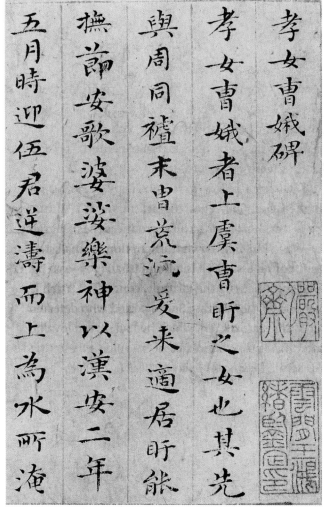

Figure 15. Chu Yün-ming (1461–1527), *Stele for the Filial Daughter Ts'ao O,* 1507 (cat. no. 24, detail).

Figure 16. Wang Hsi-chih (303–361), *Stele for the Filial Daughter Ts'ao O* (detail), rubbing. From *Shodō zenshū,* n.s,. 4: pl. 10.

indicating that he was reproducing a specific model, possibly a rubbing once owned by Chao Meng-fu.[65] Although Yü Ho's copy of the essay introduces his own abbreviations and linkages between strokes, there is no doubt that his intention was to recreate the appearance of Wang Hsi-chih's original characters. Tung Ch'i-ch'ang (1555–1636) did the same in his copy of the text (fig. 13), and the Ch'ien-lung emperor (r. 1736–95) also played by the rules in his (fig. 14).

Chu Yün-ming's copy of *Stele for the Filial Daughter Ts'ao O* (fig. 15, cat. no. 24) displays a similar relationship with its model, another famous work in small standard script by Wang Hsi-chih (fig. 16). The text describes the virtuous behavior of a distraught young girl who threw herself into the river in which her father had drowned. Although Chu's calligraphy displays the more rounded brushwork and squat proportions of characters seen in his own distinctive style,

which was based on the calligraphy of Chung Yu, he reproduces the configurations of strokes in the Wang Hsi-chih model with considerable care, as if acknowledging this work's status as a revered calligraphic model.

Once Wang Hsi-chih wrote these two texts, they *stayed* written: although there may be examples I have overlooked, when later calligraphers wrote out the *Essay on Yüeh I* or *Stele for the Filial Daughter Ts'ao O,* they recreated these texts in a particular script type and style that were thought to have originated with Wang Hsi-chih's own transcriptions. But calligraphers took surprising liberties with the most famous of all prime objects in the history of calligraphy, Wang Hsi-chih's *Preface to the Orchid Pavilion Collection (Lan-t'ing chi hsü;* fig. 17). Although this work was known only through rubbings and ink-written copies, none dating from earlier than the T'ang dynasty, they preserve a

surprisingly uniform image of the text as a mixture of running and standard script.[66] To copy this text, as countless millions of calligraphers have done, was to reproduce, in varying degrees of faithfulness, the most famous work of art in Chinese history.

"Copying" is a clumsy English term for processes that are subtly different in Chinese terminology: *mo,* to trace; *lin,* to copy freehand; and *fang,* to imitate in a freer manner.[67] The *Preface* was reproduced in all these ways, but none of these terms seems applicable to a version of the text engraved on an inkstone (fig. 18). Here, the tidy standard-script characters look more like a stele inscription than like Wang Hsi-chih's famously casual essay.[68] The *Preface* even appears engraved on a seal in archaic seal script (fig. 19) completely unrelated to the canonical embodiment of the *Preface* known through the T'ang dynasty copies.

A massive hanging scroll by Wang To (1592–1652) presents a different type of calligraphic transformation of prime objects (cat. no. 33). Here, the models for the calligraphy were letters by Wang Hsi-chih that Wang To knew through rubbings not much larger than an average-sized greeting card.[69] What began as the texts of private correspondence became in Wang To's hands a springboard for a monumental display of calligraphic invention, only tenuously related to the original writing by Wang Hsi-chih.

From these examples of copies of works by Wang Hsi-chih some preliminary conclusions can be drawn concerning the conventions that governed the reproduction of calligraphic texts. *Essay on Yüeh I* and *Stele for the Filial Daughter Ts'ao O* were not only models of

Figure 17. Wang Hsi-chih (303–361), *Preface to the Orchid Pavilion Collection* (detail), 353, rubbing of the Ting-wu version. From *Shodō zenshū*, n.s., 4: pl. 24.

Figure 18. Anonymous, *Preface to the Orchid Pavilion Collection,* 1554, engraved inkstone. Private collection. From Mayching Kao, ed., *The Quintessential Purple Stone: Duan Inkstones through the Ages* (Hong Kong: The Art Gallery, Chinese University of Hong Kong, 1991), 7, fig. 20.

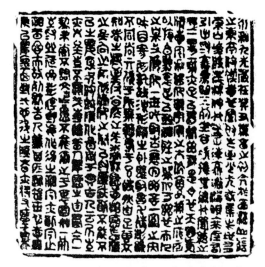

Figure 19. Anonymous, *Preface to the Orchid Pavilion Collection,* undated, engraved seal, dimensions unavailable. Private collection. From *Shōwa kichu rantei ten zuroku* (Tokyo: Goto Museum, 1973), 130.

Figure 20. Yen Chen-ch'ing (709–785), *Draft of a Eulogy for a Nephew,* 758, handscroll, ink on paper, 28.2 x 75.5 cm. National Palace Museum, Taipei, Taiwan, Republic of China.

small-standard-script calligraphy; they were also texts that dealt with matters of high moral seriousness: the loyalty of a subject to his ruler and the filial devotion of a child to her father. Transcribed by Wang Hsi-chih in standard script normally used for stelae, sutras, and other formal documents, the two texts remained tied to this script type. The content of *Preface to the Orchid Pavilion Collection* was very different. Although it concludes with a melancholy reflection on the transience of life, the text is a celebration of a literary gathering at which much wine was consumed and many poems were written. Transcribing this text, calligraphers apparently felt free to treat it as a vehicle for the exploration of different scripts and styles of writing, including inscriptions on works of decorative art, much as Su Shih's "Red Cliff" was transcribed in a variety of calligraphic forms. In the case of the Wang Hsi-chih letters transformed by Wang To, the contents of these works, like that of the *Preface,* imposed none of the restraints that a eulogy or stele text required in the decorum of textual transcription.

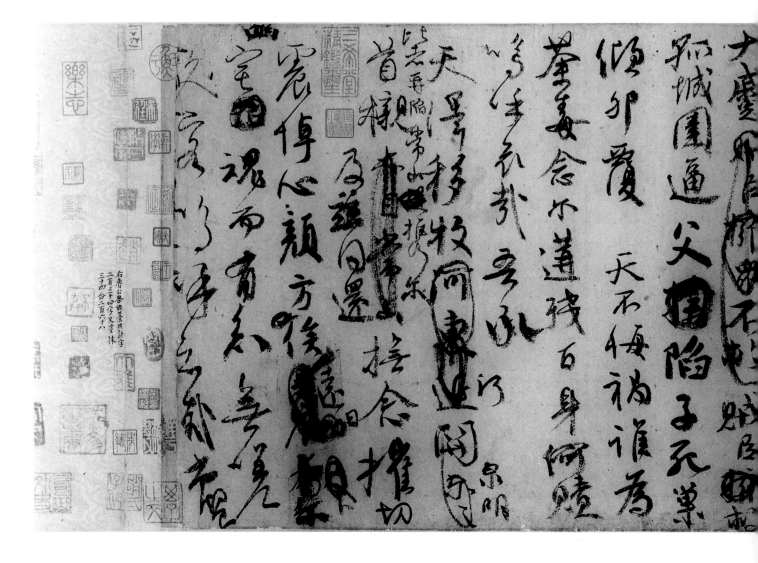

CALLIGRAPHY, TEXTS, AND SELF-EXPRESSION

No theme in Chinese historical and critical writings on calligraphy has been articulated more often or through a wider range of metaphoric and rhetorical devices than the idea that calligraphy reveals the nature of a writer's personality and temperament. This view, which we encountered in Wang Ch'ung's comments on cursive script by his friend Chu Yün-ming, is summed up in the popular saying "Writing is like the person" (*Tzu ju ch'i jen*). Mental agitation or derangement, drunkenness, and ill health also are believed to be reflected in eccentric or forceful brushwork, wild splatterings of ink, or feeble, emaciated lines. One guide to the relationship between human feelings and their external, visual expression appears among Chu Yün-ming's statements about calligraphy:

> When one is pleased, then the spirit is harmonious and the characters are expansive.
> When one is angry, the spirit is coarse and the characters are blocked.
> When one is sad, the spirit is pent up and the characters are held back.
> When one is joyous, the spirit is peaceful and the characters are beautiful.[70]

Although the interpretative strategy epitomized by this statement could be applied to any work, when the text in question is an original composition, not a transcription of a preexisting text, the bond between the calligrapher and the representation of the text is assumed to be all the stronger. In many cases a modern reader will discover only through careful research that a text and the calligraphy in which it is written are by the same person, but the original audiences for these works read them in full knowledge that the author and calligrapher were one.

As we have seen, the single most famous work of calligraphy in Chinese history, *Preface to the Orchid Pavilion Collection* by Wang Hsi-chih, was the artist's own literary composition. In this manuscript fluidly brushed running-script characters appear in casually

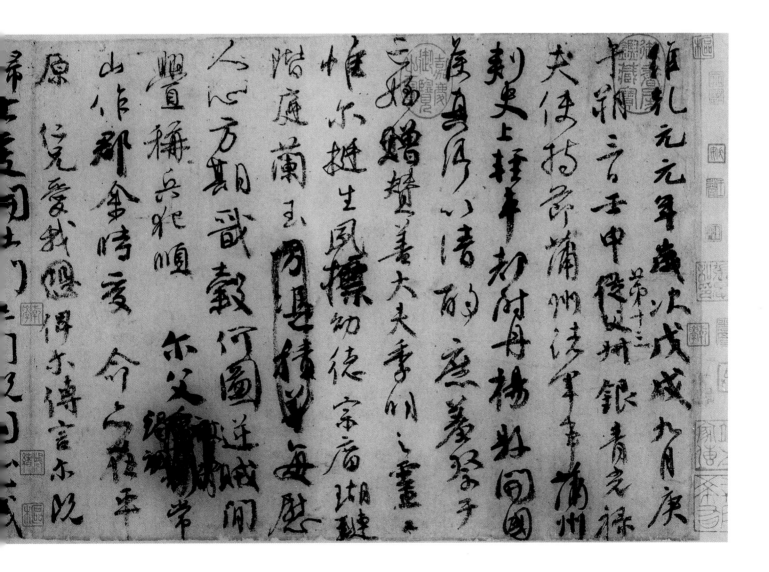

Figure 21. Tung Ch'i-ch'ang (1555–1636), *Colophon for "Ritual to Pray for Good Harvest"* (cat. no. 2; detail), 1609, handscroll, colophon only, 30.3 x 83.8 cm.

aligned columns. In several passages Wang made editorial corrections, crossing out or squeezing in characters as he felt necessary. Far from diminishing the attraction of the *Preface,* his corrections made the calligraphy all the more appealing to connoisseurs, who valued these graphic traces of Wang's mind at work. In the eyes of the T'ang dynasty theorist of calligraphy Sun Kuo-t'ing, when Wang Hsi-chih wrote the manuscript in response to the happy occasion of the gathering, "his thoughts roamed and his spirit soared."[71]

In his *Eulogy for a Nephew* (*Chi chih Chi-ming wen-kao;* fig. 20), Yen Chen-ch'ing (709–785) wrote of tragic events utterly unlike those that inspired Wang Hsi-chih's *Preface.* In 756, during the rebellion of An Lu-shan (703–757), Yen and his cousin, Yen Kao-ch'ing, led troops against the rebel armies in north China. Unfortunately, Yen Kao-ch'ing was captured, and when he refused to submit to the rebels, his son, Chi-ming, was beheaded. In his *Eulogy,* Yen Chen-ch'ing laments the young man's death. Although Yen may have intended to recopy his composition in standard script, in the draft manuscript he mixed rapidly brushed running- and cursive-script characters punctuated visually by

thick, heavy strokes, especially in passages written with a fully inked brush. Circled characters and passages inked out with impatiently scribbled marks make the surface of the manuscript like a battlefield on which Yen struggled to find words to express his anger and grief. The final passage of the text is the most heavily edited and ends in a nearly illegible tangle of cursive-script characters. In the twisting strokes and jabbing attacks on the paper seen in Yen Chen-ch'ing's manuscript, readers have discovered a vivid fusion of calligraphic form and verbal content. In his comments on the manuscript, Ch'en I-tseng (1286–1345) states that in certain lines of the calligraphy he detects "pent-up rage" and in others "bone-deep pain," all pouring out from Yen Chen-ch'ing's brush "with such spontaneity and natural feeling that one is deeply moved."[72]

Theories of the expressive function of calligraphy are remarkably similar to theories of poetry in China, and when a poem appears in the calligraphy of its author the two arts were thought to fuse into a unified externalization of feeling. Focusing on works in the Elliott Collection, an essay in this volume, "The Two

Perfections: Reading Poetry and Calligraphy," deals with interpretative problems raised by the relationship between poetry and calligraphy. It can be noted here, however, that in addition to seeing these integrated works of poetry and calligraphy as revelations of temperament or mood, it is also possible to interpret them as vehicles through which writers consciously manufacture personae, constructing identities for themselves as they wished to be perceived by their readers.[73]

Letters, the subject of Qianshen Bai's essay, also constitute a type of unique composition in which author and calligrapher are one. But unlike poems, which could be written in nearly any format or calligraphic style, letters imposed considerable restraints on their writers. The conventions of formal letter writing demanded that the author-calligrapher observe widely accepted rules that in some ways were as exacting as those that governed the transcription of Buddhist sutras or the production of stele inscriptions. Polite phrasing and the decorum of spacing lines of text and individual characters to indicate respect for the recipient of the letter are observable even in the letters of a great eccentric like Mi Fu (cat. no. 7).

The colophon is another category of writing in which author and calligrapher are the same person. When these inscriptions are added to a work of calligraphy, often on the same piece of paper or silk, the writer responds in the medium and format of the original work.[74] Colophons, like collectors' seals, also have the effect of bracketing or framing the original work and setting it off for display, appreciation, and analysis.

Although brief notes and comments were added to scrolls of painting and calligraphy as early as the Six Dynasties period, it was not until the Sung dynasty (960–1279), especially among the circle of Su Shih and his friends, that colophon writing emerged as a genre of belles lettres in which writers ranged freely over not only artistic matters, but historical, anecdotal, and philosophical issues as well.[75] As they became longer, colophons began to take on the status of independent works of art. Writing a colophon could place a calligrapher in an agonistic relationship with not only the artist of the original work, but also with the writers of other colophons. Long chains of colophons, sometimes spanning many centuries, could thus become displays of subtle competition among writers.

Colophons that accompany *Ritual to Pray for Good Harvest,* a tracing copy of a letter by Wang Hsi-chih in the Elliott Collection (cat. no. 2), range from a simple title piece written by Emperor Hui-tsung to the final colophon by Tung Ch'i-ch'ang, which is a major work of calligraphy in its own right. Perhaps the boldest colophon writer in Chinese history, the Ch'ien-lung emperor also inscribed the scroll several times, placing one of his inscriptions directly to the right of the two columns of Wang Hsi-chih's calligraphy, thus inviting a comparison that a less assertive (or more prudent) calligrapher might have dreaded.[76]

In many cases, the significance of the calligraphic style in which a colophon is written emerges only when its content, its function within the practices of criticism and connoisseurship, and the circumstances of its production are interpreted together. The inscriptions on *Ritual to Pray for Good Harvest* by Tung Ch'i-ch'ang illustrate this phenomenon and provide a final set of examples of how the process of reading calligraphy must be an essential part of its interpretation. Tung Ch'i-ch'ang acquired the letter around the year 1604. He inscribed on it a title piece, a transcription of the text of the letter, and three colophons before the scroll passed into the hands of his friend Wu T'ing

(fl. ca. 1575–1625) sometime before 1614, when Wu included it in an anthology of rubbings taken from works in his collection.[77]

Tung's inscriptions reflect several different types of artistic and intellectual engagement with Wang Hsi-chih's letter. The title piece, written near the opening of the scroll in one line of small standard script, simply duplicates the title written in the early twelfth century by Emperor Hui-tsung. Of far greater interest is Tung Ch'i-ch'ang's transcription of the text of the letter, also in one line of small standard script. Tung's decision to add this transcription to the scroll gives lie to the idea that connoisseurs were indifferent to the text of a piece of calligraphy. Clearly, Tung Ch'i-ch'ang recognized that the cursive-script text of the letter was difficult to interpret and supplied his transcription in order to decipher the characters for other readers.

In his first colophon, Tung quotes the words of Su Shih, written for a piece of calligraphy by Wang Hsien-chih but appropriate, Tung believed, for *Ritual to Pray for Good Harvest* as well: "These two lines and thirteen characters are worth more than ten thousand other scrolls." Following the two lines of this inscription Tung Ch'i-ch'ang added his signature and the phrase "authenticated and inscribed." This notation asserts another function of colophon writing: to certify authenticity. When the scroll entered Tung's collection, its whereabouts since the time of Hui-tsung were a complete mystery. This gap in the history of the transmission of the letter made the authoritative opinion of Tung Ch'i-ch'ang all the more important and inevitably increased the value of the calligraphy.

The content of Tung's next colophon, dated 1604, deals with issues of historical transmission, collecting, connoisseurship, and style—subjects remarkably like those that might be covered in a modern art-historical essay on Wang Hsi-chih's letter. Written in his familiar running script, a form of writing one might think of as Tung's "everyday" hand, the colophon is a businesslike and unexceptional piece of calligraphy.

But in his final colophon (fig. 21), dated 1609, Tung Ch'i-ch'ang created something very different, something that demands to be evaluated by the same aesthetic standards applied to the writing of Wang Hsi-chih himself. Leaving behind dry art-historical information, Tung Ch'i-ch'ang bursts out in rhapsodic praise: "Wherever this scroll is, there must be auspicious clouds hovering over it, but human eyes cannot see them." In large, widely spaced characters that combine elements of standard, running, and cursive script, Tung Ch'i-ch'ang not only praises Wang Hsi-chih's writing by evoking stories about supernatural phenomena associated with famous works of art: in this act of calligraphic boldness, so different from his earlier inscriptions on the scroll, Tung also asserts his own claim to a position in a lineage of great calligraphers extending back to Wang himself.

We can explain this outburst of critical exuberance and calligraphic prowess by considering both the content of the colophon and the information Tung Ch'i-ch'ang gives us about the circumstances under which it was written. In the final section of the colophon Tung records the date on which he wrote it, July 26, surely a sweltering day in southeast China, where he was at the time. Tung also notes that he did the calligraphy while looking at the letter with two other people: Wu T'ing, who later bought the scroll, and Ch'en Chi-ju (1558–1639), Tung's close friend and fellow connoisseur. In other words, Tung Ch'i-ch'ang had an *audience*: his sudden departure from both the empirical commentary and restrained style of his earlier colophons was witnessed, and probably inspired by, two distinguished observers whose presence Tung chose to acknowledge.

It would be hard to imagine a text more unlike the stele inscriptions and Buddhist sutras with which we began this discussion of reading Chinese calligraphy. But just as the calligraphers of works in those genres met expectations generated by texts, so too did Tung Ch'i-ch'ang produce his calligraphy in response to a text, in this case of his own invention, and in response to a particular set of expectations shaped by social and cultural conventions. In the case of Tung's colophon, these conventions were not dictatorial, but they did suggest ways in which a great connoisseur and calligrapher, on the occasion of a literary gathering to admire a fragment of writing by the most famous calligrapher in history, might suitably display his appreciation and his skill with brush and ink in the presence of two learned friends. But we learn this only when, like Tung Ch'i-ch'ang himself trying to decipher the text of Wang Hsi-chih's letter, we read what calligraphy has to tell us.

NOTES

1. Roger Chartier, *Forms and Meanings: Texts, Performances and Audiences from Codex to Computer* (Philadelphia: University of Pennsylvania Press, 1995), 2. Among other important studies of writing, printing, and reading in the West that have been of particular help in the preparation of this essay are the following: Johanna Drucker, *The Visible Word: Experimental Typography and Modern Art, 1909–1923* (Chicago: University of Chicago Press, 1994); D. F. McKenzie, *Bibliography and the Sociology of Texts: The Panizzi Lectures, 1985* (London: British Library, 1985); Henri-Jean Martin, *The History and Power of Writing*, trans. by Lydia G. Cochrane (Chicago and London: University of Chicago Press, 1994); and Alberto Manguel, *The History of Reading* (New York: Viking Press, 1996).

2. For studies of the history of reading in China, see Susan Cherniack, "Book Culture and Textual Transmission in Sung China," *Harvard Journal of Asiatic Studies* 54 (1994): 5–125; and Jean-Pierre Drège, "La lecture et l'écriture en Chine et la xylographie," *Études chinoises* 10, nos. 1–2 (Spring–Autumn 1991): 77–111.

3. Yu-kung Kao, "Chinese Lyric Aesthetics," in Alfreda Murck and Wen C. Fong, eds., *Words and Images: Chinese Poetry, Calligraphy, and Painting* (New York: The Metropolitan Museum of Art, 1991), 70.

4. Over twenty years ago Christian Murck wrote of the need to incorporate the content of texts into the study of calligraphy: "Perhaps it is time to turn the problem around, and ask, what is the significance of the verbal content of a work of calligraphy? This is simply to suggest that the cultural significance of a work of art, its total expression from the point of view of the artist and the cultural setting, often extends beyond formal style" ("Chu Yün-ming [1461–1527]: Problems of Style and Meaning in His Calligraphy," paper presented at the Symposium on Chinese Calligraphy, Yale University, April 8–10, 1977).

5. For a general introduction to the history of Chinese writing, see William Boltz, *The Origin and Early Development of the Chinese Writing System*, American Oriental Series, 78 (New Haven: American Oriental Society, 1994).

6. The vast bibliography on Wang Hsi-chih grows almost monthly. The best general introduction in English remains Lothar Ledderose, *Mi Fu and the Classical Tradition of Chinese Calligraphy* (Princeton: Princeton University Press, 1979). Among important recent studies in Chinese are Hua Jen-te, "Lun Tung-Chin mu-chih chien-chi *Lan-t'ing* lun-pien," *Ku-kung hsüeh-shu chi-k'an* 13, no. 1 (Oct. 1995): 27–62; and Liu T'ao, ed., *Wang Hsi-chih, Wang Hsien-chih*, vols. 18 and 19 in the series *Chung-kuo shu-fa ch'üan-chi* (Peking: Jung-pao-chai, 1991). I am grateful to Qianshen Bai for these references.

7. John Hay, "The Human Body as a Microcosmic Source of Macrocosmic Values in Calligraphy," in Susan Bush and Christian Murck, eds., *Theories of the Arts in China* (Princeton: Princeton University Press, 1983), 74–102.

8. Jonathan Chaves has called attention to this fact in his article "The Legacy of Ts'ang Chieh: The Written Word as Magic," *Oriental Art*, n.s. 23, no. 2 (Summer 1977): 212.

9. Wei Heng, *Ssu t'i shu-shih*, in Huang Chien, ed., *Li-tai shu-fa lun-wen hsüan* (hereafter, *LTSF*) (Shanghai: Shang-hai shu-hua ch'u-pan-she, 1979), 1: 11–17.

10. Yang Hsin, *Ku-lai neng-shu jen-ming*, in *LTSF*, 1: 44–48.

11. Recorded in Chang Yen-yüan, *Fa-shu yao-lu* (*I-shu ts'ung-pien* ed.), 38–43.

12. Robert H. van Gulik, *Chinese Pictorial Art as Viewed by the Connoisseur* (Rome: Instituto Italiano per il Medio ed Estremo Oriente, 1958), 139.

13. This system of organizing calligraphy collections is a good example of how, in the words of Craig Clunas, "different historical and social moments have configured meaning out of the otherwise uncontrollable and promiscuous profusion of things, natural and 'unnatural' " ("Commodities, Collectibles, and Trade Goods: Some Modes of Categorizing Material Culture in Sung-Yüan Texts," in Maxwell K. Hearn and Judith G. Smith, eds., *Arts of the Sung and Yüan* [New York: The Metropolitan Museum of Art, 1996], 45).

14. Hsiung Ping-ming, *Chung-kuo shu-fa li-lun t'i-hsi* (Hong Kong: Shang-wu yin-shu-kuan, 1984), 3.

15. See the essay by Wen C. Fong in this volume. See also the comments of Yu-kung Kao, who argues that "the abstraction of calligraphical art followed when content was no longer a contributing factor (at least not an essential one) to the overall artistic expression" ("Chinese Lyric Aesthetics," 76).

16. Yü Ying-shih, "Individualism and the Neo-Taoist Movement in Wei-Chin China," in Donald J. Munro, ed., *Individualism and Holism: Studies in Confucian and Taoist Values* (Ann Arbor: Center for Chinese Studies, University of Michigan, 1985), 122, cited in Charles Holcombe, *In the Shadow of the Han: Literati Thought and Society at the Beginning of the Southern Dynasties* (Honolulu: University of Hawaii Press, 1994), 4.

17. Holcombe, *In the Shadow of the Han*, 4.

18. Ibid., 13–14.

19. See K. C. Chang, "Writing as the Path to Authority," in his *Art, Myth, and Ritual: The Path to Political Authority in Ancient China* (Cambridge, Mass.: Harvard University Press, 1983), 81–94.

20. Wu Hung, *Monumentality in Early Chinese Art and Architecture* (Stanford: Stanford University Press, 1995), 189–201.

21. Chang Huai-kuan, *Wen-tzu lun*, in *LTSF*, 1: 208–9; see also Nakata Yūjirō ed., *Chūgoku shoron taikei* (hereafter *CST*) (Tokyo: Nigensha, 1977–92), 3: 220.

22. For an introduction to the history of letter writing in China, see the essays by Qianshen Bai and myself in this volume. The role of Taoism in early Six Dynasties calligraphy is the subject of an important study by Lothar Ledderose, "Some Taoist Elements in Calligraphy of the Six Dynasties," *T'oung Pao* 70 (1984): 246–78.

23. For these two letters, *Presenting Oranges* (*Feng chü t'ieh*) and *Disorder during Mourning* (*Sang luan t'ieh*), see *Shodō zenshū*, n.s., (Tokyo: Heibonsha, 1960), 4: pls. 34–35, pp. 28–31.

24. The forms of cursive and running script commonly used in Eastern Chin letters originated as practical abbreviations that facilitated everyday clerical tasks; adopted by elite calligraphers, these forms of writing were valued for the directness with which they recorded the individuality of the writer's hand, especially on the absorbent surface of paper, which had come into common use around A.D. 100. See Craig Clunas, *Art in China* (Oxford and New York: Oxford University Press, 1997), 135. As Clunas notes, the development of cursive script was also related to its use in Taoist practices (136–37). See also Ledderose, "Some Taoist Elements."

25. On the early readership of Eastern Chin letters, see Hua, "Lun Tung-Chin mu-chih." Improvisatory effects in letters

often resulted in texts that were nearly illegible and that imposed considerable interpretative demands on their recipients. These difficulties are addressed in later anthologies of rubbings that include for the convenience of the reader standard-script transcriptions of the texts of letters written in running or cursive script. See, for example, rubbings of letters by Wang Hsi-chih included in the anthology *Ch'eng-ch'ing-t'ang t'ieh,* in *Shodō zenshū,* n.s., 4: pls. 64–66.

26. For a succinct introduction to the problem of modernism and visual experience, see Charles Harrison, "Modernism," in Robert S. Nelson and Richard Shiff, eds., *Critical Terms for Art History* (Chicago and London: University of Chicago Press, 1996), 142–55.

27. Pierre Bourdieu, *The Field of Cultural Production Essays on Art and Literature* (New York: Columbia University Press, 1993), 265.

28. Sun Kuo-t'ing, *Shu-p'u,* in *LTSF,* 1: 124; see also *CST,* 2: 100; trans. in Ch'ung-ho Chang and Hans H. Frankel, *Two Chinese Treatises on Calligraphy* (New Haven and London: Yale University Press, 1995), 1.

29. Chang Huai-kuan, *Wen-tzu lun* , *LTSF,* 1: 209; *CST,* 3: 222.

30. Rumjahn Hoosain, "Perceptual Processes of the Chinese," in Michael Harris Bond, ed., *The Psychology of the Chinese People* (Hong Kong and Oxford: Oxford University Press, 1986), 60. For the study of Chinese readers cited by Hoosain, see I. Biederman and Y. C. Tsao, "On processing Chinese ideographs and English words: some implications from Stroop-test results," *Cognitive Psychology* 11 (1979): 125–32. The findings of Biederman and Tsao have been challenged by Marilyn C. Smith and Kim Krisner in their article "Language and orthography as irrelevant features in colour-word and picture-word Stroop interference," *Quarterly Journal of Experimental Psychology* 34A, no. 1 (Feb. 1982): 153–70.

31. Ou-yang Hsiu, *Ou-yang Hsiu ch'üan-chi* (Peking, 1986), 506; cited in Amy McNair, "Engraved Calligraphy in China: Recension and Reception," *Art Bulletin* 77, no. 1 (March 1995): 112.

32. This information appears in a colophon by Yen Ch'eng (fl. mid-16th century) attached to the album.

33. Chu Hsi, "Chu-tzu tu-shu fa," *chüan* 1: 10b–11a, cited and translated into French in Drège, "La lecture," 97. Reading aloud was also normal in the West until texts began to be produced with separations between words and with punctuation marks (Manguel, *The History of Reading,* 41–53).

34. Drucker, *The Visible Word,* 4.

35. Senior scholars and connoisseurs such as Hsü Pang-ta, Ch'i Kung, and Yang Jen-k'ai continue to publish with undiminished acuity studies that deal with problems of attribution and aesthetics. Among recent Chinese publications that explore social and cultural issues related to calligraphy are the following: Chiang Ch'eng-ch'ing, *Chung-kuo shu-fa ssu-hsiang shih,* in the series *Chung-kuo shu-hsüeh ts'ung-shu* (Changsha: Hu-nan mei-shu ch'u-pan-she, 1994), and, by the same author, *Shu-fa wen-hua ts'ung-t'an* (Hangchow: Che-chiang mei-shu hsüeh-yüan ch'u-pan-she, 1992); Chin K'ai-ch'eng and Wang Yüeh-ch'uan, eds., *Chung-kuo shu-fa wen-hua ta-kuan* (Peking: Pei-ching ta-hsüeh ch'u-pan-she, 1995); and Lu Fu-sheng, *Shu-fa sheng-t'ai lun* (Hangchow: Che-chiang mei-shu hsüeh-yüan ch'u-pan-she, 1992). See also the studies by Hua Jen-te, "Lun Tung-Chin mu chih"; and Liu T'ao, *Wang Hsi-chih.*

36. A recent work that includes extensive translations of calligraphic texts is Peter C. Sturman, *Mi Fu: Style and the Art of Calligraphy in Northern Song China* (New Haven: Yale University Press, 1997).

37. See Wen C. Fong, *Beyond Representation: Chinese Painting and Calligraphy, 8th–14th Century* (New York: The Metropolitan Museum of Art, 1992), 160. See also Jonathan Chaves's discussion of the relationship between the form and meaning of characters in a scroll by Huang T'ing-chien ("The Legacy of Ts'ang Chieh," 213).

38. Peter Sturman suggests that it was precisely this type of word-play that Mi Fu himself found vulgar in the wild-cursive-script writing of certain of his contemporaries (*Mi Fu,* 134).

39. As early as the 1930s Chiang Yee, in the first popular account of Chinese calligraphy published in the West, likened calligraphic forms to pictorial effects in the paintings of surrealist artists such as Hans Arp (*Chinese Calligraphy: An Introduction to Its Aesthetic and Technique,* 2d ed. [London: Methuen & Co., Ltd., 1963], 108). Attempts to explain Chinese calligraphy through comparisons with abstract art are discussed by Richard Curt Kraus in *Brushes with Power: Modern Politics and the Chinese Art of Calligraphy* (Berkeley, Los Angeles, Oxford: University of California Press, 1991), 18–22. See also Chaves, "The Legacy of Ts'ang Chieh," 200.

40. Quoted in Carl Nagin, "The John M. Crawford, Jr. Collection of Calligraphy and Painting in the Metropolitan Museum of Art," part 1, *Oriental Art,* n.s. 31, no. 4 (Winter 1985–86): 437.

41. Joanna Shaw-Eagle, "Traces of the Brush: The Poetry of the Painted Word," *Art News* 76, no. 7 (Sept. 1977): 86.

42. Richard M. Barnhart, "Chinese Calligraphy: The Inner World of the Brush," *Metropolitan Museum of Art Bulletin* 30, no. 5 (April/May 1972), 233.

43. Ulfert Wilke, "Chinese Calligraphy at the Metropolitan," *Art in America* (Sept.–Oct. 1972), 118.

44. For an introduction to the origins of the stele, see *Shodō zenshū,* n.s., 2: 30–36.

45. For a discussion of the signifying power of size relationships, see Meyer Schapiro, "On Some Problems in the Semiotics of Visual Art: Field and Vehicle in Image-Signs," in his *Theory and Philosophy of Art: Style, Artist, and Society* (New York: George Braziller, 1994), 22–26.

46. *Wen-ch'üan Ming,* a stele inscription dated 648, by Emperor T'ang T'ai-tsung (r. 627–49), is a rare and frequently cited example of a stone inscription in running-cursive script (*Shodō zenshū,* n.s., 7: pls. 90–95).

47. For an introduction to the role of ink rubbings in the history of calligraphy, see Amy McNair, "Engraved Calligraphy in China: Recension and Reception."

48. See the essay by Amy McNair in this volume.

49. Tseng Yuho, *A History of Chinese Calligraphy* (Hong Kong: Chinese University Press, 1993), 260, figs. 8.24 and 8.25. The calligrapher Fu Shan (1607–1684/85) once transcribed the *Lotus Sutra* in seal script—surely one of the most laborious feats of sutra transcription on record. See the essay by Dora C. Y. Ching in this volume.

50. Cited by Chaves, "The Legacy of Ts'ang Chieh," 210.

51. Ibid.

52. Drège, "La lecture," 94.

53. See the analysis of Chang Chih-chih's style in Shen C. Y. Fu et al., *Traces of the Brush: Studies in Chinese Calligraphy* (New Haven: Yale University Art Gallery, 1977), 138.

54. Drège, "La lecture," 80. On the distinction between recalling or recognizing a text and discovering it, see Chartier, *Forms and Meanings*, 17.

55. Chartier, *Forms and Meanings*, 6–24.

56. Velmir Khlebnikov, with Alexei Kruchenyk, "The Word as Such," in Velmir Khlebnikov, *Collected Works* (Cambridge, Mass.: Harvard University Press, 1987), 2: 257, cited by Johanna Drucker, *The Visible Word*, 70.

57. On a frequently cited experiment in which subjects were asked to respond to abstract patterns of lines, see A. T. Poffenberger and B. E. Barrows, "The Feeling Value of Lines," *Journal of Applied Psychology* 8 (1924): 187–205. See also Martin Scheerer and Joseph Lyons, "Line Drawings and Matching Responses to Words," *Journal of Personality* 25, no. 3 (March 1957): 251–73.

58. Several cross-cultural studies of responses to abstract forms are summarized in Hans Kreitler and Shulamith Kreitler, *Psychology of the Arts* (Durham, N.C.: Duke University Press, 1972), 113–14.

59. Pien Yung-yü, comp., *Shih-ku-t'ang shu-hua hui-k'ao* (reprint of 1921 facsimile; Taipei: Cheng-chung shu-chü, 1958), *chüan* 25: 412, cited in Fu et al., *Traces of the Brush*, 214.

60. For an introduction to cursive script, see Fu et al., *Traces of the Brush*, 81–123; see also Peter C. Sturman, "The 'Thousand Character Essay' Attributed to Huaisu and the Tradition of Kuangcao Calligraphy," *Orientations* 25, no. 4 (April 1994), 38–46.

61. Murck, "Chu Yün-ming (1461–1527): Problems of Style and Meaning," 55.

62. Hsü Ch'eng, "Ch'ien-tzu wen," part 1, *Ku-kung wen-wu yüeh-k'an* 1, no. 4 (Dec. 1983), 57–61.

63. For Chao Meng-fu's transcriptions of "The Thousand Character Essay," see National Palace Museum, ed., *Chung-hua wu-ch'ien nien wen-wu chi-k'an, shu-fa pien*, no. 6 (Taipei: National Palace Museum, 1986), 148–216.

64. National Palace Museum, ed., *Ninety Years of Wu School Painting (Wu-p'ai hua chiu-shih nien)* (Taipei: National Palace Museum, 1975), 366.

65. On the relationship between Chao Meng-fu and Yü Ho, see Chang Kuang-pin, "Ts'ung Wang Yu-chün shu *Yüeh I lun* ch'uan-yen pien Sung-jen mo Ch'u ts'e," *Ku-kung chi-k'an* 14, no. 4 (1980), 41–62.

66. For a thorough account of the problems surrounding this work, see Ledderose, *Mi Fu*, 19–24.

67. Fu et al., *Traces of the Brush*, 3–20.

68. Mayching Kao, ed., *The Quintessential Purple Stone: Duan Inkstones through the Ages* (Hong Kong: The Chinese University of Hong Kong Art Gallery, 1991), 69–71.

69. See the essay by Dora Ching in this volume.

70. Quoted by Hsiung Ping-ming, *Chung-kuo shu-fa li-lun t'i-hsi*, 62.

71. Sun Kuo-t'ing, *Shu-p'u*, in *LTSF*, 1: 128; trans. in Chang and Frankel, *Two Chinese Treatises*, 10–11.

72. Recorded in Pien, comp., *Shih-ku-t'ang shu-hua hui-k'ao*, 1: 367; cited by Bai Qianshen, "The Brush Sings and the Ink Dances: Performance and Rhetoric in Chinese Calligraphy" (paper presented at the annual conference of the Association for Asian Studies, Boston, March 24–26, 1994).

73. On manipulations of calligraphic style employed by Mi Fu during periods of official service and periods of retirement, see Sturman, *Mi Fu*, chap. 3, "Styles In and Out of Office."

74. This phenomenon is discussed by Lothar Ledderose in "Chinese Calligraphy: Its Aesthetic Dimension and Social Function," *Orientations* 17, no. 10 (Oct. 1986), 35–50.

75. For a history of colophons, see Nakata Yūjirō, "Hōsho daibatsu no reikishi" in Nakata Yūjirō and Fu Shen, eds., *Ōbei shūzō Chūgoku hōsho meisekishū* (Tokyo: Chūōkōron-sha, 1981–83), 1: 115–22. See also Fu et al., *Traces of the Brush*, 180–85.

76. Additional colophons, by Sun Ch'eng-tse (1592–1676) and Chang Ta-ch'ien (1899–1983), appear on the scroll.

77. Tung Ch'i-ch'ang's ownership of the letter is discussed in "A Letter from Wang Hsi-chih and the Culture of Chinese Calligraphy" in this volume.

趙 盖 煩 書 幵 篆 窘

妙 嚴 寺 本 名 東 際 距 吳

興 郡 城 七 十 里 而 迩 郡

徐 林 東 接 爲 戌 南 對 涵

山 西 傍 洪 澤 北 臨 洪 城

暎 帶 清 流 而 離 絕 躋 塵

誠 一 方 朦 境 也 先 提 宋

Chinese Calligraphy: Theory and History

WEN C. FONG

The importance of the theory and history of calligraphy to Chinese art has never been sufficiently understood by the Western art historian. In Chinese painting theory representation was linked through calligraphic brushwork to the artist's physical presence, and the calligraphic aesthetic was basic to the development of literati painting in that it was regarded as a form of self-expression. The problem for Western students of Chinese art is that in the social and material dimensions of artistic creation, the function of Chinese painting as self-expression appears irrelevant as a basis for either historical analysis or theoretical discourse.

Western scholars have met with several problems in understanding calligraphy as a medium of artistic expression. Ever since Aristotle characterized dramatic poetry as mimesis, the work of art has been perceived in Western aesthetic theory—in an approach that favors the representational over the presentational function—as a sign. Aristotle's identification of dramatic poetry with imitation rather than with the immediate presentation of action posits a fundamental dichotomy between the artist who represents and that which is represented, between the physical presence of the artist and his absence, which is implied in any concept of imitation.[1] Although art in the West has generally been analyzed as a symbolic or symptomatic expression of reality, there has never been a coherent theory that can explain the relationship between presented qualitative structures and what they express.[2] Because calligraphy embodies an artist's identity, and its gestures form a projection of the artist's body language, we may begin to understand the relationship between the presented structures of calligraphy and what they express.

Modern Western theorists hold that historical narrative, far from being a neutral medium for the representation of historical events and processes, involves choices with distinct ideological and political implications.[3] In displacing historical narrative with discourse (which presupposes a speaker *persuading* a listener), modern proponents of scientific historiography have moved from historical to semiological and rhetorical analysis. By analyzing a work of art as a signifying structure, a system of signs, semiologists see art as an immanent process, one that is in a continual and changing relationship to other domains of culture.[4] In their emphasis on the conventions followed in a work of art rather than on its creative function—its tendency to conform to anonymous social and material rules and specifications—they have sought to demythologize the established notion of artistic invention, rejecting three basic premises of traditional art history: the authority of the individual artist, the originality of a work of art, and the centrality of the institution of painting. While structuralism, a relational mode of thought, seeks to dissociate itself from the analysis of a work of art in terms of stylistic structure and individual expression, I argue here that the three traditional approaches—stylistic analysis, the analysis of personal expression, and the analysis of ideology and thought—are indispensable to an understanding of Chinese art history.

In Western language theories the spoken language is privileged over the written language, which, in its phonetically represented form, is often considered merely a transcription of the spoken word. In the Chinese world, however, the written ideogram as a graphic convention constitutes an independent, formal structure within the broader system of communication.[5] According to the fifth-century scholar Yen Yen-chih (384–456), there were three kinds of sign systems: the map or diagram, such as the hexagrams of *The Book of Changes (I-ching)*, which represented nature's principles (*t'u-li*); the pictogram or ideogram, which represented concepts (*t'u-shih*); and pictorial representation, which depicted nature's forms (*t'u-hsing*).[6] When revealed to the ancient sages, pictorial and pictographic representations, like the hexagrams of *The Book of Changes*, were believed to be functionally real, imbued with

Opposite: Chao Meng-fu (1254-1322), *Record of the Miao-yen Monastery* (cat. no. 11; detail).

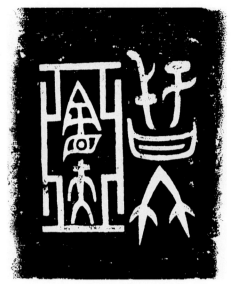

Figure 1. Seal script, ink rubbing and transcription of inscription on a *fang-lei* bronze vessel, Shang dynasty, 14th–11th century B.C. Shanghai Museum.

Figure 2. Clerical script, *Ritual Vessels Stele* (*Li-ch'i pei*), 156, ink rubbing on paper, Ch'ü-fu, Shantung. From *Shoseki meihin sōkan* (Tokyo: Nigensha, 1964), 3, no. 23: 2.

Figure 3. Cursive clerical script, attributed to Huang Hsiang (fl. ca. 220–279), *Model Essay for Draft Cursive* (*Chi-chiu-chang*; detail), undated, ink rubbing on paper. Collection of Qi Gong, Peking.

powerful cosmic forces. Because the signifying practice of all graphic conventions originates in both the physical body and the psychological state of the artist as a sign creator, calligraphy and painting are perceived as having both a representational and a presentational function.

The first broad-based theory of calligraphy was articulated during the T'ang dynasty, in the eighth century, by the writer Chang Huai-kuan (fl. ca. 714–60), who classified the written language as the pictogram (*wen*), the character (*tzu*), and the act of writing or calligraphy (*shu*). Chang believed that through the act of writing, the artist rediscovered the vital cosmic forces that informed a character's rhythm and structure, forces that had first been revealed to the ancient sages.[7] Before calligraphy could be appreciated as an art form, its formal and aesthetic dimensions had to be recognized as apart from the meaning it communicated as language. From a critical point of view, the art of calligraphy has less to do with the graphic conventions represented than with how forms are presented.

The meaning of the text becomes significant only if and when the calligraphic style imitates or is related to the object or event to which the graphs refer.

In his study of Chinese art and cultural history, Yu-kung Kao has discussed what he calls the lyric, as opposed to the narrative, aesthetic in Chinese poetry, music, and painting. Using the term "lyric aesthetics" to define the expression of mental images and emotional responses as opposed to the description of physical action, Kao proposes that music, poetry, calligraphy, and painting all underwent a process of transformation in the direction of lyric expression. In this transformation, the art of calligraphy played a central role:

As lyric experience, calligraphy concentrates on the phase of execution, which is the materialization of the power of the artist. Repeatedly, theorists warned the calligrapher to cleanse his mind before execution. It should not escape our attention that a completely cleansed mind may require the calligrapher to cut himself off from realistic experience. Divorce from

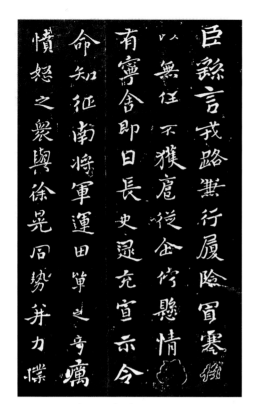

Figure 4. Early standard script, Chung Yu (151–230), *Memorial Celebrating a Victory* (*Ho-chieh piao*; detail), 219, an ink rubbing mounted as an album, 24.6 x 27.2 cm. Shodō Hakubutsukan, Tokyo. From *Shodō zenshū*, n.s., 3: pl. 113.

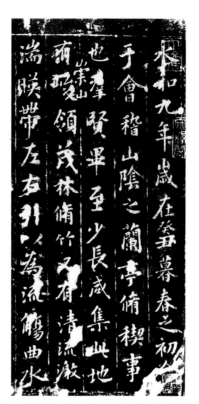

Figure 5. Attributed to Wang Hsi-chih (303–361), *Preface to the Orchid Pavilion Collection* (*Lan-t'ing chi hsü*), detail from the Ting-wu rubbing of the original dated 353. Private collection. From *Shodō zenshū*, n.s., 4: pl. 24.

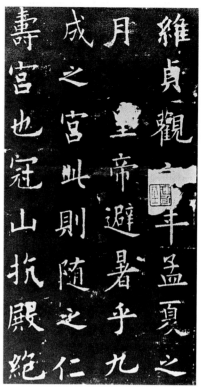

Figure 6. Ou-yang Hsün (557–641), *Inscription on the Sweet Wine Spring in the Chiu-ch'eng Palace* (*Chiu-ch'eng kung li-ch'üan ming*; detail), 632, ink rubbing on paper, 28.2 x 14.5 cm. Private collection. From *Shodō geijutsu*, 3: 69.

the outside world is a necessary condition for great performance, completely dependent as performance is upon the inner reserve the artist can release at the moment. To appreciate calligraphy is to relive the physical action in one's mind. Therefore even the physical aspect of calligraphy can be meaningful only in its mental mode.[8]

EARLY CRITICAL WRITINGS ON CALLIGRAPHY

According to tradition, Chinese civilization emerged when signs on the back of the divine tortoise from the Lo River and drawings on the body of the celestial dragon of the Yellow River were first revealed to the sage kings of antiquity. The ninth-century art historian Chang Yen-yüan (ca. 815–ca. 880) wrote that "[the sage Ts'ang] Chieh, who had four eyes and was able to read the emblems [of *The Book of Changes*], by imitating the bodily prints of birds and tortoises established the forms of written characters."[9]

The Chinese writing system was established in about 2000 B.C., after which it underwent a centuries-long process of evolution, arriving at its present form in the eighth century A.D. The curvilinear, picturelike form of the Bronze Age oracle bone (*chia-ku*) and seal (*chuan*) scripts (fig. 1) of the Shang, Chou, and Ch'in periods (ca. 16th century–206 B.C.) evolved to the standardized, squared-off clerical script (*li;* fig. 2) of the Han (206 B.C.–A.D. 220). Cursive or grass script (*ts'ao;* fig. 3), a variation of clerical script, and modern-clerical (*chin-li;* fig. 4) or early standard (*cheng* or *k'ai*) script was developed in the early third century. An informal, running script (*hsing;* fig. 5) emerged in the fourth century. And finally, in the T'ang (618–907), we see the establishment of the perfected standard script (fig. 6).

Calligraphy is never divorced from the physical body of the writer who produces it, and critical writings on calligraphy are replete with metaphorical references to the body: "flesh," "bone," "sinew," and "vein" are routinely part of the vocabulary that describes calligraphy.[10] The analysis of the calligraphic practice

is a self-reflexive enterprise that requires a constant revisiting of the relationship between the subjective and the objective. As the sociologist Pierre Bourdieu has noted in *The Logic of Practice,* "the relationship . . . between the observer and the observed is . . . [that] between knowing and doing, interpreting and using, . . . between logical logic . . . and the universally pre-logical logic of practice."[11] Like ritual and dance, calligraphy, as "doing" and "using" through practice, is at once a physical and a social act. It involves not only conscious and unconscious knowledge, but expresses a state of mind and body that reflects personal feelings, social values, and cultural beliefs.

The analysis of calligraphy begins with its style. Meyer Schapiro, in his discussion of the semiotics of nonmimetic elements in image-signs, analyzed "the field [or ground] as a space with a latent expressiveness . . . in printed and painted verbal signs."[12] "The space around [the painted figure] is inevitably seen not only as ground in the sense of *Gestalt* psychology," he notes, "but also as belonging to the body [of the figure] and contributing to its qualities."[13] Some of Schapiro's observations can be usefully applied to analyzing Chinese bronze inscriptions, where, because the writing style imparts a meaning beyond that of the meaning of the character itself, it is the style of the character that is our principal concern. Shapiro points to the differences in expressive quality implied between such elements as broad and narrow, large and small, upper and lower, left and right, central and peripheral: "The qualities of upper and lower are probably connected with our posture and relation to gravity and perhaps reinforced by our visual experience of earth and sky." He also points out that "pertinent to semiotics is . . . the vital importance of left and right to ritual and magic, which has influenced the meaning of these two words, their metaphorical extensions in everyday speech as terms for good and evil, correct and awkward, proper and deviant."[14] Calligraphic writing, executed with a stylus or a brush, moves directionally within each character from upper left to lower right, and sequentially, character by character and column by column, from right to left; the viewer reads by retracing the execution of the writing. Because the Chinese perception of form is embedded in patterns of negative and positive (*yin* and *yang*), individual calligraphic strokes are seen by the writer to create positive and negative spaces in the ground. In an engraved or carved-in-relief design, the body of the character seems at once to animate and to incorporate the empty space around it.

Seal and clerical scripts, both of which were used for ritual and commemorative inscriptions that appeared on oracle bones and on ancient bronze and stone monuments, are frontal and emblemlike, with axial, architectonically balanced forms whose horizontal and vertical strokes cross one another at right angles. Individual strokes are for the most part even and unmodulated, indicating the earlier use of a stylus or a knife rather than a writing brush. Toward the late Han, in the second century A.D., the flexible movement of the writing brush on a smooth ground (i.e., paper) gave expression to clerical script. Known as the split style (*pa-fen;* fig. 2), the squat character spreads laterally with two prominent sideways strokes (thus the split), each ending with a flaring, wavelike flourish. The late Han also saw the development of an informal, cursive version of clerical script (*ts'ao-li*), known as draft cursive (*chang-ts'ao* or *chi-chiu-chang;* fig. 3) which, in linking some strokes and omitting others, facilitated writing with speed, and led to the cultivation of calligraphy as an independent art form.[15] It was met with alarm.

The first critical writings on calligraphy by Confucian moralists, who believed that calligraphy must be taught within the context of a practical classical education that would lead to service in the imperial government, are diatribes against that very cultivation as an act of dissipation. In "A Polemic against Cursive Script" (*Chao I Fei ts'ao-shu*), the scholar Chao I (late 2nd–early 3rd century) wrote,

[Cursive script,] which shows a way of abridging and making easy, is not a vocation of the Sages. . . . Practitioners of cursive script are among the most inconsequential of artisans. Counties and towns do not use such skill to test people; neither does the imperial court use it to classify the officials. . . . Those who attend exclusively to what is within [such a specialization] will necessarily fall short of what is outside [of it]; those with a small purpose can only lose sight of what is large. . . . If one cannot see that Heaven and Earth are full of great things, it is because one is too busy concentrating on insects and fleas. Rather than training one's mind and sharpening one's wit on a dissertation on cursive script, would it not be better to apply oneself to the Seven Classics?[16]

Like early Chinese literature, with its basis in the teachings of Confucius, poetry and music were also used for didactic purposes. According to the Great Preface of *The Book of Poetry,* dating from the first century A.D., good poetry, like good music, possesses an uplifting aura (*feng*), or style, that transforms those who read it.[17] Images of nature were used in poetry as metaphors for morality and political order. In *The Book of Poetry,* the fragrant orchid, for example, connotes loyalty and friendship, while the spiky bramble signifies wickedness and treachery.

After the fall of the Han empire in the early third century, scholars of the Six Dynasties (222–589), a period of prolonged political disunity, disenchanted with the world of human affairs, turned for solace to the transcendental philosophies of Taoism and Buddhism. They turned also to nature and to art in an attempt to find expression in the realm of the spiritual. With Buddhism, introduced into China from India through Central Asia at the beginning of the Christian era, came a system of metaphysics and cosmological speculation, the notion of the infinity of space and time, and a belief in a plurality of worlds and in cycles of time. Most important to the new worldview was a belief in the transmigration or metempsychosis of the soul through a never-ending cycle of rebirth, which introduced the conception of the mind's transcendence of physical and temporal boundaries.[18]

"A Prose Poem on Literature" (*Wen fu*) by Lu Chi (269–303) is among the foremost critical writings on literature in the Six Dynasties period. Lu's vision of the poet's creativity is that of a vast universe of infinite transformations in which words derive from nature: "Phrases emerge struggling from the depths, as when fish, hooks in their mouths, emerge from the bottom of deep pools."[19] Lu's indebtedness to Taoist and Buddhist teachings is reflected in his belief in the interiority of the mind as the agency that transcends and transforms the physical universe.

Lu's writing finds a close parallel in that of his contemporary So Ching (239–303), who used images of nature to describe his calligraphy. In his essay "The Forces of Cursive Script" (*Ts'ao-shu shih*), So, moved by the beauty and vitality of the newly emancipated cursive brushwork, traces its origin to the representational world of ancient pictographic writing:

When [the ancient sage] Ts'ang Chieh was born,
 writings and covenants were created;

Tadpole, bird, and seal scripts appeared as simulations
 of objects and forms [of nature].

Writing in a rhapsodic, lyrical mode, he then turns to the "force" (*shih*) of the new cursive clerical script:

Cursive script can be smooth as a silver hook,
Or light as a startled bird,
With wings outspread but not yet flying,
As if lifting then settling back . . .
Like a stallion straining in fury against the bridle,
Or the billowing sea foaming up in breakers,
Like grasses and vines linked together,
With plum trees revealing their splendor,
Like black bears crouching across mountain peaks,
Or swallows chasing one another along the water . . .
A gentle wind brushes through the forest,
Suppressing the grass and fanning the trees . . .
Crafty black dragons frolic,
And gibbons and squirrels leap.[20]

He describes the calligraphic practice as one that mediates between the objective and the subjective. The artist, after first analyzing and then internalizing calligraphic forms, creates new forms:

There are forms placed high up so they may look
 down on other forms,
Or in being combined with others, they turn back into
 themselves.
Some are unrestrained and eccentric,
Others more reflective and conventional.
An eminently talented calligrapher,
In perfecting his art,
Focuses his mind on the fine and the subtle,
Immersing himself in pictographic patterns.
By following both the orthodox and the unorthodox
And by combining forms, he creates new
 transformations.

In conclusion, So refers to the ancient "eight styles."[21] The word "style" is written as *t'i*, or "body," which refers both to the written character and, by extension, to the body of the calligrapher. Thus calligraphic practice, in resonating with the archetypal emblems of *The Book of Changes,* has the capacity to activate the cosmic forces of the universe:

By analyzing the eight styles,
[The calligrapher] learns to master forms.
In doing away with the complex but preserving the
 subtle,
He does not deviate from the archetypal emblems.
Aspiring to the heights, he reorders the universe;

Turning to the commonplace, he equalizes
 discrepancies.
In giving creativity free reign,
Rain will fall, ice will melt.
Like a high-pitched voice, a sharp brush
Will move and spread like torrential water.
Beautiful compositions will emerge one by one,
Shining and wonderful, luminous and bright.
How his style is strong and powerful,
His deportment bright as jade![22]

During the third and fourth centuries, as calligraphy became widely appreciated for its formal and aesthetic qualities, many great calligraphers flourished: Chung Yu (151–230), the first master of early standard script, was followed by Madam Wei (272–349), who, in turn, taught the Sage of Calligraphy Wang Hsi-chih (303–361). In the early sixth century the artist-connoisseur Emperor Wu (r. 502–50), of the Liang dynasty, first attempted to create a systematic formal analysis of calligraphy. A great admirer of Chung Yu, Emperor Wu, in an essay titled "Twelve Ideas about Viewing Chung Yu's Calligraphy" (*Liang Wu-ti kuan Chung Yu shu-fa shih-erh i*) describes three different aspects of Chung's early standard script (fig. 4):

[Structure of individual characters]

Horizontally stable [*p'ing*]
Vertically upright [*chih*]
Harmoniously spaced [*yün*]
Tightly organized [*mi*]

[Brushwork]

Crisp and sharp [*feng*]
Powerful in body [*li*]
Exhibiting freedom in directional change [*ch'ing*]
Decisive in making turns [*chüeh*]

[Overall composition]

Filled in as needed [*pu*]
Left blank as needed [*sun*]
Cleverly balanced [*ch'iao*]
Organized by felicitous placement [*ch'eng*][23]

In relating the formal features of calligraphy to the physical disposition of the artist, Emperor Wu analyzes calligraphy as an expression of the individual who produces it. In Chung Yu's calligraphy, he sees the written character as an embodiment of the artist's moral, social, and cultural identity: "stability" and "uprightness" refer to both the person and the writ-

ten character; "freedom in directional change" tempered by "decisiveness" is a quality desirable in both the artistic and the human sphere; and the concept of "felicitous placement" speaks for Chinese cultural values.

By the early seventh century, in the T'ang dynasty, the theoretical approach to calligraphy was framed in cosmogonic terms. An essay titled "The Nine Forces" (*Chiu-shih*), attributed to the late-Han calligrapher Ts'ai Yung (132–192) but more likely composed in the late sixth or the early seventh century, states,

Calligraphy began with nature. When nature was born, the principles of *yin* and *yang* were established. When *yin* and *yang* were established, forms [*hsing*] and forces [*shih*] emerged. By "hiding the head" and "protecting the tail" [of each stroke], the calligrapher stores power in each character. The action of the brush and the transmitting of force through that action express the beauty of the muscle and skin [of calligraphy].[24]

The Chinese conception of the universe is one in which phenomena occur without the interception of a divine creator. In the above quote, the physical act of applying brush to paper is compared to spontaneous creation.[25] The blank page is the undifferentiated oneness of the universe before creation; the first stroke, born of the union of brush and ink, establishes on the paper a primary relationship between *yin* and *yang;* and each additional stroke creates new *yin-yang* relationships, until the whole is reunited into the harmonious oneness that is Tao, the way of the universe. The introduction of the terms "head and tail" and "muscle and skin" in the description strengthens the physical correlation between the written character and the calligrapher who produced it.

Another text, *A Diagram of the Battle Formation of the Brush (Pi-chen t'u),*[26] traditionally attributed to Madam Wei but perhaps dating to the early seventh century, compares the physical movements of a calligrapher to those of someone practicing the martial arts. The essay delineates the written character by seven component strokes, which the author describes in naturalistic imagery:

— [A horizontal stroke:]
 Like a cloud formation stretching a thousand *li*. . . ;
ヽ [A dot:]
 Like a stone falling from a high peak. . . ;

Figure 7. Sun Kuo-t'ing (648?–703?), *Manual on Calligraphy* (detail), 687, ink on paper, height 27 cm. National Palace Museum, Taipei, Taiwan, Republic of China.

⟋ [A downward left thrust:]
 A rhinoceros digging its tusk into the ground;

⌣ [An upward hook:]
 Shooting from a hundred-pound crossbow;

❘ [A vertical stroke:]
 A withered vine ten thousand years old;

⌣ [A wavelike ending stroke:]
 A crashing wave or rolling thunder;

⅂ [A left hook:]
 The sinews and joints of a mighty bow.

With every stroke, dot, thrust, and hook defined kinesthetically, the different brushstrokes in a written character in early T'ang standard script (fig. 6) are seen as interacting forces or momentums within a dynamically balanced structure, each character with its carefully considered deployment of strokes exemplifying equilibrium and harmony.

The most important early T'ang treatise on calligraphy is *The Manual on Calligraphy* (*Shu p'u*; fig. 7) by Sun Kuo-t'ing (648?–703?). Dating to 687, the *Manual* summarizes aesthetic ideals and theories of calligraphy from the end of the Han through the early T'ang. Ranging broadly over a variety of subjects, Sun com-

pares ancient and contemporary calligraphy, using both naturalistic and formalist approaches, and he delves into questions of personal morality and cultural values. Sun perceives calligraphy as the miraculous apprehension of nature:

> I have seen the wonder of a drop of dew glistening from a dangling needle, a shower of rock hailing down in a raging thunder, a flock of geese gliding [in the sky], frantic beasts stampeding in terror, a phoenix dancing, a startled snake slithering away in fright. . . . Some brushstrokes are as ominous as gathering clouds, others light as a cicada's wing. When the brush moves forward, a spring bubbles forth; when it stops, the mountains are in repose. Its delicate trace is like a new moon rising on the horizon; its bright residue, like a galaxy of stars across the sky. And though [calligraphy is] varied as nature itself and seemingly beyond the powers of man, when the hand is moved by the heart's desire, ingenuity and artistry are united. For the movement of the brush is never arbitrary; it is always purposeful.[27]

In the practice of calligraphy, technical mastery and a knowledge of historical styles must predominate:

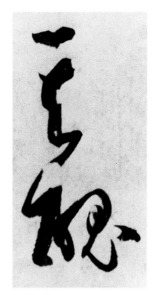

a. Standard script　　　　　　b. Cursive script

Figures 8a, b. Sun Kuo-t'ing, *Manual on Calligraphy* (details). From *Ku-kung li-tai fa-shu ch'üan-chi* (Taipei: National Palace Museum, 1976), 1: 85, 112.

Standard script builds form and substance with dots and strokes, and uses the turning of the brush to express emotion. Cursive script captures emotion through dots and strokes, and creates forms with the turning of the brush. . . . And though the two scripts are different, their basic structures are related. Similarly, [a calligrapher] must study both large and small seal script, the split style, draft cursive, and flying-white.[28]

In his own calligraphy Sun freely combines the technique of standard script (fig. 8a), which "builds form with dots and strokes and uses the turning of the brush to express emotion," with that of cursive (fig. 8b), which "creates form with the turning of the brush and captures emotion through dots and strokes." In the character for "burn" (*ts'uan;* fig. 9a), for example, while he explores the pictorial movement of cursive script, he also preserves the emblematic quality of the ancient pictograph for a cooking pot. In the character for "avoid" (*hui;* fig. 9b), he combines round with angular brush techniques, creating intricate interlocking patterns; the wavelike ending stroke in the split style is round inside and square outside, the rapidly turning brushstrokes within an enclosed space making positive and negative spaces that seem to move and flicker.

Sun also uses style to enhance the semantic meaning of the written word. In the character for "crashing down" (*peng;* fig. 9c), the downward-thrusting

strokes beneath the mountain radical vividly express the crushing force of a landslide. Written in the early T'ang cursive-clerical style, Sun's calligraphy graphically illustrates the critical lessons of his text, in which he teaches that only with technical proficiency can freedom of expression be achieved: "When mastery is achieved through practice and all rules are clearly understood, every movement will happen naturally. [Then] with ideas leading the way and the brush following freely and smoothly, the ink will flow and the spirit will soar."[29] He in turn links calligraphy to moral self-cultivation and inner growth:

> When a person first learns to structure his writing, he begins with the level and straight; after the level and straight, he seeks the daring and precipitous; but after learning the daring and precipitous, he returns again to the level and straight. At the outset he does not go far enough; in mid-life he ventures beyond the boundaries; only late in life does he achieve full comprehension. With full comprehension both the man and his calligraphy reach maturity. As Confucius said, "At fifty I learned Heaven's will; at seventy I learned how to follow my own heart." Only after a person has encountered the precipitous and experienced the ways of the unorthodox will he be able to act without deliberation—and to act without erring; only then, when the moment is propitious, will he be able to

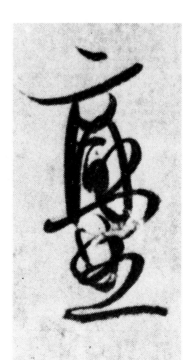

b. The character *hui.*

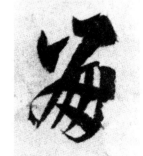

a. The character *ts'uan.*　　　　　　c. The character *peng.*

Figures 9a–c. Sun Kuo-t'ing, *Manual on Calligraphy* (details). From *Ku-kung li-tai fa-shu ch'üan-chi,* 1: 90, 96, 120.

speak out and to express himself in the right way. This is why the work of Wang Hsi-chih in his late years is so marvelous; for by then, his thoughts were well considered and his intent [chih] and breath [ch'i] in perfect harmony and balance. Never agitated, never sharp, [Wang's] style and demeanor naturally resonate far [tzu-yüan].[30]

The last part of this passage is informed by teachings attributed to Confucius, who was quoted as saying, "When there is intent [chih], it is speech [yen] which communicates that intent. . . . But if speech is without literary refinement, it will not resonate far [pu-yüan]."[31] This validation of the artist's intention, the notion that artistic refinement is an expression of the psychological state of the artist, was for Sun—who stated that "the movement of the brush is never arbitrary; it is always purposeful"—the very foundation of his theory.[32]

FOUR CALLIGRAPHIC REVOLUTIONS

An art of graphic designs, calligraphy has a history that can be understood through an analysis of style. In his discussion of the concept of style, Berel Lang has described two models of style. "Style as instrument" serves formal analysis in describing what takes place in pictorial space; "style as person" accounts for what he defines as "a mode of personification and an end in itself."[33] Lang's "style as person" matches the Chinese concept of style as the expression of the artist's experience of the world. The recognition of style as a product of human intention has clear methodological implications for the art historian. By acknowledging that art not only reflects but also alters cultural attitudes, we are able to focus on the function of a work of art as an agent of social change.

The history of Chinese calligraphy may be divided into two principal phases. The earlier, evolutionary phase, as noted above, began with the invention of the ideo-pictogram in about 2000 B.C. and ended with the modern form of standard script in about A.D. 750, in the T'ang period. During this phase, the artist was concerned with the representation of the written character, which evolved in its formal structure from seal, clerical, and cursive to standard and running script. This was followed by successive revivals of historical styles, which extended from about 1050, in the late

Northern Sung, to modern times. In the second phase the emphasis shifted from the structural to the visual and the expressive. The great calligraphers invariably revitalized earlier traditions, interacting with history while pursuing their own individual styles.

As the art of the ruling scholar elite, calligraphy was inextricably linked with the political and social fabric of the Confucian imperial state. There was a distinct correlation between ideology and style: the orthodox with the more formal standard script and the rebellious with the freer running script. The development of the running style, beginning in the Six Dynasties, represented a rejection of the state-sponsored monumental style. Implicit in the newly liberated running style was a new political agenda characterized both by a staunch individualism and by a deep respect for history. Subsequently the new style, co-opted by the court, would become part of a new state-sponsored monumental style, one that would lead inevitably to its rejection, and so on and so forth.

The four stylistic revolutions in Chinese calligraphic history, which alternated between orthodoxy and rebellion,[34] were the invention of the running style in the Eastern Chin (317–420), the creation of a state-sponsored monumental standard style in the early T'ang, the rise of a highly individualistic running style in the late Northern Sung (960–1127), and the re-formulation of the monumental standard style in the Yüan (1260–1368)—styles inseparably associated with Wang Hsi-chih, the calligraphers of the early T'ang court, the scholar-official artists of the late Northern Sung, and Chao Meng-fu (1254–1322). After Chao Meng-fu, there was little creativity in state-sponsored monumental standard script, while Ming and Ch'ing calligraphers created a rich diversity of individualistic styles through archaic, cursive, and running scripts.

WANG HSI-CHIH (303–361)

The collapse of the Han empire in the year 220 was followed by the Six Dynasties period, three and a half centuries marked by fundamental cultural change. With the decline of Han Confucianism, neo-Taoism, known as the "mysterious learning" (hsüan-hsüeh), caught the imagination of scholars and artists who, disillusioned with the world of the court, chose to turn away from political engagement. Aristocratic men

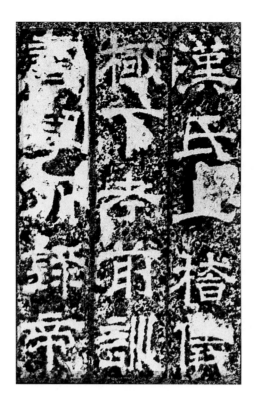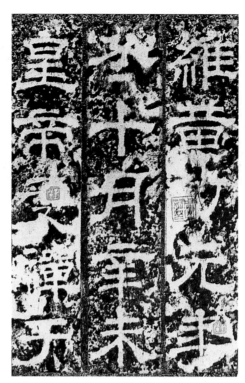

Figure 10. Attributed to Chung Yu, *Accepting the Yielding of the Throne* (detail), stele dated 220, ink rubbing on paper, 26.9 x 14.9 cm. Palace Museum, Peking. From *Chung-kuo mei-shu ch'üan-chi: Shu-fa chuan k'o pien* (Peking: Jen-min mei-shu ch'u-pan-she, 1986), 2: p. 1, pl. 2.

of leisure decrying the strictures of the Confucian way of life, they cultivated the romantic air of "wind and stream" (*feng-liu*), abandoning themselves to the artistic expression of naturalism and spontaneity.[35]

Wang Hsi-chih was born into a highly prominent family from Shantung that fled south in the early fourth century in the wake of nomad invasions in the north. Despite influential family connections, Wang served in only minor government posts before retiring in 355 to live in the Shan-yin district in Chekiang, devoting himself to the mystic philosophies of neo-Taoism and Buddhism, and to poetry, music, and calligraphy. Wang's most important contribution to Chinese art history is the legendary *Preface to the Orchid Pavilion Collection* (*Lan-t'ing chi hsü*) known through the Ting-wu version (fig. 5), a stone engraving made after a tracing copy by the early T'ang calligrapher Ou-yang Hsün (557–641).

On the third day of the third lunar month of the year 353, Wang and some forty members of Eastern Chin society gathered at the Orchid Pavilion in Kuei-chi, Chekiang, to celebrate the spring festival of purification.[36] The weather was fair, and the friends held a poetry contest by a stream, drinking freely as cups of wine were placed on leaves floating downstream. Toward dusk Wang wrote a preface for the thirty-seven poems that had been written, producing a lyrical masterpiece celebrating the pleasures of life and lamenting its impermanence:

When I consider what it was that aroused the emotions of writers past, it is [the impermanence of life]. Sighing with grief as I bend over my writings, I am unable to express the feelings in my heart. I know only that to equate death with life is but an empty affectation, and to pretend to aspire to an early death is a lie. Future writers shall view us as we view those who passed before us. How sad it is![37]

Preface to the Orchid Pavilion Collection represents a revolution in calligraphic imagery. The new running script practiced by Wang and his friends transformed the ancient monumental style of writing into an informal, private mode of expression. Inscriptions on monumental bronzes and early stone carvings (figs. 1, 2), as the ruler's instrument of legitimation, had served ritual and political functions. Archaic calligraphy, in both seal and clerical scripts, cast and engraved, was frontal and emblemlike, with axially balanced, architecturally built forms and horizontal and vertical strokes crossing one another at right angles. Wang's informal running script, by contrast, served neither a ritual nor a public function. Executed with a supple pointed brush, it was practiced solely for its visual beauty and expressive spontaneity.

By the third and early fourth centuries, the new critical awareness of the formal properties of the different script types stimulated rapid and innovative developments. The engraved memorial *Accepting the Yielding of the Throne* (*Shou shan piao*; fig. 10), dated A.D. 220 and

attributed to the Wei chief minister and calligrapher Chung Yu, exemplifies the early third-century monumental clerical style. *Memorial Celebrating a Victory* (*Ho-chieh piao;* fig. 4), also by Chung Yu and dated 219, shows Chung's work in the less formal, early standard style. Wang Hsi-chih's own standard-script style, based on Chung's, is best seen in *Essay on Yüeh I* (*Yüeh I lun;* fig. 11), dated 348. Compared with the rigid frontality of archaic clerical script (fig. 10), the standard-script styles of Chung and Wang are slanting and undulating, with brushstrokes of varying thickness.

As a calligrapher Wang Hsi-chih excelled in writing in different styles. The short handscroll *Ritual to Pray for Good Harvest* (fig. 12, cat. no. 2) is a rare early T'ang tracing copy of a letter by Wang written in cursive-clerical script. Recorded in a ninth-century catalogue of Wang's calligraphy by Chang Yen-yüan, the scroll is inscribed with a title written in gold ink by the late Northern Sung Emperor Hui-tsung (r. 1100–1126).[38] An example of Eastern Chin cursive-clerical script, *Ritual* compares stylistically with an archaeologically recovered scroll from Lou-lan datable to the early fourth century (fig. 13). Wang's work, as seen in the precisely executed tracing copy (fig. 12), however, is far superior, and best described in the words of So Ching, as "smooth as a silver hook, light as a startled bird."[39] Characters of varying sizes and shapes and executed with different pressures and speed contrast with and complement one another, the brush moving fluently along vertical columns.

As distinguished as Wang Hsi-chih was in his standard and cursive-clerical writings, it is through his running script, used especially in informal letter writing, that he has achieved renown. In *Ritual,* which follows

Figure 11. Wang Hsi-chih, *Essay on Yüeh I* (detail), original dated 348, from *Sung Rubbings of T'ang Engravings of Eight Kinds of Chin and T'ang Small Standard Script Writings*, bearing an imperial seal of the Hsi-Hsia datable to 1034, ink rubbing on paper, mounted onto 45 album leaves, 23.8 x 9.6 cm. The Metropolitan Museum of Art, New York (1989.141.2).

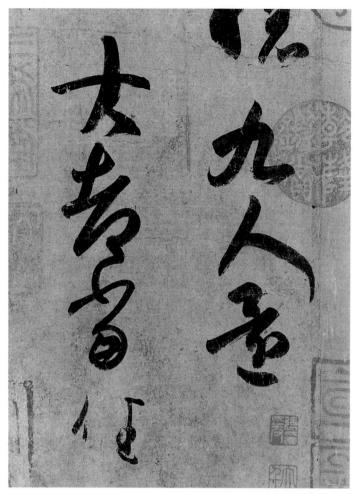

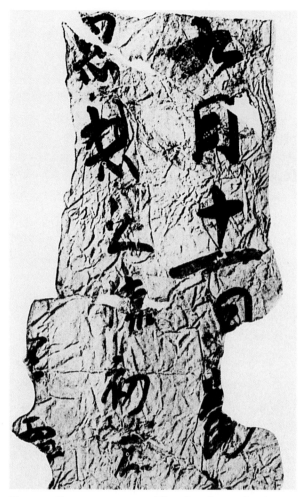

Figure 12. Wang Hsi-chih, *Ritual to Pray for Good Harvest*, undated (cat. no. 2, detail).

Figure 13. Document recovered from Lou-lan, early 4th century, ink on paper. From *Shodō zenshū*, n.s., 3: pl. 20.

the structural principles of clerical script (figs. 2, 10), Wang's brush moves right and left in single movements, creating strokes that are either of uniform or gradually thinning and thickening pressure; individual characters remain frontal and aligned on a grid pattern, with parallel strokes crossed at right angles by horizontal and vertical strokes. The handscroll *Three Passages of Calligraphy: P'ing-an, Ho-ju, and Feng-chü* (*P'ing-an, Ho-ju, Feng-chü san t'ieh chüan;* fig. 14), another early T'ang tracing copy of a work by Wang, is a prime example of his running script, which follows the structure of his standard script (fig. 11). Here the brushwork links slanting and undulating brushstrokes in a continuous running movement. The flicking and turning brushwork, constantly changing speed and direction, suggests foreshortening and three-dimensionality. Individual characters are expressed as fully articulated organic forms in the round, moving independently in space. Compare, for example, the

characters for "peace and tranquility" (*p'ing-an*) in Wang's cursive-clerical and running scripts (figs. 15a, b): the swiftly executed running brushwork, in wrapping its thickening-and-thinning movements left and right around a central axis, transforms a relatively static two-dimensional image into a three-dimensionally articulated organic form, the power of which lies not in its structure but in its movement and use of the space around it.

In Emperor Wu's "Twelve Ideas about Viewing Chung Yu's Calligraphy," the standard-script writings of both Chung (fig. 4) and Wang (fig. 11) are seen as harmonious two-dimensional representations of the written character. Individual forms are stable, upright, and well spaced yet tightly organized; brushwork is sharp, powerful, and easy but decisive; and the overall composition is accommodating, simple, and balanced.[40] In linking together in his running style different standard-script brushstrokes in a continuous

movement (fig. 15b), Wang transforms conventional characters into a kinesthetic expression of his own physical movements, the flicking and turning strokes graphically reflecting the pivoting actions of his fingers and wrist, which move according to the commands of his mind and heart: "In preparing to write . . . one should visualize first the shapes of the characters: large or small, turning downward or upward, straight and frontal or expressing movement, so that their sinews and arteries will connect. Let the idea precede the brush—only then should one write."[41]

Wang's kinesthetic brushwork also inspired a new approach to critical writing about calligraphy, which came to be described in physical terms such as "bone" and "sinew." In *A Diagram of the Battle Formation of the Brush,* attributed to Wang's teacher Madam Wei, the author writes,

> Those skilled at imparting strength to their brush have much bone, while those not so skilled have much flesh. Calligraphy with much bone and little flesh is called sinewy; that which has much flesh and little bone is called ink pig. Writing that displays great strength and a richness of sinew is sagelike; that which has neither strength nor sinew is defective.[42]

Wang's running characters for "peace and tranquility" (*p'ing-an;* fig. 15b) exemplify this description, the rapidly pivoting brush movements balancing in space around an imaginary central axis, creating a sinew-and-bone structure.

It is perhaps difficult to imagine the excitement with which Wang's new running script must have been greeted. A free spirit in a repressive Confucian state, Wang captured in his art the pulse of life, expressing liberation from an archaic past. It is small wonder that his official biographer attributed Wang's success to divine power: "In its thousand changes and ten-thousand transformations, [Wang's calligraphy] partakes of divine creation. . . . The ideas it evokes are nature's myriad phenomena."[43] The early fifth-century historian of calligraphy Yang Hsin (370–442) had high praise for Wang: "[Wang] Hsi-chih is superior to all others, ancient or modern. By combining the methods of many, he has created a unique style of his own."[44] Paradoxically, Wang's Taoist-inspired running script eventually became the instrument of a repressive Confucian state. It was followed by all later calligraphers. The interplay between orthodoxy and rebellion, tradition and innovation, together with the combining

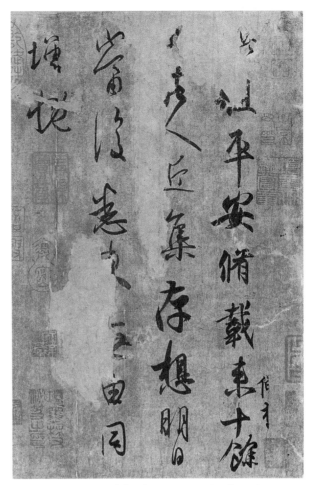

Figure 14. Wang Hsi-chih, *Three Passages of Calligraphy: P'ing-an, Ho-ju, and Feng-chü* (detail), early T'ang tracing copy, handscroll, ink on *ying-huang* (hard yellow) paper, 26.7 x 46.8 cm. National Palace Museum, Taipei, Taiwan, Republic of China.

a. b.

Figures 15a, b. The characters *p'ing-an*
a. Cursive-clerical script, Wang Hsi-chih, *On the Seventeenth Day (Shih-ch'i t'ieh*; detail), ink rubbing on paper. From *Shodō zenshū,* n.s., 4: p. 47.
b. Running script, Wang Hsi-chih, *Three Passages of Calligraphy: P'ing-an, Ho-ju, and Feng-chü* (detail).

Figure 16. Ch'u Sui-liang (596–658), *Preface to the Sacred Teaching (Sheng chiao hsü; detail)*, 653, ink rubbing on paper, 24.5 x 14.3 cm. Tokyo National Museum. From *Shodō geijutsu*, 3, frontispiece.

Figure 17. Anonymous, *Epitaph for Chang Meng-lung (Chang Meng-lung pei; detail)*, 522, ink rubbing on paper, 23.6 x 13.5 cm. Shodō Hakubutsukan, Tokyo. From *Shodō zenshū*, n.s., 6: pl. 24.

of the methods of many to create a style that was new and extraordinary would become in later centuries central concerns in critical writings on calligraphy.

THE CALLIGRAPHERS OF THE T'ANG COURT

After more than three and a half centuries of political disunity, north and south China were once again united, first briefly under the Sui (581–618; unification of China in 589) and then under the T'ang dynasty. The early T'ang emperors strove to reinstate the ancient cultural traditions of the Han dynasty, and the great ambition of the T'ang scholar-officials was to reintegrate the diverse strands of their inherited traditions to provide models for a newly unified empire.[45] Following the Han model, court calligraphers under the patronage of the second emperor, T'ai-tsung

(r. 626–49), in their attempt to establish institutional standards created a new monumental standard script.[46]

T'ai-tsung, an ardent admirer of Wang Hsi-chih, was himself an excellent calligrapher. The emperor's love of calligraphy set the tone for the aesthetic ideal at court. In attendance at court were two leading calligraphers from the Sui court, Yü Shih-nan (558–638) and Ou-yang Hsün (557–641; fig. 6), and the much younger Ch'u Sui-liang (596–658; fig. 16). These three great calligraphers, all of whom were from the south, combined in their writing the formal monumental engraving tradition of the north with the freer, more fluid style of the southern tradition established by Wang Hsi-chih.

Following the monumental stone engraving tradition of the late Han, three types of stone monuments had been made in the north during the Northern Dynasties period (386–581): mortuary stelae (fig. 17) and epitaphs, Buddhist dedicatory inscriptions, and

Figure 18. Attributed to T'ao Hung-ching (452–536), *Eulogy on Burying a Crane* (detail), ca. 512–14, ink rubbing of an inscription carved on a boulder, Chiao-shan Island, Chen-chiang, Kiangsu. From *Shodō zenshū*, n.s., 5: pl. 29.

cliff carvings (fig. 18).[47] The brushwork and overall composition of Northern Dynasties monumental writing is best described in Emperor Wu's "Twelve Ideas," discussed above: horizontally stable, vertically upright, filled in as needed, left blank as needed, and so forth. Evolving from the monumental clerical script of the late Han, which is based on a rectilinear structure and lateral brushstrokes, pre-T'ang monumental standard script, with a slanted structure and a greater variety of brushstrokes, focuses on compositional invention and the harmonious interaction of brush movements. In both mortuary and Buddhist inscriptions, in which uniform characters fill the spaces of a square grid and a decorative quality is desired, a square brushwork with wedge-shaped strokes is favored. In large cliff carvings, however, a bold and more adventurous style is developed, with simplified rounded brushwork made by centering the brushpoint and containing it within the brushstroke; characters, freely contracting

and expanding, are asymmetrically balanced, often with individual strokes veering in different directions.

Yü Shih-nan was a native of Yü-yao in Yüeh-chou, Chekiang, and a member of a distinguished family, his father and great-grandfather both having served in the Liang dynasty. As a calligrapher, Yü was a disciple of the monk Chih-yung (fl. late 6th–early 7th century; fig. 19), a seventh-generation descendant of Wang Hsi-chih, and the leading exponent of the Wang tradition. Yü's influence at court, supported by Emperor T'ai-tsung's own admiration for the calligraphy of Wang Hsi-chih, ensured that Wang would become the preeminent model for all early T'ang calligraphers. In 639 T'ai-tsung had his calligrapher-connoisseur Ch'u Sui-liang compile a catalogue of the more than two thousand works by Wang Hsi-chih then in the imperial collection.[48] And having acquired the legendary famous work by Wang, *Preface to the Orchid Pavilion Collection,* the emperor had copies made by

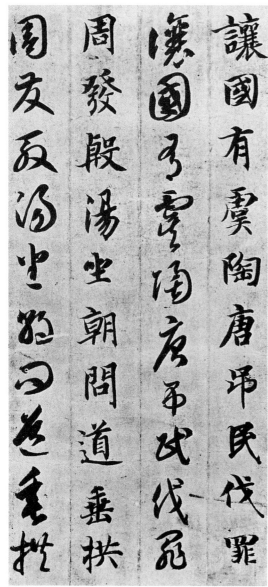

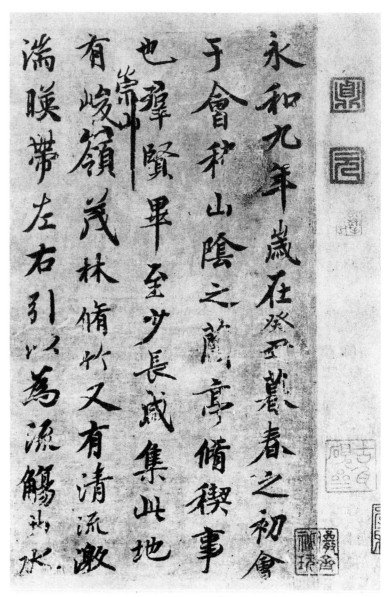

Figure 19. Chih-yung (fl. late 6th–early 7th century), *The Thousand Character Essay (Ch'ien-tzu wen;* detail), late 6th century, ink on paper, 24.5 x 10.9 cm. Ogawa Collection, Kyoto. From *Shoseki meihin sōkan* 6, no. 69: 6–7.

Figure 20. Attributed to Ch'u Sui-liang, *Copy of Preface to the Orchid Pavilion Collection* (detail), early 7th century, handscroll, ink on paper, 24.7 x 70.3 cm. Collection unknown. From *Shodō zenshū,* n.s., 4: pl. 12.

his leading court calligraphers, among them Ou-yang Hsün and Ch'u Sui-liang. Although carefully and precisely executed, each copy nevertheless betrays the hand of the copyist. The Ting-wu version by Ou-yang Hsün (fig. 5) shows unmistakable similarities to Ou-yang's own writing (fig. 6), the narrow, tightly organized characters emerging from thinly brushed, crisp strokes and graceful, saber-sharp turns. Ch'u Sui-liang's version (fig. 20), on the other hand, exhibits his characteristically supple and lively brushwork of thickening-and-thinning strokes and flicking brush movements (fig. 16), with a broader character formation that suggests indebtedness to clerical script (fig. 2).

Although calligraphy does not, like painting, replicate images in the visual world, it expresses them kinesthetically. In "The Eight Methods of the Character 'yung'" (Yung-tzu pa-fa), traditionally attributed to the monk Chih-yung, Yü Shih-nan's teacher, but probably dating from the seventh century,[49] the character *yung* (fig. 21)—the first character of Wang Hsi-chih's *Preface to the Orchid Pavilion Collection*—is described as embodying the essence of Wang's style. The eight strokes and segments of strokes of which the character is composed illustrate all the brushstrokes listed in *A Diagram of the Battle Formation of the Brush*: (1) the dot is like "a stone falling from a high peak," (2) the

Figure 21. The character *yung*, from Wang Hsi-chih's *Preface*, third Eight Pillar version (*Pa-chu ti-san-pen*). From *Shodō geijutsu*, 1: 37.

short horizontal is like a "cloud formation," (3) the vertical stroke is like "a withered vine," (4) the bottom lefthand hook is like the "sinews. . . of a mighty bow," (5) at left, the upward whip is like an arrow shot from a "crossbow," and (6) a downward thrust resembles "a rhinoceros digging its tusk into the ground," (7) another downward thrust at upper right represents this same movement, and finally, (8) a wavelike ending stroke is like "a crashing wave or rolling thunder."

The anonymous author of an essay on the eight calligraphic methods used by Ou-yang Hsün relates the calligraphic practice to the strict and repressive idea of Confucian rectitude. The written character should stand "balanced on all four sides, ready and complete in all eight directions. . . . Leaning or standing upright like a proper gentleman, the upper half [of the figure] sits comfortably, while the bottom half supports it."[50]

The monumental standard calligraphy of the early T'ang court exhibits characters that are upright and perfectly balanced, with a firmly built rectangular frame of supports and walls. Within each character every stroke, hook, and dot is perfectly delineated, and the construction of each character, with a careful interaction of elements, reflects an analytical method. Both characters and individual brushstrokes can be repeated in an infinite number of subtle variations.

By the middle of the eighth century, a new standard was established by the bold and simplified style of Yen Chen-ch'ing (709–785; fig. 22). Born in the T'ang capital, Ch'ang-an, Shensi, Yen, a descendant of a great Confucian family of scholars and statesmen, was a heroic defender of T'ang territories against the rebel forces of An Lu-shan in the mid-750s. He rose to be minister of justice and was made grand preceptor to the heir apparent, dying a martyr at the hands of the rebel general Li Hsi-lieh in 785. A prolific calligrapher,

Yen produced some dozen stele inscriptions. Writing in large standard script, he rejected the early T'ang court manner of complexity and sophistication, choosing instead a simple monumentality. Except for his wavelike ending strokes, where the influence of Ch'u Sui-liang's turning and flicking technique (fig. 16) can be detected, Yen generally contains his brushstrokes by "hiding" or "protecting" them within a round movement.[51] By rendering all his strokes with round brushwork, he achieves a new structural cohesiveness that expresses strength and harmony. Yen's simplified round brushwork, which imparts a flow of energy that gives his writing a single expressive drive, has been compared to that of his friend the cursive calligrapher Huai-su (ca. 735–ca. 799; fig. 23). Huai-su is said

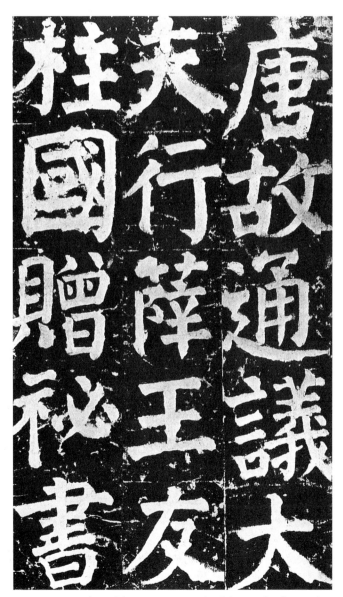

Figure 22. Yen Chen-ch'ing (709–785), *Stele of the Yen Family Temple (Yen-shih chia-miao pei;* detail), 780, ink rubbing on paper, height 31 cm. Shodō Hakubutsukan, Tokyo. From *Shoseki meihin sōkan 8*, no. 86: p. 1.

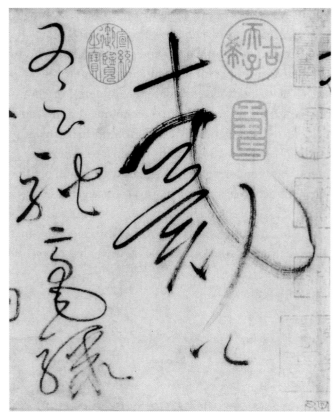

Figure 23. Huai-su (ca. 735–ca. 799), *Autobiographical Essay (Tzu-hsü t'ieh;* detail), 777, handscroll, ink on paper, 28.2 x 755 cm. National Palace Museum, Taipei, Taiwan, Republic of China.

wall." Whereupon Yen replied, "What about the staining patterns that result from rain running down a wall under a leaky roof?"[52]

With Yen Chen-ch'ing, the monumental standard script of the T'ang completes a full cycle of development in the formal structure of the written character. In the character *kuan,* "to observe," for example, which is made of two elements placed side by side, earlier calligraphers, from Wang Hsi-chih in the fourth century (fig. 24a) to Chih-yung in the sixth (fig. 24b) to Ou-yang Hsün in the seventh (fig. 24c), built the two halves of the character as additive components, and while they balance each other, they remain separate and independent. In Li Yung's early-eighth-century *kuan* (fig. 24d), an effort is made to combine the two elements, and the form of the character now serves to express the diagonal momentum of the brush. Finally, Yen Chen-ch'ing in the late eighth century (fig. 24e) effectively integrates the two halves of the *kuan* into a single design.[53]

Yen Chen-ch'ing was renowned not only as a great calligrapher but as a patriot and scholar-statesman of the highest integrity. His calligraphy was viewed by later generations as the embodiment of both aesthetic perfection as well as the upright principles and moral courage of a heroic age, his simplified but graceful brushwork suggesting restraint and spiritual harmony. By the eleventh century, the Yen Chen-ch'ing style had become the calligraphic model for Neo-Confucian reformist statesmen such as Ou-yang Hsiu (1007–1072), who saw it as the preferred alternative to the repressive court style of the orthodox Wang Hsi-chih manner.[54]

to have once remarked to Yen, "When I see extraordinary mountains in summer clouds, I try to imitate them. Good calligraphy resembles a flock of birds darting out from the trees, or startled snakes scurrying into the grass, or cracks bursting in a shattered

a. b. c. d. e.

Figures 24a–e. The character *kuan*
a. Wang Hsi-chih, *Essay on Yüeh I* (fig. 11, detail). b. Chih-yung, *The Thousand Character Essay* (detail), late 6th century. From *Shoseki meihin sōkan 6,* no. 69: p. 22. c. Ou-yang Hsün, *Inscription on the Sweet Wine Spring in the Chiu-ch'eng Palace,* 632 (fig. 6, detail). d. Li Yung (678–747), *Epitaph for the Yün-hui General, Li Ssu-hsün (Yün-hui chiang-chün Li Ssu-hsün pei;* detail), after 739, ink rubbing on paper. From *Shoseki meihin sō kan 8,* no. 82: p. 2. e. Yen Chen-ch'ing, *Record of the Altar of the Goddess Ma-ku (Ma-ku hsien-t'an chi;* detail), 771, ink rubbing on paper. From *Shoseki meihin sōkan 8,* no. 88: p. 40. Handscroll, ink on paper, 28.2 x 755 cm. National Palace Museum, Taipei, Taiwan, Republic of China.

With the declining power of the aristocracy and the rise of a scholar-bureaucrat class in the late T'ang, the ancient ideal of a just Confucian empire gave way to an increasingly absolutist imperial rule. By the late Northern Sung, in the late eleventh century, the conflict within the Confucian state between the interests of the imperial court and traditional moral values had resulted in a permanent schism between the ideology of the state and the private discourse of the scholar-officials. In the aesthetic realm the scholar-officials were more concerned with the rhetorical and expressive dimensions of the visual arts than with their representational and descriptive roles.[55]

The late Northern Sung witnessed the failure of the most ambitious court-directed campaign of social and fiscal reform ever embarked upon in imperial China, and it stretched the limits of change within the Confucian state.[56] Seen in the context of a power struggle between the court and the scholar-officials, the *fu-ku,* or revival, movement in literature and art espoused by the reformist leader Ou-yang Hsiu and his followers had a correlative development in political reform, also inspired by the vision of an archaic, mythic purity.[57] While the scholar-officials' advocacy of Confucian morality failed to solve political and social problems, their pursuit in art and literature of archaic simplicity led to revolutionary changes. Retreating from politics they sought personal transcendence through Taoism and Buddhism.

The literati artists of the late Northern Sung lived at a time when a newly emerging awareness of psychological reality demanded a different mode of expression, one that would reflect a changed world. Rejecting realism in art as merely the imitation of outward reality, Su Shih (1037–1101), the leader of the new literati aesthetic of the late eleventh century and a protégé of Ou-yang Hsiu, declared that "anyone who judges painting by form-likeness shows merely the insight of a child."[58] Having observed that artistic development had reached its pinnacle as early as the eighth century, Su believed the time was ripe for radical change:

> Wise men create; competent men transmit. . . . The learning of superior men and the skills of hundreds of craftsmen, having originated in the Three Dynasties [Hsia, Shang, Chou] and having passed through the

Han and T'ang, had reached a state of completeness. By the time poetry had produced a Tu Fu, prose writing a Han Yü, calligraphy a Yen Chen-ch'ing, and painting a Wu Tao-tzu, the stylistic variations of past and present as well as all technical possibilities had been fully explored.[59]

Su and his fellow scholar-artists saw the study of ancient history and the integration of its lessons as a way of bringing about calligraphic reform. Rejecting the polished brushwork and elegant, balanced compositions of the T'ang court style, they advocated a return to the archaic simplicity and naturalness of pre-T'ang models, experimenting with the unbeautiful and the plain in their attempt to create individual styles.

Huang T'ing-chien (1045–1105), a native of Fen-ning, Kiangsi, was a follower of Su Shih. A political conservative, Su had engaged in a bitter power struggle with the "new party" led by the political reformer Wang An-shih (1021–1086). In 1094, after the death of the dowager empress Kao, who had given her support to the conservatives, the new party again became influential at court, and Su Shih and his friends came under attack. Although Huang T'ing-chien never held an office of sufficient rank to involve him directly in political infighting, his close association with Su Shih resulted in his denunciation. Exiled to Szechwan in 1098, he was pardoned in early 1101 and again exiled in 1103. He died in 1105.

As a calligrapher Huang was dissatisfied with the rigidity and oversophistication of early Northern Sung writing. He complained also that "the untrammeled quality of the calligraphy of Wang Hsi-chih and his son [Wang Hsien-chih] is missing [in the work of the T'ang masters] Ou-yang Hsün, Yü Shih-nan, and Ch'u Sui-liang."[60] Rejecting T'ang models, he turned to archaeological sources for inspiration. One of these was the sixth-century stone engraving *Eulogy on Burying a Crane* (*I-ho ming;* fig. 18), which Huang believed to be the work of Wang Hsi-chih. Discovered in the eleventh century, the inscription, with its bold calligraphic style, created great excitement among scholars. For Huang T'ing-chien it became a model to emulate—the plain, rounded forms and dynamic, asymmetrically balanced characters representing the antithesis of the laboriously balanced square compositions he so disparaged.

In *Scroll for Chang Ta-t'ung* (fig. 25, cat. no. 6), dated 1100 and written when the artist was in Jung-chou, Szechwan, Huang describes the harsh conditions of

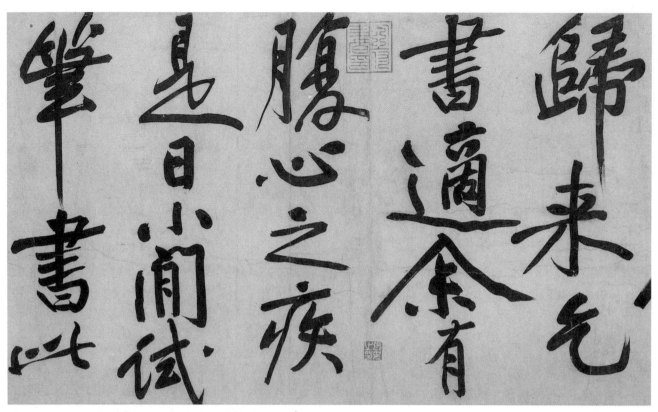

Figure 25. Huang T'ing-chien (1045–1105), *Scroll for Chang Ta-t'ung,* 1100 (cat. no. 6, detail).

his life in exile: "Weeds grow in my house, and rats share my path. . . . I have foot trouble and cannot bend over, and my stomach feels hard, as if carrying a tile or stone."[61] Yet his large, bold running script is powerfully energetic; its gestures and forms may be read as the artist's body language—exuberant, even defiantly triumphant. Using the asymmetrically balanced forms of *Eulogy on Burying a Crane* to define his mood, he creates pure energy and movement through the momentum, or force (*shih*), of his brushwork. The secret of imitation, he wrote, is to let "the mind respond to suggestion. . . . When I use a quotation from the past, it becomes an elixir that transforms iron into gold."[62] Holding the brush perpendicular to the paper and using a simplified, round brushwork that carefully conceals the brush tip, he wrote with his wrist and elbow suspended, following through on each stroke with the power of his entire body rather than flicking the brush with his wrist and fingers. "Hold the palm round and hollow, while the fingers grip the brush firmly and solidly," he instructed, "holding back as well as releasing energy" and "driving every stroke with full force."[63] Huang's grip of the brush was so powerful that it imparted a tremulous quality to the brushstrokes.

A highly disciplined Confucian scholar, Huang T'ing-chien in exile turned to Taoism and Ch'an Buddhism. Referring to a passage by the fourth-century B.C. Taoist mystic Chuang-tzu, he wrote, "My body is like dry wood, my mind like dry ashes."[64] His friend Su Shih saw in his calligraphy a struggle to resolve contradictions:

> His characters, both oblique and lopsided, strain
> toward equilibrium;
> Even when playful, he remains true and honest;
> He executes details with a large and open heart;
> Such are the three paradoxes [of Huang T'ing-chien].[65]

Huang perceived his calligraphy as visual abstraction, and described it as having resonance (*yün*), a term usually applied to music.[66] An admirer of the fourth-century recluse poet T'ao Ch'ien (365–427), he compared T'ao's unadorned poetry to "the music of a stringless zither"—as having a resonance that transcended the characters/notes of which it was composed.[67] It was with such resonance that he wanted his own calligraphy to sing.

A very different artistic personality from Huang T'ing-chien was Mi Fu (1052–1107).[68] A native of Hsiang-yang, Hupei, and the son of a military official

and a lady-in-waiting to the future empress, Mi was a reader at the Imperial Library, served briefly as a district officer in the southern city of Kuei-lin, and held a clerical position in Ch'ang-sha. An eccentric, Mi devoted himself to the study and collecting of fine calligraphy and painting, strange garden rocks, and rare early inkstones rather than partaking of more conventional social pastimes. He called himself the Wild Scholar of Hsiang-yang and was known as Mi the Crazy. Beginning in 1081 he spent ten years traveling, recording most of the known ancient paintings and calligraphy in private collections throughout China. Between 1086 and 1088 he finished his first book on calligraphy, *The Catalogue of Precious Calligraphies* (*Pao-chang tai-fang lu*).[69]

With his incomparable knowledge of ancient sources, Mi developed an encyclopedic approach to his own work. He once gave an account of his course of study, methodically working backward, step by step, from the T'ang masters through the early T'ang, back to the Chin and Wei, and, finally, to the earliest archaeological sources.[70] Later he strove to create a distinctive style of his own:

> Before I was able to establish my own style, people criticized my calligraphy as the writing of a collector-antiquarian. I used to select from the best styles and combine them in my own. It was not until after reaching old age that I found my own idiom. On seeing my calligraphy now, no one can tell who is my real model.[71]

Three Letters (cat. nos. 7a, b, c) relate to events in Mi's life that took place in 1092–94. In 1092 Mi was appointed district magistrate of Yung-ch'iu, Honan. Three years later he was brought to trial for failing to collect grain taxes, after which he was dismissed from office.[72] In *Abundant Harvest* (cat. no. 7a), probably written in 1093, Mi, confident and self-satisfied, greets a newly appointed magistrate from a neighboring district with advice on how to govern:

> I, Fu, bowing my head, beg to speak again. My district is blessed with an abundant harvest and no unusual happenings, and because there is not much to do, I am allowed to earn my salary, to continue to cultivate my incompetence. But Your Excellency, having just arrived in a new governing post, must help the populace to lead a long and humane life. A good magistrate must follow the people's wishes and help to spread a civilizing influence. He must clear his eyes and listen intently,

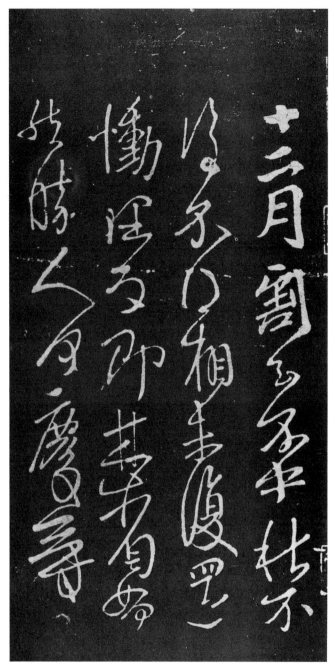

Figure 26. Attributed to Wang Hsien-chih (344–388), *The Twelfth Month (Shih-erh yüeh t'ieh)*, original undated, ink rubbing on paper from the *Pao-Chin-chai Anthology (Pao-Chin-chai fa-t'ieh)*. Collection unknown. From *Shodō geijutsu*, 1: 142.

so that he and his subjects may together gradually achieve harmony.

Later that year, in the wake of a failing harvest, the court dispatched an inspector to hasten the collection of grain taxes. To support the starving peasants, Mi refused to collect. *Escaping Summer Heat* (cat. no. 7b), probably written in 1094, when Mi was attempting to escape from political as well as seasonal heat, betrays a less contented state of mind:

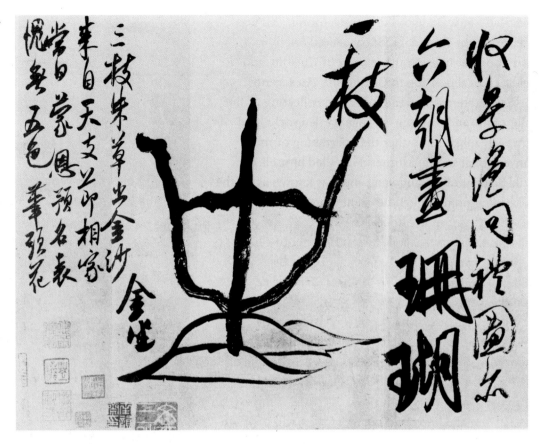

Figure 27. Mi Fu (1052–1107), *Letter about a Coral Tree,* ca. 1100, handscroll, ink on paper, 26.6 x 47.1 cm. Palace Museum, Peking. From Nakata Yūjirō, *Bei Futsu* (Tokyo: Nigensha, 1982), 2: 123.

I, Fu, escaping the summer heat, have come to the mountains to seek relief. In life we live with illusions. [Illegible] gives us fever, while heat causes us to be vexed. As the saying goes, rich [or poor,] we all suffer from the heat. . . . When I was beset by the heat, I was able to come here. Am I not fortunate? By autumn I shall be able to leave.

Hasty Reply before Guests (cat. no. 7c) was written while Mi was entertaining guests. It most likely dates to late summer 1094:

I was disappointed to miss you earlier, when you came and left a note. You inform me that my luggage has arrived. I have chosen to avoid the inspection visit of Official Lin, pleading to stay home but instead running

Figure 28. Mi Fu, *Poem Written in a Boat on the Wu River* (detail), ca. 1100, handscroll, ink on paper, 31.3 x 559.8 cm. The Metropolitan Museum of Art, New York.

to the ferry before his arrival. . . . I reply to you in haste while entertaining some guests.

All these letters, written in Mi's stylistic maturity, exhibit a combination of influences. *Abundant Harvest,* rendered in finely modulated brushstrokes, displays a smooth, elegant style derived from Ch'u Sui-liang (fig. 16). *Escaping Summer Heat* derives from the more severe, angular style of Ou-yang Hsün (fig. 6). And *Hasty Reply* is written in a freer running-cursive script that recalls the calligraphy of Wang Hsien-chih (344–388; fig. 26), whose work Mi himself described as "natural, true, transcendental, and untrammeled."[73]

Like Huang T'ing-chien (fig. 25), Mi favored calligraphy with oblique rather than frontal, upright strokes. But while Huang's brushwork is tightly controlled, Mi's is spontaneous and unpredictable. Whereas Huang gripped his brush, Mi believed the brush should be held easily, with a light touch: "Let the palm arch loosely and freely, so that the brush movement can be swift and natural, and can happen without intention. . . . The pressure of the fingers on the brush should not always be the same."[74] Mi's objective was to achieve a spontaneity that he found lacking in the works of even the most respected T'ang calligraphers. "When Yen Chen-ch'ing began to follow the style of Ch'u Sui-liang, achieving fame for his flicking and kicking brushstrokes," he wrote, "his style became affected. It lacks the natural qualities of simplicity and lightness."[75]

In his large cursive writing, exemplified in *Letter about a Coral Tree* (*Shan-hu t'ieh;* fig. 27), Mi was inspired by the earliest seal script, the pictograph (fig. 1). "By the time clerical script emerged, the ancient method of the great seal was no longer in use," he wrote. "In seal script, characters are sometimes large and sometimes small; they symbolize the forms of hundreds of things [in nature]—alive and full of motion, round and complete, each a self-contained image."[76] Dating to the last years of Mi's life, *Letter about a Coral Tree* is a list of the antique scrolls and curios the artist had recently collected. To describe a recently acquired piece of coral, Mi drew the three-branched object mounted on a metal stand; it is reminiscent of a pictograph inscribed on a Shang-dynasty ritual bronze vessel.

In the handscroll *Poem Written in a Boat on the Wu River* (*Wu-chiang chou-chung shih;* fig. 28), made around 1100 when he was in the Lake T'ai region, Mi Fu's cal-

Figure 29. Yen Chen-ch'ing, *A Poem to General P'ei (Sung Pei chiang-chün shih;* detail), ink rubbing on paper, Chung-i Studio version (1215–17), 34.5 x 19.7 cm. Shodō Hakubutsukan, Tokyo. From *Shodō zenshū,* n.s., 10: pl. 71.

ligraphy approaches abstract painting. Large characters, he wrote, "should look as if they were small ones, complete with sharp-edged strokes, and without an artificial and labored look."[77] Su Shih described Mi's unbridled cursive calligraphy as "a sailboat in a gust of wind, or a warhorse charging into battle,"[78] and Mi characterized his own brushwork as "scrubbing" with a brush.[79] The dramatic visual impact of Mi's writing is rivaled only by that of Yen Chen-ch'ing (fig. 29), although Yen's characters emphasize architectonic structure and Mi's are fluid and painterly. In the character *kuan* (figs. 30a, b), for example, where Yen stresses articulation of brushwork and stability of

 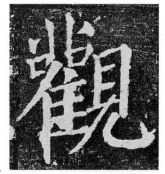

a. b.

Figures 30a, b. The character *kuan*
 a. Mi Fu, *Poem Written in a Boat on the Wu River* (fig. 28, detail).
 b. Yen Chen-ch'ing, *Stele of the Yen Family Temple (Yen-shih chia-miao pei;* detail), 780. From *Shoseki meihin sōkan* 8, no. 88: 40.

composition, Mi emphasizes brush force, visual abstraction, and movement.

After the fall of the Northern Sung, Kao-tsung (r. 1127–62; cat. no. 8) became the first emperor of the Southern Sung. An ardent calligrapher, he created a new court style (fig. 31), basing his manner on those of the pre-T'ang masters Chung Yu (fig. 4) and Chih-yung (fig. 19). Following Mi Fu's aesthetic preference, Southern Sung calligraphers used pre-T'ang models to achieve spontaneity and naturalness. Chang Chi-chih (1186–1266), a native of Ho-chou, Anhwei, was the leading Southern Sung master of standard script.[80] A devout Buddhist layman, Chang befriended disciples of the famous Ch'an master Wu-chun Shih-fan (ca. 1177–1249) at T'ien-t'ung Monastery in the T'ien-t'ai Mountains.[81] In his transcription of the *Diamond Sutra,* dated 1246 (fig. 32, cat. no. 10), Chang's standard script echoes the traditions of both the T'ang master Yen Chen-ch'ing (fig. 22) and the Northern Sung master Mi Fu (fig. 27). Chang's brushwork, done with a rapid movement and characterized by alternating thick, heavy strokes with fine, thin ones, follows Mi's "scrubbing" with a light, easy touch.[82] Although his broad, square characters evoke the heroic style of Yen Chen-ch'ing, Chang's calligraphy is less controlled and less structured, reflecting in its bold, blunt manner the Ch'an spirit of simplicity and direct intuition.

Toward the end of the Southern Sung, in the late thirteenth century, the scholar-painter Chao Meng-chien (1199–1267) criticized the calligraphy of his time for its attention to surface appearance rather than to internal structure:

It is common belief that it is preferable to follow the [Eastern] Chin style than to follow the T'ang. Yet how can one follow the Chin [without first mastering the T'ang]? To follow the T'ang is to learn the basic methods and principles [of calligraphy]. To follow the Chin without first mastering the T'ang is to misjudge one's own capabilities. If one merely slants one's characters, trying to make them look good but not succeeding, it is like attempting to draw a tiger and ending up with a dog. Why so? In calligraphy every character must rest firmly on a frame of supports and walls; only then will it not look weak and crooked. In Ssu-ling's [Emperor Sung Kao-tsung's] calligraphy [fig. 31], though it is smooth and fluent, not enough attention is given to the building of supports and walls. This problem should be discussed among the connoisseurs.[83]

Figure 31. Emperor Kao-tsung (r. 1127–62), *Preface to the Anthology by Emperor Hui-tsung (Hui-tsung wen-chi hsü),* 1154, album leaf, ink on paper. Collection unknown. From *Shodō zenshū,* n.s., 16: pls. 22–23.

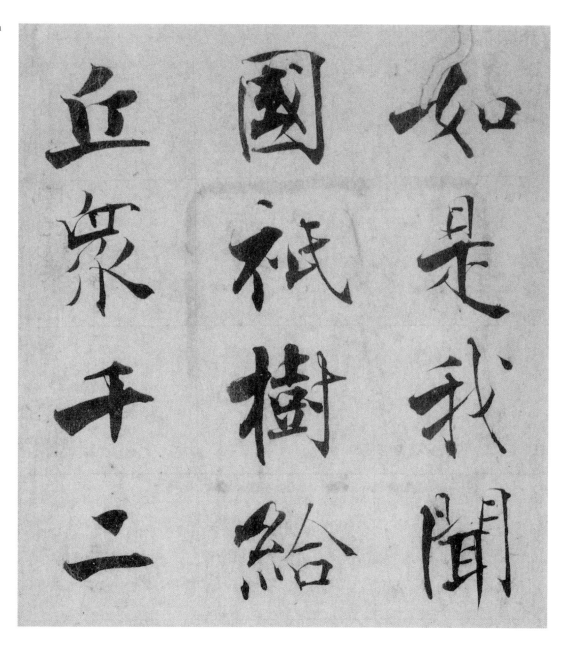

Figure 32. Chang Chi-chih (1186–1266), *Diamond Sutra,* 1246 (cat. no. 10, detail).

CHAO MENG-FU (1254–1322)

The Mongol conquest of the Southern Sung in 1279 for the first time subjected all of China, under the Yüan dynasty, to alien rule. The disenfranchised scholarly class, disillusioned by the failure of traditional Confucian teachings to salvage their country, turned to artistic pursuits, attempting under the constraints imposed by Mongol rule to reaffirm their ancient heritage. The reunification of north and south not only brought together different regional styles but stimulated the revival of earlier northern traditions long neglected or forgotten in the south, and in the great urban centers lovers of antiquities gathered to collect, study, and practice calligraphy and painting. Thus while their political fortunes suffered, Yüan scholars led a renaissance of the arts.

Born in 1254 in Wu-hsing, Chekiang, Chao Meng-fu was an eleventh-generation descendant of the founder of the Sung dynasty. At age thirty-two, in 1286, he presented himself at the Yüan court in Peking and immediately became a favorite of Emperor Shih-tsu (Khubilai Khan; r. 1260–94). At court he served first as a member of the Ministry of War, supervising the Post Service (1287), and then as a member of the Academy of Worthies (1290). After the death of Shih-tsu, Chao was director of Confucian studies in Hangchow (1299–1308) before he was called back to Peking to be a reader at the Hanlin Academy (1310), of which he was eventually made director (1316). After his retirement in 1319, he returned to Wu-hsing, where he died in 1322.

Figure 33. Chao Meng-fu (1254–1322), *Colophon to the Manuscript "The Great Tao,"* attributed to Wang Hsi-chih, 1287, handscroll, ink on paper. National Palace Museum, Taipei, Taiwan, Republic of China.

Figure 34. Chao Meng-fu, *Colophon to "Confucius Making an Offering in a Dream"* by Ou-yang Hsün, 1291, handscroll, ink on paper. Liaoning Provincial Museum, Shenyang.

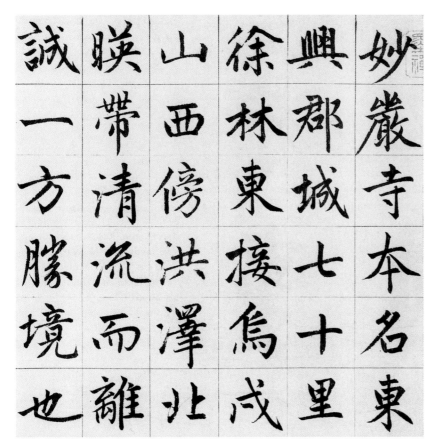

Figure 35. Chao Meng-fu, *Record of the Miao-yen Monastery,* ca. 1309–10 (cat. no. 11, detail).

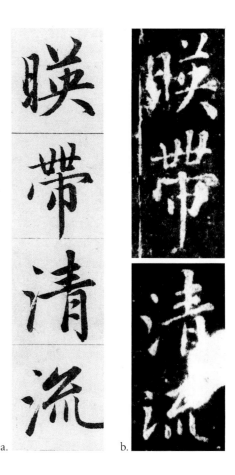

a.

b.

Figures 36a, b. The phrase *ying-tai ch'ing-liu*
a. Chao Meng-fu, *Record of the Miao-yen Monastery* (cat. no. 11, detail).
b. Wang Hsi-chih, *Preface to the Orchid Pavilion Collection* (detail).

Chao's colophons on ancient masterworks reveal him to be both a keen commentator and a diligent practitioner. His early calligraphy reflects his training in the Southern Sung court style exemplified by Emperor Kao-tsung's archaizing standard script (fig. 31). A colophon (fig. 33) dated 1287, on the manuscript *The Great Tao (Ta-tao t'ieh),* attributed to Wang Hsi-chih, shows the influence of Kao-tsung's squat standard-script style, with smooth modulated brushstrokes revealing the pointed brush tip. In the 1290s, in an effort that reflected Chao Meng-chien's injunction, quoted above, that "to follow the T'ang is to learn the basic methods and principles [of calligraphy]," Chao Meng-fu concentrated on studying the styles of the T'ang masters. A colophon (fig. 34) dated 1291, on Ou-yang Hsün's *Confucius Making an Offering in a Dream (Chung-ni meng-tien t'ieh),* is written in Yen Chen-ch'ing's style (fig. 22).

During his years in Hangchow, Chao made an extensive study of Eastern Chin calligraphy, especially that of Wang Hsi-chih. In the fall of 1310, in answer to a call

to serve in the capital, he traveled by boat from his hometown Wu-hsing to Peking via the Grand Canal. The journey took thirty-two days. Confined to his cabin, Chao used the time to study a prized rubbing of the Ting-wu version of *Preface to the Orchid Pavilion Collection* (fig. 5). He wrote a total of thirteen colophons, commenting on a range of topics, among them how to judge a good rubbing of the *Preface,* the collector's market, art criticism, and autograph seekers. And he wrote also about brushwork and character composition:

> While compositional structures of the written character have changed over time, brushwork has remained the same over a thousand ages. The compositional forces of Wang Hsi-chih's calligraphy represent a major transformation of the ancient methods, their power and elegance a natural gift.[84]

In *Record of the Miao-yen Monastery* (fig. 35, cat. no. 11), a major work written in late 1309 or early 1310, Chao's mature large standard script displays a fluent

Figures 37a, b. The characters *wei,*
t'u/kuo, and *shih*

a. Chao Meng-fu, *Record of the
Miao-yen Monastery* (cat. no. 11,
details).

b. Yen Chen-ch'ing, *Certificate of
Appointment (Kao-shen t'ieh;* detail),
780, handscroll, ink on paper, 30 x
220.8 cm. Shodō Hakubutsukan,
Tokyo. From *Shodō zenshū,* n.s., 10:
pls. 60–62.

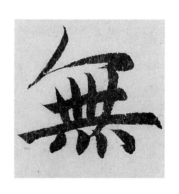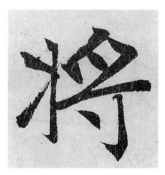

a.

b.

Figures 38a, b. The characters *ting, ssu, wu,* and *chiang*
 a. Chao Meng-fu, *Record of the Miao-yen Monastery* (cat. no. 11, details).
 b. Ch'u Sui-liang, *Preface to Sacred Teaching* (details). From *Shoseki meihin sōkan* 7, no. 77: 6, 28, 29, 53.

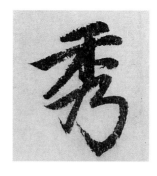

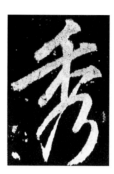

synthesis of Chin, T'ang, and other models. In the phrase "a shining belt of clear stream" (*ying-tai ch'ing-liu;* figs. 36a, b), for example, while the compositional structure of Wang Hsi-chih's characters in the *Preface* is carefully reproduced, the brushstrokes are entirely Chao's own, combining and harmonizing elements from the calligraphy of Ou-yang Hsün (fig. 6), Ch'u Sui-liang (fig. 16), and Yen Chen-ch'ing (fig. 22). Yen was particularly important. In the characters *wei, t'u,* and *shih* (figs. 37a, b), the influence of his square forms and round brushwork is clearly evident. For the most part, however, Chao preferred a more elegant style, so he also turned to the earlier T'ang court style of Ch'u Sui-liang. In the characters *ting, ssu, wu,* and *chiang* (figs. 38a, b), Chao reflects Ch'u's influence, mixing tightly knit vertical elements with wide horizontal clerical strokes to achieve structural stability. Another source was Li Yung (678–747), whose slanting strokes and angular turns can readily be seen in Chao's characters *yeh, nai,* and *hsiu* (figs. 39a, b).

Chao's most important contribution was to revitalize Southern Sung calligraphy by introducing a firm frame of supports and walls for the written character. To strengthen his verticals and horizontals, he employed carefully articulated brush techniques. In the characters *t'u* and *shih* (figs. 37a, b), for example, the vertical stroke ending with an upward hook is made, after Yen Chen-ch'ing, with a fully developed bulge

a. b.

on the right side of the stroke and a hook in which the brush is retracted into the stroke before being lifted upward. In the characters *fang* and *yang* (figs. 40a, b), Chao sets his diagonal element at a 45-degree angle to serve as a structural brace for the walls of the characters. In the characters *fang* and *yang,* the diagonal motif is a diamond framed by an imaginary square.

With his beautifully balanced characters displaying an easily recognized and repeatable array of brushstrokes, Chao Meng-fu created the first new standard script since Yen Chen-ch'ing. It could be adapted to both small and large writing, from characters the size of a fly to a height of several inches, and by the early fourteenth century it was the dominant style, adopted even in printed books after the 1330s (fig. 41).

Figure 41. Chang Yü (1277–1348), *Record of Mount Mao (Mao-shan chih;* detail), ca. 1328, blockprint, ink on paper. From *National Palace Museum Bulletin* 10, no. 6 (Jan.–Feb. 1976): 5.

FROM REPRESENTATION TO SELF-EXPRESSION

In his book *Art and Illusion* (1960), E. H. Gombrich develops a theory of Western art based on the psychology of vision.[85] In characterizing the work of a painter as "making before matching [reality]" through a process of "schema and correction," Gombrich compares schema, the painter's transcriptive tool, with the provisional hypothesis of the scientist. Just as the work of the scientist is a continual process of experiment based on hypotheses, the work of the painter is a process of "gradual modification of the traditional schematic conventions of image-making under the pressure of novel demands." The perception of the painter, reflected in the painting he creates, is the result of modifications, or corrections, of inherited schema, and is thus both culturally and historically determined. In positing the process of schema and correction as a progressive sequence toward visual realism, Gombrich's theory of art is predicated on the development of science in the Western world:

> In the Western tradition, painting has been pursued as a science. All the works of this tradition. . . apply discoveries that are the result of ceaseless experimentation. . . . The history of naturalism in art from

the Greeks to the Impressionists is the history of a successful experiment, the real discovery of appearances, as Roger Fry described it.[86]

There is an important difference between the approach of the Chinese critic to painting and that of the Western critic. Whereas Western formal analysis is phenomenological and deals only with what takes place in representational space, Chinese painting, because of its reliance on brushwork as the artist's personal handwriting, is equally concerned with the presentational qualities of the artist. The first principle of painting as defined by the fifth-century critic Hsieh Ho (fl. ca. 479–502) is "breath-resonance-life-motion" (*ch'i-yün sheng-tung*). Expanding his definition, he uses a number of "breath" compounds: "breath energy," "robust breath," "spirited breath," "breath of life," and "cultivated breath," all of which are expressed through the trace of the brush, the hand of the artist.[87]

Although the Chinese did not, like Western artists, pursue art as a science, they did achieve illusionistic representation in both figure and landscape painting.[88] From the late sixth through the early eighth century, Chinese figural representation in sculpture and painting underwent a development similar to that of the

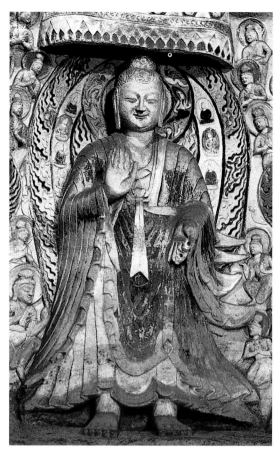

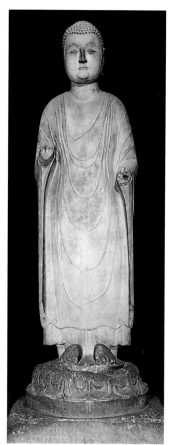

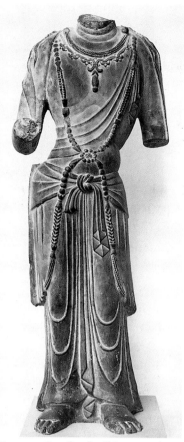

Figure 42. Buddha, early 6th century (Northern Wei dynasty), sandstone, from Yün-kang cave 6. From Yün-kang shih-k'u wen-wu pao-kuan-so pien, *Yün-kang shih-k'u* (Peking: Wen-wu ch'u-pan-she, 1991), 1: pl. 115.

Figure 43. Amitābha, ca. 587 (Sui dynasty), white marble bearing traces of paint, height 268.6 cm, width at base 99.0 cm. Royal Ontario Museum, Toronto, Canada (923.18.13).

Figure 44. Standing bodhisattva, 8th century, stone, height 101.7 cm, width 40.9 cm. Courtesy of the Freer Gallery of Art, Smithsonian Institution, Washington, D.C. (16.365).

Greek "miracle of awakening" of the fifth century B.C., when the representation of the human figure evolved from one of rigid archaic frontality to one of natural movement in space.[89] An early sixth-century Buddha image from Yün-kang, Cave VI (fig. 42) is shown in the rigidly frontal pose characteristic of the archaic Northern Wei style; the focus is on the linear drapery pattern, with little concern for the body underneath. An early Sui Buddha (fig. 43), dating to only half a century later, shows a fully plastic figure; here, the drapery folds are suppressed to emphasize the cylindrical mass of the body. Finally, a standing T'ang bodhisattva (fig. 44) of the early eighth century is a three-dimensional rendition of the figure in a subtle contrapposto pose and with naturalistic, "transparent" drapery; the body is constructed with a strong sense of tectonic structure, and well-defined parts are coordinated and unified into an organic whole.

During the seventh and eighth centuries, Buddhist themes gained in popularity, and scenes of Pure Land Paradise and of Hell provided the locus for the development of illusionistic representation.[90] By the early seventh century, images both sculpted and painted had been united in architectural settings to create environments that physically enveloped the viewer in the Pure Land. In cave 321 at Tun-huang (fig. 45), directly above the sculpted images in the inner sanctum, on a painted ceiling surely as vivid as a Tiepolo, celestial beings depicted in foreshortened perspective are shown soaring over a heavenly balustrade that rests on an encircling band of floor tiles in patterns that recede and project in space.

Landscape painting arose as a major genre at the end of the T'ang. To use Gombrich's terminology, the basic schemas established by early masters in the tenth century were followed, with increasingly naturalistic modifications, by painters during the eleventh, twelfth, and thirteenth centuries. The development of landscape and flower-and-bird paintings of the Northern Sung reflected an increasing interest in the objec-

tive exploration of the natural world. This interest in nature coincided with the development of Sung Neo-Confucian thought, which advocated the study of principles of the universe, teaching that "the extension of knowledge lies in the investigation of things." As landscape painters came to master representation in space, the modeling of forms and the compositional structure of landscape painting progressed in three discernible stages. In the first stage (fig. 46), from about 700 to about 1050, the treatment of form and space is additive and compartmentalized. In the second stage (fig. 47), from about 1050 to about 1250, modeling techniques and composition match more closely the way we actually see landscape in a unified spatial continuum. By the third stage (fig. 48), between 1250 and 1350, naturalistic representation in landscape painting, with foreshortening and an integrated ground-plane in spatial recession, is achieved.[91] It was after illusionism was fully mastered in the Yüan that Chao Meng-fu and

other literati artists, venturing beyond representation, transformed landscape painting by the use of a purely calligraphic vocabulary.[92]

In his painting Chao made a systematic study of Northern Sung landscape styles, defining them in terms of calligraphic patterns and creating a new vocabulary for what he called "writing" (hsieh) rather than "painting" a landscape. In Twin Pines, Level Distance (Shuang-sung p'ing-yüan; fig. 49), dating to about 1310, Chao draws two pine trees in the style of Kuo Hsi (fig. 47), turning Kuo's representational brushwork into a calligraphic formula. Compared with Kuo's image of gnarled trees and billowing rocks, Chao's assertive calligraphic brushstrokes, no longer subordinate to realistic representation, have an independent energy of their own. There is a narrative quality in Kuo's illusionistic representation of nature. Dramatic tree forms emerge from dense mists, and alternating dark and light passages, rendered in smoothly graded

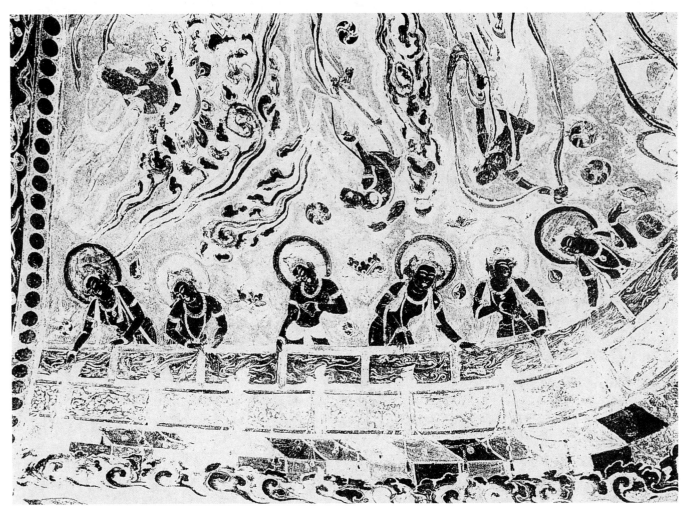

Figure 45. Wall painting from cave 321, Tun-huang, ca. 7th century. From Tuan Wen-chieh, ed., *Chung-kuo pi-hua ch'üan-chi, Tun-huang 5, ch'u T'ang* (Shenyang: Liao-ning mei-shu ch'u-pan-she, 1987), pl. 97.

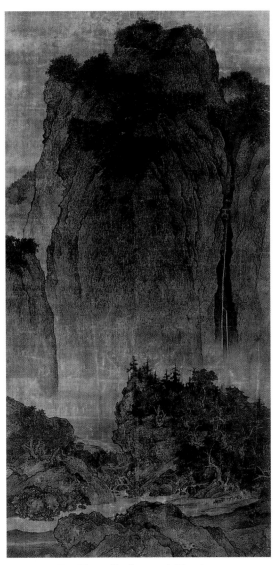

Figure 46. Fan K'uan (d. after 1023), *Travelers among Streams and Mountains (Hsi-shan hsing-lü)*, ca. 1000, hanging scroll, ink and color on silk, 206.3 x 103.3 cm. National Palace Museum, Taipei, Taiwan, Republic of China.

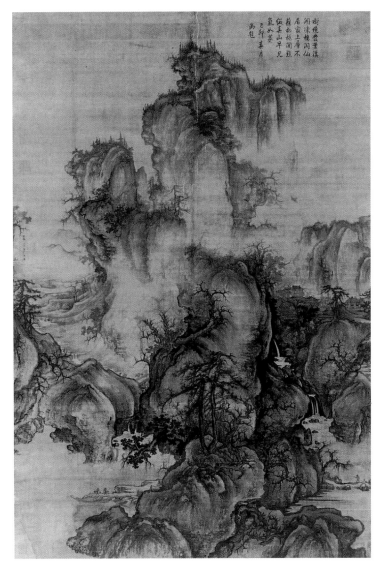

Figure 47. Kuo Hsi (ca. 1000–ca. 1090), *Early Spring (Tsao ch'un t'u)*, 1072, hanging scroll, ink and color on silk, 158.3 x 108.1 cm. National Palace Museum, Taipei, Taiwan, Republic of China.

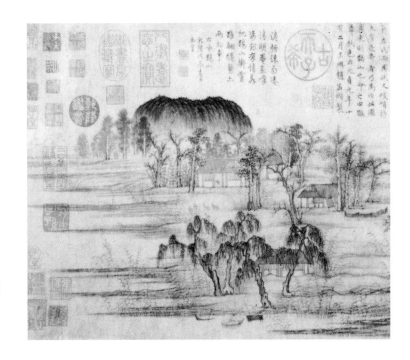

Figure 48. Chao Meng-fu, *Autumn Colors of the Ch'üeh and Hua Mountains (Ch'üeh Hua ch'iu-se)*, 1295, handscroll, ink and color on paper, 28.4 x 93.2 cm. National Palace Museum, Taipei, Taiwan, Republic of China.

ink washes on the silk surface, run together to create a wet, blurry, atmospheric environment. Chao's calligraphic image, by contrast, having been removed from its naturalistic context and placed against a starkly white ground, displays individual brushstrokes as isolated gestures that embody the artist's own identity. In merging painting with calligraphy, Chao Meng-fu thus initiated a fundamental redirection in painting, turning pictorial representation into calligraphic self-representation—into Berel Lang's "mode of personification."[93]

This shift from naturalistic representation to self-representation—in calligraphy, from the representation of the written character to that of historical styles—in Sung and Yüan China seems to echo what Michel Foucault has described as the great epistemological change that occurred in Western culture on the eve of the modern age. Before the nineteenth century, Foucault writes, there was a coherence "between the theory of representation and the theories of language, [and] of the natural orders." From the nineteenth century onward, "the theory of representation disappears as the universal foundation [of knowledge]. . . [and] a profound historicity penetrates into the heart of things Language loses its privileged position and becomes, in its turn, a historical form. . . [and] things become increasingly reflexive, seeking the principles of their intelligibility only in their own development, and abandoning the space of representation."[94]

CALLIGRAPHY OF THE MING (1368–1644) AND EARLY CH'ING (1644–CA. 1750)

The Ming empire was notorious for its harsh, despotic rule. The purges conducted by the first Ming ruler, T'ai-tsu, better known as the Hung-wu emperor (r. 1368–98), marked a new era of imperial brutality. The Ming emperors were hostile also to the Confucian scholar-officials and their often independent ways. In 1530 the court downgraded the symbol of the scholar-officials' institutional authority, the Temple of Confucius, changing the title of the sage from Supreme Sage, King of Spreading Culture, to Our Deceased Teacher Confucius.[95] The tension between imperial interests and the interests of the scholar-official bureaucracy, which in effect defined court life, was reflected in the arts in the opposition between official court style and the rebellion against repressive state orthodoxy.

THE COURT CHANCELLERY STYLE

During the tumultuous final decades of the Yüan and the beginning of the Ming dynasty, a generation of younger artists, wishing to enter public life, attempted to reinstate the public role of calligraphy and painting. Sung K'o (1327–1387) was the leading calligrapher of the early Ming. Born to a wealthy family in Ch'ang-chou, Kiangsu, Sung initially pursued a military career, though he soon retired to Soochow, around 1356,

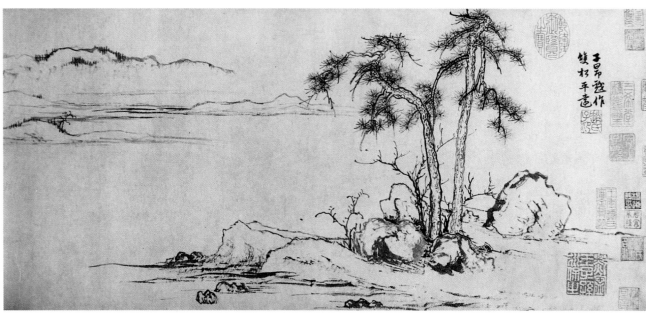

Figure 49. Chao Meng-fu, *Twin Pines, Level Distance*, ca. 1310, handscroll, ink on paper, 26.7 x 107.3 cm. The Metropolitan Museum of Art, New York.

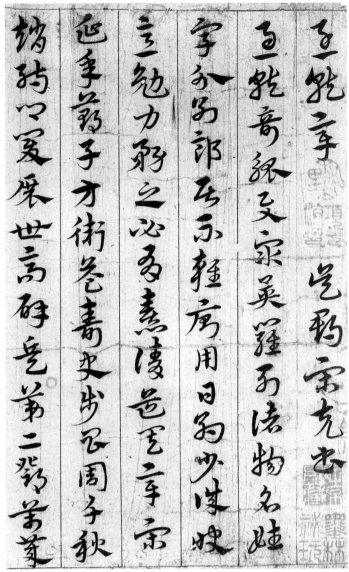

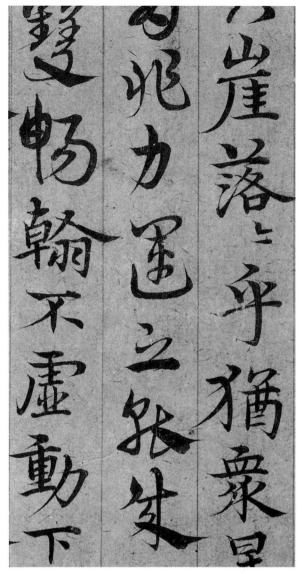

Figure 50. Sung K'o (1327–1387), *Model Essay on Draft Cursive,* 1370, handscroll, ink on paper, 20.4 x 343.8 cm. Palace Museum, Peking. From *Kokyu hakubutsuin* (Tokyo: Kodansha, 1995), 2: 1.

Figure 51. Sung K'o, *Transcription of Sun Kuo-t'ing's "Manual on Calligraphy,"* undated (cat. no. 18, detail).

devoting himself to poetry and to the practice of calligraphy.[96] Sung's fame as a calligrapher led to his being summoned to serve at the Hanlin Academy in the new Ming capital, Nanking. He was also posted as a deputy prefect to Feng-hsiang, Shensi.

Sung's most famous work is *Model Essay on Draft Cursive (Chi-chiu chang;* fig. 50), dated 1370.[97] Based on *Model Essay on Draft Cursive,* attributed to the third-century calligrapher Huang Hsiang (fl. ca. 220–79; fig. 3), Sung's transcription follows similar works by Chao Meng-fu and others.[98] His draft-cursive, based on Chao Meng-fu's interpretation, combines and harmonizes lessons from all four historical scripts: clerical, standard, running, and cursive. From the clerical, he takes the frontal axis; from the standard, he derives

the sense of repetition, giving the same weight and rhythm to each character; from the running he takes flexibility, tension, and the small interstices between the brushstrokes; and from the cursive, a sinuosity and sense of the crescendo in the overall composition.

In *Transcription of Sun Kuo-t'ing's "Manual on Calligraphy"* (cat. no. 18), dating from around 1370, a work that transcribes Sun Kuo-t'ing's famous text (fig. 7) but does not copy his style, Sung demonstrates his study of different historical scripts by mixing and harmonizing standard, running, and draft-cursive in a single piece of calligraphy. Writing fluently and with great flourishes (fig. 51, cat. no. 18), he moves freely from the technique of standard script, which, as Sun Kuo-t'ing wrote, "builds form with dots and strokes and uses

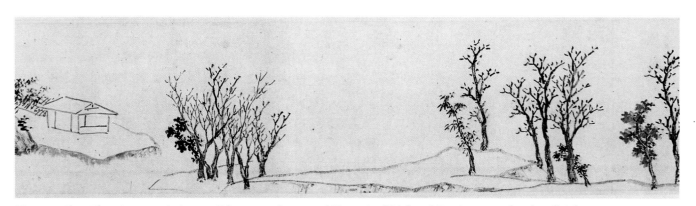

Figure 52. Shen Chou (1427–1509), *Autumn Colors among Streams and Mountains (Hsi-shan ch'iu-se)*, ca. 1480, handscroll, ink on paper, 19.8 x 640.2 cm. The Metropolitan Museum of Art, New York.

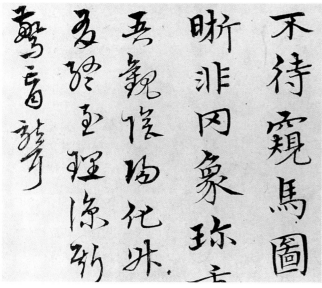

Figure 53. Shen Tu (1357–1434), *Collected Poems,* undated (cat. no. 19, detail).

the turning of the brush to express emotion," to that of cursive, which "creates form with the turning of the brush and captures emotion through dots and strokes,"[99] and back again to standard.

Juxtaposing and harmonizing different scripts, Sung K'o established a new genre that comprised the writing of four calligraphic scripts (*ssu-t'i-shu*). When adopted by painters, this treatment of style as subject matter also created a new paradigm for Ming painting. The

leading Wu (Soochow) school painter Shen Chou (1427–1509), in his *Autumn Colors amid Streams and Mountains (Hsi-shan ch'iu-se;* fig. 52), explores the brush idioms of the four late Yüan masters, Ni Tsan (1306–1374), Huang Kung-wang (1269–1354), Wang Meng (ca. 1308–1385), and Wu Chen (1280–1354), much as Sung K'o had treated the writing of four calligraphic scripts in a single handscroll composition, bringing to the autumnal scenery a wide range of lyrical expression.

Sung K'o's most important followers were the brothers Shen Tu (1357–1434) and Shen Ts'an (1379–1453), from Hua-t'ing, Kiangsu. During the Yung-lo reign (1403–1424), the two Shens served as court calligraphers in the Hanlin Academy, and the Yung-lo emperor proudly praised Shen Tu as the Wang Hsi-chih of his dynasty.[100] In the handscroll *Collected Poems* (fig. 53, cat. no. 19), Shen Tu transcribes eight poems composed by Chu Hsi (1130–1200), writing them alternately in standard and draft-cursive script. Executed with refinement and precision, the two script forms complement one another, creating an elegant and rhythmically varied composition. The calligraphy of the Shen brothers exemplifies the court Chancellery style (*T'ai-ko t'i*), the standard for all official documents during the early Ming period. And just as Chao Meng-fu's standard script, a re-formulated monumental style, was used for state-sponsored printed books during the

Figure 54. Page from the book *Deeds of Filial Piety (Hsiao-shun shih-shih),* preface dated 1420, detail of blockprint, ink on paper. Gest Oriental Library, Princeton University.

Yüan (fig. 41), so was Shen's calligraphy, based on that of Chao, used for imperially sponsored printed books in the early Ming (fig. 54).

THE PHILOSOPHY OF THE SCHOOL OF THE MIND

The dynamic political and cultural expansion that had taken place under the early Ming emperors was followed in the second half of the fifteenth century by a period of military setback and political decline. After the death of Emperor Hsüan-tsung in 1435, the throne was occupied for nearly a century by a succession of weak young rulers. Imperial patronage of the arts was also curtailed, and intellectual and cultural activities of the scholar-officials were engaged in without attendant critical discourse. Then at the beginning of the sixteenth century, during the reign of the Hung-chih emperor (r. 1488–1505), the pace of intellectual and artistic debate among high officials suddenly quickened, reflecting political factionalism at court.

Throughout the sixteenth century the rising voice of individualism was reflected in the debate over the artist's relationship to ancient models. In the literary arena, early in the century, the Seven Early Masters rejected the ornate Chancellery style in prose writing and poetry. Espousing naturalism and directness of expression, they advocated in prose the revival of the simple style of the ancient Ch'in and Han dynasties and in poetry the robust model of the High T'ang. In the second half of the century the Seven Later Masters held sway, arguing that to grasp the essence of the ancient models one must oneself undergo a transformation (*pien*) and that literature was first and foremost an expression of the self. At the end of the sixteenth century a new literary wave, led by the Kung-an (Hunan) school of poetry, which held that artistic rejuvenation could be achieved *only* through individual

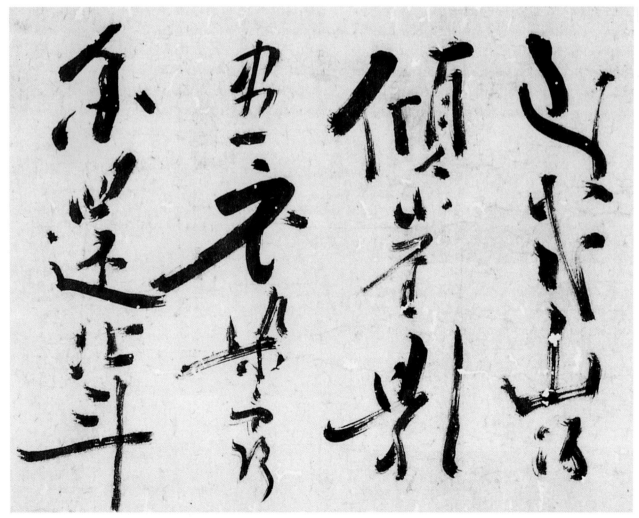

Figure 55. Ch'en Hsien-chang (1428–1500), *Writing about Plum Blossoms while Ill,* 1492 (cat. no. 22, detail).

transformation (*i-pien wei-fu*), advocated the rejection of ancient models altogether.[101]

In philosophy the revivalists, who adhered to ancient models, followed the orthodox Neo-Confucian School of the Principle (*Li-hsüeh*), led by Chu Hsi, which argued for the existence of immutable metaphysical principles and objective truth. The radical reformers, on the other hand, turned to the School of the Mind (*Hsin-hsüeh*), which held the relativistic view that "the universe is the mind, the mind, the universe" and that the fulfillment of the self was incompatible with the imitation of ancient models.

Ch'en Hsien-chang (1428–1500), from Hsin-hui, Kwangtung, was an early leader of the School of the Mind.[102] Having failed twice to pass the metropolitan examination, he returned to Hsin-hui determined to study Confucian sagehood. He did not, however, accept Chu Hsi's idea of objective truth, believing instead that knowledge derives from personal insight. In this belief he embraced the Taoist and Ch'an practice of meditation and devoted himself to quiet sitting as a method of self-cultivation. A gifted poet and calligrapher, Ch'en was known for his individualistic style of cursive calligraphy, done, especially in his later years, with a coarse brush made of rush. In the handscroll *Writing about Plum Blossoms while Ill* (fig. 55, cat. no. 22), dated 1492, the blunt brushwork illustrates his statement "My learning [and art] is based on the natural."[103] His calligraphy, like his religious practice, reflects a cultivation of the self through freedom and spontaneity. Like his Ch'an masters, he embraced the belief that nothingness produces creativity; for only by remaining quiescent and open can the mind possess insight and understanding and reach a state of being that is simultaneously stimulated by and responsive to the external world.[104] It is the mind, understood here as will and intent (*i-chih*) and fortified by self-acquired insight (*tzu-te*), that gives the scholar-artist the psychic energy to create.

The leading exponent of the School of the Mind in the early sixteenth century was Wang Yang-ming (Wang Shou-jen, 1472–1529). A native of Yü-yao, Chekiang, Wang from an early age pursued a wide range of interests, from the military arts to religion and literature.[105] Passing the metropolitan examination in 1499, he was exiled in 1507 to Kweichow for having angered a powerful palace eunuch, but then went on to enjoy a successful political and military

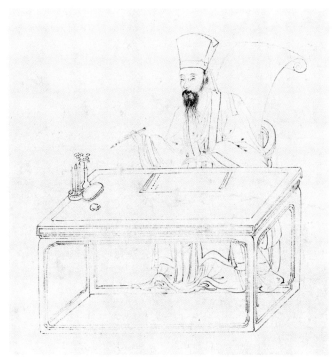

Figure 56. Artist unknown, *Portrait of Wang Shou-jen* [*Wang Yang-ming*], ca. 1523–1525 (cat. no. 28, detail).

career. As a student of Neo-Confucian philosophy, Wang had grappled with Chu Hsi's doctrine of "the investigation of things," the idea that everything in the universe embodies within itself a single immutable principle. It was during his exile in primitive Kweichow, in 1508, that he came to believe that objective reality is an illusion and that the universe exists only in the mind of the perceiver. He developed a theory about knowledge and action: "Knowledge is the beginning of action, and action the completion of knowledge." This insight gave his political career a new purpose, as he went on to suppress banditry in Fukien and Kwangtung in 1517 and 1518 and the rebellion of Prince Ning in Kiangsi the following year. As governor of Kiangsi, he carried out social and political reforms, and when the Chia-ching emperor (r. 1522–67) ascended the throne, Wang was appointed minister of war at the southern capital, Nanking. Wang Yang-ming's philosophical thought culminated in his belief in what he called "the extension of innate knowledge" (*chih liang-chih*), that one's sense of morality derives from intuitive knowledge.

The handscroll *Letters to Cheng Pang-jui* (1523–25; cat. no. 28) shows at the opening a portrait of Wang Yang-ming (fig. 56), a frail scholar-official bending over his desk, brush in hand, with the recipient of the letters, Cheng Pang-jui, respectfully in attendance. Wang was

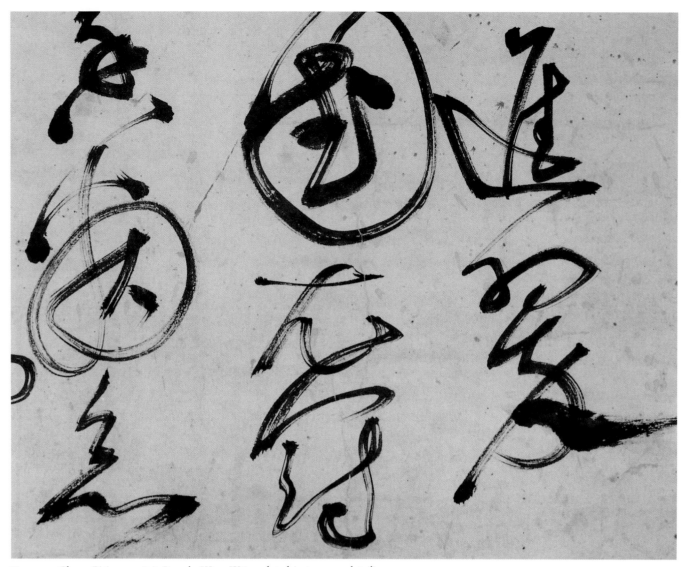

Figure 57. Chang Pi (1425–1487), *Poem by Wang Wei*, undated (cat. no. 21, detail).

a first cousin of Cheng Pang-jui, and the letters relate to family matters.[106] Wang's elegant calligraphy in running script shows his appreciation of the historical styles of Wang Hsi-chih (fig. 5), Li Yung, and Huang T'ing-chien (fig. 25), but there is no attempt made to imitate closely the earlier models. Although Wang was less known for his accomplishments as a calligrapher than for his writings on philosophy, his theories of combining will and purpose with action transformed the art of both calligraphy and painting of the late Ming period. For his followers, revivalism was perceived as an act of discovery rather than as an end in itself. In its pursuit the artist, by holding fast to his will and intent, freely experienced the transforming powers of his own intuitive knowledge and bold action.

THE REVOLT AGAINST ORTHODOXY

The rise of Chu Yün-ming (1461–1527) and other calligraphers of the Wu school in the early sixteenth century coincided with the decline of imperial patronage of the arts in the two Ming capitals, Peking and Nanking. Unlike Peking, the imperial city in the north, where court politics imposed severe restrictions on artistic freedom, life in Soochow, a bustling urban center in the south with a population of well over a million, was more open and diverse, offering to talented young scholars sophistication and opportunity. Artistic circles were permeated by a radical skepticism toward orthodoxy and convention.

Beginning in the second half of the fifteenth century, under the leadership of Shen Chou (fig. 52), calligraphers in Soochow had followed in the tradition of

scholar-artists of the late Northern Sung and Yüan, who advocated a direct and natural approach as opposed to that of the followers of the more ornate court style. Shen, for example, followed the late Northern Sung manner of Huang T'ing-chien, and the connoisseur-calligrapher Wu K'uan (1436–1504; cat. no. 23) followed the style of Su Shih. In cursive writing, the first distinct break from Sung K'o's disciplined, orthodox draft-cursive came with Chang Pi (1425–1487), a native of Sung-chiang, not far from Soochow, who turned to the untrammeled mode of the wild-cursive T'ang calligrapher Huai-su (fig. 23). In *Poem by Wang Wei* (fig. 57, cat. no. 21), Chang, limiting his draft-cursive elements to wavelike ending strokes, freely executes large looping movements with the flying-white technique. Chang's bold cursive style was a precursor of the wild-cursive calligraphy of a new wave of calligraphers led by Chu Yün-ming in the middle Ming period.

A member of a distinguished family in Ch'ang-chou (Soochow), Chu Yün-ming was a precocious child.[107] A nonconformist, he was a believer in the unity of the three teachings—Confucianism, Buddhism, and Taoism—and in his writings rejected repressive orthodox doctrine, concerning himself with social issues. At the age of fifty-four, he finally received an appointment as magistrate of Hsing-ning, Kwangtung, where he governed for the next five years. Retiring in 1521, he devoted himself for the rest of his life to literary and artistic pursuits.

As a Soochow artist, Chu had to contend with rivalry from calligraphers from the nearby town of Sung-chiang, the birthplace of the Shen brothers. Chu's rejection of the Chancellery style, exemplified in the calligraphy of the Shen brothers (fig. 53), was not only regional but ideological. Regarding the court style as overly ornate and therefore too confining, he returned to the more natural, archaic standard script of the Wei and Chin periods and led a revival of the study of Wang Hsi-chih and of Chung Yu, the third-century calligrapher whose *Memorial Recommending Chi-chih* (*Chien Chi-chih piao;* fig. 58) became available in the 1520s to students of calligraphy in and around Soochow.[108] The manuscript had been acquired by Shen Chou in 1491,[109] and after Shen died in 1509, it passed into the hands of the Wu-hsi collector Hua

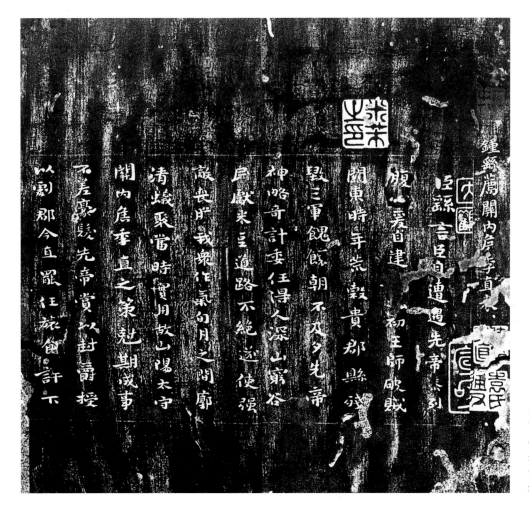

Figure 58. Attributed to Chung Yu, *Memorial for Recommending Chi-chih* (detail), undated, ink rubbing on paper. Collection unknown. From *Shodō zenshū,* n.s., 3: pl. 111.

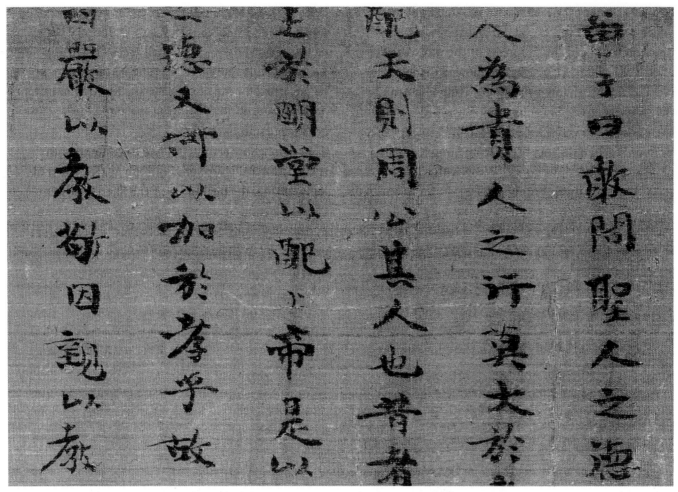

Figure 59. Li Kung-lin (ca. 1041–1106), *Classic of Filial Piety (Hsiao ching t'u;* detail), ca. 1085, handscroll, ink on silk, 21.9 x 475.5 cm. Collection of P. Y. and Kinmay W. Tang Family, promised gift of Oscar L. Tang to The Metropolitan Museum of Art, New York.

Hsia, who in 1522 published it in his anthology of rubbings *Model Calligraphies in the Chen-shang Studio (Chen-shang-chai t'ieh)*. Recent scholarship regards *Memorial Recommending Chih-chih* as an early twelfth-century forgery by a follower of Li Kung-lin (fig. 59, ca. 1041–1106).[110]

In the album *Copying Small Standard Writings of the Two Wangs,* dated 1507, Chu Yün-ming copies (fig. 60, cat. no. 24) Wang Hsi-chih's *Stele for the Filial Daughter Ts'ao O* (fig. 61). Chu's plain, square characters reflect the influence of *Memorial Recommending Chi-chih,* by Chung Yu, Wang Hsi-chih's stylistic progenitor. Basing his re-creation of Wang Hsi-chih's calligraphy on what he considered the source of Wang's style, Chu made an art-historical reconstruction of the classical Chung-Wang tradition. And following the belief that the practice of calligraphy is itself a moral education, he used style as a means of engaging in political and social discourse. To teach Confucian rectitude, he spoke of

"erecting walls. . . and building a frame" in his characters. "Keep the brushwork round, and the character formation square. . . . [Just as] every brushstroke must evoke an archaic idea, every character must be based on a historical source," he wrote.[111] Chu was interested in the abstract dimension of Confucian values, but when confronted with specific social and political issues in his writings, he firmly rejected orthodox Neo-Confucian doctrine.[112] In his calligraphy, style itself becomes a stratagem for making the artist charismatic, enabling him to make the most common moral pronouncement sound interesting.

After his retirement in 1521, Chu Yün-ming used a wild-cursive style, fusing the ideas of Huai-su (fig. 23) and Huang T'ing-chien into a relaxed personal style.[113] He now found in art itself a source of moral excitement, as he continued to base his cursive writing on the same principles found in his standard script: "The placing of each stroke should be heavy and powerful,

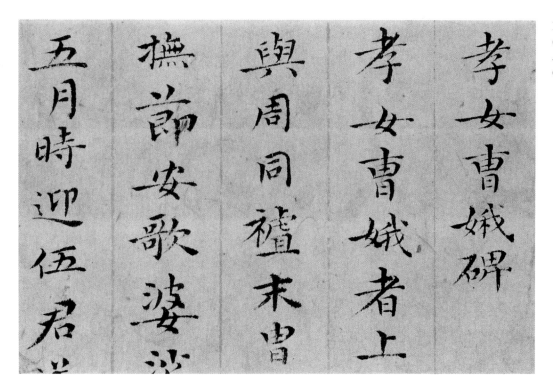

Figure 60. Chu Yün-ming (1461–1527), *Stele for the Filial Daughter Ts'ao O,* 1507 (cat. no. 24, detail).

as in standard script. Every dot and stroke should be forthright, strong, and precise."[114] In the handscroll *The Arduous Road to Shu* (fig. 62, cat. no. 25), dating to the 1520s, Chu drives the stroke with the force of his whole arm, firmly placing each stroke but keeping the brush tip at the center, pressing the brush down and lifting it up in rapid succession. With brushstrokes exploding in all directions, the characters all but dissolve in abstraction. A consummate performer, Chu expressed with wild-cursive script a passionate intensity and drama in a style that is marked by a seemingly effortless skill.

The success of Chu's wild-cursive led to the increasing popularity of the bold and the eccentric in late

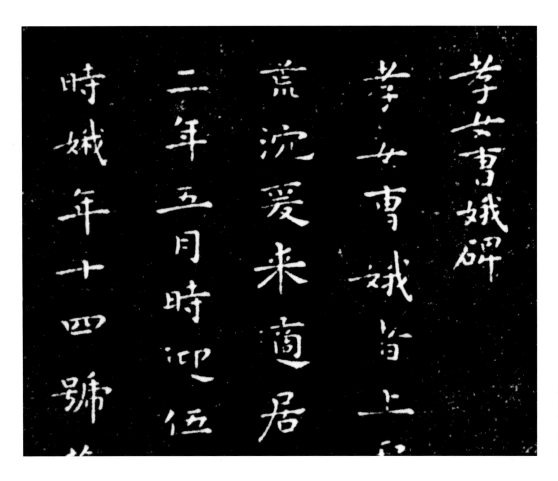

Figure 61. Wang Hsi-chih, *Stele for the Filial Daughter Ts'ao O,* ink rubbing on paper. From *Shodō zenshū,* n.s., 4: pl. 10.

Figure 62. Chu Yün-ming, *"The Arduous Road to Shu" and "Song of the Immortal,"* undated (cat. no. 25, detail).

Ming calligraphy, which invited stern criticism from more orthodox critics, who considered these trends to be self-indulgent, vulgar, and undisciplined.[115]

TUNG CH'I-CH'ANG (1555–1636) AND FU SHAN (1607–1684/85)

The artists of the middle Ming period believed that to achieve true correspondence with ancient models, one must learn how to depart from them. Wang Shih-chen (1526–1590), the leader of the Seven Later Masters, who advanced this theory, explained,

If one's own method corresponds [with that of the ancients], one must attempt to express oneself; if one's method departs [from that of the ancients], one must concentrate on returning [to them]. When there is departure in correspondence and correspondence in departure there shall be awakening.[116]

By the end of the sixteenth century a new literary wave initiated by Yüan Hung-tao (1568–1610) and his brothers, the leaders of the Kung-an school of poetry, had come to reject altogether the imitation of ancient models. With their interest in Ch'an, the Yüan brothers espoused the teachings of the radical thinker Li Chih (1527–1602), who believed that authenticity and

truth are born of a "childlike mind" (*t'ung-hsin*) and advocated the return,"in a state of nakedness," to a condition uncontaminated by learning.[117]

The leading calligrapher, painter, connoisseur, and critic of the late Ming period was Tung Ch'i-ch'ang (1555–1636).[118] A native of Hua-t'ing, near Shanghai, the seat of the prefectural government of Sung-chiang, Tung was born to a family of commoners. While still a young student at the prefectural school, he was drawn to the study of Ch'an. During the 1590s, he became friends with the Yüan brothers and, through them, with Li Chih. Tung's approach to painting and calligraphy was strongly influenced by these men, but unlike

them he never denied the importance of early models. Instead, he borrowed from Wang Shih-chen the idea of creative transformation, of achieving true correspondence with the ancients by departing from, or transforming, their models. And he sought to create what he called a "great synthesis" (*ta-ch'eng*) of all ancient models.

Tung believed that in order to avoid the imitative representation of nature, a painter should approach painting through calligraphy: "When a scholar turns to painting, he should apply to it the methods of writing unusual characters in cursive clerical script."[119] "If one considers the strangeness of natural scenery,

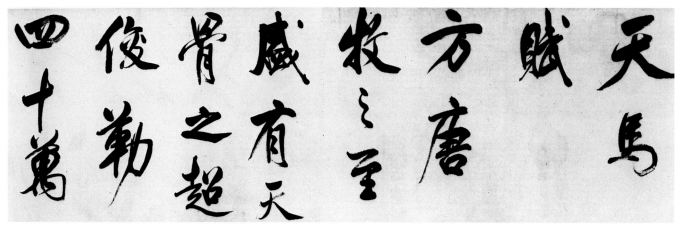

Figure 63. Tung Ch'i-ch'ang (1555–1636), *After Mi Fu's "Rhyme-Prose on the Celestial Horse,"* 1612, handscroll, ink on silk, 41.9 x 1831.2 cm. Shanghai Museum. From Wai-kam Ho, ed., *The Century of Tung Ch'i-ch'ang, 1555–1636*, 2: cat. no. 20.

then painting is not the equal of real landscape; if one considers the wonders of brush and ink, then landscape can never equal painting."[120] By analogy with the instantaneous, intuitive awakening of the Southern school of Ch'an Buddhism, Tung theorized a Southern school lineage of scholar-painters, who by listening to intuition and allowing spontaneity, "entered the land of Tathāgata Buddha in a single leap."[121]

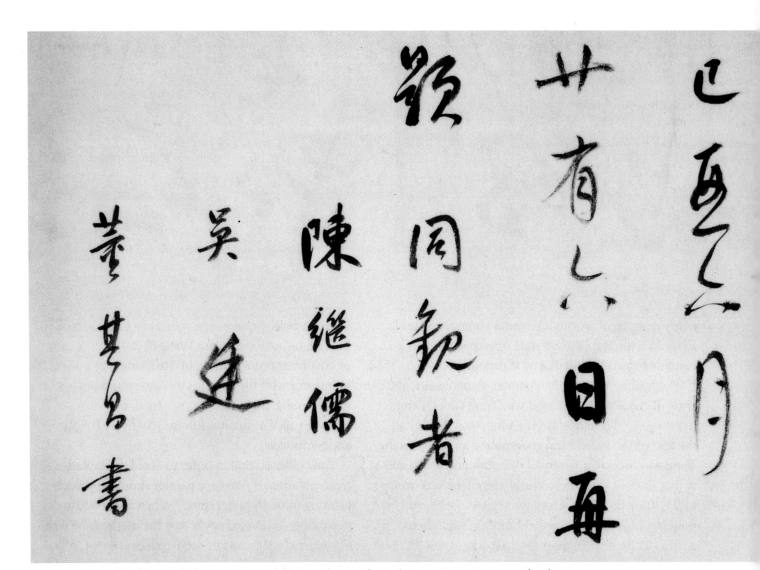

Figure 64. Tung Ch'i-ch'ang, *Colophon to Wang Hsi-chih's "Ritual to Pray for Good Harvest,"* 1609 (cat. no. 2, detail).

In calligraphy Tung saw himself as both heir to and leader of the Sung-chiang school, which, in his view, had surpassed the Soochow Wu school in excellence. He extolled the virtues of his Sung-chiang forebears:

Although Wen Cheng-ming and Chu Yün-ming became exemplars of a kind, they could never surpass the two Shens [Shen Tu and Shen Ts'an]. Their achievements are more empty than substantial. This is why I have satisfied myself by ignoring their influences and by not wishing to compete with them![122]

To surpass the Wu school calligraphers, Tung focused his studies on the styles of the Chin and T'ang masters. He saw as his only true rival in history the early Yüan calligrapher Chao Meng-fu, and consequently spent much time deprecating Chao's achievements, writing, for example, in a colophon dated 1611, "Whereas Chao's calligraphy appeals to the popular eye because of its technical facility, mine exhibits an elegance

because of its freshness. Chao's calligraphy is self-conscious, mine spontaneous."[123]

For Tung, a good copy was one that did not follow the model too closely:

The calligraphic styles of Wang Hsi-chih and his son [Wang Hsien-chih] were exhausted in the Ch'i and Liang periods. By the early T'ang, when Yü Shih-nan, Ch'u Sui-liang, and others transformed the methods of the two Wangs, a new correspondence with the ancient models was discovered. Wang Hsi-chih and his son were alive again. . . . While copying or imitating [a style] is easy, spiritual communion [with the ancients] is difficult. [The landscape master] Chü-jan [fl. ca. 976–993] followed Tung Yüan [d. 962], Mi Fu followed Tung Yüan, Huang Kung-wang followed Tung Yüan, and Ni Tsan followed Tung Yüan. Although they all followed the same Tung Yüan, each created something different. When an ordinary painter makes a copy, what he produces looks like any other

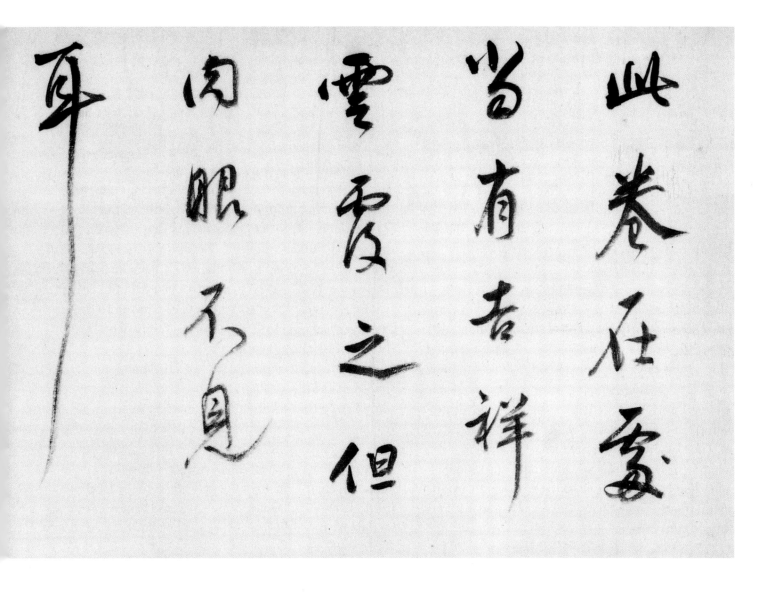

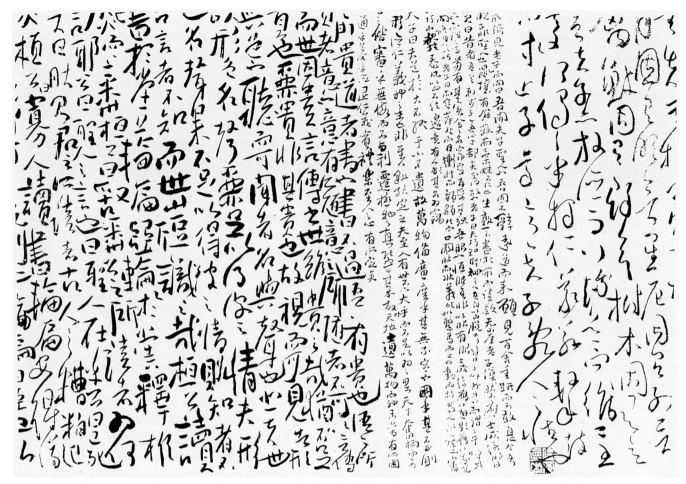

Figure 65. Fu Shan (1605–1684/85), *Wonderful Brushwork from the Se-lu Studio,* handscroll, ink on paper. Ho Ch'uang-shih Calligraphy Foundation, Taipei.

copy. How can such a work be treasured by future generations?[124]

Because the truth of an ancient model is grasped through one's own perceptions, fidelity to the old is the same as following one's own heart.

In his search for individual transformation, Tung spoke of departure from his models, or "no resemblance."[125] In *After Mi Fu's "Rhyme-Prose on the Celestial Horse"* (*Hsing-shu tu-tzu lin Mi Hai-yüeh "T'ien-ma fu"*; fig. 63), he freely fuses the brush techniques of Mi Fu (fig. 28) and Yen Chen-ch'ing (fig. 22) while attempting to achieve a simple, childlike quality. In an outstanding work of his stylistic maturity, a colophon (fig. 64) to Wang Hsi-chih's *Ritual to Pray for Good Harvest* (cat. no. 2), Tung's natural and spontaneous brushwork, while alluding to two of his most admired T'ang models, Yen Chen-ch'ing and Huai-su (fig. 23), departs from them, transforming them into a personal style that is uniquely his own.

Tung's subjectivity in copying models extended also to his connoisseurship. In his *Model Calligraphies from the Hall of Playing Geese* (*Hsi-hung-t'ang fa-t'ieh*), published in 1603, a work in sixteen volumes representing his reconstruction of the history of calligraphy, he not only makes arbitrary attributions but also freely manipulates evidence to promote his views as a collector and authenticator.[126] Unlike his theory of the Southern school painters' imitation of Tung Yüan, however, which in effect produced a new kinesthetic landscape style,[127] Tung's revisiting of Chin and T'ang models in calligraphy did not cause a fundamental breakthrough in that art.

Nevertheless, the pursuit of individual metamorphosis in late Ming calligraphy stimulated experimentation and a taste for the strange, even the eccentric, in calligraphy. At the forefront of the new calligraphy was the scholar-artist Fu Shan, who was also a medical doctor, paleographer, and seal cutter.[128] Born in Yan-chü, Shansi, Fu grew up with access to the local princely families, leading merchants, and bankers—and their art collections. After the Manchu conquest in 1644 Fu lived as a Ming loyalist, donning the cap and robe of a Taoist priest. Fu's conflicts in his own life as

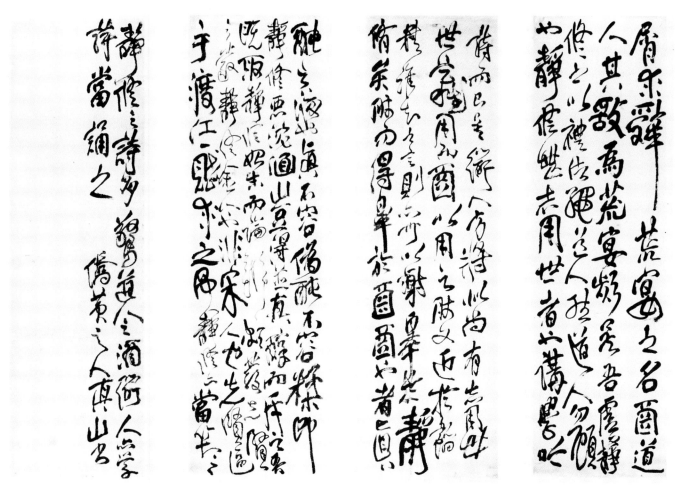

Figure 66. Fu Shan, *Twelve Hanging Scrolls: Frank Words As a Farewell Gift to Wei I-ao*, ca. 1657, the last four hanging scrolls from a set of twelve, ink on silk, each scroll, 167.6 x 50.8 cm. Collection of H. Christopher Luce.

a "leftover citizen" paralleled the problems of early Ch'ing society, in which political, social, and moral boundaries were constantly shifting—between past and present, between loyalists and turncoats, between scholar- and professional artists. Accused of plotting against the new rulers, he was imprisoned, escaping death only after the intervention of influential friends. In 1678 the Ch'ing government conducted special examinations in an effort both to placate and to recruit Ming loyalists. Fu was recommended as a candidate, but he refused to take part in the examination. Instead, he retired to Taiyuan, Shansi, earning a living as a professional calligrapher. He died either in 1684 or in early 1685.

Fu first followed Yen Chen-ch'ing (fig. 22), a model of moral uprightness and integrity, vociferously reject-ing Chao Meng-fu (fig. 35), the man who had compro-mised himself by collaborating with the Mongols:

> [Chao] was like someone who tried to model himself after a man of principle, but finding it too difficult, gave up and began associating with the bandits. . . . When someone's heart turns sour, his hand follows. Thus I

returned to the study of Yen Chen-ch'ing, and have spoken of the method of calligraphy as follows:
> It is better to be awkward than to be clever, better to be ugly than charming, to be disharmonious rather than lightweight and slick, straightforward rather than manipulative.[129]

Fu Shan had from an early age a fascination with archaic seal and clerical scripts. His earliest extant works, dating from the 1640s and 1650s, use obscure and unusual forms of seal characters, as recorded in old etymological and archaeological dictionaries.[130] In the late Ming and early Ch'ing, the revival of the archaeological study of ritual bronze and monumental stone engravings went hand in hand with the rigorous study of early texts known as evidential scholarship (*k'ao-cheng hsüeh*). In the handscroll *Wonderful Brush-work from the Se-lu Studio* (*Se-lu miao-han;* fig. 65), dating from the early 1650s, Fu Shan's juxtaposition of pas-sages in different styles and sizes, with characters exploding into a sea of dots and lines, offers a whimsi-cal image of the world of printed words. In *Twelve Hanging Scrolls: A Farewell Gift to Wei I-ao* (*Tan-yai*

Figure 67. Fu Shan, *Poem on the Heavenly Emperor*, undated (cat. no. 35, detail).

mo-han; fig. 66), dating to about 1657, Fu combines standard, running, seal, and clerical elements in a wild-cursive style that in its simplified round brushwork and free-flowing, curvilinear compositional structure also evokes archaic seal writing.

In the 1660s and 1670s Fu returned to the free-style copying of rubbings of Han clerical inscriptions and the cursive writings of Wang Hsi-chih and Wang Hsien-chih. In *Poem on the Heavenly Emperor* (fig. 67, cat. no. 35), datable to the 1670s, he draws his characters, on satin rather than silk, with a combination of standard, seal, and clerical scripts, the satin producing a lustrous inky quality and a wet, bleeding effect that dramatically heightens the visual appeal. Yet despite its brilliant virtuoso display, Fu's calligraphy speaks with directness and truth.

KAO FENG-HAN (1683–1748/49)

During the eighteenth century the professional artists known as the Eight Eccentrics of Yangchow, who worked in the thriving commercial city of Yangchow, in northern Kiangsu, and continued the individualist traditions of the seventeenth century, made further advances in the integration of calligraphy with painting and the transformation of strange and eccentric writing into painting. Kao Feng-han, a native of Chiao-chou, Shantung, whose name was frequently linked with those of the Eight Eccentrics of Yangchow, began life as a scholar-official, serving in 1733 and 1734 as a magistrate in T'ai-chou, a town near Yangchow. As a political protégé of Lu Chien-tseng (1690–1768), the chief salt commissioner in Yangchow from 1736 to 1737 who was indicted for wrongdoing and later exiled, Kao, too, was implicated and imprisoned.[131] Although soon released, he had to abandon his official career. A severe illness left him without the use of his right arm, whereupon he trained himself to paint and write with the left. In homage to the left-handed Yüan scholar Cheng Yüan-yu (1292–1364), he adopted the pen name Later Left-handed Scholar.

It was with his left hand that Kao created *In Wind and Snow* (cat. no. 37), an album dated the twelfth lunar month of 1737, some months after his illness. Made for his friend and patron Wu-kang, the album is composed of ten leaves of passionately executed, and wildly eccentric, calligraphy and painting. The six large painterly characters in cursive-clerical script filling the title page (fig. 68) translate, "In wind and snow, you are my only support." The smaller characters give the date, dedication, and signature, much like an inscription on a painting.

Two pages of explanation (figs. 69a, b) follow:

In addition to hearing from you less than ten days ago, I am again the recipient of your gift. In my present state of helpless ruination, it is difficult for me to produce anything to my satisfaction. Since my illness has subsided I have had little to do, but in my attempt to regain my interest in life, I have once again turned to brush and ink. As my right hand is paralyzed and unresponsive to my command, I have used my left hand to make this album to present to you. I have also painted a hanging scroll for the Honorable Magistrate of Chin. But I am especially pleased with this album, for in its rawness and disharmony I find it full of natural flavor. I hope that you, my brother, will look after it carefully. Although insignificant as an object, it embodies the heart and blood of your good friend. With a deep sigh, [I present this to] the Venerable Wei, my dear brother.

The album includes only two paintings. *In Wind and Snow* (cat. no. 37, leaf g), a diffuse pattern of freely scattered brushstrokes, dots, and inkwash with light touches of gray-green and brown, depicts an indistinct but sparkling view of a snow-covered rock and tree silhouetted against a darkened sky. The inscription at the top reads,

In painting snow, a blurry, airy, crisp [quality] is best. This is how I wish to capture the feeling of snow. Nan-fu, with his left hand, painted this picture and inscribed the comments.

In the lower left corner the cyclical date *ting-ssu* (1737), written in seal script, is covered with a red seal that translates "left hand." The second painting, *Broken Chrysanthemum* (cat. no. 37, leaf h), which shows a damaged stalk fallen to the ground, bears the inscription,

A chrysanthemum plant in the courtyard, broken by a vicious wind, causes me to linger in sadness. I try to depict it in brush and ink.
Old Fu, with his left hand, [painted and] recorded this. [The] Ch'ien-lung [reign]. *Ting-ssu* [1737], winter.

The theme of loss and regret reverberates throughout the album. A poem on peonies (fig. 70), symbol of

wealth and worldly success, is written in a slow regular script, reflecting a pensive mood:

> In old age and illness I paint peonies for others;
> Writing a poem on the painting brings me only
> sadness;
> How much wealth and success there is in the world,
> How I have wasted forty years of my life!
> I started painting this flower when I was fourteen or
> fifteen. Now I am fifty-five.

Figure 68. Kao Feng-han (1683–1748/49), title page from *In Wind and Snow,* 1737 (cat. no. 37, detail, leaf a).

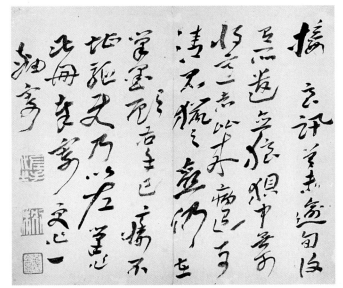

Figures 69a, b. Kao Feng-han, introductory passages from *In Wind and Snow* (cat. no. 37, details, leaves b and c).

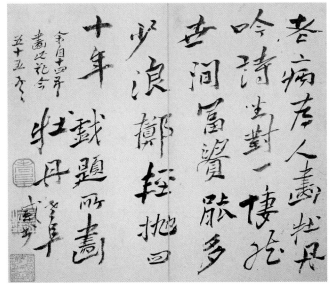
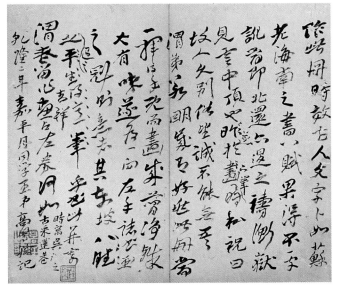

Figure 70. Kao Feng-han, leaf i, from *In Wind and Snow* (cat. no. 37, detail).

Figure 71. Kao Feng-han, concluding leaf from *In Wind and Snow* (cat. no. 37, detail, leaf j).

On the concluding leaf (fig. 71), Kao negotiates with his patron:

> In making this album, I have emulated the ancient custom of practicing divination with letters and words. When the venerable Su Shih was in exile on Hainan Island, he wrote eight prose poems in one sitting in the belief that should he manage to finish writing without making a single mistake, it meant that he would soon return home to the north. . . . Yesterday, as I set my brush to paper, I uttered a silent prayer: Since you and I have not seen each other for some while, I cannot help but mention my vulgar [monetary] expectations. Dear brother Wei, [I prayed], should the new year bless you with good fortune, my work would be realized by a single stroke. And indeed, my painting turned out to be simple, clean, and full of feeling. It ranks among my best left-handed calligraphy and painting. In will and intent it compares with the most auspicious works by Su Shih. . . . I write this to send to:
> The Venerable Wei, who may keep this work as the deed for a painting divination.

In proudly proclaiming the album to be one of his finest works and, by implication, worthy of a good price, Kao echoes another of the Eight Eccentrics of Yangchow, Cheng Hsieh (1693–1765), who bluntly states in his famous "Price List": "When cash is offered, my heart is joyful and my calligraphy and painting will be excellent."[132] And by perceiving his work as an act of divination, Kao neatly sums up the Chinese belief that calligraphy is the embodied expression of the artist's psychic powers.

NOTES

1. Immanuel Kant, the father of modern Western aesthetics, as Nietzsche suggested, "like all philosophers, instead of envisaging the aesthetic problem from the point of view of the artist [the creator], considered art and the beautiful purely from that of the spectator [the viewer]" (Friedrich Nietzsche, *On the Genealogy of Morals,* trans. Walter Kaufmann and R. J. Hollingdale [New York: Vintage Books, 1969], 103–4).

2. See Arthur Szathmary's discussion of Suzanne K. Langer's theory of presentational symbolization, in "Symbolic and Aesthetic Expression in Painting," *Journal of Aesthetics and Art Criticism* 8, no. 1 (Sept. 1954): 86–96.

3. See Hayden White, *The Content of the Form: Narrative Discourse and Historical Representation* (Baltimore: Johns Hopkins University Press, 1987).

4. See Jan Mukarovsky, "Art as Semiotic Fact," trans. I. R. Titunik, in Ladislav Matejka and Irwin R. Titunik, eds., *Semiotics of Art* (Cambridge, Mass.: MIT Press, 1976), 8. Semiological analysis owes its origin to Ferdinand de Saussure's theory of the primacy of language over speech as the true medium of communication or signification. See Ferdinand de Saussure, *Course in General Linguistics,* trans. C. Bally and A. Sechehaye (New York: McGraw-Hill, 1959); and Norman Bryson, *Vision and Painting: The Logic of the Gaze* (New Haven: Yale University Press), 77–86.

5. The ancient Chinese followed a conventionalist view of language and representation. See Chad Hansen, *Language and Logic in Ancient China* (Ann Arbor: University of Michigan Press, 1983), 72–87.

6. Chang Yen-yüan, *Li-tai ming-hua chi,* in *Hua-shih ts'ung-shu,* ed. Yü An-lan (Shanghai: Jen-min mei-shu ch'u-pan-she, 1963), vol. 1, *chüan* 1: 1. See also William R. B. Acker, *Some T'ang and Pre-T'ang Texts on Chinese Painting* (Leiden: E. J. Brill, 1954), 65–66.

7. See Yu-kung Kao, "Chinese Lyric Aesthetics," in Alfreda Murck and Wen C. Fong, eds., *Words and Images: Chinese Poetry, Calligraphy, and Painting* (New York: The Metropolitan Museum of Art; and Princeton: Princeton University Press, 1991), 75.

8. Ibid., 80.

9. Acker, *Some T'ang and Pre-T'ang Texts on Chinese Painting,* 62–63.

10. See John Hay, "The Human Body as a Microcosmic Source of Macrocosmic Values in Calligraphy," in Susan Bush and Christian F. Murck, eds., *Theories of the Arts in China* (Princeton: Princeton University Press, 1983), 74–102.

11. Pierre Bourdieu, *The Logic of Practice,* trans. Richard Nice (Stanford: Stanford University Press, 1990), 19.

12. Meyer Schapiro, "On Some Problems in the Semiotics of Visual Art: Field and Vehicle in Image-Signs," *Semiotica* 1, vol. 3 (1969): 223–42.

13. Ibid., 229.

14. Ibid., 230, 232–33.

15. See Fang-yu Wang, "The Historical Development of Chang-ts'ao [Chang Cursive Script]," in *The International Seminar on Chinese Calligraphy in Memory of Yen Chen-ch'ing's 1200th Posthumous Anniversary* (Taipei: Council for Cultural Planning and Development, 1987), 211–48.

16. Wang Yüan-ch'i et al., comps. *P'ei-wen-chai shu-hua p'u* (Peking, 1708), *chüan* 5: 2a–3b. See Acker, *Some T'ang and Pre-T'ang Texts on Chinese Painting,* liv–lviii.

17. See Stephen Owen, *Readings in Chinese Literary Thought* (Cambridge, Mass.: Harvard University Press, 1992), 38–40.

18. See Joseph Needham, with Wang Ling, *Science and Civilization in China* (Cambridge: Cambridge University Press, 1956), 2: 570–72.

19. For another translation, see Stephen Owen, *An Anthology of Chinese Literature* (New York: Norton and Co., 1996), 337.

20. Wang Yüan-ch'i et al., comps., *P'ei-wen-chai shu-hua p'u,* *chüan* 1: 8b–9b.

21. According to the Han dynasty scholar Hsü Shen (30–124), the eight styles are large seal script, small seal script, script used for courier vouchers, wiggly-worm-shaped script, script used

in engraving seals, script used for ornamental tablets, script used for inscriptions on weapons, and clerical script. See Chang Ch'ung-ho and Hans H. Frankel, *Two Chinese Treatises on Calligraphy* (New Haven: Yale University Press, 1995), 8 n. 17.

22. Wang Yüan-ch'i et al., comps., *P'ei-wen-chai shu-hua p'u,* chüan 1:8b–9b.

23. Ibid., *chüan* 3: 4b–5a; see analysis by Nakata Yūjirō, in *Chūgoku shoran taikei* (Tokyo: Nigensha, 1977–79), 1:227–33.

24. Wang Yüan-ch'i et al., comps., *P'ei-wen-chai shu-hua p'u,* chüan 3: 1a.

25. On the Chinese correlative universe, see Needham, *Science and Civilization in China,* 2: 287.

26. Wang Yüan-ch'i et al., comps., *P'ei-wen-chai shu-hua p'u,* chüan 3: 1b–3a. For a discussion of this famous essay, see Richard Barnhart, "Wei Fu-jen's *Pi-chen T'u* and Early Texts on Calligraphy," *Archives of the Chinese Art Society of America* 18 (1964): 13–25.

27. Sun Kuo-t'ing, *Shu-p'u* (687), in Wang Yüan-ch'i et al., comps., *P'ei-wen-chai shu-hua p'u, chüan* 5: 24a–24b; reproduced in *Shoseki meihin sōkan* (Tokyo: Nigensha, 1983), no. 25: 12–13. See also Chang and Frankel, *Two Chinese Treatises on Calligraphy,* 3–4.

28. Sun Kuo-t'ing, *Shu-p'u.*

29. Ibid.

30. Ibid.

31. For another translation, see James Legge, trans., *"The Ch'un Ts'ew"* with *"The Tso Chuan"* [*The Spring and Autumn Annals with The Tso-chuan Commentary*], vol. 5 of *The Chinese Classics* (1872; reprint, Oxford: Oxford University Press, 1939), pt. 2: 517, s.v. "Duke Seang, 25th Year."

32. In structuralist theory of aesthetics, which regards the work of art as a system of signs, both the idea of "intentionality"— the validity of the artist's intention—and the notion that art is an expression of the psychological state of the artist are rejected as a basis for analysis. The discrediting of the author's intentionality is accompanied by the poststructuralist discourse on the "death of the author." See Roland Barthes, "The Death of the Author," in *Image-Music-Text,* trans. Stephen Heath (New York: Hill and Wang, 1977). Michael Baxandall has modified the notion of intentionality, introducing the concept of the "painter's charge," the context of expectations within which a painter works. Intention, for Baxandall, refers to the painting rather than the painter, to "a construct descriptive of a relationship between a picture and its circumstance" (*Patterns of Intention: On the Historical Explanation of Pictures* [Yale University Press, 1985], 42).

33. Berel Lang, "Style as Instrument, Style as Person," *Critical Inquiry* 4 (1979): 716. For a discussion of Lang's ideas of style in relation to Chinese painting, see Peter C. Sturman, *Mi Fu: Style and the Art of Calligraphy in Northern Song China* (New Haven: Yale University Press, 1997), 6–12.

34. Shih Shou-chien, in his study of stylistic change within the context of history and culture, discusses the relationship between style and culture in the light of leading artists in history. See Shih Shou-chien, *Feng-ko yü shih-pien: Chung-kuo hui-hua shih lun-chi* (Taipei: Yün-ch'en wen-hua, 1996), 3–15.

35. See Fung Yu-lan, *A History of Chinese Philosophy,* trans. Derk Bodde (Princeton: Princeton University Press, 1953), 190–91.

36. See J. D. Frodsham, "The Origins of Chinese Nature Poetry," *Asia Major* 8 (1960): 68–104, esp. 89.

37. On the importance of Wang Hsi-chih's *Preface* in the history of Six Dynasties literature, see Kang-i Sun Chang, *Six Dynasties Poetry* (Princeton: Princeton University Press, 1986), 6–7.

38. See Shen C. Y. Fu et al., *Traces of the Brush: Studies in Chinese Calligraphy* (New Haven: Yale University Art Gallery, 1977), 5–8.

39. See p. 33 above.

40. See p. 34 above.

41. See Barnhart, "Wei Fu-jen's *Pi-chen T'u,*" 21.

42. Ibid., 16.

43. Quoted in Ma Tsung-huo, ed., *Shu-lin tsao-chien* (1936; reprint, Taipei: Shang-wu yin-shu-kuan, 1965), 1: 52.

44. Ibid.

45. See Peter Bol, *"This Culture of Ours": Intellectual Transitions in T'ang and Sung China* (Stanford: Stanford University Press, 1992), 1–14.

46. On Emperor T'ai-tsung's support of early T'ang court calligraphers, see Stephen J. Goldberg, "Court Calligraphy of the Early T'ang Dynasty," *Artibus Asiae* 49, nos. 3/4 (1988–89): 189–237.

47. See *Shodō zenshū,* n.s. (Tokyo: Heibonsha, 1966), vols. 5, 6.

48. See Wang Yüan-ch'i et al., comps., *P'ei-wen-chai shu-hua p'u,* chüan 91: 4a-11b.

49. Ibid., *chüan* 3: 4a.

50. Ibid., *chüan* 3: 3b–4a.

51. According to the essay "The Nine Forces," the calligrapher should always "hide the head" and "protect the tail" of each stroke: "Touching the paper with a rounded brush, keep the tip of the brush moving in the middle of the dot or stroke. . . . When the force of a stroke or dot is spent, use full power to halt and pull back" (ibid., *chüan* 3: 1a).

52. Ibid., *chüan* 5: 9b.

53. See Wen C. Fong, "The Wang Hsi-chih Tradition and Its Relationship to T'ang and Sung Calligraphy," in *The International Seminar on Chinese Calligraphy,* 249–66.

54. See Amy McNair, *The Upright Brush: Yan Zhenqing's Calligraphy and Song Literati Politics* (Honolulu: University of Hawaii Press, 1998).

55. See Martin J. Powers, "Discourses of Representation in Tenth-and-Eleventh-Century China," in *The Art of Interpretation,* Papers in Art History from the Pennsylvania State University 8 (University Park: Pennsylvania State University, 1995).

56. See James T. C. Liu, *Reform in Sung China: Wang An-shih (1021–1086) and His New Politics,* Harvard East Asian Studies 3 (Cambridge, Mass.: Harvard University Press, 1959).

57. See David S. Nivison, "A Neo-Confucian Visionary: Ou-yang Hsiu," in James T. C. Liu and Peter J. Golas, eds., *Change in Sung China: Innovation or Tradition?* (Lexington, Mass.: D. C. Heath, 1969), 74–78; and Ronald C. Egan, *The Literary Works of Ou-yang Hsiu (1007–72)* (Cambridge: Cambridge University Press, 1984).

58. Susan Bush, *Chinese Literati on Painting: Su Shih (1037–1101) to Tung Ch'i-ch'ang (1555–1636),* Harvard-Yenching Institute Studies 27 (Cambridge, Mass.: Harvard University Press, 1971), 26.

59. Bol, *"This Culture of Ours,"* 297–98.

60. Huang T'ing-chien, "T'i Yen Lu-kung t'ieh," in *Shan-ku t'i-pa* (*I-shu ts'ung-pien* ed.), vol. 22 (Taipei: Shih-chieh shu-chü, 1962), *chüan* 4: 39.

61. For a detailed study of this scroll, see Shen C. Y. Fu, "Huang T'ing-chien's Calligraphy and His Scroll for Chang Ta-t'ung: A Masterpiece Written in Exile" (Ph.D. diss., Princeton University, 1976).

62. Huang T'ing-chien, "Tsai tz'u-yün Yang Ming-shu ssu-shou," in Jen Yüan et al., *Shan-ku shih chi-chu* (Taipei: I-wen yin-shu-kuan, 1969), *chüan* 12: 710.

63. See Huang T'ing-chien, "Pa yü Chang Tsai-hsi shu chuan-wei" and "Pa Hsiang-t'ieh ch'ün-kung shu," in *Shan-ku t'i-pa, chüan* 5: 49–51.

64. *Huang Shan-ku shih ch'üan-chi* (1899; reprint, Shanghai: Chu-i-t'ang shu-chü, 1919), vol. 1, *chüan* 3: 3a.

65. Su Shih, "Pa Lu-chih wei Wang Chin-ch'ing hsiao-shu *Erh-ya*" in Su Shih, *Tung-p'o t'i-pa*, in *I-shu ts'ung-pien* (Taipei: Shih-chieh shu-chü, 1962), vol. 22, *chüan* 4: 86.

66. See discussion in Wen C. Fong et al., *Images of the Mind: Selections from the Edward L. Elliott Family and John B. Elliott Collections of Chinese Calligraphy and Painting at The Art Museum, Princeton University* (Princeton: The Art Museum, Princeton University, 1984), 83–84.

67. Huang T'ing-chien, "Tseng Kao Tzu-mien ssu-chou," in Jen et al., *Shan-ku shih chi-chu, chüan* 16: 881.

68. For the latest study of Mi Fu in English, see Peter Sturman, *Mi Fu: Style and the Art of Calligraphy in Northern Song China* (New Haven: Yale University Press, 1997).

69. Mi Fu, *Pao-chang tai-fang lu*, in *I-shu ts'ung-pien* (reprint, Taipei: Shih-chieh shu-chü, 1967), part 1, vol. 2.

70. See Mi Fu, *Pao Chin ying-kuang chi* (Taipei: Hsüeh-sheng shu-chü, 1971), *chüan* 8: 66. The rubbing of Mi's original essay is illustrated in *Ch'ün-yü-t'ang*, in *Shoseki meihin sōkan* (Tokyo: Nigensha, 1960), 43: 3–11, 16–59, 67. See also discussion by Cheng Chin-fa, "Mi Fu Shu-ssu t'ieh" (master's thesis, National Taiwan University, Taipei, 1974).

71. Mi Fu, *Hai-yüeh ming-yen*, in *I-shu ts'ung-pien* (Taipei: Shih-chieh shu-chü, 1962), vol. 2.

72. See Mi Fu, *Letter to Brother Lo* (*Lo-hsiung t'ieh*), dated 1095, in Tokyo National Museum, translated and discussed in Wen C. Fong et al., *Images of the Mind*, 88.

73. Mi Fu, *Shu-shih*, in *I-shu ts'ung-pien*, 2: 11.

74. Mi Fu, *Pao Chin ying-kuang chi, chüan* 8: 66.

75. Mi Fu, *Hsi-yüeh t'i-pa*, in *I-shu ts'ung-pien*, 2: 16–17.

76. Mi Fu, *Hai-yüeh ming-yen*, 3.

77. Ibid., 2.

78. Ma Tsung-huo, *Shu-lin tsao-chien*, vol. 2, *chüan* 9: 226b.

79. Mi wrote: "Huang T'ing-chien draws [*miao*] his characters, Su Shih paints [*hua*] his . . . [but] I sweep [*shua*] mine" (Nakata Yūjirō, *Bei Futsu* [Tokyo: Nigensha, 1982], 1: 254).

80. See Fu Shen, "Chang Chi-chih ho t'a-te chung-k'ai," *Ku-kung chi-k'an* 10, no. 4 (1976): 43–65.

81. Chang Chi-chih's *Diamond Sutra* transcription of 1253, now in the Chishaku-in, Kyoto, was presented to Wu-chün's disciple Hsi-yen Liao-hui (1198–1262).

82. See note 79 above.

83. Chao Meng-chien, "Chao Tzu-ku shu-fa lun," in Pien Yung-yü, comp., *Shih-ku-t'ang shu-hua hui-k'ao* (1682; reprint, Taipei: Cheng-chung shu-chü, 1958), vol. 1, *chüan* 3: 506.

84. A complete rubbing version of Chao Meng-fu's thirteen colophons is found in the anthology *K'uai-hsüeh-t'ang fa-shu*, ed. Feng Ch'üan (preface 1779), *chüan* 5: 32b–42b.

85. E. H. Gombrich, *Art and Illusion: A Study in the Psychology of Pictorial Representation* (Washington, D.C., and New York: Pantheon Books, 1960), 33–34.

86. Ibid., 326.

87. See Wen C. Fong, "*Ch'i-yün sheng-tung*: Vitality, Harmonious Manner, and Aliveness," *Oriental Art* 12, no. 3 (Autumn 1966): 159–64.

88. A leading Southern Liang dynasty painter, Chang Seng-yu (fl. ca. 500–550), was said to have filled a temple dedicated in 537 in Nanking with paintings in an illusionistic, "receding-and-protruding" style. See Wen C. Fong, "*Ao-t'u-hua* or 'Receding-and-Protruding Painting' at Tun-huang," in *Kuo-chi Han-hsüeh-hui lun-wen-chi* (Taipei: Chung-yang yen-chiu-so, 1981), 73–94.

89. On the "Greek miracle," see Gombrich, *Art and Illusion*, 116–45.

90. Jennifer McIntire, a graduate student at Princeton University, is preparing a Ph.D. dissertation, "Visions of Paradise: Sui and Tang Buddhist Pure Land Representations at Dunhuang."

91. For a full description of these three stages, see Wen C. Fong et al., *Images of the Mind*, 20–22.

92. See Wen C. Fong, *Beyond Representation: Chinese Painting and Calligraphy, 8th–14th Century* (New York: The Metropolitan Museum of Art, 1992).

93. See p. 37 above.

94. Michel Foucault, *The Order of Things: An Archaeology of the Human Sciences* (New York: Vintage Books, 1973), xxii–xxiii.

95. See Huang Chin-hsing, *Yu-ju sheng-yü: ch'üan-li, hsin-yang yü cheng tang hsing* (Taipei: Yün-ch'en wen-hua shih-yeh ku-feng yu-hsien kung-ssu, 1994), 138.

96. See Sung K'o's biography by James J. Y. Liu, in L. Carrington Goodrich and Chaoying Fang, eds., *Dictionary of Ming Biography, 1368–1644* (New York and London: Columbia University Press, 1976), 2: 1223–24.

97. Fushimi Chūkei, "Min Sō Koku Kyūshūshō" (The "Model Essay for Draft Cursive" by Sung K'o), *Shohin*, no. 140 (1963), 20–55.

98. See Fang-yu Wang, "The Historical Development of Chang-ts'ao [Chang Cursive Script]," figs. 28, 29.

99. See p. 36 above.

100. See Ma Tsung-huo, ed., *Shu-lin tsao-chien*, 2: 296.

101. See Kuo Shao-yü, *Chung-kuo wen-hsüeh p'i-p'ing shih* (Shanghai: Chung-hua shu-chü, 1961), 323; and Wai-kam Ho, "Tung Ch'i-ch'ang's New Orthodoxy," in Christian F. Murck, ed., *Artists and Traditions: Uses of the Past in Chinese Culture* (Princeton: The Art Museum, Princeton University, 1976), 113–29.

102. See Ch'en Hsien-chang's biography by Huang P'ei and Julia Ching, in Goodrich and Fang, eds., *Dictionary of Ming Biography*, 1: 153–56; and Jen Yü-wen, "Ch'en Hsien-chang's Philosophy of the Natural," in William Theodore de Bary et al., *Self and Society in Ming Thought* (New York: Columbia University Press, 1970), 53–92.

103. See Jen Yü-wen, "Ch'en Hsien-chang's Philosophy of the Natural," 64.

104. On Ch'en Hsien-chang on *kan-ying*, or being responsive to the external world, see ibid., 71.

105. See Wang Yang-ming's biography by Wing-tsit Chan, in Goodrich and Fang, eds., *Dictionary of Ming Biography*, 2: 1408–16.

106. See Pao-chen Ch'en's entry on no. 22, Wang Shou-jen, in Wen C. Fong, et al., *Images of the Mind,* 346–49.

107. See Chu Yün-ming's biography by Hok-lam Chan, in Goodrich and Fang, eds., *Dictionary of Ming Biography,* 1: 392–97.

108. See Christian F. Murck, "Chu Yün-ming (1461–1527) and Cultural Commitment in Suchou" (Ph.D. diss., Princeton University, 1978).

109. A photograph of the manuscript has been reproduced in *Shu-p'u* 70, no. 3 (Hong Kong, 1986), 22–27.

110. See Wen C. Fong, *Beyond Representation,* 142–43.

111. See Ho Chuan-hsing, "Chu Yün-ming chi ch'i shu-fa i-shu," part 2, *Ku-kung hsüeh-shu chi-k'an* 10, no. 1 (1992): 7.

112. See Hok-lam Chan, "Chu Yün-ming," 394–95.

113. On Huang T'ing-chien's wild-cursive script, see Wen C. Fong, *Beyond Representation,* 150–52.

114. Quoted by Ho Chüan-hsing, "Chu Yün-ming," 16.

115. See Shen C. Y. Fu et al., *Traces of the Brush,* 214–15.

116. Kuo Shao-yü, *Chung-kuo wen-hsüeh p'i-p'ing-shih,* 323.

117. On Li Chih, see W. Theodore de Bary, "Individualism and Humanitarianism in Late Ming Thought," in de Bary et al., *Self and Society in Ming Thought,* 118–225; and Ray Huang, *1587, A Year of No Significance: The Ming Dynasty in Decline* (New Haven: Yale University Press, 1981), 221.

118. See Celia Carrington Riely, "Tung Ch'i-ch'ang's Life (1555–1636)," in Wai-kam Ho, ed., *The Century of Tung Ch'i-ch'ang, 1555–1636* (Kansas City, Mo.: The Nelson-Atkins Museum of Art, 1992), 2: 387–457.

119. Tung Ch'i-ch'ang, *Hua-yen,* in *I-shu ts'ung-pien,* series 1 (reprint, Taipei: Shih-chieh shu-chü, 1981), 12: 18.

120. Ibid., 25.

121. Ibid., 24.

122. See Tung Ch'i-ch'ang, "On Calligraphy," in *Hua-ch'an-shih sui-pi* (1720), comp. Yang Wu-pu, *chüan* 1: 8.

123. Quoted in Xu Bangda, "Tung Ch'i-ch'ang's Calligraphy," in Wai-kam Ho, ed., *The Century of Tung Ch'i-ch'ang,* 1: 115.

124. Tung Ch'i-ch'ang, *Hua-yen,* 40.

125. Chu Hui-liang sees Tung Ch'i-ch'ang's attitude toward copying as the beginning of "a new direction for copying the ancients" in Ch'ing calligraphy. See Chu, "Lin-ku chih hsin-lu: Tung Ch'i-ch'ang i-hou shu-hsüeh fa-chan yen-chiu chih-i," in Wai-ching Ho, ed., *Proceedings of the Tung Ch'i-ch'ang International Symposium* (Kansas City, Mo.: The Nelson-Atkins Museum of Art, April 17–19, 1992).

126. See Qi Gong, "Tung Ch'i-ch'ang's Connoisseurship of Calligraphy as Seen in the *Hsi-hung-t'ang t'ieh,*" in Wai-ching Ho, ed., *The Proceedings of the Tung Ch'i-ch'ang International Symposium.*

127. See Wen C. Fong and James C. Y. Watt, *Possessing the Past: Treasures from the National Palace Museum, Taipei* (New York: The Metropolitan Museum of Art; Taipei: National Palace Museum, 1996), 419–25.

128. See biography by C. H. Ts'ui and J. C. Yang in Arthur W. Hummel, ed., *Eminent Chinese of the Ch'ing Period* (Washington, D.C.: U.S. Government Printing Office, 1943); and Qianshen Bai, "Fu Shan (1607–1684/85) and the Transformation of Chinese Calligraphy in the Seventeenth Century" (Ph.D. diss., Yale University, 1996).

129. Fu Shan, *Fu shan ch'üan-shu* (T'ai-yüan: Shan-hsi jen-min ch'u-pan-she, 1991), 1: 50. See also Bai, *Fu Shan,* 111–12.

130. See ibid., 136–45.

131. See Ch'iu Liang-jen, "Lu Chien-seng chi ch'i Ch'u-sai-t'u," in *Ku-kung po-wu-yüan yüan-k'an,* no. 2 (1983): 43–48, 96.

132. See Ginger Cheng-chi Hsü, "Zheng Xie's Price List: Painting as a Source of Income in Yangzhou," in Ju-hsi Chou and Claudia Brown, eds., *Chinese Painting under the Qianlong Emperor: The Symposium Papers in Two Parts* (Tempe: Arizona State University, 1991), part 2: 261–71.

Catalogue

CONTRIBUTORS

Qianshen Bai	Q. B.
Dora C. Y. Ching	D.C.Y.C.
Ping Foong	P. F.
Robert E. Harrist, Jr.	R.E.H.
Emily A. Hoover	E.A.H.
Cary Y. Liu	C.Y.L.
Huiwen Lu	H.L.
Shane McCausland	S.McC.
Amy McNair	A.McN.

人之生也柔弱其死也堅強萬物草木
脆其死也枯槁故柔弱者生之徒堅強者
以兵強則不勝木強則兵強大處下柔
天之道其猶張弓乎高者抑之下者舉之
之不足者補之天之道損有餘而補不足
不然損不足以奉有餘孰能有餘以奉天
者其是聖人為而不恃功成而不處其
天下莫強過於水而攻堅強者莫之能堅強者莫
易之勝強柔之勝剛天下莫不知莫
人云受國之垢是謂社稷主受國之不祥

The earliest recognized Chinese writing, based on a system of pictographs and emblems, played an essential role in religious and political life during the Shang dynasty (ca. 1600–1100 B.C.). Inscriptions known as oracle-bone script (*chia-ku-wen*) from as early as the fourteenth century B.C. were carved on tortoise plastrons and ox scapulae and used in divinatory rituals through which Shang kings communicated with their deceased ancestors. Dedicatory inscriptions cast on bronze vessels of the Chou dynasty (ca. 1100–256 B.C.) recorded events that led to the production of these objects, also used in rituals through which rulers and powerful clans signified their authority. Longer inscriptions commemorated events such as marriages, enfeoffments, and transfers of land ownership.[1]

The growing secularization of bronze inscriptions was accompanied by the widespread use of writing by government scribes and historians during the Eastern Chou period (770–256 B.C.), the age of Confucius (551–479 B.C.) and Lao-tzu (ca. 604–531 B.C.), founders of China's two great native philosophical traditions, Confucianism and Taoism. Characters written with an animal-hair brush appear on bamboo and wooden slips and on pieces of silk discovered in tombs of the late Eastern Chou. Known as seal script (*chuan-shu*) because of its later use almost exclusively on engraved seals, the script of this period featured complex graphs written with rounded strokes of even thickness. In many characters of this script type the pictographic and emblematic origins of Chinese writing remain apparent.[2]

A landmark in the history of writing in China was the standardization of script enforced by the First Emperor, Ch'in Shih-huang-ti (r. 221–210 B.C.). In addition to unifying China under a central administration, the emperor decreed that the forms of written characters be standardized throughout his empire.[3] Although this process took far longer than traditional accounts suggest, it was a critical step in making it possible for speakers of mutually unintelligible dialects in various areas of China to read the same characters.

During the Han dynasty (206 B.C.–A.D. 220) the state continued to intervene in the history of calligraphy. At the command of Han emperors, massive stone stelae were engraved with official government decrees, epitaphs, and other formal documents. Clerical script (*li-shu*) seen on Han stelae originated, as its name suggests, among government clerks as a convenient simplification of seal-script writing. Featuring squarish characters and flaring strokes, this form of calligraphy exploited the potential of the animal-hair brush to produce modulated strokes of varying thickness. In clerical script only a few traces of pictographic forms remain.

The Han government also sponsored the carving of standard editions of the Confucian classics in multiple script types for the edification of scholars. Although government-sanctioned monumental writing was the most authoritative model for calligraphy, private citizens also erected stelae at the tombs of their ancestors. Historical records of the Han dynasty list individual calligraphers, but no consistent body of works can be associated with their names.

Monumental writing continued to be an important concern of the short-lived states that appeared after the fall of the Han dynasty. Chung Yu (151–230), who served the state of Wei (220–265) as a government official, is perhaps the first individual calligrapher in Chinese history whose style, used for stele inscriptions, can be reconstructed with some confidence today.[4] Another early

calligrapher, So Tan (ca. 250–ca. 325), is represented in the Elliott Collection by a partial transcription of the Taoist classic the *Tao-te ching* (cat. no. 1). Although his transcription of the text is in the less monumental format of a handscroll, intended to be read by only one or two readers at a time, So Tan's calligraphy reflects an early form of standard script (*k'ai-shu*) also used for government documents and other texts that demanded clarity and legibility.

It was outside the domain of official life that calligraphy (*shu-fa*) became a major art, more or less as the term is understood today, during the Eastern Chin dynasty (317–420). Founded after the north of China was lost to foreign invaders, the Eastern Chin had its capital at Chien-k'ang (modern Nanking) and was dominated by aristocratic émigré families. Among these aristocrats was Wang Hsi-chih (303–361), not only the most influential calligrapher but also the most famous artist in Chinese history. With Wang Hsi-chih, the artist as an individual, creative personality emerges for the first time in China, as calligraphy came to be seen as an expression of the mind and personality of the writer. Along with this revolutionary development in the history of writing, art criticism, art collections, an art market, and those faithful attendants of art, forgers, became part of what might be termed the culture of calligraphy in China.

Wang Hsi-chih's fame rests primarily on his personal letters—short texts sent to friends, family members, and political associates. Unlike monumental writing on stelae, or laboriously produced transcriptions of government documents and sacred texts, Wang's letters were written in cursive (*ts'ao*) or running (*hsing*) script, forms of calligraphy in which characters are abbreviated and strokes linked in continuous motions of the brush.

Preserved in copies and rubbings, Wang's calligraphy displays complexities of brushwork that make his characters appear fully three-dimensional and reveal the motions of his hand and arm. *Ritual to Pray for Good Harvest* (cat. no. 2), a tracing copy of one of Wang's letters, typifies his calligraphy in an intimate, informal context. Letters and other texts by Wang Hsi-chih and his son Wang Hsien-chih (344–388) became models for all later calligraphers in China as well as in Japan and Korea.

<div align="right">R.E.H.</div>

Notes

1. On the early development of Chinese writing, see William G. Boltz, *The Origin and Early Development of the Chinese Writing System*. American Oriental Series 78. New Haven: American Oriental Society, 1994. For a pioneering study of oracle bone writing, see Tung Tso-pin, *Chia-ku hsüeh wu-shih nien* (Taipei: Ta-lu tsa-chih, 1955), and its English translation, idem, *Fifty Years of Studies in Oracle Inscription* (Tokyo: Centre for East Asian Cultural Studies, 1964). Neolithic pottery dating to as early as about 5000 B.C. excavated in the twentieth century reveals deliberative markings and numerals that arguably indicate a formative stage in the development of writing in China. On this question, see Cheung Kwong-yue, "Recent Archaeological Evidence Relating to the Origin of Chinese Characters," in David N. Keightley, ed., *The Origins of Chinese Civilization* (Berkeley: University of California Press, 1983), 323–91.

2. On seal-script writing incised in bronze and stone or brushed on wood, bamboo, and silk, see Tseng Yuho, *A History of Chinese Calligraphy* (Hong Kong: Chinese University Press, 1993), 21–74.

3. Sima Qian, *Records of the Grand Historian: Qin Dynasty*, trans. Burton Watson (New York: Columbia University Press, 1993), 45.

4. See Hui-liang Chu, "The Chung Yu (A.D. 151–230) Tradition: A Pivotal Development in Sung Calligraphy" (Ph.D. diss., Princeton University, 1990).

1
So Tan (ca. 250–ca. 325)
Tao-te ching

Dated 270
Handscroll (fragment), ink on sutra paper
30.8 x 208.2 cm
1998-116

COLOPHONS:
Huang Pin-hung (1864–1955), dated 1948
Yeh Kung-ch'o (1880–ca. 1968), one colophon dated 1948,
 one undated colophon, and a facsimile reproduction
 of a section of *The Record of the Three Kingdoms*
 (*San-kuo chih*) with a colophon by Pai Chien
Chang Hung (20th century), dated 1949
P'eng Sung-yin? (20th century), dated 1960

So Tan was a member of an educated elite family from the
northwest oasis town of Tun-huang whose ancestors also
had been famous calligraphers. He was around twenty
years old when he wrote this manuscript. As a young man,
he traveled to Loyang to study philosophy and astronomy
at the National University, but soon fled the murderous
political struggles at court to return home.

This scroll consists of chapters 51 through 81 (the final
third) of the ancient Taoist classic the *Tao-te ching*. Chapter
51 opens with an explanation of the relationship between
Tao (the Way) and *te* (virtue):

> The Way gives birth to them and virtue fosters them.
> Substance gives them form and conditions complete them.
> Therefore the ten thousand things venerate the Way and
> honor virtue.

The *Tao-te ching* celebrates the rightness of the natural
workings of the universe and calls on humanity to abandon
the artificial restraints of civilization and return to a pri-
mordial simplicity. As China's third religion, Taoism com-
plements the social practicality of Confucianism and the
heavenly salvation offered by Buddhism.

This manuscript was said to have been found at the
Buddhist Mo-kao Grottoes of Tun-huang, part of the cache
of thousands of religious texts and paintings discovered by
a Taoist monk in a sealed grotto in the year 1900. It is an
important document in the philological history of the
Tao-te ching. Its text differs in significant ways from the vari-
ous received versions that have been handed down through
copying over the centuries and from other recovered
versions, such as two found in the second-century B.C. tomb
discovered in 1973 at Ma-wang-tui, near Ch'ang-sha, Hunan.

In 1955 Jao Tsung-i published a study of this manuscript
comparing it to major known versions of the *Tao-te ching*
and concluding that it is in the third-century Ho-shang-
kung tradition. William Boltz, in a recent study, argues that
although the manuscript matches the Ho-shang-kung ver-
sion to some extent, it also seems to be affiliated with the
early T'ang dynasty version of Fu I. Boltz has isolated vari-
ous apparent anachronisms in the text that suggest it was
written between 735 and 960. The archaic qualities of the
calligraphy and orthography, however, are consistent with
what we know of third-century writing and are not known
to have been imitated in the T'ang.

The So Tan scroll is equally important in the history of
calligraphy. The late third century marked the culmination
of the dominance of monumental clerical script, which fea-
tures low, wide character compositions and large flaring
na (upper-left-to-lower-right diagonal) strokes. So Tan's
wedge-shaped strokes and plump final *na* strokes vigor-
ously capture the last moment when clerical script was a
popular and vital script form. In the fourth century Wang
Hsi-chih (303–361), the Sage of Calligraphy, reacting to
earlier monumental scripts, transformed writing with
brush and ink into an artistic medium of self-expression
through his cursive and running scripts while also refining
taller, more balanced compositions in the beginnings of a
standard script.

A.McN.

PUBLISHED

William G. Boltz, "Notes on the Authenticity of the So Tan Manuscript
of the *Lao-tzu*," *Bulletin of the School of Oriental and African Studies,
University of London* 59, no. 3 (1996): 508–15; Jao Tsung-i, "Wu Chien-
heng erh nien So Tan hsieh pen *Tao-te ching* ts'an chüan k'ao cheng,"
Journal of Oriental Studies 2, no. 1 (1955): 1–68, Eng. abstract, 68–71, illus.
in front; Jao Tsung-i and Hibino Jōbu, "Taijō gengen dōtokukyō," in
Shodō zenshū, n.s. (Tokyo: Heibonsha, 1965), 3: 187–88, pls. 119–20;
Frederick W. Mote, "The Oldest Chinese Book at Princeton," *Gest
Library Journal* 1, no. 1 (1986): 34–44; Frederick W. Mote and Hung-lam
Chu et al., *Calligraphy and the East Asian Book,* special catalogue issue of
Gest Library Journal 2, no. 2 (Spring 1988): 52, partly illus. and entry, 55–56.

太上玄元道德經卷終

建衡二年庚寅五月五日燉煌郡索紞寫已

疎而不失

民不畏死奈何以死愳之若使民常畏死而為奇者
吾得執而殺之孰敢常有司殺者夫代司殺者殺是
謂代天斷天也夫代大匠斷者希有不傷其手矣
民之飢以其上食稅之多是以飢民之難治以其上
之有為是以難治民之輕死以其求生之厚是以輕
死夫唯无以生為者是賢於貴生
人之生也柔弱其死也堅強萬物草木之生也柔
脆其死也枯槁故堅強者死之徒柔弱者生之徒
以兵強則不勝木強則共強大處下柔弱處上
天之道其猶張弓乎高者抑之下者舉之有餘者損
之不足者補之天之道損有餘而補不足人之道則
不然損不足以奉有餘孰能有餘以奉天下唯有道
者是以聖人為而不恃功成而不處其不欲見賢
天下柔弱莫過於水而攻堅強者莫之能勝其无以
易之弱之勝強柔之勝剛天下莫不知莫能行故聖
人云受國之垢是謂社稷主受國之不祥是謂天下
王正言若反
和大怨必有餘怨安可以為善是以聖人執左契而
不責於人有德司契无德司徹天道无親常與善人
小國寡民使有什佰人之器而不用使民重死而不
遠徙雖有舟輿无所乘之雖有甲兵无所陳之使
民復結繩而用之甘其食美其服安其居樂其俗鄰
國相望雞狗之聲相聞民至老死不相往來
信言不美言不信善者不辯辯者不善知者不博博
者不知聖人不積既以為人己愈有既以與人己愈多天
下之道利而不害聖人之道為而不爭

道生之德畜之物形之勢成
而貴德道之尊德之貴夫
之畜之長之育之成之熟
天下有始以為天下母既得
子復守其母沒身不殆塞
開其兌濟其事終身不救

2

Wang Hsi-chih (303–361)

Ritual to Pray for Good Harvest (Hsing-jang t'ieh)

Undated
T'ang dynasty tracing copy
Letter mounted as a handscroll, ink on paper
Letter alone, 24.4 x 8.9 cm; entire scroll, 30.0 x 372.0 cm
1998-140

LABELS PRECEDING THE LETTER (in chronological order):
Emperor Sung Hui-tsung (r. 1100–1126)
Tung Ch'i-ch'ang (1555–1636)
Ch'ien-lung emperor (r. 1736–95)

COLOPHONS AND INSCRIPTIONS:
Tung Ch'i-ch'ang, undated transcription of the text of the
 letter, undated colophon, two additional colophons dated
 1604 and 1609
Sun Ch'eng-tse (1592–1676), undated
Ch'ien-lung emperor, one undated inscription, two colophons
 dated 1748
Chang Ta-ch'ien (1899–1983), colophon noting that he acquired
 the scroll in 1957

Active during the Eastern Chin dynasty, the great calligra-
pher and artist Wang Hsi-chih developed new forms of
running and cursive script that transformed calligraphy
into a personally expressive medium. His masterpiece,
written in 353, *Preface to the Orchid Pavilion Collection*, was
reproduced by countless later calligraphers eager to probe
the secrets of Wang's calligraphic style. Stories of his life
inspired the creation of an iconography of Wang Hsi-chih
in painting and the decorative arts and gave rise to garden
designs and scholarly games as well.

Although Wang and other members of the Eastern Chin
elite produced many types of texts that came to be prized
as works of art, the personal letter was the format in which
the new expressive flexibility of calligraphy was most fully
realized.[1] Collectors valued these letters not for their liter-
ary content, which often concerned mundane personal
matters or inquiries about health, but for the excellence of
the calligraphy in which they were written. Owing to the
now obscure historical references they contain, many of
Wang Hsi-chih's letters are no longer fully intelligible. In
Ritual to Pray for Good Harvest, sent to an unidentified recip-
ient, Wang Hsi-chih appears to refer to a ritual sacrifice con-
ducted by a friend and inquires about the political
intentions of this person's followers.[2]

The tracing copy of the letter in the Elliott Collection,
which preserves only the first half of Wang Hsi-chih's

original text, probably dates from the early T'ang dynasty,
a period during which Wang's original works were concen-
trated in the imperial collection of Emperor T'ai-tsung
(r. 626–49) and reproduced as rubbings and ink-written
copies. To create this reproduction of Wang's calligraphy,
an expert copyist placed over the original letter (which
was lost long ago) a sheet of paper made translucent by
the application of a thin coating of wax. The copyist then
traced the outlines of the letter and filled them in carefully
with ink.

The copy recreates the buoyant, energetic flow of
Wang's characters, which seem fully three-dimensional
and are enlivened by constant changes of thickness in the
brushstrokes that resemble twisting wires. The letter also
reflects Wang's inventiveness in writing recurring configu-
rations of strokes. For example, the dots in the first two
characters of the first column and the first, third, and
fourth characters of the second column demonstrate the
wide range of visual effects that can be achieved in even
the simplest of calligraphic forms.

Ritual to Pray for Good Harvest, like other treasured copies
of Wang Hsi-chih's calligraphy produced in the T'ang
dynasty, bears the seals and inscriptions of later imperial
collectors and influential connoisseurs. A faintly visible
label written in gold ink by Emperor Hui-tsung of the
Northern Sung dynasty and six of his seals document the
presence of the letter in his collection. When Tung Ch'i-
ch'ang, the leading connoisseur and arbiter of taste of the
Ming dynasty, owned the scroll in which the letter is
mounted, he added several colophons, including a major
example of his own calligraphy dated 1609. Finally, in the
eighteenth century, the Manchu Ch'ien-lung emperor
acquired the scroll for his collection, inscribed it several
times, stamped it with his large seals, and had the letter
reproduced in an imperial anthology of rubbings.

R.E.H.

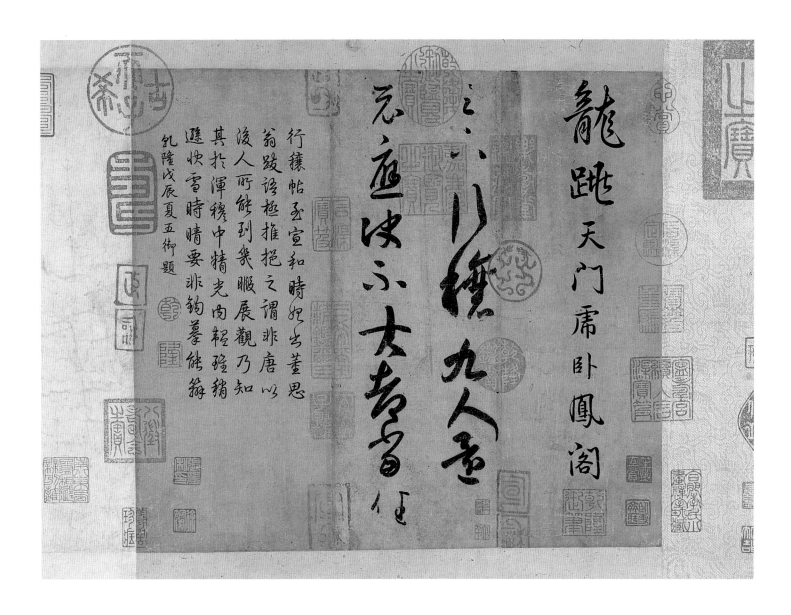

PUBLISHED

The Art Museum, Princeton University, *In Celebration: Works of Art from the Collection of Princeton Alumni and Friends of The Art Museum, Princeton University* (Princeton: Trustees of Princeton University, 1997), cat. no. 30; *Chung-kuo mei-shu ch'üan-chi: Shu-fa chuan-k'o pien* (Peking: Jen-min mei-shu ch'u-pan-she, 1986), 2, no. 48; Jan Fontein and Wu Tung, *Unearthing China's Past* (Boston: Museum of Fine Arts, 1973), 210, no. 114; Shen C. Y. Fu et al., *Traces of the Brush: Studies in Chinese Calligraphy* (New Haven: Yale University Art Gallery, 1977), 5–8, 21, 22–25, cat. no. 1; Lothar Ledderose, *Mi Fu and the Classical Tradition of Chinese Calligraphy* (Princeton: Princeton University Press, 1979), 13, 19 n. 32, 51 n. 92; Liu T'ao, ed., *Wang Hsi-chih, Wang Hsien-chih*, vols. 18 and 19 in the series *Chung-kuo shu-fa ch'üan-chi* (Peking: Jung-pao-chai, 1991), vol. 18: pl. 16; vol. 19: p. 360; Nakata Yūjirō and Fu Shen, eds., *Ōbei shūzō Chūgoku hō-sho meisekishū* (Tokyo: Chūōkōron-sha, 1981–83), 1: 130, pls. 1–6, English abstract, p. ii; Nishikawa Yasushi, "Shinjutsu no gyōjo-jo," *Shohin*, no. 142 (1963), 2–39; *San-hsi-t'ang fa-t'ieh*, 3 vols. (1755; Harbin: Hei-lung-chiang jen-min ch'u-pan-she, 1984), 1: 44–51; 3: 2628–31 (transcriptions); *Shodō geijutsu* (3d ed., Tokyo: Chūōkōron-sha, 1974), 1, no. 70; *Shodō zenshū*, n.s. (Tokyo: Heibonsha, 1960), 4: 168–69, pl. 37.

NOTES

1. For an introduction to the history of letters in China, see the essay by Qianshen Bai in this volume.

2. The letter is the subject of an essay by Robert E. Harrist, Jr., "A Letter from Wang Hsi-chih and the Culture of Chinese Calligraphy," in this volume.

The Imperial Court and Calligraphy of the T'ang Dynasty

The Period of Disunity (221–589) saw China divided into northern kingdoms controlled by non-Chinese invaders and short-lived southern kingdoms ruled by Han Chinese courts that lasted from the fourth through the sixth century. In 589 China was reunified under the Sui dynasty (581–618). Although the Sui endured for less than four decades, it set the stage for a period of energetic military expansion and cultural florescence during the T'ang dynasty (618–907). Owing to the leadership of the brilliant and energetic second T'ang emperor, T'ai-tsung (r. 626–49), China became a vast cosmopolitan empire whose influence extended into Central Asia and to Korea and Japan.[1]

The power of the T'ang state also changed the history of calligraphy. T'ai-tsung, who was an excellent calligrapher himself, deeply admired the calligraphy of Wang Hsi-chih (303–361; cat no. 2), and it was thanks to the emperor that Wang became known as the greatest calligrapher of all time. T'ai-tsung attempted to amass in his palace collection all known samples of Wang's writing and ordered that they be reproduced as ink rubbings or as written and traced copies. As original works gradually disappeared in later centuries, the reproductions made at T'ai-tsung's command became the primary means of reconstructing Wang Hsi-chih's art. The prize of T'ai-tsung's collection was Wang's *Preface to the Orchid Pavilion Collection* (*Lan-t'ing chi hsü*), dated 353, which disappeared forever when it was buried with the emperor in his tomb near Ch'ang-an (modern Sian), Shensi.[2] T'ai-tsung also promoted the calligraphy of Wang Hsi-chih by ordering officials and members of the imperial family to study Wang's style. Although the emperor's infatuation with Wang Hsi-chih no doubt reflected his personal aesthetic preferences, there was also a powerful ideological basis for his policies. Closely associated with the aristocracy of south China, Wang's calligraphy served as a symbol of national unification for T'ai-tsung, whose own base of power was in the north.[3]

At the early T'ang court, calligraphers such as Yü Shih-nan (558–638), Ou-yang Hsün (557–641), and Ch'u

Sui-liang (596–658) merged the suave and fluid brushwork of Wang Hsi-chih with the more angular, blocky forms of stone inscriptions produced in north China during the fifth and sixth centuries to create new forms of standard script (*k'ai-shu*). Their calligraphy appeared on government-sponsored monuments, most notably stelae erected at temples, tombs, and palaces.

During the eighth century, the most influential of all T'ang calligraphers, Yen Chen-ch'ing (709–785), developed a new monumental model of standard script in which elements of characters are fused into tightly integrated compositions and each stroke displays carefully articulated changes of brush direction. In the eyes of later critics, Yen's standard-script characters engraved on stelae embodied the heroic virtues of this statesman-calligrapher, who died a martyr at the hands of antigovernment rebels.[4] The importance of Yen Chen-ch'ing's standard script for the later history of calligraphy is apparent in works by Chao Meng-fu (1254–1322; cat. no. 11) and T'ang Yin (1470–1524; cat. no. 26), both of whom carefully studied Yen's style.

In addition to Yen's standard script, which continues to be an important model for calligraphers, the wild-cursive (*k'uang-ts'ao*) script of Yen's friend the monk Huai-su (ca. 735–ca. 799) was another innovation of the eighth century that had enduring effects in the history of calligraphy. Unlike Yen Chen-ch'ing's monumental stone inscriptions intended for public viewing, Huai-su's *Autobiographical Essay* (*Tzu-hsü t'ieh*), dated 777, appeared in the more intimate format of the handscroll. The monk was noted for writing while inebriated and employed the force of his entire body to produce surging, untrammeled brushwork through the "centered-tip" (*chung-feng*) technique.[5] With roots in Wang Hsi-chih's cursive script, Huai-su's exuberant style served as a model for many later calligraphers who specialized in cursive script, including Chu Yün-ming (1461–1527; cat. no. 25) of the Ming dynasty.

The T'ang dynasty marked a golden age of Buddhism in China, and the history of this religion, which arrived in China from India around the second century A.D., is

intertwined with the development of Chinese calligraphy. Among the inscriptions on stone sponsored by the T'ang court were many for Buddhist institutions. One famous example, Ch'u Sui-liang's *Preface of the Sacred Teaching (Sheng-chiao hsü)*, dated 653, was erected at a temple in the capital city, Ch'ang-an.[6] Ch'u's elegant style, featuring strokes that bend and flex in response to each other, was the stylistic model for *Epitaph for the Layman Wang* (cat. no. 3), carved on stone in 658. The choice of this style, closely associated with the imperial court, added to the prestige of the inscription. The *Dhāranī Pillar* (cat. no. 5), dated 878, represents another format for Buddhist inscriptions. This monument, dedicated to the memory of a Buddhist believer by her son, bears etched images of Buddha figures and engraved prayers. The calligraphic style of these inscriptions documents the importance of the new standard-script forms for formal imperial and religious writing in the late T'ang dynasty.

In addition to stone inscriptions, Buddhist sutras and texts transcribed on paper or silk were another format in which calligraphy flourished during the T'ang dynasty. Taoist, Buddhist, and Confucian texts were often copied in a form of writing known loosely as "sutra-writing style" (*hsieh-ching t'i*). Possibly the earliest ink-on-paper scroll book in the world, So Tan's transcription of the *Tao-te ching* (cat. no. 1), dated A.D. 270, represents an early form of this type of writing with strong ties to clerical script and the beginning of standard script. In the T'ang, as displayed in the *Mahāprajñāpāramitā Sūtra* (cat. no. 4), developments in sutra writing closely paralleled refinements in standard-script forms and are characterized by balanced regularity, skillful modulation in brushstrokes, and tight spacing. Although transcriptions of sacred texts in other script types were not unknown, Buddhist sutras were almost always written in this neat, precise form of calligraphy intended to reproduce faithfully the contents of the sacred texts. The labor of producing these texts was performed by monks, government-employed scribes, or free-lance calligraphers, the vast majority of whom remain anonymous.[7]

In many instances, the copying of sacred texts was believed to embody an act of devotion and to garner religious merit for the writer.

R.E.H.

NOTES

1. For general histories of the Sui and T'ang periods, see *The Cambridge History of China,* vol. 3, *Sui and T'ang China, 589–906, Part I,* ed. Denis Twitchett (Cambridge: Cambridge University Press, 1979).

2. The most admired later copy of the *Preface,* the Ting-wu rubbing version attributed to the early T'ang calligrapher Ou-yang Hsün (557–641), is reproduced in *Shodōgeijutsu* (Toyko: Chūōkōron-sha, 1971–1973), 1: 24–25. Other ink copy versions are discussed in *Shodōzenshū,* n.s. (Toyko: Heibonsha, 1960), 4: pls. 26–44. The attribution of the original calligraphy and text of the *Preface* to Wang Hsi-chih has been questioned by Kuo Mo-jo in his "Yu Wang Hsieh mu-chih te ch'u-t'u lun tao *Lan-t'ing hsü* te chen wei," *Wen-wu,* no. 6 (1965): 1–33.

3. On T'ang imperial sponsorship of calligraphers, see Stephen J. Goldberg, "Court Calligraphy of the Early Tang Dynasty," *Artibus Asiae* 49, no. 3–4 (1988–89): 189–237.

4. See Amy McNair, *The Upright Brush: Yan Zhenqing's Calligraphy and Song Literati Politics* (Honolulu: University of Hawaii Press, 1998).

5. Reproduced and transcribed in *Ku-kung li-tai fa-shu ch'üan-chi* (Taipei: National Palace Museum, 1976), 1: 125–62, 175–77. On questions about the handscroll's authenticity, see Ch'i Kung (Qi Gong), "Lun Huai-su 'Tzu-hsü t'ieh' mo-chi pen," *Wen-wu,* no. 12 (1983): 76–83. On the influence of Wang Hsi-chih's calligraphy on Huai-su's cursive script, see Wen C. Fong, "Some Cultural Prototypes," in Wen C. Fong and James C. Y. Watt, *Possessing the Past: Treasures from the National Palace Museum, Taipei* (New York: The Metropolitan Museum of Art; and Taipei: National Palace Museum, 1996), 117–19.

6. Reproduced and transcribed in Ch'u Sui-liang, *Yen-t'a Sheng-chiao-hsü pei* (*Shoseki meihin sōkan* edition, Toyko: Nigensha, 1965).

7. A brief discussion of the development of sutra-writing style (illustrated with several works from the Elliott Collection) is included in Frederick W. Mote and Hung-lam Chu et al., *Calligraphy and the East Asian Book,* special catalogue issue of *Gest Library Journal* 2, no. 2 (1988): 51–75.

3

Ching K'o (fl. ca. 650–683)

Epitaph for the Layman Wang

Dated 658
Album, ink rubbing, ink on paper
Nine leaves, 19.5 x 9.4 cm, and six leaves of colophons
1998-139

Colophons:
Ho Ch'o (1661–1772), undated
Fang Fu (18th century–early 19th century), dated 1809
Hu Ch'ang-keng (18th century–early 19th century),
 dated 1835
Ch'eng K'un (19th century), undated
Chu Tien-i (19th century), dated 1842
Yü Tsung-ch'eng (19th century), undated

Ching K'o was an artist about whom we know nothing today, and without his signature on this epitaph inscription, we would be tempted to attribute it on the basis of style to the famous early T'ang master Ch'u Sui-liang (596–658). The standard script of the T'ang dynasty is usually clearly articulated and tightly structured. Ch'u's innovation lay in long slender strokes that seem to detach themselves from the center of the character like willow leaves falling from the tree. Ch'u was an eminent official advisor to Emperor T'ai-tsung (r. 626–49), and his style of calligraphy was the dominant influence of the seventh century.

This epitaph was written for Wang Kung (584–656), a member of an elite scholar-official family and a lay believer in the radical Three Stages (San-chieh-chiao) school of Buddhism. Followers of this school left the corpses of believers in the forest as a "donation of the body" to the birds and beasts. Their bones were later collected and buried near the tomb of the school's founder, and a pagoda was raised over the remains, with an epitaph engraved on a stone stele set into one wall. This pagoda epitaph is a laudatory biography of Wang Kung written by Shang-kuan Ling-chih (fl. 7th century), the literatus son of a high-ranking government minister.

The brick pagoda erected for Layman Wang collapsed long ago, but his stone epitaph was excavated during the Wan-li period (1573–1620) of the Ming dynasty. Owing to the beauty of the writing, many amateurs of art took ink rubbings from it. These rubbings were often cut into strips and remounted in the album format, to make them easier to read and handle. Since the stele was already broken when it was discovered and steadily deteriorated afterward, there are very few complete ink rubbings of this inscription today. Since several reengravings on stone have been made, doubts can arise about the authenticity of ink rubbings of this work. This album bears a title dating it to the Sung dynasty and is impressed with seals of the great painter and calligrapher Wen Cheng-ming, who died in 1559, years before the stone was excavated. These may be discounted as attempts by later collectors to add documentary proof of age and authenticity.

A. McN.

Published

Chou Ch'ing, "Ō koji hakutō mei," Shohin no. 150 (1950): 45–46, pls. 1–10; Ku Yen-wu, Chin-shih wen-tzu chi (Pai-pu ts'ung-shu chi-ch'eng ed.), 3/2b.

大唐王居士塼塔之銘
上官□□芝製文
敬客書
居士諱□公字孝寬太

原晉陽人也英宗顏
遠肴隆周茂緒遐
昌爵冠後魏樂府歌
其載德天下挹其家

甚多善逝其福無數無量無邊佛言善現若
薩由此因緣得福無數無量無邊佛言善現若
無量四無色定善現於意云何是菩薩摩訶
多說經弥伽沙數大劫脩行四靜慮脩行四
復次善現若菩薩摩訶薩遠離般若波羅蜜
菩提常應不離甚深般若波羅蜜多
慶是故善現若菩薩摩訶薩欲證無上正等
羅蜜多於無上正等菩提而有退轉斯有是
退轉無有是慶若菩薩摩訶薩遠離般若波
遠離般若波羅蜜多於無上正等菩提而有
德甚多於彼何以故善現若菩薩摩訶薩不
盡夜安住菩薩聖諦安住集滅道聖諦一
摩訶薩無數無量無邊佛言善現若菩薩
善逝其福無數無量無邊佛言善現若菩薩
此因緣得福多不善現答言甚多業尊甚多
滅道聖諦善現於意云何是菩薩摩訶薩由
多說經弥伽沙數大劫安住苦聖諦安住集
復次善現若菩薩摩訶薩遠離般若波羅蜜
菩提常應不離甚深般若波羅蜜多
慶是故善現若菩薩摩訶薩欲證無上正等
羅蜜多於無上正等菩提而有退轉斯有是
退轉無有是慶若菩薩摩訶薩遠離般若波

4

Anonymous

Mahāprajñāpāramitā Sūtra

(*Ta-pan-jo po-lo-mi-to ching*), Chapter 329

Dated 674
Handscroll, ink on sutra paper
25.7 x 701.3 cm
1998-109

ILLUSTRATION (front):
Image of Samantabhadra
Ink and colors on paper
25.7 x 21.7 cm

This single chapter of the *Great Sutra of the Wisdom That Reaches the Other Shore*, as the title may be translated, was probably once part of a complete transcription of the six-hundred-chapter text, translated from Sanskrit into Chinese by the great T'ang-dynasty Buddhist pilgrim Hsüan-tsang (596?–664) in the year 663. The *Great Sutra* is a collection of shorter scriptures, including the well-known *Heart Sutra* and *Diamond Sutra*, which contain the Buddha's teachings on *prajñā*, or "wisdom."

As was typical for calligraphers of the seventh century, this anonymous sutra scribe imitated the casual elegance of Ch'u Sui-liang's style of standard script. Some sutras were copied by Buddhist monks, but most were transcribed by government-employed sutra scribes or private individuals who copied sutras for a living in shops near the monasteries or at home. This sutra may be a provincial copy of a government-sponsored manuscript produced in the capital for dissemination to the provinces.

Anonymous calligraphy was largely disdained by traditional connoisseurs until the late nineteenth and early twentieth centuries, when large quantities of ordinary writing on paper by commoners from the third and fourth centuries were recovered from northwestern desert sites such as Turfan, Lou-lan, and Tun-huang. The discoveries sparked a new interest in "calligraphy of the people." In contrast to the famous works of the revered aristocratic masters such as Wang Hsi-chih (303–361), which survive only in copies of questionable fidelity, anonymous early calligraphy is original and lively, giving an immediate sense of the calligrapher's hand.

A. McN.

5
Anonymous

Dhāranī Pillar Inscribed with Buddhas
and the "Uṣṇiṣa-vijaya Dhāranī"

Dated 878
Inscribed stone pillar and ink rubbing
Height 124.5 cm, diameter at base 27.9 cm
Gift of James J. Freeman in honor of John B. Elliott
1995-115 a & b

Below the simply etched Buddha figures on this octagonal
stone pillar are *dhāranī*, or magic spells, that are found
in the *Sutra of the Honored and Victorious Dhāranī of the
Buddha's Uṣṇiṣa*. Originally in Sanskrit, the prayers are
rendered here phonetically using Chinese characters with
annotations for correct pronunciation. The sutra explains
the function of these pillars: "If anyone writes out this
dhāranī and places it on a lofty pillar. . . all such sentient
beings, whatever their sins that should result in suffering
in rebirth . . . will not be so subjected nor will they be pol-
luted by karmic defilement." Not only were believers
instructed to set up pillars inscribed with *dhāranī* to pre-
vent reincarnation in the less desirable realms, but they
could also dedicate the karmic merit gained by their pious
act to the salvation of their relatives. P'ei Ch'ien-kou, the
sponsor of this *dhāranī* pillar, dedicated it to the salvation
of his late mother, a woman of Ju-nan, near Loyang, the
eastern capital. Many such pillars survive because they
were interred in tombs.

 In the ninth century, when this pillar was engraved, the
dominant style of calligraphy was that of the high govern-
ment minister Liu Kung-ch'üan (778–865). Known for his
standard script, Liu initially studied Wang Hsi-chih (303–
361; cat. no 2), but later turned to the monumental brush
styles of Ou-yang Hsün (557–641) and Yen Chen-ch'ing
(709–785) to synthesize his own bold style of writing.
Highly popular in late T'ang aristocratic circles, Liu's style
displays square character compositions, heavy vertical
strokes, sharply angled stroke-endings, and distinctive
indentations in the underside of the *na* (upper-left-to-lower-
right diagonal) strokes and hooked *shu* (vertical) strokes.[1]
The anonymous calligrapher of this *dhāranī* pillar was a
skilled imitator of Liu's prestigious style.

<div align="right">A . McN .</div>

NOTE
1. For examples of Liu Kung-ch'üan's calligraphy, see *Shodō geijutsu*
 (Toyko: Chūōkōron-sha, 1970–73), 4: 117–56.

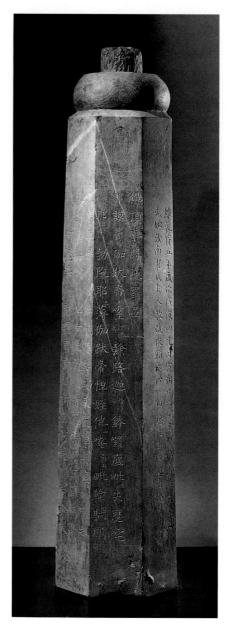

a

佛頂尊勝陀羅尼尼
那謨薄伽跋帝一室囁（丁結反）
耶路迦
勃陀薄伽跋帝怛姪他（四）唵（引五）毗輸馱耶（六）

娑摩三漫多皤婆娑婆破羅拏揭底伽呵那（上）
地阿鼻詵遮（者蘇揭多皤羅呵唵引五毗輸馱耶）
娑訶婆羅蜜弭珊（羅濕弭珊）
那阿蜜㗚多毗曬罽（阿余阿訶羅阿瑜散）

娑婆縛毗輸馱耶輸馱耶
烏瑟尼沙毗逝耶輸馱耶
珠地瑟恥多薩婆他揭多他瑟恥
羅拏毗輸馱耶三摩鉢囉底你伐但你

摩訶暮捺囇薩婆皤他你他瑟恥
耶輸提輸提伽伽那毗輸提烏瑟尼
沙毗闍耶輸提

肸鉢囉底你伐怛耶阿瑜輸提三摩
耶毗輸提末羅末羅末羅薩普吒耶
末羅毗輸提鉢囉底你跋怛耶

多瑜蒲駄耶
毗社耶毗社耶娑訶末囉末囉毗輸提鉢囉底你跋怛耶
末耶頰地瑟恥多你伐但你末你末你

麼庵甲薩婆皤他你他瑟恥耶三
鉢喇輸提输提輸提勃地勃地毗勃地三
摩三摩地瑟恥耶輸提鉢喇輸提

耻帝輸提薩婆怛他揭多薩婆皤他蒲駄耶蒲駄耶
耶三摩三漫多鉢喇輸提
輸提薩婆怛他揭多三摩三漫多鉢喇輸提

輸提薩婆皤他你他瑟恥耶輸提怛他揭多
地瑟恥多摩訶暮捺囇
摩訶暮捺囇娑婆訶

東都福先寺王〇石幢勘定本

維乹符五年歲次戊戌四月丙寅朔廿六日辛卯孤子裴虔撝奉為
先妣汝南瞿氏夫人敬造伏願承此功德往生西方見佛聞法

b

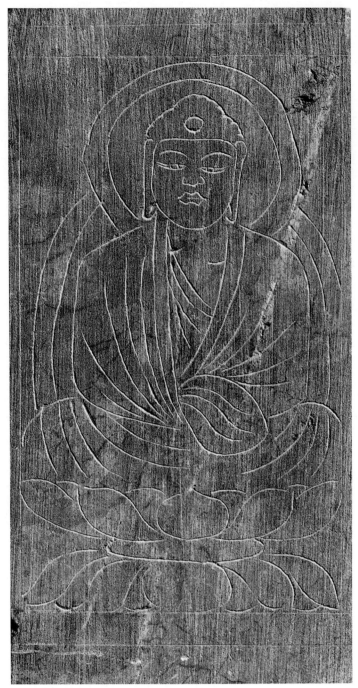

Detail of *Dhāraṇī Pillar*

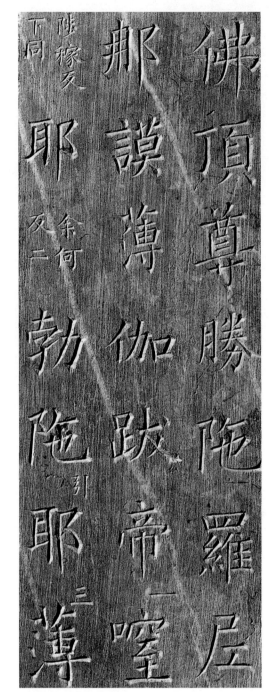

Detail of *Dhāraṇī Pillar*

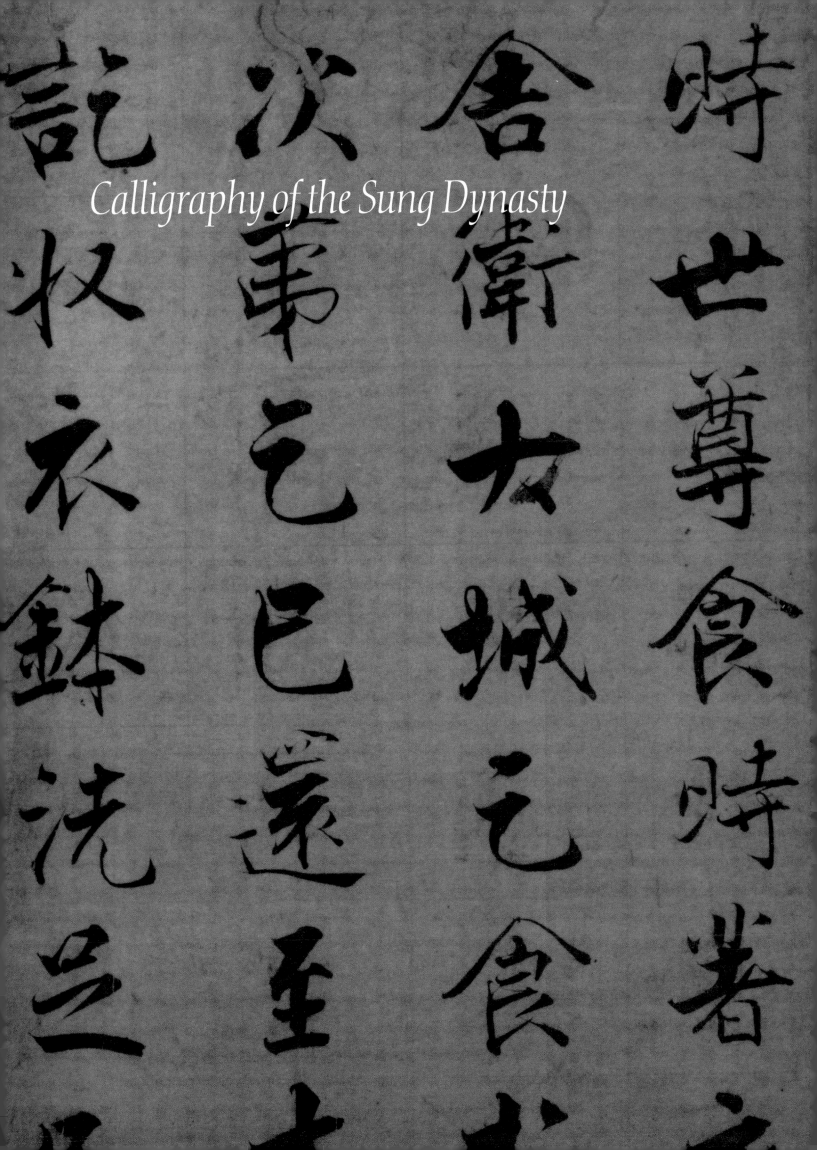

Calligraphy of the Sung Dynasty

The collapse of the T'ang dynasty (618–907) led to the disintegration of a unified Chinese empire, and for nearly fifty years China was divided into separate, politically unstable kingdoms. The reunification achieved by the first emperor of the Sung dynasty, T'ai-tsu (r. 960–76), set the stage for a period of unprecedented economic growth in China. The Sung dynasty (960–1279) also witnessed the expansion of the civil service examination system, through which, at least in theory, any educated male was eligible to compete for a position in government service. Although the dynasty was not as powerful militarily as its great predecessor, the T'ang, the Sung marked a golden age of restless creativity in the visual arts, above all in painting and calligraphy.[1]

During the Sung dynasty, as in earlier periods, a dynamic relationship between writing sponsored by the state and that produced by private individuals fueled the development of calligraphy. Government-sponsored stelae engravings became widely imitated models of calligraphy in standard script (k'ai-shu), especially the style of the T'ang calligrapher Yen Chen-ch'ing (709–785). Imperial collecting also played a major role in shaping the history of Sung calligraphy. Following the precedent set by Emperor T'ai-tsung (r. 626–49) of the T'ang dynasty, rulers of the Sung continued to acquire samples of writing by Wang Hsi-chih (303–361) and to commission copies of these works. A milestone in the transmission of Wang's art was the imperially sponsored compilation of an anthology of rubbings titled *Model Calligraphies from the Imperial Archives of the Ch'un-hua Era* (*Ch'un-hua pi-ko t'ieh*). Centered on works by Wang Hsi-chih and his followers, this anthology, published in 992, constituted a semiofficial vision of the history of calligraphy.[2]

In spite of the prestige of the imperially sanctioned anthology, later scholars sharply criticized the connoisseurship on which it was based and were suspicious of the stultifying codification of culture that it represented. Dominant models of calligraphy from the T'ang dynasty used for stele inscriptions also appeared to have become exhausted owing to their uninspired imitation by later calligraphers. Led by the statesman, poet, and artist Su Shih (1037–1101), a circle of calligraphers including Huang T'ing-chien (1045–1105) and Mi Fu (1052–1107) developed new and highly expressive forms of writing outside the influence of court patronage and taste. Like Wang Hsi-chih himself, these calligraphers created their most innovative works not in public formats, such as stele inscriptions, but in more intimate, private forms of writing, such as letters, colophons, and transcriptions of poems and essays. Their calligraphy, like their poetry, painting, and antiquarian studies, became a means through which these scholars, usually known as literati (wen-jen), defined their status as members of a cultural elite within Sung dynasty society.[3]

One of the most inventive of Sung calligraphers, Huang T'ing-chien (cat. no. 6), shared with many other scholars of the Northern Sung a deep interest in archaeology and antiquarian studies. He based his large running script (hsing-shu), for which he is best known, on a long-forgotten inscription titled *Eulogy on Burying a Crane* (*I-ho ming*; ca. 512–14) carved on a cliff in south China. In the long, wavering strokes of his characters, Huang created an unmistakable personal style that owed little to the classical perfection of T'ang calligraphy or to the elegant, subtle brushwork of the Wang Hsi-chih tradition.[4]

Huang's friend Mi Fu devoted a lifetime to the study of calligraphy and probably saw more early masterpieces

than did any other scholar of his time. His versatility with and knowledge of early styles allowed him to develop his own highly personal writing style. Although his *Three Letters* (cat. no. 7) draw on the suave, fluid style of Wang Hsi-chih and Wang Hsien-chih (344–388), Mi Fu's brushwork is far more unpredictable and varied, and his characters tilt and bend as they move down the page.[5]

After the conquest of north China by the Jurchen in 1127, the dynasty was reconstituted and a new capital established at Hangchow. Under Emperor Kao-tsung (r. 1127–1162), the first Southern Sung emperor, the visual arts became powerful tools of political propaganda, through which the emperor asserted his legitimacy to rule. Once again, a Chinese emperor played an active role in shaping the history of calligraphy, in this case not merely as a collector or patron but as an artist. An ardent student of Wang Hsi-chih and other earlier calligraphers, Kao-tsung developed distinctive styles of both standard and cursive (*ts'ao*) script, which later imperial calligraphers of the Southern Sung continued to use in their inscriptions on fans and album leaves. Kao-tsung's own poem, *Quatrain on an Autumn Fan* (cat. no. 8), likely was paired with a painting by a court artist. Empress Yang (1162–1232), one of the few women to achieve fame in the history of Chinese calligraphy, continued Kao-tsung's style, but her writing (cat. no. 9) also displays her independent assimilation of other sources, including the bold, "masculine" style of Yen Chen-ch'ing.

Outside the Southern Sung imperial court, calligraphers continued to explore highly personal styles. Chang Chi-chih (1186–1266), a scholar and Buddhist layman, used an idiosyncratic form of standard script to transcribe the *Diamond Sutra* (cat. no. 10) as a votive offering for his deceased father. Although Buddhist sutras, like other texts, were widely available in woodblock-printed editions by the Sung dynasty, pious believers such as Chang Chi-chih continued to write out these texts as acts of devotion intended to accumulate karmic merit for themselves or to lessen the travails of deceased loved ones in the afterlife.

R.E.H.

NOTES

1. For a general introduction to the history and art of the Sung dynasty, see Patricia Buckley Ebrey, *The Cambridge Illustrated History of China* (Cambridge: Cambridge University Press, 1996), 136–63. See also Wen C. Fong, *Beyond Representation: Chinese Painting and Calligraphy, 8th–14th Century* (New York: The Metropolitan Museum of Art; and New Haven: Yale University Press, 1992).

2. See *An Ssu-yüan ts'ang shan-pen pei t'ieh hsüan*. Peking: Wen-wu ch'u-pan-she, 1996. See also *Ch'un-hua ko-t'ieh*, ed. and comp. Ch'in Ming-chih and Hsü Tsu-fan, 2 vols. (Lan-chou: Kan-su jen-min ch'u-pan-she, 1988).

3. On literati culture, see Peter Bol, *"This Culture of Ours": Intellectual Transitions in T'ang and Sung China* (Stanford: Stanford University Press, 1992). On literati writings about the arts, see Susan Bush, *The Chinese Literati on Painting: Su Shih (1037–1101) to Tung Ch'i-chang (1555–1636)*, Harvard-Yenching Institute Studies 27, 2d ed. (Cambridge, Mass.: Harvard University Press, 1978).

4. For a detailed study of Huang T'ing-chien's calligraphy, see Shen C. Y. Fu, "Huang T'ing-chien's Calligraphy and his *Scroll for Chang Ta-t'ung*: A Masterpiece Written in Exile" (Ph.d. diss., Princeton University, 1976). For a study of *Eulogy on Burying a Crane*, see Robert E. Harrist, Jr., "Eulogy on Burying a Crane: A Ruined Inscription and its Restoration," *Oriental Art* 44, no. 3 (Autumn 1998): 2–10.

5. For detailed studies of Mi Fu's calligraphy, see Lothar Ledderose, *Mi Fu and the Classical Tradition of Chinese Calligraphy* (Princeton: Princeton University Press, 1979) and Peter C. Sturman, *Mi Fu: Style and the Art of Calligraphy of Northern Song China* (New Haven: Yale University Press, 1997).

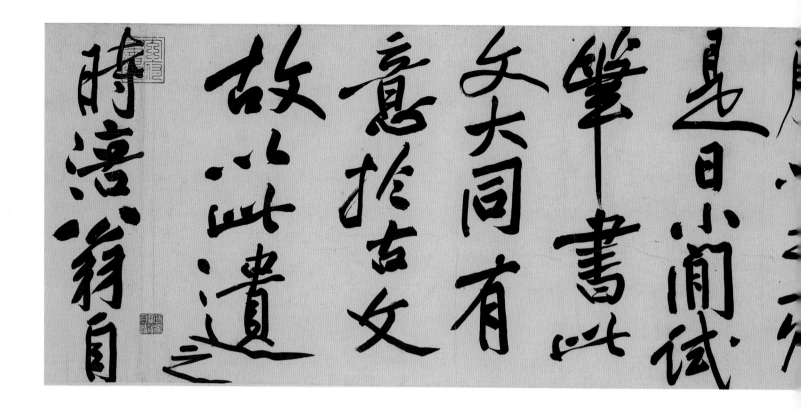

6
Huang T'ing-chien (1045–1105)
Scroll for Chang Ta-t'ung

Dated 1100
Handscroll, ink on paper
34.1 x 552.9 cm
1992-22

Colophons:
Wu K'uan (1436–1504), undated
Li Tung-yang (1447–1516), undated
Wang To (1592–1652), dated 1646
Mo Shao-te (early 19th century), dated 1812
Chang Ta-ch'ien (1899–1983), dated 1948

Huang T'ing-chien lived during a period of intense creativity in the history of Chinese art. Renowned for both his poetry and his calligraphy, Huang was part of a circle of artists and intellectuals who founded a tradition of art by scholar-amateurs or literati (*wen-jen*) that endures to this day. According to the ideas articulated by these men, art practiced by scholars was a form of self-expression—a reflection of an individual's character. In their calligraphy, they developed uniquely personal styles, especially in running script, the script type displayed in Huang's *Scroll for Chang Ta-t'ung*.

While he was living in political exile in Szechwan, Huang T'ing-chien received a visit from his nephew Chang Ta-t'ung. As he was preparing to return home, the young man, who was interested in classical literature, asked his uncle for a sample of calligraphy. Huang responded by transcribing the essay "Preface to Seeing Off Meng Chiao" by the T'ang prose master Han Yü (768–824). Although this transcription was lost long ago, Huang's colophon (translated in the appendix to the essay by Jay Xu in this volume) for the scroll preserved in the Elliott Collection is a magnificent example of his calligraphy from the zenith of his career as an artist.

Unlike characters written in more formal contexts, such as stele inscriptions or sacred texts, those in Huang T'ing-chien's scroll are loosely spaced, and the structures of the individual characters are surprisingly asymmetrical. Elongated diagonal strokes, written with a quivering inflection of the brush, recur frequently, creating a strong impression of visual unity and inner strength.

Although Huang T'ing-chien's style is among the most original and distinctive in the history of Chinese art, it was founded on his study of earlier calligraphy. Like many scholars of the Northern Sung, Huang was fascinated by an inscription known as *Eulogy on Burying a Crane* (*I-ho ming*; ca. 512–14). This work, originally carved on a cliff on the island of Chiao-shan, near Chen-chiang, Kiangsu, was

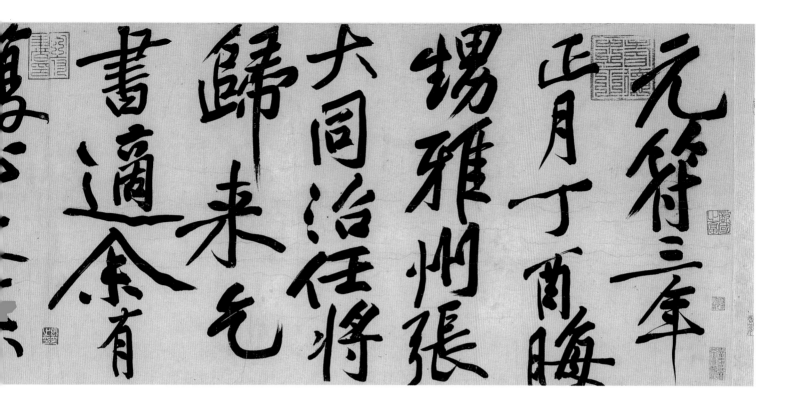

struck by lightning sometime before the eleventh century; fragments of the stone inscription fell into the Yangtze River and were visible only during the months of autumn and winter, when the waters of the river receded. It was primarily through ink rubbings that the *Eulogy* became known to students of calligraphy. In the strangely shaped characters of this work, which he believed had been written by Wang Hsi-chih (303–361), Huang found a powerful new model for large-scale writing. He adopted from the calligraphy of the *Eulogy* a form of brushwork executed by holding his arm suspended above the writing surface and by using the centered-tip brush technique, which produces rounded strokes like those seen in archaic seal script, another source of inspiration mentioned in Huang's comments on calligraphy. The malleable, organic compositions of individual characters in the *Eulogy*, especially the two widely flaring diagonal strokes of the "rooftop" radical, also are echoed in Huang's writing.[1]

In spite of the impression of vitality the scroll projects, Huang, who was fifty-six at the time he wrote it, complains in the text of ill health: "My feet are ailing and I cannot bend over. My belly feels hard, as if carrying a tile or stone. I do not know if, on another day, I will be able to write characters like these again."

R.E.H.

PUBLISHED

Richard Barnhart, "Chinese Calligraphy: The Inner World of the Brush," *The Metropolitan Museum of Art Bulletin* 30, no. 5, (April/May 1972): 231, 232, figs. 1, 2; *Chung-kuo li-tai fa-shu mo-chi ta-kuan*, gen. ed. Hsieh Chih-liu (Shanghai: Shang-hai shu-tien, 1987–), 6: 175–90; *Chung-kuo mei-shu ch'üan-chi: Shu-fa chuan-k'o pien* (Peking: Jen-min mei-shu ch'u-pan-she, 1986), vol. 4, no. 25; Wen C. Fong et al., *Images of the Mind: Selections from the Edward L. Elliott Family and John B. Elliott Collections of Chinese Calligraphy and Painting at The Art Museum, Princeton University* (Princeton: The Art Museum, Princeton University, 1984), 76–84, 256–61, cat. no. 1; Shen C. Y. Fu, "Huang T'ing-chien's Calligraphy and His *Scroll for Chang Ta-t'ung*: A Masterpiece Written in Exile" (Ph. D. diss., Princeton University, 1976); Shen C. Y. Fu et al., *Traces of the Brush: Studies in Chinese Calligraphy* (New Haven: Yale University Art Gallery, 1977), 127–28, 245, cat. no. 6; Fushima Chūkei, "Kō Teikan shozō Chō Daidō kan," *Shohin* 150 (1964): 10–16, pls. 1–28; Hsü Pang-ta, *Ku shu-hua kuo yen yao-lu* (Ch'ang-sha: Hu-nan mei-shu ch'u-pan-she, 1987), 276–77; Julia Murray, "Sung Kao-tsung as Artist and Patron: The Theme of Dynastic Revival," in Li Chu-tsing et al., eds., *Artists and Patrons* (Lawrence, Kans.: Kress Foundation, Department of Art History, University of Kansas, 1989), 29, fig. 2 (detail); Nakata Yūjirō and Fu Shen, eds. *Ōbei shūzō Chūgoku hōsho meisekishū* (Tokyo: Chūōkōron-sha, 1981–83), 1: 66–77, 139, pls. 59–66.

NOTE

1. See the essay by Jay Xu in this volume.

7
Mi Fu (1052–1107)

Three Letters

Undated, ca. 1093–94
Three album leaves, ink on paper
a. *Abundant Harvest*, 31.7 x 33.0 cm
b. *Escaping Summer Heat*, 30.9 x 40.6 cm
c. *Hasty Reply before Guests*, 31.7 x 39.7 cm
1998-51

During the Northern Sung the imperial court was an important center for the collecting and study of calligraphy. Unlike the T'ang dynasty, however, this period witnessed no major developments in calligraphy sponsored by the court; the most innovative calligraphers were scholars whose styles, especially in running script, owed nothing to imperial patronage. The most prominent of these calligraphers were Su Shih (1037–1101), Huang T'ing-chien (1045–1105), and Mi Fu.

Born in the Northern Sung capital of Kaifeng, where his mother served as a lady-in-waiting at the imperial court, Mi Fu was appointed to several government positions without having passed the *chin-shih* examinations, through which most scholars entered the civil bureaucracy. His true vocation, however, was that of artist, collector, and connoisseur.[1] For much of the 1080s he roamed south China, seeking out important collections of painting and calligraphy and winning a reputation for odd behavior. Brilliant and proud, he was known to his contemporaries as Crazy Mi.

Like his contemporary Huang T'ing-chien (cat. no. 6), Mi Fu developed a highly personal, idiosyncratic form of running-script calligraphy, though he took pride in having mastered the styles of many earlier masters. He especially admired the effect of casual, unaffected spontaneity seen in letters by Eastern Chin calligraphers such as Wang Hsi-chih (303–361) and Wang Hsien-chih (344–388), whose brushwork seemed to reflect their moods and feelings. Similar qualities enliven Mi's three letters (translated in the appendix to the essay by Jay Xu in this volume) in the Elliott Collection, which date from 1093 to 1094, when Mi was serving as a local official in Yung-ch'iu District, Honan.[2] Identified by their opening lines, the letters display subtle contrasts of brushwork that correspond to the differing circumstances under which they were written.

In *Abundant Harvest*, Mi Fu refers to his good fortune in holding office during a time of peace and prosperity. His

a

帶頓首毒啟獎邑宰歲豐

無事足以養拙苟祿無足以為

者然

明公初當當軸當措生民於仁

壽縣令承流宣化惟日拭目

傾聽徐与会靈共陶

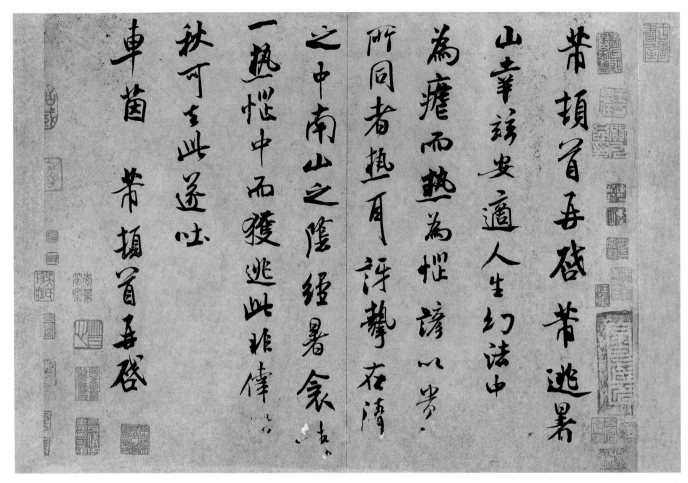

b

calligraphy was written at a leisurely pace with smooth, elegant turns of the brush derived from the style of the T'ang calligrapher Ch'u Sui-liang (596–658). *Escaping Summer Heat*, probably written in 1094, reports his satisfaction at spending the summer in the cool mountains near Yung-ch'iu; unmentioned in the letter, however, is Mi's refusal, earlier in the year, to collect taxes from local peasants hurt by an unexpected bad harvest. In this letter, Mi employs more angular brushwork, derived from the style of Ou-yang Hsün (557–641), in characters that appear slightly awkward and misshapen. Finally, in *Hasty Reply*

before Guests, Mi confesses to a friend that he is dodging a visit from an official dispatched by the imperial court to investigate his management of district affairs. Mi's unease seems to be reflected in the impetuous, tangled, more cursive brushwork of the letter.

In all of these works the variety and inventiveness of Mi Fu's brushwork illustrate his advice to other calligraphers: "The movements should be swift, natural, and true, and [they should] emerge unintentionally. . . . No stroke should resemble another."[3]

Eds.

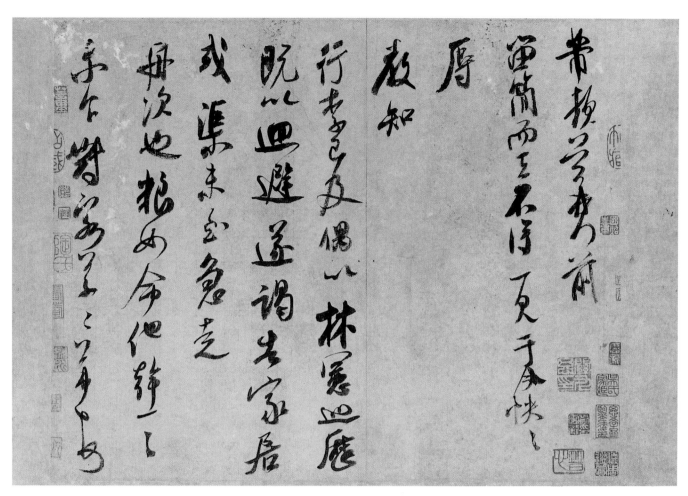

c

PUBLISHED

Wen C. Fong et al., *Images of the Mind: Selections from the Edward L. Elliott Family and John B. Elliott Collections of Chinese Calligraphy and Painting at The Art Museum, Princeton University* (Princeton: The Art Museum, Princeton University, 1984), 84–91, 262–64, cat. no. 2; Shen C. Y. Fu et al., *Traces of the Brush: Studies in Chinese Calligraphy* (New Haven: Yale University Art Gallery, 1977), 101, 148–49, 246–47, cat. nos. 9a–c; Hsü Pang-ta, *Ku shu-hua kuo yen yao-lu* (Ch'ang-sha: Hu-nan mei-shu ch'u-pan-she, 1987), 364–65; Nakata Yūjirō, *Bei Futsu* (Tokyo: Nigensha, 1982), 1: 217–18; Nakata Yūjirō and Fu Shen, eds. *Ōbei shūzō Chūgoku hōsho meisekishū* (Tokyo: Chūōkōron-sha, 1981–83), 1: 140–41, pls. 74–76; Peter C. Sturman, *Mi Fu: Style and the Art of Calligraphy in Northern Song China* (New Haven: Yale University Press, 1997), pls. 37, 39; Suzuki Kei, comp., *Chūgoku kaiga sōgō zuroku*, vol. 1, *Amerika-Kanada hen* (Tokyo: University of Tokyo Press, 1982), pl. A17–105.

NOTES

1. Mi Fu's career is the subject of an excellent study by Peter C. Sturman, *Mi Fu: Style and the Art of Calligraphy in Northern Song China*. See also the essay by Jay Xu in this volume.

2. These three letters were part of a set of five. The other two letters are now in Japan. See Fu Shen, "Kaisetsu: Shin Tō Hokusō no sho," in Nakata and Fu, eds., *Ōbei shūzō Chūgoku hōsho meisekishū*, 1: 127.

3. Mi Fu, *Pao Chin ying-kuang chi (Ts'ung-shu chi-ch'eng chien-pien* edition), *chüan* 8: 66; trans. in Fong et al., *Images of the Mind*, 89.

8

Emperor Kao-tsung
(1107–1187, r. 1127–62)

Quatrain on an Autumn Fan

Undated
Fan mounted as an album leaf, ink on silk
24.6 x 23.3 cm
1998-75 a

COLOPHONS:
Lo T'ien-ch'ih (*chin-shih* degree, 1826), undated
Ch'en Ch'i-k'un (*chin-shih* degree, 1826), undated

Chinese emperors participated in the history of calligraphy as collectors, critics, and artists. For Emperor Kao-tsung calligraphy was not only a source of aesthetic enjoyment but also a tool through which to assert the legitimacy of his reign. After his father, Emperor Hui-tsung (r. 1100–26), and his elder brother, Emperor Ch'in-tsung (r. 1126–27), were taken captive when the Jurchen invaded north China in 1127, Kao-tsung established a new capital at Lin-an (modern Hangchow), thus beginning the period known as the Southern Sung. Because Kao-tsung was not the rightful heir to the throne, it was important that he remove any doubts about his mandate to rule. One of the ways he attempted to do so was by linking himself to China's artistic and cultural heritage through the patronage and production of works of art.[1] He commissioned painters at his court to make illustrations of Confucian classics, such as *The Book of Poetry (Shih ching),* and personally transcribed the accompanying texts in his own calligraphy or had assistants do so in his style. He also asserted his commitment to Confucianism, the source of moral authority on which imperial legitimacy was founded, by having his transcriptions of *The Analects (Lun yü), Mencius (Meng-tzu),* and other canonical texts inscribed on stelae set up at government schools.

In addition to these large-scale calligraphic projects, for which the entire Chinese empire constituted his readership, Kao-tsung produced works of calligraphy as gifts for members of the imperial family, other residents of the palace, and high-ranking court officials or statesmen. The most intimate of these gifts were fans inscribed with poems—either original compositions or transcriptions of well-known verses. The quatrain on this example, apparently Kao-tsung's own composition, draws on conventions of Chinese poetic writing that equate neglected flowers with beautiful women whose charms go unnoticed:

Downstairs, who is burning nighttime incense?
Jade pipes, in sad resentment, sound in the early chill.
Facing the wind, a guest sings of an autumn fan.
As she bows to the moon, no one sees her evening makeup.

In its original format, the inscribed fan almost certainly was mounted back to back with another piece of round silk bearing a painting of either a lady or an image of the flower mentioned in Kao-tsung's poem.

The emperor's calligraphy on the fan is in cursive script, the form of Chinese writing in which characters are the most abbreviated. Strokes that in standard script are written with separate motions of the brush are in cursive script linked in continuous, fluid lines.[2] The emperor's personal style draws on his study of calligraphy by the monk Chih-yung (fl. late 6th–early 7th century), a distant descendant of Wang Hsi-chih. Although this script type would have been inappropriate for a stele inscription or a transcription of a Confucian classic, it was favored for informal texts such as poems and letters, in which the artistic impulses of the individual calligrapher were given free expression.

Although the fan is unsigned, colophons by Lo T'ien-ch'ih and Ch'en Ch'i-k'un on its mounting attribute it to Emperor Kao-tsung. A close comparison of the calligraphy of the fan with Kao-tsung's transcription of "Prose Poem on the Nymph of the Lo River," a well-known example of his cursive-script writing, confirms this attribution.[3]

R.E.H.

NOTES

1. On Kao-tsung's activities as a patron and producer of art, see Julia K. Murray, *Ma Hezhi and the Illustration of the Book of Odes* (Cambridge and New York: Cambridge University Press, 1993).

2. For studies of calligraphy by Kao-tsung and other Southern Sung rulers, see Chu Hui-liang, "Imperial Calligraphy of the Southern Sung," in Alfreda Murck and Wen C. Fong, eds., *Words and Images: Chinese Poetry, Calligraphy, and Painting* (New York and Princeton: The Metropolitan Museum of Art and Princeton University Press, 1991), 289–312 and Hsü Pang-ta, "Nan Sung ti-hou t'i-hua shih-shu k'ao-pien," *Wen-wu,* no. 6 (1981): 52–64.

3. See *Chung-kuo mei-shu ch'üan-chi: Shu-fa chuan-k'o pien,* vol. 4, *Sung, Chin, Yüan shu-fa* (Peking: Jen-min mei-shu ch'u-pan-she, 1986), 80–81.

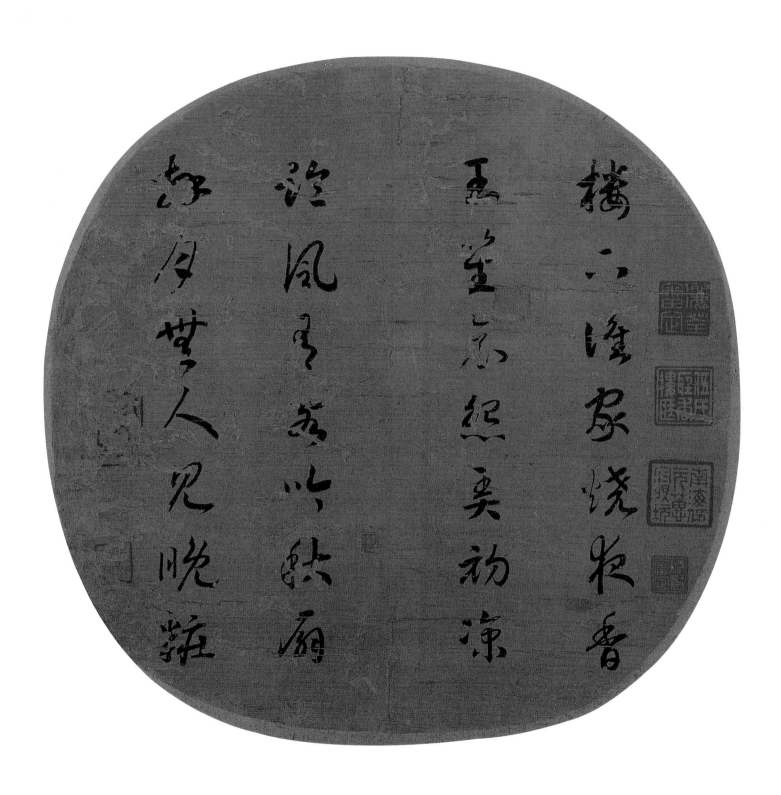

9

Yang Mei-tzu
(Empress Yang, 1162–1232)

Quatrain on Autumn

Undated
Album leaf, ink on silk
25.4 x 27.4 cm
1998-75 b

COLOPHONS:
Lo T'ien-ch'ih (chin-shih degree, 1826), undated
Ch'en Ch'i-k'un (chih-shih degree, 1826), undated
Wu Yüan-hui (1834–1865), undated
P'an Shih-ch'eng (chü-jen degree, 1832), undated

Empress Yang was one of the few women to achieve fame in the history of calligraphy, an art, like most others in imperial China, dominated by men. The consort of Emperor Ning-tsung (r. 1195–1224) of the Southern Sung, she frequently inscribed poems on paintings by court artists such as Ma Yüan (fl. ca. 1160–after 1225) and Ma Lin (fl. ca. 1180–after 1256).[1] This album leaf, which bears two of the seals of the empress, may have been paired with a painting by one of these artists.[2]

The empress's quatrain refers to the Double Ninth Festival (Ch'ung-yang), the ninth day of the ninth lunar month, on which revelers traditionally ascended hills or high towers to enjoy distant views:

> On festival days of the four seasons people busily hurry;
> From this one knows we are living in a happy domain.
> The ninth day [of the ninth month] approaches, yet beside the fence it is lonely;
> Only when the chrysanthemums blossom will the Ch'ung-yang Festival arrive.

The festival also came to be associated with the autumn-blooming chrysanthemum, without which, the quatrain suggests, the day would not be complete.

The style of Empress Yang's calligraphy derives from that of Emperor Kao-tsung (r. 1127–62; cat. no. 8), the founder of the Southern Sung.[3] The empress subtly varies this imperial style, however, introducing flaring diagonal strokes and twisting verticals inspired by the T'ang calligrapher Yen Chen-ch'ing (709–785).

Although the content of her poem is blandly conventional, Empress Yang often presented inscribed fans and album leaves such as this to her political allies, using these gifts as signifiers of bonds between herself and those favored with samples of her calligraphy.

R.E.H.

PUBLISHED

Hui-liang Chu, "Imperial Calligraphy of the Southern Sung," in Alfreda Murck and Wen C. Fong, eds., *Words and Images: Chinese Poetry, Calligraphy, and Painting* (New York and Princeton: The Metropolitan Museum of Art and Princeton University Press, 1991), 306; Nakata Yūjirō and Fu Shen, eds. *Ōbei shūzō Chūgoku hōsho meisekishū* (Tokyo: Chūōkōron-sha, 1981–83), 2: 140, pl. 25; Eng. abstract, p. ii.

NOTES

1. Empress Yang is the subject of an exhaustive study by Hui-shu Lee, "The Domain of Empress Yang (1162–1233): Art, Gender and Politics at the Late Southern Song Court" (Ph.D. diss., Yale University, 1994). See also Chiang Chao-shen, "The Identity of Yang Mei-tzu and the Paintings of Ma Yüan," *National Palace Museum Bulletin* 2, no. 2 (May 1967): 1–14; 2, no. 3 (July 1967): 8–14.
2. In his inscription on the mounting of the album leaf, P'an Shih-ch'eng, apparently overlooking the two seals used by Yang Mei-tzu, attributes the calligraphy to Emperor Kao-tsung.
3. See Hsü Pang-ta, "Nan Sung ti-hou t'i-hua shih-su k'ao-pien," *Wen-wu*, no. 6 (1981): 60–64; and Chu, "Imperial Calligraphy of the Southern Sung," 30.

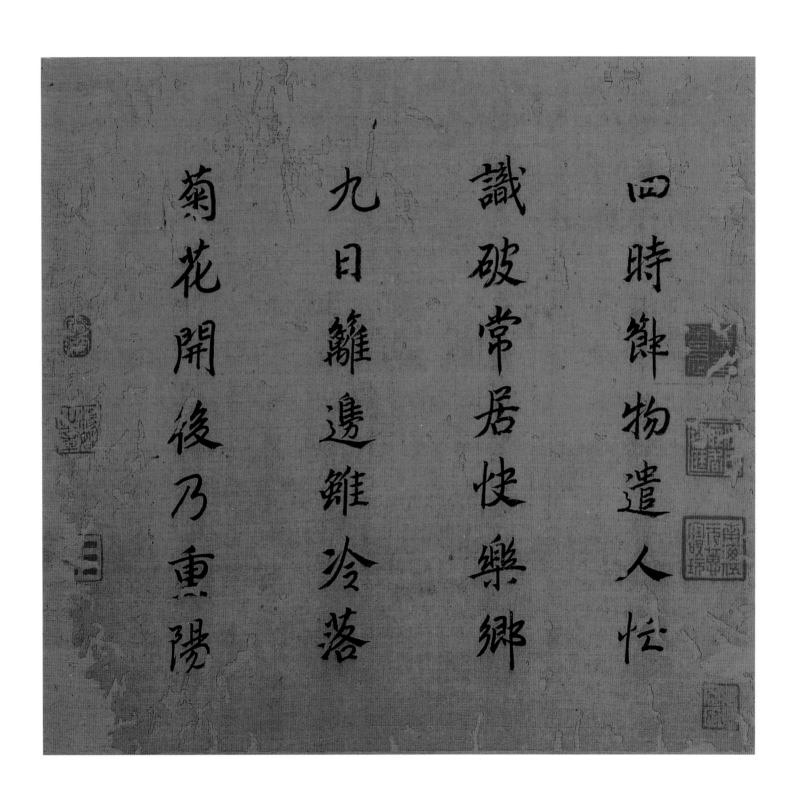

四時餚物遣人忙

識破常居快樂鄉

九日籬邊雞冷落

菊花開後乃重陽

10

Chang Chi-chih (1186–1266)

Diamond Sutra (Chin-kang ching)

Dated 1246
Album of 128 leaves and 54 leaves of colophons,
 ink on paper
Each leaf, 29.1 x 13.4 cm
1998-52

COLOPHONS:
Ch'en Ch'ien (fl. ca. 1463), dated 1463
Pi Hsi chih (fl. ca. 1620), author; Chao Huan-kuang (1559–1625),
 calligrapher, dated 1620
Tung Ch'i-ch'ang (1555–1636), dated 1620
Pi Mao-k'ang (*chin-shih* degree, 1598), dated 1624
Pi Ting-ch'en (fl. 1640–1664), dated 1664
Chang T'ing-chi (1768–1848), dated 1837
Lin Tse-hsü (1785–1850), dated 1841
Chang Ying-ch'ang (1790–1870), dated 1860
Hsü Yüeh-shen (fl. late 19th century), dated 1885
Yü Yüeh (1821–1907), dated 1885

Chang Chi-chih was a scholar-official of the Southern Sung
and a devout Buddhist layman. This transcription of the
Diamond Sutra was written for the karmic benefit of his
deceased father. The Buddhist scriptures teach that the
propagation of doctrine generates good karma, which the
benefactor may transfer to another for merit toward a
higher rebirth or salvation. The writing of a sutra such as
this is both a proof of devotion to the faith and an act of
filial piety. Thus many famous calligraphers wrote out
sutras, not to earn a livelihood as the professionals did,
but for the spiritual improvement of themselves or their
deceased relatives. Generally the calligraphy is quite
careful, since perfection in the writing of sutras was
thought to enhance their religious efficacy.

The scroll is written in Sung dynasty standard script,
which incorporates informal elements from running script,
such as delicate ligatures connecting individual strokes.
Chang Chi-chih's style, which he based on that of his uncle,
the famous poet Chang Hsiao-hsiang (1133–1170), is distinc-
tive and unusual. His characters combine thick and thin
strokes with great drama, and thickly drawn dark charac-
ters alternate with finely drawn light ones, creating a
nearly three-dimensional effect. In addition, initial strokes
are often emphasized, so that character compositions
tend to be darker and heavier on the left side.

In a colophon appended to this sutra in 1620, the collec-
tor Pi Hsi-chih wrote, "Connoisseurs say the composition

of his characters resembles Ch'u Sui-liang's [596–658],
while the movements and turns of the brush are like
those of Mi Fu [1052–1107]." Pi saw the loose connections
between strokes in Chang's characters as resembling those
of Ch'u, and Chang's brushwork, with its inventive modu-
lations and articulations, as resembling that of Mi. This
method of looking for sources in the artists of the classical
tradition is quite conventional. In another colophon of
1620, the great painter and art theorist Tung Ch'i-ch'ang
offered a different analysis of Chang Chi-chih's style:
"Looking at how he moves the brush and the composition
of his characters, I see that he follows no earlier man. Each
[character] is independently created. This is what a Ch'an
person would call 'the outflowing of the innermost self
extending out to engulf the universe.'" The *Diamond Sutra*
is an important text of the Ch'an (Zen) school, in which the
Buddha teaches that "all phenomenal appearances are not
ultimate reality but rather illusions, projections of one's
own mind." Tung Ch'i-ch'ang was a Ch'an devotee whose
art criticism is filled with references and analogies bor-
rowed from Ch'an scriptures and koans. Here Tung
employs Ch'an terminology to describe Chang's creativity
as being purely self-generated.

A. McN.

PUBLISHED

Fu Shen, "Chang Chi-chih ho t'a-te chung-k'ai," *Ku-kung chi-k'an* 10, no. 4
(1976): 49–51, pls. 5–6, Eng. trans. pp. 21–39; Fu Shen, "Chin-kang po-jo
p'o-lo-mi-t'o ching ping t'i-pa," in Nakata Yūjirō and Fu Shen, eds. *Ōbei
shūzō Chūgoku hōsho meisekishū* (Tokyo: Chūōkōron-sha, 1981–83), 2:
149–51, pls. 52–107, Eng. abstract, p. iii; Shen C. Y. Fu et al., *Traces of the
Brush* (New Haven: Yale University Art Gallery, 1977), 51–52, 66–67
(illus.), 248–49, 288; Hsü Pang-ta, *Ku shu-hua kuo yen yao-lu* (Ch'ang-sha:
Hu-nan mei-shu ch'u-pan-she, 1987), 553–54; Frederick W. Mote and
Hung-lam Chu et al., *Calligraphy and the East Asian Book,* special cata-
logue issue of *Gest Library Journal* 2, no. 2 (1988): 67–69, 71–72 (illus.);
Suzuki Kei, comp., *Chūgoku kaiga sōgō zuroku,* vol. 1, *Amerika-Kanada
hen* (Tokyo: University of Tokyo Press, 1982), pl. A17–105.

金剛般若波羅蜜經

如是我聞一時佛在舍衛
國祇樹給孤獨園與大比
丘眾千二百五十人俱爾

時世尊食時著衣持鉢入
舍衛大城乞食於其城中
次第乞已還至本處飯食
訖收衣鉢洗足已敷座而

The Yüan Dynasty:
Chinese Calligraphy under Mongol Rule

*I*n 1279 the Southern Sung fell to the Mongols, who had earlier founded the Yüan dynasty (1260–1368). The Mongol rulers adopted many features of Chinese culture, but their conquest profoundly disrupted life for the southern literati elite. The Mongols, especially early in their rule, were suspicious of Chinese scholars, who, under normal circumstances, would have staffed the highest positions in the civil service bureaucracy. At the same time, some scholars were reluctant to enter public life or serve the Mongols in any way, preferring to live as hermits or to adopt unconventional professions such as painting, fortune telling, and medicine.[1] Rather than stifling creativity, however, the tension between the Mongols and their Chinese subjects appears to have energized the visual arts.[2]

Chao Meng-fu (1254–1322) looms over the history of both calligraphy and painting during the early decades of the Yüan dynasty. A native of Wu-hsing in south China and a descendant of the Sung imperial family, Chao followed the example of many other loyalists by eschewing public life following the Mongol conquest. Eventually he was recruited back into government service under the reign of Khubilai Khan (Emperor Shih-tsu, r. 1260–94) and held several official posts in the Yüan government.

As an amateur painter, Chao Meng-fu undertook a comprehensive study of the styles of earlier masters, facilitated by his freedom to travel in north China, where he was able to see and acquire works of art long inaccessible to artists living in the south. As a calligrapher, Chao explored an equally diverse range of styles. Drawing on the structural principles of monumental writing from the Han (206 B.C.–A.D. 220) and T'ang (618–907) dynasties, and the fluid brushwork of Wang

Hsi-chih (303–361), Chao produced a new monumental standard script (*k'ai-shu*), displayed in his *Record of the Miao-yen Monastery* (cat. no. 11) and other stele inscriptions. Within a short time, his style became a model for calligraphy throughout China. Perhaps in no earlier period had the work of a single calligrapher so thoroughly dominated the practice of this art. Chao's work also inspired a new typeface that became the standard for woodblock-printed books.[3] Although later calligraphers continued to produce distinctive personal styles, Chao's invention of a new model of standard script was the last truly revolutionary innovation in this form of calligraphy.

Other members of Chao Meng-fu's family also excelled at calligraphy. His wife, Kuan Tao-sheng (1262–1319; cat. no. 12), like Empress Yang (1162–1232; cat. no. 9) of the Southern Sung, was one of the few women in Chinese history to become famous as a calligrapher. She was also a painter of bamboo, and Khubilai Khan himself is said to have praised Kuan Tao-sheng for her distinction as an artist.

Chao Meng-fu's friend Hsien-yü Shu (ca. 1257–1302) grew up in north China, which had been under Mongol control since 1234. After the reunification with the south in 1279, he moved south with his family to the city of Hangchow, where he met Chao and other scholars and connoisseurs. He continued to write, however, in a bold, slightly coarse calligraphic style based on T'ang and Sung (960–1279) models that had been popular in the north during his youth. In his handscroll *Admonitions to the Imperial Censors* (cat. no. 13) Hsien-yü Shu employed this style to transcribe a morally edifying text, embodying its stern precepts in large, vigorously written characters.

The Mongol emperors preserved many features of their own culture, continuing to spend periods of each year hunting and living in tents, but a gradual process of sinicization led members of the Mongol court to patronize Chinese artists and to engage in art collecting. Nevertheless, the only significant development in the history of calligraphy resulting directly from Mongol rule was the founding of the Hall of Literature (*K'uei-chang-ko*) by Emperor Wen-tsung (r. 1328–32), the most sinicized of the Mongol emperors.[4] This institution became the center for the preservation of Chinese culture at Wen-tsung's court and was staffed by prominent southern scholars who supervised the imperial art collections and performed other artistic and literary duties. Scholars assigned to the Hall of Literature frequently wrote in small-standard script (*hsiao-k'ai*), a form of calligraphy in which Chao Meng-fu had also excelled. K'o Chiu-ssu (1290–1343), a calligrapher and poet who served in the Hall of Literature, employed this script type in colophons written for scrolls in the imperial collection and for transcriptions of his own poems (cat. no. 14) in which he evoked the splendors of Emperor Wen-tsung's court. The pervasive influence of Chao Meng-fu's calligraphy and the popularity of small-standard script are evident also in the work of Yü Ho (1307–1382). His copy of Wang Hsi-chih's *Essay on Yüeh I* (cat. no. 16) preserves the basic features of this classical model of small-standard script but introduces complexities of brushwork derived from his study of Chao's style.

Although Chinese civilization had always encompassed people from diverse ethnic and cultural backgrounds, Mongol rule intensified the interactions among them. A major calligrapher of the Yüan dynasty, K'ang-li Nao-nao (1295–1345), was not a Han Chinese but a member of a Central Asian tribe.[5] His mastery of Chinese culture was so complete, however, that he tutored the Mongol emperor Shun-ti (r. 1333–67) in the Confucian classics. His cursive-script (*ts'ao-shu*) calligraphy (cat. no. 15) was based on the style of Wang Hsi-chih.

R.E.H.

NOTES

1. On the history of the Yüan dynasty, see John D. Langlois, Jr., ed., *China under Mongol Rule* (Princeton: Princeton University Press, 1981); *The Cambridge History of China,* vol. 7, *The Ming Dynasty, 1368–1644, Part I,* eds. Frederick W. Mote and Denis Twitchett (Cambridge: Cambridge University Press, 1988). On the practice of Confucian eremitism in the Yüan, see Frederick W. Mote, "Confucian Eremitism in the Yüan Period," in Arthur F. Wright, ed., *The Confucian Persuasion* (Stanford: Stanford University Press, 1960), 202–40. For an alternative view of the treatment of scholars, see Hsiao Chi-ch'ing, "Yüan-tai te ju-hu: Ju-shih ti-wei yen-chiu shih-shang te i chang," in *Yüan-tai shih hsin-t'an* (Taipei: Hsin-wen-feng ch'u-pan-she, 1983), 1–58.

2. For an overview of the arts in the Yüan, see Sherman E. Lee and Wai-kam Ho, *Chinese Art under the Mongols: The Yüan Dynasty, (1279–1368)* (Cleveland: The Cleveland Museum of Art, 1968).

3. See Frederick W. Mote and Hung-lam Chu et al., *Calligraphy and the East Asian Book,* special catalogue issue of *Gest Library Journal,* 2, no. 2 (Spring 1988): 111–35.

4. The question of Mongol sinicization is sometimes tied to the ability of the emperors to speak and read Chinese. See Herbert Franke, "Could the Mongol Emperors Read and Write Chinese?" in idem., *China under Mongol Rule* (Aldershot, England: Variorum, 1994), 28–42.

5. Many "foreigners"(*se-mu jen*) from the western regions who were educated in Confucian scholarship and art served in the Yüan government. Besides K'ang-li Nao-nao, the high official Yeh-lü Ch'u-ts'ai (1189–1243) also excelled at calligraphy. On other "foreigners" who were known for their calligraphy, see Ch'en Yüan, *Western and Central Asians in China under the Mongols: Their Transformation into Chinese,* trans. Ch'ien Hsing-hai and L. Carrington Goodrich, Monumenta Serica Monographs Series 15 (1966; reprint, Nettetal, Germany: Steyler Verlag, 1989).

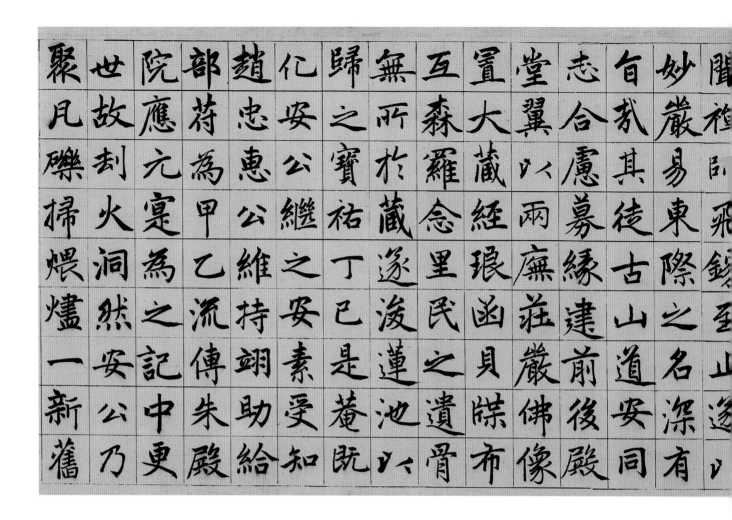

11
Chao Meng-fu (1254–1322)

Record of the Miao-yen Monastery

(*Hu-chou Miao-yen-ssu chi*)

Undated, ca. 1309–10
Handscroll, ink on paper
34.2 x 364.5 cm
1998-53

COLOPHONS:
Yao Shou (1423–1495), four colophons dated 1468, 1471, 1474,
 and 1482
Chang Chen (fl. mid-15th century), undated
Chang Ch'ien (1853–1926), dated 1909
Wang T'ung-yü (1855–1939?), dated 1932

Although he was a descendant of the founder of the Sung dynasty, Chao Meng-fu accepted a succession of government appointments under the Mongol conqueror Khubilai Khan (Emperor Shih-tsu, r. 1260–94) and under two later Mongol emperors. Some of his contemporaries and many later historians scorned Chao's decision to serve a foreign regime, but his participation in government actually bettered the lot of Chinese scholars, especially those of the Chiang-nan region of south China, whom the Mongols had originally viewed with suspicion.

Chao Meng-fu was not a professional artist but a classic model of the literati ideal of the scholar-amateur—a person who pursues the arts of painting, calligraphy, and poetry as forms of self-cultivation. In spite of the essentially private nature of much of his work as a calligrapher, Chao responded to scores of requests for writing addressed to a public audience. One major example of his public calligraphy is *Record of the Miao-yen Monastery*. The text of this scroll, composed by another scholar-official, Mou Yen (1227–1311), is a history of a monastery located near Chao's hometown of Wu-hsing, Chekiang. Mou's record describes the setting of this Buddhist institution, the eminent clerics who lived and taught there, and the rebuilding of the monastery carried out in the late thirteenth century.[1]

The scroll opens with a title piece written in large seal-script characters. This section of the calligraphy would have been engraved at the top of the stele on which the entire inscription was intended to appear. The even, unmodulated strokes of the seal-script title set it off visually from

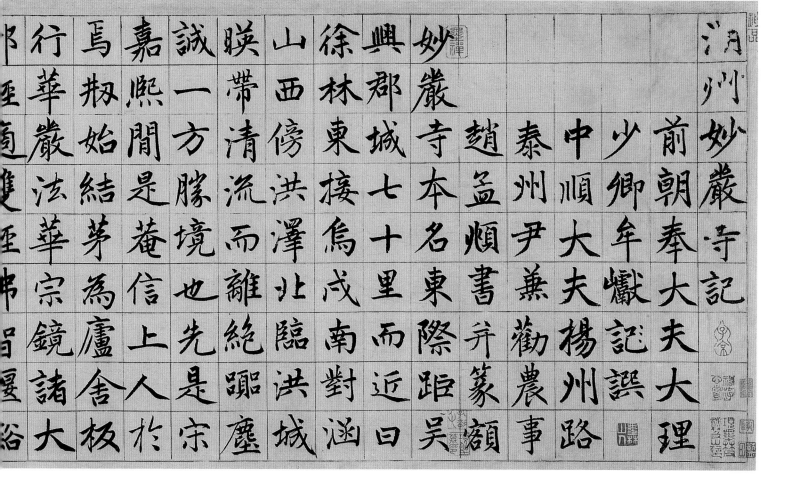

the more varied brushwork and complex forms of the standard-script characters used for the body of the text.

Chao's study of calligraphy included models from the third through the twelfth centuries. His innovations in standard script combined the elegant, fluid brushwork of Wang Hsi-chih (303–361; cat. no. 2) and Ch'u Sui-liang (596–658) with the structural solidity of calligraphy by Yen Chench'ing (709–785). Chao's tendency to tilt characters toward the upper right also reflects his close study of stele inscriptions by Li Yung (678–747). This synthesis resulted in a powerful new style that corrected what many critics saw as the weakness of Southern Sung calligraphy, which had been dominated by the somewhat flaccid styles of Emperor Kaotsung (r. 1127–62) and his imperial successors. Within a few years of Chao's death, his standard-script calligraphy had become a popular model for woodblock-printed books.[2]

In addition to being an important monument in the history of calligraphy, *Record of the Miao-yen Monastery* is an artifact of religious and intellectual syncretism during the Yüan dynasty. Although both Chao Meng-fu and Mou Yen were Confucian scholars, they collaborated on inscriptions for Buddhist and Taoist institutions. Chao was especially close to a number of Buddhist monks, with whom he frequently exchanged social calls and letters (cat. no. 12).

<div align="right">R.E.H.</div>

PUBLISHED

Chiang I-han, "Chao Meng-fu shu *Hu-chou Miao-yen-ssu chüan*," *Ku-kung chi-k'an* 10, no. 3 (Spring 1976): 59–81; Wen C. Fong et al., *Images of the Mind: Selections from the Edward L. Elliott Family and John B. Elliott Collections of Chinese Calligraphy and Painting at The Art Museum, Princeton University* (Princeton: The Art Museum, Princeton University, 1984), 94–102, 284–87, cat. no. 7; Shen C. Y. Fu et al., *Traces of the Brush: Studies in Chinese Calligraphy* (New Haven: Yale University Art Gallery, 1977), 169, 251–52, cat. nos. 15a–b; Frederick W. Mote and Hung-lam Chu et al., *Calligraphy and the East Asian Book,* special catalogue issue of *Gest Library Journal* 2, no. 2 (Spring 1988): 114–15, cat. no. 57; Nakata Yūjirō and Fu Shen, eds. *Ōbei shūzō Chūgoku hōsho meisekishū* (Tokyo: Chūō-kōron-sha, 1981–83), 3: 23–27, 138, pls. 18–26; Suzuki Kei, comp., *Chūgoku kaiga sōgō zuroku*, vol. 1, *Amerika-Kanada hen* (Tokyo: University of Tokyo Press, 1982), 130–31, pl. A17–055; Tseng Yuho, *A History of Chinese Calligraphy* (Hong Kong: Chinese University Press, 1993), 183; Yin Sun, ed. *Chung-kuo shu-fa-shih t'u-lu* (Shanghai: Shang-hai shu-hua ch'u-pan-she, 1989), no. 683.

NOTES

1. On other stele inscriptions by Chao Meng-fu, see the essay by Zhixin Sun in this volume.
2. On the impact of Chao Meng-fu's style on Chinese printing, see Mote and Chu et al., *Calligraphy and the East Asian Book,* 111–35.

12
Chao Meng-fu (1254–1322) et al.
Collected Letters of the Chao Meng-fu Family

Six letters mounted as a handscroll, ink on paper
 a. Chao Meng-fu, 29.5 x 50.2 cm
 b. Chao Meng-fu, 27.7 x 49.6 cm
 c. Kuan Tao-sheng (1262–1319), 29.0 x 49.7 cm
 d. Chao Yung (1290–ca. 1362), 32.6 x 61.8 cm
 e. Chao Yung, 30.0 x 51.9 cm
 f. Chao Yu-hsi (fl. late 13th–early 14th century), 28.3 x 42.4 cm
 1998-54

TRANSLATION OF THE FIRST LETTER, BY CHAO MENG-FU:
Meng-fu clasps his hands and respectfully replies to his teacher,
Monk Chung-feng: Now that my late wife's second anniversary
has just passed,[1] I am entrusting my words to [your disciple]
Ch'ien-chiang, that he may convey them to you. I beg your
forbearance for your first having sent him to carry out these
Buddhist rituals, and then for your sending [another disciple]
I-chung such a long way to carry out your commands. Though
I have transgressed, I received the offerings and censers [you
sent], and I presented them before my wife's ancestral tablet.
As for all the statues you kindly sent, I have often in the past
received my master's compassion in this way. Now, as I again
receive these, I truly tremble in shame. I respectfully send
them back with I-chung to you, and I keenly thank you for
your esteemed kindness. Happily, the rituals were completed
as I had hoped, and I again thank you, teacher, for especially
making me a selection of the omniscient words of the Buddha.
My late wife definitely has a hope of being reborn in heaven, and
this would not have been possible if not for the kindness
of you, our teacher. As I humbly write this letter to you, I am
overcome by the extent of my grief. Numerous affairs make me
write these words without due respect. As it is hot now, I hope
only that you are taking care of yourself, etc. Your pupil Chao
Meng-fu clasps his hands and respectfully replies. Fifth month,
eleventh day.[2]

Famous father-and-son calligraphers are well-known in
Chinese art history—Wang Hsi-chih (303–361) and his son
Wang Hsien-chih (344–388), and Mi Fu (1052–1107) and
Mi Yu-jen (1074–1151) are illustrious predecessors of Chao
Meng-fu and his son Chao Yung. Famous women artists are
few: among the early ones can be counted Wang Hsi-chih's
calligraphy teacher Madam Wei (272–349) and the bamboo
painter Kuan Tao-sheng, who was the devoted wife of
Chao Meng-fu.[3] The Chao family also included several
other artists noted for their calligraphy and painting.

 These letters by members of the Chao family candidly
reveal aspects of their private lives. Although written in a
conventionally formal literary style, they were executed
in the style of cursive script developed by Chao Meng-fu
through his study of Wang Hsi-chih's *Letters of the Seven-
teenth (Shih-ch'i t'ieh)* collection.[4] This highly flexible script
allowed each of the Chao family writers to subtly express
their feelings through calligraphy.

 Chao Meng-fu's letter, translated above, is deeply
moving in its expression of gratitude to his Ch'an master,
the famous monk Chung-feng Ming-pen (1263–1323). The
monk arranged religious services on the second anniver-
sary of the death of Kuan Tao-sheng, who had died in 1319.
In the letter, which reveals Chao's intimacy with his master,
he confesses to being "overcome by the extent of my grief."
The arrangements for Kuan's funeral are the topic of the
letter from the couple's eldest daughter, Chao Yu-hsi, to
her husband. Besides discussing numerous funeral and
domestic arrangements, she alludes to her father's fragile
mental state and asks that "a bunch of good, big persim-
mons" be sent for him to eat.

 Kuan Tao-sheng's letter, datable to between 1310 and
1319, and thought to have been written on her behalf, unbe-
knownst to her, by Chao Meng-fu, congratulates a senior
female relative on the homecoming of a son who had
achieved official rank. Although Kuan plays down her
accompanying gift as a trifle—it included "ten catties
[pounds] of purple chestnuts, ten catties of winter bamboo
shoots, one hundred pepper cakes, and three hundred
heads of bok choy"—the letter reveals the family's prosper-
ity and career goals. The letters by Chao Yung, the second
son of Chao Meng-fu and Kuan Tao-sheng, offer apologies
to a friend. In one letter, Chao Yung begs the friend to put
in a good word with his high-ranking father: Chao was late
with a commissioned painting and did "not dare to reply
to the minister" himself.

 The form and style of the letters are equally intriguing.
The prose style of Chao Meng-fu's letter to Chung-feng
Ming-pen is self-deprecatory. The many short lines are the
product of the convention whereby at each mention of the
recipient, a new line is begun to show respect. By contrast,
in Chao Yu-hsi's familiar letter to her "dear husband," she
fills in the empty spaces created by this convention with
short reminders—"Don't leave the fans lying around" and
"I hope you can send the persimmons quickly." The cursive
script was used not just out of necessity—as Chao Yu-hsi
writes, "The messenger is returning soon, so I scribble this
in reply"—but to convey emotion.

S. McC.

PUBLISHED
Chiang I-han, "Chao-shih i men ho cha yen-chiu," *Ku-kung chi-k'an* 11,
no.4 (1977): 23–50, pls. 1–12, Eng. trans. pp. 33–37; Nakata Yūjirō and Fu
Shen, eds. *Ōbei shūzō Chūgoku hōsho meisekishū* (Tokyo: Chūōkōron-sha,

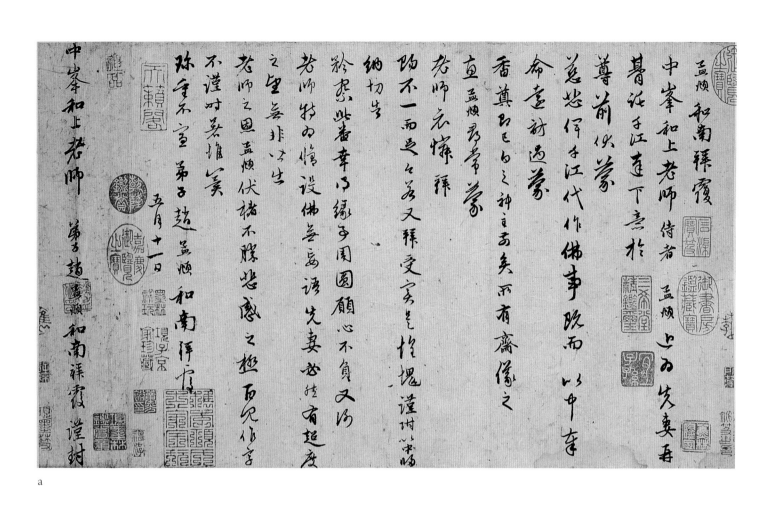

a

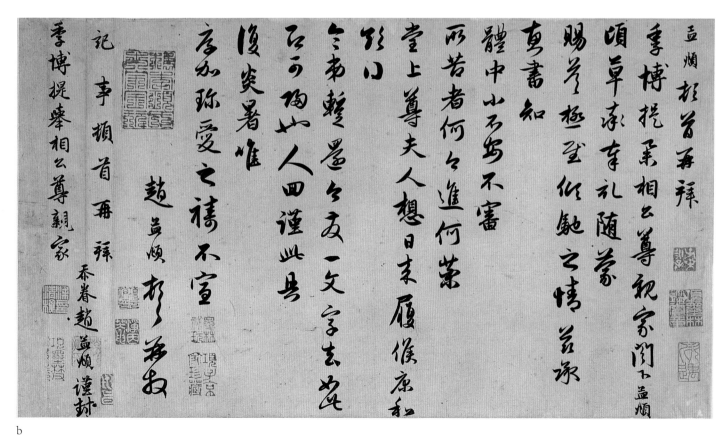

b

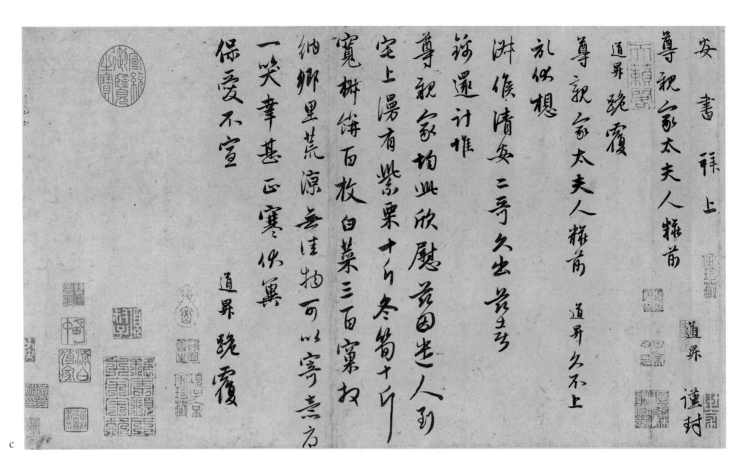

c

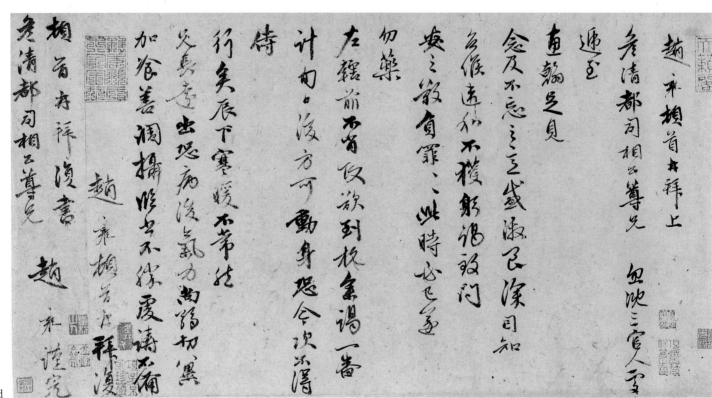

d

1981–83), 3: nos. 44–49; Suzuki Kei, comp., *Chūgoku kaiga sōgō zuroku*, vol. 1, *Amerika-Kanada hen* (Tokyo: University of Tokyo Press, 1982–83), pl. A17–055.

NOTES

1. Kuan Tao-sheng died in the fifth month of 1319, as she and Chao Meng-fu were traveling home to retirement.

2. Translated with the help of Qianshen Bai and Li-chiang Lin.

3. On Kuan Tao-sheng's calligraphy and painting, see Ch'en Pao-chen, "Kuan Tao-sheng ho t'a-te chu-shih," *Ku-kung chi-k'an* 11, no. 4 (1977): 51–84; and Chiang, "Chao-shih i-men ho cha yen-chiu," 23–30.

4. See *Shodō zenshū*, n.s. (Toyko: Heibonsha, 1960), 4: 46–57.

13
Hsien-yü Shu (ca. 1257–1302)

Admonitions to the Imperial Censors

(*Yü-shih chen*)

Dated 1299
Handscroll, ink on paper
50.1 x 409.6 cm
1998-49

INSCRIPTION (front):
Chang Ta-ch'ien (1899–1983), dated 1969

COLOPHONS:
Chao Meng-fu (1254–1322), undated
Teng Wen-yüan (1259–1329), undated
Chang Ying (1260–1329), undated
Chou Ch'ih (fl. 1280–1315?), dated 1304
T'ang Ping-lung (1241–after 1319), undated
Joint colophon, undated:
 a. Ch'iu Yüan (1247–after 1327)
 b. Ku Wen-ch'en (fl. 1295–1305?)
 c. Po T'ing (1248–1328)
 d. Han Yu-chih (fl. 1295–1305?)
 e. Han Yu-wen (fl. 1295–1305?)
Yüeh Yüan-chang (fl. 1285–1320?), dated 1304
Kuo Ta-chung (fl. 1300–1320?), undated
T'ai Pu-hua (1304–1352), undated
Mo Ch'ang (fl. 1300–after 1352), dated 1352

The Mongol conquest of China, completed in 1279, brought to an end a period of over one hundred fifty years of political disunion. During this time the territory north of the Huai River had been controlled by the Jurchen Chin dynasty, while the south was ruled by a native Chinese dynasty, the Southern Sung. With the reunification achieved by the Mongols, travel and cultural exchange between north and south increased greatly. Hsien-yü Shu, whose family was from the north, moved to Hangchow around 1283 and became an associate of many leading southern Chinese intellectuals, including Chao Meng-fu (1254–1322; cat. no. 11). His affiliation with literary and artistic traditions of the north was reflected, however, in his art.[1] Both the text of *Admonitions to the Imperial Censors*, composed by a Chin dynasty writer, and the calligraphic style of the scroll demonstrate this northern heritage.

The text was composed by Chao Ping-wen (1159–1232), a northerner who served as an official under the Chin dynasty. Addressed to imperial censors charged with rooting out corruption and offering advice to the emperor,

Chao's *Admonitions* draws on a tradition of rhymed prose know as *chen* (admonition), in which the writer discusses the rise and fall of dynasties and exhorts himself or others to faithfully discharge their duties. In his exhortation to imperial censors, Chao Ping-wen reminds these officials of their sacred obligations to warn and remonstrate with the emperor. He acknowledges that the honesty and courage required of those who serve as censors could result in alienation, loneliness, or even death. Regardless of these dangers, Chao urges the censors to be "as pure as frost" and "as impartial as a pair of scales." It is likely that Chao composed his *Admonitions* in an effort to rally the flagging morale of government officials in the final years of the Chin dynasty, which fell to the Mongols in 1234.

Like Chao Ping-wen, Hsien-yü Shu enjoyed a reputation for courage and moral rectitude. In transcribing Chao's *Admonitions*, he not only allied himself with the Chin writer's views expressed in the text but also with Chao's calligraphy. Chao himself was a famous calligrapher and made a transcription of his *Admonitions* in large characters. Although this scroll was lost long ago, Hsien-yü Shu may have seen it and taken it as a model for his own transcription of the text, which is written in unusually large characters.[2] Hsien-yü Shu's scroll, about twenty inches in height, has four characters per line, and each character is four to five inches tall. He also chose a bold, vigorous calligraphic style, writing with a slightly worn-out brush. His characters are balanced and stable, and the brushstrokes are rounded and of even thickness.

Many of the writers of colophons attached to his scroll praise the heroic vigor of Hsien-yü Shu's calligraphy and mention feelings of deep respect that it inspired. Viewed historically, the scroll evokes calligraphy from the Chin and pre-dynastic Yüan—the era between 1234, when the Mongols conquered the Chin, and 1260, when they founded the Yüan dynasty. The principal models for northern calligraphers during these periods were Yen Chen-ch'ing (709–785) and his artistic follower Su Shih (1037–1101). Following the example of these masters, northern calligraphers aimed for powerful visual effects rather than subtleties of brushwork. It is this northern tradition that Hsien-yü Shu continued in a reunified China.

H.L.

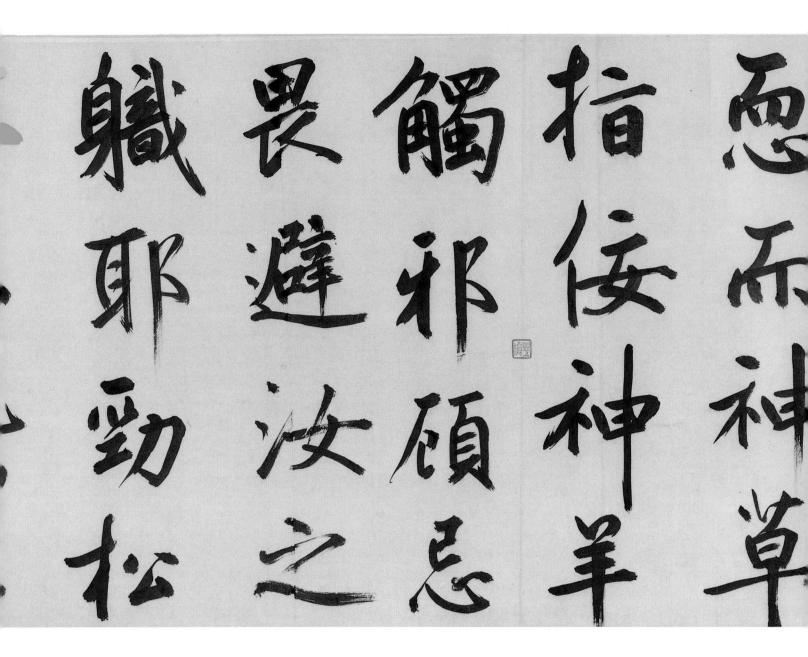

PUBLISHED

Tseng Yu-ho Ecke, *Chinese Calligraphy* (Philadelphia: Philadelphia Museum of Art; and Boston: Boston Book and Art Publishers, 1971), cat. no. 34; Marilyn Wong Fu [M. W. Gleysteen], "The Impact of the Reunification: Northern Elements in the Life and Art of Hsien-yü Shu (1257?–1302) and Their Relation to Early Yüan Literati Culture," in John D. Langlois, ed., *China under Mongol Rule* (Princeton: Princeton University Press, 1981), viii, 395, 416–20, 422–28; Shen C. Y. Fu, *Traces of the Brush: Studies in Chinese Calligraphy* (New Haven: Yale University Art Gallery, 1977), 15–17, 32–33, 140–41; Nakata Yūjirō and Fu Shen, eds. *Ōbei shūzō Chūgoku hōsho meisekishū* (Tokyo: Chūōkōron-sha, 1981–83), 4: 62–67; *Shih-ch'ü pao-chi ch'u-pien* (1744–45; *Mi-tien chu-lin shih-ch'ü-pao-chi* rpt. ed., Taipei: National Palace Museum, 1971),4/5b-6a [pp. 934–35]; Yin Sun, ed., *Chung-kuo shu-fa-shih t'u-lu* (Shanghai: Shang-hai shu-hua ch'u-pan-she, 1989), no. 683.

NOTES

1. On the cultural impact of the reunification of China under the Mongols, see Marilyn Wong Fu, "Hsien-yü Shu's Calligraphy and His 'Admonitions' Scroll of 1299" (Ph.D. diss., Princeton University, 1983). See also Marilyn Wong Fu, "The Impact of the Reunification," 371–433.
2. Wang Yün (1227–1304), a contemporary of Hsien-yü Shu and imperial censor at the Yüan court, saw Chao Ping-wen's scroll and wrote about his experience. See Wang Yün, *Ch'iu-chien hsien-sheng ta-chuan wen-chi,* in *Ssu-pu ts'ung-kan ch'u-pien so-pen* (Taipei: Shang-wu yin-shu-kuan, 1967), 38: 388–89.

稱　斯　斯　安　塞
脈　衣　冠　歸　路
中　德　有　有　持
心　不　矣　鐵　此

14
K'o Chiu-ssu (1290–1343)
Palace Poems (Shang-ching kung-tz'u)

Undated
Handscroll, ink on paper
30.5 x 53.0 cm
1998-55

COLOPHONS:
Liu Yung (1719–1804), dated 1787
Weng Fang-kang (1733–1818), undated
T'ieh-pao (1752–1824), dated 1789
Ch'ung-pen (*chin-shih* degree, 1755), dated 1790
Mao-pen (*chü-jen* degree, 1792), dated 1794
Wang Wen-chih (1730–1802), dated 1800

A native of Hsien-chü, in what is now Chekiang Province, K'o Chiu-ssu came from a family of Confucian scholars who had served in the imperial government for many generations. This family tradition was not disrupted by the Mongol conquest of China in 1279. Like his father, K'o Chiu-ssu traveled to the capital at Ta-tu, the site of modern Peking, and eventually rose to prominence during the reign of Emperor Wen-tsung (r. 1328–32).[1]

Of all the Mongol emperors of China, Wen-tsung was the most sinicized. Among his projects that signified his benevolent sponsorship of Chinese culture was the founding of the Hall of Literature (*K'uei-chang-ko*), an institution devoted to preserving Chinese artistic and literary culture.[2] Wen-tsung appointed K'o Chiu-ssu to the staff of the Hall as an official connoisseur of calligraphy and treated him as a trusted confidant and artistic advisor.

K'o Chiu-ssu composed "Palace Poems" while serving under Emperor Wen-tsung and transcribed five of them in this scroll.[3] Studded with allusions to virtuous rulers of antiquity and ornate descriptions of imperial rituals, the poems evoke the golden days of Wen-tsung's reign and the high point of K'o's own career. In a passage from the first poem, K'o depicts the emperor at his summer retreat but reminds the reader that Wen-tsung never forgot the welfare of his agriculturalist subjects:

> A thousand officials, honored at a banquet, all arrayed in
> palace embroidery,
> Ten thousand horses, galloping for the pennant, all with
> jade trappings.
> Yet still there are minor officials standing at attention:
> Though enjoying celestial leisure, His Majesty inquired
> of the autumn harvest.

After the death of his imperial patron, whose reign he celebrates in "Palace Poems," K'o Chiu-ssu returned to south China. It was there, probably in the mid-1330s, that he transcribed the poems for a Buddhist monk named Wu-yen. K'o's calligraphy in the scroll is the same neat, trim, small standard script that he and other scholars at Wen-tsung's court used for colophons written on works of art owned by the emperor. Although K'o was living in retirement, the imagery of the poems and the calligraphy in which they were written encouraged informed readers to recall his days as a favored member of Emperor Wen-tsung's court.[4]

<div align="right">H.L.</div>

PUBLISHED

Chiang I-han, "K'o Chiu-ssu shu kung-tz'u chüan," suppl., in his *Yüan-tai K'uei-chang-ko chi K'uei-ch'ang jen-wu* (Taipei: Lien-ching ch'u-pan-she, 1981), 217–44, figs. 26–29; *Chung-kuo mei-shu ch'üan-chi: Shu-fa chuan-k'o pien* (Peking: Jen-min mei-shu ch'u-pan-she, 1986), vol. 4, no. 100; Shen C. Y. Fu et al., *Traces of the Brush: Studies in Chinese Calligraphy* (New Haven: Yale University Art Gallery, 1977), 142, 170–71, 255–56, cat. no. 20; Nakata Yūjirō and Fu Shen, eds. *Ōbei shūzō Chūgoku hōsho meisekishū* (Tokyo: Chūōkōron-sha, 1981–83), 4: 137–38, pls. 1–5; Suzuki Kei, comp., *Chūgoku kaiga sōgō zuroku*, vol. 1, *Amerika-Kanada hen* (Tokyo: University of Tokyo Press, 1982), pl. A17–051; Yin Sun, ed., *Chung-kuo shu-fa-shih t'u-lu* (Shanghai: Shang-hai shu-hua ch'u-pan she, 1989), no. 712.

NOTES

1. Tsung Tien, *K'o Chiu-ssu shih-liao* (Shanghai: Shang-hai jen-min mei-shu ch'u-pan she, 1985).
2. This institution is the subject of a detailed study by Chiang I-han, *Yüan-tai K'uei-chang-ko chi K'uei-chang jen-wu.*
3. See Nakata and Fu, *Ōbei shūzō Chūgoku hōsho meisekishū*, 4: 137. For a translation of the last two poems, see Francis W. Cleaves, "The 'Fifteen Palace Poems' by K'o Chiu-ssu," *Harvard Journal of Asiatic Studies* 20, no. 3/4 (Dec. 1957): poems 6 and 11, pp. 421 and 423.
4. Another version of *Palace Poems* is in the collection of Ch'en Ch'i. See Tseng Yuho, *A History of Chinese Calligraphy* (Hong Kong: Chinese University Press, 1993), 216, fig. 7.86. Fu Shen judges this version to be a close copy of the Elliott scroll. Fu et al., *Traces of the Brush*, 302, no. 77. See also "The Two Perfections: Reading Poetry and Calligraphy" by Robert E. Harrist, Jr., in this volume .

輦路千門喜氣浮太平
天子祀圜丘奉常奏備離溫山
尚服陳罷進大裘雲載朱旂翶
彩鳳天臨玉輅駕翠虬腐儶繆
金闕籍目醉縈光出御樓蒼
自茅初奠備韶韺月色當增簫
清親祀甘泉除祕祝受釐宣室
蒼生星乘仙仗神光日遠
天顏瑞彩明多少泛官齋呼嵩

清親祀廿泉除祕祝受釐宣室問

蒼生星乘仙仗神光日遠

天額瑞彩明多少泛官齋呼嶽

豐年有家蒙樂昇平

宮詞二首

至尊明日慶生辰準備龍衣尉貼新

奉御進呈先取言窋珠鎗落聞麒麟

三椀調冰瀣雪花金絲纏扇繡紅紗

彩賤御製題端午勅送皇姑必

主家

柯九思錄呈

無言大禪師

上京宮詞

灤京三伏暑無多仙樂飄颻落
禁坡翡翠樓高臥曉日水精殿冷
看天河千官錫宴齊宮錦萬馬
爭標盡寶珂獨有小臣如鵠立
九重閶闔問秋禾

應制賦郊祀大禮慶成二首

輦路千門喜氣浮太平
天子祀圜丘奉常奏備離溫室
尚服陳雕進大裘雲載朱旂飄
彩鳳天臨玉輅駕翠虬亂腐儒繆杂
金闕籍目辟紫光出卸樓蒼

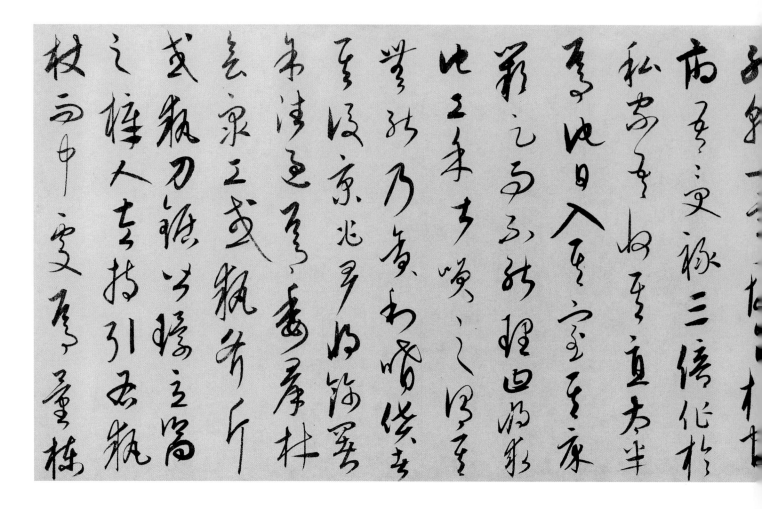

15

K'ang-li Nao-nao (1295–1345)

Biography of a Carpenter (Tzu-jen chuan)

Dated 1331
Handscroll, ink on paper
27.8 x 281.0 cm
Gift in honor of Lucy L. Lo
1985-11

<small>COLOPHONS:</small>

Wu Jung-kuang (1773–1843), dated 1836
P'an Shih-ch'eng (*chü-jen* degree, 1832), dated 1850
Yang Chen-lin (fl. mid-19th century), dated 1834
Ch'en Ch'i-k'un (*chin-shih* degree, 1826), undated
Viewed by the two men, written by Chang Heng, dated 1946:
 a. Hsü Ssu-ch'ien (fl. mid-20th century)
 b. Chang Heng (1915–1963)

Under Mongol rule during the Yüan dynasty, the popula-
tion of China was made up of many different ethnic groups
whose cultures interacted. The Han Chinese absorbed
Mongol language and customs, as we can see in Yüan
literature and drama, and non-Han people who were
brought up in China studied the Confucian classics,
practiced calligraphy, and painted. K'ang-li Nao-nao's ances-
tors were from the K'ang-li tribe in Central Asia, but he was
well known as a Confucian scholar and calligrapher.

According to K'ang-li Nao-nao's biography, he held
several positions at the imperial court and advocated
Confucian ideals of government. He served as the tutor
of the Mongol emperor Shun-ti (r. 1333–67), faithfully
instructing the emperor in the Chinese classics. The text
transcribed in this handscroll, "Biography of a Carpenter,"
was one of K'ang-li Nao-nao's favorite pedagogical essays
for the emperor. An allegory by the T'ang scholar Liu
Tsung-yüan (773–819), it tells the story of the carpenter
Yang Ch'ien, whose superior intellect made him a master
builder. Liu Tsung-yüan argues at the end of the piece that
it was because Yang Ch'ien gave up mere craftsmanship
to concentrate on planning that he was able to grasp the
subtle points of architecture. He represents the ideal of
a wise man who works with his mind, as opposed to a
merely skillful man who works with his hands. The wise
man is the one who is suitable for helping the emperor
rule the country. K'ang-li Nao-nao used this allegory to
teach the emperor the value of assigning people with
different characteristics to positions in which they would
be most effective.

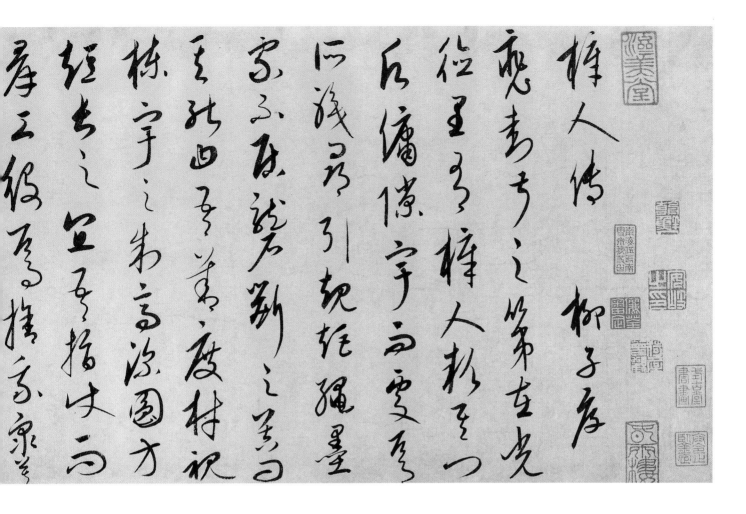

This handscroll is written in cursive script following the model known as *Letters of the Seventeenth* (*Shih-ch'i t'ieh*) by Wang Hsi-chih (303–361). These letters display cursive script in its early stage of development, in which characters were abbreviated for rapid writing.[1] Characters are still written separately instead of being linked together as in "wild-cursive" script, which was developed in the eighth century and became most popular among calligraphers of the Sung dynasty. During the fourteenth century Chao Meng-fu (1254–1322) advocated "revival of the ancients" (*fu-ku*) and went back to the works of Wang Hsi-chih for inspiration. In response to this artistic trend, K'ang-li Nao-nao followed Wang Hsi-chih's model in cursive script.

K'ang-li Nao-nao departed from Wang's style in several ways. Writing with his wrist lifted from the table and using the tip of the brush in a technique known as the "centered-tip," he produced fluid, smooth brushstrokes of even thickness. This manner of writing differs from the free alternation of thick and thin strokes seen in the writing of both Wang Hsi-chih and Chao Meng-fu. K'ang-li Nao-nao was greatly influenced by the T'ang monk calligrapher Huai-su (ca. 735–ca. 799), whose style he studied from the abundant works kept in the various collections in Ta-tu (modern Peking), the Yüan capital. It is interesting that

while K'ang-li Nao-nao adopted the structure and composition of characters from Wang Hsi-chih, he used the brush technique of the wild-cursive script master Huai-su. This combination distinguished him from those who followed Chao Meng-fu's "revival of the ancients." The process of selecting, retaining, and excluding stylistic elements demonstrates how a calligrapher could both borrow from ancient models and transform them for his own use.

H . L .

PUBLISHED

Shen C. Y. Fu et al., *Traces of the Brush: Studies in Chinese Calligraphy* (New Haven: Yale University Art Gallery, 1977), 21, 86–87, 103, 256–57; Marilyn Wong Fu [M. W. Gleysteen], "The Impact of the Reunification: Northern Elements in the Life and Art of Hsien-yü Shu (1257?–1302) and Their Relation to Early Yüan Literati Culture," in John D. Langlois, ed., *China under Mongol Rule* (Princeton: Princeton University Press, 1981), 412, 415–16, esp. 415 n. 95; Nakata Yūjirō and Fu Shen, eds. *Ōbei shūzō Chūgoku hōsho meisekishū* (Tokyo: Chūōkōron-sha, 1982), 3: pls. 72–78; *Record of The Art Museum, Princeton University* 45, no. 1 (1986): 36–37; *Selections from The Art Museum, Princeton University* (Princeton: The Art Museum, Princeton University, 1986), 212; Suzuki Kei, comp., *Chūgoku kaiga sōgō zuroku*, vol. 1, *Amerika-Kanada hen* (Tokyo: University of Tokyo Press, 1982), pl. A17–052.

NOTE

1. For reproductions of *Letters of the Seventeenth*, see *Shodō zenshū*, n.s. (Toyko: Heibonsha, 1960), 4: 46–57.

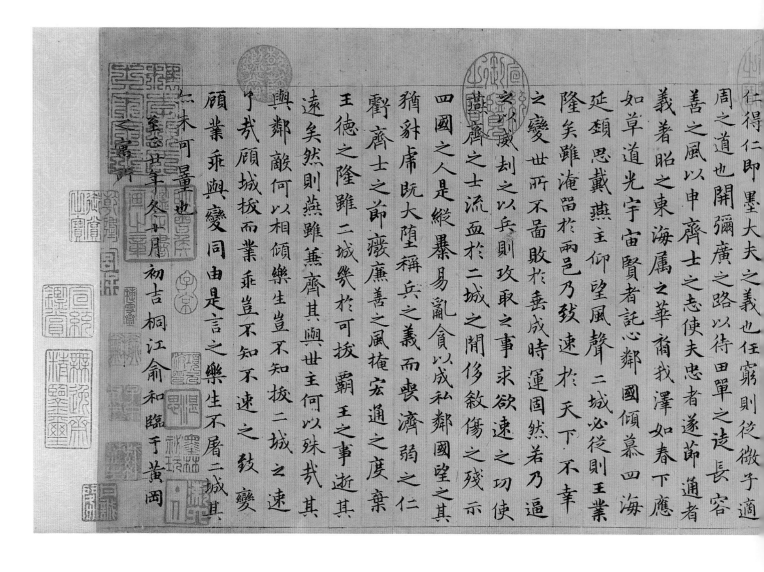

16
Yü Ho (1307–1382)

Essay on Yüeh I (Yüeh I lun)

Dated 1360
Handscroll, ink on paper
24.7 x 68.5 cm
1998-76

<small>COLOPHONS:</small>
Wen Ts'ung-chien (1574–1648), two colophons, both dated 1631
Nien Keng-yao (d. 1725), undated

All calligraphers begin their training as copyists: there is
no other way to learn calligraphy than by imitating preex-
isting samples of writing. In the rigorous and hierarchical
pattern of traditional calligraphic instruction, no writer is
expected to develop a distinctive personal style before first
achieving considerable skill in copying earlier models. Like
a virtuoso pianist practicing scales, a mature calligrapher

continues to make copies of earlier works in order to main-
tain sure control of the brush.

Copying has also played a critical role in the historical
transmission of calligraphy. Yü Ho's copy of *Essay on Yüeh I*
is based on a work attributed to Wang Hsi-chih (303–361).[1]
The text of this short prose essay, composed by Hsia-hou
Hsüan (209–254), discusses the virtues of Yüeh I, a general
of the Warring States period who defected from the state of
Yen, which he had served loyally, after losing the trust of his
ruler. The earliest reference to Wang Hsi-chih's transcrip-
tion of this text appears in the correspondence on calligra-
phy conducted by Emperor Wu (r. 502–50) of the Liang
dynasty and his aesthetic advisor T'ao Hung-ching
(452–536). In the seventh century the T'ang emperor T'ai-
tsung (r. 626–49) had multiple copies of the essay made at
his court as part of a comprehensive effort to collect and
promote the calligraphy of Wang Hsi-chih. The original
copy of Wang's *Essay on Yüeh I*, according to one account,
disappeared forever when an old woman who had stolen
it from a condemned imperial princess became anxious
about possessing the scroll and threw it into a stove. The

destruction of the piece did not diminish its importance for the later history of Chinese calligraphy. By the Sung and Yüan dynasties Wang Hsi-chih's *Essay on Yüeh I* was widely known through ink-written copies and through rubbings that varied slightly in content and calligraphic style.

For over one thousand years, *Essay on Yüeh I* served as a model for small standard script. Although this term refers to a script type, not the style of a particular historical era, this form of calligraphy was closely associated with works from the third and fourth centuries attributed to Chung Yu (151–230), Wang Hsi-chih, and Wang Hsien-chih (344–388) that display small, trim characters and lingering traces of clerical-script brushwork. Yü Ho's scroll is a freehand copy of *Essay on Yüeh I,* and he introduces several personal innovations, including strokes that begin with sharply tapering points, dots and strokes ending in wedge-shaped tips, and horizontal strokes written with a slight twist or bend. These features, which add to the lively, fluid appearance of the characters, appear also in works of small standard script by Chao Meng-fu (1254–1322; cat. nos. 11, 12), whose calligraphy Yü Ho studied throughout his life.[2]

R.E.H.

PUBLISHED

Chang Kuang-pin, "Ts'ung Wang Yu-chün shu *Yüeh I lun* ch'uan-yen pien Sung jen mo Ch'u ts'e," *Ku-kung chi-k'an* 14, no. 4 (1980): 45, pl. 7; Frederick W. Mote and Hung-lam Chu et al., *Calligraphy and the East Asian Book,* special catalogue issue of *Gest Library Journal* 2, no. 2 (Spring 1988): 116–17, 131 n. 6, cat. no. 58; Nakata Yūjirō and Fu Shen, eds. *Ōbei shūzō Chūgoku hōsho meisekishū* (Tokyo: Chūōkōron-sha, 1981–83), 4: 153–54, pl. 40; *Shih-ch'ü pao-chi ch'u-pien (Mi-tien chu-lin shih-ch'ü-pao-chi* rpt. ed., Taipei: National Palace Museum, 1971), 537; Suzuki Kei, comp., *Chūgoku kaiga sōgō zuroku,* vol. 1, *Amerika-Kanada hen* (Tokyo: University of Tokyo Press, 1982), pl. A17–053.

NOTES

1. See *Shodō zenshū,* n.s. (Tokyo: Heibonsha, 1960), 4: 153–55; and Chang, "Ts'ung Wang Yu-chün," 41–62.
2. Another copy of *Essay on Yüeh I* signed by Yü Ho and dated 1359 was in the collection of Lo Chen-yü. See *Chen-sung-t'ang li-tai ming-jen fa-shu* (Taipei: Wen-shih-che ch'u-pan she, 1976), 33–36. Chang Kuang-pin appears to have confused this scroll by Yü Ho with the copy in the Elliott Collection. See Chang, "Ts'ung Wang Yu-chün," pl. 7.

17
Ch'an Monks

Poems and Letters

(*Yüan Ming ku-te*)

Album of twelve leaves, ink on paper
1998-56

a. Chih-na (1078–1157)
Poem in Cursive Script
Undated
Album leaf, ink on paper
31.6 x 46.4 cm

b. Ta-hsin (1284–1344)
Poems
Dated 1342
Album leaf, ink on paper
25.4 x 55.3 cm

c. I-chien (d. after 1392)
Letter to the Buddhist Monk Kan-lu T'ang-shang
Undated
Album leaf, ink on paper
30.1 x 50.7 cm

d. Tao-yen (1335–1418)
Poem and Letter to the Buddhist Master Hsi-hsü
Dated 1389
Album leaf, ink on paper
25.6 x 39.7 cm

Members of the clergy have been among the best-educated segment of the population in many cultures. In China, Buddhist monks often were well-versed in secular texts as well as scriptures, and many were accomplished calligraphers. Among the best known were Chih-yung (fl. late 6th–early 7th century), a descendant of Wang Hsi-chih (303–361; cat. no. 2); and Huai-su (ca. 735–ca. 799), a monk active during the T'ang dynasty who excelled in wild-cursive script. These works in the Elliott Collection by four Buddhist monks active between the eleventh and the fifteenth centuries reflect the wide-ranging interest and calligraphic skills of these clerics.

Chih-na, a native of Hsiu-chou, Chekiang, served as abbot of the Ling-yin Temple in Hangchow and received many honors from the imperial court during the Southern Sung period. His poem reads,

> Peaceful, silent, my window is dustless;
> Sometimes, burning incense, I attain naturalness.
> Transcending the material world,
> I leave behind worldly concerns—
> No need to retreat to the mountains.

Chih-na modeled his calligraphy on the cursive script of Huai-su. Linked strokes appear in alternating dry and ink-saturated passages. Characters are highly abbreviated. In the last column (from right to left), the vertical stroke in the fourth character, *chung*, is written so swiftly and freely that it reaches the lower edge of the paper, leaving no space for the remaining three characters, which Chih-na squeezed in to the right.

Ta-hsin, a native of Nan-ch'ang, Kiangsi, became a Buddhist monk when he was seven years old. He was the disciple of several prominent Ch'an priests. Respected in both Buddhist and literary circles for his intellectual ability and other talents, Ta-hsin had broad contact with contemporary literary figures, such as Yü Chi (1272–1348), Kao K'o-kung (1248–1310), and Chao Meng-fu (1254–1322; cat. nos. 11, 12). In 1329 he was granted an official title by the court; the following year he was presented gifts by the emperor.

Ta-hsin's album leaf consists of three poems written in response to three others composed by Yü Chi. In the first poem Ta-hsin mentions the calligraphers Ou-yang Hsün (557–641) and Su Shih (1037–1101). His casually written standard script strongly resembles the calligraphy of Su Shih: the expansive characters are written with plump strokes and tilt upward to the right. Su himself had many friends among Buddhist monks, and his calligraphy was popular in the Buddhist world during the Sung and Yüan dynasties.[1]

I-chien was a native of I-hsing, Kiangsu. He studied calligraphy with Chang Yü (1283–1350), who had been a student of Chao Meng-fu. This heritage is apparent in both the structure and brushwork of I-chien's carefully executed characters.

Tao-yen, whose secular name was Yao Kuang-hsiao, was born in Soochow. Although his family had long practiced medicine, he became a Buddhist monk at the age of fourteen. In addition to mastering Buddhist and Confucian texts, he also appears to have studied military strategy. During his struggle for the throne, Prince Yen, the future Yung-lo emperor (r. 1403–24), sought Tao-yen's assistance. After the prince ascended the throne, he appointed Tao-yen to a senior position at his court. The monk wore official dress at court and changed back to his Buddhist robes when returning to his temple. He also participated in the compilation of the *Yung-lo Encyclopedia* (*Yung-lo ta-tien*). Tao-yen's poem was sent to the Buddhist master Hsi-hsü.[2] Although

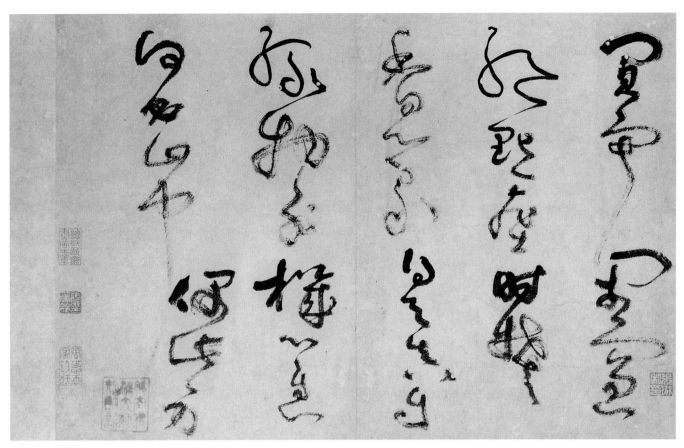

a

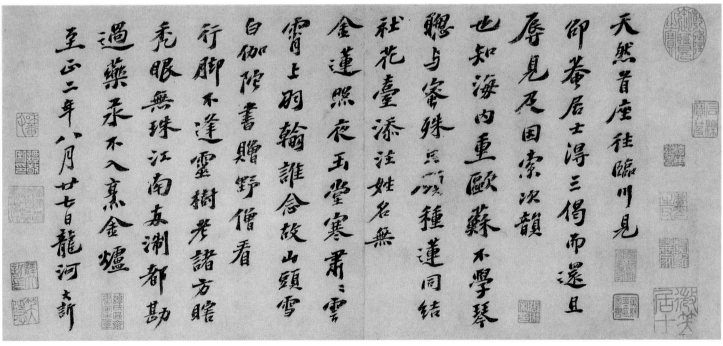

b

Tao-yen used running and cursive scripts, he wrote the
poem with great care to indicate his respect for the fellow
cleric to whom it was sent.

<div align="right">Q. B.</div>

PUBLISHED

Nakata Yūjirō and Fu Shen, eds. *Ōbei shūzō Chūgoku hōsho meisekishū*
(Tokyo: Chūōkōron-sha, 1981–83), 4: pls. 45, 46, 48, 50.

NOTES

1. For examples of Su Shih's calligraphy, see *Shodō zenshū*, n.s. (Tokyo:
Heibonsha, 1954), 15: pls. 32–57.

2. For Tao-yen's biography, see L. Carrington Goodrich and Chaoying
Fang, eds., *Dictionary of Ming Biography, 1368–1644* (New York:
Columbia University Press, 1976), 1561–65.

壽菴再拜報恩傑公承
佳偈和章見寄讀之其於
高妙慶深知
徑山家法得不衰寨甚慰。我龍
河熱鐵輪於此老漢也難當此
一嘆但老病之軀致
賢弟看寒暑之念衣盂遠及
不勝愧感
鶴林青鞋報恩茶壺卧褥等物
同至一日之間得整舊鐵何以當
此和見時就出此呈致謝葦甚
天禧方丈二為助喜嘸葦申
意不一。壽菴再拜復
甘露堂上和尚法弟
壽公

c

偈寄
東林社主西緒大法砌
渡口菴居迥絕塵六時
蓮漏禮彌勤山乎山乎
君休論我六來林社
裏人
洪武二十二年歲在
屠維大荒落秋七
月廿又三日
燕山慶壽 道衍再拜

d

Calligraphy of the Ming Dynasty

The overthrow of the Mongols in 1368 and the establishment of the Ming dynasty (1368–1644) marked a return to native Chinese rule.[1] The early Ming emperors recognized the importance of calligraphy and painting both as efficacious vehicles for government propaganda and as symbols of cultural legitimacy.[2] By rewards of prestigious employment, the imperial court attracted talented calligraphers who established a court calligraphy style. Sung K'o (1327–1387; cat. no. 18), who began his career as a military leader, became the dominant court calligrapher during the early decades of the dynasty. Besides developing a distinctive small-standard (hsiao-k'ai) script style, he specialized in an archaic form of writing known as draft cursive (chang-ts'ao or ts'ao-li), in which fluid, rapidly written strokes are mixed with sharp, angular forms derived from clerical script (li-shu). Two of his followers, the brothers Shen Tu (1357–1434) and Shen Ts'an (1379–1453; cat. no. 19), became influential calligraphers during the reign of the Yung-lo emperor (r. 1403–24). They adapted Sung K'o's style of calligraphy to perfect an exacting standard script (k'ai-shu) model, known as Chancellery style (T'ai-ko t'i), or Academy style (Kuan-ko t'i), that came to be used for government documents.[3]

By the middle of the fifteenth century, imperial interest in calligraphy had waned, and innovations in this art form occurred in regional centers far removed from the court. Many scholars living in south China devoted themselves to artistic endeavors as esteemed government positions became more difficult to obtain. Led by Shen Chou (1427–1509), a tightly knit group of scholars in Soochow developed a wide range of new calligraphic styles.[4] They revived the styles of Northern Sung masters and infused their calligraphy with personal significance. Shen Chou based his own running script (hsing-shu), marked by plump, round strokes written with a slightly trembling brush, on that of Huang T'ing-chien (1045–1105; cat. no. 6); Shen's student Wen Cheng-ming (1470–1559) also followed Huang but developed the dramatic, monumental style seen in his massive hanging scroll *Poem on Lake T'ai-yeh* (cat. no. 27). Chu Yün-ming (1461–1527), another Soochow native, excelled at small standard script (cat no. 24), but his greatest impact on the history of calligraphy came from his experiments in wild-cursive (k'uang-ts'ao) writing. In handscrolls of poems written in this script, such as *"The Arduous Road to Shu" and "Song of the Immortal"* (cat. no. 25), Chu attacked the paper with such force that some characters seem to explode into patterns of ink dots.

As both an artistic and a social practice, calligraphy in Soochow during the fifteenth and sixteenth centuries reflected bonds of friendship and family connections that unified the literati elite of the city. Dedicatory inscriptions added to an album of essays on calligraphy transcribed by Wu K'uan (1436–1504; cat. no. 23) reveal how calligraphic works could be exchanged as gifts. Artistic interaction among the Soochow literati is also illustrated through a set of poems on the theme of fallen flowers that T'ang Yin (1470–1524; cat. no. 26) wrote in response to a sequence of similar poems by his friend and mentor Shen Chou. In many cases, friends in Soochow interpreted works of calligraphy as expressions of the writer's

hopes and frustrations. The choice of text might reflect unstated meanings, as in the case of *The Nine Songs,* a scroll by Wang Ch'ung (1494–1533; cat. no. 29); at the end of the scroll, Wang's friend Ch'en Ch'un (1483–1544; cat. no. 44), added a colophon hinting that Wang had transcribed the ancient verses by the frustrated poet Ch'ü Yüan (343–278 B.C.) to express his own disappointment over his failure to succeed in the civil service examinations.

Toward the end of the sixteenth century, Tung Ch'i-ch'ang (1555–1636), a native of Sung-chiang Prefecture, dominated both the theory and practice of calligraphy in that region. He disparaged the achievements of calligraphers in nearby Soochow and stressed the need to study works from the Eastern Chin (317–420) and T'ang (618–-907) dynasties.[5] He advocated not close copying of the superficial stylistic traits of these models, but probing analysis of what was most essential in their styles. Practical application of his theory can be seen in his synthesis of the powerful, blocky standard script of Yen Chench'ing (709–785) and the wild-cursive characters of Huaisu (ca. 735–ca. 799) in one of Tung's colophons to Wang Hsi-chih's *Ritual to Pray for Good Harvest* (cat. no. 2).

A final generation of Ming calligraphers, several of whom lived to see the dynasty fall to the Manchus in 1644, explored idiosyncratic styles that seem far removed from the classical models revered by Tung Ch'i-ch'ang. Contemporary critics, as well as several of the calligraphers themselves, used the term *ch'i,* translatable as "unusual" or "strange," to describe innovations in calligraphy that depart radically from long-accepted norms of composition and brushwork.[6] Wang To (1592–1652; cat. no. 33), who claimed that his style, though "strange," was based on classical masters, dedicated much of his career as a calligrapher to copying works by Wang Hsi-chih, but his re-creation of these models completely reconfigured them. Another calligrapher, Fu Shan (1607–1684/85; cat. no. 35), who lived through the fall of the Ming and refused to serve in government under the Manchus, produced highly individualistic calligraphy using archaic characters and oddly shaped forms that distort classical models. Calligraphy at the close of the Ming dynasty is characterized by experimental styles and great individual freedom of artistic expression.

R.E.H.

NOTES

1. For a general history of the Ming dynasty, see *The Cambridge History of China*, vol. 7, *The Ming Dynasty, 1368–1644*, Part 1, ed. Frederick W. Mote and Denis Twitchett (Cambridge: Cambridge University Press, 1988).
2. On the use of art as propaganda, see Wang Cheng-hua, "Ch'uant'ung Chung-kuo hui-hua yü cheng-chih ch'üan-li—I-ko yen-chiu chiao-tu te ssu-k'ao," *Hsin-shih hsüeh* 8, no. 3 (1997): 161–216. On the related subject of imperially sponsored court painting, see Richard Barnhart et al., *Painters of the Great Ming: The Imperial Court and the Zhe School* (Dallas: The Dallas Museum of Art, 1993).
3. Cheng Kuang-jung "T'ai-ko t'i ho Kuan-ko t'i," *Wen-wu,* no. 4 (1979): 79–80.
4. See Chuan-hsing Ho's essay in this volume.
5. See Xu Bangda, "Tung Ch'i-ch'ang's Calligraphy" in Wai-kam Ho, ed., *The Century of Tung Ch'i-ch'ang, 1555–1636* (Kansas City, Mo.: Nelson-Atkins Museum of Art, 1992), 1: 105–32.
6. See the essay by Dora C. Y. Ching in this volume.

18
Sung K'o (1327–1387)

Transcription of Sun Kuo-t'ing's

"Manual on Calligraphy"

Undated, ca. 1370
Album of fourteen leaves, ink on yellow-tinted paper
Each leaf, 20.3 x 12.4 cm
1998-124

FRONTISPIECE:
Hsü Teng (fl. ca. 16th century)

COLOPHON (front):
Pai Chien (fl. early 20th century), with T'ao Chu-sheng,
 Hsüeh Hsüeh-ch'in, P'eng Wei-tzu, Hsü An, Chiang Tsu-i,
 and P'an Hou (1904–1943), colophon dated 1935

COLOPHONS (back):
Sun K'o-hung (1553–1611), dated 1567
Hsi? (unknown), dated *t'ing-ssu*
Yeh Kung-ch'o (1880–ca. 1968), undated
T'an Tse-k'ai (fl. ca. late 19th–early 20th century), dated 1929
T'an Yen-k'ai (1876–1930), dated 1930
Ching-fu (unknown), dated 1972 (unmounted sheet)

Sung K'o, a native of Ch'ang-chou, Kiangsu, was the leading calligrapher of the late Yüan and early Ming. Following Chao Meng-fu's (1254–1322; cat. nos. 11, 12) example, he studied to combine and harmonize different historical scripts: standard, running, and draft-cursive. His most famous work, *Model Essay on Draft Cursive* (*Chi-chiu chang*), dated 1370, in the Palace Museum, Peking, is based on a work of the same title attributed to the third-century calligrapher Huang Hsiang (fl. ca. 220–279).[1] *Transcription of Sun Kuo-t'ing's "Manual on Calligraphy,"* an album of fourteen leaves dating from around 1370, is a partial transcription of the text of the famous *Manual on Calligraphy* (*Shu-p'u*) by the early T'ang calligrapher and critic Sun Kuo-t'ing (648?–703?), now in the National Palace Museum, Taipei. Dated 687, Sun Kuo-t'ing's work summarizes aesthetic ideals and theories of calligraphy from the late Han through the early T'ang and explores, in particular, the relationship between standard and cursive scripts.[2] Although Sung K'o in his transcription does not copy Sun's calligraphic style, he graphically demonstrates this dynamic relationship, combining and harmonizing the features and techniques of both script types.

Sung's colophon at the end of the album addresses the circumstances of the album's creation and identifies the recipient, his friend Yü Meng-ching:

> Yü Meng-ching (Chung-chi) and I, through our families and our shared interests in literature and calligraphy, have long been good friends. Both he and his father, as keen followers of Chung [Yu] and [Wang Hsi-chih], learned to wield the writing brush with a suspended wrist, in a truly extraordinary fashion. His younger brother Chi-ming, who is barely twenty years old, has repeatedly requested that I give him an example of my calligraphy. So I started the *Manual on Calligraphy*, but before I could finish it, young Master Yü, on the eve of his departure on a long journey of several thousand *li*, came to my door to say good-bye. And thus I presented this album to him.

The Elliott Collection work compares closely with Sung K'o's transcription of Chang Huai-kuan's "Discussing Ten Methods in Brushwork," which may also be dated to around 1370.[3]

Eds.

PUBLISHED

Ch'i Kung, "Sun Kuo-t'ing *Shu-p'u k'ao*," in *Ch'i Kung ts'ung-kao* (Peking: Chung-hua shu-chü, 1981), 79.

NOTES

1. For a reproduction of Huang Hsiang's *Model Essay on Draft Cursive*, see fig. 50 of Wen C. Fong's introductory essay in this volume.
2. On Sun Kuo-t'ing's *Manual on Calligraphy*, see Ch'ung-ho Chang and Hans H. Frankel, trans., *Two Chinese Treatises on Calligraphy* (New Haven and London: Yale University Press, 1995).
3. Published in *Chung-kuo ku-tai shu-hua ching-p'in-lu* (Peking: Wen-wu ch'u-pan-she, 1984).

世百論池之志觀夫懸針垂露之異奔

墜石之奇鴻飛獸駭之資鸞舞蛇驚之態

絕岸頹峰之勢臨危據槁之形或重若崩雲

或輕如蟬翼導之則泉注頓之則山安纖

猶眾星之初月之出兵崖落乎猶眾星之

可河溢同自然之妙有非力運之能成信

可謂智巧兼優心手雙暢翰不虛動下必

有由一畫之間變起伏於鋒杪一點之內殊衄

19
Shen Ts'an (1379–1453) and Shen Tu (1357–1434)

Collected Poems

Undated
Handscroll, ink on paper
Shen Ts'an, 28.0 x 152.4 cm;
Shen Tu, 25.9 x 86.1 cm
1998-57

COLOPHON:
Chang Chao (1691–1745), dated 1738

This handscroll consists of two sections by the brothers Shen Tu and Shen Ts'an, who were known for their calligraphy as well as their prose and poetry in the early Ming period. In this scroll Shen Tu transcribed poems by the Southern Sung philosopher Chu Hsi (1130–1200), whereas Shen Ts'an transcribed his own poems written on his return from Peking to his home in Sung-chiang in 1426. The section by the elder brother, Shen Tu, is now mounted after Shen Ts'an's work, but they did not collaborate on

this handscroll. The heights of the papers of the two sections are different, and the contents are not related. A collector who acquired the works most likely remounted them as one handscroll because of the comparable fame of the brothers.

The Shen family developed a distinctive calligraphic manner known as the Chancellery (*T'ai-ko t'i*) or Academy (*Kuan-ko t'i*) style, a form of small standard script used in writing official documents at the early Ming court. Upon recommendation, Shen Tu entered the Hanlin Academy shortly after the Yung-lo emperor (r. 1403–24) was enthroned in 1402, when the court was looking for qualified calligraphers. Among the writing of the many calligraphers at court, his was most admired by the emperor, and official copies of many important rescripts and documents of this period were in his hand. Soon his brother Shen Ts'an and his son Shen Tsao (fl. ca. late 15th century) joined him in Peking. The Shen family style also was favored by later Ming emperors and widely used by calligraphers of the Hanlin Academy.

The Shen brothers received many favors from the Yung-lo emperor and accompanied him on his trips between Peking and Nanking on several occasions. In 1426 Shen Ts'an was permitted to return home for tomb-sweeping.

As he traveled by boat on the Grand Canal from Peking to Sung-chiang, he composed poems at eight different places along the journey. In these poems, later transcribed in the Elliott scroll, Shen Ts'an writes of his career serving the emperor but laments getting old and staying apart from his family for so many years.

The Shen family's small standard script was derived from that of Sung K'o (1327–1387; cat. no. 18), a native of Soochow, who was active mainly in the Shens' hometown of Sung-chiang. However, the Shens transformed Sung K'o's rich variety of compositions and powerful brushstrokes into more balanced, standardized forms. This transformation probably reflects the Shens' adaptation of Sung K'o's style for the transcription of official documents, which demanded clarity and easy legibility.

Shen Tu's transcription of Chu Hsi's poems in this scroll shows the calligrapher working in an informal context that allowed him great stylistic freedom. The transcription includes three different scripts: small standard, draft-cursive, and cursive. Draft-cursive script was developed in the third century as an abbreviated form of clerical script for rapid writing. It retains the squat compositions and the flaring strokes of clerical script mixed with other swiftly written strokes. This is one of the early scripts revived by Chao Meng-fu (1254–1322; cat. nos. 11, 12) during the fourteenth century as part of his efforts at a "revival of the ancients" (fu-ku).[1] Under his influence, combining modern and ancient scripts in one piece of work or adding archaic strokes in modern script became widely popular in the late Yüan and early Ming periods. The alternation of three different scripts in Shen Tu's work and the flaring stroke ends in Shen Ts'an's cursive script in Collected Poems are products of this new aesthetic.

H.L.

PUBLISHED

Shen C. Y. Fu, Traces of the Brush: Studies in Chinese Calligraphy (New Haven: Yale University Art Gallery, 1977), 174; Frederick W. Mote and Hung-lam Chu et al., Calligraphy and the East Asian Book, special catalogue issue of Gest Library Journal 2, no. 2 (Spring 1988): 118, 120 (illus.), 121–22, 132 n. 13–16; Nakata Yūjirō and Fu Shen, eds. Ōbei shūzō Chūgoku hōsho meisekishū (Tokyo: Chūōkōron-sha, 1982), 4: 62–67.

NOTE

1. For an insightful discussion of the concept of fu-ku, see F. W. Mote, "The Arts and the 'Theorizing Mode' of the Civilization," in Christian F. Murck, ed., Artists and Traditions: Uses of the Past in Chinese Culture (Princeton: The Art Museum, Princeton University, 1976), 3–8.

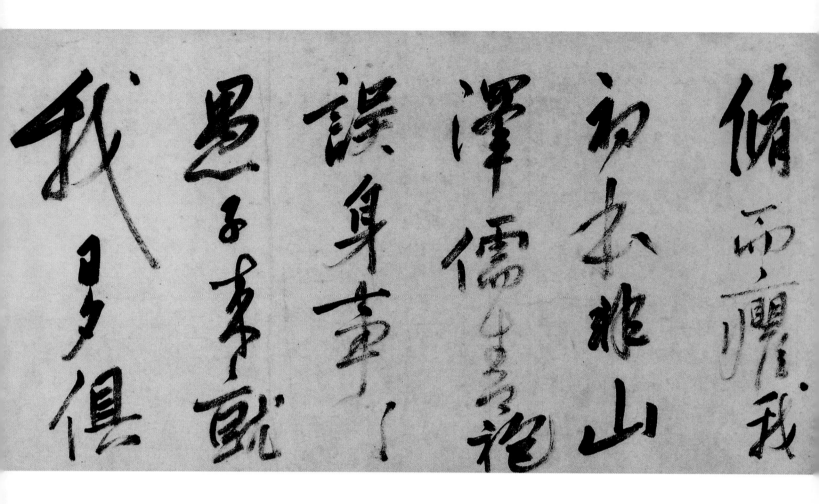

20
Yao Shou (1423–1495)

Poems about Banana Plants

Dated 1489
Handscroll, ink on paper
30.5 x 781.8 cm
1998-59

COLOPHONS:
Yeh Kung-ch'o (1880–ca. 1968), undated
Yeh Shih-ch'ing (ca. 1870–after 1922), dated 1920

Scrolls of poetry composed by members of China's literati elite often documented social events attended by poet-calligraphers and the recipients of their works. This exuberantly written prose poem by Yao Shou,[1] a painter, calligrapher, and collector, commemorates a visit from an unnamed friend who called on Yao at his home in Chia-hsing, Chekiang, in 1489. The text weaves together literary allusions and references to the visitor's own home, which,

Yao Shou states, was located on a mountainside and faced a grove of banana plants, common then as now in south China. The text also alludes to the T'ang dynasty callig-rapher Huai-su (ca. 735–ca. 799), who wrote on banana leaves, and to the T'ang poet-painter Wang Wei (700–761), who was said to have made a painting of a banana plant covered in snow. Other levels of meaning, which Yao Shou's original readers could have been expected to grasp, tie the imagery of the poems to the Taoist master and artist Chang Yü (1283–1350), whom Yao Shou deeply admired.[2] One year before writing the poems, Yao Shou had seen and inscribed Chang Yü's painting *Banana Pond and Piled Snow*, which depicted a banana plant and a white stone.

Just as a reader familiar with Chinese would detect allusions to earlier art and literature, as well as subtle auto-biographical references, in Yao Shou's poems, so too would

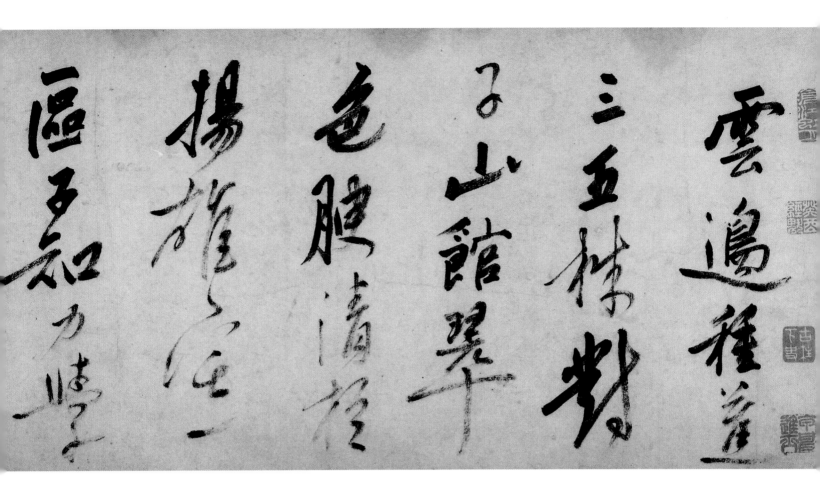

a viewer immersed in the history of calligraphy recognize visual echoes of earlier calligraphers in the large, running-script characters. Rounded strokes produced with the centered-tip brush technique, as well as exaggerated diagonal strokes, strongly resemble motifs in the calligraphy of Huang T'ing-chien (1045–1105; cat. no. 6), whom both Yao Shou and his idol Chang Yü had studied. Yao Shou's study of Huang T'ing-chien heralded an important reorientation in calligraphy of the Ming dynasty, as artists such as Shen Chou (1427–1509) and Wu K'uan (1436–1504; cat. no. 23) turned away from the powerful influence of Chao Meng-fu (1254–1322; cat. nos. 11, 12) to base their styles on those of Northern Sung masters.

R.E.H.

PUBLISHED

Jon Rawlings Bourassa, "The Life and Work of the Literati Painter Yao Shou" (Ph.D. diss., Washington University, 1978); Tseng Yu-ho Ecke, *Chinese Calligraphy* (Philadelphia: Philadelphia Museum of Art, 1971), no. 38; Shen C. Y. Fu et al., *Traces of the Brush: Studies in Chinese Calligraphy* (New Haven: Yale University Art Gallery, 1977), 131, 154, 261, cat. no. 28; Nakata Yūjirō and Fu Shen, eds. *Ōbei shūzō Chūgoku hōsho meisekishū* (Tokyo: Chūōkōron-sha, 1981–83), 4: 165, pls. 75–82; Tseng Yuho, *A History of Chinese Calligraphy* (Hong Kong: Chinese University Press, 1993), 314, fig. 9.38.

NOTES

1. For Yao Shou's biography, see Bourassa, "The Life and Work of the Literati Painter Yao Shou"; and L. Carrington Goodrich and Chaoying Fang, eds., *Dictionary of Ming Biography, 1368–1644* (New York: Columbia University Press, 1976), 1560–61.
2. See Chang Kuang-pin, "An Investigation into the Dates of Chang Yü, Wai-shih of Kou-ch'ü," parts 1 and 2, *National Palace Museum Bulletin* 10, no. 5 (1975): 1–13; and no. 6 (1976): 1–16.

21
Chang Pi (1425–1487)

Poem by Wang Wei

Undated
Hanging scroll, ink on paper
155.4 x 61.5 cm
1998-115

TRANSLATION:
The red-turbaned guardkeeper of sacrificial chickens announces
 the night watch;
Just then the chief steward of the imperial robes presents the
 verdant-cloud furs.
The nine-storied main gate opens onto the palace halls;
The myriad foreign dignitaries in full court dress pay homage
 to His Majesty.
Sunlight at this moment shines upon the immortal's-hand
 dew-basin;[1]
Fragrant incense wafts closely about the emperor's dragon robe.
The court audience over, you still must prepare the imperial
 proclamations on five-colored paper;
With jade pendants sounding, you return to the head of
 Phoenix Pond.[2]

Outspoken as an official, a poet, and a calligrapher, Chang Pi claimed his calligraphy was inferior to his poetry and that his large-size calligraphy was better than his small writing. As a calligrapher he excelled at running and cursive scripts, and injected a new freedom to the latter that was a forerunner to later Ming developments in cursive calligraphy.[3]

The poem transcribed in this scroll, "Poem in the Prosody of Drafter Chia's Composition on the Morning Audience at the Ta-ming Palace" (*Ho Chia she-jen tsao-ch'ao Ta-ming-kung chih tso*) was composed by the T'ang poet Wang Wei (700–761). In the T'ang dynasty, imperial officials lined up before dawn for the morning audience held in front of the Ta-ming Palace (*Ta-ming-kung*). At daybreak the emperor would arrive, wearing his dragon robe, and accept the bows of the gathered foreign and state officials. This poem describes the magnificent scene of hundreds of officials bowing to the emperor just as the morning sun shines through daybreak. At the end Wang Wei addresses the author of the model poem, a court drafter named Chia, whose duty was to help the emperor issue decrees after the morning session. Popular among later generations, this poem describing life at the T'ang court was repeatedly transcribed by calligraphers. Although Chang Pi did not specify the recipient, he most likely transcribed the poem for a friend serving at the Ming court. By choosing a poem

on the theme of court life, Chang Pi could gracefully compliment his friend for his success in office.

Chang Pi's scroll is written in wild-cursive script, the form of calligraphy for which he is most famous. In this script type not only are individual characters written in abbreviated forms, but the characters themselves are often joined by elongated linking strokes. The origin of wild-cursive script can be traced back to Chang Hsü (fl. ca 700–750) and Huai-su (ca. 735–ca. 799) of the T'ang dynasty. During the late fourteenth century, calligraphers in the region of Hua-t'ing, Sung-chiang Prefecture, near modern Shanghai, most notably Ch'en Pi (fl. ca. 14th century), revived this style.[4] A generation later Chang Pi continued in this regional tradition of cursive script. However, instead of the smooth fluency found in Ch'en Pi's calligraphy, Chang emphasized abrupt pauses, bold brushstrokes, and great contrast of wet and dry ink as seen in this hanging scroll. Because of these stylistic innovations, Chang's contemporaries described his calligraphy as "bizarre" and "obtrusive." Chang Chün (fl. ca. mid-15th century), another Hua-t'ing calligrapher, wrote in a similar style, and together they were called the Two Changs of wild-cursive script.[5] Chang Pi's own fame soon spread to Japan, where his works were collected as early as the sixteenth century.

H.L.

NOTES
1. An alternate interpretation of the "immortal's-hand dew-basin" is "mountains shaped like the immortal's hand."
2. Trans. by Liu I-wei. *Ch'üan T'ang shih* (Peking: Chung-hua shu-chü, 1960), 4: 1296. There are several different or variant characters in Chang Pi's transcription. While this poem describes a morning audience at court, it also alludes to immortal realms and the emperor's close relationship to heaven. For example, the "nine-storied main gate" (*chiu-t'ien Ch'ang-ho*) refers to the Ch'ang-ho main gate in the celestial palace, upon which the emperor's palace layout is supposedly modeled. The "immortal's hand" (*hsien chang*), a basin for catching the elixir of the morning dew, had precedents in a bronze example cast by Emperor Wu (r. 140–87 B.C.) of the Han dynasty.
3. For Chang Pi's biography, see L. Carrington Goodrich and Chaoying Fang, eds., *Dictionary of Ming Biography, 1368–1644* (New York: Columbia University Press, 1976), 98–99. On his calligraphy, see Ho Chuan-hsing, "Chang Pi chi ch'i *Tsa-shu chüan*," *Ku-kung wen-wu yüeh-k'an* 7, no. 6 (1989): 112–17.
4. For an example of Ch'en Pi's calligraphy, see *Lin Chang Hsü Ch'iu shen t'ieh*, in *Chung-kuo mei-shu ch'üan-chi: Shu-fa chuan-k'o pien* (Shanghai: Shang-hai ch'u-pan she,1989), 5: 3.
5. On Chang Chün, see Ho San-wei, *Yün-chien chih lüeh* (Taipei: Hsüeh-sheng shu-chü, 1987), 2: 565. For an example of his calligraphy, see *Tzu-shu ch'i-yen chüeh-chü shih*, in *Chung-kuo mei-shu ch'üan-chi: Shu-fa chuan-k'o pien*, 5: 30.

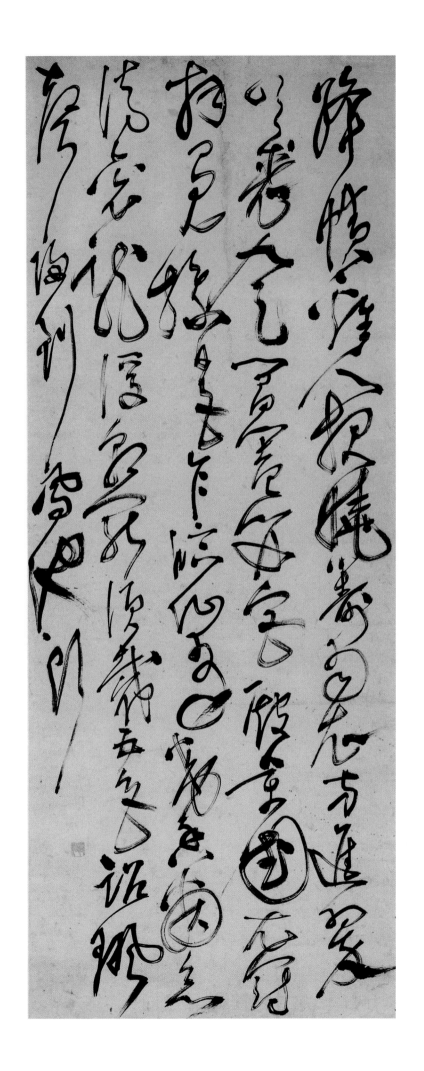

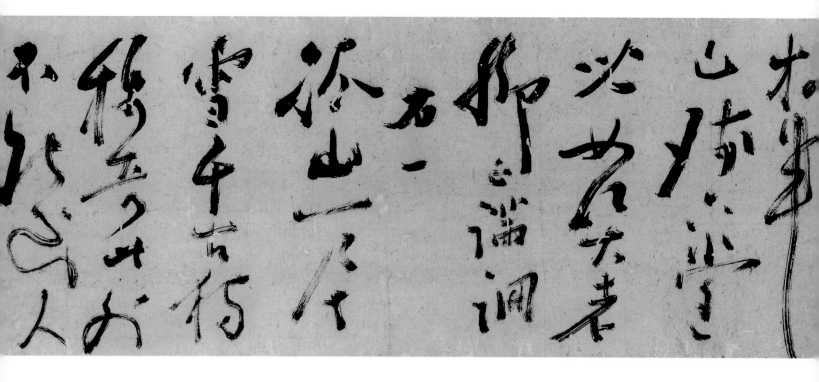

22

Ch'en Hsien-chang (1428–1500)

Writing about Plum Blossoms while Ill

(*Mei-hua ping-chung tso*)

Dated 1492
Handscroll, ink on paper
30.5 x 897.4 cm
1980-43

COLOPHONS:
T'ao Yün-ping?, Ming dynasty?
Pao Chen (19th century?), dated 1869?
Su T'ing-k'uei (ca. 1800–1871), dated 1871

Ch'en Hsien-chang was an important Neo-Confucian philosopher. A key concept of his teachings, which he claimed to have grasped only after years of arduous study and meditation, was the fundamental unity of mind and matter, summed up in the term "naturalness" (*tzu-jan*).[1] According to his students, this philosophical principle could be discerned in Ch'en's highly unusual calligraphy. Ch'en himself wrote, "The more awkward [my calligraphy], the more skillful it is; the stronger, the more able to be soft. When the forms are set, force races through them. Ideas are fully conceived and marvels overflow in them. [Calligraphy] rectifies my mind, harmonizes my feelings, and

tunes my nature. This is why I wander in [this] art."[2] Ch'en produced the rugged, awkward strokes of this scroll of poems with a homemade brush fashioned from miscanthus rush. Unlike normal brushes made from the hair of goats, weasels, mice, and other animals, this implement did not leave evenly inked strokes on the paper, and Ch'en Hsien-chang seems to have exploited its tendency to produce rough, fuzzy shapes.

Although the practice of calligraphy has been credited with therapeutic powers, calligraphers frequently call attention to their ill health. In the first of his ten poems, Ch'en contrasts his good health of the year before with his current weakened condition:

Last year, boasting of my health,
I searched for plum blossoms in the mountains.
Emptying wine cups by the cliff until shadows darkened,
Clothes damped with fragrant dew, I returned home.
What direction does the Northern Dipper now point?
Southern branches have lost half their blossoms.
As I come downstairs, my sons and daughters laugh
While I limp along on my old, weak feet.[3]

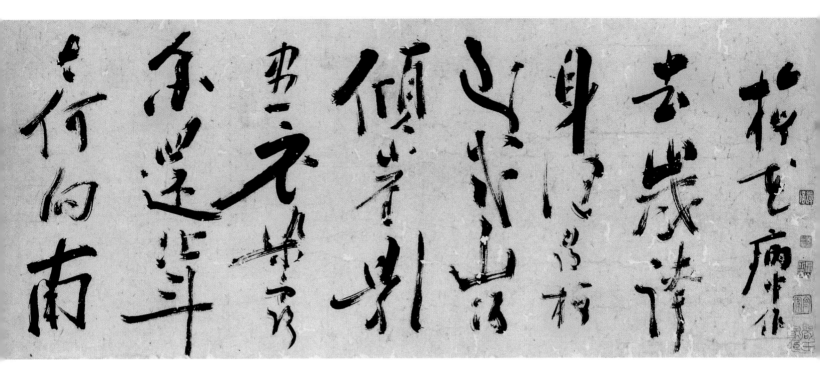

Letters that Ch'en wrote to friends around the time he composed *Writing about Plum Blossoms while Ill* refer to his many ailments, including heat stroke and digestive trouble, as well as injuries suffered in a fall. In these letters Ch'en also reveals that in spite of his philosophy of naturalness, he sometimes tired of responding to the ceaseless requests for samples of his calligraphy with which he was bombarded.[4]

<div align="right">R.E.H.</div>

Published

Maggie Bickford et al., *Bones of Jade, Soul of Ice: The Flowering Plum in Chinese Art* (New Haven: Yale University Art Gallery, 1985), 91, 92, 258, cat. no. 18; Wen C. Fong et al., *Images of the Mind: Selections from the Edward L. Elliott Family and John B. Elliott Collections of Chinese Calligraphy and Painting at The Art Museum, Princeton University* (Princeton: The Art Museum, Princeton University, 1984), 309–18, cat. no. 16; Shen C. Y. Fu et al., *Traces of the Brush: Studies in Chinese Calligraphy* (New Haven: Yale University Art Gallery, 1977), 262, cat. no. 20; Nakata Yūjirō and Fu Shen, eds. *Ōbei shūzō Chūgoku hōsho meisekishū* (Tokyo: Chūōkōron-sha, 1981–83), 4: 165–66, pls. 83–92; *Record of The Art Museum, Princeton University* 40, no. 1 (1981): 17; *Selections from The Art Museum, Princeton University* (Princeton: The Art Museum, Princeton University, 1986), 215.

Notes

1. See Huang Tsung-hsi, *Ming ju hsüeh-an*, 2 vols. (Peking: Chung-hua shu-chü, 1985), 78–92; and Jen Yu-wen, "Ch'en Hsien-chang's 'Philosophy of the Natural,'" in William Theodore de Bary et al., *Self and Society in Ming Thought* (New York: Columbia University Press, 1970), 53–92. For a concise biography of Ch'en Hsien-chang, see L. Carrington Goodrich and Chaoying Fang, eds., *Dictionary of Ming Biography, 1368–1644* (New York: Columbia University Press, 1976), 153–56.

2. "Shu-fa," in *Ch'en Hsien-chang chi*, punctuated and annotated by Sun T'ung-hai (Peking: Chung-hua shu-chü, 1987), 1: 80; for an alternate and partial translation, see Fu et al., *Traces of the Brush*, 95.

3. Based on a translation by Ch'en Pao-chen, in Fong et al., *Images of the Mind*, 309. The Chinese text is transcribed in Nakata and Fu, *Ōbei shūzō Chūgoku hōsho meisekishū*, 4: 165–66.

4. See Robert E. Harrist, Jr., "The Two Perfections: Reading Poetry and Calligraphy," in this volume.

23
Wu K'uan (1436–1504)
Essays on Calligraphy

Undated
Album of twelve leaves, ink on paper
Each leaf, 28.7 x 14.4 cm
1998-60

FRONTISPIECE:
Chang Feng-i (1527–1613), undated

COLOPHONS (front):
Ming Yüeh (*chin-shih* degree, 1835), dated 1846
Wang Tao-sen (fl. mid-19th century), dated 1852
Wen Fu (fl. mid-19th century), dated 1854

COLOPHONS (back):
Li Yao (fl. mid-19th century), undated
Shen Pei-lin (fl. mid-19th century), dated 1853
Hsü Nai-p'u (1787–1866), undated
Wu Ch'ing-kao (1786–1849), undated
Wu Ch'ing-peng (1786–1850s), undated

Born into a wealthy family of merchants in Soochow, Wu K'uan placed first in the *chin-shih* examinations of 1472 and had a distinguished career as a scholar-official at the Ming capital, Peking.[1] He returned to Soochow after retiring from official life and devoted much time to the practice of calligraphy. His study of the work of the Northern Sung literatus Su Shih (1037–1101) was part of a larger trend among calligraphers of the Soochow area who revived the styles of masters from the Northern Sung.

In this small album Wu K'uan transcribed excerpts from essays on calligraphy by several earlier writers, including Ou-yang Hsün (557–641), Han Fang-ming (fl. late 8th–early 9th century), Chang Ching-hsüan (fl. late 8th–early 9th century), and Wu Ch'iu-yen (1272–1311). In a passage from Ou-yang Hsün's essay on standard-script calligraphy, Wu K'uan illustrated the eight basic strokes used to write this script. The metaphoric descriptions of these strokes, which Wu K'uan wrote out beneath each one, were codified originally in *A Diagram of the Battle Formation of the Brush* (*Pi-chen t'u*), a text attributed to Madam Wei (272–349). According to these descriptions, a dot should create the

effect of "a stone falling from a high peak," whereas a vertical stroke should be like "a wisteria vine ten-thousand years old."[2]

A note appended to the album in 1853 by Shen Pei-lin states that this is a work from Wu K'uan's later years. Wu himself added a short dedicatory inscription stating that the album was written for a friend named Ho-shan, whose identity remains unknown.

R.E.H.

PUBLISHED

Suzuki Kei, comp., *Chūgoku kaiga sōgō zuroku,* vol. 1, *Amerika-Kanada hen* (Tokyo: University of Tokyo Press, 1982), pl. A17–100.

NOTES

1. For Wu K'uan's biography, see L. Carrington Goodrich and Chaoying Fang, eds., *Dictionary of Ming Biography, 1368–1644* (New York: Columbia University Press, 1976), 1487–89.
2. Richard M. Barnhart, "Wei Fu-jen's *Pi-chen T'u* and the Early Texts on Calligraphy," *Archives of the Chinese Art Society of America* 18 (1964): 13–25.

氣神靜慶端已正宏東筆悲生臨池志逸廬拳直脈搖

利劍截幽犀象之牙

勁弩倒折箭掛名庭

丶 一波常三過筆

乚 如萬鈞之發弩

丨 若千里之陣雲

丶 似長空之初月

丶 如高峰之隆石

⺍ 如萬歲之枯藤

震晚懸筆手腕著紙便字不活相

慶自好寫日月等字須更放小蓋印文中匾口并口字
及子字上口墨都須寬使口中見豈捐多字始混厚寫
篆把筆只須單鈎郤伸臂不夾觀方圓平直各有名字
盡集人各得師傳只好常把筆而以指多歙斜畫以不
能真且字勢不倚也若初學時當置慶手心伸中指令二指
于几上寫畫如此乃拘方寸孫筆此玩景高夘篆大字者

Leaves e and f

後凜之小牛神溫之沙嬌潤鼓以枯勁和以閒雅必能傍通
畫之情傍荒好絡之隆鋒鑄矗篆陶鈞草隸一點咸一
字之規一字的鈴篇之作遠而不犯卻而不同喬不常遠
不傾疾帶燥方潤將濃遂枯泯規矩于方圓遁鈎繩
于曲直

長洲吳寬為

鶴山賢友書

及搴向上欲石欠右一筆作章草狀石是捺抱字已開
口腳乃是以天美而字是戈遠直
作一筆不是點來審不不字及挑腳羨首一闕右注如
此無多墨拳其大築持此法可以親天下之蘭亭美五字
搨本者流流帶在天五字有搨也
作篆悠娜而遠隸如精則羨草貴流而暢章務檢而使然

Leaves k and l

24

Chu Yün-ming (1461–1527)

"Stele for the Filial Daughter Ts'ao O" and

"Prose Poem on the Nymph of the Lo River"

(Hsiao-nü Ts'ao O pei, Lo-shen fu)

Dated 1507
Album of thirteen leaves, ink on paper
Each leaf, 17.1 x 10.6 cm
1998-117

Chu Yün-ming excelled in both free, improvisatory cursive script (see cat. no. 25) and small standard script, the latter being used frequently for formal texts and stele inscriptions.[1] The two works copied by Chu in this album were models of small standard script by the two most famous calligraphers of early China: Wang Hsi-chih (303–361; cat. no. 2) and his son Wang Hsien-chih (344–388).[2] *Stele for the Filial Daughter Ts'ao O* was Wang Hsi-chih's transcription of the text of a stele erected in A.D. 152 to honor a young woman who drowned herself in grief after the death of her father. Chu copied only a segment of Wang Hsien-chih's transcription of the classic "Prose Poem on the Nymph of the Lo River" by Ts'ao Chih (192–232).[3]

These works were transmitted through ink-written versions and through collections of rubbings, including *Model Calligraphies from the Hall of Lingering Clouds (T'ing-yün-kuan t'ieh)*, an anthology compiled by Chu Yün-ming's friend Wen Cheng-ming (1470–1559; cat. no. 27) and other members of the Wen family. Although the rubbings ostensibly preserve the styles of the two fourth-century calligraphers, they betray the hands of copyists of the T'ang dynasty or later who introduced stylistic traits of their own periods. These include the regular alternation of thin horizontal and thick vertical strokes, squared "shoulders" of characters, and wedge-shaped points at the ends of strokes—all characteristic of seventh- and eighth-century calligraphy. As if to edit out these stylistic anachronisms, Chu Yün-ming reshaped the characters into squat, archaic forms and simplified the brushwork, substituting for the complex shapes derived from T'ang calligraphy blunt

curving strokes written with a single motion of the brush. These transformations evoke the style of Wang Hsi-chih's predecessor Chung Yu (151–230), whose work Chu Yün-ming and other calligraphers in Soochow studied intently in the late fifteenth and early sixteenth centuries.[4] Revising rather than simply copying his models, Chu rewrote, quite literally, part of the history of calligraphy in a display of skill and art-historical knowledge.

R.E.H.

PUBLISHED

Sotheby's, *Fine Chinese Paintings from the Yuzhai (Jade Studio) Collection*, Dec. 5, 1985, lot 1.

NOTES

1. For Chu Yün-ming's biography and discussions of his calligraphy, see Shen C. Y. Fu et al., *Traces of the Brush: Studies in Chinese Calligraphy*, (New Haven: Yale University Art Gallery, 1977), 203–36; L. Carrington Goodrich and Chaoying Fang, eds., *Dictionary of Ming Biography, 1368–1644* (New York: Columbia University Press, 1976), 392–97; and Ho Chuan-hsing, "Chu Yün-ming chi ch'i shu-fa i-shu," parts 1 and 2, *Ku-kung hsüeh-shu chi-k'an* 9, no. 4 (1992): 13–35; and 10, no. 1 (1992): 1–60.

2. For a discussion of Wang Hsi-chih, see Robert E. Harrist, Jr., "A Letter from Wang Hsi-chih and the Culture of Chinese Calligraphy," in this volume.

3. For the history of *Stele for the Filial Daughter Ts'ao O* and *Prose Poem on the Nymph of the Lo River*, see *Shodō zenshū*, n. s. (Tokyo: Heibonsha, 1960), 4: 157–58, 191–92.

4. See Fu et al., *Traces of the Brush*, 203–36; and Christian F. Murck, "Chu Yün-ming (1461–1527) and Cultural Commitment in Su-chou" (Ph.D. diss., Princeton University, 1978).

孝女曹娥碑

孝女曹娥者上虞曹旴之女也其先

與周同礼末曹荒流爰来適居旴能

撫節安歌婆娑樂神以漢安二年

五月時迎伍君逆濤而上為水所淹

不得其屍時娥年十四號慕思旴哀

吟澤畔旬有七日遂自投江死經五

日抱父屍出以漢安迄于元嘉元年

青龍在辛卯莫之有表度尚設祭之

誄之辭曰

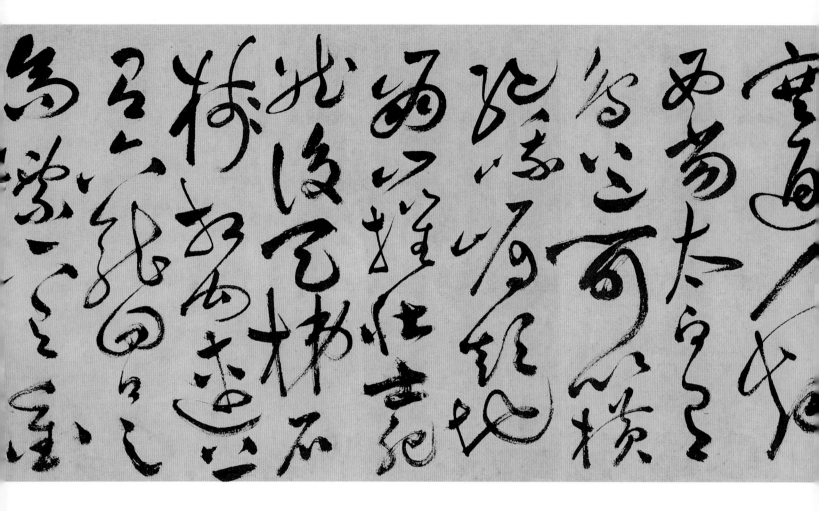

25
Chu Yün-ming (1461–1527)

"The Arduous Road to Shu" and "Song of the Immortal" (Shu tao nan, Huai hsien ko)

Undated
Handscroll, ink on paper
Calligraphy, 29.4 x 510.6; frontispiece, 29.3 x 92.5
Museum purchase, gift of the Mercer Trust for the
John B. Elliott Collection
1998-148

FRONTISPIECE:
P'u Ju (1896–1963)

Cursive script originated during the Ch'in and Han dynasties as a form of calligraphy in which the elements of characters could be abbreviated and written swiftly in continuous, linked strokes. This script, which fully exploited the potential of the animal-hair writing brush to create modulated lines and dots, became a vehicle for the development of expressive personal styles among calligraphers of later periods, including Wang Hsi-chih (303–361; cat. no. 2), who used cursive script in his letters. During the T'ang

dynasty a new form of cursive writing known as "wild cursive" developed among calligraphers such as Chang Hsü (fl. ca. 700–750) and Huai-su (ca. 735–ca. 799). Often written in the presence of an admiring audience during wine-induced states of exhilaration, wild cursive by these calligraphers displayed new abbreviations, extensive links between characters, and exaggerated forms that pushed calligraphy to the brink of illegibility. Huang T'ing-chien (1045–1105; cat. no. 6), holding his brush upright and keeping the tip at the center of each stroke, produced a new model of wild cursive influential among calligraphers of the Ming dynasty, including Chu Yün-ming.[1]

Although Chu Yün-ming was born into a prosperous Soochow family and received an excellent education, he failed the civil service examination seven times and held a low-level government position for only a few years. He devoted most of his life to literary and artistic pursuits and, along with his friend Wen Cheng-ming (1470–1559; cat. no. 27), is known as one of the great calligraphers of the Ming dynasty. During his lifetime, Chu was especially noted for his calligraphy in wild-cursive script. His friends attributed his affinity for this type of writing to his impetuous personality. According to Wang Ch'ung (1494–1533; cat. no. 29), "His nature and personality are bold and direct, and he has

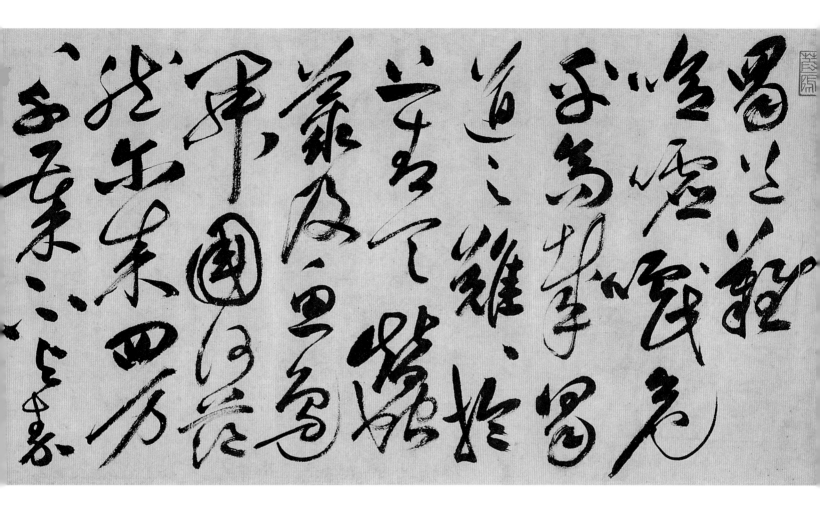

no patience for strictness and reserve. Therefore in his calligraphy he produced more wild-cursive and large scrolls."[2]

In this handscroll Chu Yün-ming transcribed two poems by the T'ang poet Li Po (701–762), whose reputation for eccentric behavior and heavy drinking recalls Chu's own. The first poem, "The Arduous Road to Shu," is a dramatic account of traveling among the precipitous mountains of Szechwan Province. In a passage describing the thrilling but dangerous scenery, Li writes,

> Peak upon peak less than a foot from the sky,
> Where withered pines hang inverted from sheer cliffs,
> Where cataracts and roaring currents make noisy clamor,
> Dashing upon rocks, a thunderclap from ten thousand glens.
> An impregnable place like this—
> I sigh and ask why should anyone come here from
> far away?[3]

The second, shorter poem transcribed by Chu, "Song of the Immortal," belongs to a poetic genre known as "roaming with immortals," in which the poet envisions journeys in search of supernatural beings.[4]

Chu Yün-ming's impetuous brushwork complements the extravagance of Li Po's poetic language. Swiftly written rounded strokes as well as sharper, more angular strokes written with the side of the brush fly across the surface

of the paper.[5] Ink dots, deployed in an endless variety of forms, recall stones cascading down a mountainside. Despite the improvisatory freedom of Chu's writing, individual characters retain their structural coherence, and the brushwork displays the tensile strength of all good calligraphy.

<div style="text-align: right">R.E.H.</div>

Notes

1. For an example of cursive script by Huang T'ing-chien, see his *Biographies of Lien P'o and Lin Hsiang-ju* (The Metropolitan Museum of Art), in Kwan S. Wong, *Masterpieces of Sung and Yüan Dynasty Calligraphy from the John M. Crawford Jr. Collection* (New York: China House Gallery, 1981).
2. Trans. based on Shen C. Y. Fu et al., *Traces of the Brush: Studies in Chinese Calligraphy* (New Haven: Yale University Art Gallery, 1977), 214. See also Ho Chuan-hsing, "Chu Yün-ming te ts'ao-shu," *Ku-kung wen-wu yüeh-k'an* 7, no. 11 (1990): 124–31.
3. Trans. Irving Y. Lo, in Wu-chi Liu and Irving Y. Lo, eds., *Sunflower Splendor* (New York: Anchor Books, 1975), 105.
4. Chu Yün-ming identifies the poem with the title "Small [Poem] on Roaming with Immortals." For the complete text, see Chü T'ui-yüan and Chu Chin-ch'eng, annotators, *Li Po chi chiao-chu* (Shanghai: Shang-hai ku-chi ch'u-pan she, 1980), 2: 576.
5. Fu Shen points out that this mixture of "tip" and "belly" brush movements is a hallmark of Chu Yün-ming's genuine works (Fu et al., *Traces of the Brush*, 218).

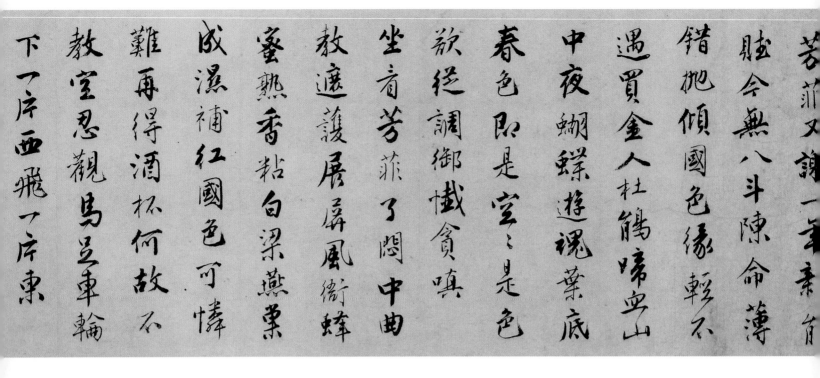

26

T'ang Yin (1470–1524)

Odes to Fallen Flowers (Lo-hua shih)

Undated, ca. 1505
Album leaves mounted as a handscroll, ink on paper
25.1 x 649.2 cm
1998-102

During the middle years of the Ming dynasty, owing to political corruption, many aspiring scholars were unable to secure government positions. Instead, they turned to the practice of art, shifting their sense of moral duty from government to culture. The prosperous city of Soochow became the center of this new literati culture and witnessed the growth of a vibrant scholarly and artistic community. Traditional lines between classes began to blur, however, as artistic activity rivaled examination success as a measure of achievement. T'ang Yin's life and art reflect this new social ambiguity.[1]

The son of a Soochow restaurant owner, T'ang Yin had high aspirations for an official career. From an early age, he was widely recognized by members of the scholarly elite for his precocious intelligence and artistic talent. His dreams were thwarted, however, when he was implicated in an examination scandal in 1499 and barred from advancing in a political career. He spent the rest of his relatively short life as a professional painter and calligrapher in Soochow. Considered one of the Four Masters of the Mid-Ming, T'ang Yin was part of a community of prominent

scholar-artists, including Chu Yün-ming (1461–1527; cat. nos. 24, 25), his closest friend; Shen Chou (1427–1509), his sponsor; and Wen Cheng-ming (1470–1559; cat. no. 27), his classmate and friend. Because he supported himself through the sale of his painting and calligraphy, T'ang Yin bridged the seemingly disparate worlds of the private scholar whose art was traditionally not for sale and that of the professional artist.

In 1504 Shen Chou composed a set of poems, "Odes to Fallen Flowers," after having been ill for a month and finding, upon his recovery, that all the flowers in his garden had withered. Four of his friends, including T'ang Yin, wrote their own sets of poems in response. The text of this handscroll is a selection of twenty-one of the thirty poems in T'ang's set.[2] His participation in this literary exchange demonstrates his intimate ties to the prominent scholar-artists of Soochow as well as to the literati tradition of artistic collaboration among a select group of friends. T'ang Yin's poems are meant not to stand alone but to be part of the set of "Fallen Flowers" poems by Shen Chou and his friends. Nonetheless, they are charged with personal meanings—T'ang uses the image of fallen flowers as a metaphor for his own failed political career, as in the melancholy fourth poem in this scroll:

> White clouds suspended over the distant horizon;
> In spring, sparrows flit through garden groves.
> Shimmering leaves of the peach tree—no one is looking to take a ferry;
> Cascading apricot blossoms—I am reminded of the time of the examinations.

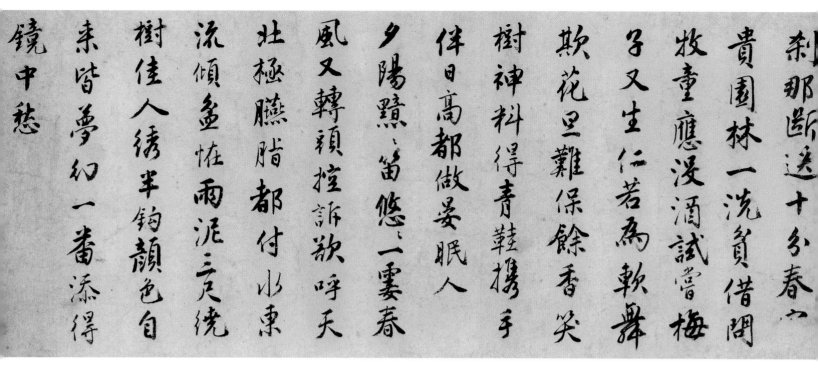

In the middle of the night, the moon is bright, and [I listen to] dogs barking in the village;

After the rain has passed, orioles sing, and leaves blanket the town.

The traveler has not yet returned, but another spring is passing;

With whom can I go arm in arm and sing a tune?

Tang Yin's calligraphy in *Odes to Fallen Flowers* displays his syncretic style. The plump brushwork and strong, square configuration of the characters derive from the style of the T'ang calligrapher Yen Chen-ch'ing (709–785). This is in keeping with other works of his from the first decade of the sixteenth century, in which he takes Yen as his primary model. Yet interspersed with this plump style are thin, tensile characters, at times alternating thick and thin one after the other. This produces a visual effect much like that seen in the works of the Southern Sung calligrapher Chang Chi-chih (1186–1266; cat. no. 10). Chang, known primarily for his sutra-style writing, was seldom chosen as a model in the Ming. While we cannot prove that T'ang Yin had Chang Chi-chih in mind, it is not unlikely, based on what we know of his painting of this period, in which he combined Northern and Southern Sung idioms, achieving a "fusion of formal means and expressive qualities that the critics had always regarded as confined to separate traditions."[3] T'ang Yin's flair for mixing contrasting elements extended to his calligraphy, as evidenced by *Odes to Fallen Flowers*.

E. A. H.

PUBLISHED

Chiang Chao-shen, *Kuan-yü T'ang Yin te yen-chiu* (Taipei: National Palace Museum, 1976), 98–99, pl. 33b; Wen C. Fong, et al., *Images of the Mind: Selections from the Edward L. Elliott Family and John B. Elliott Collections of Chinese Calligraphy and Painting at The Art Museum, Princeton University* (Princeton: The Art Museum, Princeton University, 1984), 331–36, pl. 20; Nakata Yūjirō and Fu Shen, eds. *Ōbei shūzō Chūgoku hōsho meisekishū* (Tokyo: Chūōkōron-sha, 1983), *Ming–Ching* 1: 169–71, color pl. 4, pls. 35–41; Yin Sun, ed., *Chung-kuo shu-fa-shih t'u-lu* (Shanghai: Shang-hai shu-hua ch'u-pan she, 1989), pl. 769.

NOTES

1. On T'ang Yin's life and art, see Chiang, *Kuan-yü T'ang Yin te yen-chiu*; Anne de Coursey Clapp, *The Painting of T'ang Yin* (Chicago and London: University of Chicago Press, 1991); and L. Carrington Goodrich and Chaoying Fang, eds., *Dictionary of Ming Biography, 1368–1644* (New York: Columbia University Press, 1976), 1256–59.

2. Three other versions of T'ang Yin's *Ode to Fallen Flowers* are in the following collections: Chinese Museum of Art, Peking (see *Shu-p'u*, [1989], vols. 4 and 5); Liaoning Provincial Museum, Shenyang (see *Liaoning sheng po-wu-kuan ts'ang fa-shu hsüan-chi*, set 2 [Peking: Wen-wu ch'u-pan she, 1982], vol. 13); and the Ling-yen Temple, Soochow (see *Shodō gurafu* 5 [1980]). There is no indication on the Elliott scroll for whom this version was made; it is signed only "Chin-ch'ang T'ang Yin kao" (written by T'ang Yin of Chin-ch'ang [Soochow]).

3. Clapp, *The Painting of T'ang Yin*, 228.

27
Wen Cheng-ming (1470–1559)

Poem on Lake T'ai-yeh

Undated
Hanging scroll, ink on paper
344.0 x 96.4 cm
1998-98

The poem transcribed in this enormous scroll was the second from a set of ten composed by Wen Cheng-ming in the spring of 1525, on the occasion of a visit he made with three friends to the imperial Western Garden (*Hsi-yüan*) in Peking, site of Lake T'ai-yeh.[1]

> The water's expanse, the vast pond merging with heaven;
> Ten *li* of lotus, a smooth embroidered cloud.
> I have heard that Yüeh-fu caused the yellow crane to sing
> And seen the Ch'iu-feng move a stone whale to swim.
> The curved jade rainbow descends across the blue sky;
> The silver mountains rise from the world through the mist.
> Following those places where the phoenix chariot passed,
> The wild geese wheel round the air, never startled.[2]

The poem evokes the magical aura of the lake, with its "ten *li* of lotus" and its surrounding forests, "curved jade rainbow," and "silver mountains rising from the world through the mist." This mysterious, watery landscape, introduced visually by the three-dot "water" radicals on the left of six of the first seven characters, is inhabited not by humans but by singing cranes, swimming whales, and circling wild geese—allusions to Taoist paradises long used in poetry on the theme of imperial palaces and gardens.[3] Wen Cheng-ming does not name the recipient of this scroll, though its enormous size and mythical imagery indicate that it may have been intended for a wealthy patron or possibly a temple.

Wen's principal model for his running-standard-script calligraphy, as well as for the literary style of this poem, was Huang T'ing-chien (1045–1105). Huang once used a metaphor from Taoist alchemy to explain his own use of stylistic allusions: "When I use a quotation from the past, it becomes the elixir that transforms iron into gold."[4] For Wen, this adaptation of Huang's mature style, seen in *Scroll for Chang Ta-t'ung* (cat. no. 6), asserted his position in a lineage of illustrious scholar-calligraphers. Huang's own interest in Taoism had been fostered by periods of political exile and inspired by archaeologically recovered calligraphic monuments: the elongated, oblique strokes of Huang's model, the mysterious *Eulogy on Burying a Crane* (*I-ho ming;* 512–514), are echoed in Wen's scroll. The ideology of the

scholar-official class was reflected in Huang's other main model, the upright official and martyr Yen Chen-ch'ing (709–785). Huang, and later Wen, quoted the squarely composed characters and full brushstrokes of Yen's writing as if to ally themselves with his moral rectitude and courage.[5]

It was, then, a personal emulation of these greatly admired qualities—resolution, defiance, directness—that Wen sought in his style. This is most obvious in the blunt, "inelegant" appearance of certain strokes, such as the first stroke of the "person" radical in the character *fu* (second line from right, second character from top). In the signature each character is uncompromisingly placed in an imaginary square and written with firm, fat brushstrokes. Wen Cheng-ming's bold writing, a taste for which he inherited from his teacher Shen Chou (1427–1509), contrasted starkly with the ornate styles practiced at the imperial court by career bureaucrats.

S. McC.

PUBLISHED

Tseng Yu-Ho Ecke, *Chinese Calligraphy* (Philadelphia: Philadelphia Museum of Art and Boston: Boston Book and Art Publishers, 1971), no. 49; Richard Edwards, *The Art of Wen Cheng-ming (1470–1559)* (Ann Arbor: University of Michigan Museum of Art, 1976), 95–96, no. xx; Suzuki Kei, comp., *Chūgoku kaiga sōgō zuroku*, vol. 1, *Amerika-Kanada hen* (Tokyo: University of Tokyo Press, 1982), pl. A17–095.

NOTES

1. Wen Cheng-ming, *Wen-shih wu-chia chi* (WYKSKCS edition, Taipei: T'ai-wan shang-wu yin-shu-kuan, 1983), *chüan* 6: 23b; see also Wen Cheng-ming, *Fu-t'ien chi* (Ming-tai i-shu-chia hui-k'an, facsimile reproduction of Chia-ching edition, Taipei: Kuo-li chung-yang t'u-shu-kuan, 1968), *chüan* 10: 5b–6a. For Wen Cheng-ming's biography, see L. Carrington Goodrich and Chaoying Fang, eds., *Dictionary of Ming Biography, 1368–1644* (New York: Columbia University Press, 1976), 1471–74.

2. This translation and the following notes are by Ling-yün Shih Liu. "Yüeh-fu" refers to songs collected by the Music Office (*Yüeh-fu*) during the Han dynasty. The yellow crane was a huge bird ridden by immortals. "Ch'iu feng" was a tune from the Wu dynasty (A.D. 222–80). The carved stone whale, thirty feet long, was located in K'un-ming, Yunnan.

3. Ecke, *Chinese Calligraphy*, no. 49.

4. Huang T'ing-chien, "Tsai tz'u-yüan Yang Ming-shu ssu-shou," in Jen Yüan et al., eds., *Shan-ku shih chi-chu* (Taipei: I-wen yin-shu-kuan, 1969), vol. 2, *chüan* 12: 710; see also Wen C. Fong, *Beyond Representation: Chinese Painting and Calligraphy, 8th–14th Century* (New York: The Metropolitan Museum of Art, 1992), 147.

5. For examples of Yen Chen-ch'ing's calligraphy, see *Shodō geijutsu* (Tokyo: Chūōkōron-sha, 1971), 4: 1–116.

泱漭滄池混太清芙蓉十里錦雲平曾聞

樂府歌黃鵠還見秋風動石鯨玉練蟬蜍

遠琚落銀山縹緲自寰瀛從知鳳輦經遊地

鳬雁回翔挼不驚

徵明

28

Wang Shou-jen
(Wang Yang-ming, 1472–1529)

Letters to Cheng Pang-jui

Undated, ca. 1523–25
Handscroll, ink on paper
Painting, 24.3 x 43.0 cm; calligraphy, 24.0 x 292.8 cm
Gift of Mrs. Edward L. Elliott
1979-95

COLOPHONS:

Huang Wan (fl. 1480–1554), undated
Hsiao Ching-te (fl. 16th century), undated
Huang Hung-kang (1492–1561), dated 1523
Yeh Liang-p'ei (*chin-shih* degree, 1523), undated

TRANSLATION (Letter 1):

When the Wang-kuei Mountain Temple was being restored, I donated a beam specifically on behalf of my maternal grandfather and my second eldest maternal uncle. I heard that the community therefore had my name written on the beam. Since the temple had been so significant to the history of our community, why did you not go earlier to state your problem to the provincial governor? Instead, you waited until the Hsiang family had already bought the temple and then spoke out. By that time our fellow villagers had lost the chance to act. I have never before written memorials to be sent to a provincial governor. If the villagers would be willing to collect money to redeem the temple from the Hsiang family, I do not think that the provincial governor would disagree. Your aunt [Wang Shou-jen's wife] is still sick. Her medicine is of no use. My thanks to my second eldest maternal aunt who cared about my wife so much that she sent a messenger to see us. Yang-ming [Wang Shou-jen] sends this letter to his nephew Pao-i [Cheng Pang-jui]. You may also let our fellow villagers know [the contents of the letter].[1]

Wang Shou-jen, more commonly known by his sobriquet Yang-ming, was a famous philosopher of the Ming dynasty. He rejected the orthodox theories of Neo-Confucianism established by Chu Hsi (1130–1200), which held that knowledge was obtained through empirical investigation of the phenomenal world. Wang asserted instead that knowledge was acquired through cultivation of the innate intelligence and purity of the human mind. Calligraphy, he believed, was a "mind print" or "reflection" of the soul.[2]

Wang Yang-ming once described his training and his approach to the art of calligraphy: "I began the study of calligraphy by freely copying classical models, but what I learned was merely superficial likeness. Later I learned to hold my brush and never wrote quickly until I had my thoughts concentrated, my worries pacified, and the classical models excluded from my mind. In this way, I gradually came to understand the principles of calligraphy."[3] Although he created his own style, Wang's calligraphy, particularly his running script, reflects his study of Wang Hsi-chih (303–361; cat. no. 2), Li Yung (678–747), and Huang T'ing-chien (1045–1105; cat. no. 6).

In the three letters mounted together in this handscroll, which opens with an anonymous portrait of Wang Yang-ming, his calligraphy is sharp and angular, and the characters are vertically elongated. The brushwork appears rapid and agitated. Wang's calligraphy may reflect anxieties expressed in the content of the letters, which were addressed to his nephew Cheng Pang-jui and can be dated to between 1523 and 1525. Wang writes of the burden of managing his family's affairs after the death of his father in 1522, the illness of his wife (who died in 1525), and his obligation to arrange the marriage of a niece.[4] Together, these letters in Wang's own hand provide a rare glimpse into the everyday life of the noted philosopher.

Eds.

PUBLISHED

Chiang I-han, "P'u-lin-ssu-tun ta-hsüeh mei-shu-kuan ts'ang Wang Yang-ming san-cha chüan," *Ming-pao yüeh-k'an* 10, no. 1 (Jan. 1975): 58–65; Wen C. Fong et al., *Images of the Mind: Selections from the Edward L. Elliott Family and John B. Elliott Collections of Chinese Calligraphy and Painting at The Art Museum, Princeton University* (Princeton: The Art Museum, Princeton University, 1984), 346–53, cat. no. 22; Nakata Yūjirō and Fu Shen, eds. *Ōbei shūzō Chūgoku hōsho meisekishū* (Tokyo: Chūōkōron-sha, 1981–83), Ming–Ching 1: no. 97; Suzuki Kei, comp., *Chūgoku kaiga sōgō zuroku*, vol. 1, *Amerika-Kanada hen* (Tokyo: University of Tokyo Press, 1982), pl. A16–051; Wang Nan-p'ing, ed., *Ming Ch'ing shu-hua hsüan-chi* (Hong Kong: Nan-hua yin-shua yu-hsien kung-ssu, 1975), 75.

NOTES

1. Trans. by Pao-chen Ch'en in Fong et al., *Images of the Mind*, 346.
2. For Wang Shou-jen's biography, see L. Carrington Goodrich and Chaoying Fang, eds., *Dictionary of Ming Biography, 1368–1644* (New York: Columbia University Press, 1976), 1409–16. On his philosophy, see William Theodore de Bary et al., *Self and Society in Ming Thought* (New York: Columbia University Press, 1970).
3. Ch'ien Te-hung et al., eds., *Wang Yang-ming ch'üan-chi* (1936; reprint, Shanghai: Shih-chieh shu-chü, 1959), 10–11. Trans. by Pao-chen Ch'en.
4. These letters are translated and discussed in greater detail in Pao-chen Ch'en's entry in Fong et al., *Images of the Mind*, 346–53, cat. no. 22.

二曾母坦羡兄悦、此后
况而作曆收之數社年
自可望情生理署客人智
傍些價誇形塊系平柘
六宋以不聰如幽大母病
如歷快業金不敬存
二窜母掛念遗人未竟
傍二場配字空窜一燃
权系　社中年人六一上
　　　霞仙

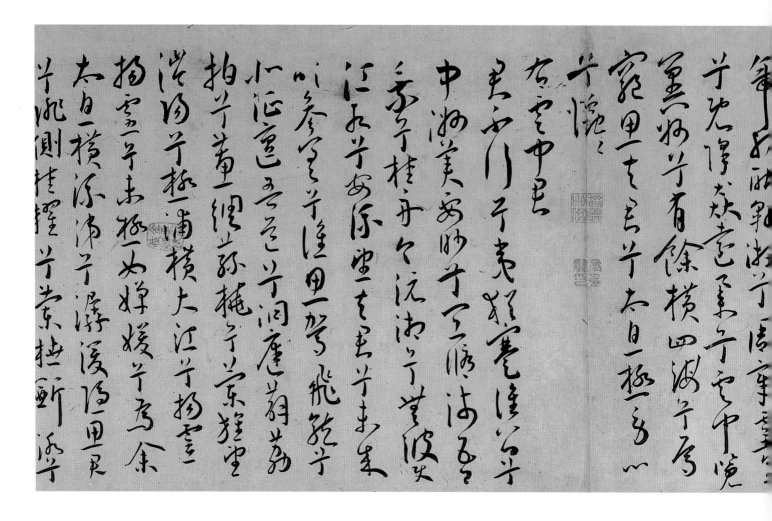

29

Wang Ch'ung (1494–1533)

The Nine Songs (Chiu ko)

Dated 1527
Handscroll, ink on paper
29.1 x 479.0 cm
1998-58

Colophons:

Ch'en Ch'un (1483–1544), undated
Chou T'ien-ch'iu (1514–1595), dated 1540
Meng Chou-kuang (fl. mid-16th century), dated 1550
Chin Yung (fl. mid-16th century), dated 1563
K'uei Kung (fl. mid-19th century), one colophon dated 1853,
 two colophons dated 1857, two undated colophons

Instructed in poetry and calligraphy by the illustrious Wen
Cheng-ming (1470–1559; cat. no. 27), Wang Ch'ung grew
up among the literati elite of Soochow during a golden age
of the city's history as a center of Chinese culture. In spite
of his excellent education, Wang Ch'ung suffered the igno-
miny of failing the civil service examinations eight times

between 1510 and 1531. He was widely esteemed, however,
as a poet and calligrapher and attracted many students
of his own.[1]

The text transcribed in Wang Ch'ung's scroll is "The
Nine Songs," part of a collection known as *The Songs of
Ch'u (Ch'u-tz'u)*, attributed to the tragic poet Ch'ü Yüan
(ca. 343–278 B.C.), who after failing to win recognition from
the lord of the state of Ch'u, drowned himself in the Mi-lo
River. The songs are in the form of shamanistic lyrics
that originated in south China during the late Bronze
Age. According to David Hawkes, "The Nine Songs" are
charged with a "strange mixture of voluptuousness, mag-
nificence, and melancholy." These qualities are apparent
in a passage from the first of the songs:

> The singing begins softly to a slow, solemn measure;
> Then, as pipes and zithers join in, the singing grows shriller.
> Now the priestesses come, splendid in their gorgeous apparel,
> And all the hall is filled with a penetrating fragrance.
> The five sounds mingle in a rich harmony:
> And the god is merry and takes his pleasure.[2]

Calligraphers transcribed "The Nine Songs" and other
sections of *The Songs of Ch'u* in a wide array of script styles.
When writing the text to accompany painted illustrations,

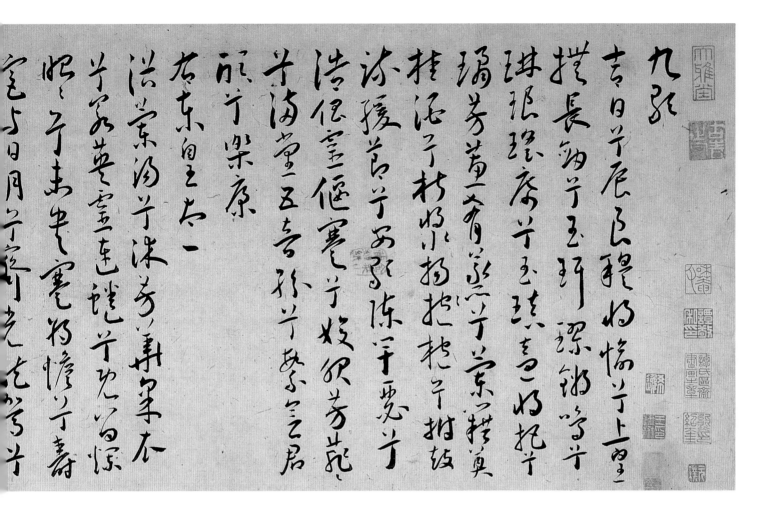

calligraphers frequently chose seal or clerical script, apparently with the intention of evoking through these archaic forms of writing the ancient world of myth and ritual in which the poems were first sung. In his handscroll, Wang Ch'ung uses cursive script punctuated with blunt horizontal strokes and tightly curved hooks that resemble strokes in draft cursive, an early form of cursive script. A special feature of the text of "The Nine Songs" is the recurring use of the particle *hsi,* which has no semantic meaning but serves as an incantatory rhythmic interjection in nearly every line of the text. Wang Ch'ung adds to the visual interest of his transcription by writing the character—two dots slanting inward above a horizontal stroke balanced above a vertical—in a slightly different way each time it appears.

Calligraphic transcriptions of literary classics raise difficult issues of artistic intention. Pressured by requests for samples of their writing, the production of which could bring social, political, or economic rewards, harried calligraphers could display their skill by transcribing familiar poems or essays without worrying about the literary content of these works. In his inscription at the end of the scroll, Wang Ch'ung says nothing about the circumstances under which he did the calligraphy or the intended recipient of the scroll, limiting his remarks to a fairly conventional summary of ideas about Ch'ü Yüan and the origins of "The Nine Songs." A colophon by his close friend Ch'en Ch'un hints, however, that artists who illustrated or transcribed these ancient poems did so to express their own feelings through the imagery of the poems. According to a recent interpretation offered by Chuan-hsing Ho, Wang Ch'ung may well have identified himself and his repeated examination failures with the frustrated and ill-fated poet Ch'ü Yüan.[3]

R.E.H.

PUBLISHED

Suzuki Kei, comp., *Chūgoku kaiga sōgō zuroku,* vol. 1, *Amerika-Kanada hen* (Tokyo: University of Tokyo Press, 1982), pl. A17–098.

NOTES

1. For Wang Ch'ung's biography, see L. Carrington Goodrich and Chaoying Fang, eds., *Dictionary of Ming Biography, 1368–1644* (New York: Columbia University Press, 1976), 1368–69.
2. *Ch'u Tz'u: The Songs of the South,* trans. David Hawkes (New York: Oxford University Press, 1959), 36.
3. See the essay by Chuan-hsing Ho in this volume.

30

Wang Ku-hsiang (1501–1568)

The Thousand Character Essay (Ch'ien-tzu wen)

Dated 1541
Handscroll, ink on paper
23.5 x 329.0 cm
1998-110

FRONTISPIECE:
Hsü Chu (fl. mid-16th century), undated

COLOPHON (front):
Wu Jung-kuang (1773–1843), dated 1811

COLOPHONS (back):
Chou T'ien-ch'iu (1514–1595), dated 1547
Ku Yün-lung (fl. mid-16th century), dated 1547
Wen P'eng (1498–1573), undated
Wen Chia (1501–1583), dated 1547
Wen Po-jen (1502–1575), dated 1547
Yung Hsing (1723–1823), dated 1822
Ch'eng En-tse (fl. mid-19th century), dated 1836
K'ung Kuang-t'ao (fl. mid-19th century), dated 1859

For nearly 1,500 years "The Thousand Character Essay" has served as a reading primer and as a calligraphy exercise in China.[1] The text, which consists of exactly one thousand characters, each used only once, originated in the sixth century during the reign of Emperor Wu (r. 502–50) of the Liang dynasty. The emperor ordered the court official Chou Hsing-ssu (d. 520) to select the characters from samples of calligraphy by Wang Hsi-chih (303–361; cat. no. 2) in the imperial collection. Chou is said to have accomplished this feat of literary cleverness in a single night, though the effort turned his hair white.

The essay consists of useful knowledge and moral exhortations arranged in rhymed four-character phrases. From the sixth century onward, children were taught to recite the text by heart. The text was so familiar to well-educated Chinese that the sequence of characters was used to mark the order of books in libraries, objects in art collections, and even stalls used in government examinations.

Because the essay contains one thousand different characters, it is an ideal text for transcription by students struggling to master the intricacies of brushwork and composition in Chinese calligraphy. But mature calligraphers also frequently wrote out the text, both to maintain their skills and to display their command of different script types. A tradition of transcribing the essay in multiple script types began with the monk Chih-yung (fl. late 6th–early 7th century), a descendant of Wang Hsi-chih, who wrote hundreds of copies in both standard and cursive script. In the Yüan dynasty, calligraphers such as Chao Meng-fu (1254–1322; cat. nos. 11, 12) copied the essay in combinations of standard, running, seal, and cursive script.

During the fifteenth and sixteenth centuries, calligraphers living in Soochow and its environs produced countless copies of "The Thousand Character Essay."[2] A native of Soochow, Wang Ku-hsiang studied literature and calligraphy with both Chu Yün-ming (1461–1527; cat. nos. 24, 25) and Wen Cheng-ming (1470–1559; cat. no. 27). In this transcription of the essay, Wang uses a fluid style of running script that closely resembles the calligraphy of Wen Cheng-ming. The sharply pointed beginnings and endings of strokes reveal Wang's adaptation of Wen's "exposed-tip" brush technique, and the calligraphy of both men derives ultimately from the style of Wang Hsi-chih. Several of the colophons appended to Wang Ku-hsiang's scroll are from the hands of other followers of Wen Cheng-ming or members of the Wen family. Collectively, these colophons reflect the bonds of friendship and family ties that structured literati life in Soochow during the sixteenth century.

R.E.H.

NOTES

1. For studies of "The Thousand Character Essay," see Pai Hung, "T'ang-tai te shu-fa chiao-yü," *Shu-fa yen-chiu* 67, no. 5 (1995): 67–92, esp. 80–92; Paul Pelliot, "Les Ts'ien Tseu Wen ou 'Livre des Milles Mots,'" *T'oung Pao* 24 (1926): 179–214; and She Ch'eng, "Ch'ien-tzu wen: Ku-tai te tzu-t'ieh ho chiao-k'o shu," parts 1 and 2, *Ku-kung wen-wu yüeh-k'an* 1, no. 9 (Dec. 1983): 57–61; and 1, no. 10 (Jan. 1984): 91–95.

2. Among the Soochow calligraphers who made copies of the classic were Chu Yün-ming, Wen Cheng-ming, Ch'en Ch'un, Wang Ch'ung, and Wen P'eng (1498–1573). See the essay by Chuan-hsing Ho in this volume.

千字文

天地玄黃宇宙洪荒日月
盈昃辰宿列張寒來暑
往秋收冬藏閏餘成歲律
呂調陽雲騰致雨露結為
霜金生麗水玉出崑岡劍
號巨闕珠稱夜光果珍
李柰菜重芥薑海鹹河
淡鱗潛羽翔龍師火帝
鳥官人皇始制文字乃服
衣裳推位讓國有虞陶
唐弔民伐罪周發殷湯
坐朝問道垂拱平章愛
首黎

31
Yang Chi-sheng (1516–1555)

Poem by Chao Yen-chao

Undated
Hanging scroll, ink on paper
164.3 x 45.7 cm
1998-66

TRANSLATION:
Six dragons pull the sun's chariot in the morning light;
A pair of fabulous seabirds draw the boat into the green water.
One can look up at the lofty tower rising beyond the clouds;
One can look out at the floating bridge hovering over the sea.[1]

Yang Chi-sheng is remembered today for his short but dramatic political career. An ambitious and loyal official, he was on his way to a promising career after receiving his *chin-shih* degree and a government appointment in 1547. However, he spent most of the following eight years in exile or prison after vehemently denouncing corruption, misuse of office, and unwise policies. In 1555, at the age of thirty-nine, he was publicly executed at a market in Peking.[2]

Although primarily a statesman, Yang was also known for his paintings of bamboo and landscape, as well as for his calligraphy, of which this scroll is a rare example. The lines transcribed here are extracted from "Poem in the Prosody of 'On the Imperial Tour of the Princess An-lo's Mountain Villa' Respectfully Composed in Response to Imperial Order" (*Feng ho hsing An-lo kung-chu shan-chuang ying chih shih*) by the T'ang poet Chao Yen-chao (fl. ca. 8th century), which describes Emperor Chung-tsung's (656–710, r. 705–10) visit.[3] The poem belongs to a genre of T'ang poetry composed at the behest of the emperor on special occasions such as festivals at the palace or imperial visits to Buddhist or Taoist temples. Filled with supernatural imagery alluding to omens of immortality and eternal happiness, these poems were designed to flatter the T'ang royal family. The grandiloquent diction of these poems was favored by later generations, and calligraphers often transcribed lines from them as gifts for friends on social occasions. This hanging scroll is probably such a work.

The calligraphy is in the style of Wen Cheng-ming (1470–1559; cat. no. 27), a leading figure in painting and calligraphy in sixteenth-century Soochow, who combined the calligraphic styles of Huang T'ing-chien (1045–1105; cat. no.

6) and Chao Meng-fu (1254–1322; cat. nos. 11, 12) into one of his own. It is not clear what kind of contact Yang had with Wen and his followers, but it has been suggested that the style of Yang's painting is related to that of Wen's close friend Ch'en Ch'un (1483–1544),[4] and we know that Wen's student Chü Chieh (1527–1586) painted a portrait of Yang.[5]

H.L.

PUBLISHED

Suzuki Kei, comp., *Chūgoku kaiga sōgō zuroku,* vol. 1, *Amerika-Kanada hen* (Tokyo: University of Tokyo Press, 1982), pl. A17–116.

NOTES
1. An alternative interpretation of the last two lines reads,
 From the lofty tower, one can look up [at mountains] beyond the clouds;
 On the floating bridge, one can look out [at the boat] moving across the sea.
2. For a concise biography of Yang Chi-sheng, see L. Carrington Goodrich and Chaoying Fang, eds., *Dictionary of Ming Biography, 1368–1644* (New York: Columbia University Press, 1976), 1503–05.
3. *Ch'üan T'ang shih* (Peking: Chung-hua shu-chü, 1960), *chüan* 103: 1089.
4. A painting dated 1551 by Yang Chi-sheng is in the Phoenix Art Museum. See *Heritage of the Brush: The Roy and Marilyn Papp Collection of Chinese Painting* (Phoenix: Phoenix Art Museum, 1989), 28–29.
5. The portrait also bears a colophon written by Yang himself in 1552. See *Shih-ch'ü pao-chi hsü-pien* (Taipei: National Palace Museum, 1971), 4: 2004–5.

六龍齊幹御朝曦雙鵾維舟下
綠池飛觀俯看雲孤漟浮橋宜
見海中移

楊继盛

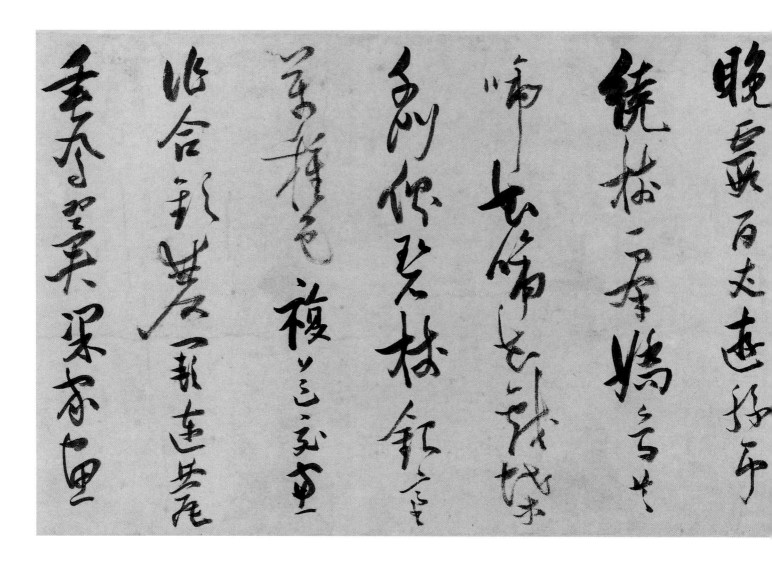

32
Chang Jui-t'u (1570–1641)
Ch'ang-an, the Ancient Capital (Ch'ang-an ku-i)

Dated 1634
Handscroll, ink on paper
28.2 x 466.5 cm
1998-100

Chang Jui-t'u wrote *Ch'ang-an, the Ancient Capital* in the autumn of 1634. A few years earlier, in 1629, shortly after retiring to his hometown in the southern province of Fukien, he had been stripped of his rank as a high-level government official and reduced to the status of a commoner during a political purge of all those associated with the powerful grand eunuch Wei Chung-hsien (1568–1627). Denounced in part because he had provided the calligraphy for inscriptions in shrines honoring the eunuch, Chang remained in retirement and took refuge in leading a simple life away from the complexities of the imperial court,

practicing Ch'an (Zen) Buddhism, and dedicating his days to composing poetry and writing calligraphy.[1]

For the text of this handscroll, Chang Jui-t'u chose a poem in seven-character meter, "Ch'ang-an, the Ancient Capital" by the T'ang poet Lu Chao-lin (fl. 650–669). In this lengthy poem, Lu conjures up images of lost luxuries and fanciful riches in the Western Han capital, Ch'ang-an; his true subject, however, is the city as it existed during his own time, when it was the capital of the T'ang dynasty. The opening of the poem depicts the hustle and bustle of a vibrant city:

> Ch'ang-an's broad avenues link up with narrow lanes,
> There black oxen and white horses, coaches of fragrant woods,
> Jade-fit palanquins go left and right past the mansions of lords,
> Gold riding whips in a long train move toward the homes
> of barons.[2]

At the end of the poem, however, Lu expresses disillusionment and a sense of impermanence, perhaps conveying nostalgia for better times and a presentiment of a bleak future:

> Mulberry fields and green oceans interchange in an instant.
> Where once were the golden stairs, the halls of white marble,
> We now see only the green pines remaining.[3]

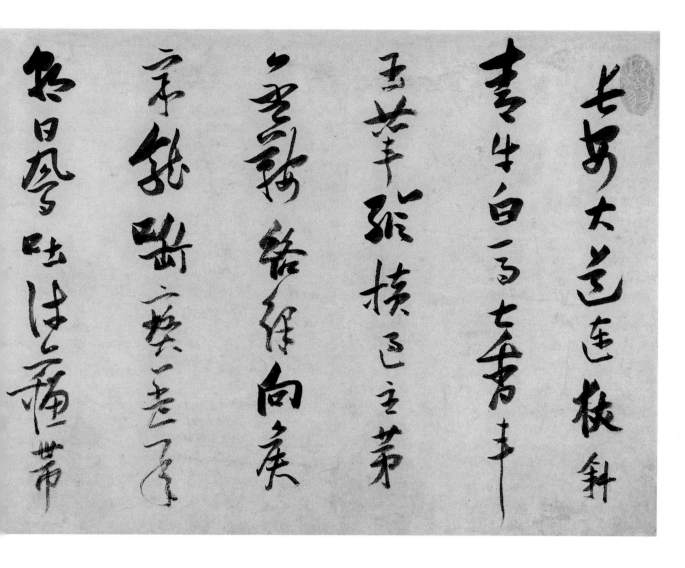

Although Chang Jui-t'u gave no explanation of why he selected this poem, its bitter tone may have reflected his own attitudes toward the extravagances of life in the late Ming or his own sense of mortality. At the end of the scroll Chang simply inscribed, "The poem 'Ch'ang-an, the Ancient Capital' by Lu Chao-lin, written in the autumn of 1634 at the Pai-hao-ching Studio by Kuo-t'ing Shan-jen, Jui-t'u."

Ch'ang-an, the Ancient Capital reflects Chang Jui-t'u's mature artistic style in cursive calligraphy, a script in which he excelled in his later years. Most striking is his inventive composition, in which he spaced columns of tightly packed characters unusually far apart. He devised this compositional scheme from his early experimentation with standard script and eventually applied it to cursive script as seen in this work. He also imbued his calligraphy with a hard-edged, prickly quality, accentuating the oblique traces of brushstrokes. Chang Jui-t'u's innovative compositions and idiosyncratic brushwork won him many admirers during his lifetime and among later critics.[4] He is considered one of the four masters of calligraphy of the late Ming, along with Hsing T'ung (1551–1612), Tung Ch'i-ch'ang (1555–1636; cat. nos. 2, 45), and Mi Wan-chung (d. 1628).

D.C.Y.C.

PUBLISHED

Tseng Yu-ho Ecke, *Chinese Calligraphy* (Philadelphia: Philadelphia Museum of Art; and Boston: Boston Book and Art Publishers, 1971), no. 65; Hirotsu Unsen, *Chō Zuito no shohō* (Tokyo: Nigensha, 1981), 2: 146–73; Nakata Yūjirō and Fu Shen, eds. *Ōbei shūzō Chūgoku hōsho meisekishū* (Tokyo: Chūōkōron-sha, 1983), *Ming–Ching* 2: nos. 16–19; Tseng Yuho, *A History of Chinese Calligraphy* (Hong Kong: Chinese University Press, 1993), 281, fig. 8.55.

NOTES

1. For Ch'ang Jui-t'u's biography, see L. Carrington Goodrich and Chaoying Fang, eds., *Dictionary of Ming Biography, 1368–1644* (New York: Columbia University Press, 1976), 94–95. On his art, see Hirotsu, *Chō Zuito no shohō*; and *Chung-kuo shu-fa ch'üan-chi*, ed. Liu Cheng-ch'eng, vol. 55 (Peking: Jung-pao-chai, 1992).
2. Slightly modifed from the complete translation in Stephen Owen, *The Poetry of the Early T'ang* (New Haven and London: Yale University Press, 1977), 105–8.
3. Ibid.
4. See also the essay by Dora C. Y. Ching in this volume.

33
Wang To (1592–1652)
Calligraphy after Wang Hsi-chih

Dated 1643
Hanging scroll, ink on silk
246.0 x 52.0 cm
1998-144

The seventeenth century witnessed a proliferation of calligraphers who developed idiosyncratic styles. Wang To, a renowned scholar-official of the late Ming and early Ch'ing, was among a number of calligraphers—such as Chang Jui-t'u (1570–1641; cat. no. 32), Huang Tao-chou (1585–1646), Ni Yüan-lu (1593–1644), and Fu Shan (1607–1684/85; cat. no. 35)—who transformed traditional calligraphic styles into personal idioms of individual expression.[1]

Wang To learned calligraphy at an early age and honed his skills through the conventional manner of copying the works of famous calligraphers. His primary models were the letters of Wang Hsi-chih (303–361; cat. no. 2) and his son Wang Hsien-chih (344–388). Through persistent copying and concentrated study, Wang To completely transformed the classical elegance of the fourth-century styles into his own inventive, artistic language. *Calligraphy after Wang Hsi-chih* is a prime example of his reformulation of the traditional models.

As in many of his scrolls, Wang To chose for his text classic model-book letters by Wang Hsi-chih, in this instance *Letter Recently Received (Chin-te-shu t'ieh)* and *Letter of the 23rd Day of the Fourth Lunar Month (Ssu-yüeh nien-san jih t'ieh).*[2] Instead of copying the texts faithfully, however, he approximated them with little regard for readability, haphazardly omitting characters and entire lines. Many of Wang To's works reveal this free copying and wanton disregard for comprehensibility. The texts functioned simply as a medium for calligraphic expression, and their literary content became negligible. *Calligraphy after Wang Hsi-chih* also diverges significantly from the actual Wang Hsi-chih letters in size and script type. Wang To converted the small characters of Wang Hsi-chih's intimate letter into monumental calligraphy befitting a large hanging scroll. His expressive, cursive script, furthermore, bears little relationship to the running script of his model.

Wang To wrote *Calligraphy after Wang Hsi-chih* to satisfy the request of a friend identified only by his personal name, Chao-liu. Inscribing the scroll in the lower left-hand corner, he wrote, "In the sixth month of *kuei-wei* [1643], I met Chao-liu at the Southern Garden. The following day Chao-liu came back to the Western Sluice to entreat me for calligraphy. He loves calligraphy so! Isn't this commendable?" When he made this scroll in 1643, Wang To was in temporary retirement from government service to mourn the death of a parent. During his lifetime he had held a number of government positions. He first entered civil service at the Hanlin Academy after achieving a distinguished rank in the metropolitan examination of 1622. By 1641 he had attained the position of minister of rites, but retired soon thereafter. In 1644, only one year after writing *Calligraphy after Wang Hsi-chih*, he was recalled into government service. At that time, however, the Ming government was collapsing under pressure from rebel and Manchu forces. Wang eventually accepted a government post under the Manchus, who conquered China and established the Ch'ing dynasty. Throughout his official career Wang remained a dedicated calligrapher, practicing nearly every day and producing countless scrolls such as this one at the request of friends and acquaintances.

D.C.Y.C.

NOTES

1. For Wang To's biography, see L. Carrington Goodrich and Chaoying Fang, eds., *Dictionary of Ming Biography, 1368–1644* (New York: Columbia University Press, 1976), 1434–36. On his calligraphy, see Murakami Mishima, ed., *Ō Taku no shohō* (Tokyo: Nigensha, 1979); *Chung-kuo shu-fa ch'üan-chi*, ed. Liu Cheng-ch'eng, vols. 61, 62 (Peking: Jung-pao-chai, 1993); and also the essay by Dora C. Y. Ching in this volume.

2. See *Shodō zenshū*, n.s. (Tokyo: Heibonsha, 1960), 4: pls. 62, 63.

34

Ch'en Hung-shou (1598–1652)

Poem on Wandering in the Mountains

Undated
Hanging scroll, ink on paper
114.6 x 32.0 cm
1971-1

Ch'en Hung-shou is now best known as a professional figure painter, although his calligraphy was also esteemed in his time. The subjects of his paintings and woodblock-print designs—scholarly gentlemen, beautiful women, and heroes from contemporary fiction and drama—derive from long-standing pictorial traditions. However, his archaistic stylization often creates a sense of ironic melancholy, sometimes tinged with whimsy and humor. These qualities seem to reflect Ch'en's personal regrets and disappointments: he not only failed the official exams twice, but lived through the downfall of the Ming dynasty, which he had hoped to serve.[1]

Few major calligraphic works by Ch'en Hung-shou are extant. This hanging scroll is a rare example of his large-scale writing and is done in a lively, running-cursive script. The characters are dynamically elongated and are made up of both heavy and light strokes. In the places where Ch'en loads his brush with sooty ink, the strokes are heavy and dark. Where he allows his brush to run dry, he produces a contrasting effect known as "flying white." Although his calligraphy is dominated by rounded motions of the brush, strong angular accents add variety to the shapes of the characters. Ch'en's study of the calligraphy of Tung Ch'i-ch'ang (1555–1636; cat. nos. 2, 45) is detectable in his use of pointed tips at the beginnings of strokes, sharply turning loops, and rapidly modulated strokes. Nevertheless, as in his painting, Ch'en was an eccentric in calligraphy. For example, the long, leftward pull of the "tail" of strokes is an effect not found in the more classically controlled writing of Tung Ch'i-ch'ang.

Ch'en Hung-shou dedicated this scroll to the son of his sworn brother, Yin-jen, who remains unidentified. His poem reads,

> How I love to wander in the hills,
> While indulging in a cup of wine.
> At this moment, I encounter regret,
> But if I do not seek [to return], what else is left to do?

The mingled feelings of exhilaration and longing expressed in his poem are characteristic of short inscriptions that often accompany Ch'en's paintings. Other poems he wrote in the 1630s, in the guise of the drunken recluse T'ao Ch'ien (365–427), also reflect moodiness or pessimism.

Although the scroll does not bear the self-mocking sobriquets Old Lotus (*Lao-lien*) or Belated Repentant (*Hui-ch'ih*), which Ch'en commonly signed on works produced after 1644, Tseng Yu-ho Ecke suggests that the tone of regret on which the poem ends reflects Ch'en's depression after the fall of the Ming. It also seems possible that this work was done earlier, since the calligraphic style resembles that of a large hanging scroll in the National Palace Museum in Taipei, datable to the late 1630s.[2]

P.F.

PUBLISHED

Tseng Yu-ho Ecke, *Chinese Calligraphy* (Philadelphia: The Philadelphia Museum of Art; and Boston: Boston Book and Art Publishers, 1971), pl. 73; Nakata Yūjirō and Fu Shen, eds. *Ōbei shūzō Chūgoku hōsho meisekishū* (Tokyo: Chūōkōron-sha, 1981–83), 2 pl. 36; *Record of The Art Museum, Princeton University* 31, no. 1 (1972): 27 (illus.); Suzuki Kei, comp., *Chūgoku kaiga sōgō zuroku*, vol. 1, *Amerika-Kanada hen* (Toyko: University of Toyko Press, 1982), pl. A16–027; Tseng Yuho, *A History of Chinese Calligraphy* (Hong Kong: Chinese University Press, 1993), 322, fig. 9.49; Wan-go Weng, *Chen Hongshou: His Life and Art* (Shanghai: Shang-hai jen-min ch'u-pan-she, 1997), 3: 180.

NOTES

1. For Ch'en Hung-shou's biography, see Huang Yung-ch'üan, *Ch'en Hung-shou nien-p'u* (Peking: Jen-min mei-shu ch'u-pan-she, 1960); and Arthur W. Hummel, ed., *Eminent Chinese of the Ch'ing Period* (Washington, D.C.: U.S. Government Printing Office, 1943), 87–88. On his painting and calligraphy, see Anne Burkus-Chasson, "Elegant or Common? Ch'en Hung-shou's Birthday Presentation Pictures and Professional Status," *Art Bulletin* 76, no. 2 (1994): 279–300; James Cahill, *The Compelling Image: Nature and Style in Seventeenth-Century Chinese Painting* (Cambridge, Mass., and London: Harvard University Press, 1982), 106–45; Kohara Hironobu, "An Introductory Study of Chen Hongshou," parts 1 and 2, trans. Anne Burkus, *Oriental Art* 32, no. 4 (1986/87): 398–410; and 33, no. 1 (1987): 67–83; Weng, *Chen Hongshou*; and Roderick Whitfield, *In Pursuit of Antiquity* (Princeton: The Art Museum, Princeton University, 1969), 33–34, cat. nos. 6, 7.

2. *Wan Ming pien-hsing chu-i hua-chia tso-p'in chan* (Taiwan: National Palace Museum, 1977), pl. 87

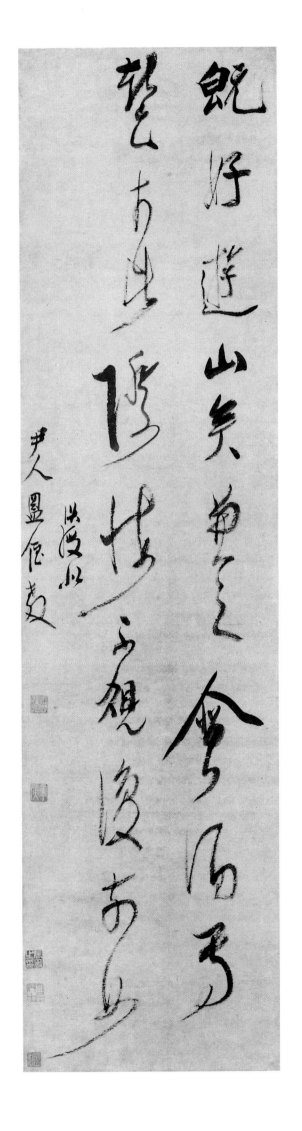

35
Fu Shan (1607–1684/85)

Poem on the Heavenly Emperor

Undated, ca. 1670s
Hanging scroll, ink on satin
284.5 x 47.1 cm
1998-99

Fu Shan was a scholar of the Chinese classics and a medical doctor who specialized in women's health. As an artist, he was a talented seal carver, painter, and calligrapher. A Ming loyalist, he refused to serve the Manchus when they established the Ch'ing dynasty in 1644. Instead, he adopted the lifestyle and dress of a Taoist and devoted himself to erudite activities such as writing essays, composing poetry, painting, and practicing calligraphy."[1]

Fu Shan studied the traditional models of calligraphy early in his career, but he professed a strong desire to invent his own style. He wrote that "in practicing calligraphy, if one does not achieve a metamorphosis, then one cannot achieve the marvelous."[2] He also claimed that he "would rather [his own calligraphy] be awkward, not skillful; ugly, not charming; fragmented, not slick; and spontaneous, not premeditated."[3] Fu Shan did not simply repeat clichés about achieving a transformation of past styles and disdaining superficial beauty; he developed an arsenal of techniques that eschewed mechanical perfection and conventional form. *Poem on the Heavenly Emperor*, a mature work stylistically datable to the 1670s, exemplifies his eccentric style.

In this towering, narrow hanging scroll, Fu Shan used an unusual hybrid of running and cursive scripts, writing many characters in running script but executing them with the quickness and abbreviated brushwork of cursive calligraphy. He stretched the majority of characters vertically, particularly *hsüan*, the seventh of the first column on the right, thus accentuating the height of the scroll. Some characters are also deliberately distorted, such as *pu*, the twelfth character of the first column, and *lun*, the twelfth character of the second column. The brushstrokes in these characters twist and turn chaotically, resembling tangled ribbons. In addition, Fu Shan created dynamic rhythms of dark and light strokes, capitalizing on the different effects of wet and dry ink on satin. The heavily inked strokes produce a luscious, wet quality where the ink soaked into the satin, whereas the dry strokes seem to hover atop the surface to evoke an impression of speed.

For his text, Fu Shan transcribed a poem by the T'ang poet Ts'ao T'ang (fl. 847–873), excerpted from a collection of ninety-eight verses, *Poems on Wandering Immortals*:

> Within the deeply locked heavenly palace, the red pavilion stands open,
> The heavenly emperor speaks aloud of the gate to eternal life.
> After the officials bid him farewell,
> Astride dragons and tigers, they descend Mount K'un-lun.[4]

His choice of this text peopled with immortals reflects his deep interest in Taoism. In addition to writing poems with Taoist themes, Fu Shan also experimented with secret writing associated with Taoist charms and amulets. As a Taoist priest he would have been well-versed in Taoist magic scripts, though he did not employ such writing in this scroll.[5] The content of the poem may indicate that he intended this scroll as a gift to a friend with Taoist sympathies, but Fu Shan provides no information on a possible recipient, simply signing the lower left corner, "Written by Shan."

<div align="right">D.C.Y.C.</div>

Published

Tseng Yu-ho Ecke, *Chinese Calligraphy* (Philadelphia: Philadelphia Museum of Art; and Boston: Boston Book and Art Publishers, 1971), no. 77; Pai Hsüeh-lan, "Fu Shan chih shu-hua yen-chiu" (M.A. thesis, Chung-kuo wen-hua ta-hsüeh, 1983), 42; Suzuki Kei, comp., *Chūgoku kaiga sōgō zuroku*, vol. 1, *Amerika-Kanada hen* (Tokyo: University of Tokyo Press, 1982), A17–097.

Notes

1. For Fu Shan's biography, see Arthur W. Hummel, ed., *Eminent Chinese of the Ch'ing Period* (Washington, D.C.: U.S. Government Printing Office, 1943), 260–62. On his art, see Quianshen Bai, "Fu Shan (1607–1684/85) and the Transformation of Chinese Calligraphy in the Seventeenth Century" (Ph.D. diss., Yale University, 1996); *Chung-kuo shu-fa ch'üan-chi*, ed. Liu Cheng-ch'eng (Peking: Jung-pao-chai, 1996), vol. 63; and Min Shin Bunjin kenkyūkai, ed., *Fu Zan* (Tokyo: Geijutsu shincho shinbusha, 1994).
2. Fu Shan, *Fu Shan ch'üan-shu* (Taiyuan: Shan-hsi jen-min ch'u-pan-she, 1991), 1: 519.
3. Ibid., 50. Translation adapted from Bai, "Fu Shan," 50–51.
4. There are several discrepancies between the original poem by Ts'ao T'ang and Fu Shan's transcription. Most notable is Fu Shan's substitution of "the Pu-lao Gate of Loyang"(*Pu-lao-men*) in the second line for "gate to eternal life" (*pu-ssu-men*). My translation follows Ts'ao T'ang's poem because Fu Shan's substitution makes little sense. For interpretations of *Pu-lao-men*, see *Chung-wen ta tz'u tien* (Taipei: Chung-kuo wen-hua ta-hsüeh, 1973, 1990), 1: 342b. For the original poem, see *Ch'üan T'ang shih* (Peking: Chung-hua shu-chü, 1985), chüan 641: 7351.
5. On Fu's interest in Taoist secret writing and the innovative nature of his calligraphy, see the essay by Dora C. Y. Ching in this volume.

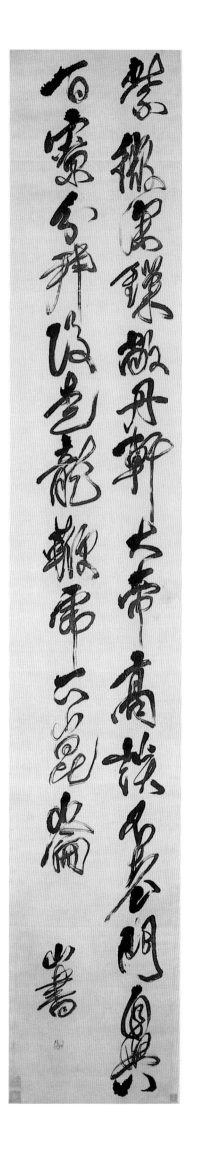

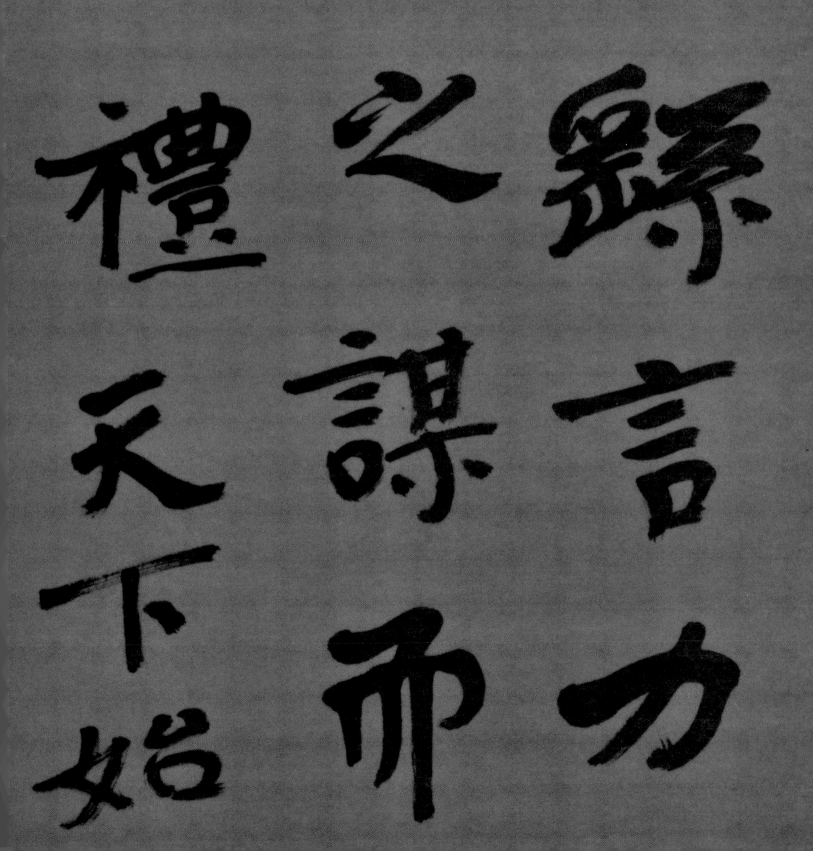

Calligraphy of the Ch'ing Dynasty:
Model-Books and Stelae

*I*imperial misrule, factional struggles, and natural disasters weakened the Ming dynasty in the early decades of the seventeenth century. In 1644 the dynasty fell to the Manchus, a people from the area that is now Heilungkiang and Kirin Provinces. The dynasty they founded, the Ch'ing, marked a final apogee of imperial power in China.

The Manchus recognized that in order to govern successfully, it was essential for them to win the loyalty of Confucian scholars, who traditionally staffed China's vast civil service bureaucracy. Following the example of many earlier rulers, the Manchu emperors manipulated the visual arts, especially calligraphy, to help demonstrate their political legitimacy and their enlightened commitment to Chinese culture.

The K'ang-hsi emperor (r. 1662–1722), an expert calligrapher who frequently conferred samples of his writing on his subjects, greatly admired the calligraphy of the Ming dynasty artist and critic Tung Ch'i-ch'ang (1555–1636; cat. nos. 2, 45), which became a semiofficial style used for writing government documents. The K'ang-hsi emperor's grandson, the Ch'ien-lung emperor (r. 1736–95), was an even more ardent practitioner and student of calligraphy, and he amassed the single largest collection of this art ever seen in imperial China. His taste as a collector gave final shape to the canon of Chinese calligraphy studied in our own time. Among his treasures was the letter known as *Ritual to Pray for Good Harvest* by Wang Hsi-chih (303–361; cat. no. 2). In addition to his many seals, traces of the emperor's ownership of this letter appear in the form of colophons, through which Ch'ien-lung boldly asserted his own position in a lineage of calligraphers extending back to Wang Hsi-chih himself.

To document the choicest works from his collection, Ch'ien-lung commissioned in 1747 an anthology of model-book rubbings known as *Model Calligraphies from the Hall of the Three Rarities (San-hsi-t'ang fa-t'ieh)*. The title of this anthology came from the name of the private studio where the emperor stored three precious samples of writing by Wang Hsi-chih, Wang Hsien-chih (344–388), and Wang Hsün (350–401). Like earlier imperial anthologies, such as *Model Calligraphies from the Imperial Archives of the Ch'un-hua Era (Ch'un-hua pi-ko t'ieh)*, compiled in the tenth century, the rubbings published under Ch'ien-lung's aegis functioned as a state-sanctioned overview of the history of calligraphy. This project paralleled his efforts to control and standardize other domains of Chinese culture and to display the beneficent patronage of the dynasty and its symbolic legitimacy to rule. Perhaps his most ambitious undertaking, carried out by a committee of editors at his court, was the compilation of *The Comprehensive Library of the Four Treasuries (Ssu-k'u ch'üan-shu)*, the largest book compilation ever produced in dynastic China, which included some 3,470 texts divided into classics, histories, philosophy, and miscellaneous works of literature.[1]

In spite of Ch'ien-lung's efforts, many Ch'ing calligraphers rejected the canonical authority of anthologies of model-book rubbings, arguing that these widely imitated compilations, often based on works of dubious authenticity, distorted the history of calligraphy. An early example of this was the individualistic style of Kao Feng-han (1683–1748/49). Known as one of the Eight Eccentrics of Yangchow, Kao taught himself to paint and write with his left hand after an illness robbed him of the use of the right hand. His album *In Wind and Snow* (cat. no. 37) integrates painting and running-script *(hsing-shu)* calligraphy

in startlingly awkward but dynamic compositions that show the artist transforming his affliction into a new source of creativity.

Seeking earlier sources of inspiration, other calligraphers turned to ancient inscriptions. One early manifestation of this revival of interest in archaic styles is Chin Nung's (1687–1764) *Appreciating Bamboo* (cat. no. 38), written in a blocky form of clerical script (*li-shu*) derived from stone inscriptions from the Three Kingdoms period. Liu Yung (1719–1804; cat. no. 39) and I Ping-shou (1754–1815; cat no. 40) also based their styles on that of ancient calligraphy and were exemplars of an artistic and scholarly movement known as the "study of metal and stone" (*chin-shih hsüeh*), which includes inscriptions cast on bronze vessels or carved on stone monuments. The foremost proponent of this movement was the epigrapher Juan Yüan (1764–1849). In his writings, Juan divided the history of calligraphy into the Model-book school (*T'ieh-hsüeh*) and the Stele school (*Pei-hsüeh*). In the context of Ch'ing dynasty calligraphy, the Stele school included calligraphers who based their styles on stone engravings such as *Ritual Vessels Stele (Li-ch'i pei)* of the Han dynasty or *Eulogy on Burying a Crane (I-ho ming)* from the Six Dynasties period. Calligraphers associated with the Stele school also frequently wrote in seal script *(chuan-shu)*, imitating even earlier forms of calligraphy seen on Chou dynasty ritual bronze vessels.

Calligraphers of the Stele school helped popularize the format of paired hanging scrolls *(tui-lien)*.[2] The origins of this calligraphic format have been traced to apotropaic markers displayed in ancient China on either side of doorways, shrines, and altars. Paired inscriptions also were used in rituals to commemorate auspicious days for the erection of buildings. Couplets in the form of identifying plaques and inscriptions on buildings remained an important part of Chinese architecture, but this format for calligraphy is most commonly associated with parallel poetic couplets written on pairs or sets of hanging scrolls. Calligraphers of the Stele school often wrote couplets that allude to the style or content of vessel and stele inscriptions from the Northern Wei, Han, and early periods. The calligraphers Ho Shao-chi (1799–1873; cat. no. 41) and Li Jui-ch'ing (1867–1920; cat. no. 43) carried this practice through the late Ch'ing period and into the early twentieth century. To this day, couplets are hung as decorative frames for family altars or ancestor portraits in Chinese homes, echoing their use in ancient rituals.

R.E.H.

NOTES

1. On the *Ssu-k'u ch'üan-shu*, see Huang Ai-p'ing, *Ssu-k'u ch'üan-shu tsuan-hsiu yen-chiu* (Peking: Chung-kuo jen-min ta-hsüeh ch'u-pan-she, 1989); Kuo Po-kung, *Ssu-k'u ch'üan-shu tsuan-hsiu k'ao* (Shanghai: Kuo-li Pei-p'ing yen-chiu-yüan shih-hsüeh yen-chiu-hui, 1937); and Cary Y. Liu, "The Ch'ing Dynasty Wen-yüan-ko Imperial Library: Architecture and the Ordering of Knowledge" (Ph.D. diss., Princeton University, 1997). Because seven manuscript sets were compiled and completed at different times amidst ongoing censorial review, the total count and content varied from set to set. On the number of works in each set, see Liu, "The Ch'ing Dynasty Wen-yüan-ko," 55–57 esp. no. 40.
2. See the essay by Cary Y. Liu in this volume.

36
Cha Shih-piao (1615–1698)
Poem on Greenwood Shade and Azure Mountains

Undated
Hanging scroll, ink on paper
139.5 x 52.1 cm
1998-112

Cha Shih-piao was born in Hsiu-ning, Anhwei, and became known as one of the Four Masters of his home region for his artistic achievements.[1] Cha's early pursuit of an official career ended with the fall of the Ming dynasty in 1644. Benefiting from his family's large collection of ancient bronze vessels, Sung and Yüan dynasty paintings, and calligraphy, Cha turned to a career first as a connoisseur and calligrapher, and then in the 1660s as a serious painter. In his mature painting style Cha melded the dry-ink sparse-brush styles of the Yüan masters Ni Tsan (1306–1374) and Wu Chen (1280–1354) with that of his fellow Anhwei painter Hung-jen (1610–1664) and later the Ming artist-official Tung Ch'i-ch'ang (1555–1636; cat. no. 45). Forced by necessity to sell his artwork to earn a living, by the early 1670s Cha had settled in the cultural and economic center of Yangchow. From this base he became well acquainted with a large circle of artists, scholars, and patrons in the region.

In calligraphy Cha Shih-piao was influenced by Mi Fu (1052–1107; cat. no. 7), but, again, demonstrated a particular devotion to Tung Ch'i-ch'ang, whose influence on both painting and calligraphy in the late Ming to early Ch'ing period was immense. Tung's art-historical theory of Northern and Southern painting lineages was to have important ramifications in other fields, including calligraphy. The scholar-official Juan Yüan (1764–1849) was to echo Tung by categorizing past calligraphers into a southern, Model-book school (*T'ieh-hsüeh*) characterized by small-size writing models from Wang Hsi-chih (303–361; cat. no. 2) to Tung Ch'i-ch'ang, and a northern, Stele school (*Pei-hsüeh*) based on models of monumental writing found on engraved bronzes, stelae, and cliffsides. This dichotomy

became a major point of dialogue among Ch'ing calligraphers (see cat. nos. 38–43) after Cha Shih-piao.

In this poem, Cha Shih-piao writes,

> Layers upon layers of greenwood shade, the birds are
> singing;
> Wild grass and fragrant flowers despoiled by the night's rain.
> The heavens disperse the drifting clouds, until wholly
> swept away;
> Allowing one, all along the road, to see the azure mountains.

This poem written in running-script calligraphy emulates the restrained grace and fluid writing style of Tung Ch'i-ch'ang. Cha was able to achieve the elegance and naturalness of Tung's calligraphy, yet he was never able to capture completely his raw spontaneity. Still, Cha's deliberate imitation demonstrates the transmission of Tung's style in literati circles during the early Ch'ing, before interest shifted to monumental writing and earlier forms.

C.Y.L.

Published

Sotheby's, New York, *Fine Chinese Works of Art and Paintings,* June 4, 1982, lot 118.

Note

1. For Cha Shih-piao's biography, see L. Carrington Goodrich and Chaoying Fang, eds., *Dictionary of Ming Biography, 1368–1644* (New York: Columbia University Press, 1976), 34–35. See also Richard M. Barnhart et al., *The Jade Studio: Masterpieces of Ming and Qing Painting and Calligraphy from the Wong Nan-p'ing Collection* (New Haven: Yale University Art Gallery, 1994), 152–54; and Wai-kam Ho, ed., *The Century of Tung Ch'i-ch'ang, 1555–1636,* (Kansas City, Mo.: Nelson-Atkins Museum of Art, 1992), 2: 152–53.

綠陰重疊鳥間關睡起

香宿雨餘天半浮雲都擁樹

寂人一謝看青山　查士標

37

Kao Feng-han (1683–1748/49)

In Wind and Snow

Dated the twelfth lunar month of 1737
Album of ten double leaves, ink and color on paper
Each double leaf, 24.1 x 28.7 cm
1998-111

A native of Chiao-chou, Shantung, Kao Feng-han was serving as assistant magistrate of She County, Anhwei, when, through the influence of Lu Chien-tseng (1690–1768), he was appointed magistrate of T'ai-chou, a town near Yangchow, Kiangsi. In early 1737 Lu, a chief salt commissioner headquartered in Yangchow, was charged with a felony, and due to their association, Kao was falsely implicated and imprisoned. Although he was soon released, Kao became ill and lost the use of his right arm. Turning hardship to advantage, he began seriously to paint and write with his left hand and soon displayed great aplomb, as witnessed by *In Wind and Snow*, which is dated the end of 1737. This year and the next saw an increase in Kao's artistic production as he shied away from returning to government service and began selling his painting and calligraphy to earn a meager living. This album of calligraphy and painting compares closely with another album by Kao, also in the collection of The Art Museum, Princeton University, *Flowers and Calligraphy*, which is dated 1738.[1]

Presently mounted in a rearranged order, the paintings and calligraphies of Kao Feng-han's album express sorrow about the arrival of autumn winds and winter snows. He likens officials unwilling to bow down under the cruelties of corrupt government to plants that resist icy winds. On a brighter note, he uses the imagery of spring flowers to hint at the hope of renewal at winter's end. In a poem about peonies, a traditional symbol of riches and honor, he playfully notes that in his eccentric use of wet ink and wild brushwork, "riches and honor will come out of the confusion." In this line Kao also recognizes the pictorial and divinatory origins embodied in the use of brush and ink.

Despite regaining partial use of his right arm by 1739, Kao continued to write and paint mainly with his left arm, favoring the spontaneity and awkwardness that yielded a highly animated individual style. According to his friend and fellow artist Cheng Hsieh (1693–1765), "After being crippled, Kao used his left arm and his calligraphy and painting became even stranger."[2] The personal style and strange nature of his artwork accounts for his frequent inclusion among the group of individualist artists known as the Eight Eccentrics of Yangchow.

C.Y.L

NOTES

1. Richard M. Barnhart, "Chinese Calligraphy and Painting: The Jeannette Shambaugh Elliott Collection at Princeton," *Record of The Art Museum, Princeton University* 38, no. 2 (1979): cat. no. 21; Shen C. Y. Fu et al., *Traces of the Brush: Studies in Chinese Calligraphy* (New Haven: Yale University Art Gallery, 1977), cat. no. 74; and Vito Giacalone, *The Eccentric Painters of Yangzhou* (New York: China House Gallery, China Institute in America, 1990), cat. no. 7.

2. Howard Rogers, *Masterworks of Ming and Qing Painting from the Forbidden City* (Lansdale, Penn.: International Arts Council, 1988), 190.

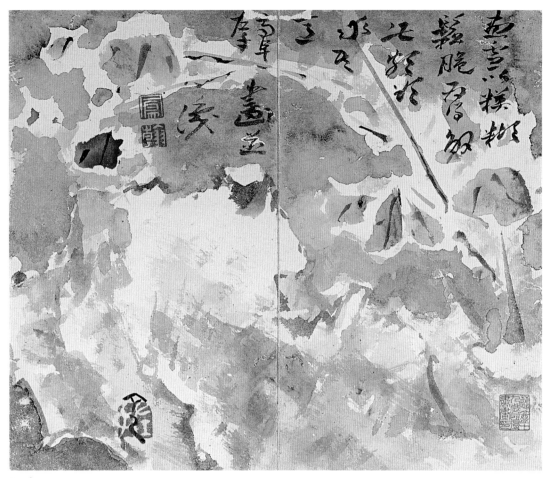

Leaf g

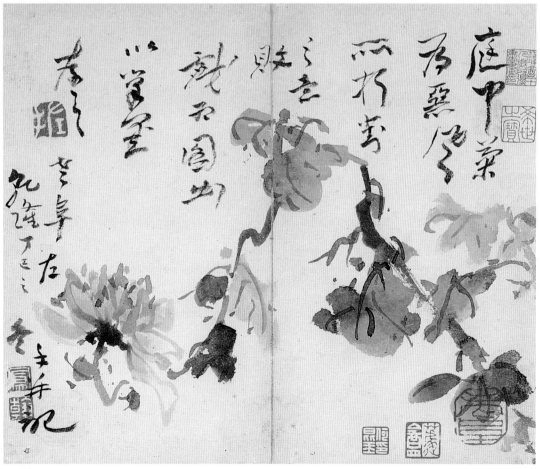

Leaf h

38

Chin Nung (1687–1764)

Appreciating Bamboo

Undated
Hanging scroll, ink on paper
116.0 x 49.5 cm
1998-113

Born in Hangchow, Chin Nung was described by his friends as an "extreme eccentric." As a young man he excelled at poetry and came to the attention of Chu I-tsun (1629–1709), a noted scholar and student of ancient stone and bronze epigraphy. In imitation of Chu, Chin Nung traveled extensively from 1714 to 1723 in order to study ancient inscriptions and amassed a large collection of rubbings, which benefited his development as a calligrapher and seal engraver.

In 1736 Chin Nung was in Peking to take an extraordinary examination for select scholars, but for some reason, he evaded sitting for the exam, essentially ending his opportunities for an official career. Returning south to Hangchow, he lived off his talents as a poet and calligrapher. During the 1740s he developed an archaistic "lacquer script" (*ch'i-shu*), a bold, square-ended, block-character style modeled after Wu Kingdom (222–80) stele inscriptions such as the *Divine Omen Stele* (*T'ien-fa shen-ch'an pei*) and *Stele of Mount Kuo* (*Kuo-shan pei*), both dated to 276. He named his script style after a type of flat-edged brush used for the application of lacquer, which was perfectly suited for making square-ended strokes. Despite a widespread demand for his calligraphy from as far away as Japan, at the age of fifty-nine Chin Nung began painting professionally in hopes of improving his finances. Moving to the artistic and commercial center of Yangchow in 1750, he came to be counted among the group of individualist painters known as the Eight Eccentrics of Yangchow.

As a painter, Chin Nung dedicated himself to the painting of bamboo, and even planted a bamboo grove in front of his studio in order to study and watch it grow. About his own painting, he writes,

> I paint rushes for my own appreciation. If I chanced to meet Wang Fang-p'ing, I would give him [my bamboo] to serve as a fishing rod. . . . [Wang] fishes but does not catch any fish, and even if he caught any he would not sell them. Among the retired sages [*i-min*], he was one who stepped high to escape the cares of the world. If such a person were to exist today, I would make him my friend.[1]

In this hanging scroll written in Chin Nung's lacquer script, his painted bamboo becomes a gift of a fishing pole to a figure from the past, Wang Fang-p'ing of the Han dynasty. As a retired official, Wang declined repeated imperial summons to return to office. After forcefully being brought to court, he refused to speak, but in a burst of communication, wrote over four hundred characters on the palace gate. The embarrassing writing was scraped off, but magically reappeared. After Wang finally was allowed to return home, he took his own life one night to escape the cares of the world. In this scroll, Chin Nung sets Wang Fang-p'ing as a figure to be revered, yet he also seems to question whether there is anyone with such lofty ideals in his own age; or, Chin may simply be likening his painted bamboo to Wang's writing on the palace gate.

C.Y.L.

NOTE

1. Translated with the help of Huiwen Lu.

舊：王筆畫以自賞價逢王方

王苔歲贈真上具置上

晉江二石頭隸曰之魚宋以

決宋得二火宋貴此逸民中高

友之暗遺由之

鈞麾金廛

39
Liu Yung (1719–1804)
Quotations on Canonical Texts

Undated
Hanging scroll, ink on paper
175.2 x 45.3 cm
1998-69

The son of the grand secretary Liu T'ung-hsün (1700–1773), Liu Yung served in numerous official posts, but his fortunes constantly wavered between success and catastrophe. Known for his integrity and propriety, Liu found himself at odds with the Ch'ien-lung emperor's favorite, Ho-shen (1750–1799), and was held accountable for the actions of his father and subordinates. Though repeatedly demoted, and at one time even condemned to die, he always returned to official service and eventually rose to the rank of grand secretary.[1]

Renowned as a calligrapher, Liu Yung, like many candidates hoping for success in the official examinations, first followed the Wang Hsi-chih (303–361; cat. no. 2) brush tradition as interpreted by Tung Ch'i-ch'ang (1555–1636; cat. no. 45) and Chao Meng-fu (1254–1322; cat. nos. 11, 12). After passing the 1751 metropolitan examination and assuming office, his models in calligraphy shifted to the Sung dynasty masters Su Shih (1037–1101) and Huang T'ing-chien (1045–1105; cat. no. 6), as well as the T'ang calligrapher Yen Chen-ch'ing (709–785). In most cases, his models would have been model-books (t'ieh), small-sized ink rubbings taken from engraved stone or wood. Rubbings, however, preserved only silhouettes of the original ink traces, so a calligrapher had to recreate and orchestrate the movements of the brush and the subtleties of the ink to suit the model, like a musician following a score. Recreating a performance of brush and ink was the focus of this so-called Model-book school (T'ieh-hsüeh) tradition, Liu Yung's mastery of which combined a fleshy, wet-ink style with a studied awkwardness and inner structure.

After the age of seventy, Liu Yung began to concentrate more on Six Dynasties stele inscriptions written in monumental scripts that revealed an awkward vigor and archaic plainness. Liu began to conceal his brush tip to produce rounded strokes that resembled engraved lines, yet he was never able to escape his early model-book training. His study of monumental writing parallels the growing interest among calligraphers in early bronze and stone inscriptions—what would later be known as the Stele school

(Pei-hsüeh) tradition. Unlike the earlier focus of the model-book tradition on brush and ink, the aim of the new monumental-script calligraphers was to capture the boldness of carved strokes and their rough, weathered appearance. Brush and ink became the media through which to represent the forms of carved characters.

The analogy between calligraphy and musical performance is appropriate for this hanging scroll, which gathers commentaries on ancient texts including *The Book of Changes (I ching)* and the *Chuang Tzu*. The final commentary concerns two odes in *The Book of Poetry (Shih ching)*:

> Yüan-fu said that the "Nan-kai" and "Pai-hua" odes have musical tones but no vocal rhyme, so they were played on *sheng* pipes and not voiced in song. They had meaning but no lyrics. They were not lost.[2]

The "Nan-kai" and "Pai-hua" are two of six odes traditionally believed lost from *The Book of Poetry*, but, as argued by the Neo-Confucian scholar Chu Hsi (1130–1200), their texts were never really lost, because they were originally only musical tunes. Although they had no lyrics, they had meaning; for example, the "Nan-kai" stood for filial sons admonishing each other on the duty of parental support. Hence, despite the absence of words, the performance of music imparts meaning. Similarly, calligraphy—even writing that cannot be read—could express meaning through its mere performance.

C.Y.L.

Notes

1. For Liu Yung's biography, see Arthur W. Hummel, ed., *Eminent Chinese of the Ch'ing Period* (Washington, D.C.: U.S. Government Printing Office, 1943), 536–37.
2. "Yüan-fu" may be the courtesy name (with an alternate character) for the scholar official Liu Ch'ang (1019–1068), whose collected writings, *Kung-shih chi*, were partly reconstructed during Liu Yung's lifetime from excerpts in the Ming *Yung-lo ta-tien* encyclopedia. This raises the possibility that all of the transcribed passages in this scroll may have been drawn from works being reconstructed from the Ming encyclopedia during the Ch'ing compilation of *The Comprehensive Library of the Four Treasuries*, in which Liu Yung participated. Alternatively, "Yüan-fu" may be a respectful reference to Chu Hsi.

介甫云輔嗣云家謂馬者必形之物鎮席云威盛
之蒙自晦而上玉以則泗負吉悔之吳沖卿玉座
于姑射今人棗湌心惟吾羲惟吾於社二坊
原甫云南陰白華有聲無病如云筌不云歌
有于蒙二具翁非俟之也

石菴

40

I Ping-shou (1754–1815)

Couplet on Venerable Officials

Dated 1813
Pair of hanging scrolls, ink on gold-flecked paper
Each scroll, 162.7 x 32.9 cm
1998-64 a & b

Written in his mature clerical script, characterized by bold uniform lines and an overall decorative appearance, this couplet was executed by I Ping-shou near the end of his life. The couplet can be translated literally:

> Venerable officials and pure scholars are the trees,
> left and right;
> Divine sages and immortal beings are the flowers,
> high and low.

A close reading allows the subject to be identified as being virtuous and venerable officials, which may indicate that I Ping-shou executed it as a gift for a fellow official.[1]

A native of Ting-chou, Fukien, I Ping-shou served in government office for most of his life.[2] Passing the metropolitan examination in 1789, he was appointed to a series of posts, including that of prefect of Yangchow in 1802. Because of years of scribal duty, I Ping-shou was well versed in the Chancellery script (*T'ai-ko t'i*) style used for imperial documents, but his government career also garnered him a reputation as an honest and upright official (*hsün-li*), hence his affinity for the bold brushwork of the loyal official Yen Chen-ch'ing (709–785).[3] Combined with his studies of Han dynasty epigraphic models such as *Stele for Chang Ch'ien* (*Chang Ch'ien pei*) and *Ritual Vessels Stele* (*Li-ch'i pei*), and *The Hsi-p'ing Stone Classics* (*Hsi-p'ing shih-ching*), as well as ancient bronze inscriptions and Six Dynasties materials, I Ping-shou developed a unique clerical script using a concealed- or centered-tip brush technique. The square composition and spacing are modeled after such ancient engravings, while the vertically held brush produced bold, even, centered-tip strokes with vibrant contours and blunt ends. In a thirty-two character maxim on calligraphy, I Ping-shou argued for the need to provide a strong, underlying square-and-upright structure (*fang-cheng*) for each character, which then could be enlivened by wielding brush and ink with wondrous unrestraint (*ch'i-ssu*) in brush sentiment and unrestrained indulgence (*tzu-tsung*) in brush force.[4] In his terminology, this description of enlivening calligraphy clearly implied visual and moral aspects that were to be embodied in written images. It is this deliberate mixture of bold, upright brush styles of past models, such

as Yen Chen-ch'ing and Liu Kung-ch'üan (778–865), with the unexpected, novel qualities drawn from his study of archaic inscriptions that imparted strong moral and personal associations to I Ping-shou's distinctive clerical-script style.

I Ping-shou's early predilection toward ancient epigraphic models was probably motivated by his training as a calligrapher under Liu Yung (1719–1804; cat. no. 39) and coincided with his study of the art of seal carving. He may also have been influenced by the patronage he received from scholars such as Chi Yün (1724–1805), the compiler-in-chief of *The Comprehensive Library of the Four Treasuries* (*Ssu-k'u ch'üan-shu*); and the official and scholar Chu Kuei (1731–1807), an instructor of the emperor's sons and a chief proofreader for *The Comprehensive Library of the Four Treasuries* project. He also was influenced by friendships with other calligraphers, antiquarians, and officials known for their study of metal and stone relics (*chin-shih hsüeh*), including Kuei Fu (1736–1805) and Juan Yüan (1764–1849). In his writings on calligraphy, Juan Yüan was the first to divide calligraphers into Model-book school (*T'ieh-hsüeh*) and Stele school (*Pei-hsüeh*) lineages, and he credits I Ping-shou, with his interest in ancient epigraphic models, as being one of the founders of the Stele-school movement in the Ch'ing period.

C.Y.L.

NOTES

1. For a more detailed analysis of the reading and translation of this couplet, see Cary Y. Liu's essay in this volume.
2. For I Ping-shou's biography and discussion of his calligraphy, see Chu Jen-fu, *Chung-kuo ku-tai shu-fa shih* (Peking: Pei-ching ta-hsüeh ch'u-pan-she, 1992), 519–24; *Chung-kuo shu-fa wen-hua ta-kuan*, ed. Chin K'ai-ch'eng and Wang Yüeh-ch'uan (Peking: Pei-ching ta-hsüeh ch'u-pan-she, 1995), 598–603; and special issue of *Shohin* no. 67 (1965): 1–56.
3. On Yen Chen-ch'ing's calligraphy as a stylistic model embodying loyalty, integrity, and upright behavior, see Amy McNair, *The Upright Brush: Yan Zhenqing's Calligraphy and Song Literati Politics* (Honolulu: University of Hawaii Press, 1998).
4. *Chung-kuo shu-fa wen-hua ta-kuan*, 601–2.

薈宮青士左右封

癸百二月

神君儸人高下等

汀州伊書霞

41

Ho Shao-chi (1799–1873)

Couplet on Transcending Limitations

Undated
Pair of hanging scrolls, ink on paper
Each scroll, 153.5 x 36.1 cm
1998-63 a & b

Ho Shao-chi, the son of a court minister, began his official career as a compiler in the Hanlin Academy in 1839.[1] In 1855 he was dismissed from his position as educational commissioner of Szechwan after being accused of submitting imprudent proposals to the throne. Never to return to public office, Ho traveled extensively before settling in the mid-1860s in Soochow, where he was esteemed for his calligraphy.

This clerical-script couplet expresses wishes for overcoming challenges and obstacles:

> The cosmos is unbounded, yet the myriad mountains rise;
> The clouds and mist are motionless, yet the eight windows
> are clear.[2]

The couplet was dedicated to a local official named T'ung-hsüan, which suggests that it may have been composed to commemorate the latter's new appointment to higher office and to wish him success in overcoming future challenges and obstacles. Beyond mere words of well wishes, however, such calligraphic couplets embodied portals or passages between successive stages in life. As written diagrams (*t'u-shu*), such couplets charted passage to future success; they were believed to embody forces that had been associated with the Chinese written word since its origins with the legendary River Diagram (*Ho-t'u*) and Lo Writing (*Lo-shu*) outlined in *The Book of Changes (I ching)*.[3]

In his writings about calligraphy, Ho Shao-chi declared allegiance to the Stele school and its preference for ancient inscriptions on metal and stone. Early in his career he followed the monumental brush style of Yen Chen-ch'ing (709–785) and other T'ang dynasty calligraphers. Later, he began to incorporate elements of seal and clerical script styles learned from copying Six Dynasties, Han, and earlier inscriptions. By studying such monumental models and inscriptions, Ho synthesized his own brush style using a suspended-arm (*hsüan-pi*) technique that restricted brush movement yet produced controlled, tensely powerful strokes that appeared to be engraved into the surface.

C.Y.L.

Notes

1. For Ho Shao-chi's biography and discussion of his calligraphy, see *Chung-kuo shu-fa wen-hua ta-kuan*, ed. Chin K'ai-ch'eng and Wang Yüeh-ch'uan (Peking: Pei-ching ta-hsüeh ch'u-pan-she, 1995), 603–8; and Arthur W. Hummel, ed., *Eminent Chinese of the Ch'ing Period* (Washington, D.C.: U.S. Government Printing Office, 1943), 287–88.

2. For a more detailed analysis of the reading and translation of this couplet, see Cary Y. Liu's essay in this volume.

3. For various interpretations concerning the River Diagram and Lo Writing, see Cary Y. Liu, "The Ch'ing Dynasty Wen-yüan-ko Imperial Library: Architecture and the Ordering of Knowledge" (Ph.D. diss., Princeton University, 1997), 282–83; Florian C. Rieter, "Some Remarks on the Chinese Word *T'u* 'Chart, Plan, Design,'" *Oriens* 32 (1990): 308–27; and Tu Hsüeh-chih, "Ho-t'u Lo-shu pa-kua yü t'u-hui chi-shih," *Ta-lu tsa-chih* 8, no. 5 (1954): 12–13.

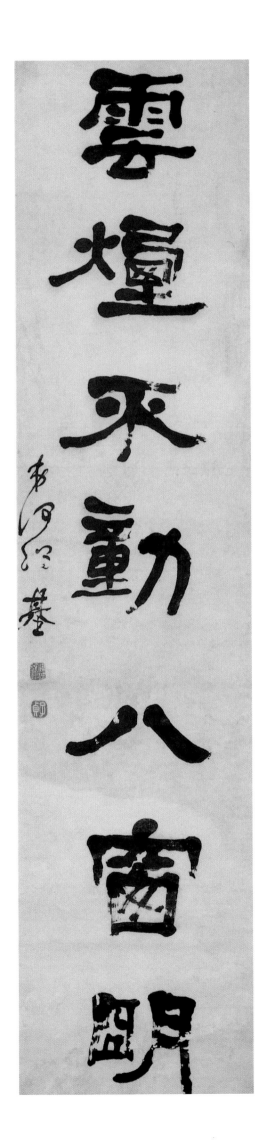

雲煌天動八窗明

宇宙無邊萬山空

Calligraphy after Chung Yu

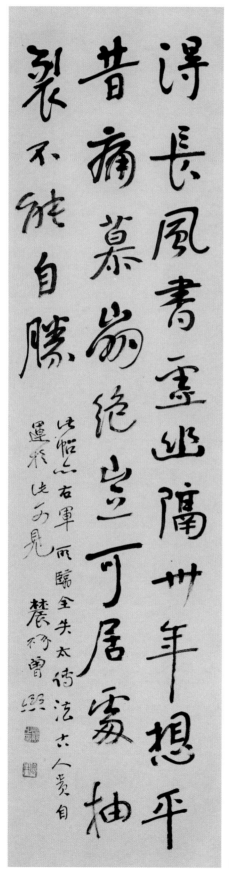

得長風書靈幽隔卅年想平
昔痛慕崩絕豈可居霧袖
裂不能自勝

法帖右軍而臨全失太傅法古人貴自
運形於而見
農石曹熙

白騎遂內書不俟車駕討吳
人權道情懷急切當以時月
待取伏罪之言蓋不以疑

太傅此帖蓋右軍
所臨熙

d

c

臣縣言力命之用以至三幄
幄之謀而又愚老聖恩低佪以
殊禮天下始定帥土欣戴

臨太傅力命
麓材

眾生所任之處其地之豐壤肥
腰過於餘地克曼國地所生之
物莫得增長兹茂

光明經墨蹟之太傅
餘波熙

Undated
Four hanging scrolls, ink on paper
Each scroll, 150.3 x 39.8 cm
1998-67 a–d

An innovative calligrapher and painter, Tseng Hsi was known as one of the Four Eccentrics of Shanghai, along with Li Jui-ch'ing (1867–1920; cat. no. 43), Kao Yung (1850–1921), and Lü Feng-tzu (1886–1959). Tseng Hsi, a native of Heng-yang, Hunan, passed the 1903 metropolitan examination and served at the Ch'ing court in Peking until the dynasty's collapse in early 1912.[1] Moving to Shanghai, he began selling his calligraphy to earn a living in 1915. Especially adept at writing in seal and clerical script, he became a leading figure in artistic circles and is known for his role as a mentor of the painter Chang Ta-ch'ien (1899–1983).

Tseng's calligraphy was modeled after his study of ancient inscriptions on metal, stone, and bamboo slips. He also valued the assertive yet awkward quality of Han dynasty clerical script and Northern Dynasties stele inscriptions. According to his close friend Li Jui-ch'ing, Tseng particularly emulated the clerical-script style of the Han official and calligrapher Ts'ai Yung (133–192), combining it with brush elements gleaned from studying the celebrated calligraphers Chung Yu (151–230) and Wang Hsi-chih (303–361; cat. no. 2).[2] In this series of four hanging scrolls, Tseng creatively combined aspects of the Model-book school (T'ieh-hsüeh) and Stele school (Pei-hsüeh) traditions that dominated the dialogue in calligraphic circles after formulation by the scholar-official Juan Yüan (1764–1849). The calligraphy and text of each scroll are modeled on writings by Chung Yu found in well-known model-books (t'ieh)—

ink rubbings that served as models for countless generations of calligraphers. For example, the transcribed texts of two scrolls were included in *Model Calligraphies from the Imperial Archives of the Ch'un-hua Era* (Ch'un-hua pi-ko t'ieh), carved in 922, and a third text was first cut into a model-book in the Southern Sung period and later included in *Model Calligraphies from the Yü-yen Hall* (Yü-yen-t'ang t'ieh) of 1612.

The textual content of these four scrolls is less important than the stylistic models to which Tseng Hsi's calligraphy alludes. He only partially recorded each text and transformed what had been small writing in the model-book tradition into monumental writing. Enlarging the characters to fit a hanging scroll format, he adopted new brush methods and techniques learned from his study of ancient stele inscriptions. The intellectual basis for this innovation may have been Juan Yüan's claim that the Model-book and Stele schools had common origins in early Six Dynasties calligraphy that predate Wang Hsi-chih (cat. no. 2), in particular the calligraphy of Chung Yu. On this basis Tseng Hsi combined the small-scale Model-book and monumental Stele school calligraphic traditions, playing with their shared stylistic sources.

C.Y.L.

NOTES

1. For Tseng Hsi's biography, see Li Jui-ch'ing, "Heng-yang Tseng Tzu-ch'i yü-shu chih-li yin," in idem, *Ch'ing-tao-jen i-chi* (N.p.: Chung-hua shu-chü, 1939), "I-kao," 15b–16b; and Ma Tsung-huo, comp., *Shu-lin tsao-chien* (Ch'ing-tai chuan-chi ts'ung-k'an ed., Taipei: Ming-wen shu-chü, 1985), 262–63.
2. Li Jui-ch'ing, "Pa Tseng Nung-jan Hsia Ch'eng pei lin-pen," in idem, *Ch'ing-tao-jen i-chi*, "I-kao," 27b.

43
Li Jui-ch'ing (1867–1920)

Couplet on Achievements and Virtues

Dated 1916
Pair of hanging scrolls, ink on paper
Each scroll, 148.5 x 39.8 cm
1998-65 a & b

A man of imposing physical stature, Li Jui-ch'ing pursued advanced studies at the Hanlin Academy in Peking after passing the metropolitan examination in 1894.[1] In the latter years of the Ch'ing dynasty he refused to flee Nanking as

rebel forces advanced. Participating in the city's military defense, he expressed his willingness to emulate past patriot-martyrs, and after the Ch'ing collapse in early 1912 steadfastly refused to serve the new regime. Disguising himself as a Taoist, he became known as the Taoist Ch'ing (Ch'ing Tao-jen) to demonstrate his loyalty to the fallen dynasty. Living as a professional artist, Li moved to Shanghai, where his close friend the calligrapher Tseng Hsi (1861–1930; cat. no. 42) resided.

Li was best known for infusing his large-scale writing with elements of seal and clerical scripts learned from

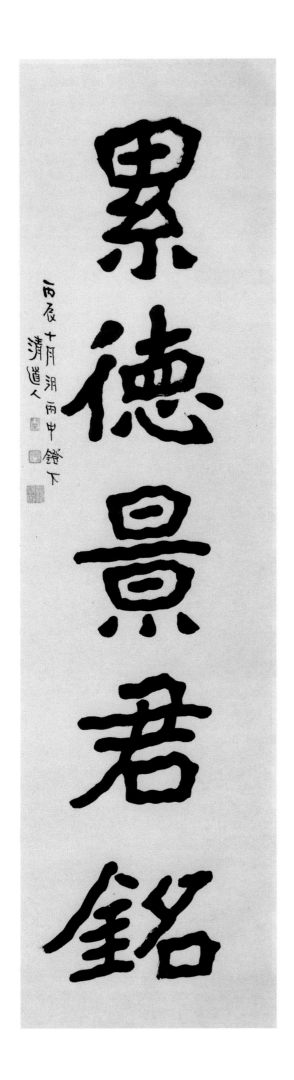

累德景君銘

紀功燕山石

studying ancient bronze and stone inscriptions. As displayed in this couplet, Li's large standard-script style was produced by a tightly held brush wielded like a stylus to produce tremulous strokes similar to those seen on worn stone engravings. Li Jui-ch'ing argued that all calligraphy originally derived from ancient seal-script writing. A second great source, Li claimed, was stone engravings from the Han and Northern Wei dynasties. As confirmed by his inscription on this pair of hanging scrolls, the text of the couplet consists of words taken from the Han *Stele for Hsia Ch'eng* (*Hsia Ch'eng pei*), while the style of the standard-script calligraphy is based on the Northern Wei *Later Stele for Cheng Wen-kung* (*Cheng Wen-kung hsia pei*).

A close relationship between literary content and calligraphic style in the couplet serves to reinforce the thematic content of the words:

> Recording achievements [*kung*] like the *Yen-shan Stone*;
> Enumerating virtues [*te*] like the *Ching-chün Inscription*.

The *Yen-shan Stone* was a clerical-script stone inscription carved during the Later Han period and erected atop Mount Yen-jan to commemorate a victory over the Hsiung-nu people in A.D. 89. The *Ching-chün Inscription* was carved on a Han stele dated A.D. 143. It listed the virtues of an official and later become a model for clerical-script calligraphy.[2] By basing his own calligraphic style on that of ancient monuments he wrote about, Li Jui-ch'ing manifested his theory of the development of calligraphy from its roots in seal- and clerical-script engravings to its culmination in standard-script forms.

<div align="right">C.Y.L.</div>

NOTES

1. For Li Jui-ch'ing's biography, see Chao Erh-hsün et al., comps., *Ch'ing shih kao* (Taipei: Hung-she ch'u-pan-she, 1981), *chüan* 486: 13437; and Chiang Kuo-pang and Liu Chao-chia, in Wang Chao-yung, comp., *Pei-chuan chi san pien,* reprint ed. (Hong Kong: Ta-tung t'u-shu, 1978), *chüan* 21: 1245–55.
2. For a more detailed analysis of the reading and translation of this couplet, see Cary Y. Liu's essay in this volume.

衡

翁尊師大人先生

門生陳衛復

門下

*Letters from the Ming and
Ch'ing Dynasties*

Personal letters were among the first works of Chinese calligraphy to be collected, subjected to critical evaluation, sold, and forged.[1] They were valued not for their literary contents, however, which often were banal, but for the quality of the calligraphy in which they were written. Transmitted through handwritten copies and in rubbings, letters by Wang Hsi-chih (303–361; cat. no. 2) constituted the heart of the classical tradition of calligraphy and served as models for later calligraphers who hoped to have their own letters judged by the same aesthetic standards.

Owing to their informal, personal nature, letters by Wang Hsi-chih and by other members of the aristocracy of the Eastern Chin dynasty embodied the cultural ideal of self-expression through calligraphy. During the Northern Sung period, the calligrapher Mi Fu (1052–1107) conducted an exhaustive study of calligraphy by Wang Hsi-chih, which is preserved mainly in the form of letters. In Mi's own letters (cat. no. 7) his restless, change-able brushwork embodies through brush and ink a rec-ord of his responses to the events he describes. Letters by Chao Meng-fu (1254–1322; cat. no. 12), the leading callig-rapher of the Yüan dynasty, and members of his family reveal that even when writing about mundane affairs, members of elite social classes took care to observe rules of decorum, such as leaving blank spaces before a recipi-ent's name to indicate respect. Woodblock-printed manu-als on letter writing (shu-i) provided guidance for writers who were unsure of these rules of spacing or proper forms of address.

Thousands of letters surviving from the Ming and Ch'ing dynasties document the continuing importance of this format of calligraphy and reveal ties of friendship, political alliance, and intellectual comradeship that bound China's literati elite. Although formal standard script (k'ai-shu) might be appropriate in a letter to an elderly relative or a person of exalted social status, most were written in combinations of informal running (hsing) and cursive (ts'ao) script.

In many letters the choice of stationery comple-mented the calligraphy and signified refined scholarly taste (cat. nos. 48, 49, 50, 51). Papers of different colors, materials, and texture were sometimes hand painted or printed using woodblocks with decorative designs or ruled columns. The use of such decorated letter paper has early origins. Wang Hsi-chih is said to have once written on violet paper, and many decorated papers became famous in the history of Chinese paper-making.[2] Decorated papers were esteemed as artworks in their own right and often were signed by the designer. In the Ming and Ch'ing periods the choice of stationery—along with the selection of ink, inkstone, brush, and other scholarly implements—became part of a writing process that complemented the artistic style and very content of calligraphy.

The letters in the John B. Elliott Collection demon-strate that this calligraphic format was often a means of publication. Among some four hundred letters, the con-tents range from literary poems and essays, descriptive observations and travelogues, and everyday notes and

shopping lists to personal missives and sentimental fare-wells. The Elliott Collection also contains examples of copying. For example, letters by the Ming loyalist Ni Yüan-lu (1593–1644) are found in duplicate, and a letter by the painter Shih-t'ao (Yüan-chi; 1642–1707) is also found in another collection.[3] This reflects the function of letter-copying as an informal medium of publication in an era without magazines and journals. Major works were published with the help of wealthy patrons, but lesser writings such as essays or notes could be disseminated through inclusion in letters. Letters were often meant to be copied—sometimes in the calligraphic style of the original—and circulated among one's colleagues to be discussed and criticized.[4]

The practice of collecting letters as calligraphic models, as historical and literary documents, and as artistic expressions of the writers continued to grow in the Ming and Ch'ing dynasties. Among the letter writers represented in the Elliott Collection are major figures in artistic, literary, religious, and official circles, such as Ch'en Ch'un (1483–1544; cat. no. 44), Tung Ch'i-ch'ang (1555–1636; cat. no. 45), and Wang Shih-chen (1634–1711; cat. no. 48); a scholar of epigraphy, Wu Ta-ch'eng (1835–1902; cat. no. 55); and a military leader, Liu Ming-ch'uan (1836–1896; cat. no. 52). These are synthetic works of literary and calligraphic art, paper-making, printing, and design. As collectibles, letters could be mounted as hanging scrolls or handscrolls, but were most commonly compiled in albums, as were a large set of letters in the Elliott Collection compiled in the late Ch'ing period.

Collections were probably assembled incrementally, with individual letters sometimes passing through the hands of several collectors; this may explain the almost haphazard ordering of letters found in albums.

The engraving and reproduction of letters as ink rubbings also developed in novel ways in the Ming and Ch'ing. New formats of display included engraved letters installed in the walls of gardens and architectural settings. The practices of taking rubbings from such engraved works and of copying letters widened the dissemination of letters; ironically, works usually associated with a private readership increasingly entered a public sphere.

R.E.H./C.Y.L.

NOTES

1. See the essay by Qianshen Bai in this volume.
2. Joseph Needham, ed., *Science and Civilisation in China*, vol. 5, part 1: *Paper and Printing*, by Tsien Tsuen-hsuin (Cambridge: Cambridge University Press, 1985), 91–96. For a study of decorated stationery of the Late Ming, see Suzanne E. Wright, "Visual Communication and Social Identity in Woodblock-Printed Letter Papers of the Late Ming Dynasty" (Ph.D. diss., Stanford University, forthcoming).
3. Shih-t'ao's original letter, now in the collection of the Shanghai Museum, is reproduced in Cheng Wei, ed., *Shih-t'ao* (Shanghai: Shang-hai jen-min mei-shu ch'u-pan-she, 1990), III, no. 1. We are grateful to Jonathan Hay for bringing this to our attention.
4. See David S. Nivison, *The Life and Thought of Chang Hsüeh-ch'eng (1738–1801)* (Stanford: Stanford University Press, 1966), 41, 106–7.

44
Ch'en Ch'un (1483–1544)

Letter to Wen Cheng-ming

Undated
Two album leaves, ink on paper
Right, 25.4 x 16.4 cm; left, 25.4 x 14.2 cm
1998-77 p & q

45
Tung Ch'i-ch'ang (1555–1636)

Two Letters

Undated
Double album leaf, ink on paper
24.7 x 31.7 cm
1998-79 c

Ch'en Ch'un, also known as Ch'en Tao-fu, was born into a prominent family in Soochow. His grandfather was a high-ranking government official and his father was a business-man. Both collected calligraphy and paintings. Although Ch'en Ch'un failed the civil service examinations and was unsuccessful in business, he became one of the most accomplished calligraphers and painters of the mid-Ming period. During his lifetime Soochow was the cultural center of China, and the Wu school of painting, made up of artists who lived in and around the city, was at its peak. Members of Ch'en's family had been friends with Shen Chou (1427–1509), the leading artist of the Wu school, and Ch'en himself studied with Wen Cheng-ming (1470–1559; cat. no. 27), another Wu school master. As an artist, Ch'en Ch'un excelled in the "boneless" (*mo-ku*) style of flower painting, in landscapes in the tradition of Mi Fu (1052–1107), and in cursive-script calligraphy.[1]

Ch'en's letter to his teacher Wen Cheng-ming is a rare example of his standard-script calligraphy. The letter invites Wen to attend the wedding of Ch'en's fifth son.[2] In most cases, Chinese letters are written in running or cursive script. Standard script is used for serious, formal occasions and for writing to one's parents and grandparents. Here Ch'en wrote in standard script to show respect for his teacher, although he allowed himself to use a few running-script characters.

The influence of the Wu school declined in the second half of the sixteenth century, as artists from the prefecture of Sung-chiang (near modern Shanghai) rose to promi-

nence. The dominant figure among Sung-chiang artists, and the most widely influential calligrapher of the entire Ming dynasty, was Tung Ch'i-ch'ang. Tung was born into a prominent family and passed the *chin-shih* examination in 1588. He enjoyed a highly successful official career, rising to the rank of president of the Ministry of Rites.[3]

In calligraphy, Tung Ch'i-ch'ang based his style on that of Wang Hsi-chih (303–361; cat. no. 2) but also synthesized elements from other masters to create a distinctive new style notable for its sudden changes of brush direction and tilted character structures. In the first of these two letters from the Elliott Collection, Tung thanks an unnamed recipient who had composed a poem or essay in honor of Tung's birthday. In the second letter, Tung mentions his son and grandson and alludes to matters concerning his family. Unlike Ch'en Ch'un's letter, written in more formal standard script, Tung's letters are in fluent and gracious running script, which he used for the great majority of his extant works of calligraphy.

Q.B.

NOTES

1. For Ch'en Ch'un's biography, see L. Carrington Goodrich and Chaoying Fang, eds., *Dictionary of Ming Biography, 1368–1644* (New York: Columbia University Press, 1976), 179–80.
2. For a translation of the letter, see the essay by Qianshen Bai in this volume.
3. On Tung Ch'i-ch'ang's biography and art, see Wai-kam Ho, ed., *The Century of Tung Ch'i-ch'ang, 1555–1636*, 2 vols. (Kansas City, Mo.: Nelson-Atkins Museum of Art, 1992).

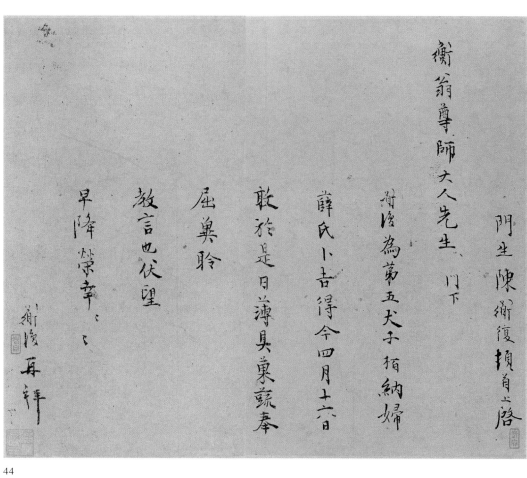

44

45

46
Chin Jen-jui (1608–1661)

Letter to Mao-ch'ing

Undated
Album leaf, ink on paper
28.0 x 15.3 cm
1998-83 n

47
Li T'ien-fu (1635–1699)

Letter to Kao Shih-ch'i

Undated
Two double album leaves, ink on paper
First double leaf, 18.1 x 22.1 cm;
Second double leaf, 18.1 x 22.3 cm
1998-81 aa & bb

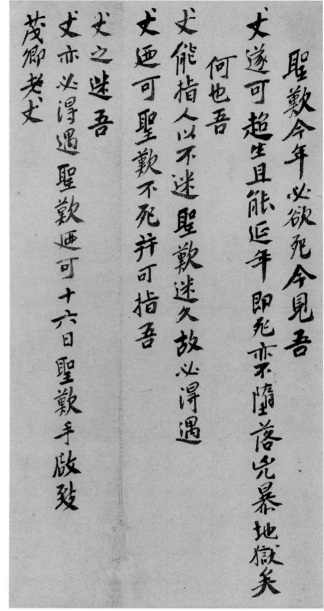

46

Born into a poor family near Soochow, Chin Jen-jui, also
known as Chin Sheng-t'an, displayed exceptional talent in
literature at an early age. He became a popular essayist and
humorist and wrote critical commentaries on the novel *The
Water Margin* and the play *Romance of the Western Chamber*.
Owing to his involvement in the Laments and the Temple
(*K'u-miao*) affair, an infamous political vendetta against
members of the Chinese gentry in Kiangsu, Chin was exe-
cuted by the Manchu government in 1661.

Chin's letter was sent to a person named Mao-ch'ing,
apparently a Buddhist monk. It reads,

> Sheng-t'an may die this year. But if he can see you soon, he
> will be able to release his soul from suffering and achieve
> long life. And if he does die, he will not fall into the vicious-
> ness of hell. And why not? Because you can point out the
> mental blocks that have long bound him. Therefore, Sheng-
> t'an must receive your help so he can beat hell. If Sheng-t'an
> should not die, he can in return point out your own mental
> blocks. For this reason, my master, you need Sheng-t'an, too.
> Sheng-t'an writes to Master Mao-ch'ing on the sixteenth day.

In his letter, Chin, who was a lover of vernacular fiction,
used informal language like that in his writings for a popu-
lar audience. Chin was also an eccentric, and this letter
asking his master's blessings is strangely worded.

Li T'ien-fu was from Ho-fei, Anhwei. He earned his *chin-
shih* degree in 1658 and became a highly successful scholar-
official during the early decades of the Ch'ing dynasty. He
held several important posts during the reign of the K'ang-

hsi emperor (1662–1722), serving in the ministries of
Works, War, and Personnel. In 1692 he joined the Grand
Secretariat.

Li's letter was addressed to Kao Shih-ch'i (1645–1703), a
calligrapher and art collector who also served the K'ang-hsi
emperor as a secretary in the imperial study. In this capac-
ity, Kao accompanied the emperor on tours of inspection.
In 1689 he was forced to retire after being accused of
accepting bribes. In his letter Li invites Kao to a banquet.
Although undated, the letter likely was written when Kao
was about to retire and return to his home in south China.
Perhaps because Li was both a friend and an important
political figure, Kao treasured this letter. Reading it again in
1701, he inscribed a note on the back of it and recalled the
banquet to which Li had invited him.

Q.B.

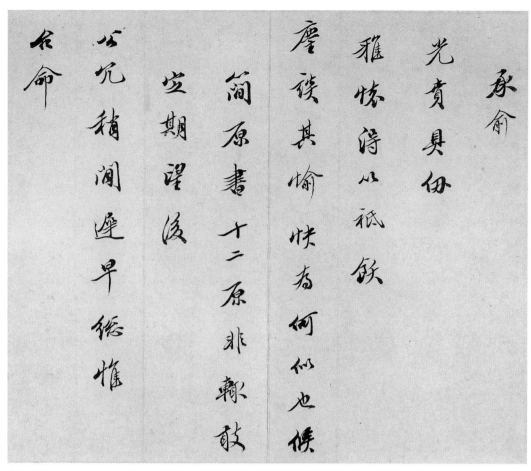

47 aa

47 bb

48
Wang Shih-chen (1634–1711)

Letter to a Friend

Undated
Double album leaf, ink on decorated paper
19.0 x 27.0 cm
1998-83 a

49
Hang Shih-chün (1696–1773)

Letter to Yü-ssu

Undated
Two album leaves, ink on decorated paper
Each leaf, 25.9 x 12.0 cm
1998-84 a & b

Wang Shih-chen, a poet and scholar-official of the early Ch'ing dynasty, came from a prominent family in Hsin-ch'eng, Shantung. After earning his *chin-shih* degree in 1658, he began a distinguished political career. He held many senior positions, including censor-in-chief and minister in the Ministry of Justice. In 1704 he was accused of misconduct and deprived of all his ranks and offices. He spent the rest of his life enjoying a peaceful retirement.[1]

Wang Shih-chen displayed remarkable literary talent in childhood and published his first anthology of verse when he was only fifteen. He went on to become a major poet and literary critic. His theory of poetry, founded on the

48

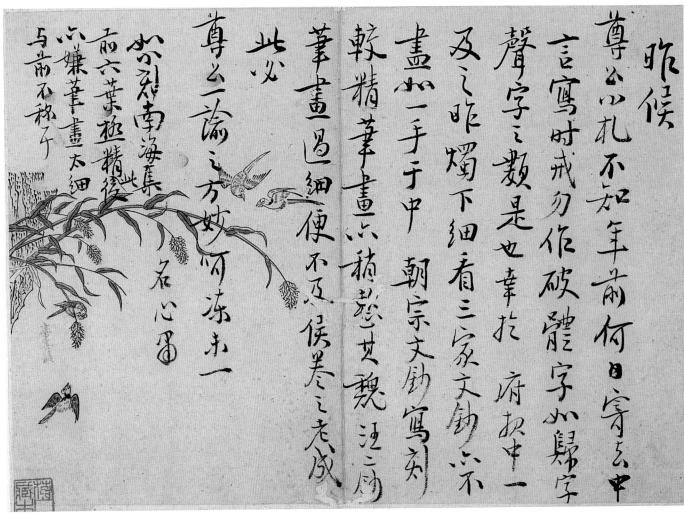

concept of *shen-yün,* or "mysterious spiritual harmony," had a profound influence on later literary criticism.

In this letter to an unnamed friend, Wang comments on the printing quality of three recent literary anthologies. The letter is written on ornamental paper, a form of material culture that flourished during the seventeenth century. The patterns on the letter paper create a complementary background for the thin, elongated strokes of Wang's calligraphy.

In his letter to a man named Yü-ssu, Hang Shih-chün[2]—a scholar, editor, and amateur painter—also employed ornamental letter paper. The bold, heavy strokes of his calligraphy contrast with the delicate floral patterns of the paper. The form of archaic clerical script that Hang used in this letter may have been inspired by Chin Nung (1687–1764; cat. no. 38), whom he befriended in Yangchow.

<div align="right">Q.B.</div>

NOTES

1. For Wang Shih-chen's biography, see Arthur W. Hummel, ed., *Eminent Chinese of the Ch'ing Period* (Washington, D.C.: U.S. Government Printing Office, 1943), 831–33.
2. For Hang Shih-chün's biography, see ibid., 276–77.

49 b

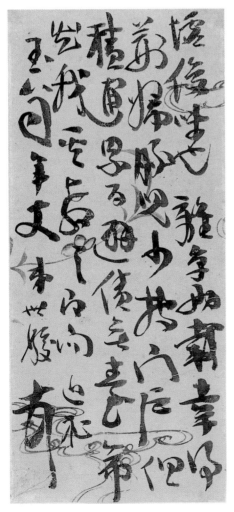

49 a

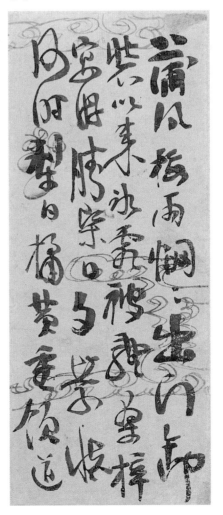

50

Wang Hsüeh-chin (1748–1804)

Letter to Chih-fang

Undated
Four album leaves, ink on decorated paper, stamped with
 "Hsü-pai-chai chih"
Each leaf, 23.9 x 14.2 cm
1998-90 o–r

51

Ch'in En-fu (1760–1843)

Letter to Tsu-p'ing

Undated
Two album leaves, ink on decorated paper, stamped with
 "Hsü-pai-chai chih"
Each leaf, 22.9 x 13.0 cm
1998-91 iii–jjj

52

Liu Ming-ch'uan (1836–1896)

Two Letters to Ting Jih-ch'ang

Undated
Three album leaves, ink on decorated paper
Each leaf, 23.0 x 12.8 cm
1998-90 bbb–ddd

Wang Hsüeh-chin, a native of Chen-yang, Kiangsu, obtained his *chin-shih* degree in 1781 and held several official posts, including that of imperial tutor. While still a young man, he also won fame as a poet. In calligraphy he followed the style of Chao Meng-fu (1254–1322; cat. nos. 11, 12), which was promoted by the Ch'ing court. In this letter Chao's influence is apparent in the well-balanced compositions and skillfully executed strokes. Although Wang wrote some of the characters in cursive script, these are not joined by linking strokes, and the overall effect of the letter indicates that he took considerable care in writing it to indicate respect for its recipient, whom Wang identifies as his teacher.

Ch'in En-fu was born in Chiang-tu, Kiangsu, and earned his *chin-shih* degree in 1789. He later served in the Hanlin

Academy. The eighteenth century witnessed the growth of book collecting and bibliographic studies, and Ch'in was well known both as a collector and as an expert on rare editions. With the assistance of the famous scholar Ku Ch'ien-li (1766–1835), he collated a number of important classics. Because of Ch'in's fame as a scholar, books he edited were known as "Ch'in editions." When the epigrapher Juan Yüan (1764–1849) was governor of Chekiang, he invited Ch'in to be the chairman of the prestigious Ku-ching Academy. Ch'in's letter, addressed to someone named Tsu-p'ing who lived in Nanking, concerns the receipt of a stone carving and a handscroll painting by the Southern Sung artist Ma Ho-chih (fl. ca. 1130–ca. 1170). Executed with great precision, the characters of Ch'in's letter seem to reflect the orderly mind of a careful editor and collator.

During the Ch'ing dynasty, literati often exchanged gifts of letter paper. The sheets of paper used by both Wang Hsüeh-chin and Ch'in En-fu bear the studio name "Hsü-pai-chai." Although the designs are not the same, both sheets bear vertical lines marking the columns and have borders decorated with flowers; these motifs, along with the studio name, may indicate that the stationery came from a single source.

Unlike the literati Wang Hsüeh-chin and Ch'in En-fu, Liu Ming-ch'uan came from a military background. He was born into a farming family in Ho-fei, Anhwei. As a young man he became involved in the illicit trade of salt, an enterprise at which he displayed extraordinary organizational ability. When his hometown was threatened in the 1850s during the Taiping Rebellion, he organized a local militia, which later proved to be an important force in resisting the rebels. In recognition of this deed, the Manchu government appointed Liu commander-in-chief of Chihli when he was only twenty-nine. After a series of military victories, Liu returned to Ho-fei, where he built a luxurious house and devoted himself to study and to entertaining visiting scholars. Later the Ch'ing government summoned him to conduct several military campaigns. In 1884 he successfully led Chinese troops against the French in Taiwan. The next year he was appointed the first governor of Taiwan and launched a series of reforms based on Western models to encourage modernization.

Although Liu rose from a humble background, he was a highly educated person. His two letters to Ting Jih-ch'ang (1823–1882), written in the 1870s, mention public affairs but also allude to his literary interests. The stationery is decorated with a pattern of I-hsing teapots, ceramics favored by the literati. Liu's choice of this paper indicates that although he was a military officer, he was eager to emulate the elegant cultural practices of the scholarly elite.

Q.B.

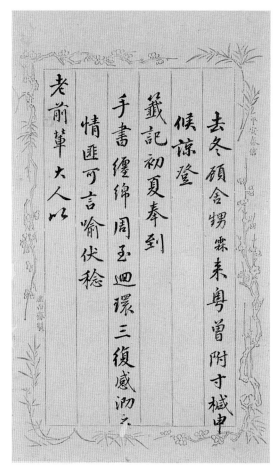

去冬頃舍甥霖來粵曾附寸楮申
候諒登
籤記初夏奉到
手書纏綿周至迴環三復感�
情匪可言喻伏稔
老前輩大人以

Leaf o

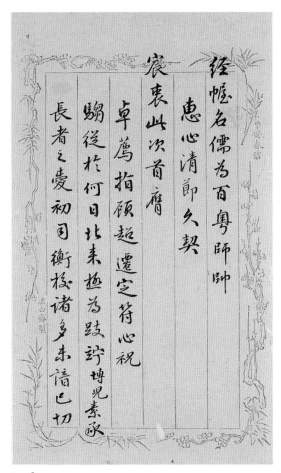

經幃名儒為百粵師帥
惠心清節久契
衰山次首庸
卓薦指顧超遷定符心祝
嬲從柽何日北來趨為跂竚博兒素承
長者之慶初司衡校諸多來信已切

Leaf p

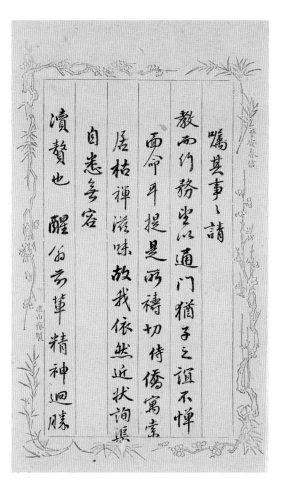

囑其事之請
教而行務望底通門猶子之誼不憚
而命年提是祈禱切侍僑寓業
居枯禪滋味故我依然近狀詢悉
自巻多客
瀆瀆也
醒㑷前輩精神迴賸

Leaf q

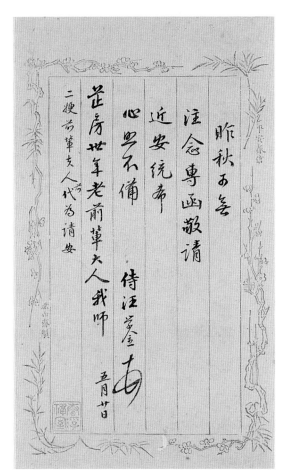

昨秋之冬
注念專函敬請
近安統希
心照不備
芷房世年老前輩大人我師
　　　　　　侍汪堂叩
　　　　　　五月廿日
二嫂前輩夫人代為請安

Leaf r

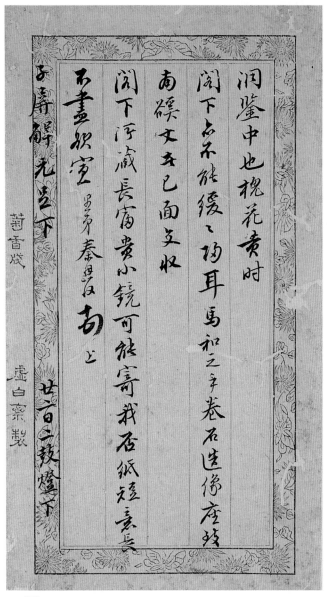

Leaf jjj

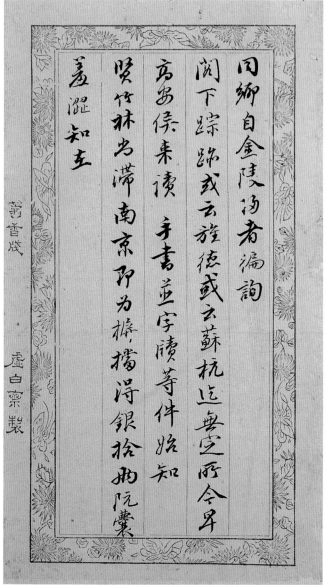

Leaf iii

Leaf bbb

雨生仁兄大人麾右闊別數年正深馳
念頃奉
手示欣悉
東山澒起　行旌已抵涪審挹入
觀後空結　至知川江兩省城目侍之弟
自壬申歸里閉戶養疴硯下如常歲
予告　慰自知魁直不善附和功名之

Leaf ccc

念之絕惟世事多變不特不把憂餘得
老兄持節兩江救蕃雪此於
業蕃為皖年百姓此願已三矣年重蒙
獎飾慚感何極言哀有近作詩稿一本
尊雪有近作詩稿一本人＝傳誦此有
人＝傳誦此有自籍未者謀
剩本祈
賜一部以便頒

Leaf ddd

教師家居毛亭偶爾看書大書覽筆鏡律
人學究之功未嘗早師蒙
垂問謹以附告承
賜會橙四十按此化廉順氣之品散雪願
不易得拜頷之下愧無覆報惟有叩
頷道謝弟於五月杪到蜀或予暇
教手此澶謝順卯
大喜玉芝等澥頻伍亭

53
Yü Yüeh (1821–1907)
Letter to Mr. Chung-hsiu

Undated
Two album leaves, ink on paper
Each leaf, 23.2 x 11.3 cm
1998-90 a & b

54
Tai Wang (1837–1873)
Letter to Chung-i

Undated
Album leaf, ink on paper
17.7 x 8.9 cm
1998-86 p

55
Wu Ta-ch'eng (1835–1902)
Letter to Ting Jih-ch'ang

Undated
Three album leaves, ink on paper
Each leaf, 24.2 x 12.7 cm
1998-86 aa–cc

Yü Yüeh was born into a scholar-official family in Te-ch'ing, Chekiang. He obtained his *chin-shih* degree in 1850. After seven years in government service he retired to devote himself to the study of Confucian classics and history, and in 1865 was appointed director of the Tzu-yang Academy in Soochow, where he lived for the rest of his life. It was from the name of his garden there, the Ch'ü-yüan, that Yü came to be known as Mr. Ch'ü-yüan.[1]

Yü Yüeh's letter is addressed to a person identified only as Mr. Chung-hsiu, who owned a rare copy of a treatise by Chang Hsüeh-ch'eng (1738–1810) titled *General Principles of Literature and History (Wen-shih t'ung-i)*. Yü states that although he knows Chung-hsiu is busy studying it, he would like to borrow the book. Should that not be possible, Yü offers to send money to have the text transcribed. Yü also mentions an essay of his own on ancient rituals that accompanied his letter. To give his letter an archaic and scholarly flavor, Yü Yüeh wrote it in clerical script, a form of calligraphy that had been used for stele inscriptions during the Han dynasty.

Tai Wang, a native of Te-ch'ing, Chekiang, never progressed academically beyond the *chu-sheng* degree, although he did study under several distinguished scholars and excelled in etymology and paleography. In spite of his

Leaf b

Leaf a

been a highly educated person able to read and appreciate the archaic characters. The format of the letter is also noteworthy. The two large characters in the upper right corner are Tai's name; the body of the letter is written in smaller characters. Although Tai's name is larger than that of the letter's recipient, the two characters of Chung-i's name are elevated to indicate respect. The resulting visual format recalls that of a modern business card, on which the bearer's name is the most eye-catching element. Receiving a letter in this format, the recipient would know immediately who sent it and would decide quickly whether it deserved special attention.

early death at the age of thirty-six, Tai left behind a voluminous body of scholarly works. In his letter, addressed to someone identified only as Chung-i, Tai reports that he had been invited to visit Chien Jung-t'ang, a Fukien official.

In the Ch'ing dynasty, paleography was a prestigious field of research and was thought to be an important method for studying the Confucian classics. Paleography also fostered interest in ancient scripts, including small seal script, one of the oldest forms of Chinese writing. This is the script type used by Tai Wang here. Consisting of over 230 characters, the letter required a great deal of time to write. Tai's efforts indicate that Chung-i himself must have

Wu Ta-ch'eng, a native of Soochow, studied under Yü Yüeh at the Tzu-yang Academy and became the most accomplished paleographer of the late Ch'ing dynasty. He earned his *chin-shih* degree in 1868 and was appointed to several official posts, including those of compiler in the Hanlin Academy and governor of Kwangtung and Hunan. Wu also became deeply involved in military and diplomatic affairs during the crises that faced China in the second half of the nineteenth century. He was sent by the government to border areas to settle conflicts with Russia, France, and Japan. In the Sino-Japanese War of 1884–85, troops led by Wu were defeated, and he retired soon afterward.[2]

An antiquarian, scholar, and collector, Wu Ta-ch'eng had a thorough knowledge of ancient jades, bronze inscriptions, and seals. Even today, his works on these subjects are often cited. As the most distinguished paleographer of his time, Wu sometimes wrote letters in great seal script, a form of writing even more ancient than the small seal script used by Tai Wang here. Wu's letter to Ting Jih-ch'ang (1823–1882), however, is written in running script and discusses official business, including the payment of custom duties in Tientsin and the purchase of machinery. Although Wu based his running script on that of Huang T'ing-chien (1045–1105; cat. no. 6), he edits out Huang's idiosyncratic mannerism to produce a more carefully balanced and conventional form of writing.

<div align="right">Q.B.</div>

NOTES

1. For Yü Yüeh's biography, see Arthur W. Hummel, ed., *Eminent Chinese of the Ch'ing Period* (Washington, D.C.: U.S. Government Printing Office, 1943), 944–45.
2. For Wu Ta-ch'eng's biography, see ibid., 880–82.

Leaf p

雨生大公祖大人閣下敬里愚之未獲暢聆
教益婁江道中泐布寸緘計已早達
典籤敬維
福德日崇
勛名益泰上祝
八座下慰蒼生莫名抃頌弟此次由滬來津連日北風
大作輪船行匝十日始達沽口馮竹翁屬鐵深疲凡
因未購到屬其隨後支輪船寄津再託要便帶都

Leaf aa

手書及茶葉適有同鄉入都先託帶去益之胶明
旭師呶几因不便帶寄後續寄也節相李
命萬理洋務事權歸一柞高坡不乞禪益添設津海關
道一缺奏請陳子敬署理頗洽眾望節相六
深資臂助益留品蓮在此辦理機器邺迤事整
頓不乞以除積習而者浮費惟開辦之始專任審
安士以時議即家章核實撐節末免多所任審
耳者三整隊西行㸃與劇佳若再庸已朱賢耷

Leaf bb

勛安臨穎依馳百不宣一 治愚弟期吳大澂頓首閏月初言
餘即興云否等任企仰手肋敬請
乃及時疏濬寶蘇松太名屬數十百年之利年内
承遵行未忘 僉相顧任後意見何如耳瀕湖蕩港俱
裁即陂由後路糧台安放業已批餉桂道俟
謝裁撤多船 節相益云興議慶麥多歸如一律云
尊見以為益滙揚水師李
乃人而理他名帖名姱為名臣不獨有禪軍政

Leaf cc

Essays

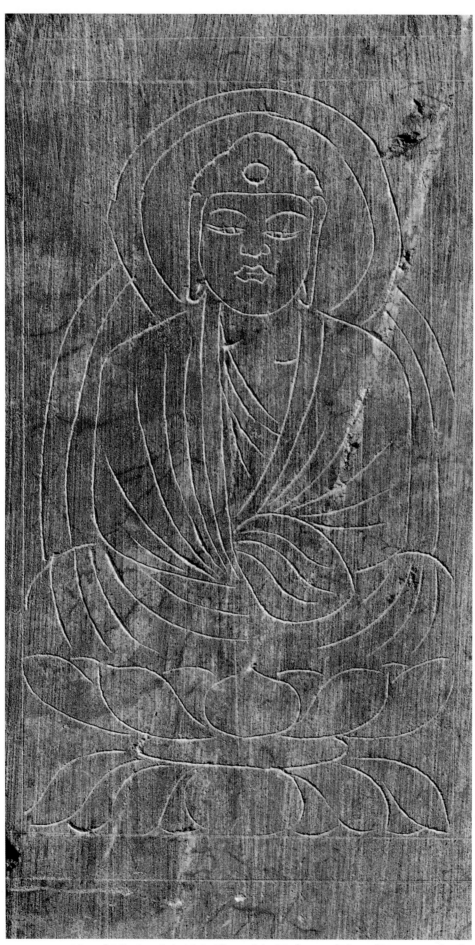

Anonymous, *Dhāraṇī Pillar Inscribed with Buddhas and the "Uṣṇīṣa-vijaya Dhāraṇī"* (cat. no. 5, detail).

Texts of Taoism and Buddhism and the Power of Calligraphic Style

AMY MᴄNAIR

Before the invention of printing in China, the transcription and propagation of religious texts required the skills of expert calligraphers sponsored by the imperial court, monastic institutions, or private patrons. Even after the use of printing made mass production of texts relatively inexpensive and efficient, handwritten Taoist classics and Buddhist sutras continued to be produced as acts of devotion in which the perfection of the calligraphy was thought to enhance their religious efficacy. Inscriptions for epitaphs or stelae erected at tombs, temples, and monasteries also demanded writing that was formal, precise, and easily legible. With remarkable consistency, standard script (*k'ai-shu*) was the form of calligraphy deemed most suitable for these texts. This script type, which emerged around the third century A.D. and achieved its full maturity during the T'ang dynasty, features characters written with carefully articulated brushstrokes and is the most easily legible of all forms of Chinese writing. Although the history of this script, like that of all forms of calligraphy, is dominated by famous masters who generally were members of elite social classes, a dynamic relationship between their styles and those of anonymous scribes fascinated and at times perplexed collectors and critics of calligraphy.

Six works of Taoist and Buddhist calligraphy in the Elliott Collection (cat. nos. 1, 3, 4, 5, 10, 11), all written in standard script, span a millennium in the history of this script type. They are diverse not only in style, but in content, format, and function, and they speak eloquently of the political and cultural environments in which they were produced. In addition, the colophons appended to these works by later writers offer a view of their reception in traditional and modern times.

The oldest manuscript in the Elliott Collection is a scroll consisting of chapters 51 through 81 of the *Tao-te ching*, the Taoist classic traditionally attributed to Lao-tzu (ca. 604–531 B.C.). The manuscript is dated to the year 270 and signed with the name So Tan (cat. no. 1). The paper of the scroll is as brown as a tobacco leaf, but the ink is lustrous and black. This manuscript was said to have been found at the Buddhist Mo-kao Grottoes of Tun-huang, in the northwestern province of Kansu, as part of the cache of thousands of religious texts and paintings discovered by a Taoist monk in a sealed grotto in the year 1900. The contents of the grotto were looted over the next decade, first on a small scale by the monk, then on a grand scale by foreign explorers from Britain and France, and, finally, by the very Chinese officials charged with protecting what was left. In 1910 the Ministry of Education collected the thousands of scrolls that remained, but thanks to his personal connections with an official in Kansu, the Chinese diplomat Li Sheng-to (1860–1937) was able to sift through the material and retain certain items for himself.[1] He is said to have divided some longer scrolls into two or three parts, in order to disguise the thefts and bring the collection back up to its official number.[2] Perhaps that explains why the So Tan manuscript consists of only the final third of the *Tao-te ching* text. The scroll does bear impressions of Li Sheng-to's seals, although their authenticity has been questioned.[3] After Li's death, the scroll passed to Chang Ku-ch'u in 1947, who soon departed Peking for Hong Kong. In 1985 it entered the Elliott Collection.

So Tan (ca. 250–ca. 325) was a member of an educated elite family from Tun-huang that included the famous calligrapher So Ching (239–303). He was around twenty years old when he wrote this manuscript. As a young man, he traveled to the capital at Loyang, in central China, to study at the National University. His official biography does not claim he was a Taoist per se, but reports that beyond his erudition in the Confucian classics, *yin-yang* philosophy, and astronomy, he was skilled at the arts of prognostication. Indeed, he was prescient enough to flee the

Figure 1. Anonymous, *Annals of Wu* (detail), late 3rd century, hand-scroll, ink on paper, height 23.5 cm. Shodō Hakubutsukan, Tokyo. From Nakata Yūjirō, *Chinese Calligraphy*, trans. Jeffrey Hunter (New York and Tokyo: Weatherhill, 1982), pl. 15.

murderous struggles at the Western Chin court in Loyang and to return home. Jao Tsung-i has speculated that from Loyang, So Tan first went south to Nanking, capital of the kingdom of Wu (222–80).[4] Such a journey, though unproven, could explain why the manuscript was dated by So Tan to the Chien-heng era (269–271) of the Wu Kingdom.

The So Tan scroll has attracted mainly philological interest as an early version of the Taoist classic. In 1955 Jao Tsung-i published his study of the text, in which he compared it to the main versions of the *Tao-te ching* known to him then. (The two Ma-wang-tui versions of the second century B.C. were not discovered until 1972.)[5] Jao concluded that it was in the third-century Ho-shang-kung tradition. William Boltz, in a recent study, argues that the So Tan manuscript matches the Ho-shang-kung version to some extent, but also seems to be affiliated with the early T'ang-dynasty version of Fu I.[6] According to Boltz, various anomalies in the text point to a date between 735 and 960. One is that the So Tan manuscript is titled *T'ai shang hsüan yüan Tao-te ching*. According to the basic annals of *Old T'ang History* (*Chiu T'ang shu*), the title *T'ai shang hsüan yüan* was given to Lao-tzu, the presumed author of the *Tao-te ching,* by Emperor Kao-tsung in the year 666. Soon after 666 several commentaries and texts of the *Tao-te ching* were produced with *T'ai shang hsüan yüan* in the title.

Another apparent anachronism appears in chapter 58, where a passage of the So Tan manuscript differs from all other recovered and received versions of the text. Boltz has identified this variant as being quite similar to Emperor Hsüan-tsung's "Imperial Commentary" on these lines, which was completed in 735. In the So Tan manuscript the grammatical structure has been rearranged to clarify the meaning of the text. Boltz points out other such clarifications in chapters 65, 66, and 74.

Two additional methods can be used to assess this scroll: orthography and stylistic analysis. In terms of orthography, there are archaic characters found in the So Tan manuscript that would not have been used by a T'ang writer. Orthography, or "correct writing" (*cheng-tzu fa*), was promoted by private scholars and by the state, beginning in the early T'ang, as necessary to success in the official examinations. As a result, the accuracy of orthography in the T'ang dynasty was extremely high.[7] As one example of the pre-T'ang orthography of the So Tan manuscript, the character used for the word *chi* in chapter 52 (the fourth character in line seven) is cited as an archaic character by the sixth-century dictionary *Jade Bookleaves* (*Yü p'ien*).[8] It is doubtful that this character would have been in current use in the T'ang dynasty.

Figure 2. Anonymous, *Personal letter*, fragment from Lou-lan, 3rd century, ink on paper. From *Shodō zenshū*, n.s. (Tokyo: Heibonsha, 1965), 3: pl. 6.1.

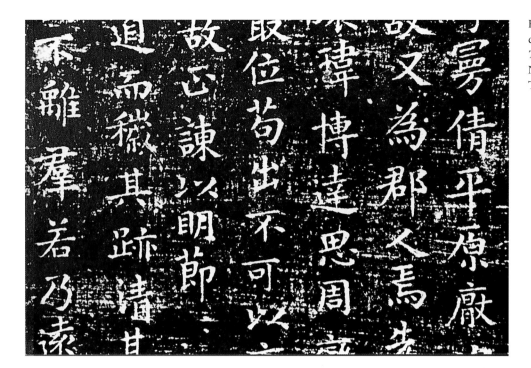

Figure 3. Attributed to Wang Hsi-chih, *Encomium on a Portrait of Tung-fang Shuo*, 356, ink rubbing. National Palace Museum, Taipei, Taiwan, Republic of China.

A stylistic comparison of the So Tan manuscript and a section of a late-third-century transcription of *The Annals of Wu* (*Wu chih*), recovered from Turfan and now in the Shodō Hakubutsukan in Tokyo (fig. 1), reveals that the tall, narrow character forms, the wedge-shaped strokes, and the plump final *na* (upper-left-to-lower-right diagonal) strokes are remarkably similar in the two works. This evidence places the calligraphy of the So Tan manuscript convincingly in the context of third-century writing. Moreover, no known work of T'ang calligraphy makes an archaizing reference to third-century standard script. T'ang standard script is classicizing, founded on the fourth-century classical tradition of Wang Hsi-chih (303–361), but attempts at archaism were limited to somewhat modernized reproductions of Han dynasty clerical script (*li-shu*) and Ch'in dynasty seal script (*chuan-shu*).

The style of the So Tan manuscript also agrees with the third-century material excavated in 1901 by the Swedish explorer Sven Hedin (1865–1952) from the ancient site of Lou-lan, west of Tun-huang. One fragment of a personal letter on paper (fig. 2) shows a crucial hallmark of third-century calligraphic style that was soon to disappear under the dominating style of the fourth-century Wang Hsi-chih. This appears in the "shoulders" of characters, the point where a horizontal stroke, moving to the right, turns and becomes a vertical stroke. In *Encomium on a Portrait of Tung-fang Shuo* (*Tung-fang Shuo hua-tsan;* fig. 3), long attributed to Wang Hsi-chih, the right shoulders of characters were formed as the brush paused, was lifted slightly,

and then pressed down, creating a knoblike shape. Thanks to the official promotion of the style of Wang Hsi-chih by the throne, T'ang dynasty standard script uniformly displays this "articulated shoulder." All of the T'ang dynasty manuscripts from Tun-huang display this trait, as does the *Mahāprajñāpāramitā Sūtra* scroll discussed below. Neither the So Tan manuscript nor the letter from Lou-lan exhibits any sign of this feature. There is no pausing or pressing down of the brush at the shoulder. Instead, the thin line drawn sideways to form the horizontal stroke simply turns, without pausing, into the thick line of the vertical stroke.

In sum, although the textual variations and the inexplicable date of the *Tao-te ching* scroll may suggest that it was written in the T'ang dynasty, the orthography and calligraphy do not. If the calligrapher was a man of the T'ang, however, he might have chosen a venerable style to match the calligraphic style to the aura of power and mystery appropriate to this sacred text. Perhaps there existed a continuous tradition of a So family style of calligraphy practiced at Tun-huang. If this calligrapher were an eighth-century participant in that tradition, he may have with some justification signed the name of So Tan to this scroll. Another possible explanation is that the style of the scroll is deliberately archaizing, perhaps part of the trend that revived the clerical and seal scripts in the mid-eighth century. As we know from the handwritten manuscripts discovered in cave 17, the major trends in calligraphy that originated in metropolitan areas also

Figure 4a. Ch'u Sui-liang, *Preface to the Buddhist Canon* (detail), 653, ink rubbing. From *Shodō zenshū*, n.s., 8: pl. 17.

Figure 4b. Ching K'o (fl. mid-7th century), *Epitaph for the Layman Wang*, 658 (cat. no. 3, detail).

were followed at Tun-huang. In the end, however, calligraphic style is stronger evidence than is textual variation. The textual variation in the So Tan *Tao-te ching* may simply indicate that it represents a textual tradition peculiar to the Tun-huang area in the third century.

A work that truly embodies T'ang dynasty calligraphic style is *Epitaph for the Layman Wang* (cat. no. 3). This ink rubbing, now mounted in an album, was likely taken sometime during the seventeenth century from a stone stele engraved in 658. The subject of this epitaph was Wang Kung (584–656), a member of a long-established scholar-official family from Taiyuan and a lay believer in the radical Three Stages school of Buddhism. To acknowledge the equality of all sentient beings, it was the practice of this school to leave the corpses of its monks and lay believers in the forest as a "donation of the body" to birds and beasts. Their bones were later collected and buried near the tomb of Hsin-hsing (540–594), the school's Sui dynasty founder, in the hills south of the capital city of Ch'ang-an. A pagoda was raised over the remains. In Wang Kung's case, a stone slab about two feet square engraved with a biographical epitaph was set into the side of the pagoda. The author of his epitaph was Shang-kuan Ling-chih (fl. 7th century), who was probably the son of Shang-kuan I (d. 664), a high-ranking T'ang government minister. Over time, the brick pagoda collapsed, but the stone epitaph was excavated during the Wan-li period (1573–1620) of the Ming dynasty. Owing to the beauty of the writing, many amateurs of art took ink rubbings from it. Since it was already broken when it was discovered, under all this loving handling it soon splintered into smaller pieces. As a consequence,

there are very few complete ink rubbings of this inscription today.

The ink rubbing in the Elliott Collection reveals calligraphy with a lively, graceful compositional balance and smooth, swelling brushstrokes. It is signed with the name Ching K'o, an artist about whom we know nothing, except that his calligraphy bears an uncanny resemblance to that of the famous early T'ang master Ch'u Sui-liang (596–658). A comparison of Ch'u Sui-liang's *Preface to the Sacred Teaching* (*Sheng chiao hsü*) of 653 and Ching K'o's *Epitaph for the Layman Wang* shows the extraordinary similarity of tense, slender strokes in, for example, the character *huo* in Ch'u Sui-liang's work and *mieh* in Ching's (figs. 4a, b).

Why is the epitaph written in a style so close to Ch'u Sui-liang's? Owing to his eminent position in politics, Ch'u was virtually the official imperial calligrapher of his day. He was such a trusted personal advisor to Emperor T'ai-tsung (r. 626–49) that he received the emperor's deathbed instructions to the heir apparent. In 653, four years after T'ai-tsung's death, Emperor Kao-tsung asked Ch'u to write out the texts for two stelae. One was the preface T'ai-tsung had written for the sutra translations made by Hsüan-tsang (596?–664), and the other was a record of the event composed by Kao-tsung himself. Imperial commissions such as this were written and engraved in the palace and paraded through the streets of Ch'ang-an to be seen by the populace. These two stelae may still be seen today, flanking the southern doorway to the Large Wild Goose Pagoda in Sian. Ch'u Sui-liang's *Preface to the Buddhist Canon* was the most famous Buddhist stele of its day and one of the most influential of all time. Its style would have been ideal for the high-ranking Buddhist patrons of *Epitaph for the Layman Wang*. In the very year it was written, however, Ch'u Sui-liang had just died in exile. Evidently the imitation of his style by the otherwise unknown Ching K'o was a suitable substitute.

The critical life of *Epitaph for the Layman Wang* began only in the early Ch'ing dynasty. Scholars' remarks on this work since its excavation offer a clear view of the changes in critical and connoisseurial standards from the early Ch'ing to the present. The earliest colophons express the traditional literati obsession with orthodox traditions. The resultant anxiety about anonymous works of art may be sensed, for example, in a colophon by the early Ch'ing critic Wang Shu (1668–1743),

in which he attempted to muster an official pedigree for Ching K'o:

Ching K'o's name was not outstanding in his day; however, his calligraphic method is particularly slender and vigorous, very much like that of Master Ch'u. Thus we know that many of the capable calligraphers of the T'ang period could not avoid being eclipsed by the great masters. The Ching clan has few famous members, except for one man of the Northern Wei dynasty named Ching Hsien-hsieh, who held the official posts of Cavalry General-in-Chief and Commander Unequalled in Honor, with many achievements in punitive expeditions. This Ching K'o, couldn't he be his descendant?[9]

In the mid-Ch'ing the rise of "evidential research" and "stele studies" produced a revolution in critical thought and a search for authentic documents in the form of archaeologically recovered engraved stone

Figure 5. Wang Hsiao-hsien, *Stele for the Lung-ts'ang Monastery*, 586, Cheng-ting, Hopei, ink rubbing. From *Shodō zenshū*, n.s., 7: pl. 3.

stelae. Anonymous engraved stele calligraphy of the Northern Dynasties was elevated to equal status with that of the exemplars of the classical tradition, such as Ch'u Sui-liang. Thus the late Ch'ing critic K'ang Yu-wei (1858–1927) declined to find Ching K'o's stylistic source in Ch'u Sui-liang's writing, but located it instead in *Stele for the Lung-ts'ang Monastery* (*Lung-ts'ang-ssu pei*), set up in 586 in Cheng-ting, Hopei, by the otherwise unknown Wang Hsiao-hsien.[10] Although the calligraphy of *Stele for the Lung-ts'ang Monastery* (fig. 5) is somewhat similar to that of *Epitaph for the Layman Wang*, this method of arguing for undocumented stylistic affiliations with essentially anonymous calligraphers is highly problematic. We have to be more realistic about what influences were possible. In this instance, it seems far more likely that a Ch'ang-an calligrapher such as Ching K'o writing for an eminent Ch'ang-an patron would work in the style of a famous Ch'ang-an calligrapher such as Ch'u Sui-liang than in the style of an official in distant Hopei.

Ultimately, the passion for ink rubbings of *Epitaph for the Layman Wang* was such that several re-engravings were made, each of which changed the style of the calligraphy.[11] Consequently, earlier collectors raised doubts about the authenticity of the rubbings. The album in the Elliott Collection bears a title vainly dating the ink rubbing to the Sung dynasty and seals of the great painter Wen Cheng-ming, who died in 1559, nearly fifty years before the stone was excavated. These are simply clumsy attempts to add documentary proof of age and authenticity to an object that needs no such assistance.

Another work of Buddhist calligraphy in the Elliott Collection is a transcription of chapter 329 of the *Mahāprajñāpāramitā Sūtra* written in ink on a paper handscroll (cat. no. 4). The *Great Sutra of the Wisdom That Reaches the Other Shore*, as the title may be translated, is actually a collection of smaller scriptures, including the well-known *Heart Sutra* and *Diamond Sutra*, which contain the Buddha's teachings on *prajñā*, or "wisdom." They likely date to the beginning of the Common Era. The single scroll in the Elliott Collection was probably once part of a complete transcription of the six-hundred-chapter version, which was translated by the great T'ang dynasty Buddhist pilgrim Hsüan-tsang in the year 663. The *Mahāprajñāpāramitā Sūtra* was of paramount importance to Hsüan-tsang. Not only did he collect a copy of it in India for the

Figure 6a. Anonymous, *Mahā-prajñāpāramitā Sūtra*, chapter 329, dated 674 (cat. no. 4, detail).

Figure 6b. Ch'u Sui-liang, *Preface to the Buddhist Canon* (detail).

great spiritual truths it contained, but he also credited the presence of the scrolls in his luggage with preserving his life on his return trip to China.[12]

This scroll is dated to 674 and is signed by one Li I-hai, who probably served as the collator for this transcription, checking it for accuracy against the original. The writing is a sharp and glossy standard script interspersed with running-script (*hsing-shu*) characters. It was written in the period when Ch'u Sui-liang's style was still paramount, and its debt to his style is evident. The character *pien* resembles the character *cheng* in Ch'u Sui-liang's *Preface to the Buddhist Canon,* with the composition balanced to the upper right by a long, slender final *na* stroke (figs. 6a, b). The center part of the character *pien* is rather crudely abbreviated, however, suggesting that our copyist might not have met the high calligraphic standards demanded in the capital.

Wang Yüan-chün, a researcher at the T'ang History Research Institute of Shensi Normal University, has devoted a chapter of his book *Calligraphy and Culture of the T'ang* to the subject of T'ang dynasty sutra scribes and sutra calligraphy. According to Wang's analysis of the signatures on extant T'ang sutras, some were copied by Buddhist monks, but most were transcribed by government-employed sutra scribes or private individuals who copied sutras for a living in shops near the monasteries or at home. The government sutra scribes were not regular officials, but simply employees who worked under the jurisdiction of the Imperial Library and the Chancellery. In the early eighth century, for example, there were eighty calligraphers employed by the Palace Library. It is quite likely they were trained at the Institute for the Advancement of Literature (*Hung-wen-kuan*), at which Ou-yang Hsün

(557–641) and Yü Shih-nan (558–638) had taught, so that they were proficient in the imperially sanctioned early T'ang version of the Wang Hsi-chih style of standard script.

According to Wang Yüan-chün, most of the sutras copied by government scribes were distributed to the prefectures to provide models for imitation. As a result, the rules for sutra copying were very strict, and a well-organized system for their production was formed. This system may be discerned from the colophons at the end of a government sutra.[13] For example, in the signatures at the end of a Tun-huang manuscript of chapter 6 of the *Lotus Sutra* (fig. 7), dated to 672, the first column gives the date and the name of the sutra scribe. In the next column we read how many sheets of paper were used. Then follow the names of the mounter and the first proofreader, who was the sutra scribe himself. Next are listed two more proofreaders and the four examiners, all Buddhist monks. Wang Yüan-chün says the examiners were monks because the copyists were "not necessarily deeply conversant with the doctrines of Buddhism." The second-to-last column lists the supervisor, an official from the Foundry Office of the Directorate for Imperial Manufactories, and in the last column we meet the specially appointed commissioner, Yü Ch'ang, the son of Yü Shih-nan. Since the scroll in the Elliott Collection is signed with only one collator's name and not a complete roster of copyists, mounters, proofreaders, and supervisors, as the government sutras are, it likely was a provincial copy.

Although sutra scribes were obviously literate and frequently signed their work, their manner of employment, as government or shop workers, put them in the class of artisans. As such, their names were not recorded in the calligraphy histories written in the T'ang dynasty by such connoisseurs as Sun Kuo-t'ing (648?–703?), Li Ssu-chen (d. 696), and Chang Huai-kuan (fl. ca. 714–760).[14] The work of anonymous artisans could not compete for the critics' attention against artists such as the eccentric official Chang Hsü (fl. ca. 700–750) or the wandering monk Huai-su (ca. 735–ca. 799), who executed displays of "mad-cursive" style calligraphy before elite audiences and were celebrated by contemporary poets such as Tu Fu and Li Po. After the T'ang, the writing of sutra scribes was largely ignored or denigrated in calligraphy criticism, although it has occasionally been defended.[15] The scholar-amateur

taste for self-expression dominated the critical scene from at least the eleventh century onward, largely smothering praise for the virtues of formal standard script. Since the names and biographies of the sutra scribes were omitted from the standard histories of art, scholarly connoisseurs, who depended so heavily on notions of the unity of style between writers and their art, were left without any accepted avenue for discussion of sutra calligraphy.

A breech in the traditional scholar-amateur aesthetic came in the mid-Ch'ing with the stele studies movement and its promotion of anonymous engraved calligraphy. In the late Ch'ing, scholars promoted the idea of *min-chien shu-fa,* or "calligraphy of the people." In the early twentieth century, a flood of ink-written texts of all kinds was recovered archaeologically from sites such as Turfan, Lou-lan, and Tun-huang in the modern provinces of Sinkiang and Kansu, in the far northwest of China. These new discoveries coincided with revolutionary political and cultural movements, in which many traditional ways of thought were intentionally overthrown. The idea of "calligraphy of the people" was taken up and fervently developed by the socialist art critics of the People's Republic. The philosophical-historical basis for this is the idea that all calligraphy produced before the rise of the scholar-amateur, or literati, aesthetic was the art of the people. Wang Yüan-chün's view is representative:

Calligraphy, like all the other arts, comes from the people. Oracle bone script, Stone Drum script, and ritual bronze script all were created by anonymous people. Until the rise of the literati calligraphers in the T'ang, calligraphy belonged to the people. Although Wang Hsi-chih was called the Sage of Calligraphy, he certainly had no intention of dominating the calligraphers of his day. This title was conferred on him by people in the T'ang, and the calligraphy of Wang Hsi-chih was not that influential in his own time. In sum, the field of calligraphy before the T'ang was being quietly tilled by folk calligraphers, and the standards of calligraphy developed themselves under the unselfconscious calligraphy aesthetic of folk calligraphers, the result of which was that each period has its own distinct and admirable aesthetic. In this period there was not too much interference from the literati, so the people's field of vision was relatively pure and they did not have to accept tendentious interference.[16]

Into this Eden came a serpent in the form of Emperor T'ai-tsung of the T'ang. T'ai-tsung rapaciously collected all extant pieces attributed to Wang Hsi-chih, had them copied at his court, and ordered officials to study them. The result was two-fold, in Wang Yüan-chün's opinion. First, calligraphy was elevated to a new level of regard and became an important aspect of scholar-amateur activity, so that literati crowded out folk calligraphers and suppressed their further development. Next, literati silenced everyone else

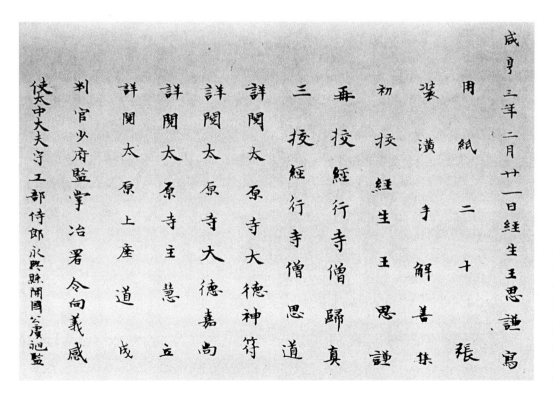

Figure 7. Wang Ssu-ch'ien, *Lotus Sutra,* chapter 6, dated 672, handscroll, ink on paper, 26.2 x 325.0 cm. Tun-huang County Museum. From *Tun-huang i-shu shu-fa hsüan* (Lanchou: Kan-su jen-min ch'u-pan-she, 1985), 83.

with a flood of critical writing that was aggressively conscious of rank and distinctions of professional and amateur status and that promoted their own aesthetic. This aesthetic favored calligraphy that looked casual or even awkward, in which the artist sought self-expression and "spirit resonance." Naturally, this literati aesthetic was seriously at odds with the neat and uniform styles required of the sutra scribes.[17]

After 1949 it became politically necessary to find new standards of criticism in order to appreciate sutra writing. Marxist criticism celebrates the working-class status of calligraphy done by professionals and focuses on its utilitarian functions and the process of production, making the anonymous T'ang sutra scribe an artist of the masses. For example, Marxist critics such as Wang Yüan-chün talk about the physical conditions of work under which sutras were made. Indeed, it can be instructive to look at how these demands shaped the writing itself. We know, for instance, from poems written by sutra scribes at Tun-huang, that the scribes had to work long hours at high speed to earn a decent living.[18] This is evident in the sutras not so much from mistakes, but rather from a general tendency toward abbreviation. Many characters are written in a slightly simplified form, and the rapidity with which they are written is revealed by the fine connecting ligatures between what, in standard script, are normally separate strokes.

Another prominent school of criticism in China today pursues the goal of finding genuine calligraphy of the past, stressing not the social status of the artist but the aesthetic property of calligraphy itself. The greatest proponent of this approach is Ch'i Kung of Peking Normal University, the venerable calligraphy teacher and critic.[19] In his opinion, the ink-written material recovered from Sinkiang and Tun-huang is the only authentic writing of antiquity available to us now. The traditions that have dominated the visual and critical discourse up to our own time are those of stelae (*pei*) and letters (*t'ieh*). The stele tradition (or epigraphy) refers to inscriptions on stone, from which ink rubbings are taken, while the letters tradition (also called the classical tradition) refers to the calligraphy of Wang Hsi-chih and other aristocrats of the Eastern Chin, which consists mainly of brief personal letters. In his view, they are both hopelessly compromised. Ch'i Kung argues against seeing epigraphy as authentic writing because an ink rubbing is actually a print.

It lacks any nuance of gesture or ink tonality from the brush. His reason for rejecting the letters tradition is that virtually all classical-tradition calligraphy exists only in the form of later copies. We see not the hand of the artist, but a lifeless tracing. Only in calligraphy such as the ink-written sutras from Tun-huang is the touch of the artist immediately evident. Only that kind of writing displays real vividness in the handling of ink and brush, a liveliness that no copy or ink rubbing can approach.

We have seen a representative work of the radical Three Stages school of Buddhism in *Epitaph for the Layman Wang* and a mainstream Mahāyāna-school text in the *Mahāprajñāpāramitā Sūtra*. Also represented in the Elliott Collection is an object that reveals the tremendous popularization of practices associated with the Tantric, or Esoteric, school of Buddhism. The *Dhāraṇī Pillar Inscribed with Buddhas and the "Uṣṇīṣavijaya Dhāraṇī"* is an octagonal stone pillar some four feet in height (cat. no. 5). At the top of each face is a simply etched Buddha figure with halo and nimbus, seated cross-legged on a lotus throne. Below the Buddhas is engraved the Chinese transliteration of the *dhāraṇī*, or magic spells, originally in Sanskrit, that are found in the *Sūtra of the Honored and Victorious Dhāraṇī of the Buddha's Uṣṇīṣa,* in which Śākyamuni preaches the power of *dhāraṇī* and how to chant them.

The Chinese word for this type of pillar is *ch'uang,* which means "banner." The long vertical format of the stone pillar seems to echo an earlier practice in which *dhāraṇī* spells were written on cloth banners, as is still done today in Tibet. The transition to a stone surface may be explained by medieval Chinese notions of permanence in funerary ritual and the widespread practice of engraving the texts of the dharma in "imperishable stone" to survive the cataclysm to come at the end of the present era. The modern scholar Yen Wen-ju has speculated that the octagonal pillar shape may be an adaptation of the native grave-pillar form, which dates back to the Han dynasty, before the advent of Buddhism in China. Alternatively, he thinks it may be a simplified pagoda shape.[20] Both of these ideas have their source in the function of the pillars. The *Uṣṇīṣavijaya Dhāraṇī Sūtra* itself explains,

If anyone writes out this *dhāraṇī* and places it on a lofty pillar, mountain, tower, or pagoda, and if monks, nuns, laymen, or laywomen see this *dhāraṇī* on a pillar or other structure, or allow its shadow to fall on them,

or allow the dust blown off it by the wind to fall on them, all such sentient beings, whatever their sins that should result in suffering in rebirth in the realms of hell, animals, King Yama's realm, or that of the *asuras* [demons], will not be so subjected nor will they be polluted by karmic defilement.[21]

In other words, believers were instructed to set up pillars and pagodas inscribed with *dhāranī* to prevent reincarnation in the less desirable realms. Like many other Buddhist artifacts produced as acts of filial piety, these pillars were frequently erected to prevent the inauspicious rebirth of deceased parents. To serve this function, in addition to being set up at Buddhist temples and next to thoroughfares, they were also commonly interred in tombs or set up beside them. The *dhāranī* pillar in the Elliott Collection bears a dedication in smaller characters by the donor, which reads,

> Collated version of the jade stone pillar of Fu-kuang Monastery in the Eastern Capital. On the twenty-sixth day, a *hsin-mao*, of the fourth month, of which the first day was a *ping-yin*, in the year *wu-hsü*, the fifth year of the Supernal Talisman era [May 31, 878], I, the orphan P'ei Ch'ien-kou, reverently made this [*dhāranī* pillar] in offering to my late mother, a lady of the Chai clan of Ju-nan. I humbly pray she may receive this act of merit, to be reborn in the West, there to see the Buddha and hear the dharma.

Here the donor adds to the Tantric apotropaic function of the *dhāranī* the salvationist prayer that his mother may be reborn in the Western Paradise, which is the primary goal of the Pure Land school of Buddhism. This is typical of the syncretism of popular worship in the T'ang dynasty. The text of the *dhāranī* was evidently copied from a famous monument in a Loyang monastery, and it is likely that this pillar was in or near the tomb of the lady of the Chai clan.

The *Uṣṇīṣa-vijaya Dhāranī Sūtra* was translated into Chinese for the first time in the early T'ang period, around 683, and the earliest known pillar bearing the *Uṣṇīṣa-vijaya Dhāranī* dates from only six years later.[22] The production of these pillars soon became ubiquitous throughout China and continued from the T'ang through the Ch'ing dynasty. The pillar for P'ei Ch'ienkou's mother was set up in 878. By this time, the dominant style in calligraphy had long since ceased to be that of Ch'u Sui-liang and was instead that of the high government minister Liu Kung-ch'üan (778–865). A scholar of the Confucian classics, Liu served three

emperors in policy-making positions. He gained fame for his calligraphy early in life. He once said, apropos of his transcription of the *Diamond Sutra* on a stele at the Hsi-ming Monastery, that his style combined elements from the earlier calligraphers Chung Yu (151–230), Wang Hsi-chih, Ou-yang Hsün, Yü Shih-nan, Ch'u Suiliang, and Lu Chien-chih (fl. late 7th century).[23] The critics of the Sung dynasty believed his style was closest to that of the greatest calligrapher immediately preceding him, the high official Yen Chen-ch'ing (709–785). The Sung literati-statesman Fan Chung-yen (989–1052) coined the famous phrase "sinews of Yen, bones of Liu," which has forever linked the two.[24] Liu's style shares Yen's four-square, upright-character compositions, a reliance on heavy vertical strokes and sharply angled stroke-endings, and a curious mannerism known in Chinese as *t'iao-t'i,* which may be translated as "flicking and kicking."[25] This refers to the indentations Yen Chen-ch'ing created in the underside

Figure 8. Liu Kung-ch'üan, *The Army of Divine Strategy's Record of Imperial Virtue Stele* (detail), 843, ink rubbing. From *Shodō zenshū,* n.s., 10: pl. 91.

Figure 9. Chang Chi-chih (1186–1266), *Diamond Sutra*, 1246 (cat. no. 10, detail).

of his final *na* strokes and hooked *shu* (vertical) strokes by lifting the brush just before the end. The mannerism is plainly evident in works of Liu Kung-ch'üan's late period, such as *The Army of Divine Strategy's Record of Imperial Virtue Stele* (*Shen ts'e chün chi sheng te pei*) of 843 (fig. 8), and it is equally obvious in this anonymous *dhāraṇī* pillar of 878. As we have seen, there is no one style for Buddhist calligraphy, and it has no particular association with antiquarianism or classicism. Rather, the makers of Buddhist votive monuments employed the most prestigious calligraphic styles of their day. The popularity of Liu Kung-ch'üan's style was such, it is said, that if a high-ranking official could not get Liu to write out his late parents' epitaphs, he was not regarded as a filial son.[26] Evidently, persons of lower rank, such as P'ei Ch'ien-kou, felt the same obligation, which could be fulfilled by sponsoring a *dhāraṇī* pillar written in imitation of Liu's distinctive style.

Another work inspired by filial piety is Chang Chi-chih's *Diamond Sutra* transcription of 1246 (cat. no. 10), which was written for the karmic benefit of his deceased father. Chang Chi-chih (1186–1266) was a devout Buddhist householder and a friend of disciples of the Ch'an master Wu-chun Shih-fan (ca. 1177–1249) at T'ien-t'ung Monastery, in the T'ien-t'ai Mountains outside modern-day Ningpo. He was also a scholar-official of the Southern Sung whose family had filled high positions in government for several generations. Unlike the productions of the government sutra scribes, Chang's was a purely private transcription made in the service of Buddhist faith and filial piety. His choice of the *Diamond Sutra* is not surprising for a lay follower of Ch'an. Hui-neng (638–713), the sixth Ch'an patriarch, was said to have attained enlightenment upon hearing the *Diamond Sutra* recited, and it became an important text of the Ch'an school in the eighth century. In it, the Buddha teaches that "all phenomenal appearances are not ultimate reality but rather illusions, projections of one's own mind."[27]

The scroll is written in Sung dynasty standard script (*Sung k'ai*), which incorporates informal elements from running script. Chang's style is distinctive and unusual. The characters show an extraordinary variety of thick and thin strokes, mounting a wonderful visual drama as the thickly drawn dark characters give way to finely drawn light ones, creating a nearly three-dimensional effect. In addition, initial strokes are often emphasized, so that character compositions tend to be darker and heavier on the left-hand side. For example, in the character *tu*, the left-hand semantic element is written in thick black strokes, while the phonetic element to the right is much finer and smaller (fig. 9). Although Chang is now considered the last great calligrapher of the Southern Sung, his style has not always been admired. A Ming dynasty connoisseur noted that "men in the past reviled Chang Chi-chih's

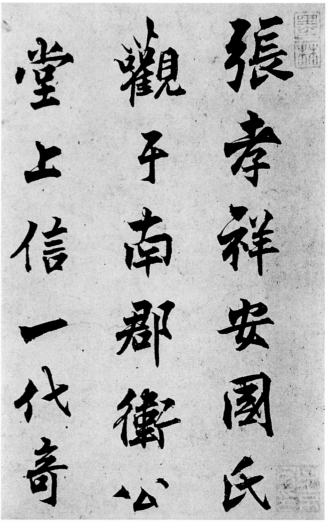

Figure 10. Chang Hsiao-hsiang (1133–1170), *Colophon*, 1168, to Huang T'ing-chien (1045–1105), *Poem on the Shrine to the Spirit of Ma Fu-po*, 1101, ink on paper. Private collection, Japan. From *Shoseki meihin sōkan* (Tokyo: Nigensha, 1958–81), vol. 23.

calligraphy as vulgar writing."[28] One of those "men in the past" was a Confucian instructor of the early fourteenth century named Cheng Shao (fl. ca. 1324–1328), who wrote a history of calligraphy with a strong Confucian bias. He condemned Chang for having "no method," meaning that he could not be affiliated with the classical style, and pronounced that "from Chang Chi-chih onward, the Way of Calligraphy was entirely in ruins."[29]

Cheng Shao's criticism reflects the neoclassicism of the early fourteenth century, which was dominated by Chao Meng-fu's (1254–1322) revival of direct study of the art of Wang Hsi-chih. From this point of view, the "problem" with Chang's style is that, like most other artists of the Southern Sung, he was not a student of antique styles but was content to base his style on that of his contemporaries. As a child, he studied the style of his uncle, the famous poet Chang Hsiao-hsiang (1133–1170).[30] The unusual emphasis on the left-hand side of the characters in Chang Hsiao-hsiang's standard script (fig. 10) should make it evident that his style was the primary source for Chang Chi-chih. Ultimately, I suspect Chang Chi-chih was disparaged by the Confucian Cheng Shao for a combination of reasons: his Ch'an connections, his unclassical style, and his having lived during the late Southern Sung, which was seen as a time of cultural and political decadence.

Chang Chi-chih's lack of affiliation with the classical tradition was addressed by two critics of the seventeenth century in colophons appended to the Elliott Collection transcription of the *Diamond Sutra*. The first, dated to 1620 by a scholar-official and Buddhist layman named Pi Hsi-chih, relates how he had this transcription copied and engraved in stone, so that ink rubbings could be made of it. This project was a pious Buddhist act intended to disseminate multiple copies of the sutra. At the same time, engraving one's calligraphy collection for public edification was a common scholarly practice in the Ming. Pi Hsi-chih's colophon opens with praise for the efficacy of the *Diamond Sutra*, then goes on to discuss Chang Chi-chih's calligraphic style. Unlike the critics of the fourteenth century, who saw no connection between Chang and the classical tradition, Pi Hsi-chih identified elements from classical-tradition calligraphers in Chang's style. Pi wrote, "Connoisseurs say the composition of his characters resembles Ch'u Sui-liang's, while the movements and turns of the brush are like those of Mi Fu [1052–1107]."[31]

Figure 11a. Chang Chi-chih, *Diamond Sutra*, 1246 (cat no. 10, detail).

Figure 11b. Ch'u Sui-liang, *Preface to the Buddhist Canon* (detail).

In spite of Pi Hsi-chih's arguments, there is little visual evidence that Chang Chi-chih actually studied these two masters of the classical tradition. Pi calls attention to the composition of Ch'u Sui-liang's characters, which are noted for their loose structure and slender strokes, and relates this trait to the lack of contact between the strokes in a given character in Chang Chi-chih's calligraphy. Compare, for example, the character *chung* in Chang Chi-chih's *Diamond Sutra* (fig. 11a) and *hsiang* in Ch'u Sui-liang's *Preface to the Buddhist Canon* (fig. 11b). They share a similar quality of disconnectedness of strokes, but they also reveal that Chang did not employ the standard character composition of the classical tradition to which Ch'u Sui-liang belonged, a composition described as "left tight, right loose," meaning that the character form fans out to the right. Chang's characters rarely expand to the right, but are usually larger on the left side. This shows that the influence of Ch'u Sui-liang (and of Mi Fu) that Pi Hsi-chih posits was at most second-hand. Chang Chi-chih's uncle Chang Hsiao-hsiang could write in a Ch'u Sui-liang manner, as in his *Epitaph for Meditation Master Hung-chih (Hung-chih ch'an shih ming)*,[32] and in a Mi Fu manner, common in the Southern Sung (fig. 10). So although Pi Hsi-chih's references to Ch'u Sui-liang and Mi Fu are not wrong, they are not exactly right, either, since they imply direct study of these masters that we have no indication took place. Pi's theory obscures the historical reality of calligraphy in the Southern Sung, when direct study of the classical masters had declined.

Why did Pi Hsi-chih make these tenuous connections between Chang Chi-chih's style and those of Ch'u Sui-liang and Mi Fu? Presumably he was attempting to affiliate Chang Chi-chih directly with the high-status classical tradition, elevating him above the mass

of Southern Sung calligraphers who learned from sources that were seen as too contemporary. From the Ming dynasty onward, showing one's high cultural level by recognizing an artist's place in the orthodox lineage was a fundamental purpose of writing appreciative colophons. In my view, this nearly automatic search for earlier masters with which to identify an artist carries the danger of ignoring possible contemporary or low-status influences and thereby falsifying the historical record. Why did Pi Hsi-chih not mention the style of Chang Hsiao-hsiang as an influence or point out similarities to other Southern Sung artists? Why did he not explore the relationship between Chang's sutra calligraphy and that of sutras transcribed by anonymous scribes from the Sung dynasty or earlier, which a man as pious and as well-connected as Pi Hsi-chih had surely seen? One reason may have been that Pi had the typical scholarly propensity to ignore contemporary influences in favor of ancient models and to look down on the low-status writing of artisan-class sutra scribes.

The colophon following Pi Hsi-chih's on the sutra in the Elliott Collection was written by the Ming artist and arbiter of taste Tung Ch'i-ch'ang (1555–1636), also in 1620. Tung offers a different analysis for Chang Chi-chih's style:

> Looking at how he moves the brush and the composition of his characters, I see that he follows no earlier man. Each [character] is independently created. This is what a Ch'an person would call "the outflowing of the innermost self extending out to engulf the universe."[33]

Tung Ch'i-ch'ang employed Ch'an terminology to describe Chang's creativity as being purely self-generated. This terminology is typical of Tung's art criticism, which is filled with Ch'an references and analogies.[34] It is a celebration of the very idea of "no method," which in the eyes of fourteenth-century Confucian critics was a grave shortcoming. The notion of a Ch'an-inspired, spontaneously generated calligraphic style may have been one that Chang Chi-chih himself would have endorsed, yet it is difficult to find his style entirely original because the debt to his uncle is so clear. Ignoring influences from Chang's immediate milieu, Tung perpetuated the invisibility of sutra scribes and contemporary models in the critical and historical record. Ultimately, despite the differences in their opinions, Tung Ch'i-ch'ang and Pi Hsi-chih pursued the same traditional goal: to ascribe Chang Chi-chih's creativity to an exalted source. For Pi Hsi-chih, that source was the classical tradition; for Tung Ch'i-ch'ang, it was the unbridled Ch'an self.

The artist whose style eclipsed the calligraphers of the Southern Sung was Chao Meng-fu, a scion of the fallen Sung royal house who served the Mongol court of Khubilai Khan (r. 1260–94) during the Yüan dynasty. Chao revolutionized scholar-amateur painting in the Yüan, reinterpreting the painterly landscapes of the tenth-century artist Tung Yüan (d. 962) in calligraphic brushwork. His zealous antiquarianism in painting was matched in his calligraphy. Although Chao and his circle of artist-collector friends admired the art of Northern Sung calligraphers such as Su Shih (1037–1101), Huang T'ing-chien (1045–1105), and Mi Fu, the absence of any influence of the Sung masters' styles in their calligraphy suggests that they found Sung brush methods too raw and too individual to be canonical. They also avoided imitating the calligraphers of the Southern Sung, many of whom perpetuated and amplified the mannerisms of the Northern Sung masters.

Chao Meng-fu instead advocated direct study of the masters of the classical tradition, especially Wang Hsi-chih. Chao left a record of the artists he studied during his development as a calligrapher. As a young man he began by copying the works of the classical-tradition calligraphers Chung Yu, Hsiao Tzu-yün (492–553), Ch'u Sui-liang, Hsü Hao (703–782), and especially *The Thousand Character Essay (Ch'ien-tzu wen)* of Chih-yung (fl. late 6th–early 7th century).[35] In early middle age, Chao immersed himself in study of the style of the Two Wangs, father and son, making hundreds of copies of Wang Hsi-chih's *Preface to the Orchid Pavilion Collection* and the transcription of *Prose Poem on the Nymph of the Lo River (Lo-shen fu)* by Wang Hsien-chih (344–388).

An important work of his later years, now in the Elliott Collection, is *Record of the Miao-yen Monastery* (cat. no. 11). Chao was asked to write out the *Record* in late 1309 or early 1310, when he lived in retirement in his hometown of Wu-hsing. The text was composed by an eminent former Sung official from Wu-hsing, Mou Yen (1227–1311), who described the vicissitudes of the monastery, which was rebuilt after it was destroyed by fire in the Southern Sung dynasty. Although Mou was a Confucian scholar, he gladly participated in this Buddhist project. He and Chao had

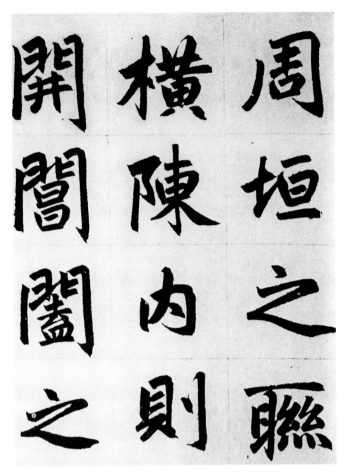

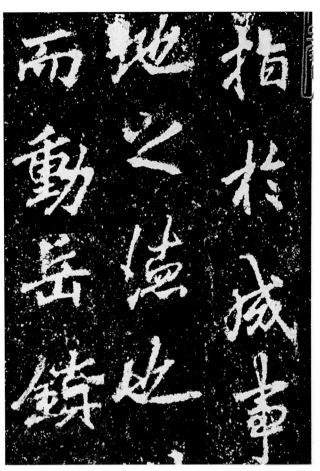

Figure 12. Chao Meng-fu, *Record of the Restoration of the Three Gates of the Hsüan-miao Priory,* 1303, handscroll, ink on paper, height 31 cm. Tokyo National Museum. From *Shodō zenshū,* n.s., 17: pl. 3.

Figure 13. Li Yung, *Stele for Lu-shan Monastery* (detail), 730, ink rubbing. National Palace Museum, Taipei, Taiwan, Republic of China.

collaborated in a similar fashion in 1302, 1306, and 1308, producing records for a Confucian school, a Taoist priory, and another Buddhist monastery.[36] Local literary men were often requested to write out public documents for monasteries and schools, donating their literary skills and the glamour of their calligraphic style to such documents as subscription appeals for funds (which were circulated by monks) and historical records (which were engraved on a stele standing on the monastery grounds).

When Chao Meng-fu wrote standard script to be engraved on public monuments, he blended references to other calligraphers with the classical Wang Hsi-chih foundation that underlay the style of his letters and other private documents.[37] Indeed, stele inscriptions seem to have been a fertile ground for experimentation for Chao in his later years. Although he espoused the Wang style in his critical writings, when his friend Hsien-yü Shu (1257–1302) remarked that Chao followed the stele style of the early sixth-century Northern Wei calligrapher Shen Fu, Chao agreed.[38] The square,

heavy strokes and triangular hook endings associated with engraved calligraphy of the Northern Wei may be seen in Chao Meng-fu's *Record of the Restoration of the Three Gates of the Hsüan-miao Priory (Hsüan-miao kuan ch'ung-hsiu san-men chi)* of 1303 (fig. 12).

This manner was superseded around 1308 by a rather different inspiration. Chao made no remarks on his stylistic sources in this period of his life, as far as I know, yet there survives a small cluster of inscriptions dated from 1308 to 1310 that mark a special phase in his artistic development. These include *Record of the Pao-yün Monastery in Sung-chiang (Sung-chiang Pao-yün ssu chi)* and *Epitaph for Route Commander Chang (Chang Tsung-kuan mu chih ming),* both of 1308, and *Record of the Miao-yen Monastery* of 1309–10.[39] All three take the slender, tensile qualities of the style of the mid-T'ang calligrapher Li Yung (678–747) as their primary antique reference. A typical inscription by Li Yung is *Stele for Lu-shan Monastery (Lu-shan ssu pei)* of 730 (fig. 13). Li Yung is also affiliated with the classical tradition, but his style is distinguished by its tall, slender character

Figure 14a. Li Yung, *Stele for Lu-shan Monastery* (detail).

Figure 14b. Chao Meng-fu, *Record of the Miao-yen Monastery,* ca. 1309–10 (cat. no. 11, detail).

forms and the extreme upward tilt to the right in the horizontal strokes. These traits have clearly been borrowed by Chao Meng-fu for the *Miao-yen Monastery* inscription. In Chao Meng-fu's character *ch'eng,* the tightly contracted left and center elements seem to release that compressed energy in the extended diagonal hooked *ko* stroke on the right (figs. 14a, b). This distinctive feature could have been learned only from the calligraphy of Li Yung.

Why did Chao Meng-fu adopt the gestures of Li Yung's hand to transcribe *Record of the Miao-yen Monastery?* Although Chao surely was attracted to the style of Li Yung's calligraphy, his choice also reflected the magnetic appeal for literati calligraphers of affiliation with other calligraphers of the past. For an inscription such as *Record of the Miao-yen Monastery,* which was composed by the eminent literatus Mou Yen and destined to be inscribed on a stele in the prominent public location of a metropolitan Buddhist monastery, Chao needed a stylistic reference that embodied the authority of the past in order to match the grandeur of the text and the setting. A suitable antique reference would quicken the efficacy of the inscription. Li Yung was a member of an eminent scholar family and served in important official positions. Since he was a famous calligrapher, when he served as governor in

various provinces, he was asked to write out the records of Buddhist monasteries and epitaphs for worthy men to be engraved on stelae. Li Yung's many stele inscriptions were quite well known, and ink rubbings of his *Stele for Lu-shan Monastery* and other works were widely circulated in the Sung dynasty and afterward. In selecting a calligraphic mode to give the authority of antiquity to his transcription of *Record of the Miao-yen Monastery,* perhaps Chao found a special power in the style of this classical-tradition calligrapher of the High T'ang, who, like himself, was a public servant who created public art.

The calligraphic manner seen in Chao's *Record of the Miao-yen Monastery* became a model for calligraphy in book printing soon after his lifetime. An annotated edition of the Confucian Four Books, published in Hangchow in 1330, was written out by four calligraphers who could imitate Chao's style.[40] The qualities of fluid brushwork, legibility, dynamic balance, and consistency in his standard script made it easy to copy and easy to read. As a result, Chao Meng-fu's style became a major calligraphic model for bookprint, together with the styles of Ou-yang Hsün and Yen Chen-ch'ing.

The history of standard script is closely bound to the transcription of religious texts. As we see in the ink-written and engraved examples in the Elliott Collection, this script type conferred on texts qualities of legibility, precision, and formality. These were the same qualities demanded by the imperial court for the calligraphy of documents and monuments that permeated the empire. To enhance the prestige of their writing, professional calligraphers such as sutra scribes often imitated the elite styles of their day. When literati-amateur calligraphers transcribed religious texts—not only sutras, but also epitaphs and monastery records—they added the authority of antiquity to their transcriptions through scholarly allusions to styles of canonical masters of the past.

NOTES

1. Jao Tsung-i, "Wu Chien-heng erh nien So Tan hsieh pen *Tao-te ching* ts'an chüan k'ao cheng," *Journal of Oriental Studies* 2, no. 1 (1955): 2.

2. Wo Hsing-hua, *Tun-huang shu-fa i-shu* (Shanghai: Shang-hai jen-min ch'u-pan-she, 1994), 9.

3. Jao Tsung-i, in *Shodō zenshū*, n.s. (Tokyo: Heibonsha, 1965), 3: 187.

4. Ibid.

5. See Robert G. Henricks, trans., *Lao-tzu Tao-te ching: A New Translation Based on the Recently Discovered Ma-wang-tui Texts* (New York: Ballantine Books, 1989).

6. William G. Boltz, "Notes on the Authenticity of the So Tan Manuscript of the Lao-tzu," *Bulletin of the School of Oriental and African Studies, University of London* 59, no. 3 (1996): 508–15.

7. Shih An-ch'ang, "T'ang-tai cheng-tzu hsüeh-k'ao," *Ku-kung po-wu-yüan yüan-k'an* 1982.3: 77–84. See also Amy McNair, "Public Values in Calligraphy and Orthography in the Tang Dynasty," *Monumenta Serica* 43 (1995): 263–78.

8. See *Chung-wen ta tz'u-tien* (Taipei: Chung-hua hsüeh-shu-yüan, 1990), entry 18097. See also *Pei pieh tzu hsin pien* (Peking: Wen-wu ch'u-pan-she, 1985), 382, where this form is attested only in a Northern Wei epitaph.

9. Ts'ui Erh-p'ing, ed., *Li-tai shu-fa lun-wen-hsüan hsü-pien* (Shanghai: Shang-hai shu-hua ch'u-pan-she, 1993), 658.

10. *Kuang I-chou shuang-chi*, in Huang Chien, ed., *Li-tai shu-fa lun-wen-hsüan* (Shanghai: Shang-hai shu-hua ch'u-pan-she, 1979), 2: 822.

11. Yang Jen-k'ai and Tung Yen-ming, "T'ang Wang Chü-shih chuan t'a ming," *Shu-fa ts'ung-k'an* 6 (1983): 18.

12. Stanley Weinstein, *Buddhism under the T'ang* (Cambridge: Cambridge University Press, 1987), 30.

13. *T'ang-jen shu-fa yü wen-hua* (Taipei: Tung-ta t'u-shu kung-ssu, 1995), 130.

14. See Amy McNair, "*Fa shu yao lu,* a Ninth-century Compendium of Texts on Calligraphy," *T'ang Studies* 5 (1987): 69–86.

15. One text that speaks highly of the T'ang sutra scribes is the court-sponsored *Hsüan-ho Calligraphy Catalogue* (*Hsüan-ho shu-p'u*) of ca. 1120. It is hardly surprising, however, that a calligraphy critic at the court of Emperor Hui-tsung would find very precise standard script admirable, since the emperor created a special style of very fine standard script called "slender gold" (*shou chin t'i*).

16. *T'ang-jen shu-fa yü wen-hua,* 145–56.

17. Ibid., 146.

18. Ibid., 134–35.

19. See, for example, Ch'i Kung, *Ch'i Kung lun-shu cha-chi* (Peking: Pei-ching shih-fan ta-hsüeh ch'u-pan-she, 1992), 12.

20. Yen Wen-ju, "Shih ch'uang," *Wen-wu,* no. 8 (1959): 47–48.

21. Taken from the earliest translation, done around 683 by Buddhapāla and Tu Hsing-i. See Yen Wen-ju, "Shih ch'uang," 47–48; and Liu Shu-fen, "Dhāraṇī Sūtra and the Growth of Dhāraṇī Pillars in T'ang China," *Bulletin of the Institute of History and Philology, Academia Sinica* 67, no. 1 (1996): 153.

22. Ibid., 48.

23. *Shodō zenshū*, n.s., 10: 188.

24. From Fan Chung-yen's eulogy for Shih Man-ch'ing (994–1041), quoted in Ma Tsung-huo, *Shu-lin tsao-chien* (1936; reprint, Taipei: Shang-wu yin-shu-kuan, 1982), 9: 197b.

25. Wen C. Fong et al. *Images of the Mind: Selections from the Edward L. Elliott Family and John B. Elliott Collections of Chinese Calligraphy and Painting at The Art Museum, Princeton University* (Princeton: The Art Museum, Princeton University, 1984), 90.

26. *Shodō zenshū*, n.s., 10: 188.

27. *The Shambhala Dictionary of Buddhism and Zen* (Boston: Shambhala, 1991), 57.

28. An Shih-feng, quoted from his *Mo-lin k'uai-shih,* in Wang Yüan-ch'i, ed., *P'ei-wen-chai shu-hua-p'u* (reprint, Peking: Chung-kuo shu-tien, 1984), 78: 17a.

29. Cheng Shao, *Yen-chi,* commentary by Liu Yu-ting (fl. ca. 1324–1328), in Huang, ed., *Li-tai shu-fa lun-wen-hsüan,* 1: 460.

30. See Huang P'ei-yü, *Chang Hsiao-hsiang yen-chiu* (Hong Kong: San-lien shu-tien, 1993), 263.

31. Colophon transcribed in Nakata Yūjirō and Fu Shen, *Ōbei shū-zō Chūgoku hōsho meisekishū* (Tokyo: Chūōkōron-sha, 1981–83), 2: 149.

32. A stele of 1158, reproduced in Huang, *Chang Hsiao-hsiang yen-chiu,* pl. 1.

33. In Nakata Yūjirō, ed., *Chinese Calligraphy: A History of the Art of China,* trans. Jeffrey Hunter (New York, Tokyo, Kyoto: Weatherhill and Tankosha, 1982), 194. Colophon transcribed in Nakata and Fu, *Ōbei shūzō Chūgoku hōsho meisekishu,* 2: 149.

34. See Xue Yongnian (Hsüeh Yung-nien), "Declining the Morning Blossom and Inspiring the Evening Bud: The Theory and Practice of Tung Ch'i-ch'ang's Calligraphy," in *Proceedings of the Tung Ch'i-ch'ang International Symposium* (Kansas City, Mo.: Nelson-Atkins Museum of Art, 1991).

35. Wang Lien-ch'i, "Chao Meng-fu chi ch'i shu-fa i-shu chien-lun," *Ku-kung po-wu-yüan yüan-k'an,* no. 2 (1994): 44-45.

36. *Shodō zenshū*, n.s., 17: 204.

37. For an analysis of possible stylistic influences in *Record of the Miao-yen Monastery,* see Fong et al., *Images of the Mind,* 99–102.

38. Yang Renkai, "Masterpieces by Three Calligraphers: Huang T'ing-chien, Yeh-lü Ch'u-ts'ai, and Chao Meng-fu," in Alfreda Murck and Wen C. Fong, eds., *Words and Images: Chinese Poetry, Calligraphy, and Painting* (New York and Princeton: The Metropolitan Museum of Art and Princeton University Press, 1991), 37.

39. *Record of the Pao-yün Monastery in Sung-chiang* is probably in the Peking Palace Museum (reproduced in *Ku-kung po-wu-yüan yüan-k'an,* no. 2 [1994]: fig. 13). *Epitaph for Route Commander Chang* is in the Peking Palace Museum (reproduced in *Shu-fa ts'ung-k'an* 10 [1986]: 41–50).

40. Frederick W. Mote, Hung-lam Chu, et al., *Calligraphy and the East Asian Book,* special catalogue issue, *Gest Library Journal* 2, no. 2 (Spring 1988): 119, 121.

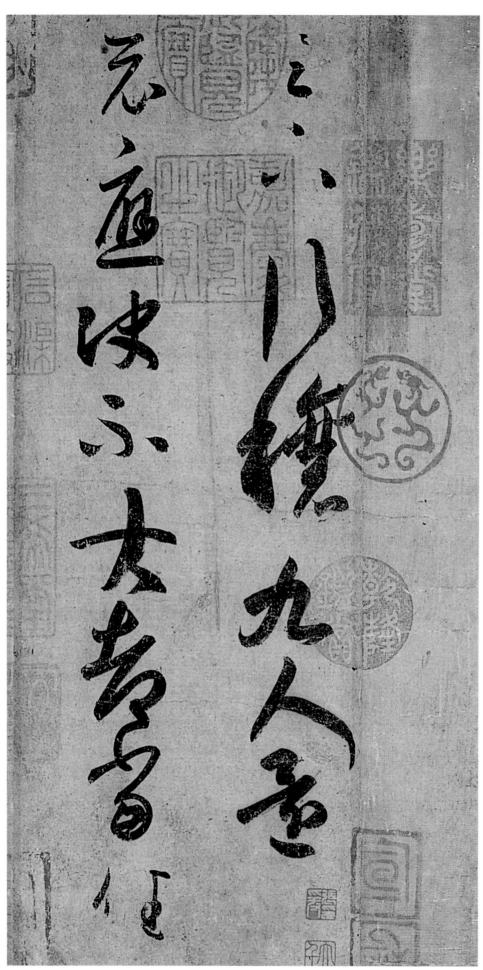

Wang Hsi-chih (303–361), *Ritual to Pray for Good Harvest* (cat. no. 2, detail of fig. 1).

A Letter from Wang Hsi-chih and the Culture of Chinese Calligraphy

ROBERT E. HARRIST, JR.

Around the middle of the fourth century, Wang Hsi-chih (303–361) wrote a short letter in fluid cursive script (*ts'ao-shu*) and dispatched it to a recipient whose name is now unknown. A fragment of this letter, titled *Ritual to Pray for Good Harvest*, survives today as a copy mounted in a short handscroll (fig. 1, cat. no. 2). Dozens of seals record the passage of the letter through the hands of imperial collectors and private connoisseurs, and inscriptions by these owners or their friends express their veneration for Wang Hsi-chih's calligraphy. Although contemporary art historical scholarship and theoretical writings challenge the authority of canonical traditions, close study of *Ritual to Pray for Good Harvest* reveals the remarkable continuity of a classical tradition of calligraphy centered on the art of Wang Hsi-chih.[1] Tracing the history of the letter also illuminates fundamental concepts and practices that constitute what might be called the culture of calligraphy in China. These include the role of imperial taste and ideology in shaping the canon of calligraphic masterpieces, the preservation and reproduction of these works, and the development of a specialized discourse through which ideas about calligraphy were articulated in language.

A LETTER FROM WANG HSI-CHIH

The story of Wang Hsi-chih's life is well known.[2] He was a member of one of the aristocratic families from north China that fled to the south in the early fourth century as the Western Chin dynasty disintegrated. His family assisted in the founding of a new dynasty, the Eastern Chin, the first of a series of short-lived dynasties that ruled south China while the north was controlled by non-Chinese invaders. Like most men from prominent families of this period, Wang partici-

pated in government service, holding several minor positions and eventually earning the rank of general of the Army of the Right. Despite the martial ring of this title, Wang never actually led troops into battle, but he did engage in debates over whether the Eastern Chin should attempt a military campaign to reclaim the lost territories of north China. While still relatively young, around the age of forty-nine, he retired permanently from government service—a wise choice during an age when miscalculations in public life often led to banishment or execution. The intellectual environment in which Wang Hsi-chih lived was shaped by a fertile composite of beliefs.[3] While Confucianism remained the source of social and ideological norms during the Eastern Chin, Wang and members of his family adhered to a sect of Taoism known as the Way of the Celestial Master.[4] He also counted among his circle of friends Buddhist monks, including the learned cleric Chih-tun (314–366).

What set apart participants in elite culture of the Eastern Chin from those of earlier periods was their intense interest in the arts, above all the art of calligraphy.[5] Although there are clear signs that as early as the Han dynasty, handwriting was treated as the object of aesthetic appreciation, it was during the Eastern Chin that a distinct culture of calligraphy took shape, encompassing the formation of collections, the emergence of an art market, and the production of theoretical and critical writings. As Qianshen Bai explains in his essay in this volume, the most important format for display of calligraphic skill during this period was the personal letter. Often consisting of no more than two or three lines of writing, letters circulating among members of émigré families from the north who dominated the cultural and political life of the Eastern Chin were viewed not simply as literary compositions but as works of visual art.[6]

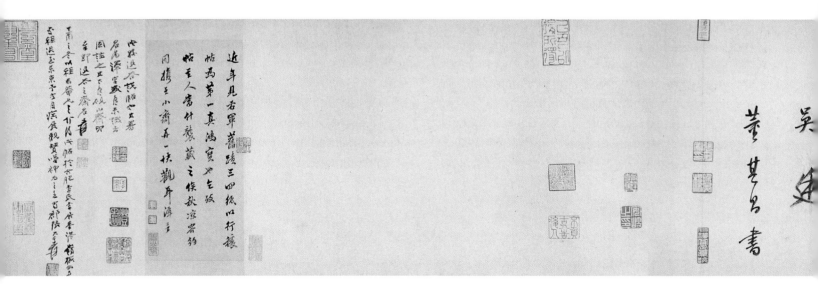

Colophon by Tung Ch'i-ch'ang, dated 1604

Seal of An Ch'i

Seal of Wu T'in

Colophon by
Chang Ta-ch'ien

Colophon by
Sun Ch'eng-tse

Figure 1. Wang Hsi-chih (303–361), *Ritual to Pray for Good Harvest*,
undated, T'ang tracing copy (cat. no. 2).

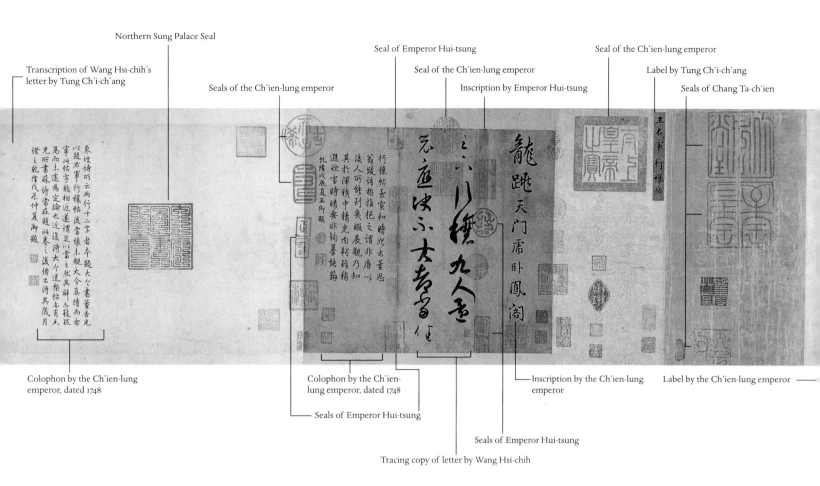

Northern Sung Palace Seal

Transcription of Wang Hsi-chih's
letter by Tung Ch'i-ch'ang

Seals of the Ch'ien-lung emperor

Seal of Emperor Hui-tsung

Seal of the Ch'ien-lung emperor

Inscription by Emperor Hui-tsung

Seal of the Ch'ien-lung emperor

Label by Tung Ch'i-ch'ang

Seals of Chang Ta-ch'ien

Colophon by the Ch'ien-lung
emperor, dated 1748

Colophon by the Ch'ien-
lung emperor, dated 1748

Inscription by the Ch'ien-lung
emperor

Label by the Ch'ien-lung emperor

Seals of Emperor Hui-tsung

Tracing copy of letter by Wang Hsi-chih

Seals of Emperor Hui-tsung

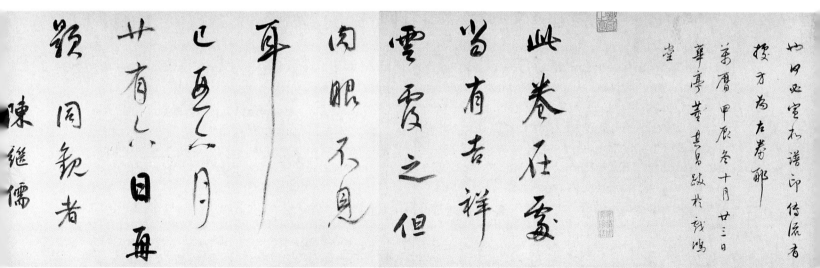

Colophon by Tung Ch'i-ch'ang, dated 1609

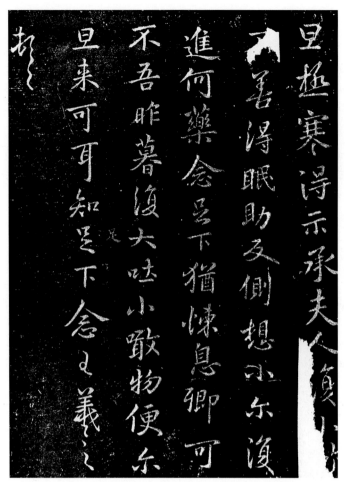

Figure 2. Copy after Wang Hsi-chih, *Extreme Cold*, rubbing from *Model Calligraphies from the Imperial Archives of the Ch'un-hua Era*. From Liu T'ao, ed., *Wang Hsi-chih, Wang Hsien-chih*, in the series *Chung-kuo shu-fa ch'üan-chi* (Peking: Jung-pao-chai, 1991), 18: pl. 73.

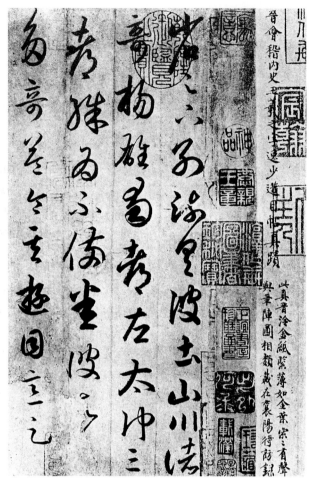

Figure 3. Copy after Wang Hsi-chih, *Sightseeing* (detail), letter mounted as a handscroll, ink on paper (destroyed during World War II). From Liu T'ao, ed., *Wang Hsi-chih, Wang Hsien-chih*, 18: pl. 17.

Wang Hsi-chih's most illustrious work of calligraphy was a prose essay known as *Preface to the Orchid Pavilion Collection* (*Lan-t'ing chi hsü*), written in the spring of 353 on the occasion of a literary gathering he hosted.[7] His other works transmitted to later centuries include a handful of transcriptions of prose texts composed by various authors.[8] But the great majority of the works on which Wang's fame as an artist rests were letters. Although Wang, like other aristocratic calligraphers of the time, must have realized that his letters would be seen by readers other than those to whom they were written, and therefore worded them with care, early connoisseurs of calligraphy had little to say about the contents of his letters. Nevertheless, these texts, like all works of calligraphy, compel anyone literate in Chinese to decipher what they say. Three samples translated below give some sense of the range of subjects the letters discuss. Perhaps the most common topic in Wang's letters is that of ill health, his own and that of his correspondents. A characteristic record of ailments appears in a letter known as *Extreme Cold* (*Chi-han t'ieh*; fig. 2), addressed to an unidentified friend:

> This morning it was extremely cold. I received your letter and learned from it that your wife again has a cough, cannot sleep well, and tosses and turns. I trust her illness is a little better now. What medicine has she taken? I am thinking of you also, worrying about your asthma. Are you any better? Yesterday evening I vomited heavily, ate a little food, and vomited again. Since this morning I have felt better. I know you are thinking of me. Wang Hsi-chih knocks his head [in respect].[9]

In spite of the unpleasant content of this letter, it was treasured by collectors and included in many anthologies of Wang's calligraphy.

In a letter known as *Sightseeing* (*Yu-mu t'ieh;* fig. 3), sent to a friend who was serving as an official in Szechwan, Wang expresses his longing to visit the famed scenery of that area:

Reading what you have described in your letter about the marvels of scenery where you are, I find that these have been recorded thoroughly in neither "Rhapsody on the Capital of Shu" by Yang Hsiung [53BC–AD18] nor "Rhapsody on the Three Capitals" by Tso Ssu [fl. early 4th century]. The many marvels of your area make me long to sightsee there to satisfy my curiosity. Were I one day able to do so, I would ask you to meet me. Were I to miss this opportunity, I truly would come to feel that the days are as long as years. I believe that since you are stationed there, the court has no reason to move you elsewhere. So I hope that while you are there we can together climb Wen Ridge and Mount

Figure 4. Copy after Wang Hsi-chih, *Presenting Oranges* (detail), letter mounted as a handscroll, ink on paper, height 24.7 cm. National Palace Museum, Taipei, Taiwan, Republic of China.

O-mei. These would be great events. Just expressing this wish makes my heart want to gallop to you.[10]

Among Wang Hsi-chih's letters, the two translated above are fairly lengthy. Some of those most treasured by collectors consist of scarcely more than one or two sentences. The shortest of all is *Presenting Oranges* (*Feng-chü t'ieh*), a letter Wang wrote to accompany a gift of oranges sent to a friend (fig. 4):

I present three hundred oranges. Frost has not yet fallen. I cannot get any more.[11]

Consisting of only twelve characters, this letter was among those collected by Emperor T'ang T'ai-tsung (r. 626–49), reproduced as a tracing copy at his court, transmitted through later imperial collections, and preserved today in the National Palace Museum in Taipei.[12]

Unfortunately, many of Wang's letters preserved in extant copies and recorded in literary sources are frustratingly difficult to read, owing to the now obscure references to historical events or personal matters they contain. The text of *Ritual to Pray for Good Harvest* is especially difficult to interpret owing to the fact that it is only half of an original letter, the complete text of which was first recorded in a ninth-century survey of calligraphy, *Essentials of Calligraphy* (*Fa-shu yao-lu*) by Chang Yen-yüan (ca. 815–ca. 880).[13] While the letter known today consists of fifteen characters, the text transcribed by Chang had thirty-two, including two characters he could not decipher.[14] The second half of the letter has survived as a separate piece of calligraphy, known by its first two characters as the *Hsüan-liang Letter* (*Hsüan-liang t'ieh*), and appears in several anthologies of rubbings (fig. 5).[15] The thin, angular brushwork in this rubbing seems quite different from the style of calligraphy seen in *Ritual,* and the relationship between the two fragments is so complex as to warrant a separate study. These pieces of cursive-script calligraphy also contain several illegible characters that continue to defy interpretation.[16] Given these problems, it is possible to offer only a tentative summary of the contents of the letter. In it Wang appears to address a friend or political associate who had carried out a ritual accompanied by nine other men. Wang asks if these men have yet made a decision regarding whether to accept government office and suggests that they should respond favorably. He closes by politely stating that he "stands waiting" for a response from the unnamed recipient of the letter.

Figure 5. Copy after Wang Hsi-chih, rubbing from *Model Calligraphies from the Hall of Playing Geese*, 1603. Far Eastern Archives, Princeton University.

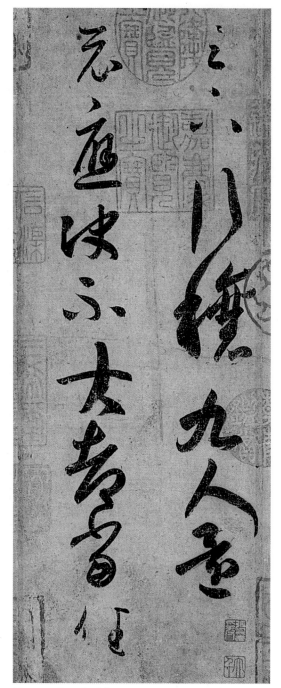

Figure 6. Detail of figure 1.

As a work of calligraphy, *Ritual to Pray for Good Harvest* displays many of the qualities for which Wang Hsi-chih's art has been most admired. Although the letter seems to have been written rapidly, in irregularly spaced columns of characters that vary considerably in size, brushstrokes are carefully formed and create a sense of disciplined energy flowing down the page (fig. 6). Another hallmark of Wang's style apparent in the letter is his inventiveness in writing recurring configurations of strokes. For example, the dots that appear in the first two characters of the first column and in the first, third, and fourth characters of the second column demonstrate the wide range of visual effects that can be achieved in even the simplest of strokes. Although this writing displays a fascination with effects of speed, changes of brush direction, and modulation of strokes new in cursive script of the fourth century, Tung Ch'i-ch'ang (1555–1636) detected in the calligraphy of the letter, produced by keeping the brush tip "hidden" in the center of the strokes, traces of archaic seal-script writing, which was produced through this same brush technique (fig. 7).[17]

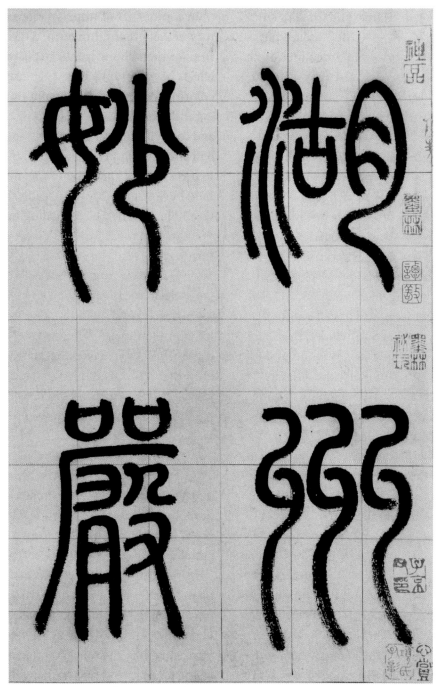

Figure 7. Chao Meng-fu (1254–1322), frontispiece to *Record of the Miao-yen Monastery*, ca. 1309–10 (cat. no. 11, detail).

EARLY COLLECTING AND CRITICAL APPRAISAL

During Wang Hsi-chih's lifetime, samples of his writing were hoarded by the recipients of his letters, and it was thanks to their care in preserving his calligraphy that works became available to early collectors in the decades following Wang's death. Lothar Ledderose has identified the warlord Huan Hsüan (369–404) as the first known collector of calligraphy by Wang Hsi-chih.[18] Huan's interest in Wang's art was encouraged by his friendship with the early historian of calligraphy

Yang Hsin (370–442), whose text *Capable Calligraphers from Antiquity Onward (Ku-lai neng-shu jen-ming)* asserts for the first time that Wang Hsi-chih was the greatest calligrapher in history. In the words of Yang Hsin, "From antiquity to the present, he has no equal."[19] At the same time that this view of Wang's status in the history of art was taking shape, demand for his calligraphy fueled the growth of a rudimentary art market and launched the careers of early forgers who sold imitations of his works. Some of these tricksters were said to have imitated Wang's hand so successfully that the

master himself was fooled.[20] Duke Hui (d. 444), another early collector of Wang Hsi-chih's calligraphy, fell victim to forgers who sold to him imitations of Wang's letters that had been soaked in dirty water to make them appear older.[21]

Although powerful aristocrats of the Eastern Chin and Liu Sung dynasties appear to have been the first to collect Wang Hsi-chih's calligraphy, it was the intervention of imperial collectors, deploying the full resources of their authority and wealth, that codified Wang's status in the history of Chinese art. Emperor Ming (r. 465–72) of the Liu Sung reassembled works by Wang Hsi-chih and his son Wang Hsien-chih (344–388) that had been in the collections of his ill-fated imperial predecessors, most of whose brief reigns ended violently, and confiscated other pieces of calligraphy by the two Wangs that were in private hands. He also appointed an expert calligrapher to study and catalogue the works in his collection; this man, Yü Ho (fl. ca. 465–471), thus stands at the beginning of a long line of imperially appointed connoisseurs whose chief duties were to evaluate and catalogue the calligraphy of Wang Hsi-chih. In his *Memorial on Calligraphy (Lun-shu piao)* presented to Emperor Ming in 470, Yü Ho reported on the works by the two Wangs in the imperial collection, which he had remounted in a total of sixty scrolls, and also recorded a number of anecdotes that became part of the scholarly lore on Wang Hsi-chih.[22] As we will see, one of these anecdotes, concerning Wang's love of geese, inspired the production of illustrated scenes from the calligrapher's life nearly a thousand years after his death.

Emperor Wu (r. 502–49) of the Liang dynasty not only collected works by Wang Hsi-chih but also actively participated in shaping the critical discourse that ranked Wang as the greatest calligrapher of all time. In his correspondence with the Taoist master and authority on calligraphy T'ao Hung-ching (456–536), Emperor Wu engaged in learned critiques of calligraphic style and discussions on connoisseurship.[23] He also addressed an issue that continues to trouble students of early calligraphy—how to evaluate the profusion of copies, imitations, and forgeries that collectively preserve, or distort, the legacy of Wang Hsi-chih's art. As part of his own efforts to address this problem, Emperor Wu assigned a staff of connoisseurs to authenticate works in his collection, which included many letters by Wang.

In another act of imperial intervention in the history of calligraphy, Emperor Wu contributed to the store of metaphoric language through which the visual effects of calligraphy have been expressed in words. A colorful vocabulary of metaphoric expressions likening the forms of calligraphy to phenomena in nature and to mythological creatures, especially the dragon, had already begun to take shape in the third century. In texts such as *The Forces of Cursive Script (Ts'ao-shu shih)* by So Ching (239–303), calligraphy is said to resemble a startled bird, a galloping horse, frolicking dragons, leaping squirrels, and breaking waves.[24] Imagery derived from physiology and medicine also provided a vivid range of metaphors such as "bone" (ku), "flesh" (jou), and "vital energy" (ch'i), which described structural qualities of brushwork and composition in calligraphy.[25] The most powerful metaphoric expressions applied to calligraphy are those connoting movement, speed, and force that evoke the energy released by the calligrapher in the physical act of writing itself.[26] Examples of these appear in *A Diagram of the Battle Formation of the Brush (Pi-chen t'u)*, a text attributed to the teacher of Wang Hsi-chih, Madam Wei (272–349), but more likely a work of the T'ang dynasty. Here, strokes in standard-script (k'ai-shu) calligraphy are likened to "a stone falling from a high peak" and "[an arrow] shot from a hundred-pound crossbow."[27]

It was Emperor Wu who coined a phrase adopted by many later commentators to describe the calligraphy of Wang Hsi-chih: "Dragons leaping at the Gate of Heaven, tigers crouching at the Phoenix Tower."[28] Structured like a parallel couplet in poetry, this eight-character phrase contrasts the realized kinetic force of the dragon in action with the still-latent energy of the crouching tiger. Twelve hundred years after Emperor Wu's time, it was his words that the Manchu emperor Ch'ien-lung (r. 1736–95) inscribed just to the right of the two lines of Wang's calligraphy in *Ritual to Pray for Good Harvest* (fig. 1). Ch'ien-lung began his transcription of these words in large characters, then, as if having misjudged the amount of space available, reduced the size of the characters below. Although Ch'ien-lung's calligraphy looks flaccid and uninspired next to Wang Hsi-chih's, his boldly placed quotation of Emperor Wu's phrase links his response to Wang's calligraphy with that of an early imperial sponsor of the Wang tradition.

The efforts of earlier rulers to collect and promote the calligraphy of Wang Hsi-chih pale in comparison with those of Emperor T'ai-tsung of the T'ang. Aside from Ch'in Shih-huang-ti (r. 221–210 B.C.), who promoted the unification of script throughout his empire, no other Chinese emperor had a greater impact on the history of calligraphy. T'ai-tsung assembled in his palace collection over two thousand pieces of Wang's calligraphy and required that members of the T'ang aristocracy and calligraphers at his court study Wang's style. He also personally composed Wang's biography for the official history of the Chin dynasty. The emperor's enthusiasm for Wang Hsi-chih, like that of earlier imperial collectors, was no doubt fueled by genuine appreciation of Wang's elegant calligraphy. But many scholars detect ideological as well as aesthetic motivations for T'ai-tsung's ardent commitment to the Wang Hsi-chih tradition. The second emperor of the dynasty, whose role in the consolidation of T'ang power actually surpassed that of his father, the founding emperor Kao-tsu (r. 618–26), T'ai-tsung was eager to exert his influence in cultural as well as political affairs. His policy of vigorously promoting the art of Wang Hsi-chih, closely associated with the aristocratic culture of south China, also allowed the emperor, whose power base was in the north, to use calligraphy as a symbol of national unification.[29]

T'ai-tsung realized that his huge collection of Wang's calligraphy included forgeries and imitations, and he assigned leading calligraphers and connoisseurs to evaluate his holdings. One of these experts, Ch'u Sui-liang (596–658), compiled the earliest extant catalogue of Wang Hsi-chih's calligraphy, a list of 266 items, most of which were letters.[30] The trophy of T'ai-tsung's collection was the original manuscript of Wang's *Preface to the Orchid Pavilion Collection,* which he acquired through trickery and eventually had buried with him in his tomb.[31]

The most enduring legacy of T'ai-tsung's sponsorship of the Wang Hsi-chih tradition was his role in ordering the reproduction of original works, both as ink-written tracing copies and as rubbings. Although debate still rages over how faithfully these T'ang dynasty recensions, including *Ritual to Pray for Good Harvest,* and later works based on them preserve the

style of fourth-century calligraphy, scholars and collectors long ago accepted the reality that the earliest extant works attributed to Wang Hsi-chih are actually reproductions dating from no earlier than the time of T'ai-tsung.[32] Had T'ai-tsung chosen to collect and reproduce the works of some other artist, the later history of Chinese calligraphy would have been very different.

As noted earlier, *Ritual to Pray for Good Harvest* was first mentioned by Chang Yen-yüan in the late T'ang dynasty, but the actual production of the copy in the Elliott Collection may well date from the time of Emperor T'ai-tsung. The material on which the letter was copied has been identified as *ying-huang,* or "hard-yellow" paper. This refers to a type of hemp-fiber paper treated with yellow wax to make it semitranslucent.[33] Placing this paper over an original piece of calligraphy, a copyist carefully traced the outlines of the characters in continuous strokes of the brush or used a method known as "outline tracing and filling in," through which the outlines of the characters were traced in fine, thin lines and then filled in with ink. According to Fu Shen's detailed study of the Elliott letter, both methods were used to copy it.[34] Several other well-known copies of Wang Hsi-chih's letters also were reproduced in this way on *ying-huang* paper, including *Presenting Oranges.*[35]

T'ai-tsung's reign witnessed an early flowering of both the political and military strength of the T'ang empire and a zenith of imperial sponsorship of calligraphy. During the Five Dynasties, a period of political disunion that followed the collapse of the T'ang, works that had been accumulated in the T'ang imperial collection were dispersed among private collectors; others entered the collections of the rulers of the short-lived Later Shu Kingdom, the Southern T'ang, and the Wu-Yüeh Kingdom. When China was reunified under the Sung dynasty, calligraphy by Wang Hsi-chih and other early masters flowed back into a centralized imperial collection. Under Emperor Sung T'ai-tsung (r. 976–97), whose interest in Wang Hsi-chih was almost as intense as that of his T'ang predecessor known by the same posthumous title, court calligraphers were instructed to study Wang's style and imperial agents scoured the empire for samples of Wang's writing.[36] T'ai-tsung ordered Wang Chu (d. 990), a noted calligrapher said to be a descendant of the same Wang clan to which Wang Hsi-chih himself belonged,

Figure 8. Ch'ien Hsüan (ca. 1235–before 1307), *Wang Hsi-chih Watching Geese*, handscroll, ink and color on paper, 23.2 x 92.7 cm. The Metropolitan Museum of Art, New York.

to evaluate the works that had accumulated in the newly revived imperial collection and to select the best pieces to be engraved on wooden blocks and reproduced as rubbings. The emperor also authorized Wang Chu to borrow works from private collectors, thus bringing under imperial control, at least temporarily, pieces not actually owned by the emperor. This project, completed in 992, yielded the first anthology of *fa-t'ieh,* or "model calligraphies," in Chinese history.[37] Reproduced through rubbings taken from engraved woodblocks, this anthology of calligraphy was titled *Model Calligraphies from the Imperial Archives of the Ch'un-hua Era* (*Ch'un-hua pi-ko fa-t'ieh*) and functioned as an officially sanctioned survey of the history of calligraphy.[38] Of the ten volumes in the anthology, copies of which T'ai-tsung conferred on officials at his

court, three were devoted entirely to letters by Wang Hsi-chih, including the letter known as *Sightseeing* translated above. Although later scholars of the Sung period sharply criticized Wang Chu's connoisseurship, *Model Calligraphies* was a landmark in the imperial codification of the Wang Hsi-chih tradition and in the history of state-sponsored standardization of culture in China.[39]

In spite of Wang Chu's wide-ranging efforts to assemble specimens of Wang Hsi-chih's writing for the imperial anthology, *Ritual to Pray for Good Harvest* escaped his notice. Nothing is known of its whereabouts between the time it was recorded by Chang Yen-yüan in the ninth century and its reemergence in the early twelfth century in the collection of another voracious imperial connoisseur, Emperor Hui-tsung

Figure 9. Sheng Mao-yeh (fl. 1594–1640), *The Orchid Pavilion Gathering*, 1621, handscroll, ink and colors on silk, 31.1 x 214.7 cm. The University of Michigan Museum of Art, Ann Arbor, Margaret Watson Parker Art Collection.

Figure 10. After Ch'ien Kung (fl. ca. 1579–1610), *Garden Views of the Huan-ts'ui Studio* (*Huan-ts'ui-t'ang yüan-ching t'u*; detail), woodblock-printed handscroll, 24.0 x 14.7 cm. From *Huan-ts'ui-t'ang yüan-ching t'u* (Peking: Jen-min mei-shu ch'u-pan-she, 1981).

of the Sung dynasty. *Ritual to Pray for Good Harvest* is listed in the catalogue of his collection, *The Hsüan-ho Calligraphy Catalogue* (*Hsüan-ho shu-p'u*), and his seals appear stamped on the scroll overlapping the paper of the fifteen-character fragment and the yellow silk mounted at its borders (fig. 1).[40] Also faintly visible on the scroll is the title of the letter written in gold, apparently by Hui-tsung himself.

Although Hui-tsung's highly individual style of calligraphy did not derive from the tradition of Wang Hsi-chih, Hui-tsung did play a role in disseminating Wang's art by issuing a new version of the *Model Callig-raphies* imperial anthology, retitled *Model Calligraphies of the Ta-kuan Era* (*Ta-kuan t'ieh*), and by sponsoring the completion of a new anthology of rubbings, *Sequel to the Imperial Archives Model Calligraphies* (*Pi-ko hsü t'ieh*), begun during the reign of Emperor Che-tsung (1086–1101). This collection, which unfortunately is no longer extant, comprised works from the Imperial Archives that had not been included in the earlier anthology. Two volumes reproduced calligraphy by Wang Hsi-chih and another included works by Wang and other members of his family.

Figure 11. Copy after Wang Hsi-chih, *Ritual to Pray for Good Harvest*, rubbing from *Model Calligraphies from the Yü-ch'ing Studio*, 1614. From *Yü-ch'ing-chai fa-t'ieh* (Hofei: An-hui mei-shu ch'u-pan she, 1992), 158.

WANG HSI-CHIH TRIUMPHANT AND THE FATE OF *RITUAL TO PRAY FOR GOOD HARVEST*

When the Northern Sung dynasty fell in 1127, hundreds of works of painting and calligraphy from Hui-tsung's collection were carried off by invading Jurchen troops; thousands more simply disappeared. The fate of *Ritual to Pray for Good Harvest* between this time and its reappearance in the late Ming dynasty remains a mystery. While the letter was absent from the body of materials through which Wang's style was transmitted, the tradition went through several periods of revival and transformation. During the early Yüan dynasty Chao Meng-fu (1254–1322) undertook an extensive

study of Wang's style as part of a larger enterprise of reexamining early traditions of both painting and calligraphy. Combining elements from Wang's fluid brushwork with structural principles derived from standard and clerical script models of the Han and T'ang, Chao produced a striking new synthesis in his own calligraphy (cat. no. 11), which became the most widely imitated model of writing in the Yüan period.

During the Yüan dynasty, when China was ruled by the Mongols, a distinctive iconography of Wang Hsi-chih took shape in painting, reflecting a fascination with the remote past detectable also in Chao Meng-fu's studies of early art. Although the Northern Sung scholar-artist Li Kung-lin (ca. 1041–1106) may have been the first to illustrate scenes of Wang's life,[41] the earliest extant painting of the calligrapher is a short handscroll (fig. 8) by Ch'ien Hsüan (ca. 1235–before 1307), a friend of Chao Meng-fu. Placed in a landscape rendered in the archaic blue-green manner, Wang Hsi-chih stands in a pavilion looking out at geese swimming in the water below. This scene alludes to stories of Wang's fondness for geese first recorded in the fifth century by Yü Ho.[42] Painted by an artist who lived through the fall of the Sung dynasty, this image of Wang Hsi-chih may have been intended as a quiet reaffirmation of Chinese cultural traditions, which many intellectuals of Ch'ien Hsüan's generation believed were threatened by the Mongol conquest.[43]

The iconography of Wang Hsi-chih continued to expand in the Ming dynasty, when depictions of the Gathering at the Orchid Pavilion became a popular subject in painting.[44] In scenes from a handscroll by Sheng Mao-yeh (fl. 1594–1640), Wang Hsi-chih sits at a table in the Orchid Pavilion composing his masterpieces while several guests look on. Other guests stroll about or sit on the banks of a stream, in which wine cups float by on lotus leaves (fig. 9).

Although these images of Wang Hsi-chih and his friends were fanciful visualizations of an event that took place in 353, they also reflected the characteristic pleasures of Ming literati and others who followed their lead in building gardens and holding literary gatherings. In the garden of the writer and publisher Wang T'ing-na (fl. 1590s) illustrated in a woodblock print (fig. 10), the words Orchid Pavilion appear over the entrance to a courtyard.[45] Within the courtyard, potted orchid plants rest on a table identified as the Orchid Platform, and, gathered around a large stone

Figure 12. Anonymous, *The Ch'ien-lung Emperor in a Garden* (detail), 1753, handscroll, ink on paper. Collection unknown. From *Ch'ing-tai ti-hou hsiang,* no. 4 (Peking: Ku-kung po-wu-yüan, 1931), part 2, no. 6.

table inlaid with a winding stream on which wine cups are afloat, a group of gentlemen, some of them apparently drunk, reenact Wang Hsi-chih's famous party.

For calligraphers of the Ming dynasty, Wang Hsi-chih remained a powerful presence, but unlike rulers of earlier dynasties, the Ming emperors played almost no role in maintaining Wang's stature. Although various calligraphers did receive imperial favor, and works of calligraphy continued to be accumulated in imperial and princely collections, no state-sponsored projects comparable to those of the T'ang and Sung dynasties promoted Wang Hsi-chih.[46] But thanks to the increasing dissemination of anthologies of rubbings published by private collectors, knowledge of Wang's style became more widespread than ever.[47] In nearly all of these anthologies, works by Wang Hsi-chih outnumber those of any other calligrapher. The classical tradition of his art, which had been closely tied to imperial sponsorship in earlier periods, had achieved a life of its own.

Of all Ming dynasty students of the art of Wang Hsi-chih, Tung Ch'i-ch'ang was the most influential, devoting a lifetime to collecting and copying his works. Tung also contributed to the ongoing publication of examples of Wang's calligraphy through his own compendium of rubbings, *Model Calligraphies from the Hall of Playing Geese (Hsi-hung-t'ang fa-t'ieh)*, com-

pleted in 1603, which contains fifty-eight pieces attributed to the Eastern Chin master.[48] It was in Tung's collection that *Ritual to Pray for Good Harvest* emerged once again. In an undated colophon recorded in a compendium of Tung's notes on art, he states that he had recently purchased the letter.[49] He does not mention the price he paid, but in the overheated art market of the late Ming, it cannot have been low. In a ranking of antiques compiled by the connoisseur Li Jih-hua (1565–1635), calligraphic pieces of the Chin and T'ang dynasties come first.[50] The most expensive work of art to have changed hands during the Ming was *Close Looking (Chan-chin t'ieh)*, a letter by Wang Hsi-chih for which Hsiang Yüan-pien (1525–1590) paid two thousand ounces of silver at a time when mansions changed hands for less than half this sum.[51]

During the time he owned the scroll, Tung Ch'i-ch'ang wrote three colophons that are now mounted with it and also added a transcription of the text of the letter in small standard-script characters. His transcription apparently was intended to assist readers who had difficulty interpreting some of the cursive-script characters that continue to resist decipherment today. These inscriptions, from the hand of the most esteemed connoisseur of his day, also had the effect of raising the value of the scroll as a collectible object. From Tung Ch'i-ch'ang the letter passed into the hands

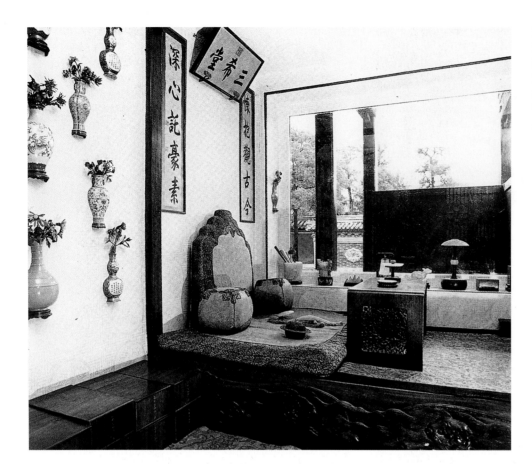

Figure 13. Hall of the Three Rarities, Palace Museum, Peking. From Yu Zhouyun, chief comp., *Tzu-chin-ch'eng kung-tien (Palaces of the Forbidden City)* (1982, New York: Viking Press; London: Allen Lane, 1984), p. 95, pl. 82.

of his friend Wu T'ing (fl. ca. 1575–1625), a collector and art dealer noted for his perspicacity—one source claims that he simply could not be taken in by forgeries.[52] The transfer of the letter into Wu's collection resulted in its publication, apparently for the first time in its history, in an anthology of rubbings, the second installment of *Model Calligraphies from the Yü-ch'ing Studio (Yü-ch'ing-chai fa-t'ieh)* issued by Wu T'ing in 1614 (fig. 11).[53] A close comparison with the ink-tracing of the letter reveals both the value of rubbings and their capacity to subtly alter the calligraphy they reproduce. Although it preserves the general configuration of the characters in the letter and captures much of the sense of energy with which they were written, the rubbing transforms the plump, rounded brushstrokes into thinner and more angular forms. Apparently at Wu T'ing's request, the engraver who produced the rubbing moved one of the seals of Emperor Hui-tsung from the far left of the silk mounting to directly between two other Hui-tsung seals stamped on the letter itself (fig. 11).[54] Through this repositioning of an imperial seal, Wu T'ing made certain that all available evidence for the impressive pedigree of the letter was fully visible in his anthology of rubbings.

The letter was seen and recorded by several connoisseurs of the seventeenth century before it entered the collection of the famous Korean merchant An Ch'i (1683–1744), who stamped eleven of his seals on the scroll and recorded it in the catalogue of his collection.[55] Within three years of An Ch'i's death the letter had passed into the largest art collection ever seen in China, that of the Manchu emperor Ch'ien-lung, the fourth ruler of the Ch'ing dynasty. No emperor in Chinese history was more alert to the ways through which artistic traditions could be harnessed to promote ideological goals, and Ch'ien-lung's lengthy reign witnessed many vast projects through which he demonstrated his authority as an arbiter of taste and scholarship.[56] Playing the role of protector and patron of Chinese culture, Ch'ien-lung frequently had himself depicted as a literati gentleman studying or producing calligraphy (fig. 12), asserting through these impersonations his place in a lineage of artists headed by Wang Hsi-chih himself.

Upon its arrival in the Ch'ing palace, *Ritual to Pray for Good Harvest* rejoined several other handwritten works attributed to Wang Hsi-chih that had been known in the T'ang dynasty, recorded in later catalogues and collectors' notes, and, in this final great gathering of masterpieces, returned to an imperial collection.[57] As a result of this reassembling of Wang's calligraphy, almost all the extant ink-written pieces

Figure 14. Huang Chen-hsiao (fl. early 18th century), small screen in the form of a wrist rest with a scene of the Gathering at the Orchid Pavilion, 1739, carved ivory, 9.2 x 4 cm. National Palace Museum, Taipei, Taiwan, Republic of China.

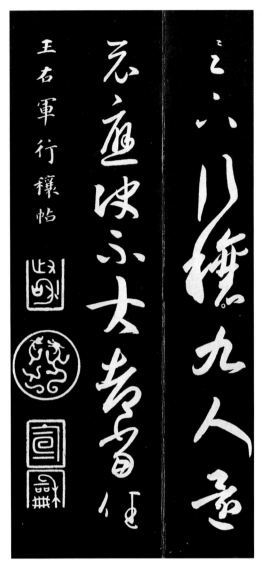

Figure 16. Copy after Wang Hsi-chih, *Ritual to Pray for Good Harvest*, rubbing from *San-hsi-t'ang fa-t'ieh*, 1747, ink on paper, 28.6 x 17.8 cm. The Metropolitan Museum of Art, Gift of Marie-Hélène and Guy Weill, 1984 (1984.496.1).

Figure 15. Inkstone depicting the Orchid Pavilion, Sung dynasty or later, T'ao River stone, 3.2 x 23.3 x 17.8 cm. National Palace Museum, Taipei, Taiwan, Republic of China.

attributed to him, aside from those preserved in Japan, bear the seals of Ch'ien-lung. In fact, the most visually conspicuous features of *Ritual* today are the traces of Ch'ien-lung's ownership: his nineteen seals stamped on the scroll and the inscriptions from his hand.

Ch'ien-lung's projects commemorating Wang Hsi-chih were not limited to collecting, stamping seals, and colophon writing. Architectural modifications to the imperial palace also demonstrated his participation in the ongoing enshrinement of Wang Hsi-chih at the center of the canon of Chinese art. One of the most intimate rooms in his palace was a small private studio that Ch'ien-lung reserved for the study of his calligraphy collection. Located in part of the Hall for Cultivating the Mind (*Yang-hsin-tien*), this room was known

Figure 17. Cover of *Traces of the Brush: Studies in Chinese Calligraphy* by Shen C. Y. Fu et al. (New Haven, Yale University Art Gallery, 1977).

Figure 18. Anonymous, *Ritual to Pray for Good Harvest,* after Wang Hsi-chih, weaving, ca. 1980, 42.6 x 35.6 cm. Private collection.

as the Hall of the Three Rarities (*San-hsi-t'ang*; fig. 13), named for three works of calligraphy that the emperor considered the prizes of his collection, all of them letters by members of the Wang family: *Timely Clearing after Snow* (*K'uai hsüeh shih ch'i t'ieh*) by Wang Hsi-chih, *Mid-Autumn Letter* (*Chung-ch'iu t'ieh*) by his son Wang Hsien-chih, and *Letter to Po-yüan* (*Po-yüan t'ieh*) by his nephew Wang Hsün (350–401). Beautifully restored, the Hall of the Three Rarities can still be seen today, adorned with a plaque bearing its name written in Ch'ien-lung's own hand. In this room, Ch'ien-lung could also enjoy works of decorative art that commemorated events in Wang's life, such as a miniature screen in the form of an ivory wrist rest carved to represent the Gathering at the Orchid Pavilion (fig. 14) and an antique inkstone engraved with a depiction of the same event (fig. 15).[58]

The name of the Hall of the Three Rarities provided the title for an anthology of rubbings from Ch'ien-lung's collection titled *Model Calligraphies of the Hall of the Three Rarities* (*San-hsi t'ang fa-t'ieh*), cut in 1747. The anthology included 340 pieces by 135 calligraphers reproduced through a painstaking process of copying

the originals, transferring the outlines of the characters onto stone, engraving the characters, as well as the seals stamped on the original works, and printing glossy black rubbings that were bound into albums. Although Ch'ien-lung included *Ritual to Pray for Good Harvest* in this anthology, providing yet another format through which Wang's calligraphy could be disseminated, the original appearance of the letter was strangely altered in the process of reproducing it (fig. 16). Although the brushwork of the rubbing is more faithfully preserved than in the rubbing from *Model Calligraphies from the Yü-ch'ing Studio,* the spaces between several of the characters were widened, the placement of Hui-tsung's seals rearranged, and a six-character title written by Tung Ch'i-ch'ang repositioned to the left of the two lines of Wang's calligraphy.[59]

The letter appears to have remained in the Ch'ing imperial collection until the end of the dynasty, though the date of its removal from the palace is unknown. Seals stamped on the scroll indicate that it passed through the hands of three twentieth-century collectors before the famous artist and collector

Chang Ta-ch'ien (1899–1983) bought the scroll in Hong Kong in 1957. In 1970 it entered the Elliott Collection. As at many earlier points in its history, the transmission of the letter in the twentieth century has been paralleled by new formats for reproducing it. These include a facsimile scroll published in Japan in 1959, the cover of the landmark exhibition catalogue *Traces of the Brush* (fig. 17), and a weaving produced by an artist living in New Jersey (fig. 18). It is surely only a matter of time before images of *Ritual to Pray for Good Harvest* will be digitized on a CD-ROM or transmitted over the Internet.

At the end of the twentieth century the letter survives as a cultural icon, an artifact of a centuries-old enterprise of evaluating, collecting, and reproducing the calligraphy of Wang Hsi-chih. Although the facts of Wang's life are well documented, his lofty status as the Sage of Calligraphy obscures his existence as an individual, much as the collectors' seals and inscriptions on *Ritual to Pray for Good Harvest* come close to hiding the fifteen characters traced from Wang's original letter. Perhaps the secret of the fascination the letter has exercised for so long lies not just in its beauty and its status as a prestigious work of art, but in the bond, however tenuous, between this small piece of paper and the venerated but elusive man whose words and brushstrokes it transmits.

NOTES

1. On the concept of a classical tradition in Chinese calligraphy, see Lothar Ledderose, *Mi Fu and the Classical Tradition of Chinese Calligraphy* (Princeton: Princeton University Press, 1979), 3–5.

2. For a thorough biographical study of Wang Hsi-chih, see Wang Yü-ch'ih, *Wang Hsi-chih* (Peking: Tzu-chin-ch'eng ch'u-pan-she, 1991); see also Ledderose, *Mi Fu*, 12–14.

3. For a good introduction to intellectual life of the fourth century, see Charles Holcombe, chap. 5, "Literati Culture," in his *In the Shadow of the Han: Literati Thought and Society at the Beginning of the Southern Dynasties* (Honolulu: University of Hawaii Press, 1994).

4. See Ch'en Yin-k'o, "T'ien-shih-tao yü pin-hai ti-yü chih kuan-hsi," in *Ch'en Yin-k'o hsien-sheng lun-chi* (Taipei: Chung-yang yen-chiu-yüan li-shih yü-yen yen-chiu-so, 1971); and Lothar Ledderose, "Some Taoist Elements in Calligraphy of the Six Dynasties," *T'oung Pao* 70 (1984): 246–78.

5. Holcombe, *In the Shadow of the Han*, 4.

6. On the readership of these letters, see Hua Jen-te, "Lun Tung-Chin mu-chih chien-chi Lan-t'ing lun-pien," *Ku-kung hsüeh-shu chi-k'an* 13, no. 3 (Oct. 1995): 40–42; trans. Ian H. Boyden, "Eastern Jin Epitaphic Stones—With Some Notes on the 'Lanting Xu' Debate," *Early Medieval China* 3 (1997): 30–88.

7. For an introduction to the history of *Preface to the Orchid Pavilion Collection* and the many problems raised by its transmission, see Ledderose, *Mi Fu*, 19–24.

8. See cat. no. 16 for a transcription of one of these works, *Essay on Yüeh I*.

9. My translation follows the modern Chinese version in Liu T'ao, ed. *Wang Hsi-chih, Wang Hsien-chih*, in the series *Chung-kuo shu-fa ch'üan-chi* (Peking: Jung-pao-chai, 1991), 19: 385.

10. Based on the modern Chinese version in ibid., 360–61.

11. Ibid., 15.

12. The transmission of this letter is discussed in Lothar Ledderose, "Chinese Calligraphy: Its Aesthetic Dimension and Social Function," *Orientations* 17, no. 10 (Oct. 1986): 46–49.

13. Chang Yen-yüan, *Fa-shu yao-lu* (I-shu ts'ung-pien ed.), *chüan* 10: 169. It is impossible to know whether Chang's transcription of the letter was based on what he believed was an original

manuscript by Wang Hsi-chih, a copy, or a transcription from some other source.

14. There are also discrepancies between his transcription and the text of the extant letter, owing either to his own error or to mistakes that crept into printed editions of his work. These are discussed by Qianshen Bai in his essay in this volume.

15. The *Hsüan-liang Letter* is listed in the catalogue of the collection of Emperor Sung Hui-tsung (r. 1100–1126) (*Hsüan-ho shu-p'u*, in the series *Chung-kuo shu-hsüeh ts'ung-shu* [Shanghai: Shang-hai shu-hua ch'u-pan-she, 1984], *chüan* 15: 120). A rubbing of the fragmentary letter appears in the thirteenth-century anthologies *Pao-chin-chai fa-t'ieh* and *Ch'eng-ch'ing-t'ang t'ieh*, and in *Hsi-hung-t'ang fa-t'ieh*, compiled by Tung Ch'i-ch'ang, from which the illustration is taken. See Nakata Yūjirō, *Ō Gishi no chūshin to suru hōjō no kenkyū* (Tokyo: Nigensha, 1970), 39–40.

16. Some of these difficulties are discussed by Qianshen Bai in his essay in this volume. See also the entry in *Shodō zenshū*, n.s. (Tokyo: Heibonsha, 1960), 4: 168–69.

17. This statement appears in Tung Ch'i-ch'ang's colophon of 1604. See fig. 18.

18. Ledderose, *Mi Fu*, 40

19. Yang Hsin, *Ku-lai neng-shu jen-ming*, in Huang Chien, ed., *Li-tai shu-fa lun-wen hsüan* (hereafter, *LTSF*) (Shanghai: Shang-hai shu-hua ch'u-pan-she, 1979), 1: 47.

20. Yü Ho, *Lun-shu piao*, in *LTSF*, 1: 53–54; and Chang Yen-yüan, *Li-tai ming-hua chi* (I-shu ts'ung-pien ed.), 53–54, cited in Ledderose, *Mi Fu*, 37.

21. Yü Ho, *Lun-shu piao*, in *LTSF*, 1: 50, cited in Ledderose, *Mi Fu*, 40–41.

22. Yü Ho, *Lun-shu piao*, in *LTSF*, 1: 53–54. Four of the anecdotes recorded by Yü Ho were transcribed by Chao Meng-fu. See Wen C. Fong, *Beyond Representation: Chinese Painting and Calligraphy, 8th–14th Century* (New York: The Metropolitan Museum of Art; and New Haven and London: Yale University Press, 1992), 424–27, pl. 98.

23. T'ao Hung-ching, "Yü Liang Wu-ti lun-shu ch'i"; and Hsiao Yen (Liang Wu-ti), "Ta T'ao Yin-chü lun-shu," in *LTSF*, 69–71, 80.

24. See the excerpts from this text translated in the essay by Wen C. Fong in this volume.

25. These concepts are discussed in an important article by John Hay, "The Human Body as a Microcosmic Source of Macrocosmic Values in Calligraphy," in Susan Bush and Christian Murck eds., *Theories of the Arts in China* (Princeton: Princeton University Press, 1983), 74–102.

26. Michael Baxandall attributes the critical power of this type of language, which he calls "inferential criticism," to the experience of writing calligraphy shared by educated readers in China. See his essay, "The Language of Art Criticism," in Salim Kemal and Ivan Gaskell, eds., *The Language of Art History* (Cambridge and New York: Cambridge University Press, 1991), 73.

27. See the discussion of this text in the essay by Wen C. Fong in this volume. See also Richard M. Barnhart, "Wei Fu-jen's *Pi-chen T'u* and the Early Texts on Calligraphy," *Archives of the Chinese Art Society of America* 18 (1964): 13–25.

28. Liang Wu-ti, *Ku-chin shu-jen yu-lüeh p'ing*, in *LTSF*, 1: 81. Note that some editions of this text substitute the character *ko* (pavilion) for *ch'üeh* (tower). In his inscription on *Ritual to Pray for Good Harvest,* the Ch'ien-lung emperor uses the former term.

29. Richard Curt Kraus, *Brushes with Power: Modern Politics and the Chinese Art of Calligraphy* (Berkeley, Los Angeles, Oxford: University of California Press, 1991), 32, citing Wang Ching-feng and Shu Ts'ai, eds., *Shu-fa chi-ch'u chih shih* (Peking: Chieh-fang-chun ch'u-pan-she, 1988), 96–97. See also Stephen J. Goldberg, "Court Calligraphy of the Early T'ang Dynasty," *Artibus Asiae* 49, no. 3/4 (1988–89): 189–237.

30. Ch'u Sui-liang, "Chin Yu-chün Wang Hsi-chih shu-mu," in Chang Yen-yüan, *Fa-shu yao-lu, chüan* 3: 38–43.

31. The story of T'ai-tsung's acquisition of *Preface to the Orchid Pavilion Collection* is told in Han Chuang (John Hay), "Hsiao I Gets the Lan-t'ing Manuscript by a Confidence Trick," *National Palace Museum Bulletin* 5, no. 3 (July–Aug. 1970): 1–7; and 5, no. 6 (Jan.–Feb. 1971): 1–17.

32. For a survey of these debates on the reliability of copies, see Ledderose, *Mi Fu,* 33–39.

33. For a detailed description of the tracing process, see Shen C. Y. Fu et al., *Traces of the Brush: Studies in Chinese Calligraphy* (New Haven: Yale University Art Gallery, 1977), 3–7. See also Robert H. van Gulik, *Chinese Pictorial Art as Viewed by the Connoisseur* (Rome: Istituto Italiano per il Medio ed Estremo Oriente, 1958), 137 n. 2.

34. Fu et al., *Traces,* 5.

35. *Shodō zenshū,* n.s., 4: pls. 34, 35.

36. For a study of Sung T'ai-tsung's interest in calligraphy, see Ho Chuan-hsing, "The Revival of Calligraphy in the Early Northern Sung," in Maxwell K. Hearn and Judith K. Smith, eds., *Arts of the Sung and Yüan* (New York: The Metropolitan Museum of Art, 1996), 59–85.

37. *Fa-t'ieh* may also be translated as "model letter" (Amy McNair, "Engraved Model-Letters Compendia of the Song Dynasty," *Journal of the American Oriental Society* 114, no. 2 [April–June 1994]: 209–25).

38. The anthology is also known as the *Kuan fa-t'ieh* (ibid., 210).

39. The production of anthologies of rubbings was not limited to the imperial court. During the Sung dynasty, private scholars also began to commission their own anthologies, which included letters by Wang Hsi-chih as well as epigraphical material from bronze inscriptions and stelae (ibid., 214–25).

40. *Hsüan-ho shu-p'u,* 120. As noted earlier, Hui-tsung also owned the second half of the letter, listed under the title *Hsüan-liang t'ieh.* See note 15 above.

41. A painting titled *Sketch of Wang Hsi-chih Inscribing a Fan* by Li Kung-lin is listed in *Hsüan-ho hua-p'u* (*I-shu ts'ung-pien* ed.), *chüan* 7: 205. A depiction of the Gathering at the Orchid Pavilion preserved in a Ming dynasty rubbing is said to be based on a composition by Li Kung-lin (Percival David, trans., *Chinese Connoisseurship: The Ko Ku Yao Lu* [New York and Washington: Praeger Publishers, 1971], 52–55; and Sydney L. Moss, *Emperor, Scholar, Artisan, Monk: The Creative Personality in Chinese Works of Art* [London: Sydney L. Moss, Ltd., 1984], 31–35). A painting of Wang Hsi-chih watching geese attributed to Ma Yüan (fl. ca. 1160–after 1225) appears to be a much later work (Kuo-li ku-kung po-wu-yüan pien-tsuan wei-yüan-hui, ed., *Ku-kung shu-hua t'u lu* [Taipei: Ku-kung po-wu-yüan, 1989], 2: 183).

42. See note 22 above.

43. See Shih Shou-chien, "The Eremitic Landscapes of Ch'ien Hsüan (ca. 1235–before 1307)" (Ph.D. diss., Princeton University, 1984).

44. For examples of Ming paintings of the Gathering at the Orchid Pavilion, see the following: Attributed to Wen Cheng-ming (1470–1559), *The Lanting Gathering,* in James Cahill et al., *The Restless Landscape: Chinese Painting of the Late Ming Period* (Berkeley: The University Art Museum, 1971), no. 7: 51; Ch'ien Ku (1505–ca. 1578), *Gathering at the Orchid Pavilion,* dated 1560, in Roderick Whitfield, *In Pursuit of Antiquity* (Princeton: The Art Museum, Princeton University, 1969), no. 4: 76–82; Sheng Mao-yeh (fl. 1594–1640), *Gathering at the Orchid Pavilion,* dated 1621, in Alice R. M. Hyland, *Deities, Emperors, Ladies and Literati* (Birmingham, Ala.: Birmingham Museum of Art, 1987), 42–43; Chang Hung (1580–after 1650), *Gathering at the Orchid Pavilion,* dated 1616, in James Cahill, *The Lyric Journey: Poetic Painting and China and Japan* (Cambridge, Mass.: Harvard University Press, 1996), fig. 2.15, pp. 98–99.

45. See Nancy Berliner, "Wang Tingna and Illustrated Book Publishing in Huizhou," *Orientations* (Jan. 1995): 67–75.

46. On members of the Ming imperial family who collected calligraphy by Wang Hsi-chih, see Moss, *Emperor, Scholar, Artisan, Monk,* 31–35.

47. See *Shodō zenshū,* n.s., 17: 19–27.

48. These include the other half of the letter preserved in the Elliott scroll, but not *Ritual to Pray for Good Harvest* itself, which Tung did not acquire until later. See note 15 above.

49. Tung Ch'i-ch'ang, *Jung-t'ai chi,* in *Ming-tai i-shu chia chi hui-k'an* (Taipei: Kuo-li chung-yang t'u-shu-kuan, 1968), *chüan* 4: 1945. This colophon no longer appears with the letter, though a portion of it, quoting a poem by Su Shih (1037–1101) is part of an undated inscription by Tung Ch'i-ch'ang mounted before his colophon from the winter of 1604. Since the letter was not included in Tung's anthology of rubbings, *Model Calligraphies from the Hall of Playing Geese,* completed in 1603, it seems likely that Tung acquired the letter between that time and the following winter.

50. James C. Y. Watt and Chu-tsing Li, eds., *The Chinese Scholar's Studio: Artistic Life in the Late Ming Period* (New York: Asia Society Galleries, 1987); see also Craig Clunas, *Superfluous Things: Material Culture and Social Status in Early Modern China* (Urbana and Chicago: University of Illinois Press, 1991), 104–5.

51. Clunas, *Superfluous Things,* 125ff; see also pp. 177–81 for a list of prices paid for antiques ca. 1560–1620.

52. See Wang Shiqing, "Tung Ch'i-ch'ang's Circle" (in Chinese), in Wai-kam Ho, ed., *The Century of Tung Ch'i-ch'ang, 1555–1636* (Kansas City, Mo.: The Nelson Atkins Museum of Art, 1992), 2: 473.

53. Wu T'ing apparently acquired the letter from Tung Ch'i-ch'ang sometime between 1609 and 1614. In an undated note Tung simply states that he "formerly owned" the letter (*Jung-t'ai chi, chüan* 4: 1949). I am grateful to Amy McNair for lending me her reproduction of the copy of *Model Calligraphies from the Yü-ch'ing Studio* preserved in the She-hsien Museum in Anhwei. In 1880 the collector and scholar Yang Shou-ching (1839–1915) took with him to Japan a copy of *Model Calligraphies from the Yü-ch'ing Studio,* from which a facsimile was made (Fu et al., *Traces,* 242–43). According to Fu Shen, a forged version of *Ritual to Pray for Good Harvest,* now in the National Palace Museum, Taipei, also was produced in the late Ming dynasty (ibid., 8).

54. This transformation is described in Fu et al., *Traces,* 292 n. 24.

55. An Ch'i, *Mo-yüan hui-kuan lu* (Taipei: Shang-wu yin-shu-kuan, 1970), *chüan* 1: 5–6. For other records of *Ritual to Pray for Good Harvest,* see Wang K'o-yü, *Shan-hu wang shu-hua-pa* (*Wen-yüan-ko Ssu-k'u ch'üan shu* ed., Taipei: Shang-wu yin-shu-kuan, 1983–86), *chüan* 1: 9b; Pien Yung-yü, comp., *Shih-ku-t'ang shu-hua hui-k'ao* (reprint of the 1921 facsimile, Taipei: Cheng-chung shu-chü, 1958), 1: 304; Chang Ch'ou, *Ch'ing-ho shu-hua fang* (undated ed., Far Eastern Seminar, Princeton University), *ch'ou:* 26a.

During the seventeenth century the scroll also acquired a colophon written by the connoisseur Sun Ch'eng-tse (1592–1676), who states that it was one of the best works by Wang Hsi-chih he had seen in recent years.

56. For an introduction to Ch'ien-lung's role as arbiter of taste, see Harold Kahn, "A Matter of Taste: The Monumental and Exotic in the Qianlong Reign," in Chou Ju-hsi and Claudia Brown, eds., *The Elegant Brush: Chinese Painting under the Qianlong Emperor, 1735–1795* (Phoenix: Phoenix Art Museum,1985), 288–302. See also R. Kent Guy, *The Emperor's Four Treasuries: Scholars and the State in the Late Ch'ien-lung Era,* Harvard East Asian Monographs 129 (Cambridge, Mass.: Council on East Asian Studies, Harvard University, dist. by Harvard University Press, 1987).

57. *Ritual to Pray for Good Harvest* is recorded in Wang Chieh et al., eds., *Shih-ch'ü pao-chi hsü-pien* (facsimile reprint of an original manuscript, Taipei: Ku-kung po-wu yüan, 1971), 5: 2599–60.

58. See Wen C. Fong and James C.Y. Watt, *Possessing the Past: Treasures from the National Palace Museum, Taipei* (New York: The Metropolitan Museum of Art; and Taipei: The National Palace Museum, 1996), 528–31, 537–39.

59. These alterations are discussed in Fu, *Traces,* 8. Fu also discusses a facsimile rubbing, based on *Model Calligraphies from the Yü-ch'ing Studio,* made in Japan in the late nineteenth century (8, 242–43).

Mi Fu (1052–1107), *Abundant Harvest* (cat. no. 7a, detail of fig. 2a).

Opposite Paths to Originality: Huang T'ing-chien and Mi Fu

JAY XU

In Tu Fu's [712–770] poems and Han Yü's [768–824] prose, there is not a single word that does not have antecedents. Later generations, because they read too little, say that Han and Tu made up their expressions by themselves. In fact, those of old capable of composing literature were able to mold and smelt myriad materials. Though they took the stale expressions of the ancients and put them into brush and ink, they were like a pill of Spirit Cinnabar: it touches iron and turns it to gold.

—HUANG T'ING-CHIEN (1045–1105)

Tu Fu and Han Yü were two literary giants of the T'ang dynasty who inspired awe and emulation in the Northern Sung. In the statement above Huang T'ing-chien admires their magical power to assimilate and create but at the same time observes their indebtedness to still earlier masters in literature.[1] The statement is really a declaration of Huang T'ing-chien's own stance. It conveys his awareness of the vast literary tradition and renounces any hope that a composition could ever be entirely new, yet betrays no discontent with his position late in a developed tradition. It states succinctly his literary goal: assimilation and then creative transformation of the ancient sources to attain something new and marvelous. The key to success is a "pill of Spirit Cinnabar," something able by its magical alchemy to "turn iron into gold."

Huang T'ing-chien's goal in calligraphy was the same. For him, literature and calligraphy were parallel creative processes.[2] And in calligraphy even more than in literature, he achieved a singular greatness by creatively assimilating a rich inheritance.[3] The same can be said of his contemporary Mi Fu (1052–1107), who steeped himself in the tradition of calligraphy and eventually became both the most sophisticated and the most spontaneous artist in the history of Chinese calligraphy.[4] The calligraphy created by Huang and Mi shares the same high originality but in every other aspect could hardly be more different. This study compares Huang and Mi, focusing on their works in the John B. Elliott Collection (figs. 1 and 2, cat. nos. 6 and 7) and on their critical writings.[5]

As exemplified by his *Scroll for Chang Ta-t'ung* (fig. 1, cat. no. 6), written in 1100, Huang T'ing-chien's mature calligraphy possesses, in Shen Fu's words,

> a brushline of lean shape and rounded form with an occasional "trembling" or "struggling" quality, most noticeable in his elongated horizontal and diagonal strokes. . . . The internal structure. . . was governed by a principle of asymmetrical balance which expressed itself in the avoidance of parallels, the elongation of diagonals, verticals and horizontals, and a pronounced slant to the upper right. As to spatial arrangement, Huang T'ing-chien's overall spacing was characterized by spontaneous changes of character size [and] shifts in the axis of characters in a column. . . . Thus the brushstrokes, characters and columns were all intimately related in a spatially dynamic way.[6]

In short, the work combines "weighty intensity with satisfying directness" (*ch'en-cho t'ung-k'uai*), a quality Huang T'ing-chien greatly admired in the ancients and which without doubt is also found in his own calligraphy.[7]

The Elliott Collection's *Three Letters* by Mi Fu (fig. 2, cat. no. 7), datable to 1093–94, illustrate the easy grace and subtle complexity of Mi Fu's mature calligraphy in letter writing, his favorite form of calligraphic composition.[8] One letter, *Abundant Harvest*, was executed at medium speed with light, gentle brushstrokes, conveying a sense of composure (fig. 2a). Another, *Escaping Summer Heat*, was written with a more resilient brush and at a slower pace, with more inflection and undulation,

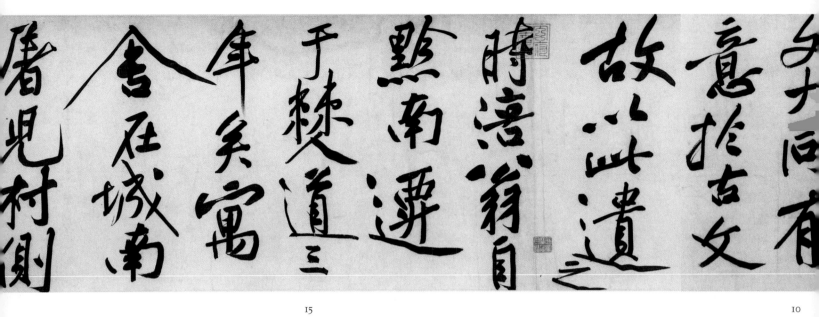

15　　　　　　　　　　　　　　　　　　　　　　　　　　　10

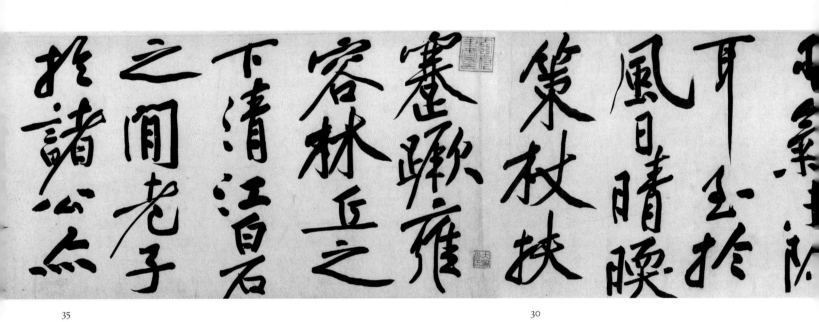

35　　　　　　　　　　　　　　　　　　　　　　　　　　30

Figure 1. Huang T'ing-chien (1045–1105), *Scroll for Chang Ta-t'ung*, 1100 (cat. no. 6).

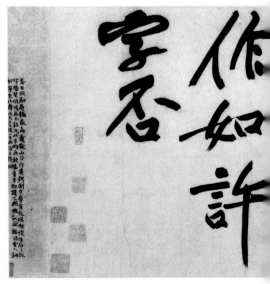

45

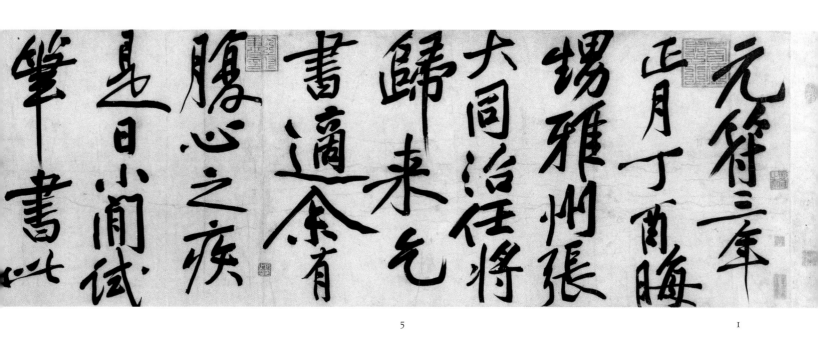

元祐三年
正月丁酉晦
錫雅州張
大同治任將
歸來气
書適余有
腹心之疾
是日小浦試
筆書以

5　　　　　　　　　1

屠見村側
逢蘿拄
宇齔齔
同徑然顏
為諸少年
文章翰
墨見強
尚有中州
時舉子

25　　　　　　　　20

有一旦之長
時語道逢
六病日不
年五十
能拜
腹中蒂
蘇如懷
瓦石束和
每日夏長

40

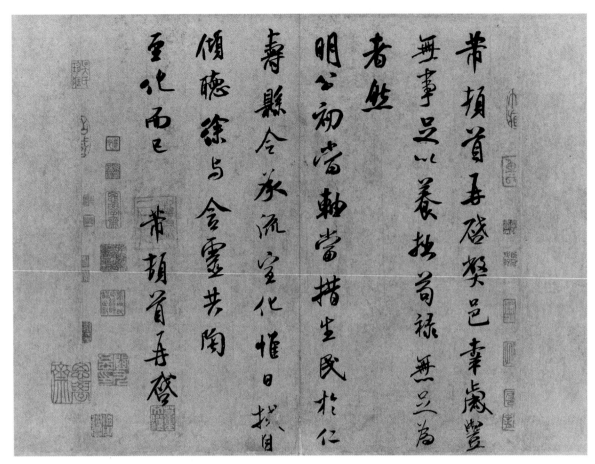

Figures 2a–c. Mi Fu, *Three Letters*, ca. 1093–94 (cat. no. 7).
a. *Abundant Harvest*

resulting in sharply defined angular brushlines and an impression of deliberate force or hesitancy (fig. 2b). *Hasty Reply before Guests* is in cursive script, with many characters linked together and abbreviated (fig. 2c). At first glance it may give the impression of a hasty draft, but individual characters are well articulated and comfortably spaced, indicating a speedy but controlled handling of the brush. The brush Mi used here must have been quite pliant, as the brushlines sometimes swell heavily. The pronounced variation between fleshy and thread-thin strokes is the result of a rhythmic lowering and lifting of the brush.

In all these details, an essential quality of Mi Fu's mature style shows through. His characters are typified by a compact structure with a centripetal movement; in other words, they have a strong tendency to collapse inward. He creates this effect largely by making vertical strokes curve toward the center of the character, by avoiding elongated strokes, and by almost always ending diagonal strokes with a reverse lifting. The latter two devices become more obvious when we compare Mi's characters with those of Huang T'ing-chien, such as the vertical stroke in the

character *erh* in figure 1 (column 28/1) and figure 2b (column 4/5) and the diagonal strokes in Huang's character *she* in figure 1 (column 17/1) and Mi's character *ling* in figure 2a (column 5/3). Huang's characters have an expansive quality, while Mi's are self-contained.

The tight cohesion of Mi Fu's characters is counterbalanced by the generous spacing he allows between individual characters and between columns. In *Abundant Harvest* the spacing contributes significantly to the letter's effect of composure. By contrast, Huang T'ing-chien's characters have an expansive quality that is offset by tight spacing between characters and between columns. Often characters intrude into one another's spaces and into nearby columns, resulting in compression (e.g., fig. 1, columns 16–18). The opposition of forces gives dynamism to the writing of both calligraphers.

Both *Scroll for Chang Ta-t'ung* and *Three Letters* express personal feelings. Huang T'ing-chien wrote the scroll for his nephew, Chang Ta-t'ung, who had come to visit him at his place of exile, Jung-chou, Szechwan, and had requested a piece of writing as a souvenir to take home. In response, Huang transcribed an essay

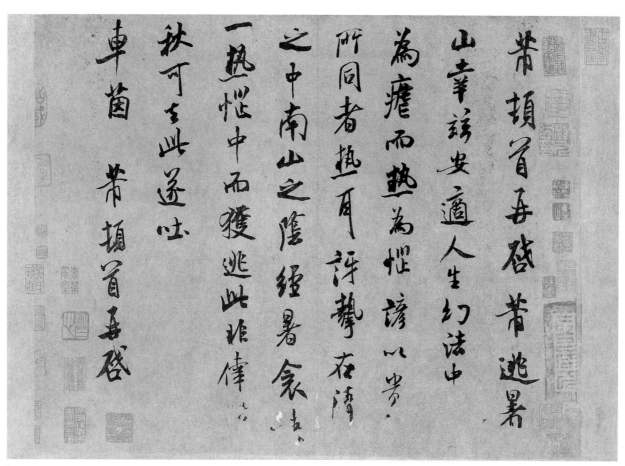

b. *Escaping Summer Heat*

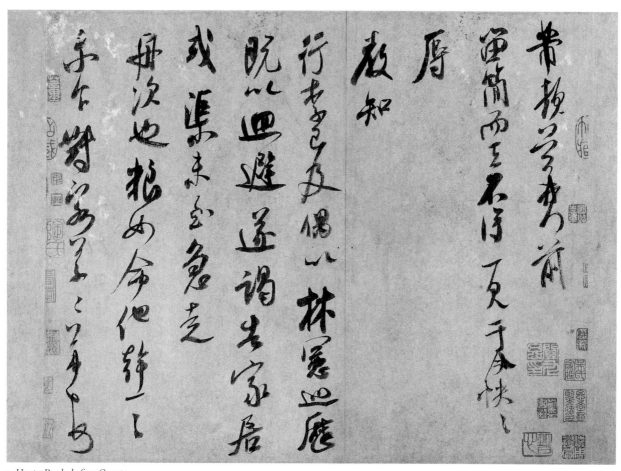

c. *Hasty Reply before Guests*

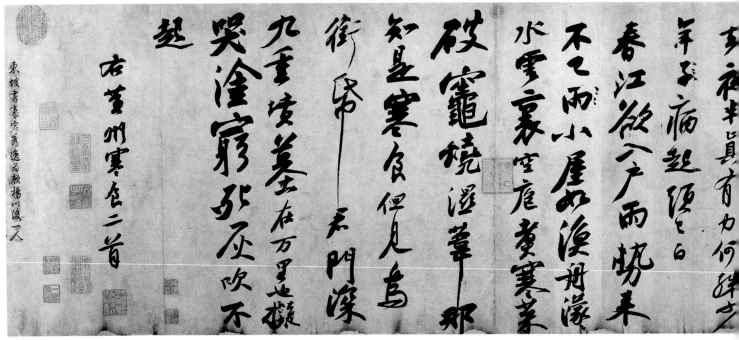

Figure 3. Su Shih (1037–1101), *Poems Written at Huang-chou on the Cold Food Festival*, datable to 1082, handscroll, ink on paper, 34.0 x 119.5 cm. National Palace Museum, Taipei, Taiwan, Republic of China.

by Han Yü, "Preface to Seeing Off Meng Chiao" (*Sung Meng Chiao hsü*), and followed it with a colophon explaining the circumstances in which the transcription was done. The transcription has long been lost, but the colophon survives.[9] In the colophon, Huang T'ing-chien describes his poor health and the depressing conditions of his life in exile. He was suffering from multiple ailments: foot trouble, chest pains, and gastrointestinal problems that made him feel as if he were carrying a stone in his belly. His neighbor was a butcher, weeds grew rampant in his yard, and rats ran around unhindered. His only solace was teaching youngsters literary composition and calligraphy and taking walks in the nearby landscape.

Mi Fu's letters are informal correspondence with colleagues and friends.[10] *Abundant Harvest* starts by expressing light-hearted contentment with his situation as a magistrate and with the good harvest in his district. He continues with advice on governance to a fellow magistrate, probably someone junior to him

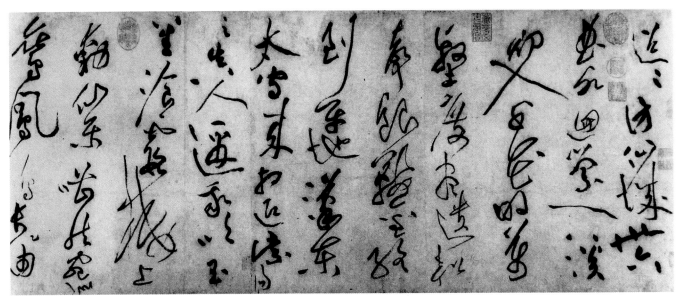

Figure 4. Attributed to Huang T'ing-chien, *"Remembering My Old Friend" by Li Po* (detail), ca. 1104, handscroll, ink on paper, 37.0 x 392.5 cm. Fujii Yūrinkan Museum, Kyoto. From Alfreda Murck and Wen C. Fong, eds., *Words and Images: Chinese Poetry, Calligraphy, and Painting* (New York and Princeton: The Metropolitan Museum of Art and Princeton University Press, 1991), 109.

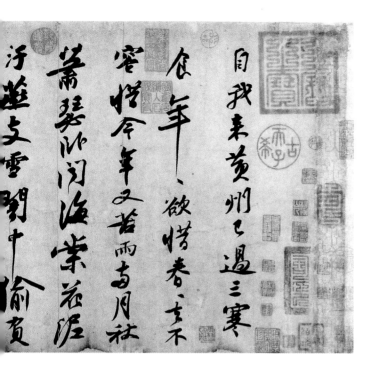

who had just arrived at a new post. The tone is slightly patronizing but perfectly kind and polite. *Escaping Summer Heat* is less happy in tone. At first Mi Fu complains to someone about the heat of summer and expresses thanks for his good fortune in having a cool mountain retreat. But he strikes a more serious note of unease when he moves from the topic of seasonal discomfort to the thought of life as illusory. *Hasty Reply before Guests* is a missive to a friend, written under the pressure of an imminent visit by a certain inspector Lin. Mi says he is ready to "run for the ferry landing" to evade him, suggesting that the impending inspection was distinctly unwelcome. The contrast with the leisurely tone of *Abundant Harvest* is marked.

When we read style and content together, the scroll and the letters show another important difference between Huang T'ing-chien and Mi Fu. In Huang's writing, the visual vigor gives no hint of the enfeebled health he claims; indeed it contradicts it. He has mustered his strength and skill to overcome his ill health and produce a work that rises above the immediate circumstances in which he wrote it. In this sense, the visual form is independent of the content. Huang T'ing-chien's approach is thus conventional and time-honored.

By comparison, Mi Fu's approach was novel. He clearly made a conscious effort in each letter to suit style to content.[11] Certainly his calligraphy can be

enjoyed on a strictly visual level. But Mi aimed at something more: he let the content shape his writing, and the writing can help inform the viewer of what the words say. Here, Mi probably owed his inspiration to Su Shih (1037–1101), who had made an earlier effort in this direction in his celebrated *Poems Written at Huang-chou on the Cold Food Festival* (*Shu Huang-chou han-shih shih*, datable to 1082; fig. 3).[12] In this work, Su Shih transcribed the poems he had written during exile in Huang-chou, poems that describe bitter circumstances of banishment not unlike those encountered by Huang T'ing-chien. The brushwork is coarse and unpolished, and the structure of individual characters unbalanced; these features convey an impression of roughness that reinforces the content of the poems. The writing is by no means typical of Su Shih's calligraphy, but it initiated a new trend in calligraphic expression that was developed by Mi Fu's hand into the great sophistication of the letters discussed here.

The difference between Huang T'ing-chien's conventional approach and Mi Fu's innovative one can be seen again in their cursive calligraphy, such as Huang's *"Remembering My Old Friend" by Li Po* (*Li Po I chiu-yu*, ca. 1104; fig. 4) and Mi's *Poem Written in a Boat on the Wu River* (*Wu-chiang chou-chung shih*, ca. 1100; fig. 5).[13] The former transcribes an emotionally charged romantic poem by the great T'ang poet Li Po (701–762), whereas the latter recounts Mi Fu's experience of an exciting boat ride. Huang's writing is cursive and powerful but hardly emotional: underneath the cursiveness is a basic consistency of brushline and ink tonality. Huang's pace never varies, and he never loses his cool-headed control of the brush, which he uses with a constant, even pressure. His choice of cursive script has no necessary connection with content; he used the same script for a chapter from an official history when he transcribed *Biographies of Lien P'o and Lin Hsiang-ju* (*Lien P'o Lin Hsiang-ju chuan*; fig. 6) from *Records of the Grand Historian* (*Shih chi*).

By contrast, Mi Fu wrote out his *Poem Written in a Boat on the Wu River* with abandon verging on ecstasy. The viewer is immediately struck by dramatic changes in brushline, character size, and ink tonality. While the characters loaded with fresh ink give a sense of smooth speed (see the character *feng*, "wind," in fig. 5, column 4/4), those with dried-up ink are agitated and full of struggle. The variation produces powerful tension, such as that in the character *chan*, "battle," in

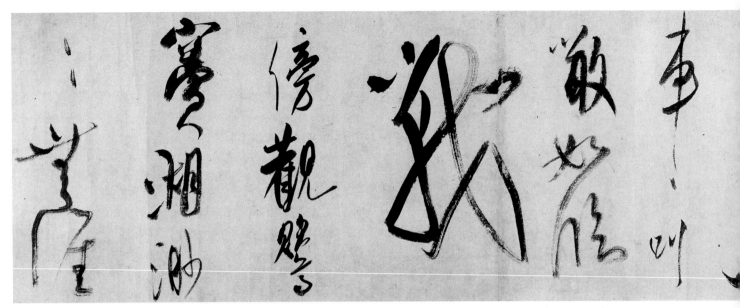

Figure 5. Mi Fu, *Poem Written in a Boat on the Wu River* (detail), ca. 1100, handscroll, ink on paper, 31.3 x 559.8 cm. The Metropolitan Museum of Art, New York. Gift of John M. Crawford, Jr., in honor of Professor Wen C. Fong, 1984 (1984.174).

column 7: the character takes up the width of two columns and turns into a battle itself.[14] To appreciate the visual effect of *Poem Written in a Boat on the Wu River*, the viewer needs to know the content; to grasp the whole meaning of the content, the visual effect becomes indispensable. Mi wrote,

Yesterday's wind arose in the northwest,
And ten thousand boats took advantage of its favor.
Today's wind, shifting, comes from the east,
And my boat has to be pulled by fifteen men.
Their strength spent, I hire some more,
But they consider one hundred in copper cash too little.
The boatmen get angry, and there are challenging
 words,
The laborers sit watching, their resentment mounting.
We added winches and pulleys for the ropes,
Yellow gorge rises in the boatmen's throats.
But the river mud seems to side with the laborers,
Stuck on the bottom, the boat won't budge.
I add more money and the boatmen are no longer angry,
Satisfied, all resentment disappears.
With a great pull the boat glides like a flying chariot
 [column 4],
The men shout out, as if rushing into battle [column 7].
To the side I look toward Ying-tou Lake,
So vast, its shores are unseen. . . .[15]

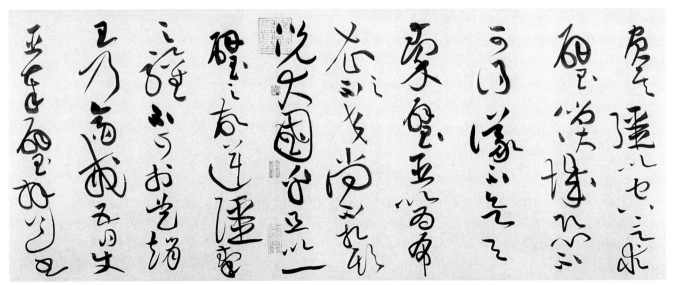

Figure 6. Huang T'ing-chien, *Biographies of Lien P'o and Lin Hsiang-ju* (detail), handscroll, ink on paper, 32.5 x 1822.4 cm. The Metropolitan Museum of Art, New York. Bequest of John Crawford, Jr., 1988 (1989.363.4).

It must be admitted that the fusion of style and content seen in the calligraphy just discussed does not exist in every work by Mi Fu. Emotion and action lend themselves to expressionistic rendering in calligraphy in a way that many other subjects do not. Even when subjects do seem suited to calligraphic expression, Mi does not always mirror content in style. What is clear and important is that he possessed the ability to unify style and content when he chose. This sets him apart from Huang T'ing-chien and others of his time.

Yet another difference between Huang T'ing-chien and Mi Fu—or a similarity, depending on how we look at it—lies in the paradoxical nature of their calligraphy.

It has long been pointed out that Huang T'ing-chien's calligraphy, at the level of brushline, character size, structure, and spacing, is individual in the extreme—extreme for his time or indeed any time. For this reason, he has rightly been praised for his innovative spirit. But we have now also seen a conventional side to his calligraphy, namely his commitment to the time-honored independence of style. Mi Fu combined the conventional and the innovative differently: his innovations rise from a classical foundation. His characters—whether looking more like those of Ch'u Sui-liang (596–658), as in *Abundant Harvest*, or those of Ou-yang Hsün (557–641), as in *Escaping Summer Heat*—are ultimately related to those of the two Wangs, Wang Hsi-chih (303–361) and his son Wang Hsien-chih (344–388), the sages of classical calligraphic tradition. Compare, for example, the character *liu* in *Abundant Harvest* (fig. 2a, column 5/5) and in Wang Hsi-chih's most famous work, *Preface to the Orchid Pavilion Collection* (*Lan-t'ing chi hsü*; fig. 7, column 5/9); and the character *tz'u* in *Escaping Summer Heat* (fig. 2b, column 7/4) and in Wang's *Preface* (fig. 7, column 3/10). The even tonality in all three letters is itself a trace of traditional convention. Even in a dramatic work such as *Poem Written in a Boat on the Wu River*, the characters are basically consistent with those in the three letters in structure, if not in other respects.

The differences between Huang T'ing-chien's calligraphy and Mi Fu's reflect their different ways of transforming the tradition they had assimilated as well as

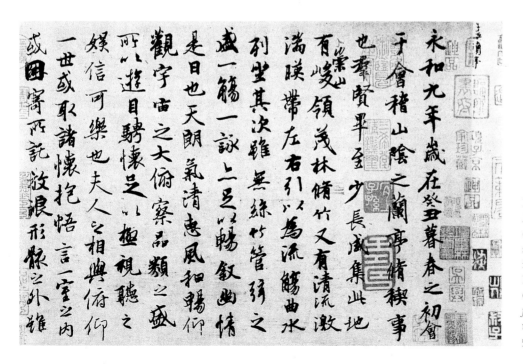

Figure 7. Wang Hsi-chih (303–361), *Preface to the Orchid Pavilion Collection* (detail), Shen-lung version, T'ang dynasty, handscroll, ink on paper, 24.5 x 69.9 cm. Palace Museum, Peking. From *Chung-kuo mei-shu ch'üan-chi: Shu-fa chuan-k'o pien* (Peking: Jen-min mei-shu ch'u-pan-she, 1986), 2: pl. 54, p. 90.

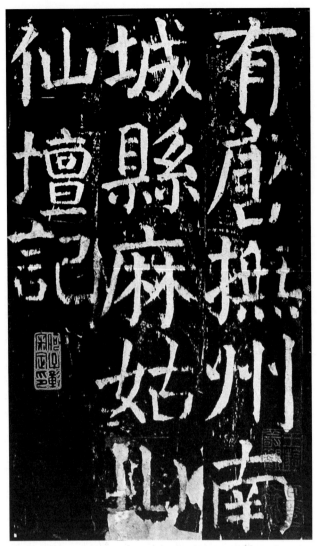

Figure 8. Yen Chen-ch'ing (709–785), *Record of the Altar of the Immortal of Mount Ma-ku* (detail), 771, rubbing of an inscription, each leaf 26.5 x 15.5 cm. Tokyo National Museum. From *Shodō geijutsu* (Tokyo: Chūōkōron-sha, 1970), 4: frontispiece.

models from which students learned calligraphy. Northern Sung scholar-officials instead championed T'ang works, finding their ideal in the monumental and powerful calligraphy of Yen Chen-ch'ing (figs. 8 and 9).[18] In choosing him over all other T'ang masters, they were much influenced by Yen's reputation for high moral integrity.[19] Soon his calligraphy became part of a larger agenda, championed by literary leaders such as Su Shih, to revive culture (*wen*) as the foundation of national life.[20]

Huang T'ing-chien accepted Yen Chen-ch'ing wholeheartedly; indeed, along with Su Shih, he was the most enthusiastic advocate of Yen's calligraphy:

> This example of Yen Lu-kung's [Chen-ch'ing] writing is extraordinary and monumental, elegant and towering: it contains all the superior style, spiritual power and bony structure of the Wei, Chin, Sui and T'ang [masters]. If I compare it with the works of Ou-yang [Hsün], Ch'u [Sui-liang], Hsüeh [Chi; 649–713], Hsü [Hao; 703–782] or Shen [Ch'uan-shih; 769–827], I find them all too much restrained by methods and principles. How can they compare to Lu-kung, who went beyond rules and was in the end able to match the essential quality of [the two Wangs]?[21]
> I once commented on Yen Lu-kung's calligraphy that [his] rules had a myriad of variations and that each is agreeable. [His] standard, running, cursive, and clerical scripts all attained the brush force of Yu-chün [Wang Hsi-chih] and his son.[22]

These statements by Huang T'ing-chien coincide with the popular endorsement of Yen Chen-ch'ing, yet at the same time betray a highly independent mind at work and a thoroughly individual understanding of the tradition. One surprise is his sweeping condemnation of virtually all other T'ang masters, which runs against the mainstream of enthusiasm for the T'ang as a whole.[23] More startling is his equation of Yen Chen-ch'ing with the two Wangs. In the thinking of Huang's time, Yen and the two Wangs were polar opposites—it was Yen against the two Wangs, Yen as an alternative to the two Wangs.[24] But Huang T'ing-chien admired Yen precisely because he saw him as the sole standard bearer and embodiment of the calligraphic virtues of the two Wangs: his commitment to the two Wangs was primary and unshakable. How unusual this view was can be seen in another colophon written by Huang T'ing-chien: "I once commented on Yen Lu-kung's calligraphy by saying that only he succeeded in

the different values that they wanted to express. Both men were acutely aware of the weight of tradition. Huang T'ing-chien has told us so in the statement on literature quoted at the beginning of this essay; as for Mi Fu, few men of his time were as well informed of the history of calligraphy as he.[16] Yet they differ in their understanding of the tradition they inherited.

The historical figure who played the largest role in eleventh-century thinking about calligraphy was Yen Chen-ch'ing (709–785) of the T'ang dynasty.[17] The rise of his reputation as a calligrapher during the Northern Sung was the result of a shared effort by leading scholar-officials to remedy what they saw as the enfeebled state of calligraphy in their time. They put the blame on corrupted versions of rubbings of calligraphy by the two Wangs, these rubbings being the primary

attaining the exceptional and transcendental [*ch'ao-i*] spirit of Yu-chün [Wang Hsi-chih] and his son. Other calligraphers did not necessarily agree with me."[25]
It is hard to escape the impression that if Huang had not managed to see the virtues of the two Wangs in Yen Chen-ch'ing, he might not have been so enthusiastic of Yen.

Mi Fu's appraisal of Yen Chen-ch'ing was even more extraordinary. Highly critical of Yen's celebrated style in standard script, he commended his running script:

[Yen] made fame for himself by using flicking and kicking strokes [in standard script]. There was too much mannerism, so his work lacks the flavor of plainness and lightness [*p'ing-tan*] and naturalness [*t'ien-chen*] Generally speaking, the flicking and kicking of Yen and Liu [Kung-ch'üan; 778–865] were the progenitors of all the bizarre and ugly writings of later generations. Beginning with them, the methods of antiquity dissipated and were no longer handed down.[26] *Letter on the Controversy over Seating Protocol* [*Cheng tso-wei t'ieh*] . . . is the most brilliant composition

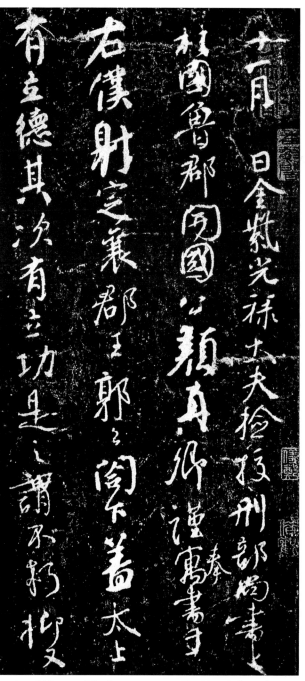

Figure 9. Yen Chen-ch'ing, *Letter on the Controversy over Seating Protocol* (detail), 764, rubbing, each leaf 31.5 x 16.8 cm. Shodō Hakubutsukan, Tokyo. From *Shodō zenshū*, n. s. (Tokyo: Heibonsha, 1966), 10: 24–25.

among Yen's works. . . . It has a completely exposed naturalness.[27]

In all fairness, Mi Fu's appraisal of Yen Chen-ch'ing's calligraphy is more objective and reasonable than is Huang's. A strong sense of artificiality can hardly escape notice in Yen's regular script; it is an integral part of the monumentality of his style, but can easily smack of mannerism (fig. 8). To find in this as well as in Yen's other scripts the brush force of Wang Hsi-chih, as Huang T'ing-chien did, demands a tremendous flight of imagination. However, objective understanding of the tradition mattered more to Mi than to Huang. As we shall see, an objective past was not really important to Huang T'ing-chien; what mattered was the past he chose to imagine.

In his passionate promotion of Yen Chen-ch'ing, Huang T'ing-chien was promoting particular aesthetic values. Huang's peers (though not Mi Fu) shared his admiration for Yen's monumental power, but he saw more than this in Yen. A quality he constantly associated with Yen and the two Wangs was the "exceptional and transcendental" (ch'ao-i or ch'ao-su) nature of their calligraphy—this is in fact the only link he offered to justify connecting them. What is significant here is the urge to surpass the common, the ordinary, and to become new, original. Making this explicit in a summary statement on calligraphy, Huang T'ing-chien in effect states his own goal: "Merely following someone else, one will always stay behind; only in creating one's own uniqueness does one begin to approach the true essence [of ancient masterpieces]."[28]

Another value that Huang T'ing-chien held equally dear was "weighty intensity with satisfying directness," a phrase he applied to the brush force of the best calligraphy.[29] Combining the "exceptional and transcendental" and "weighty intensity with satisfying directness," I believe, arrives at what Huang T'ing-chien meant by "grace" (yün), which could be used to make a qualitative judgment or simply to label a category of calligraphy judged to possess intangible greatness. Huang wrote, "Ch'ao Mei-shu [1053–1110] once commented behind my back that my calligraphy has grace, though it does not have a single dot or stroke of Yu-chün's [Wang Hsi-chih] waving brushwork,"[30] and "If calligraphy is judged for grace, who could surpass the two Wangs?"[31]

It is by now clear that Huang T'ing-chien's reading of tradition was ahistorical and subjective. He was not concerned with history; he was searching for values to guide his assimilation and transformation of the calligraphic tradition. For that reason, whether there was any stylistic relationship between Yen Chen-ch'ing and the two Wangs did not concern him, nor would he have been concerned if others disagreed with his equation of Yen and the two Wangs or if they saw in his own calligraphy few traces of the two Wangs. He was content to believe that he, Yen Chen-ch'ing, and the two Wangs all possessed the same "grace," which was "exceptional and transcendental" and had "weighty intensity with satisfying directness." Huang T'ing-chien's understanding of the calligraphic tradition was that of an artist rather than that of a historian: his history was meant for use.

Mi Fu, by contrast, was both an artist and a critical historian. His appraisal of Yen Chen-ch'ing's calligraphy has its share of subjectivity, but set next to Huang T'ing-chien's overpowering admiration for Yen, it shows a cool even-handedness. Whereas Huang's peculiar view of Yen Chen-ch'ing stemmed from aesthetic passion, Mi's view was that of a dispassionately discerning mind. The historical side of Mi Fu is best illustrated by the seriousness of his connoisseurship. At the outset of his History of Calligraphy (Shu shih), he states, "I have grown old scrutinizing calligraphy, but there are no extant ink writings from the Wei dynasty. Therefore, I started [my recording] abruptly from the Western Chin dynasty."[32] Throughout History of Calligraphy and in other writings as well, Mi Fu offered rigorous appraisals, often coupled with detailed analyses of a kind rarely found in discussions by anyone else.[33] He was interested primarily in problems of authenticity and attribution.[34] Through years of thorough investigation, he built up an understanding of the calligraphic tradition that was certainly the most comprehensive and probably the most accurate of his time.

As a critical historian, Mi Fu harbored an independent spirit unyielding to convention and authority, as is amply shown in his appraisal of Yen Chen-ch'ing's calligraphy. In the intensity of his convictions he yields nothing to Huang T'ing-chien:

Su Shih dismissed Wang Hsien-chih by quoting T'ang Emperor T'ai-tsung's [r. 626–649] opinion. . . . T'ai-tsung studied Wang Hsi-chih arduously but got nowhere. So he studied Yü Shih-nan's [558–638] running script, still trying to work his way up to Wang Hsi-chih.

Figure 10. Attributed to T'ao Hung-ching (452–536), *Eulogy on Burying a Crane* (detail), ca. 512–14, ink rubbing of an inscription carved on a boulder, Chiao-shan Island, Chen-chiang, Kiangsu. From *Shodō zenshū*, n. s. (Tokyo: Heibonsha, 1966), 5: 29.

Of course he reviled Hsien-chih, the son. But Hsien-chih is natural [*t'ien-chen*] and transcendental [*ch'ao-i*]. How can his father compare?[35]

Ultimately, however, Mi's historical investigations were undertaken in the service of aesthetic values. The values he particularly sought were "plainness and lightness" (*p'ing-tan*) and "naturalness" (*t'ien-chen*). The first connotes simplicity, easy grace, and unpretentiousness, an unforced state that is associated with antiquity.[36] Undoubtedly Mi Fu came to champion this value because of his fascination with the past. *T'ien-chen* literally means "heaven-bestowed genuineness," in other words, one's innate nature, or naturalness. But in Mi Fu's usage it means something different. It is best to quote Mi himself:

The important thing in learning calligraphy is control of the brush. It is said that when the brush is held lightly, there is of course a void in the palm. [One can thus wield the brush] quickly and naturally [*t'ien-chen*], and [the movement of the brush] is unpremeditated. For this reason, calligraphic works by the ancients are all different. If they look like each other, then they are slavish writing.[37]

It is clear that, to Mi Fu, to be natural really means to be oneself. However, the fact that a person who knows how to wield a brush is by definition educated makes the self something less pristine and more complicated than it may sound. When the self has been steeped in a vast and seductive tradition, naturalness cannot be a primordial state; it has become a marriage of nature and culture. Also clear from Mi's statement is his assumption that naturalness entails individuality, perhaps even guarantees originality. In this sense, his naturalness represents a goal not unlike that of Huang T'ing-chien. But whereas originality for Huang meant rising above the ordinary, Mi believed that one's intuition or whim could be trusted to express the self, and that originality would materialize unpremeditated and unforced, and thus appear simple and unpretentious. For Mi Fu, originality was like a coin, so to speak, the two sides of which were "plainness and lightness" and "naturalness," with tradition or history forming the solid substance in between.

The models an artist chooses to study are an immediate expression of his values and his understanding of his tradition. For Huang T'ing-chien there was essentially only one model: the two Wangs. Yen Chen-ch'ing to

him was a modern reincarnation of the two Wangs, and much the same can be said of the few other models he discusses in his critical writings.[38] It is well known that *Eulogy on Burying a Crane* (*I-ho ming*; fig. 10), a sixth-century inscription engraved on a cliff face by the island of Chiao-shan at Jun-chou, was the most important actual model for Huang's large-character calligraphy, such as his *Scroll for Chang Ta-t'ung* (fig. 1); Huang T'ing-chien even praised this inscription as the source of all later large-character calligraphy.[39] Typically he saw there the hand of Wang Hsi-chih and identified the inscription with Wang's legendary "dragon-claw" method, which had long been lost.[40] He did so even though other critical minds, such as Ou-yang Hsiu (1007-1072), thought otherwise, and we may almost be moved to agree with him, for the inscribed calligraphy is indeed exceptional for its weighty intensity combined with satisfying directness.

By contrast, Mi Fu, with all the instincts of a historian, had a broader and more rigorous training. He described his experience in calligraphy as follows:

At first I studied [the calligraphy of] Yen Chen-ch'ing. I was then seven or eight *sui* [six or seven years old]. My characters were as large as the paper itself, and I was not able to do [smaller] letter-size writing. Then I saw [calligraphy by] Liu Kung-ch'üan and became enamored of his tight composition, so I studied his *Diamond Sutra* [*Chin-kang ching*]. After a long while, I realized that Liu came out of Ou-yang Hsün, so I studied Ou-yang. After a long while, my calligraphy looked like printed blocks or counting slats. I then became enamored of [calligraphy by] Ch'u Sui-liang, which I studied the longest. I was also enamored of [the calligraphy of] Tuan Chi [fl. ca. 806–820], with its supple turns and folds, plenteous beauty, and complete multidimensionality. After a long while, I realized that Tuan had developed completely from [Wang Hsi-chih's] *Preface to the Orchid Pavilion Collection*. I therefore looked through rubbing compendia of model calligraphy and entered the plainness and lightness of Chin and Wei [calligraphy]. I passed over the method of Chung Yu [151–230] to study *Stele for Liu K'uan* [*Liu K'uan pei*] by Shih-i-kuan [ca. 168–188]. That was it. For seal script I loved *A Chant Cursing the Ch'u People* [*Tsu Ch'u wen*; ca. 320 B.C.] and *The Stone Drum Inscriptions* [*Shih-ku wen*; ca. 420 B.C.]. I also gained insights into the writings on bamboo slips, done with a bamboo stylus dipped in lacquer, as well as the wonders of the archaic inscriptions on bronze vessels.[41]

In his journey further and further back into the past, Mi Fu must have felt that he came closer and closer to the values of "plainness and lightness" and "naturalness."

Huang T'ing-chien's single-mindedness and Mi Fu's freedom in choosing models find counterparts in their brush methods. For Huang T'ing-chien, one essential principle in using the brush was "applying full force to the brushstrokes" (*pi-chung yung-li*), which requires a tight grip of the brush, mobilization of the whole arm in wielding the brush, and constancy in speed and pressure.[42] This method produced the visual consistency we see abundantly in *Scroll for Chang Ta-t'ung* and other works by Huang T'ing-chien (figs. 1, 4, and 6). One more observation may be made here. To transmit the calligrapher's full force onto the paper, the brush had to be wielded with deliberation and at relatively slow speed, even in cursive script. The result is precisely what Shen Fu calls the "trembling" or "struggling" quality in Huang's calligraphy. Surely this is what Mi Fu meant by his seemingly obscure pronouncement that "Huang T'ing-chien *traces* [*miao*] his characters," which implies a deliberate, unhurried process.[43]

Mi Fu used a very different brush method. As quoted earlier, he advocated holding the brush lightly to allow ample room for flexibility and intuitive shifts of speed and pressure. On one occasion, he suggested the intuitive character of his method, again in somewhat ambiguous words: "I *daub* [*shua*] characters in my writing"[44]—"daub" apparently describes a process of spontaneous writing. What he sought was of course the possibility of visual variations, which enabled him to fuse style and content. His method was conducive to speed but ran the risk of weak brush force. Judging from the works we have seen, however, Mi Fu escaped any hint of weakness. Huang T'ing-chien once described Mi's speed and force, thinking perhaps of his calligraphy in cursive script such as that used in *Poem Written in a Boat on the Wu River* (fig. 5):

I once described the calligraphy of Mi Yüan-chang [Mi Fu] as being like a swift sword hacking in a battle formation, or a powerful crossbow unleashing [an arrow] that travels a thousand miles: all in the way are pierced. A calligrapher's brush momentum can go no further than this. However, it also seems to have the air of a Chung-yu before he met Confucius.[45]

The negative twist at the end of an otherwise laudatory comment illustrates once again the difference

in values that separates the two masters. For Huang T'ing-chien, Mi's calligraphy was too rash and not solid enough, just like the unruly Chung-yu before he was reined in by Confucius; it lacked the firmness and consistency that Huang insisted on. No doubt Mi Fu would have replied by charging Huang with a lack of "plainness and lightness" and "naturalness."

With this look at the thinking and practice of Huang T'ing-chien and Mi Fu, we may see Huang's *Scroll for Chang Ta-t'ung* and Mi's *Three Letters* in a more intimate context. Indeed "calligraphy is the picture of the mind," to quote the famous pronouncement of Yang Hsiung (53 B.C.-A.D. 18), and the mind is the Spirit Cinnabar that "turns iron into gold," to use the metaphor quoted at the beginning of this essay.[46] And what different minds we see in the calligraphy of these two masters! The diverse and richly nuanced calligraphy of Mi Fu was a natural outcome of his immense experience with the riches of his tradition. The singular power of Huang's calligraphy was spawned from something close to a willful misunderstanding of the tradition and his ability to condense that tradition to the primary significance of the two Wangs. This ability is vividly pointed out by Wen C. Fong: Huang T'ing-chien "borrowed a single element from *Burying a Crane*—two long diagonal strokes, the roof radical, from the character *ch'in*—as the hallmark of his personal style" (figs. 11a, b).[47] Perhaps the "iron" to which Huang T'ing-chien applied his cinnabar can be reduced to a single element, but for Mi Fu the "iron" has to be the whole tradition. And while Huang T'ing-chien rose above the ordinary with his dramatically energized characters, Mi Fu achieved his originality by being him*self* and by doing something he was eminently capable of: fusing content and style.

Though we know far too little of the lives of Huang and Mi to speak with confidence of the inner sources of their artistic personalities, it is tempting to at least point to some simple correspondences between the recorded outward circumstances of their lives and the personalities that spring so lively from their pages. Huang and Mi were contemporaries, separate in age by only seven years. They were closely associated, moving in the same social circles and exchanging poems and calligraphy with each other and with mutual friends.[48] Yet their backgrounds had little in common.

Huang T'ing-chien was born into a family of scholar-officials, the most privileged social class in

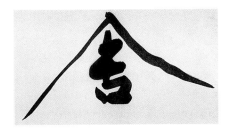

Figure 11a. The character *she*, Huang T'ing-chien, *Scroll for Chang Ta-t'ung* (detail).

Figure 11b. The character *ch'in*, (attr.), T'ao Hung-ching, *Eulogy on Burying a Crane* (detail).

the Northern Sung and one that defined the culture and way of life of the elite. He followed the standard route of studying the classics and literary composition and taking the civil service examinations. He achieved the *chin-shih* (presented scholar) degree in 1067 at the age of twenty-three, thereby formally renewing his family's membership in the scholar-official class. As expected, he was immediately appointed to office and thus began a lifelong official career. He proved a serious, dedicated official with a strong sense of moral responsibility and justice, but officialdom was ultimately a source of frustration for him. He never held a position of high influence and was eventually swept out of office by political persecution. After spending the last eleven years of his life in banishment, he died alone in Kwangsi, far away from the capital and from home.

Huang's true calling and ambition were unquestionably in the fields of literary composition and calligraphy. Born a prodigy, he became established as a poet and prose writer in his twenties, receiving high praise and admiration from cultural leaders. Later on he was closely associated with Su Shih, becoming known as one of the Four Disciples of Su, and he was eventually recognized as an equal to Su in literary composition (posterity is less generous). His approach to literature, summarized in his dictum of "turning iron into gold," had great influence on later writers and ultimately was responsible for the formation of the Kiangsi school of poetry in the twelfth century. His life and background

are just what we might expect for a great master of literature and calligraphy.

By comparison, Mi Fu's background was rather atypical. His family was non-Chinese in origin, descended from Eastern Turks. The establishment of the Mi clan on Chinese soil was due to Mi Fu's fifth-generation grandfather, who was a valiant general during the Five Dynasties period and eventually entered the service of the founding emperor of the Sung dynasty. Thereafter the family remained largely military in vocation until Mi Fu's generation.

Mi Fu grew up in an aristocratic environment because of his mother's close ties with the imperial family: she was a lady-in-waiting for the family of Prince Chao Shu (1032–1067), the future Emperor Ying-tsung (r. 1063–67). Evidently for this reason, the Mi family was invited to live in the prince's residential compound. The Sung aristocracy, including the emperors, were enthusiastic patrons of literary and artistic accomplishments. A few of them became avid art collectors and even outstanding artists themselves. While a childhood in this privileged environment did not necessarily foster the dedication to learning required for an official career, it undoubtedly exposed Mi Fu to a wealth of art. Indeed, it is said that he lacked the interest and patience to study for the civil service examinations, though he was precocious and quick in learning. Nevertheless, in 1068, at the early age of eighteen, he entered the civil service by special favor of the court in gratitude for his mother's service, thus beginning a life in and out of minor offices. Perhaps because of this early appointment, Mi never felt the need to attempt the civil service examinations, but, then again, he was never deeply interested in serving as an official. For thirty years he was able to traverse the country seeking works of calligraphy and other arts while serving in various low-ranking positions. He became the leading connoisseur in the country, and he was twice appointed Doctor of Studies of Painting and Calligraphy (*Shu-hua hsüeh po-shih*) in the imperial court.

It is evident that throughout his life Mi Fu was psychologically hampered by the essentially alien and non–scholar-official nature of his family background, which was deemed inferior. Huang T'ing-chien was born to a scholar-official family, and his attainment of the *chin-shih* degree further cemented his standing as a scholar-official; Mi Fu could neither become one of the aristocrats he grew up with nor could or would he follow the normal path into the scholar-official class. He won his place in the society of scholar-officials by outstanding artistic achievements that could not pass unnoticed. Perhaps these differences of circumstance go some distance toward explaining the difference between Huang T'ing-chien's calligraphy, which although innovative on the level of individual characters and spatial relationships is essentially conventional, and Mi Fu's, which hungrily feeds off the whole of the past and emerges with something irrepressibly new. The artistic personality that sets Mi apart from the scholar-officials also won him their constant, if not always unqualified, acceptance.[49]

Appendix: Translations of the Calligraphic Works by Huang T'ing-chien and Mi Fu in the John B. Elliott Collection

Huang T'ing-chien, *Scroll for Chang Ta-t'ung*
 (fig. 1, cat. no. 6)

On the last day of the first month of the third year of the Yüan-fu era [March 12, 1100], my nephew Chang Ta-t'ung from Ya-chou [Szechwan] was preparing his belongings to return home soon. He came to me and asked for some calligraphy. I have been having stomach and chest pains, and today I had some leisure time, so I tried using my brush to write this essay. Chang Ta-t'ung has been interested in learning ancient-style [*ku-wen*] prose, so I am giving this to him. It has been three years since I moved from Ch'ien-nan to Po-tao [Jung-chou]. I've made my home in the area south of the city near a butcher's. Weeds grow as high as the roof, and rats share the narrow path. But at least there are some young people who have persuaded me to teach them composition and calligraphy. They still preserve the habits of examination candidates in the capital area.

On a warm sunny day, I take my walking stick to help my limp and in leisure spend my time in mountains under trees or among clear streams and white stones. Among my various friends I am the oldest. Now I, Fu-weng, am fifty-six. I still have foot trouble and cannot bend over. My belly seems to have something hard in it—it's like carrying around a tile or stone. I don't know if on a later day I will ever be able to write such characters as these again.

Mi Fu, *Three Letters* (figs. 2a–c, cat. no. 7)
Abundant Harvest

I, Fu, touch my head on the ground and ask to speak again. In my district we are blessed with an abundant harvest and no matters of concern; thus I am allowed to continue cultivating my incompetence and earning a salary. There is no need to do anything. But Your Excellency, who has just assumed the role of the central axis, must lead the people to the virtues of humaneness and longevity. The district magistrate follows the prevailing current while spreading a civilizing influence. Daily he wipes his eyes clean and inclines his ears to listen, and slowly he and his subjects together are molded by the spirit and transformed. That's all there is to it. I, Fu, touch my head on the ground and ask to speak again.

Escaping Summer Heat

I, Fu, touch my head on the ground and ask to speak again. I, escaping summer heat, have come to the mountain and am fortunate to have comfort here. Human life exists within illusions. [One character missing] gives us fever, while heat causes us vexation. As the saying goes, rich [or poor], we all suffer from the heat. Ya-chih is located in the middle of the [undecipherable character], north of Southern Mountain. All summer [we sleep under] covers. When I am vexed by heat and able to escape here, am I not fortunate? By autumn I should be able to leave this place. [I] am writing [this on] the chariot cushion. I, Fu, touch my head on the ground and ask to speak again.

Hasty Reply before Guests

I, Fu, touch my head on the ground and bow again. Earlier you came by and left a note, and I did not get to see you. I am still feeling disappointed. Now you kindly inform me that my luggage has arrived. Because of the inspection visit of commissioner Lin, I have chosen to avoid him either by pleading to take days off at home or by running for the ferry landing before he arrives. [How could I] expect this? [It is] fate. Please keep me informed of all the other matters. I reply to you hastily before guests, and bow again.

NOTES

1. Huang T'ing-chien, "Ta Hung Chü-fu shu" (Letter in Reply to Hung Chü-fu), third of three, in idem, *Yü-chang Huang hsien-sheng wen-chi* (*Ssu-pu ts'ung-k'an* edition), *chüan* 19: 23b. All translations are by the author unless otherwise noted.

2. Huang T'ing-chien, no less than other writer-calligraphers, such as his mentor Su Shih (1037–1101), liked to compare calligraphy with literature. Su Shih, for example, equated Yen Chen-ch'ing's (709–785) calligraphy with Tu Fu's poetry. See Su Shih, "Shu T'ang shih liu-chia shu hou" (Colophon following the Writings by Six T'ang Masters), in idem, *Tung-p'o t'i-pa* (*I-shu ts'ung-pien* edition, 1962), *chüan* 5: 95. For an example from Huang T'ing-chien, see his "Pa fa-t'ieh" (Colophons following Model Calligraphy), in idem, *Shan-ku t'i-pa* (*Ts'ung-shu chi-ch'eng ch'u-pien* edition, 1936), *chüan* 4: 34.

3. Huang T'ing-chien's success in literature was more mixed. For recent studies of Huang's literary career, see Seng-yong Tiang, "Huang T'ing-chien (1045–1105) and the Use of Tradition" (Ph.D. diss., University of Washington, 1976); and David Palumbo-Liu, *The Poetics of Appropriation: The Literary Theory and Practice of Huang Tingjian* (Stanford: Stanford University Press, 1993).

4. An acute sensitivity toward the past and determination to rise above it were shared by some of the best Northern Sung artists in the second half of the eleventh century, such as Li Kung-lin (ca. 1041–1106) in painting. See Richard Barnhart, "Li Kung-lin's Use of Past Styles," in Christian F. Murck, ed., *Artists and Traditions: Uses of the Past in Chinese Culture* (Princeton: Princeton University Press, 1976), 51–71.

5. A wealth of scholarship has been produced about Huang T'ing-chien and Mi Fu as calligraphers, building up a comprehensive picture of their lives, styles, sources, and aesthetic values, as well as their influence on later artists. The present study is dependant on such scholarship. Among the many studies of Huang T'ing-chien and Mi Fu are four essential English-language works: Shen C. Y. Fu, "Huang T'ing-chien's Calligraphy and His Scroll for Chang Ta-t'ung: A Masterpiece Written in Exile" (Ph.D. diss., Princeton University, 1976); Lothar Ledderose, *Mi Fu and the Classical Tradition of Chinese Calligraphy* (Princeton: Princeton University Press, 1979); Wen C. Fong, "Northern Sung Calligraphy: The Picture of the Mind," in Wen C. Fong et al., *Images of the Mind: Selections from the Edward L. Elliott Family and John B. Elliott Collections of Chinese Calligraphy and Painting at The Art Museum, Princeton University* (Princeton: Princeton University Press, 1984), 74–93; and Peter C. Sturman, *Mi Fu: Style and the Art of Calligraphy in Northern Song China* (New Haven: Yale University Press, 1997).

6. Fu, "Huang T'ing-chien's Calligraphy," 106.

7. The phrase is from the colophon "Shu Yu-chün Wen-fu hou" (Colophon following *Rhapsody on Literature* by Yu-chün), in Huang T'ing-chien, *Shan-ku t'i-pa*, *chüan* 4: 31.

8. The three letters are not self-dated. However, we know that in 1091 Mi Fu changed the character for his first name to the one with which he signed these letters. The present dating is based also on other evidence internal to the letters (see Fong, et al., *Images of the Mind*, 86–87; and Sturman, *Mi Fu*, 96–101). Each letter takes its present name from a key phrase in the text.

9. See the Appendix to this essay for a complete translation of the colophon (from Fu, "Huang T'ing-chien's Calligraphy," 68–69, with slight changes). The colophon does not specify that the essay transcribed was Han Yü's "Preface to Seeing Off Meng Chiao," but that identification is persuasively presented in Fu, "Huang T'ing-chien's Calligraphy," 74–77.

10. See the Appendix for complete translations of these three letters. The translation of *Abundant Harvest* is adapted from those in Fong et al., *Images of the Mind*, 87; and Sturman, *Mi Fu*, 97. The translations of *Escaping Summer Heat* and *Hasty Reply before Guests* are slightly altered and expanded from those in Fong et al., *Images of the Mind*, 87.

11. As Wen Fong points out, Mi Fu used the beautiful style of Ch'u Sui-liang (596–658) in *Abundant Harvest* and the severe style of Ou-yang Hsün (557–641) in *Escaping Summer Heat* (Fong et al., *Images of the Mind*, 88).

12. The idea, though perhaps not the fact, of fusing style and content had existed in earlier times. For example, Han Yü describes the cursive script by the celebrated master Chang Hsü (fl. ca. 700–750): "When he was moved by joy or anger, poverty, grief, sorrow or pleasure, resentment or longing, intoxication, boredom, or discontent, he would always express it in cursive script. Furthermore, he would create a calligraphic counterpart for what he saw in nature—mountains and rivers, valleys and cliffs, birds and animals, insects and fish, grass and trees, flowers and fruit, sun and moon, the constellations, wind and rain, water and fire, thunder and lightning, song and dance, and the vicissitudes of all things in heaven and earth. Rejoicing over them, amazed by them, he would express them through his calligraphy. Thus the variations in Chang Hsü's calligraphy are as unfathomable as the motivations of gods and demons. For these reasons his name is known by later generations" (Han Yü, "Sung Kao-hsien shang-jen hsü" [Preface to Seeing Off the Monk Kao-hsien], quoted in Ma Tsung-huo, ed., *Shu-lin tsao-chien* [*I-shu ts'ung-pien* edition, 1968–71], *chüan* 8: 140b; trans. by Fumiko E. Cranston, in Nakata Yūjirō, "Calligraphic Style and Poetry Handscrolls: On Mi Fu's *Sailing on the Wu River*," in Alfreda Murck and Wen C. Fong, eds., *Words and Images: Chinese Poetry, Calligraphy and Painting* [New York and Princeton: The Metropolitan Museum of Art and Princeton University Press, 1991], 92). No adequate example of Chang Hsü's calligraphy has survived to substantiate Han Yü's claim. Judging from what survives of T'ang calligraphy, the description must have been more rhetoric than fact.

13. For a study establishing the authenticity and likely dates of Huang's *"Remembering My Old Friend" by Li Po* and *Biographies of Lien P'o and Lin Hsiang-ju* (see below), both unsigned, see Shen C. Y. Fu, "Huang T'ing-chien's Cursive Script and Its Influence," in Murck and Fong, eds., *Words and Images*, 107–22.

14. Dramatic variation of character size has an earlier precedent in the famous *Autobiographical Essay* (*Tzu-hsü t'ieh*) in wild-cursive script by Huai-su (ca. 735–ca. 799). In other respects, however, Huai-su's writing was conventional in its strong consistency in thickness and precision of strokes and in ink tonality, and supplies no precedent for Mi's calligraphy. Evidently Huai-su aimed to demonstrate his mastery of fast writing rather than to deliberately combine style with content. For an illustration of his *Autobiographical Essay*, see fig. 23 in Wen C. Fong's introductory essay in this volume.

15. Trans. with slight modification from Sturman, *Mi Fu*, 115–16.

16. As Lothar Ledderose points out, "On the whole he [Mi Fu] had a fairly complete knowledge of the pieces [i.e., earlier calligraphy] that had been handed down to his day" (Ledderose, *Mi Fu*, 49). For an account of Mi Fu's studies of earlier calligraphy, see ibid., 45–94.

17. The immense popularity and influence of Yen Chen-ch'ing's calligraphy in the eleventh century is discussed in Fu, "Huang T'ing-chien's Calligraphy," 206–13. For the latest study of Yen's calligraphy and its reception in the Northern Sung, see Amy McNair, *The Upright Brush: Yan Zhenqing's Calligraphy and Song Literati Politics* (Honolulu: University of Hawaii Press, 1998).

18. Ou-yang Hsiu (1007–1072), a leader in literary studies among the scholar-officials, remarked, "Calligraphy has never flourished more abundantly than in the T'ang, and has never been more in ruin than now" (idem, *Chi-ku lu*, quoted in Ma, ed., *Shu-lin tsao-chien, chüan* 9: 186).

19. Yen Chen-ch'ing died a martyr for refusing to betray the royal house to a rebellious general. Ou-yang Hsiu remarked, "I would say of Yen's calligraphy that it resembles a loyal minister, an exemplary scholar, or a morally impeccable gentleman. It is so correct, severe, serious, and forceful that upon first glance it is intimidating. But the longer one looks at it the more attached one becomes to it" ("T'ang Yen Lu-kung shu ts'an pei," in idem, *Liu-I t'i-pa* [*Ts'ung-shu chi-ch'eng ch'u-pien* edition, 1936], *chüan* 7: 337–38; trans. from Ronald C. Egan, "Ou-yang Hsiu and Su Shih on Calligraphy," *Harvard Journal of Asiatic Studies* 49, no. 2 [Dec. 1989], 372). Huang T'ing-chien once cried over Yen Chen-ch'ing's calligraphy while remembering Yen's heroism: "When I saw the characters minister Yen wrote on the wall [of his cell] before he was killed by Li Hsi lieh, my tears kept pouring out. Lu-kung was brilliant in literary accomplishments and glorious in military deeds, enough to compete with the sun and moon in brightness" (Huang, *Yü-chang Huang hsien-sheng wen-chi, chüan* 30: 334b–335a). On a more practical note, Peter Sturman points out that the prominence of Yen Chen-ch'ing in the Northern Sung owed largely to the accessibility of his calligraphy, particularly through stelae (Sturman, *Mi Fu*, 29). Ou-yang Hsiu, for example, recorded an abundance of Yen's works in his *Chi-ku lu*.

20. On this campaign by Su Shih and his followers, including Huang T'ing-chien, to elevate the importance of cultural activities, see Peter K. Bol, "Culture and the Way in the Eleventh-Century China" (Ph.D. diss., Princeton University, 1982).

21. Huang T'ing-chien, "T'i Lu-kung t'ieh" (Colophon on a Calligraphic Work by Lu-kung), in idem, *Shan-ku t'i-pa, chüan* 4: 39; trans. from Fu, "Huang T'ing-chien's Calligraphy," 210, with slight modification. Su Shih equated Yen Chen-ch'ing's greatness in calligraphy with that of Tu Fu in poetry and Han Yü in prose (ibid., 208).

22. Huang T'ing-chien, "T'i Yen Lu-kung Ma-ku t'an chi" (Colophon on Yen Lu-kung's *Record of the Altar of the Immortal of Mount Ma-ku*), in idem, *Shan-ku t'i-pa, chüan* 4: 39.

23. Compare, for example, Ou-yang Hsiu's sentiment quoted in note 18.

24. On the promotion of Yen over the two Wangs in the Northern Sung, see McNair, *The Upright Brush*, 120–29. Ou-yang Hsiu and Su Shih had little appreciation for the two Wangs; Han Yü, the spiritual ancestor of the late Northern Sung literary movement, condemned Wang Hsi-chih, saying "Hsi-chih's vulgar

calligraphy took advantage of its seductive beauty" (Han Yü, "Shih-ku ko," in idem, *Han Ch'ang-li chi* [Shanghai: Shang-wu yin-shu-kuan, 1936], *chüan* 2: 44; trans. from McNair, *The Upright Brush*, 122).

25. Huang T'ing-chien, "Pa Lu-kung tung hsi erh-lin t'i-min" (Colophon on Lu-kung's Inscriptions on the East and West Forests), in idem, *Shan-ku t'i-pa, chüan* 4: 39.

26. Mi Fu, "Pa Yen shu" (Colophon on Yen's Calligraphy) in *Pao Chin ying-kuang chi*, comp., Yüeh K'o (*Ts'ung-shu chi-ch'eng ch'u-pien* edition, 1939), *pu-i* (appendix): 75; trans. adapted from McNair, *The Upright Brush*, 91. Compare Su Shih's thoughts on Yen and Liu Kung-ch'üan: "After the deaths of Yen and Liu, the method of the brush declined to the point of being severed from the past" (Su Shih, "P'ing Yang shih so-ts'ang Ou Ts'ai shu," in *Su Shih wen-chi*, ed. K'ung Fan-li [reprint, Peking: Chung-hua shu-chü, 1986], *chüan* 69: 2187; trans. adapted from Sturman, *Mi Fu*, 32). Also compare what Li Yü (r. 937–78), the last emperor of the Southern T'ang dynasty, said of Yen Chen-ch'ing: "Yen Chen-ch'ing obtained the 'tendons' of Yu-chün's calligraphy, but he failed at being so coarse. Yen's calligraphy has the methods of standard script but without its merits: it stands like a rough farmer with his feet side by side and hands on his hips" (quoted in Ma Tsung-huo, ed., *Shu-lin tsao-chien, chüan* 8: 149; trans. from Fu, "Huang T'ing-chien's Calligraphy," 206, with slight changes). Here, Mi Fu sided with a decadent despot of the past rather than with the morally sensitive scholar-officials of his own time.

27. Mi Fu, *Shu shih*, in *Mei-shu ts'ung-shu*, comp. Teng Shih and Huang Pin-hung (1912–36; reprint, Taipei: Kuang-wen shu-chü, 1963).

28. Huang T'ing-chien, "Lun tso tzu," quoted in *Huang T'ing-chien shu-fa shih-liao chi*, ed. Shui Lai-yu (Shanghai: Shang-hai shu-hua ch'u-pan-she, 1993), 7.

29. See note 7. Other examples in which Huang T'ing-chien used this phrase include his "Pa Fan Wen-cheng-kung t'ieh" (Colophon on Calligraphy by Master Fan, Duke Wen-cheng), in idem, *Shan-ku t'i-pa, chüan* 6: 54; and "Shu Shih-tsung hsin-san yin tzu p'ing chih" (Self Comment after Writing on a Circular Fan by Hui-tsung), in ibid., *chüan* 7: 64.

30. Huang T'ing-chien, "Lun tso tzu," quoted in Shui, ed., *Huang T'ing-chien shu-fa shih-liao chi*, 7.

31. Huang T'ing-chien, "T'i Hsü Hao t'i chin hou" (Colophon following Hsü Hao's Inscriptions on a Sutra), in idem, *Shan-ku t'i-pa, chüan* 4: 39.

32. Mi Fu, *Shu shih*, 3; trans. from Ledderose, *Mi Fu*, 53.

33. In this respect, Mi Fu shared something with the *chin-shih* (bronze and stone) antiquarians of his time. For an introduction to *chin-shih hsüeh* (studies of bronze and stone inscriptions) in the Sung, see Richard C. Rudolph, "Preliminary

Notes on Sung Archaeology," *Journal of Asian Studies* 2, no. 2 (Feb. 1963): 169–77; and Robert Poor, "Notes on the Sung Dynasty Archaeological Catalogs," *Archives of the Chinese Art Society of America* 19 (1965): 33–44.

34. Ledderose, *Mi Fu*, 50. For examples of Mi Fu's authentication of calligraphy, see the English translations in ibid., appendix A, 97–113.

35. Mi Fu, *Shu shih*, 11; trans. adapted from Ledderose, *Mi Fu*, 107.

36. Sturman, *Mi Fu*, 141. For a detailed investigation of these aesthetics, see ibid., chap. 4, "The Pingdan Aesthetic"; and chap. 5, "Naturalness," 121–72.

37. Cited in *Pao Chin ying-kuang chi, chüan* 8: 66.

38. For a thorough account of the stylistic sources of Huang T'ing-chien's calligraphy, see Fu, "Huang T'ing-chien's Calligraphy," 188–237.

39. Huang T'ing-chien, "Lun tso tzu," quoted in Shui, ed. *Huang T'ing-chien shu-fa shih-liao chi*, 7.

40. Huang T'ing-chien, "T'i *I-ho ming* hou" (Colophon following *Eulogy on Burying a Crane*), in idem, *Shan-ku t'i-pa, chüan* 4: 32. On the *Eulogy*'s influence on Huang T'ing-chien, see Shen Fu, "Huang T'ing-chien's Calligraphy," 224–33, and Fong et al., *Images of the Mind*, 76–84.

41. Cited in *Pao Chin ying-kuang chi, chüan* 8: 66; trans. adapted from Fong et al., *Images of the Mind*, 86, and Sturman, *Mi Fu*, 62. For a thorough account of Mi Fu's stylistic development, see Sturman, *Mi Fu*.

42. For a detailed discussion of Huang T'ing-chien's brush methods, see Fu, "Huang T'ing-chien's Calligraphy," 106–18.

43. Mi Fu, *Hai-yüeh ming-yen*, in *Mei-shu ts'ung-shu, chüan* 4: 9 (emphasis added).

44. Ibid. (emphasis added).

45. Huang T'ing-chien, "Pa Mi Yüan-chang shu" (Colophon on Mi Yüan-chang's Calligraphy), in idem, *Shan-ku t'i-pa, chüan* 5: 53.

46. Yang Hsiung's dictum is quoted in Fong et al., *Images of the Mind*, 76.

47. Ibid., 83.

48. For example, both attended the Elegant Gathering in the Western Garden, perhaps the most famous gathering in the history of Chinese literati culture. Su Shih was also present. For a detailed account of Huang T'ing-chien's life, see Fu, "Huang T'ing-chien's Calligraphy," chap. 1: 7–31; on Mi Fu, see Sturman, *Mi Fu*. No further references will be given in the following brief accounts of their lives.

49. Mi Fu was also famous for his strange behavior. I suspect that after allowance is made for a peculiar natural disposition, much of his behavior was a calculated drive for publicity. For a collection of anecdotes about him, see Sturman, *Mi Fu*, 214–17.

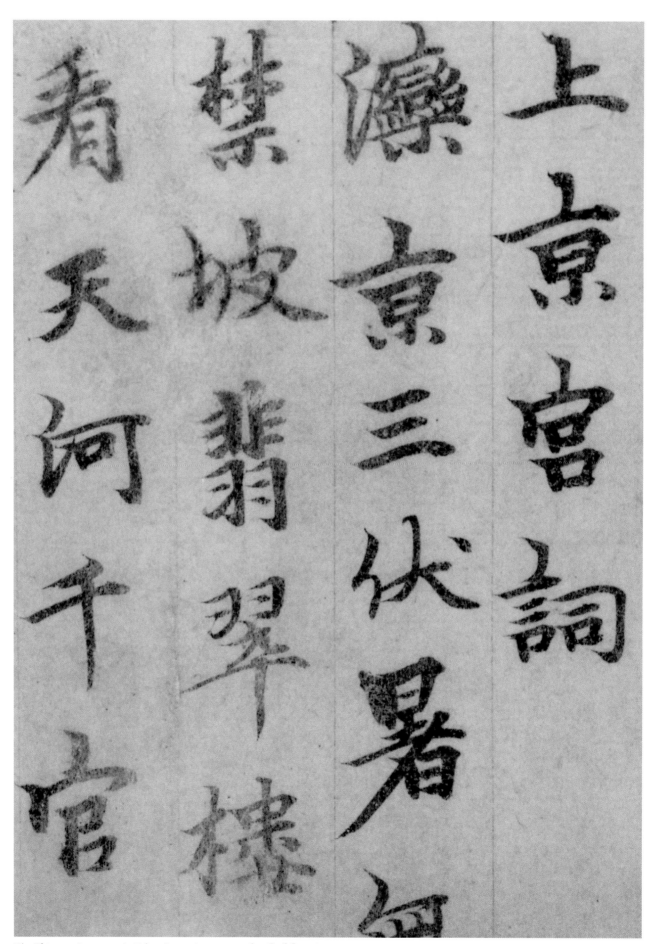

上京宫詞

灤京三伏暑

禁披翡翠樓

看天河千官

K'o Chiu-ssu (1290–1343), *Palace Poems* (cat. no. 14, detail of fig. 12).

The Two Perfections: Reading Poetry and Calligraphy

ROBERT E. HARRIST, JR.

The title of this chapter willfully distorts a familiar phrase in Chinese aesthetics: the "three perfections" include poetry, calligraphy, and painting.[1] Of the three, poetry and calligraphy, as vehicles of linguistic communication, share a unique bond in their mutual dependence on a conventionalized system of spoken and written signs. Although painting also depends on the use of schematic conventions, the production and perception of pictorial images take place outside the rules of grammar and syntax to which even the most innovative forms of poetry and calligraphy are bound.[2]

Although the arts of poetry and calligraphy have been closely linked in China as cultural practices and as the subjects of theoretical discussion for nearly two thousand years, little is known of the calligraphy of early poets such as T'ao Ch'ien (T'ao Yüan-ming, 365–427) or Hsieh Ling-yün (385–433).[3] Of the calligraphy of the great T'ang poets Tu Fu (712–770) and Wang Wei (700–761) we know nothing. Although the poet Li Po (701–762) was noted for his cursive script, only one extant fragment of calligraphy, of doubtful authenticity, is attributed to him.[4] The rarity of autograph manuscripts of poetry from the pre-T'ang era contrasts starkly with the relative abundance of other texts that were preserved by early collectors and transmitted through copies or rubbings to later centuries. The majority of works prized by these collectors were personal letters. It was this genre of writing, not poetry, that was the most prestigious format for the display of calligraphic skill during the early Southern Dynasties period, when the concept of calligraphy as an art form took shape. A new relationship between poetry and calligraphy began to emerge in the eighth century, when calligraphers such as Chang Hsü (fl. ca. 700–750) wrote in cursive script on walls and on large handscrolls in feats of calligraphic performance art. In these works intended to demonstrate both literary and calligraphic talent and to be preserved as works of art, the preferred texts were poems or essays, not private correspondence.[5]

It was not until the Northern Sung period that it became common for poet-calligraphers such as Su Shih (1037–1101), Huang T'ing-chien (1045–1105), and Mi Fu (1052–1107) to write out their works in large-character handscrolls for presentation to friends or political associates. The function of these works was not simply that of recording a poetic text: they were artifacts of both literary and visual art, intended to be collected and preserved. Huang T'ing-chien realized that this was a new phenomenon in the history of Chinese literary and artistic culture. Commenting on the calligraphy of his close friend Su Shih, Huang pointed out that earlier literary men had never been "celebrated for their calligraphic skills, and that is why Su Shih's brushwork is so much in demand."[6] Su Shih himself once noted that when a friend asked for a sample of calligraphy, he specified that it be one of Su's own poems.[7]

In later centuries calligraphers continued to transcribe poetry in every conceivable format and style. The alliance of the two arts was reinforced by aesthetic theories that treat poetry and calligraphy as uniquely powerful means of self expression. Writing in the seventeenth century, but echoing a concept almost as old as poetry itself in China, Chin Jen-jui (1608–1661) claimed that "poetry is nothing extraordinary; it is only the words which rise from the heart and lie at the tip of the tongue, and which everyone cannot help longing to utter."[8] The idea that poetry inevitably gives voice to the feelings of the poet parallels the equally common view that calligraphy is an external manifestation of powerful inner states. In the eighth century Chang Huai-kuan (fl. ca. 714–760) argued that calligraphy is even more revelatory than poetry, in that "literary composition needs several characters

to complete [the meaning of a line], whereas calligraphy can reveal the mind with only one character."[9]

When poetry *and* the calligraphy in which it appears are by the same person, a special bond exists between the two forms of expression. Viewed in light of traditional theories of the two arts, not only the words of such a poem but their physical embodiment in calligraphy as well carry the reader directly into the life and mind of the poet-calligrapher.

The Elliott Collection includes several examples of integrated works of poetry and calligraphy. The four discussed here are a fan inscribed by Emperor Sung Kao-tsung (r. 1127–62), an album leaf by Empress Yang (1162–1232), a scroll by the courtier and connoisseur K'o Chiu-ssu (1290–1343), and a long scroll by the Neo-Confucian philosopher Ch'en Hsien-chang (1428–1500). Unlike draft manuscripts of poems, which a writer may not intend to be seen by others, each of these was carefully prepared as a gift for a specific reader. An interpretive challenge that they pose, which traditional theories do not directly address, lies in discerning in them not the unproblematic reflections of temperament or mood that poetry and calligraphy were thought to embody, but traces of the complex institutional circumstances, rhetorical strategies, and sometimes contradictory personal goals that shaped their production.

POETRY AND CALLIGRAPHY
AT THE SOUTHERN SUNG COURT

Two pieces of darkened, badly worn silk in the Elliott Collection—one a round fan, the other a square album leaf (figs. 5 and 10, cat. nos. 8 and 9)—bear quatrains inscribed by members of the Southern Sung imperial family. The calligraphy on the fan is by the tireless Emperor Kao-tsung, an avid calligrapher and patron of the arts. The inscription on the album leaf is from the hand of Empress Yang, one of the most politically powerful of all Chinese empresses and one of the few women in Chinese history to achieve fame as a calligrapher. Like all participants in traditional Chinese elite culture, emperors and their consorts were expected to be accomplished poets and calligraphers. Although neither Kao-tsung nor Empress Yang was a distinguished poet, both were unusually skillful calligraphers who used samples of their writing as subtle

instruments of ideological propaganda and as intimate signifiers of political and personal favor.

For Emperor Kao-tsung, the arts were not only a source of pleasure but also a vital means of establishing the legitimacy of his reign. The ninth son of Emperor Hui-tsung (r. 1100–1126), he would not have become emperor had disaster not befallen his father, who abdicated in 1125, and his elder brother, Emperor Ch'in-tsung (r. 1126–27): both were captured by invading Jurchen armies when Kaifeng, capital of the Northern Sung, fell in 1127. After several precarious years of southward retreat and narrow escapes from enemy troops, Kao-tsung established his court in the city of Lin-an (modern Hangchow) and negotiated an uneasy peace with the Jurchen, who set up their own dynasty, known as the Chin, in the conquered territory of the north.

As soon as his rule had achieved a modicum of political and military stability, Kao-tsung turned his attention to affirming his legitimacy as emperor through state sponsorship of the arts.[10] He staffed an academy of painting at his court with artists such as Li T'ang (ca. 1070s–ca. 1150s) and Ma Ho-chih (fl. ca. 1130–ca. 1170), who illustrated historical narratives and Confucian classics in scrolls for which Kao-tsung personally transcribed the texts. With the assistance of ghostwriters, including his wife, Empress Wu (1115–1197), who had mastered Kao-tsung's style, he transcribed texts of Confucian classics and had them carved on stelae set up at the newly revived National University in the capital. Reproduced as rubbings and distributed to other schools throughout the empire, Kao-tsung's transcriptions of these canonical texts reached a wide readership. He also copied masterworks of calligraphy and transcribed literary classics as gifts for his officials. Through all of these activities, Kao-tsung demonstrated to his subjects his enlightened patronage of and participation in the same cultural enterprises through which great rulers of the past had enriched Chinese civilization. As if to reward himself for the rigors of his earlier life, Kao-tsung abdicated in 1162 in favor of his adopted son, Emperor Hsiao-tsung (r. 1163–89) and enjoyed a twenty-five-year retirement spent largely in his favorite pastime, practicing calligraphy.

Although few acts of imperial writing could be considered truly private, given the ritualized decorum of court life and the near sacerdotal efficacy that inhered

Figure 1a. Anonymous, *Autumn Mallows,* 12th century, fan, ink, colors, and gold on silk, reverse of figure 1b.

Figure 1b. Emperor Kao-tsung (r. 1127–62), *Quatrain,* undated, fan, gold on silk, 24.3 x 25.5 cm. Shantung Provincial Museum, Chi-nan. From *Wen-wu,* no. 5 (1972): pl. 2.

in traces of the imperial brush, Kao-tsung often gave samples of his calligraphy to individuals as semiprivate signifiers of imperial favor. Among these gifts were inscribed fans, which Kao-tsung produced in abundance during his lengthy retirement. Frequently mounted back to back with paintings by court artists and set in light bamboo frames, hand-held fans were objects intended for daily use as part of one's personal accoutrements, almost as intimate as an article of clothing. Judging from extant and recorded examples, paintings matched with inscriptions on fans usually were representations of scenes of court life, landscapes, and, most popular of all, birds and flowers. Morally demanding excerpts from the classics and accompanying illustrations were treated in other formats.

Although imperial calligraphers frequently transcribed on fans verses by earlier poets, the quatrain by Kao-tsung appears to be his original composition. Thus the fan was a doubly precious object, a gift of both imperial calligraphy and poetic imagination:

> Downstairs, who is burning nighttime incense?
> Jade pipes in sad resentment sound in the early chill.
> Facing the wind, a guest sings of an autumn fan.
> As she bows to the moon, no one sees her evening
> makeup.

During the Southern Sung, quatrains were a popular poetic form at the imperial court; owing to their brevity, they were ideally suited to be inscribed on fans or album leaves.[11] Kao-tsung's quatrain evokes the sadness of a neglected court beauty: though surrounded by incense and music, she spends an autumn evening alone, chanting poems in the moonlight. The autumn fan mentioned in the last line probably alludes to the story of Lady Pan Chieh-yü. An imperial concubine of the Han dynasty, Lady Pan expressed her resentment at being displaced in the emperor's favor by writing a poem likening her fate to that of a silk fan discarded in autumn as cooling breezes replace summer heat.[12]

Although Kao-tsung's poem may have accompanied a painting of a court beauty, given the conventions of Chinese poetic writing, in which beautiful women are frequently compared to flowers, the painted side of the fan also could have represented a flower.[13] A rare example of both sides of a Southern Sung fan preserved together was discovered in a Ming dynasty tomb (figs. 1a, b).[14] The painted side of the fan depicted autumn mallows and a butterfly, while on the other side was a modified version of a quatrain by Liu Ch'ang (1019–1068) transcribed by Emperor Kao-tsung:

> White dew has just passed, hurrying away the eight
> month,
> Purple corolla and red leaves share chilly loneliness.
> The yellow blossom, neglected, there is no one to see:
> Alone, it naturally inclines its heart toward the sunset.

In this quatrain, the neglected autumn blossoms are a metaphor for a lonely court beauty. The emperor's poem on the Elliott fan uses the same rhyme scheme

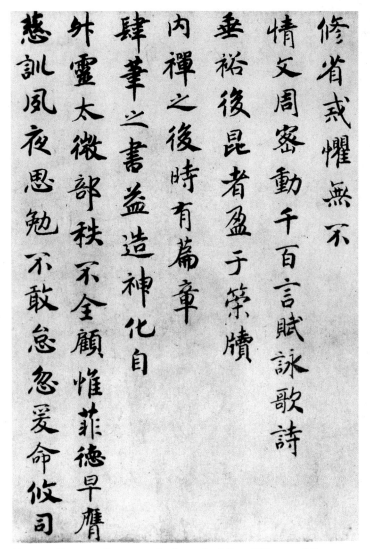

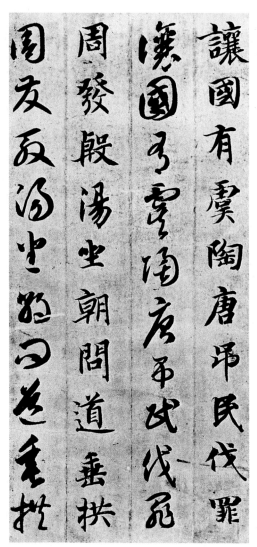

Figure 2. Emperor Kao-tsung, *Preface to the Collected Writings of Emperor Hui-tsung* (detail), 1154, handscroll, ink on paper, height 27.6 cm. Ogawa Collection, Kyoto. From *Shodō zenshū*, n.s. (Tokyo: Heibonsha, 1967), 16: pl. 22.

Figure 3. Chih-yung (fl. late 6th–early 7th century), *"The Thousand Character Essay" in Regular and Cursive Scripts* (detail), undated, handscroll, ink on paper, height 24.7 cm. Ogawa Collection, Kyoto. From *Shodō zenshū*, n.s., 5: pl. 62.

and draws on a similar repertory of melancholy images that recur frequently in Southern Sung court poetry: neglected flowers, crepuscular light, unappreciated evening makeup.

Unfortunately, neither the Elliott fan nor the fan discovered archaeologically bear dedicatory inscriptions that would allow us to reconstruct the relationship between Kao-tsung and the recipients of his poems and calligraphy. Whoever their original owners may have been, these gifts signified a special intimacy between those who received them and their imperial donor, the ultimate source of all generosity at court.[15]

Kao-tsung's major contribution to the history of Chinese calligraphy was his development of the distinctive standard script (*k'ai-shu*) used in his transcriptions of the classics and in highly formal texts such as

his *Preface to the Collected Writings of Emperor Hui-tsung* (*Hui-tsung wen-chi hsü*), dated 1154 (fig. 2). Although Kao-tsung emulated the Northern Sung masters Huang T'ing-chien and Mi Fu early in his career, his mature standard script was based on study of the calligraphic tradition of Wang Hsi-chih, especially the relaxed, malleable pre-T'ang standard script of Wang's descendant, the monk Chih-yung (fl. late 6th–early 7th century). Kao-tsung studied with special care Chih-yung's copies of "The Thousand Character Essay" (*Ch'ien-tzu wen*), which displayed both standard and cursive-script (*ts'ao-shu*) characters (fig. 3). The emperor's assimilation of Chih-yung's cursive-script style is apparent in works from his long years of retirement, when ample leisure allowed him to produce informal works, especially poems, for which cursive script was

ideally suited (fig. 4).[16] The calligraphy of the Elliott fan (fig. 5), marked by rapid changes of brush direction in loops and hooked strokes and by the frequent appearance of strokes that begin or end with sharply pointed tips, recalls the cursive script of Chih-yung and likely dates from late in Kao-tsung's career.

Kao-tsung's involvement with the arts, especially calligraphy, set a pattern followed by his successors and their consorts. Empress Yang, who was known by her nickname Yang Mei-tzu (Little Sister Yang), excelled at the arts of poetry, calligraphy, and political intrigue.[17] She entered the court as the daughter of a musician favored by Kao-tsung's wife, Empress Wu. Her beauty, intelligence, and skill as a musician caught the attention of Ning-tsung (r. 1195–1224), who made her his empress in 1202, after the death of his first wife. Empress Yang soon proved to be a political force in her own right and has been implicated in the assassination of a high minister who opposed her elevation in rank. She later sanctioned a plot led by the chief-councilor Shih Mi-yüan (1164–1233) to set aside the imperial nephew named as his successor by Ning-tsung, whose own sons had died, in favor of another who became Emperor Li-tsung (r. 1225–64).[18] Her role in Li-tsung's

succession to the throne won Empress Yang a privileged position at his court.

During the reigns of Ning-tsung and Li-tsung an increasing aestheticism in Southern Sung culture can be detected in painting, calligraphy, poetry, gardening, and other pursuits.[19] Although emperors and their consorts continued to sponsor or to participate in the production of painting and calligraphy that promoted the morally uplifting values embodied in the historical and classical themes that dominated art from early in Kao-tsung's reign, the political urgency that fired his artistic enterprises had passed; instead of transcriptions of canonical texts, poems written to accompany paintings of landscapes or flowers became the preferred texts for imperial calligraphy exchanged among members of the court or conferred on meritorious officials.

The majority of the extant and recorded inscriptions by Empress Yang are on the theme of flowers. Traditional symbols of feminine beauty, flowers also were a standard theme in poems known as "songs on objects" (*yung-wu*), which focus on isolated fragments of the natural or manmade environment. Although, by the Southern Sung period, the imagery of this genre was

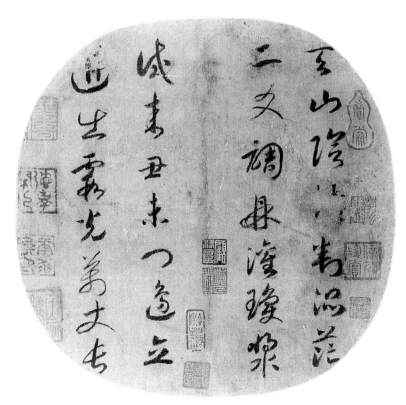

Figure 4. Emperor Kao-tsung, *Quatrain on Heavenly Mountain,* undated, fan mounted as an album leaf, ink on silk, 23.5 x 24.5 cm. The Metropolitan Museum of Art, New York.

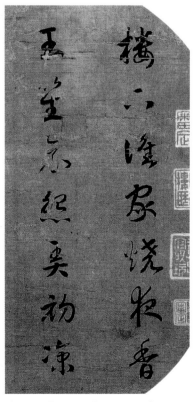

Figure 5. Emperor Kao-tsung, *Quatrain on an Autumn Fan,* undated (cat. no. 8, detail).

迎風呈巧媚
挹露逞紅妍

Figure 6. Ma Yüan (fl. ca. 1160–after 1225), *Apricot Blossoms,* inscribed by Empress Yang (1162–1232), fan mounted as an album leaf, ink and colors on silk, 25.8 x 27.3 cm. National Palace Museum, Taipei, Taiwan, Republic of China.

highly conventionalized, Hui-shu Lee has argued convincingly that Empress Yang used poems inscribed on paintings of flowers to convey subtly erotic messages to her husband, Emperor Ning-tsung.[20] A couplet inscribed by Empress Yang on a painting of apricot blossoms (fig. 6) by the court painter Ma Yüan (fl. ca. 1160–after 1225) reads, "Receiving the wind, she presents her unsurpassed beauty; / Moistened by dew, she reveals her red charms." If Lee is right about the erotic suggestiveness of this couplet (increased by use of the feminine pronoun in translation), which does seem to allude to female receptiveness to male sexual favor, the work on which this inscription appeared could have been intended for Emperor Ning-tsung himself.[21]

In addition to these highly intimate poetic offerings, Empress Yang also wrote poems on paintings commissioned for festivals, birthdays, banquets, and other events associated with peaceful times and good government.[22] The subject of her quatrain on the album leaf from the Elliott Collection (cat. no. 9), which probably accompanied a painting by a court artist, possibly Ma Yüan or Ma Lin (ca. 1180–after 1256), commemorates the arrival of the Double Ninth Festival:

On festival days of the four seasons people busily hurry;
From this, one knows we are living in a happy land.
The ninth day [of the ninth month] approaches, yet beside the fence it is lonely;
Only after the chrysanthemums blossom will the Ch'ung-yang Festival arrive.

This festival falls on the ninth day of the ninth lunar month. Traditionally an occasion for ascending a high place to enjoy the view, it also was associated with chrysanthemums and T'ao Ch'ien, who loved these flowers above all others. The words "beside the fence" (*li pien*) in Empress Yang's quatrain allude to a famous line from one of T'ao's poems: "I pick chrysanthemums by the eastern fence."[23]

As in the case of the Kao-tsung fan, Empress Yang's poem bears no dedicatory statement, but it is likely that the album leaf and the painting that originally accompanied it were intended for one of her political

allies. The most likely recipients would have been her adopted brother Yang Tz'u-shan (1139–1219), who played an important role in her elevation to the rank of imperial consort, or one of his sons.[24] Although her claims to blood relationship with the Yang family almost surely were false, these men served her reliably, and through Empress Yang's efforts they were granted high offices and aristocratic titles. Gifts of her own calligraphy and paintings by court artists duplicated in the realm of cultural products these political and economic rewards.

Empress Yang occupies an important place in the history of Chinese calligraphy in general and in that by women in particular. There are more extant examples of calligraphy from her hand than from the hand of any earlier woman writer. Although the paucity of evidence for calligraphy by women is attributable in part to their subordinate position in traditional Chinese society, a few did achieve fame as calligraphers. The earliest was Madam Wei (Wei Fu-jen, 272–349). Said to have been the teacher of Wang Hsi-chih, she occupied a near-legendary position in the history of calligraphy, but nothing is known of her own style.[25] A recurring form of praise in records of later women calligraphers is that they mastered the styles of their husbands or fathers so thoroughly that their writing could not be identified as that of a woman. For example, Empress Tou (fl. early 7th century), the wife of T'ang Kao-tsu (r. 618–26), could perfectly imitate her husband's style.[26] And, as mentioned earlier, the wife of Sung Kao-tsung, Empress Wu, assisted the emperor in his writing projects by serving as his ghostwriter. As one would expect, therefore, the calligraphy of Empress Yang was said to have resembled that of her husband, Ning-tsung. Unfortunately, too few works attributable to Ning-tsung have survived to allow us to evaluate this comparison, though according to a thirteenth-century connoisseur, the emperor "followed the family style."[27] This means, of course, the style of Emperor Kao-tsung, whose standard script has been called a "dynastic emblem" of the Southern Sung court.[28]

In the calligraphy of Empress Yang, the exposed brush tips at the beginnings of strokes, fluid ligatures, frequent use of a slanted brush technique to produce bold, flat silhouettes, and sharp, flaring *na* strokes reveal her study of Kao-tsung's style. But the empress subtly transformed this style through the assimilation of other calligraphic models, most strikingly, the stan-

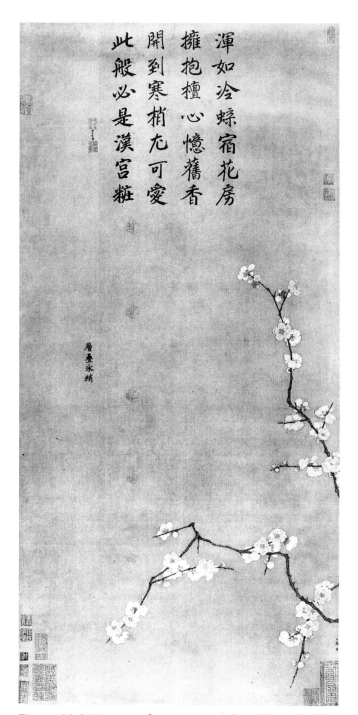

Figure 7. Ma Lin (ca. 1180–after 1256), *Layers of Icy Silk*, inscribed by Empress Yang, 1216, hanging scroll, ink and colors on silk, 101.0 x 49.6 cm. Palace Museum, Peking. From *Chung-kuo li-tai hui-hua* (Peking: Jen-min mei-shu ch'u-pan-she, 1982), 3: pl. 79.

dard script of the great T'ang calligrapher Yen Chen-ch'ing (709–785). In her poem written in 1216 on Ma Lin's *Layers of Icy Silk* (*Tseng-t'ieh ping-hsiao;* fig. 7), Empress Yang constructed tall characters in which individual elements are carefully balanced and evenly distributed, recalling the proportions of characters in Yen's works (fig. 8). Details of brushwork such as the plump, tapered vertical strokes and the "swallow-tail"

Figure 8. Yen Chen-ch'ing (709–785), *Record of the To-pao Pagoda*, 752, rubbing. From *Shodō zenshū*, n.s., 10: pl. 12.

Figure 9. Detail of figure 7.

notches at the ends of *na* strokes moving downward to the right also reveal Empress Yang's study of the T'ang calligrapher's style (fig. 9). Though less apparent, echoes of Yen's style appear also in the album leaf from the Elliott Collection (fig. 10), in the twisting vertical strokes of the "door" radicals, the extended, upturned final strokes in the characters *chiu* (nine) and *hua* (flower), and in the long, rounded *p'ieh* strokes moving downward to the left.

Although the criteria through which they reach their conclusions are somewhat vague, several modern scholars have described Empress Yang's calligraphy as an example of a feminine mode, "easily identified as from a woman's hand."[29] Her calligraphy

on the Elliott album leaf and the Ma Lin plum painting hint that had she continued to explore the style of Yen Chen-ch'ing—traditionally considered the most "masculine" of calligraphers—the empress might well have developed a new standard script model that incorporated into the calligraphy of the Southern Sung court the "supports and walls" that a thirteenth-century critic complained were missing in Kao-tsung's relaxed, somewhat flaccid calligraphy.[30] We know little about the role of gender in determining acceptable styles for male and female calligraphers, but the assumption, current even today, that certain ways of writing possess either masculine or feminine qualities clearly has deep roots. Perhaps Empress Yang did not

Figure 10. Empress Yang (1162–1232), *Quatrain on Autumn*, undated (cat. no. 9, detail).

take the final step of developing an assertive personal style because, in the world of the Southern Sung court, it would not have been a ladylike thing to do.

POETRY AND CALLIGRAPHY IN THE LIFE OF A COURTIER-CONNOISSEUR

Throughout Chinese history, officials serving the imperial court were expected to compose decorous, self-effacing poems celebrating important events or everyday pleasures enjoyed by their imperial patrons. Like all written communication destined for imperial review, such poems demanded superb calligraphy.

Although a few great eccentrics such as Li Po and Mi Fu won favor through displays of untrammeled inventiveness in the presence of the emperors they served, for most writers the exacting world of court life offered few opportunities to assert their personal identities through autobiographic content in poetry or through eccentric calligraphic styles.[31] Transferred into other contexts, however, literary and artistic forms closely tied to court life could acquire the power to signify new meanings. The *Palace Poems* of K'o Chiu-ssu that are the text of a short handscroll in the Elliott Collection (cat. no. 14) were originally composed at the court of Emperor Wen-tsung (Tugh Temür, r. 1328–32), the most sinicized of the Mongol emperors and a generous patron of Chinese literary and artistic culture. The poems, at least two of which were done on imperial command, contain no lyric outpourings or passionate statements of private feeling, and they are transcribed in the same calligraphic style K'o Chiu-ssu employed for colophons he wrote on works in the emperor's collection. Nevertheless, through the text and the calligraphy of the Elliott scroll, created as a gift to a Buddhist monk years after Wen-tsung had died, K'o constructed an unmistakable persona through which he continued to portray himself as a recipient of imperial favor.

When the Southern Sung dynasty collapsed in 1279 and China was unified by the Mongols, who founded the Yüan dynasty, scholars of the Chiang-nan region (south of the Yangtze) were at first viewed with suspicion by their conquerors. Gradually, however, the Mongols began to coax these men into government service. Although some of those who shunned public life may have done so to avoid complicity with foreign rule, John Langlois has argued that "there is very little evidence that the Chinese at the time viewed the Mongols as 'aliens' who, because of their foreign origins, were ineligible to rule the empire."[32] Throughout the dynasty, many southerners who accepted official government positions thrived under the Mongol rule. Among these were several major calligraphers, including Chao Meng-fu (1254–1322), K'o Chiu-ssu, Feng Tzu-chen (1257–after 1327), and Yang Wei-chen (1296–1370).

A native of Hsien-chü, Chekiang, K'o Chiu-ssu was born into a family with a history of service as scholar-officials extending back to the Northern Sung period.[33] This family tradition underwent little change after the Mongol conquest. K'o Chiu-ssu's father, K'o

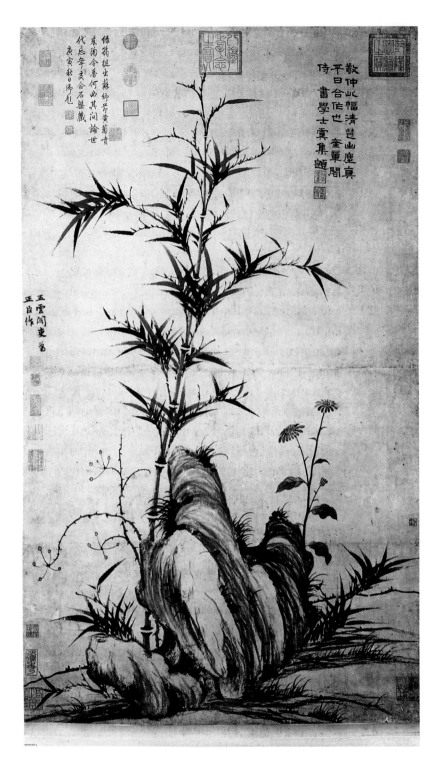

Figure 11. K'o Chiu-ssu (1290–1343), *Bamboo and Chrysanthemum*, undated, hanging scroll, ink on paper, 126.3 x 75.2 cm. National Palace Museum, Taipei, Taiwan, Republic of China.

Ch'ien (1251–1319), assisted in compiling *The Veritable Records of Shih-tsu* (Khubilai Khan, r. 1260–94) and held provincial posts under three Mongol emperors. In 1314, owing to his father's position, K'o Chiu-ssu was offered a post as district defender in Hua-t'ing. He declined this appointment, however, claiming that he lacked sufficient military knowledge for the job. After spending a number of years in Ta-tu (Peking), the Mongol capital, where he was befriended by Chao Meng-fu and won fame among literati circles for his bamboo painting (fig. 11), K'o Chiu-ssu returned to the Chiang-

nan region in 1323. A turning point in his life came two years later, when he traveled to Chien-k'ang (Nanking), where the future emperor Wen-tsung, then known as the Prince of Huai, was living. K'o's artistic skill attracted the attention of the prince, who soon became his patron. When Wen-tsung took the throne in 1328, K'o followed him to the capital.[34]

One of Wen-tsung's first official acts was to establish an institution known as the Hall of Literature (*K'uei-chang-ko*). Staffed by both Chinese and Mongol scholars, the Hall became the center for the transmission

of Chinese literary and artistic culture at the Mongol court.[35] In addition to translating Chinese texts into Mongolian and instructing imperial princes in the Confucian classics, scholars assigned to the Hall supervised the imperial library and collections of paintings, calligraphy, and other antiques. Although Wen-tsung appears to have had a genuine love of the arts, the Hall also served him well as an ideological tool. Like other Mongol emperors, he recognized the need to make clear to his Chinese subjects his rightful position as the Son of Heaven. He faced an additional challenge posed by his shaky claims to rightful succession within the Mongol imperial line. In the best traditions of his Chinese predecessors, Wen-tsung turned to the patronage of high culture as a means of demonstrating his fitness to rule. To identify himself as closely as possible with the activities of the Hall, Wen-tsung awarded ivory plaques inscribed with his own calligraphy to its staff and frequently wrote calligraphy scrolls as gifts for them.[36]

Wen-tsung accorded K'o Chiu-ssu the honor of being one of the original members of the staff of the Hall of Literature and eventually conferred on him the rank of Erudite Connoisseur of Calligraphy (*Chien-shu po-shih*). K'o's principal duty was to study and authenticate works of painting and calligraphy, and many scrolls that passed through the Mongol court at this time bear his inscriptions. He also served as an artistic advisor and confidant to Wen-tsung and engaged in exchanges of calligraphy and painting with the emperor.[37] In another demonstration of his favor, Wen-tsung ordered the erection of a stele honoring K'o Chiu-ssu's father and personally wrote the calligraphy for the stele's title, *The Teaching of Loyalty* (*Hsün-chung*).

K'o Chiu-ssu's years of service to Wen-tsung ended abruptly in 1332. In the fifth month of that year, enemies in the Imperial Censorate called for his impeachment, charging that "[K'o Chiu-ssu] was not good in character, was extremely devious in conduct, and, making the most of an insignificant skill, was a sycophant of the powerful."[38] Confronted with these charges, K'o asked the emperor for a provincial posting. Before action could be taken, however, Wen-tsung died at his summer palace in Shang-tu. K'o Chiu-ssu soon retired from office and returned to Chiang-nan, where he spent the rest of his life painting, practicing calligraphy, and viewing art within a circle of literary and artistic friends that included Huang Kung-wang

(1269–1354), Ni Tsan (1306–1374), Chang Chu (1279–1368), Yang Wei-chen, Chang Yü (1283–1350), and Ku Ying (1310–1369).

Although Wen-tsung's legitimacy to rule came under posthumous attack shortly after his death, K'o Chiu-ssu, the consummate courtier, remained faithful to the memory of his patron. At gatherings of friends, "if the conversation touched on the former reign [of Wen-tsung], he would recite poems which he had composed, sobbing copiously."[39] In the poems of the Elliott scroll, which describe life at court during Wen-tsung's reign, we hear echoes of K'o Chiu-ssu's tearful recitations.

Comparing its calligraphy with that of other works written by K'o Chiu-ssu after he retired to Chiang-nan, Fu Shen has argued that the Elliott scroll dates from the final years of K'o's life.[40] The identity of the scroll's recipient supports this theory. After the final poem, K'o Chiu-ssu signed his name and wrote, "Transcribed for presentation to Wu-yen, the Great Ch'an Master." This Buddhist monk, also known by the names Kuang-hsüan and Chih-na, lived in temples in Kiangsu and was popular among literati of the area.[41] K'o Chiu-ssu apparently met Wu-yen only after returning to the south in 1333. We know nothing about the nature of their friendship or why K'o should have decided to write out for him poems about life at court. The scroll was not, however, the only piece of writing K'o did for Wu-yen in which he evoked his years of service under Wen-tsung. In a poem inscribed on a dragon painting owned by the monk, K'o associated the mysterious creature in the painting with the emperor in retreat at his summer palace.[42] Although the scroll of *Palace Poems* was written as a gift for an individual, K'o Chiu-ssu could reasonably expect that it would be seen also by a wider audience of literati readers among Wu-yen's many secular acquaintances.

The scroll consists of five poems; the first three are regulated verses of eight lines each; the final two poems are quatrains.[43] All can be dated to the years between 1329 and 1331.[44] The first poem, "Lyric on the Summer Palace" (*Shang-ching kung tz'u*) describes the splendors of Wen-tsung's summer retreat, where K'o Chiu-ssu apparently had the privilege of accompanying the emperor:

At the upper capital in months of summer
 there is little heat;
The music of immortals floats down the forbidden
 slope.

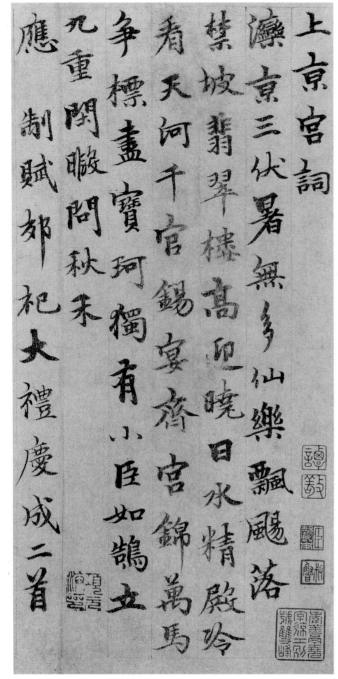

Figure 12. K'o Chiu-ssu, *Palace Poems*, undated (cat. no. 14, detail).

At the heights of jadeite towers, welcoming the
 dawning sun,
In the chill of crystal halls, observing the Milky Way.
A thousand officials, honored at a banquet, all arrayed
 in palace embroidery,
Ten-thousand horses galloping for the pennant, all
 with jade trappings.
Yet still there are minor officials standing at attention:
Though enjoying celestial leisure, [His Majesty]
 inquires of the coming autumn harvest.[45]

In this poem, K'o Chiu-ssu skillfully achieves two
goals: he describes Wen-tsung's retreat in ornate lan-
guage that associates it with splendid imperial settings
portrayed in earlier courtly literature, and, in the clos-
ing couplet, he praises his patron's tireless concern for
the welfare of his agriculturalist Chinese subjects.

The second and third poems, "Responding to an
Imperial Order: Two Poems on the Suburban Sacri-
fice" (*Ying chih fu chiao-ssu ta-tien ch'ing erh shou*), docu-
ment Wen-tsung's performance of this ancient ritual.
In the first, K'o uses allusions to events of the Han
dynasty to associate Wen-tsung's reign with a period of
Chinese military strength and cultural brilliance:

> The white rush has just been offered, and the sacrificial
> music is ready;
> Moonlight shines on the altar, and the sky above is
> cold and serene.
> Sacrificing in person at the Kan-ch'üan Palace, abolish-
> ing the secret ritualist,
> [His Majesty] is blessed in the Grand Chamber, and
> asks about the people's welfare.
> Stars descend on the guard of honor, as divine radi-
> ance draws near;
> Sunlight rings [His Majesty's] heavenly face, as auspi-
> cious colors shine.
> Countless attending officials together hail His longevity;
> A bountiful year is presaged, as joy rises in a time
> of peace.

In performing the ritual described in K'o Chiu-ssu's
poem, just as in sponsoring literary and artistic en-
deavors at his court, Wen-tsung placed himself in a
grand lineage of Chinese rulers. K'o uses historical
allusions to stress this point. The Kan-ch'üan Palace
was used by Han Wu-ti (r. 140–87 B.C.) as a site for
communing with spirits.[46] The practice of conducting
rituals in person, rather than through "secret ritual-
ists," alludes to a policy of Han Wen-ti (r. 179–157 B.C.),
as does the granting of heavenly blessings in the
Grand Chamber, a site in Wen-ti's palace.[47]

K'o Chiu-ssu himself appears in these and the other
poems transcribed in the scroll merely as an unobtru-
sive observer of imperial splendors. Yet his implied
attendance at the events he portrays reminds his read-
ers of the privileged position he enjoyed during Wen-
tsung's reign, when the poems were composed.[48] In
addition to the contents of the poems, two of the seals
K'o Chiu-ssu stamped on the scroll also remind the
reader of his life at court. A square relief seal stamped

Figure 13. K'o Chiu-ssu, Yü Chi (1272–1348), Li Chiung (1274–1332), and Chieh Hsi-ssu (1274–1344), *Colophons,* handscroll, ink on paper, 40.9 x 54.9 cm. National Palace Museum, Taipei, Taiwan, Republic of China.

under his signature reads, "The Family of Hsün-chung" (*Hsün-chung chih chia*). This legend refers to the stele honoring his father, K'o Ch'ien, set up at the command of Wen-tsung. Stamped at the upper right corner of the scroll, a square intaglio seal reads, "Erudite Connoisseur of Calligraphy of the Hall of Literature" (*K'uei-chang-ko chien-shu po-shih*), K'o's former title, conferred on him by Wen-tsung.

With remarkable consistency, K'o wrote in a distinctive, highly disciplined form of small standard script based on the styles of the T'ang calligraphers Ou-yang Hsün (557–641) and Ou-yang T'ung (d. 691) and enlivened by his study of the elegant, fluid brushwork of calligraphy by Chao Meng-fu.[49] The compact characters of K'o's calligraphy display brushstrokes written with clearly defined beginning and ending points, neat articulation of corners, and prominent hooked strokes (fig. 12). Although each had an easily identifiable personal style, scholars of the Hall used variations of small standard script regularly in their calligraphy destined for imperial review.[50] This can be seen in a set of colophons by K'o Chiu-ssu, Yü Chi (1272–1348), Li Chiung (1274–1332), and Chieh Hsi-ssu (1274–1344) once attached to a now-lost painting (fig. 13). The relative uniformity of their writing makes the inscription (third from the right) by Li Chiung, with its thin, elongated strokes and tall character structures, seem idiosyncratic and slightly out of place.

If K'o Chiu-ssu may be said to have had a profession, it was that of connoisseur and writer of colophons. The Elliott scroll is one of his few recorded or extant independent works of calligraphy. For all its learned charm and subtlety, his calligraphy is limited in range. Even after years of retirement, and in contexts that allowed great stylistic freedom, he continued to write in the same trim, elegant manner in which, during his days at court, he had so often inscribed works from Wen-tsung's collection.

In his study of autobiography in China, Stephen Owen discerns an impulse that "begins in apology, in the need to 'explain oneself.' Such a need arises only under certain conditions: the poet feels that the self and its motives are more interesting, more complicated, or simply different from what they appear to be; he is pained at the discrepancy, seeks to rectify it, show what is truer and more worthy."[51] Although K'o never refers directly to himself in his *Palace Poems,* the text and calligraphy of the scroll, circulating among readers during the final years of his life, after he had been hounded out of office and his patron had died, were like fragments of autobiography through which K'o presented a "truer and more worthy" vision of himself as an honored connoisseur loyally serving his imperial patron.

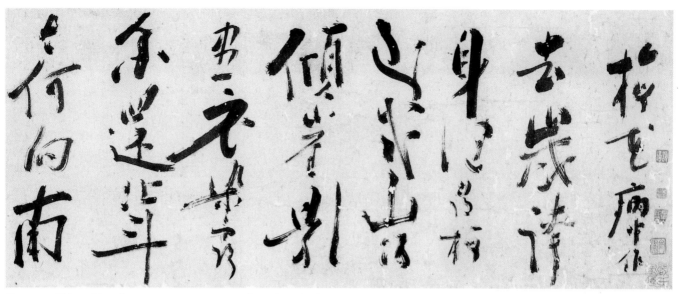

Figure 14. Ch'en Hsien-chang (1428–1500), *Writing about Plum Blossoms while Ill*, 1492 (cat. no. 22, detail).

POETRY, CALLIGRAPHY, AND ILLNESS

A long handscroll titled *Writing about Plum Blossoms while Ill* by Ch'en Hsien-chang confronts the reader with large misshapen characters that seem to have been splattered rather than brushed on the coarse paper (figs. 14 and 17; cat. no. 22). Created far from the constraints of court life that shaped the poetry and calligraphy of the Southern Sung imperial writers and K'o Chiu-ssu, Ch'en's writing asserts a strongly individualistic presence, both through the autobiographic content of the poems and through his eccentric calligraphic style, which violates all traditional canons of beauty and control in brushwork. Interpreted within the context of Ch'en's life, the scroll carries the reader into the private world of a person who was both an innovative artist and, along with Wang Yang-ming (1472–1529), one of the major thinkers of the Neo-Confucian tradition during the Ming dynasty.

Ch'en Hsien-chang was born in the Hsin-hui district of what is now Kwangtung Province and grew up in the village of Pai-sha, where he spent most of his life.[52] Located far from the cultural centers of Chiangnan and from the capital in Peking, this was a bandit-ridden coastal region with few historical claims to scholarly or artistic eminence. Although his father died shortly before Ch'en was born, his family was prosperous, and he received a good education under the care of his mother, to whom he was deeply devoted. Nevertheless, his three attempts to pass the *chin-shih* examination that would have qualified him for government service were unsuccessful. His true career

became his quest for philosophical enlightenment. After a brief spiritual apprenticeship under the philosopher Wu Yü-pi (1392–1469) in Kiangsi during 1454, Ch'en Hsien-chang returned to Pai-sha and embarked alone on an arduous program of study and meditation. Through "quiet sitting" (*cheng-tso*), a form of meditation adopted from Buddhist and Taoist practices, Ch'en eventually claimed to have achieved realization of the fundamental unity of mind and matter, man and nature.

The foundation of Ch'en's philosophy was the concept of "naturalness" (*tzu-jan*).[53] Originating in the philosophy of Chuang-tzu, this term was used in both philosophical and aesthetic discourse to refer to the harmonious interaction of human life with the eternal flux of nature. Applied in his own life, Ch'en Hsien-chang's concept of naturalness offered the potential for transcendence of worldly cares. He wrote,

> It is all the same whether I am in the mountains or the forest, whether at court or in the market. It is the same in the constant transformation of life and death. Again, it is the same whether my lot be wealth and honor or poverty and low station, or I be pressed by barbarians, adversaries, and calamities. None of these circumstances can disturb my mind.[54]

Ch'en's students and later scholars also pointed to the concept of "naturalness" as the key to understanding his poetry and calligraphy.[55] Concerning literary composition, Ch'en himself wrote,

What is good about ancient writings is that one never sees in them traces of [self-conscious] composition. They seem as if they were spoken extemporaneously, which is the marvelous quality of naturalness. There are different types among them, but those that originate in naturalness and do not seem to be composed are then perceived as being the best.[56]

The ideal of effortless externalization of feeling through art also appears in a short essay on calligraphy that Ch'en transcribed on a hanging scroll of 1491, known today through a rubbing (fig. 15):

> Whenever I write calligraphy, I try to seek serenity in action, to release but not to release, to hold back but not to hold back. This is how I achieve a marvelous quality in movement. When I attain what I wish, I am not surprised; when impeded I do not worry. This is how I preserve serenity. I have method but am not constricted by it. I am unrestrained but not loose. The more awkward [my calligraphy], the more skillful it is, the stronger, the more able to be soft. When the forms are set, force races through them. Ideas are fully conceived and marvels overflow in them. [Calligraphy] rectifies my mind, harmonizes my feelings, and tunes my nature: this is why I wander in [this] art.[57]

It was in Ch'en's calligraphy that one of his closest disciples, Chan Jo-shui (1466–1560), saw the ultimate embodiment of his teachings. "Based on the master's calligraphy," Chan wrote, "students are able to acquire his teaching of naturalness."[58] The works in which Chan Jo-shui and others found the concept of naturalness made visible were those of Ch'en's later years done with special brushes that the artist made himself. In place of the hair from goats, weasels, mice, and other animals normally used to make Chinese brushes, Ch'en bound together pieces of white miscanthus rush that grew abundantly near Pai-sha to make a writing tool he called the "rush gentleman" (*mao-chün*) or "rush dragon" (*mao-lung*).[59] A modern reproduction of Ch'en's brush (fig. 16) shows strawlike fibers tightly bound to form a pointed tip like that of a conventional animal-hair brush, but Ch'en's "rush gentleman" was far stiffer and far less absorbent. After writing only four or five large characters, the brush began to dry out and its fibers separated, producing unevenly inked strokes in which the paper shows through (fig. 17). This effect, known as "flying white," or *fei-pai,* was said to have been invented in the Han dynasty when Ts'ai Yung (132–192) saw workmen

writing large characters with a coarse broom. Returning home, he used his brush to reproduce the bristly look of the broom-written characters.[60] Ch'en Hsien-chang achieved a similar effect with his "rush gentleman," an invention replicating in miniature the broom that inspired Ts'ai Yung.

Although some reports claim that Ch'en Hsien-chang made brushes out of rush simply because it was difficult to buy high quality conventional brushes in his region, he clearly liked the appearance of calligraphy done with his homemade writing implement. Since it was difficult, if not impossible, to produce with this kind of brush the carefully calculated attacks,

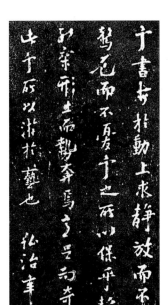

Figure 15. Ch'en Hsien-chang, *Essay on Calligraphy,* 1491, rubbing. From Ch'en Ying-yao, ed., *Pai-sha hsien-sheng i-chi,* 2d ed. (Hong Kong: Ch'en-shih keng-tu-t'ang, 1959), 39.

Figure 16. Modern reproduction of Ch'en Hsien-chang's brush. From Ch'en, *Pai-sha hsien-sheng i-chi,* 24.

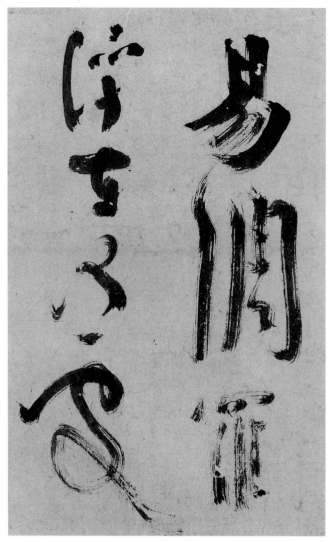

Figure 17. Ch'en Hsien-chang, *Writing about Plum Blossoms while Ill* (cat. no. 22, detail).

As several scholars have noted, it is perhaps the calligraphy of Ch'an Buddhist masters that most closely approaches the startling originality and energy of Ch'en Hsien-chang's hand,[64] though there is no evidence that he was interested in this tradition of monastic writing. Viewed historically, Ch'en Hsien-chang's individualistic calligraphy was widely admired but little imitated, remaining a style too personal to be perpetuated by later followers.

Although Ch'en Hsien-chang's philosophical statements, and those of his followers and admiring critics, promote ideals of naturalness, spontaneity, and transcendent harmony in his art, the poems and calligraphy of the Elliott scroll betray realities of illness, worry, and overwork. The nine poems Ch'en Hsien-chang transcribed on the scroll come from a set of ten that appears in his collected works under the title "Singing of Plum Blossoms while Ill" (*Ping-chung yung mei*).[65] At the end of the scroll, Ch'en added a note stating that it was written on the day corresponding to January 22, 1492, at the Hsiao-lu-kang Studio, which he had built three years earlier in Pai-sha.[66] The poems return to a theme that recurs often in his poetry—the enjoyment of plum blossoms. Simple, direct, and unencumbered by arcane allusions, Ch'en's poetic style embodies in literature the quality of "naturalness" to which he referred so often in his philosophical writing and in his comments on calligraphy. The first and third poems, translated below, typify his language and his mixed feelings of delight in the flowers and nostalgia for earlier times:[67]

> Last year, boasting of my health,
> I searched for plum blossoms in the mountains.
> Emptying wine cups by the cliff until shadows
> darkened,
> Clothes dampened with fragrant dew, I returned home.
> What direction does the Northern Dipper now point?
> Southern branches have lost half their blossoms.
> As I come downstairs, my sons and daughters laugh
> While I limp along on my old, weak feet.
> Human life is like flowing water.

> Blossoms opening are seen first on southern branches.
> Facing their shadows I am still at a distance,
> Though I smell their fragrance without moving
> my pallet.
> To prolong the moment I watch the moon a
> long while.
> In homage I crawl slowly down the stairs

fluid modulations of line, and tapered endings of strokes seen in writing done with an animal-hair brush, Ch'en seems to have viewed his calligraphy, free of all superficial beauty and polished control, as being more "natural." In the opening couplet of a poem titled "Viewing My Calligraphy with the Rush Brush," Ch'en wrote, "Where spirit leads, my vital energy naturally follows; / In these primordial interactions I feel freshly purified."[61] The rustic, awkward appearance of his calligraphy also was in keeping with Ch'en's view of himself as being "half farmer and half scholar."[62]

Confronted with Ch'en Hsien-chang's work, a reader accustomed to savoring subtle allusions to past styles is brought up short. Although Ch'en's use of odd writing tools was not unprecedented—T'ao Hung-ching (456–536) is said to have used a reed brush somewhat like Ch'en's, and Chang Hsü wrote with his own hair—his calligraphy owes little to classical sources.[63]

And sit fearing the most fragrant time has passed.
Supporting my weak body, I complete a single branch.

During the Ming dynasty, literati outings to view plum blossoms were an annual pleasure that was depicted frequently in paintings and described in countless poems.[68] For Ch'en Hsien-chang, however, enjoyment of the blossoms had been hindered by illness for several years. In a poem of 1485 Ch'en wrote, "Carrying my illness to search for fragrance, I always set out too late."[69] In two poems sent to a friend in 1491, shortly before the Elliott scroll was written, Ch'en wrote, "Presenting this to you, sir, what do I wish to say? / I laugh and pluck a plum blossom. . . ." and "In my youth I traveled without restraint / Old and sick I merely patch together verses."[70]

In letters from the years just before the creation of the Elliott scroll, Ch'en Hsien-chang also writes frequently about ailments and other worries. Beginning in 1485, the year of his mother's death, he suffered almost continuous illness. In this year he wrote to his disciple Chang Hsü (1455–1514) with complaints of diarrhea.[71] In a letter of 1486, also to Chang Hsü, he wrote,

> For several tens of days my hands and feet have been numb. I get up in the middle of every night and sit. The fortune teller says it will be around the Great Snow [seventh or eighth day of the twelfth lunar month] before the illness can be pacified. In Pao-an Circuit, people have been killed in the broad daylight. . . . There are many calamities in the area, and friends are all scattered. If by chance I cannot avoid the bandits, what can I do?[72]

In the early morning hours of the twenty-seventh day of the fourth month of 1487, presumably during a vigil like those mentioned in his letter to Chang Hsü the year before, Ch'en suffered a nasty fall: "Getting up and adjusting my clothes at the fifth drum, I lost my footing, fell, and hurt my face. I blame myself for not being careful, but it's also because of my age and long illness that my vital essence is weak and I have no strength."[73] This accident was so serious that Ch'en had to summon his servant to help him wash the blood from his face. Further letters to Chang Hsü from this same period speak of the death of Ch'en's grandson and worsening banditry. In an especially gruesome crime, bandits killed over ten members of a single family in a nearby village. Local conditions were so ominous that Ch'en thought of moving to the prefectural city, where he hoped to mourn his mother

in peace.[74] In the summer of 1489, during an outing to view mountain scenery, Ch'en suffered a heat stroke. For several days he was plagued with constipation and could not eat. This digestive trouble abated only after he took a dose of bean gruel.[75] In letters from the same year, he complains of being old and ill, and mentions in particular a pain troubling his knees.

Pleading ill health was a time-honored tactic in China for avoiding things one did not want to do, and illness and age are recurring themes in traditional Chinese poetic writing. But the all-too-real misfortunes Ch'en Hsien-chang suffered demand that we read seriously his title "Writing about Plum Blossoms while Ill" as well as the references to illness in the poems themselves. That Ch'en made his illness and other troubles the subject of his writings might seem to undermine his claim to be undisturbed by "adversaries and calamities." Nevertheless, as age and illness became biographical realities, not simply poetic tropes, Ch'en remained hopeful. In the final couplet of the fourth poem in the Elliott scroll, he wrote, "The iciness of the cliff may block the passage of my crippled feet; / Still, supported by my bramble staff, I am in high spirits."

Knowledge of the troubles that plagued Ch'en Hsien-chang when he wrote the poems in the Elliott scroll subtly changes the way a reader perceives his rugged, willfully unlovely calligraphy. The surface of the scroll comes to be seen as a site of physical, moral, and artistic struggle, in which the ailing writer marshalls his remaining energy to painfully inscribe the poems. Although Ch'en asserted that calligraphy "preserved serenity" and "harmonized [his] feelings," scattered through his writings is evidence that producing calligraphy, even with his "rush gentleman," could be a burden. In a poem sent to an old friend and neighbor, Li Chiu-yüan, Ch'en expresses regret that Li was ill and goes on to speak openly of his own problems:

> Coming out my gate I see the side of your studio;
> For ten days we have not met once.
> It is because my belly is blocked,
> And I recall that you, sir, have a head cold.
> A head cold still can be treated with moxa;
> As for constipation, how can it be relieved?
> My innate essence has always been weak:
> How much worse when attacked by illness!
> People say at fifty one starts to decline,
> But at thirty or forty I took leave of "spring and winter."

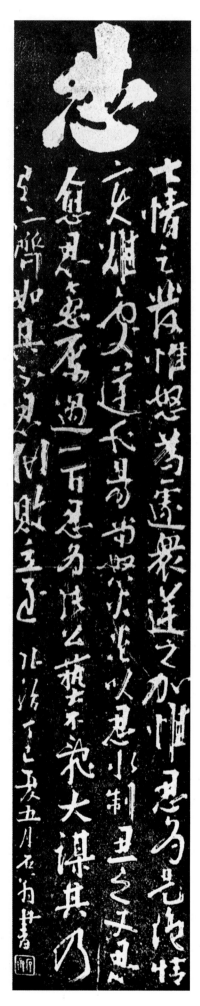

Figure 18. Ch'en Hsien-chang, *Encomium on the Word "Endurance,"* 1497, rubbing. From Ch'en, *Pai-sha hsien-sheng i-chi,* 42.

The hair at my temples and my face suddenly has
 withered;
My blood and vitality rarely are satisfactory.
Guests arrive seeking my calligraphy;
Wearing out brushes, I still cannot meet the demand.
Using my "rush gentleman" for a little while,
It merges with my hand to become a divine tool.
Thus do my days go rolling by,
As I constantly turn my back on my life's achievement.
With a long bow I would like to take leave of the "rush
 gentleman,"
And in peace and tranquility wait for my end.[76]

Like all eminent men who were noted for their calligraphy, Ch'en Hsien-chang was constantly barraged with requests for samples of his writing. References to requests for all manner of essays, tomb inscriptions, and stelae appear frequently in correspondence from late in his life, by which time calligraphy was not simply a private means of self-cultivation but a public duty that Ch'en felt compelled to perform. For one of the most revered teachers in all China, the need to supply his hundreds of students with souvenirs of his writing was alone a daunting task.[77] Although no sources speak openly of direct payments of cash, Ch'en no doubt received gifts or favors in return for his writing. The fatigue of producing large-character scrolls with his unwieldy homemade brushes occasionally made him wish, as he confessed to Li Chiu-yüan, that he could give up calligraphy for good. Commenting on this poem, Chan Jo-shui saw his teacher's desire to take leave of his brush as an expression of his determination to concentrate solely on pursuing the Way (*Tao*) of ancient philosophers.[78]

But Ch'en Hsien-chang did not give up calligraphy. To the end of his life, he continued to write, filling long handscrolls and large hanging scrolls with his poems, short essays, and moral exhortations. In his *Encomium on the Word "Endurance"* (*Jen tzu tsan;* fig. 18), a hanging scroll done in 1497, three years before his death, Ch'en seems to demonstrate visually through the power of his brushwork a truth extolled in this short text: "The more one endures, the more encouraged one becomes."[79] Written slowly and laboriously, stroke by stroke, calligraphy remained for Ch'en Hsien-chang a medium through which hardship could be faced, endured, and transcended.

The theorist of literature Liu Hsieh (ca. 465–522) believed that written characters "make up the external appearances of our speech and are the dwelling place

of literary form."[80] The poems of Emperor Kao-tsung, Empress Yang, K'o Chiu-ssu, and Ch'en Hsien-chang can be read in printed editions in which neat pages of characters record exactly the same words as the transcriptions written in the hands of these poet-calligraphers. But when the "dwelling places" of their words are redesigned in the medium of print, or in copies made by other calligraphers, the experience of reading the poems changes; the bond between the material presence of the words and their point of origin in an individual mind and body is broken. Knowledge of the decorum of court life, the rhetorical ambiguities of autobiographic writing, or the ravages of illness and fatigue may convince us that this bond was more complex and indirect than any aesthetic theory can explain; nevertheless, like listeners straining to hear the sound of a poem chanted faintly in the poet's own voice, we continue to seek it out.

NOTES

1. For an introduction to the concept of the "three perfections," see Michael Sullivan, *The Three Perfections: Chinese Painting, Poetry, and Calligraphy,* Walter Neurath Memorial Lectures (London: Thames and Hudson, 1974); see also Alfreda Murck and Wen C. Fong, eds., *Words and Images: Chinese Poetry, Calligraphy, and Painting* (New York and Princeton: The Metropolitan Museum of Art and Princeton University Press, 1991).

2. Attempts to define the relationship between words and images have produced a huge corpus of texts in the fields of philosophy, aesthetics, and art history, none of which has yielded widely accepted solutions. We are left with what W. J. T. Mitchell has called a "difference that we can live neither with nor without, but must continually reinvent and renegotiate." This statement comes at the end of a short essay that can be recommended as a good introduction to the problem of how words and images differ ("Word and Image," in Robert S. Nelson and Richard Shiff, eds., *Critical Terms for Art History* [Chicago and London: University of Chicago Press, 1996], 47–57).

3. A scroll titled *Four Ancient-Style Poems* in the Liaoning Provincial Museum, Shenyang, is attributed to Hsieh Ling-yün, as is a stone engraving of two of his poems preserved in Ch'ing-t'ien District, Chekiang (*Shodō zenshū,* n.s., [Tokyo: Heibonsha, 1966], 6: pls. 14–17, pp. 167–68).

4. Jean François Billeter, *The Chinese Art of Writing,* trans. Jean-Marie Clarke and Michael Taylor (Geneva: Skira, 1990), 194.

5. Nakata Yūjirō, "Calligraphic Styles and Poetry Handscrolls: Mi Fu's *Sailing on the Wu River,*" in Murck and Fong eds., *Words and Images,* 94.

6. Huang T'ing-chien, "Pa Tung-p'o shu-t'ieh hou, "*Yü-chang Huang hsien-sheng wen-chi* (*Ssu-pu ts'ung-k'an* ed.), *chüan* 29: 8b; trans. in Ronald C. Egan, "Ou-yang Hsiu and Su Shih on Calligraphy," *Harvard Journal of Asiatic Studies* 49, no. 2 (1989): 392–93.

7. Su Shih, "Sun Hsin-lao ch'iu Mo-miao-t'ang shih," *Su Shih shih-chi* (Peking: Chung-hua shu-chü, 1982), 8: 371–73.

8. Trans. in James J. Y. Liu, *The Art of Chinese Poetry* (Chicago and London: University of Chicago Press, 1962), 73. Liu's book remains the best English-language introduction to theories of Chinese poetry. No comparable survey of theories of calligraphy is yet available in a Western language. For an excellent introduction to this subject in Chinese, see Hsiung Ping-ming, *Chung-kuo shu-fa li-lun t'i-hsi* (Hong Kong: Shang-wu yin-shu kuan, 1984).

9. Chang Huai-kuan, *Shu tuan,* in Huang Chien, ed., *Li-tai shu-fa lun-wen hsüan* (Shanghai: Shang-hai shu-hua ch'u-pan-she, 1979), 1: 209.

10. For an extensive study of the role of painting and calligraphy in Kao-tsung's project of dynastic revival, see Julia K. Murray, *Ma Hezhi and the Illustration of the Book of Odes* (Cambridge and New York: Cambridge University Press, 1993).

11. Under the sponsorship of Emperor Hsiao-tsung, the poet and scholar-official Hung Mai (1123–1202) compiled a massive anthology of T'ang examples of this poetic genre, *Ten Thousand Quatrains by Men of T'ang* (*Wan-shou T'ang-jen chüeh-chü*).

12. The story of Lady Pan is discussed in Ellen Johnston Laing, "Erotic Themes and Romantic Heroines Depicted by Ch'iu Ying," *Archives of Asian Art* 49 (1996): 73–75.

13. Robert E. Harrist, Jr., "Ch'ien Hsüan's *Pear Blossoms:* The Tradition of Flower Painting and Poetry from Sung to Yüan," *Metropolitan Museum of Art Journal* 22 (1987): 53–70.

14. The two sides of the fan had been remounted as a handscroll, probably during the Yüan dynasty (Shan-tung-sheng po-wu-kuan, "Fa chüeh Chu Tan mu chi-shih," *Wen-wu* 5 [1972]: 2–8).

15. In a poem about the conferral of imperial gifts during the Tuan-wu Festival, Empress Yang wrote, "Close ministers brag of being given gold-inscribed fans." This glimpse of court life several decades after Kao-tsung's death shows that his custom of awarding calligraphy on fans to favored subjects was continued by his successors (*Erh-chia kung-tz'u* [*Wen-yüan-ko Ssu-k'u ch'üan shu* ed., Taipei: Shang-wu yin-shu kuan, 1983–86], vol. 1416, *hsia* 5b, p. 712).

16. On the dating of this fan, see Wen C. Fong, *Beyond Representation: Chinese Painting and Calligraphy, 8th–14th Century* (New York: The Metropolitan Museum of Art, 1992), 229–31.

17. For an extensive study of Empress Yang, see Hui-shu Lee, "The Domain of Empress Yang (1162–1233): Art, Gender and Politics at the Late Southern Song Court" (Ph.D. diss., Yale University, 1994); and idem, "Art and Imperial Images at the Late Sung Court," in Maxwell K. Hearn and Judith G. Smith, eds., *Arts of the Sung and Yüan* (New York: The Metropolitan Museum of Art, 1996), 249–69.

18. See the account of this affair in Richard L. Davis, *Court and Family in Sung China (960–1279): Bureaucratic Success and Kinship Fortunes for the Shih of Ming-chou* (Durham : Duke University Press, 1986), 95–101.

19. For studies of Southern Sung aestheticism, see Shuen-fu Lin, *Transformation of the Chinese Lyrical Tradition: Chiang K'uei and*

Southern Sung Tz'u Poetry (Princeton: Princeton University Press, 1978); and Yu-heng Feng, "Fishing Society at Hsi-sai Mountain by Li Chieh (1124–before 1197)" (Ph.D. diss., Princeton University, 1996).

20. Lee, "Art and Imperial Images," 251–52.

21. Translation adapted from ibid., 252.

22. Ibid., 253 n. 21.

23. T'ao Ch'ien, "Yin chiu erh-shih shou," in T'ao Yüan-ming shih-chien chu, with annotations by Ting Chung-hu (Taipei: I-wen yin-shu kuan, 1974), chüan 3: 111.

24. According to Hui-shu Lee, all but one of Empress Yang's works that bear dedicatory inscriptions were intended for members of the Yang family ("Art and Imperial Images," 253).

25. See Richard M. Barnhart, "Wei Fu-jen's Pi-chen t'u and the Early Texts on Calligraphy," Archives of the Chinese Art Society of America 18 (1964): 13–25.

26. Li O, ed., Yü-t'ai shu shih (Hsiang-yen ts'ung-shu ed., Shanghai: Chung-kuo t'u-shu kung-ss'u, 1914), chüan 1: 3a.

27. Chu Hui-liang, "Imperial Calligraphy of the Southern Sung," in Murck and Fong, eds., Words and Images, 305.

28. Fong, Beyond Representation, 225.

29. Kwan S. Wong, Masterpieces of Sung and Yüan Dynasty Calligraphy from the John M. Crawford Jr. Collection (New York: China House Gallery, 1982), 44.

30. Chao Meng-chien, "Chao Tzu-ku shu-fa lun," in Pien Yung-yü, comp., Shih-ku-t'ang shu-hua hui-k'ao (reprint of 1921 facsimile, Taipei: Cheng-chung shu-chü, 1958), vol. 1, chüan 6: 506, cited in Wen C. Fong et al., Images of the Mind: Selections from the Edward L. Elliott Family and John B. Elliott Collections of Chinese Calligraphy and Painting at the Art Museum, Princeton University (Princeton: The Art Museum, Princeton University, 1984), 95.

31. The validity of the concepts of "self" and "identity" in Chinese thought are debated in Roger T. Ames, with Wismal Dissanayake and Thomas P. Kasulis, Self as Person In Asian Theory and Practice (Albany: State University of New York Press, 1994). My interest in the concept of a personal identity in the context of K'o Chiu-ssu's life concerns primarily how he wished to be perceived by other people and the role of his poetry and calligraphy in shaping those perceptions.

32. John D. Langlois, "Yü Chi and His Mongol Sovereign: The Scholar as Apologist," Journal of Asian Studies 38, no. 1 (November 1978): 99.

33. My account of the life of K'o Chiu-ssu is based on Tsung Tien, K'o Chiu-ssu shih-liao (Shanghai: Shang-hai jen-min mei-shu ch'u-pan-she, 1985).

34. His reign was interrupted briefly when he abdicated in favor of his brother, Emperor Ming-tsung (Khoslila), who ruled only eight months. Upon Ming-tsung's death in 1329, probably by assassination, Wen-tsung returned to the throne.

35. This institution is the subject of a detailed study, Chiang I-han, Yüan-tai K'uei-chang-ko chi K'uei-chang jen-wu (Taipei: Lien-ching ch'u-pan-she, 1981).

36. Langlois, "Yü Chi," 108, 113–14.

37. Shortly after the founding of the Hall of Literature, K'o Chiu-ssu presented to the throne one of the treasures of his private collection, a scroll bearing the text of Stele for the Filial Daughter Ts'ao O, written, he believed, by Wang Hsi-chih. (The scroll now is in the Liaoning Provincial Museum, Shenyang.) The next year, after being given by the emperor a piece of Wang Hsien-chih's calligraphy, K'o Chiu-ssu gave his patron a version

of Preface to the Orchid Pavilion Collection, now in the Shanghai Museum. Instead of accepting the gift, Wen-tsung returned the scroll and awarded K'o a painting from the imperial collection (Tsung, K'o Chiu-ssu shih-liao, 233–34).

38. Cited in Francis W. Cleaves, "The 'Fifteen Palace Poems' by K'o Chiu-ssu," Harvard Journal of Asiatic Studies 20, no. 3/4 (1957): 408–9.

39. Hsü Hsien, "Pai-shih chi-chuan," translation adapted from Cleaves, ibid., 409.

40. Nakata Yūjirō and Fu Shen, eds., Ōbei shuzō Chūgoku hōsho meisekishū (Tokyo: Chūōkōron-sha, 1982), 4: 138. Compare the view of Chiang I-han, who thinks K'o wrote the scroll while he was still in Ta-tu (Yüan-tai K'uei-chang-ko, 223). Another version of the Palace Poems is in the collection of Ch'en Ch'i (Tseng Yuho, A History of Chinese Calligraphy [Hong Kong: Chinese University Press, 1993], 216, fig. 7.86). Shen C. Y. Fu judges this version to be a close copy of the Elliott scroll (Fu et al., Traces of the Brush: Studies in Chinese Calligraphy [New Haven: Yale University Art Gallery, 1977], 302 n. 77).

41. Chiang, Yüan-tai K'uei-chang-ko, 242–44.

42. Recorded by Wang Feng in Wu-hsi chi (Ts'ung-shu chi-ch'eng ch'u-pien ed.), chüan 5: 261. Cited in Chiang, Yüan-tai K'uei-chang-ko, 243.

43. The poems appear, with minor variations, in K'o Chiu-ssu's literary anthology, Tan-ch'iu chi (Taipei: Hsüeh-sheng shu-chü, 1971), 3, 5, 39–40, 122–23.

44. On the dating of the poems, see Chiang, Yüan-tai K'uei-chang-ko, 222–23.

45. I am grateful to Jay Xu for his help in translating K'o Chiu-ssu's poems.

46. Ssu-ma Ch'ien, Shih-chi (Peking: Chung-hua shu-chü, 1973), chüan 28: 1388.

47. Pan Ku, comp., Han-shu (Peking: Chung-hua shu-chü, 1975), chüan 48: 2230.

48. The final two poems in the Elliott scroll, which are similar in content and tone to those translated above, come from the set Fifteen Palace Poems, composed between 1329 and 1330. These have been translated with exhaustive commentary in Cleaves, "The 'Fifteen Palace Poems.'" During K'o's own lifetime these poems were admired as examples of his mastery of the kung t'zu (palace lyrics) form, a genre of poetry on themes of court life, said to have begun with the T'ang poet Wang Chien (fl. ca. 755). In the final poem K'o alludes to another patron of art and literature at the Mongol court, the Imperial Aunt, Princess Sengge Ragi (ca. 1283–1331), who assembled a large collection of painting and calligraphy and made it accessible to scholars (Fu Shen, "Princess Sengge Ragi, Collector of Painting and Calligraphy," trans. and adapted by Marsha Weidner, in Weidner, ed., Flowering in the Shadows: Women in the History of Chinese and Japanese Painting [Honolulu: University of Hawaii Press, 1990], 55–80).

49. For an analysis of K'o Chiu-ssu's calligraphy, see Fu et al., Traces, 142.

50. For a discussion of small standard script during the Yüan dynasty, see ibid., 141–43.

51. Stephen Owen, "The Self's Perfect Mirror," in Stephen Owen and Shuen-fu Lin, eds., The Vitality of the Lyric Voice (Princeton: Princeton University Press, 1986), 75.

52. See the entry on Ch'en Hsien-chang by Huang Pei and Julia Ching in L. Carrington Goodrich and Chaoying Fang, eds.,

Dictionary of Ming Biography, 1368–1644 (New York: Columbia University Press, 1976), 1: 153–56.

53. For an introduction to the thought of Ch'en Hsien-chang, see Jen Yu-wen, "Ch'en Hsien-chang's Philosophy of the Natural," in W. Theodore de Bary et al., *Self and Society in Ming Thought* (New York: Columbia University Press, 1970), 53–92.

54. Translation adapted from ibid., 82.

55. Ibid., 64.

56. "Yü Chang Yen-shih chu shih," in *Ch'en Hsien-chang chi,* punctuated and annotated by Sun T'ung-hai (Peking: Chung-hua shu-chü, 1987), 1: 163, quoted in Ch'en Yü-fu, comp., *Ming Ch'en Pai-sha hsien-sheng Hsien-chang nien-p'u* (Taipei: Shang-wu yin-shu-kuan, 1980), 72.

57. "Shu-fa," *Ch'en Hsien-chang chi,* 1: 80; for an alternate and partial translation, see Fu et al., *Traces of the Brush,* 95.

58. Colophon quoted in Ch'ü Ta-yün, ed., *Kuang-tung hsin-yü,* in the series *Ch'ing-tai shih-liao pi-chi ts'ung-kan* (Peking: Chung-hua shu-chü, 1985), 2: 364, cited in Chien Yu-wen, *Pai-sha-tzu yen-chiu* (Hong Kong: Chien-shih meng-chin shu-wu, 1970), 338.

59. See the account of Ch'en Hsien-chang's brushes in Ch'ü, ed., *Kuang-tung hsin-yü,* 364–65, cited in Chien, *Pai-sha-tzu yen-chiu,* 336–37.

60. Chu Ch'ang-wen, *Mo-ch'ih pien* (Taipei: Kuo-li chung-yang t'u-shu kuan, 1970), *chüan* 1, 7a–b: 69–70.

61. "Kuan tzu-tso mao-pi shu," in *Ch'en Hsien-chang chi,* 1: 302. See also the poem "Escorting the Rush Dragon" (*Sung mao-lung*) in Ch'en Ying-yao, ed. *Pai-sha hsien-sheng i-chi,* 2d ed. (Hong Kong: Ch'en-shih keng-tu-t'ang, 1959), 26.

62. Jen Yu-wen, "Ch'en Hsien-chang's Philosophy," 55.

63. On T'ao Hung-ching, see Li Yen-shou, *Nan-shih* (Peking: Chung-hua shu-chü, 1975), 6: 1897; on Chang Hsü, see "Li Po lieh-chuan," in Ou-yang Hsiu et al., *Hsin T'ang shu* (Peking: Chung-hua shu-chü, 1975), 18: 5764.

64. Tseng Yu-ho Ecke, *Chinese Calligraphy* (Philadelphia: Philadelphia Museum of Art and Boston Book and Art, Publisher, 1971), pl. 42; Nakata and Fu, *Ōbei* , 4: 166; Fong et al., *Images of the Mind,* 143.

65. "Ping-chung yung mei," *Ch'en Hsien-chang chi,* 1: 397–98.

66. Ch'en Hsien-chang does not make clear whether the poems were composed at the same time the scroll was written. It was common for him to return to earlier compositions for the texts of his calligraphy scrolls. A note he added to his transcription of poems following rhymes of T'ao Ch'ien, dated 1483, explains that when asked by a friend for calligraphy, he used "some old drafts" for the text (Yü An, "Mao-lung Ch'en Pai-sha," *Shu-p'u,* no. 1 [1974]: 10–11).

67. All of the poems in the Elliott scroll have been translated by Ch'en Pao-chen (Fong et al., *Images of the Mind,* 309–10). My own somewhat terser translations are based on hers.

68. For an extensive discussion of the plum blossom in Chinese culture, see Maggie Bickford, *Bones of Jade, Soul of Ice: The Flowering Plum in Chinese Art* (New Haven: Yale University Art Museum, 1985), esp. 93–94, which discuss Ch'en Hsien-chang's poems.

69. "Ch'en ch'i chiang ch'u hsün mei," *Ch'en Hsien-chang chi,* 2: 428. My dating of this and other writings by Ch'en Hsien-chang follows the detailed chronology of his life compiled by Juan Jung-ling, "Pien tz'u Ch'en Pai-sha hsien-sheng nien-p'u," included in *Ch'en Hsien-chang chi,* 2: 836.

70. "Chang K'o-hsiu pieh-chia ch'ien Wu-chou shou, lai pieh Pai-sha, tseng chi erh shou," in *Ch'en Hsien-chang chi,* 2: 524.

71. Juan, "Pien tz'u Ch'en Pai-sha," 834.

72. Ibid., 837.

73. "Ssu yüeh erh-shih ch'i jih . . . ," in *Ch'en Hsien-chang chi,* 1: 362; and Juan, "Pien tz'u Ch'en Pai-sha," 839.

74. Juan, "Pien tz'u Ch'en Pai-sha," 840.

75. Ibid., 842

76. "Ping chung hsieh huai, chi Li Chiu-yüan," in *Ch'en Hsien-chang chi,* 1: 289.

77. The persistence of this phenomenon in modern China has been studied by Richard Curt Kraus in *Brushes with Power: Modern Politics and the Chinese Art of Calligraphy* (Berkeley, Los Angeles, Oxford: University of California Press, 1991).

78. *Ch'en Hsien-chang chi,* 2: 732.

79. Ibid., 1: 80–81. A rubbing of the text appears in *Pai-sha hsien-sheng i-chi,* 42.

80. Vincent Yu-chung Shih, trans., *The Literary Mind and the Carving of Dragons* (New York: Columbia University Press, 1959), 295.

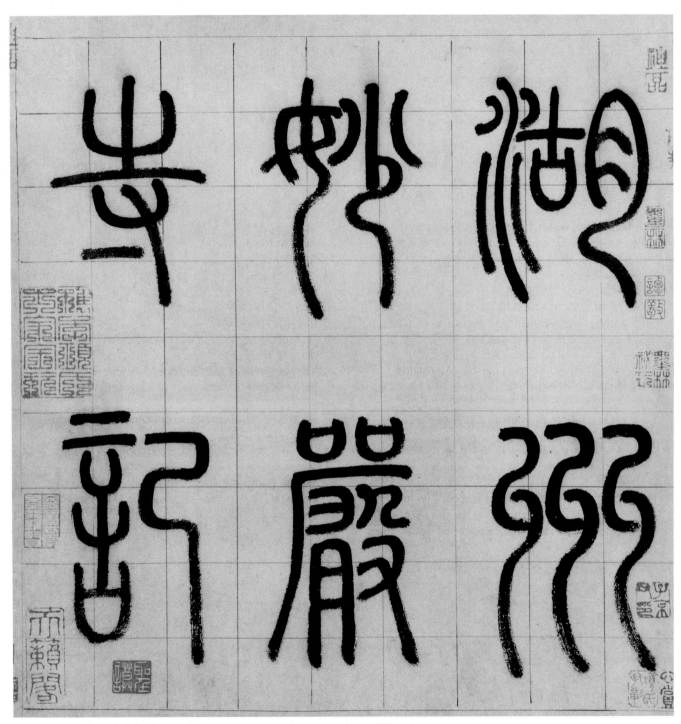

Frontispiece to *Record of the Miao-yen Monastery*, ca. 1309-10 (cat. no 11, detail of fig. 12).

A Quest for the Imperishable:
Chao Meng-Fu's Calligraphy for Stele Inscriptions

ZHIXIN SUN

His biography in *The History of the Yüan* (*Yüan shih*) describes Chao Meng-fu (1254–1322) as the most accomplished calligrapher of the dynasty. According to this source, "His seal, clerical, standard, running, and cursive scripts were absolutely unparalleled, and he was famous throughout the empire for his calligraphy."[1] Although Chao was known as a master of all script types, it was his innovative standard script, particularly in works written in large characters, that had the greatest impact on the history of calligraphy. Chao's personal style in this script evolved during the last twenty years or so of his life, a period marked also by honors bestowed upon him by the imperial court. Ironically, it was during this period that Chao gradually lost interest in his political career and became increasingly drawn to Buddhism. At the same time, however, he began to view his pursuit of art as an imperishable achievement and grew ever more enthusiastic about his practice of calligraphy. Focusing on his later years, this essay examines Chao Meng-fu's life and thought and explores his development of a personal style in large-character standard script that is displayed most notably in texts destined to be engraved on stelae.

THE LATER YEARS OF CHAO MENG-FU'S LIFE

In the tenth month of the third year of the Chih-yüan reign (1310), Ayurbarwada, then the crown prince of the Mongol Yüan dynasty, summoned Chao Meng-fu to the capital, Ta-tu (modern Peking), and granted him the position of Academician Reader-in-Waiting of the Hanlin Academy (*Han-lin shih-tu hsüeh-shih*, rank 3A).[2] In the following year, Emperor Wu-tsung (Kaishan, r. 1308–11) died, and Ayurbarwada assumed the throne. Soon after his accession, Ayurbarwada,

later known as Emperor Jen-tsung (r. 1312–20), continued to promote Chao Meng-fu, eventually bestowing upon him the prestigious position of Recipient of Edicts, Academician of the Hanlin Academy, Drafter and Chief Compiler of the Dynastic History, and the grandiloquent title of Grand Master for Glorious Happiness (*Han-lin hsüeh-shih ch'eng-chih, Chih-chih-kao Chien-hsiu kuo-shih, Jung-lu ta-fu*, rank 1B).

In less than six years Chao rose from being a moderately ranked local administrator to being a prestigious member of the imperial court. In contrast, it had taken him twenty-four years to rise from the position of director at the Ministry of War (rank 5B) to that of prefect of T'ai-chou (rank 4A) in his early career. Such rapid promotions were extremely rare during the Yüan period, particularly among Han Chinese (as opposed to Mongol) bureaucrats. In fact, Chao Meng-fu was one of only two southern Chinese known to have attained such high rank under the Mongols. During the Yüan, promotion of officials depended upon seniority and performance, but "promotions to positions above rank 3 were not determined by the administration."[3] Only the emperor had the authority to appoint high-ranking officials. It was probably Chao's artistic talents and accomplishments that won him the favor of Emperor Jen-tsung, who was one of the most supportive imperial patrons of art in Chinese history. Unlike his predecessors, Jen-tsung was raised in the heartland of China, where he received a Confucian education in his early years and grew deeply interested in traditional Chinese culture. Both of the renowned Yüan scholars Yü Chi (1272–1348) and Su T'ien-hsi (1294–1352) noted that Jen-tsung emphasized education and promoted "enlightened administration" (*wen-chih*).[4] He reinstituted the examination system and recruited talented artists and men of letters to serve at his court. Jen-tsung was particularly fond of Chao. According to Yang Tsai (1271–1323), the author

of Chao's "unauthorized biography" (hsing-chuang), Jen-tsung treated Chao with such respect that "he referred to Chao Meng-fu by his courtesy name [tzu]."[5] The emperor once compared Chao to the greatest artists of previous dynasties, such as Li Po (701–762) and Su Shih (1037–1101), and commented on several outstanding qualities that Chao possessed, describing him as "a descendant of an imperial family, endowed with a beautiful appearance, profoundly learned, of pure character and righteous conduct, able to write elegantly and up to the ancient standard, unparalleled in the art of calligraphy and painting, and also well versed and accomplished in Buddhist and Taoist study."[6]

Jen-tsung also displayed his concern for Chao's personal well-being. He once granted Chao "five hundred taels of paper money," the equivalent of several months' stipend. Fearing that the Secretariat might find excuses not to disburse the money, he specially ordered that it should be obtained from a Buddhist temple sponsored by the court.[7] When he learned that Chao was often absent from the court audience during the winter, he gave him an ermine cloak to ward off the cold.[8] Chao's promotions brought not only fame and emolument to himself but also glory to his family— his parents and grandparents were granted the posthumous titles of duke and duchess of the state of Wei.

Although Jen-tsung respected Chao as a senior official of previous reigns, an erudite scholar, and an acclaimed artist, he did not seek Chao's counsel on statecraft. Like earlier Mongol rulers, he hoped to use Chao's talents to "embellish the peace and prosperity of the reign."[9] Despite all the privileges and titles he enjoyed, Chao Meng-fu was no more than a high-ranking imperial secretary. He was expected to draft commemorative essays and poems for the emperor and empress, to authenticate and catalogue the imperial collections, and to copy Buddhist sutras on behalf of his imperial patrons. His duties also included "writing labels for painting and calligraphy works in the imperial collection and making copies of 'The Thousand Character Essay' [Ch'ien-tzu wen]."[10]

Chao Meng-fu was aware of Jen-tsung's expectations. He knew that while his position at court gave him fame and comfort, it did not afford him the opportunity to realize the aspirations he had harbored in his early years. A conversation he had with Khubilai Khan (r. 1260–94), who had also honored Chao, reveals something of his hopes: "The emperor asked the duke [Chao Meng-fu] to comment on the merits and shortcomings of Minister Liu Meng-yen [b. 1219] and Assistant Director of the Right Yeh Li [1242–1292]. The duke replied, 'The books that Yeh Li has read, I have read, too; what he knows and is able to do, I know and am able to do as well.' "[11] Scholars often take Chao's reply as an attack on Yeh Li but fail to notice his attempt to suggest to Khubilai that he had the learning and capacity to help the emperor to rule. Given the opportunity, he would perform just as well as Yeh Li and, more likely than not, provide the emperor with wiser counsel. Khubilai himself seems to have missed Chao's point and changed the topic of conversation. Chao could not go on to explain his hopes to the emperor. The thought of not having an opportunity to make full use of his abilities frustrated him; he felt that he was treated like an insignificant "blade of grass"[12] and regretted that he could "find no way to show his talent."[13]

When Chao Meng-fu chose to serve the Yüan dynasty in 1286, he was convinced that accepting a government post would be the best means of restoring order and of preserving Chinese traditions that the Mongols might otherwise destroy.[14] He also hoped for improvement in Mongol rule. He expressed such thoughts in his early poems, predicting that "traditional practice will gradually convert the foreign" and "honesty and propriety will improve uncivilized neighbors."[15] Motivated and hopeful, Chao wrote in a poem on his arrival at Ta-tu in 1286, "I have wandered in the world half of my life, / Today I have found my dream in the capital of the country."[16] Chao then viewed his earlier life as aimless and his current official post as a turning point. After taking office, he actively participated in administration and policy making, hoping to ameliorate the maladministration and brutality of the Mongol government. He made suggestions for currency reform, criminal justice, reform of the postal system, and government funding. He persuaded the emperor not to appoint officials to investigate their political enemies, so as to prevent personal revenge. He was particularly instrumental in the removal of the powerful but corrupt minister Sengge (d. 1291).

Being a southerner (nan-jen), a member of the lowest class in the social hierarchy enforced by the Mongols, and a descendant of the Sung imperial clan, Chao Meng-fu was distrusted and discriminated

against at the Yüan court. After Sengge's removal, he found himself trapped in court politics as he unknowingly made enemies of Sengge's former allies. Disappointed and disillusioned, he realized that the time was not right for him to serve and pursue his goals. It was at this moment that the idea of being a "recluse at court" (ch'ao-yin), one who performs his public and official duties while keeping his private life and inner thought separate and intact, began to take root in his mind.[17] When Khubilai wanted to assign him to a leading post in the Secretariat, he firmly declined and requested a provincial appointment. In 1292 he was appointed commander of Chi-nan Circuit. Chao was relieved to take up his new post, but his nightmare was not yet over. He almost fell victim to the plot of a corrupt Mongol supervisor whom he had offended. We can sense Chao's fear of the danger in political life in an essay he wrote during this time. He observed that rivers and seas could sink boats and take lives, but they were less dangerous than the treacherous minds of human beings.[18] Thanks to an unexpected imperial order summoning him to the capital to compile Khubilai's biography, he narrowly escaped his enemy's plot. This experience reinforced Chao's decision to live as a "recluse at court." Less than a month later, he resigned on account of ill health and left for his hometown of Wu-hsing, Chekiang.

In 1299 Chao accepted the post of supervisor of Confucian schools of Chekiang Circuit in Hangchow, where he associated with like-minded scholars and participated in cultural activities at his leisure. This was the time of his ch'ao-yin life, when he managed to keep his public duties and private life separate. A eulogy that he wrote for a friend describes his thinking at this time:

> Do not seek riches in making a living,
> Do not seek glory in serving in office.
> Be self-sufficient in one's living,
> And be content without making a fortune.
> Neighbors' praise for one's virtue is what reputation
> and fame are about.
> Why must one seclude oneself in craggy caves and
> conceal one's footsteps in forests and mountains
> to be pure and lofty? [19]

By the time of his return to Ta-tu in 1310, Chao had lived as a ch'ao-yin for some twenty years. He no longer hoped or expected to be involved in government policy making and leadership at the court. He was con-

tent with his undemanding post since it gave him the leisure to concentrate on the arts of painting and calligraphy.

As Chao lost interest in a political career, he was drawn increasingly to Buddhism. In his early years, he had not been especially interested in Buddhist practices, although he admired Buddhist scholarship and befriended monks. When a friend lost hope in life and decided to seek refuge in Buddhism, Chao cautioned him, "This is not a trivial matter and should be thoroughly thought over."[20] He also warned his friend that Buddhism could not shelter him from all problems and worries. Chao's attitude toward Buddhism changed significantly in the early 1300s after he met Chung-feng Ming-pen (1263–1323), the abbot of a Ch'an monastery at Hangchow and the eleventh patriarch of the Lin-chi school.[21] Impressed by the monk's learning and dynamic personality, Chao invited Ming-pen to

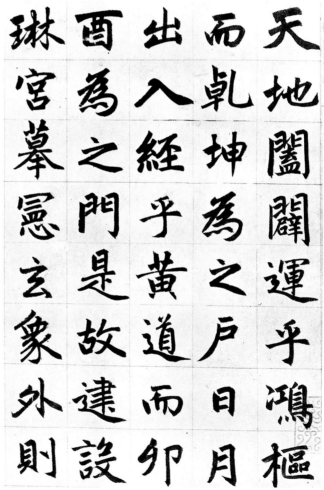

Figure 1. Chao Meng-fu (1254–1322), *Record of the Restoration of the Three Gates of the Hsüan-miao Priory* (detail), 1303, ink on paper, 35.7 x 340.4 cm. Collection unknown. From *Shodō geijutsu* (Tokyo: Chūōkōron-sha, 1970–73), 5: 56.

live at his official residence and to give lectures. After Chao left Hangchow, he frequently exchanged letters with Ming-pen. Though he was nine years older than Ming-pen, Chao treated the monk with such respect that "when he received a letter from the master, he would burn incense and bow in the direction of the master's residence."[22] He also painted Ming-pen's portrait and carried it with him for worship.[23]

It was thanks to Ming-pen that Chao became a serious Buddhist believer. Chao owed his "enlightenment" to the teachings of the master. He wrote to Ming-pen in 1313,

> In my study of the Buddha's teachings, I progressed and regressed from moment to moment during the twelve hours [shih] of the day. When I heard other people make trivial and casual comments, I joined in. After viewing your reverence's portrait and receiving your teachings, I now come to realize that all those comments make no sense and are no good. I deeply regret that I have not accomplished anything in the past fifty years. I will bear in mind your inspiring teachings and use them as an introduction to accomplishment.[24]

Ch'an Buddhism teaches that the Buddha's nature can be found in everyone. In Ch'an practice, the adept aims at calming his mind and concentrating on introspection into his own inner consciousness. He tries to feel an interest in things above the senses and to discover the presence of a spiritual faculty that bridges the gap between the finite and the infinite. When he manages to do so, he experiences an "awakening," or, in Ch'an terms, "enlightenment." An enlightened practitioner is able to keep a serene mind and cheerful disposition even amid a world of turbulent activity.[25] To achieve enlightenment, one has to learn to look directly into one's own nature but does not have to bind oneself to fastidious rituals or ascetic practice. Ch'an teachings had a particular appeal for Chao Meng-fu because they were in harmony with the modified eremitic way of life that he chose to pursue. In both Ch'an and ch'ao-yin eremitic practices, one did not have to retreat from mundane life, and the goal of both was to keep one's mind clear and one's principles intact. Accepting a government post under the Mongols had troubled Chao's conscience for years, and he had found it difficult to defend himself when criticized by his relatives and friends.[26] Ch'an emphasis on the inner soul and cultivation of the self not only helped him

justify his position, but also soothed his mind. He realized that "all the involvement and issues [in the external world] were nothing but a dead stick to tie the donkey."[27] In addition, the Buddhist view of death as a transitional stage in samsara (cycle of rebirth) and as a step toward rebirth that was hoped to be closer to the attainment of salvation probably provided explanations and solace when the successive deaths of his loved ones—his son, his daughter, and his wife—left him devastated.[28]

By the final decade of his life, Chao had come to accept the Ch'an doctrine that one should keep the cultivation of the inner soul separate from life in the external world. When Ming-pen decided to move to the mountains to avoid the disturbances of urban life, Chao wrote him a letter saying that he understood that "mundane circumstances forced Ming-pen to move," but that "it may not be in accordance with the Buddha's teachings to seek refuge in escapism. Things in the world are like clouds. When one can cast them aside, one should do so. But when one cannot, they should be accommodated and endured. Why should one try to escape from them?"[29]

While Chao was drawn to Buddhism, he never abandoned the Confucian teachings in which he had been immersed since childhood. Toward the end of his life these teachings shaped the way he thought about his painting and calligraphy. His thoughts are revealed in the poem "Self-Admonishment" (Tzu-ching):

> With missing teeth and a bald head, I am sixty-three years old;
> Things in my life have always caused embarrassment.
> Only the passion from my brush and inkstone remains,
> Which I'll leave to the world for laughter and comment.[30]

Here Chao Meng-fu assesses his life and art. A Han Chinese and a member of the Sung imperial family, he never completely overcame his guilty conscience for his involvement in the Mongol government, but he was proud of his accomplishments in art. Although he employed a conventional disclaimer that his accomplishments with "brush and inkstone" would be "for laughter and comment," he was confident that they would endure. The keys to his poem are the words "remains" and "leave to the world." In Confucian philosophy, the ultimate goal in life is not just prominence in office but "establishment of imperishable achieve-

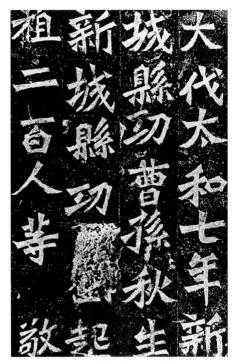

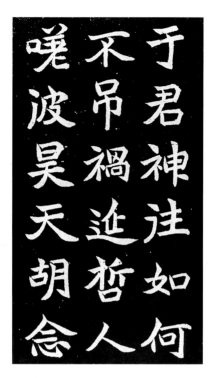

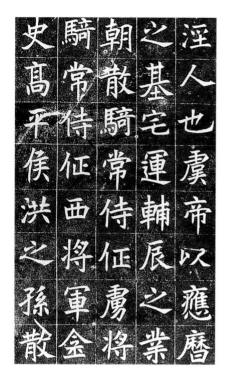

Figure 2a-c. Examples of Wei stele inscriptions.
a. Anonymous, *Buddhist Votive Stele Dedicated by Sun Ch'iu-sheng* (*Sun Ch'iu-sheng tsao-hsiang chi;* detail), stele dated 502, ink rubbing on paper mounted as album leaves, 26.3 x 13.8 cm. Shodō Hakubutsukan. From *Shoseki meihin sōkan* (Tokyo: Nigensha, 1958–81), 5, no. 55.

b. Anonymous, *Epitaph for Ho Po-ch'ao* (detail), stele dated 513, ink rubbing on paper mounted as album leaves, 26.5 x 14.3 cm. Collection unknown. From *Wei-pei ta-kuan* (Ho-fei: Huang-shan shu-she, 1989), 382.

c. Anonymous, *Epitaph for Emperor Su-tsung's Lady of Bright Deportment Hu Ming-hsiang* (detail), stele dated 527, ink rubbing on paper, 64 x 67 cm. Jinbun Kagaku Kenkyū sho, Kyoto Daigaku. From *Shodō zenshū,* n.s. (Tokyo: Heibonsha, 1966), 6: 71.

ments" (*pu-hsiu*) that will outlive the individual. The definition of such achievements appears in the Lu state minister Shu-sun Pao's reply to the Chin state minister Shih-kai when the latter asked him the meaning of "imperishable achievements" during his visit to Chin in 548 B.C.: "The words of the late minister Tsang Wen-chung of the state of Lu have remained after he died. Isn't that what the imperishable means? I have heard that the most superior is the establishment of virtue; next to it is the establishment of deeds; and the next is the establishment of words. These establishments will last forever, and are therefore called the imperishable."[31] The "three imperishable achievements" of virtue, deeds, and words were the ultimate goals of Confucian scholars, including Chao Meng-fu. Chao knew, however, that he was unable to "establish virtue" because many saw his acceptance of the Yüan official post as a permanent blemish on his moral record. Nor did time and circumstance allow him to establish any deeds in spite of his efforts in political life. In his later years, when he was interested in neither political prominence nor pursuit of wealth, he came to see that his best hope for leaving behind an imperishable achievement lay in his artistic accomplishments. He stated his view in a poem that he wrote to a friend:

What are fame and deeds?
Who cares about riches and wealth?

Figure 3. Brush movement in a square brushstroke.

Figure 4. Brush movement in a round brushstroke.

Words, and words only,
Can remain after a hundred years.
As spring water rises in the Cha River,
I will soon embark on my trip home.
At leisure I'll read T'ao Ch'ien's poems,
And write calligraphy in the style of Wang Hsi-chih.[32]

The "words" (*wen-tzu*) in the third line should be understood to refer both to the composition of literature and to the writing of calligraphy and, in a broad sense, to all of Chao's artistic pursuits. In fact, he goes on to mention both poetry and calligraphy in the following lines. He was confident that his achievement in art would endure. This was a revelation of his later years, when he pursued painting and calligraphy with more dedication and vigor than ever before. His practice of these arts was not just a source of private solace or pleasure, but a means through which to distinguish himself in his own time and to gain lasting fame in centuries to come.

The idea of leaving behind enduring monuments is particularly relevant to Chao's calligraphy in the large-character standard script (*k'ai-shu*) of his later years, which he used for numerous stele inscriptions. Inscribing texts on stone had been common since the third century B.C. As is stated in most inscriptions, the purpose of a stele is to record important events, to commemorate the deeds and virtues of outstanding individuals, or to assess the life of the deceased in the imperishable medium of stone that lasts "for hundreds and thousands of years."[33] But a stele is also a monument that preserves the achievements of the author of the inscription and of the calligrapher whose handwriting is recorded on the stone. The many stelae that Chao Meng-fu saw during his extensive travels must have made him fully aware of the permanence that these monuments conferred on the names of calligraphers.[34] In his early study of calligraphy, Chao had hoped to capture the spirit of ancient masters and to save this art from a decline that he believed resulted from the loss of ancient methods. In his later years the practice of calligraphy, especially the writing of stele inscriptions, acquired new significance for him. Chao now saw calligraphy as an ideal means through which to leave behind imperishable achievements that had been denied him in his political career. The challenge he faced was to find an appropriate calligraphic style for these monuments.

Chao Meng-fu's Calligraphy of Stele Inscriptions in Standard Script

In the early Yüan dynasty, the individualistic styles of Su Shih, Huang T'ing-chien (1045–1105), and Mi Fu (1052–1107; cat. no. 7), which had dominated Sung calligraphy, remained influential. These masters excelled in running script (*hsing-shu*), which stressed personal innovation and spontaneity. As calligraphers attracted by the boldness of the Sung masters closely followed their styles, the strict, formal standard script of the T'ang calligraphers suffered neglect and declined as a model for study. Many early Yüan scholars criticized this trend toward extremes of self-expression in calligraphy. Yü Chi, for example, commented that "since P'o [Su Shih] and Ku [Huang T'ing-chien] arose, [the entire world] has followed them like grass yielding to the wind, and the methods of the Wei and Chin were completely lost."[35] He was particularly critical of Mi Fu and Chang Chi-chih (1186–1266; cat. no. 10), denouncing their calligraphy as "strange and grotesque" and calling them "a foul influence" that prevailed throughout the country.[36] Chao Meng-fu deeply felt that "the ancient methods had long been lost."[37] Assuming the responsibility to revive the art of calligraphy, he proposed to recover the method of ancient masters[38] and reestablish the standard. The climax of his efforts came in the stele inscriptions from the final two decades of his life.

While historical documents record numerous works by Chao in large-character standard script, only a few have survived to the present day in manuscripts or through rubbings. The major ones include *Record of the Restoration of the San-ch'ing Hall of the Hsüan-miao Priory (Hsüan-miao-kuan ch'ung-hsiu San-ch'ing-tien chi)*, 1302; *Record of the Restoration of the Three Gates of the Hsüan-miao Priory (Hsüan-miao-kuan ch'ung-hsiu san-men chi)*, 1303; *Record of the Miao-yen Monastery (Hu-chou Miao-yen-ssu chi)*, 1309–10 (cat. no. 11); *Stele for the Imperial Preceptor Tan-pa (Ti-shih Tan-pa pei)*, 1316; *Epitaph for Ch'iu O (Ch'iu O mu-chih)*, 1319; and *Record of the Fu-shen Priory at Hangchow (Hang-chou Fu-shen-kuan chi)*, 1319. These works, whose dates extend over some twenty years of Chao's life, fall into three periods, each representing a distinctive stage in the development of his calligraphy. The first period includes the two restoration records of the Hsüan-miao Priory; the second, the record of the Miao-yen Monastery; and the third, the

stele for the imperial preceptor, the epitaph for Ch'iu
O, and the record of the Fu-shen Priory. Since works in
the same period share similar characteristics, this dis-
cussion will concentrate on one work from each.

*Record of the Restoration of the Three Gates of the
Hsüan-miao Priory,* most probably written in 1303, is
one of the earliest of Chao's extant stele inscriptions.[39]
A famous Taoist place of worship in Soochow, the
Hsüan-miao Priory was built in the Sung dynasty and
originally named the T'ien-ch'ing Priory (*T'ien-ch'ing-
kuan*). In 1288 it was renamed the Hsüan-miao Priory
by imperial decree. Severely damaged over the years,
the main buildings were close to collapse by the end
of the thirteenth century. The abbot Yen Huan-wen
managed to raise funds to have the main hall and front
gate restored in 1289 and 1292. To record these impor-
tant events and to acknowledge the generosity of
the patrons, he asked Mou Yen, a famous writer and
a friend of Chao Meng-fu, to write an essay, and he
asked Chao to transcribe it for the stele. Commission-
ing a celebrated writer and calligrapher to produce a
stele was a common practice because the fame of the
persons involved not only would add commemorative
value to the stele, but also would promote the fame
of the institution where it was erected.

Representative of Chao's early style in large-charac-
ter standard script, *Restoration of the Three Gates* dis-
plays broad, modestly modulated square brushwork,
and a somewhat squat character composition (fig. 1).
Evidently this work is not modeled after Wang Hsi-
chih's calligraphy, which Chao had practiced since his
early years. Nor is it in the style of Chung Yu (151–230),
a key figure in the transformation of clerical into stan-
dard script, whom Chao followed in his early study of
standard script.[40] Although the squat shapes and some-
what naive look of some characters recall works attrib-
uted to Chung Yu, these were all in small-character
standard script and could not have provided a model
for Chao's brush technique in large-scale writing. The
primary model for *Restoration of the Three Gates* was in
fact the stele inscriptions of the Northern Wei dynasty.

Critics over the ages have been almost obsessed
with Chao Meng-fu's place in the Wang Hsi-chih tra-
dition. As a result, they have tended to overlook his
debt to the anonymous calligraphers of the Wei stelae,
whose style, usually called "Wei stele script" or "style"
(*Wei pei*), developed in north China during the fifth
and sixth centuries (figs. 2a–c). Standard script was still

relatively new at this time and did not attain its fully
mature form until the T'ang dynasty; the Wei stele
style reflects this transitional stage. While the modu-
lated brushwork and character composition of Wei
stelae presage those of the later standard script, they
retain many characteristics of Han dynasty clerical
script (*li-shu*), including the "square brushstroke"
(*fang-pi*) and squat character composition. The
"square brushstroke" and its counterpart, the "round
brushstroke" (*yüan-pi*), are two fundamental types of
brush technique. In writing a square brushstroke, a
calligrapher begins with an exposed brush tip and
draws with even and steady pressure, creating a full,
broad line (fig. 3). He executes a round brushstroke by
starting with a concealed brush tip and drawing with
less pressure (fig. 4). As he moves his hand, he keeps
the tip of the brush along the central axis of the stroke,
thus producing a relatively lean and unmodulated line.
Seal script (*chuan-shu*) is written with round brush-
strokes, while clerical script is written mostly with
square brushstrokes. Wei stele script is written with a
combination of both types of brushwork, though the
majority of characters tend to display more square
brushstrokes than in mature standard script.

The calligraphy of the Wei stelae was written by
various calligraphers who were not copying or imi-
tating established masters. Their calligraphy may be
unsophisticated, naive, and even a bit awkward at
times, but it is natural, spontaneous, expressive, and,
above all, original. Written mainly by anonymous cal-
ligraphers, these stelae were largely ignored in the
following three centuries. It was not until the Sung
dynasty that growing interest in antiquities led to the
collection and study of the stelae along with ancient
bronzes. This in turn developed into a new discipline
known as epigraphical studies (*chin-shih hsüeh*). Many
renowned Sung scholars became enthusiastic students
of stelae.[41] As they conducted historiographical and
philological research on the texts, they came also to
see the beauty of the calligraphy. Ou-yang Hsiu (1007–
1072) was probably the first scholar to appreciate the
calligraphy of Wei stelae. In his *Record of the Collection
of Antiquities (Chi-ku lu)*, he wrote, "The characters and
brushwork [of the Wei stelae] are often well made,
beautiful, dynamic . . . and retain ancient methods."[42]
By the end of the Sung dynasty, thousands of stelae
and epitaphs had been documented and numerous
rubbings made from them.[43] Efforts were even made

Figure 5a. The characters *yü* and *ch'ao,* from Chao Meng-fu, *Record of the Restoration of the Three Gates of the Hsüan-miao Priory.*

Figure 5b. The character *chih,* from Anonymous, *Epitaph for Ho Po-ch'ao;* the character *ming,* from Anonymous, *Epitaph for Emperor Su-tsung's Lady of Bright Deportment Hu Ming-hsiang.*

to replicate famous stelae that were either damaged or located in remote areas. The ensuing mass production of rubbings made the stelae easily accessible, thus facilitating the study of ancient models and further promoting interest in this calligraphic style.

As a learned scholar, an ardent student of antiquity, and an enthusiastic pioneer of seal carving, Chao Meng-fu was not only well informed about the calligraphy of ancient stelae, but also collected stele rubbings.[44] His years of service in the north, particularly in the Shantung area, where many Wei stelae still survived during the Yüan, also exposed him to these ancient models. Although Chao closely followed the Wang Hsi-chih tradition, he was not impervious to other ancient models and sources of inspiration. In a colophon recorded by the Ming scholar Chan Ching-feng in *Records of the Spectacles Seen by Chan Ching-feng* (*Chan-shih hsüan-lan pien*), Chao acknowledged his debt to the Wei stelae:

> Chao Meng-fu's *Thousand Character Essay* in running script bears a colophon by Hsien-yü, registrar in the Court of Imperial Sacrifices [Hsien-yü Shu], which says, "[This] follows Shen Fu's style." Next to it is Sung-hsüeh's [Chao Meng-fu] own colophon, which says, "Shen Fu, a native of Wu-hsing, served the Wei dynasty. He wrote the calligraphy of *Stele of Receiving the Mandate* [Shou-shan pei]. His brush method is ancient and elegant; people generally do not recognize

Figure 6a. The characters *chung, yen,* and *jen,* from Chao Meng-fu, *Record of the Restoration of the Three Gates of the Hsüan-miao Priory.*

Figure 6b. The character *an,* from Anonymous, *Epitaph for Emperor Su-tsung's Lady of Bright Deportment Hu Ming-hsiang;* the characters *ho* and *ch'en,* from Anonymous, *Epitaph for Ho Po-ch'ao.*

this, but His Excellence the registrar in the Court of Imperial Sacrifices does. I am happy about this and therefore write [this colophon] myself."[45]

In another colophon Chao also observed that the masters of the Northern and Southern Dynasties retained ancient methods in character composition.[46]

Works by Shen Fu (fl. 500–515) are no longer extant, but examples of contemporaneous calligraphy suggest what his style was like.[47] Comparing Chao's calligraphy with examples of Wei stele inscriptions, it is apparent that he derived his squat character composition and broad square brushwork from stelae such as *Epitaph for Ho Po-ch'ao* (*Ho Po-ch'ao mu-chih;* 513; fig. 2b) and *Epitaph for Emperor Su-tsung's Lady of Bright Deportment Hu Ming-hsiang* (*Su-tsung Chao-i Hu Ming-hsiang mu-chih;* 527; fig. 2c).[48] In characters made up of two elements, such as *yü* and *ch'ao,* Chao gave each element a fairly equal space and aligned the two on a level axis (fig. 5a). With characters that would otherwise appear to be tall, such as *chung, yen,* and *jen,* Chao brought down their heights by shortening the vertical elements, elongating one of the horizontal strokes, or stretching the left and right diagonals (fig. 6a). Examples of similar structures can be found in the two epitaphs, in the characters *chih* and *ming* (fig. 5b) and *ho, an,* and *ch'en* (fig. 6b). Such compositions not only enabled him to produce a balanced and stable structure but also helped him to achieve visual consistency in the entire text.

Chao also drew inspiration from the brushwork of Wei stelae. In writing the "shoulders" of the character *er,* he did not follow the model of late T'ang masters who pulled up the brush and then pressed down to produce an angular and weighty form; instead he employed the method seen in the Wei stelae by slowly and gently twisting the brush along the bend of the "shoulder" (figs. 7a, b). He thus created a round shoulder that extends into a bulging vertical stroke. This brushwork recalls the techniques used in seal script. In writing the hook in the character *nei* (fig. 8a), Chao applied the same technique as in the Wei stelae (fig. 8b) that still retained characteristics of clerical script. At the end of the vertical stroke, he did not pause to retract the tip of the brush as in the Yen Chen-ch'ing (709–785) style; instead, he slightly twisted the brush, pushed it toward the left and then finished with a gently tapered point. For Chao Meng-fu, these techniques were not just a superficial imitation of earlier

Figure 7a. The character *erh,* from Chao Meng-fu, *Record of the Restoration of the Three Gates of the Hsüan-miao Priory.*

Figure 7b. The character *erh,* from Cheng Tao-chao (d. 515), *Stele for Cheng Hsi* (*Cheng Hsi hsia-pei;* detail), stele dated 511, ink rubbing on paper mounted as album leaves, 26.9 x 13.5 cm.

Figure 8a. The character *nei,* from Chao Meng-fu, *Record of the Restoration of the Three Gates of the Hsüan-miao Priory.*

Figure 8b. The character *k'ao,* from Anonymous, *Epitaph for Ho Po-ch'ao.*

models, but a conscious effort to recover "ancient methods" (*ku-fa*).

Restoration of the Three Gates also reflects the influence of Ch'u Sui-liang (596–658) and Yen Chen-ch'ing, whose work Chao studied in his early practice of large-character standard script, though the traces of their influence are subtle and less obvious. The hook in the character *huo,* for example, definitely follows the model of Yen Chen-ch'ing (fig. 9). So do the broad and powerful right diagonal lines with a flared ending (fig. 10). Although the overall appearance of the calligraphy in *Restoration of the Three Gates* is remarkably different from that of Yen Chen-ch'ing, its brushwork and character compositions display the same robust and monumental quality. As the Ming art critic Li Jih-hua (1565–1635) perceptively noted, "It has P'ing-yüan's [Yen Chen-ch'ing's] spirit without copying his appearance."[49] Chao's debt to Ch'u Sui-liang in this early work can be seen in the long horizontal stroke of the character *yu* (fig. 11a). While this broad line seems to

Figure 9. The character *huo*, from Chao Meng-fu, *Record of the Restoration of the Three Gates of the Hsüan-miao Priory*.

Figure 10. The character *chih*, from Chao Meng-fu, *Record of the Restoration of the Three Gates of the Hsüan-miao Priory*.

Figure 11a. The character *yu*, from Chao Meng-fu, *Record of the Restoration of the Three Gates of the Hsüan-miao Priory*.

Figure 11b. The character *ting*, from Ch'u Sui-liang (596–658), *Preface to the Sacred Teaching*, stele dated 653, ink rubbing on paper mounted as album leaves, 23.5 x 14.9 cm. Tokyo National Museum. From *Shoseki meihin sōkan*, 7, no. 77.

誠　暎　山　徐　興　妙
一　帶　西　林　郡　嚴　趙
方　清　傍　東　城　寺　孟
朦　流　洪　接　七　本　頫
境　而　澤　爲　十　名　書
也　離　北　戌　里　東　幷
先　絕　臨　南　而　際　篆
是　顚　洪　對　近　距　額
宗　塵　城　涵　曰　吳

Figure 12. Chao Meng-fu, *Record of the Miao-yen Monastery* (cat. no. 11, detail).

resemble that in the Wei stele script, the movement of the brush is closer to that of Ch'u's technique (fig. 11b). Chao began the stroke by pressing the brush with an exposed tip that pointed toward the upper left; then with a slight twist to keep the brush tip in the middle of the stroke, he moved the brush toward the right while keeping a steady pressure against the paper; finally he retracted the brush tip toward the left to conceal it as he finished the stroke. The movement of the brush is more sophisticated than in stele script, giving the stroke a "square head" instead of a "pointed" one. The gently arched shape looks like a fully drawn bow bursting with tension.

Record of the Miao-yen Monastery represents the next stage in the development of Chao's standard script.[50] Compared with those of *Restoration of the Three Gates*, character composition in *Record of the Miao-yen Monastery* is more square and the brushwork exhibits more sophistication in its fully modulated strokes, varied hooks, and diagonals (fig. 12, cat. no. 11). Chao's primary models for this work were Wang Hsi-chih and Yen Chen-ch'ing.[51] Chao also incorporated elements from Ch'u Sui-liang, Li Yung (678–747), and Huang T'ing-chien. By this time Chao had studied Wang Hsi-chih's calligraphy for nearly three decades and internalized all the subtleties of Wang's brushwork. The four characters *ying-tai ch'ing-liu* in *Record of the Miao-yen Monastery* recall stroke for stroke those in Wang's *Preface to the Orchid Pavilion Collection* (figs. 13a, b).[52] Although these characters in the two texts appear to be almost identical, the writing techniques are quite different. *Orchid Pavilion* is in small-character running script, in which the calligrapher writes each character by moving his fingers. The large-character script, on the other hand, is written by moving the arm with a locked wrist. In order to reproduce these characters in large script without sacrificing their elegance, Chao Meng-fu had to develop a new set of brush techniques. In other words, he had to transform finger movements into arm movements.

To achieve this end, Chao turned to the brush techniques of Yen Chen-ch'ing and other T'ang masters. We may also use the characters *ying-tai ch'ing-liu* discussed above to illustrate this point. In *Orchid Pavilion,* the two dots in the character *ying* are written with comparatively swift movements of the tip of the brush, whereas in *Record of the Miao-yen Monastery,* Chao wrote the left dot by first pressing the brush with an

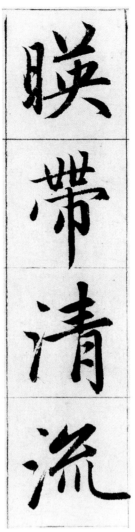

Figure 13a. The phrase *ying-tai ch'ing-liu,* from Chao Meng-fu, *Record of the Miao-yen Monastery.*

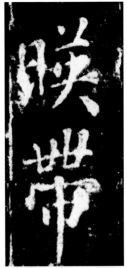
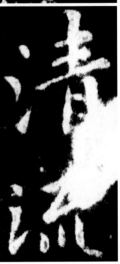

Figure 13b. The characters *ying, tai, ch'ing,* and *liu,* from Wang Hsi-chih (attributed), *Preface to the Orchid Pavilion Collection,* original dated to 353, copy ca. 11th century, ink rubbing on paper, 26.0 x 60.5 cm. Collection unknown. From *Shodō geijutsu,* 1: 42.

exposed tip, then moving slightly downward before retracting the tip into the center of the dot, and finally lifting off toward the right. Continuing the momentum from the lift-off, Chao landed the brush on the right with the tip pointing toward upper left and then, gradually reducing the pressure, drew a tapered diagonal. The juxtaposition of the two strokes gives us an exhilarating feel of the momentum that "catapulted" the brush from left to right. In the character *liu* (fig. 14a), Chao wrote the upper element in lively and angular folds by using the brushwork that he derived from Li Yung (fig. 14b). In fact, the influence of Li Yung was

Figure 14a. The character *liu,* from Chao Meng-fu, *Record of the Miao-yen Monastery.*

Figure 14b. The character *wei,* which has the same upper element as Chao Meng-fu's character *liu,* from Li Yung (678–747), *Stele for Fa-hua Monastery,* stele dated 735, ink rubbing on paper, height 24.8 cm. Collection unknown. From *Shodō geijutsu,* 5: 24.

Figure 15a. The character *ch'eng,* from Chao Meng-fu, *Record of the Restoration of the Three Gates of the Hsüan-miao Priory.*

Figure 15b. The character *ch'eng,* from Li Yung, *Stele for Lu-shan Monastery (Lu-shan ssu pei;* detail), stele dated 730, ink rubbing on paper mounted as album leaves, 27.2 x 13.4 cm. ShodōHakubutsukan, Tokyo. From *Shodō geijutsu,* 5: 2.

already present in *Restoration of the Three Gates,* as can be seen in the character *ch'eng,* but at that point in Chao's career Li Yung's style was not yet an important source (figs. 15a, b). When Chao wrote *Record of the Miao-yen Monastery,* he began to draw increasingly from Li Yung's calligraphy. Chao's borrowing of slanting strokes, angular folds, and tilted characters from Li Yung's running script lent speed and momentum to his calligraphy and also enriched the variety of his brushwork. Moreover, the occasional use of running-script characters, rarely seen in stele inscriptions from the T'ang dynasty on, brought a brisk and lively rhythm to the otherwise grave-faced standard script. However, the influence of the Wei stelae is not absent from *Record of the Miao-yen Monastery,* though it is subtle and integrated with that of the T'ang masters. The uniformly broad strokes, gently bent hooks, and square brushwork all remind us of Chao's study of works by the anonymous Wei calligraphers.

Epitaph for Ch'iu O, dated to 1319, was among Chao's final works in large-character standard script. Ch'iu O was vice-surveillance commissioner of Min-hai Circuit, Fukien. He died in 1311 at Kao-yu, in what is now Kiangsu, where he lived after retirement from his post. In 1319 his sons brought his ashes back to Ta-tu for reburial. Since Chao had been a friend of Ch'iu's and was the most celebrated calligrapher of the day, it was only natural for the Ch'iu family to request his essay and calligraphy for the tomb stele.[53] In late April of the same year, Chao left Ta-tu for his hometown of Wu-hsing, never to return to the north. He therefore

probably wrote the calligraphy for the epitaph shortly before his departure.

Then sixty-five years old, Chao was at the peak of his powers as a calligrapher when he wrote *Epitaph for Ch'iu O.* Since the time of his boat trip down the Grand Canal in 1310, when he happily acquired and diligently studied an eleventh-century rubbing of *Preface to the Orchid Pavilion Collection* that was deemed to be the most faithful reproduction of the day, Chao had continued to reinforce and refine his mastery of Wang Hsi-chih's style. Meanwhile, his years in the north expanded his knowledge of ancient monuments. With decades of dedicated study and practice, he was now able to combine the excellence of the leading masters in the Wang Hsi-chih lineage and the merits of the anonymous calligraphers of the Wei stelae into a harmonious synthesis in his mature personal style (fig. 16). In each cohesively structured character, his brushwork is dynamic, spontaneous, and monumental. Instead of relying solely on the square brushwork of the Wei stelae, Chao used more combinations of round and square brushwork, thus giving the characters a strongly three-dimensional appearance, creating the illusion that they are not shapes on a flat piece of paper but solid configurations in an imaginary space. While the slightly squat shapes of the characters and the broad robust brushwork remind us of the Wei stele style, the variety of character compositions and the diversity of the brushwork show extraordinary complexity and sophistication. The seemingly simple character *san* is a good example (figs. 17a, b). In *Restoration*

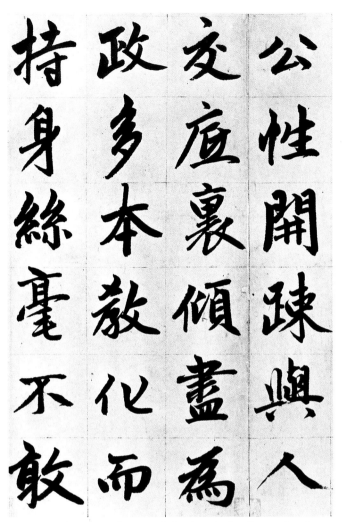

Figure 16. Chao Meng-fu, *Epitaph for Ch'iu O* (detail), 1319, hand-scroll, ink on paper, height 37.2 cm. Yōmyō Bunko, Kyoto. From *Shodō geijutsu*, 7: 76.

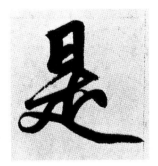

Figure 18. The character *shih*, from Chao Meng-fu, *Epitaph for Ch'iu O*.

and rounder look, and at the same time bending them slightly downward. He then elongated and trimmed the third stroke into a more slender shape. Gently bending it upward, he juxtaposed the stroke in tension against the other two.

In *Epitaph,* Chao's strong attraction to the style of Li Yung is apparent in the characters, which tilt upward to the right, creating a lively rhythm and dynamic look. Reading down the columns, we feel the energy flow from one character into another until the very end of the text. The continuous momentum of Chao's brush can be clearly seen in the thin, fluid, interconnected lines that link the individual strokes in the character *shih* (fig. 18). In characters with multiple horizontal strokes, Chao varied the shapes of each and placed them at slightly different angles to increase the structural complexity (fig. 19). In the character *kan,* he deliberately increased the tilt of the long diagonal stroke to build up tension and then balanced this with a bulging vertical stroke (fig. 20). While concentrating on Li Yung's method, Chao also introduced elements of other master calligraphers. In the character *ho,* for example, he used a structure based on the calligraphy of Li Yung, but to increase the tension in the character, he lengthened the right vertical stroke and pushed the

of the Three Gates, Chao wrote the three horizontal lines as almost identical shapes, though he varied their lengths to increase the visual complexity of the character. In contrast, he shaped each line differently in *Epitaph for Ch'iu O,* giving the first two lines a thick

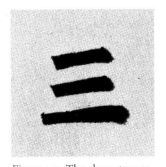

Figure 17a. The character *san,* from Chao Meng-fu, *Record of the Restoration of the Three Gates of the Hsüan-miao Priory.*

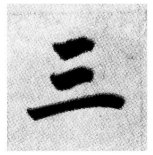

Figure 17b. The character *san,* from Chao Meng-fu, *Epitaph for Ch'iu O.*

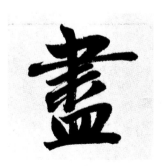

Figure 19. The characters *chin* and *pai,* from Chao Meng-fu, *Epitaph for Ch'iu O.*

Figure 20. The character *kan,* from Chao Meng-fu, *Epitaph for Ch'iu O.*

a.

b.

c.

Figures 21a–c. The character *ho.* a. From Chao Meng-fu, *Epitaph for Ch'iu O.* b. From Li Yung, *Stele of Lu-shan Monastery.* c. From Mi Fu (1052–1107), *Nine Letters,* ca. 11th century, handscroll, ink on paper, 23.5 x 36.8 cm. National Palace Museum, Taipei, Taiwan, Republic of China. From *Ku-kung li-tai fa-shu ch'üan-chi* (Taipei: National Palace Museum, 1977), 2: 156.

Figure 22a. The characters *hsia* and *kuo,* from Chao Meng-fu, *Epitaph for Ch'iu O.*

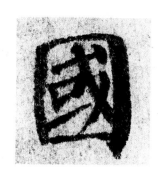

Figure 22b. The character *hsia,* from Ch'u Sui-liang, *Preface to the Sacred Teaching; from Shoseki meihin sōkan,* 7, no. 77. The character *kuo,* from Yen Chen-ch'ing, *Certificate of Appointment (Kao-shen t'ieh;* detail), 780, ink on paper, 30.0 x 220.8 cm. Shodō Hakubutsukan, Tokyo; from *Shodō zenshū,* n.s., 10: 61.

mouth radical to a position directly under the horizontal stroke, which is typical of the character structure in Mi Fu's calligraphy (figs. 21a–c).

Epitaph for Ch'iu O well demonstrates Chao's extensive study of the early masters and his excellent command of various brush techniques. While we detect the influence of earlier models in this work, we see in each one of the characters Chao's ingenious transformation of his sources. For Chao, the mastery of the ancient models lay not in faithful reproduction but in internalizing the models and producing his own interpretation. Although all of the T'ang calligraphers that he followed derived from Wang Hsi-chih, each had his own characteristics. Copying them would only have produced a stylistic hodgepodge. To avoid this Chao

devised his own formula to create a consistent and harmonious script. While retaining the general structure of the original model, he painstakingly adjusted the proportions and dimensions of each character to approach a square shape and a uniform size. Examples can be seen in the characters that Chao adapted from Yen Chen-ch'ing and Ch'u Sui-liang's works (figs. 22a, b). As Chao wrote, a "perfect and beautiful character is a round and smooth one that is lean without baring its tendon and plump without hiding its bone."[54] *Epitaph for Ch'iu O* well exhibits Chao's effort to achieve his ideal form. He trimmed Yen Chen-ch'ing's thick and heavy brushwork and reduced Yen's dramatic contrast between vertical and horizontal strokes to add a touch of grace.[55] To the lean strokes of Ch'u Sui-liang

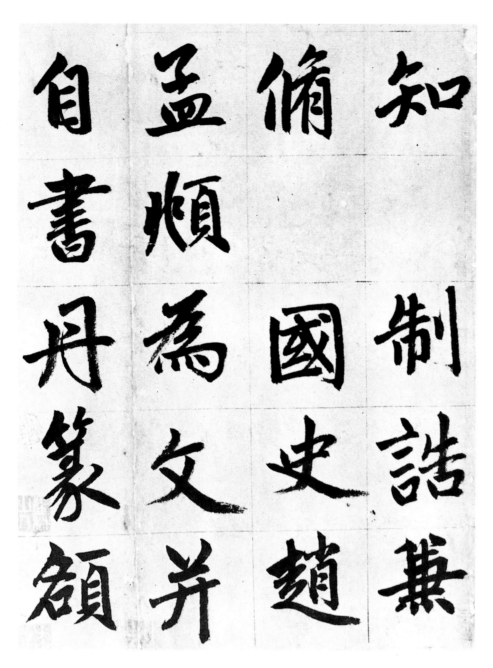

Figure 23. Chao Meng-fu, *Epitaph for Ch'iu O* (detail).

and Li Yung, he added "muscles" to give more weight and substance.

For Chao Meng-fu, writing the calligraphy for stelae was not only a way to honor institutions and individuals but also a way by which to establish monuments for himself and his art. Chao's pride in his achievement echoes in his statement in *Epitaph for Ch'iu O* that he "personally executed the calligraphy and wrote in seal script the heading of the stele" (fig. 23). He was justly confident that his calligraphy would, together with the imperishable stone, go down in history and "last forever with heaven and earth."[56]

NOTES

I would like to thank the Department of Art and Archaeology, Princeton University, for the grant from the Spears Fund that supported my research and made my visit to overseas collections possible, and also to thank Robert Bagley and Robert Harrist for their invaluable comments and suggestions.

1. Sung Lien et al., *Yüan-shih* (Peking: Chung-hua shu-chü, 1976), *chüan* 172: 4023.

2. Translation of official titles follows Charles Hucker, *Dictionary of Official Titles in Imperial China* (Stanford: Stanford University Press, 1985).

3. *Ta Yüan sheng-cheng kuo-ch'ao tien-chang,* preface dated 1303, facsimile reprint of 1908 ed. (Taipei: Wen-hai ch'u-pan-she, 1964), *chüan* 8: 3a–3b.

4. Yü Chi, "Wang Chih-chou mu-chih-ming," in *Tao-yüan hsüeh-ku lu* (Ssu-pu ts'ung-k'an ed., Shanghai: Shang-wu yin-shu kuan, 1946), *chüan* 19: 1a; Su T'ien-hsi, "Li Wen-chien kung shen-tao-pei," in *Tzu-hsi wen-kao,* preface dated 1351, facsimile reprint (Taipei: Kuo-li chung-yang t'u-shu-kuan, 1970), *chüan* 10: 9a.

5. Yang Tsai, "Ta Yüan ku Han-lin hsüeh-shih ch'eng-chih jung-lu ta-fu chih-chih-kao chien-hsiu kuo-shih Chao-kung hsing-chuang," in Chao Meng-fu, *Sung-hsüeh-chai wen-chi,* preface dated 1339, facsimile reprint (Taipei: Hsüeh-sheng shu-chü, 1970), appendix, 503. On the contents and editions of *Sung-hsüeh-chai wen-chi,* see Sun K'o-kuan, "Sung-hsüeh-chai wen-chi," in *Yüan-tai Han wen-hua chih huo-tung* (Taipei: Chung-hua shu-chü, 1984.), 120–32.

6. Ibid., appendix, 504.

7. Ibid., appendix, 505.

8. Ibid.

9. "Ch'ih-wen," in Chao Meng-fu, *Sung-hsüeh-chai wen-chi,* 2–3.

10. Wang Shih-tien and Shang Ch'i-weng, *Pi-shu-chien chih,* preface dated 1342, reprint (Hangchow: Che-chiang ku-chi ch'u-pan-she, 1992), 97, 104.

11. Yang Tsai, "Ta Yüan ku Han-lin hsüeh-shih," 496.

12. Chao Meng-fu, "Tsui ch'u," in his *Sung-hsüeh-chai wen-chi, chüan* 2: 89–90.

13. "Ku-feng shih shou," in Chao Meng-fu, *Sung-hsüeh-chai wen-chi, chüan* 2: 69.

14. Shou-chien Shih, "The Mind Landscape of Hsieh Yu-yü by Chao Meng-fu," in Wen C. Fong et al., *Images of the Mind: Selections from the Edward L. Elliott Family and John B. Elliott Collections of Chinese Calligraphy and Painting at The Art Museum, Princeton University* (Princeton: The Art Museum, Princeton University, 1984), 238.

15. Chao Meng-fu, "Yung i-min," in his *Sung-hsüeh-chai wen-chi, chüan* 2: 75.

16. Chao Meng-fu, "Ch'u-chih tu-hsia chi-shih," in his *Sung-hsüeh-chai wen-chi, chüan* 5: 208.

17. On *ch'ao-yin,* see Shou-chien Shih, "The Mind Landscape of Hsieh Yu-yü by Chao Meng-fu," 238. See also Frederick W. Mote, "Confucian Eremetism in the Yüan Period," in Arthur Wright, ed., *Confucian Persuasion* (Stanford: Stanford University Press, 1960), 202–40.

18. Chao Meng-fu, "I-chai shuo," in his *Sung-hsüeh-chai wen-chi, chüan* 6: 236.

19. *Ku-kung shu-hua lu* (1956; 2d ed., Taipei: National Palace Museum, 1965), 1: 245. The translation is adapted from Shou-chien Shih's version in his "The Mind Landscape of Hsieh Yu-yü by Chao Meng-fu," 238–39.

20. Shan Kuo-ch'iang, "Chao Meng-fu hsin-cha hsi-nien ch'u-pien," in *Chao Meng-fu yen-chiu lun-wen chi* (Shanghai: Shang-hai shu-hua ch'u-pan-she, 1995), 549.

21. Neither Chao Meng-fu nor Chung-feng Ming-pen recorded when they first met. In his "Record of the Huan-chu Temple at Ku-su" (*Ku-su Huan-chu-an chi*) Sung Lien wrote that when Ming-pen settled in Soochow in 1300, Chao Meng-fu inscribed his door board, thus dating their acquaintance to no later than 1300 (Sung Lien, *Sung wen-hsien kung ch'üan-chi,* facsimile reprint of 1810 ed. [Taipei: Chung-hua shu-chü, 1965], *chüan* 29: 5b).

22. Yü Chi, "Chih-chüeh ch'an-shih ta-ming," in *Tao yüan hsüeh-ku lu, chüan* 48: 6a.

23. It should be noted, however, that the relationship between Chao and Ming-pen was not just that of master and disciple but also of friends. Chao Meng-fu himself was well versed in Buddhist scholarship, while Ming-pen was interested in art and admired Chao's artistic talents. There are many examples of friendship in their exchange of letters, poems, and gifts. For more discussion, see Jen Tao-pin, *Chao Meng-fu hsi-nien* (Cheng-chou: Ho-nan jen-min ch'u-pan-she, 1984); and Shan Kuo-chiang, "Chao Meng-fu hsin-cha hsi-nien ch'u-pien," 544–90.

24. Chao Meng-fu, letter to Chung-feng Ming-pen, ca. 1313, *Shodō geijutsu* (Tokyo: Chūōkōron-sha, 1972), 7: 207–8, letter 1.

25. For a brief introduction to the doctrine and practice of Ch'an Buddhism, see Kenneth Ch'en, *Buddhism in China* (Princeton: Princeton University Press, 1964), 350–64; and Heinrich Dumoulin, *Zen Enlightenment: Origin and Meaning,* trans. John C. Maraldo (New York: Weatherhill, 1979). For more discussion on the history and development of Ch'an Buddhism in China, see also Heinrich Dumoulin, *Zen Buddhism: A History,* trans. James W. Heisig and Paul Knitter (New York: Macmillan Publishing Company, 1988). On association and exchanges between scholar-officials and Ch'an monks, see Ko Chao-kuang, *Ch'an-tsung yü Chung-kuo wen-hua* (Shanghai: Jen-min ch'u-pan-she, 1986).

26. Chao once tried to defend his position in a poem on a painting of T'ao Yüan-ming's (T'ao Ch'ien, 365–407) return to his recluse home. He suggested that choosing between service and withdrawal was a matter in which one must make his own decision, according to his own time. See Mote, "Confucian Eremetism in the Yüan Period," 236–37.

27. Chao Meng-fu, letter to Chung-feng Ming-pen, ca. 1309, *Shodō geijutsu,* 7: 208, letter 3.

28. See Chao Meng-fu's descriptions of his misery and misfortune as illusions in his correspondence with Ming-pen, ca. 1313, *Shodō geijutsu,* 7: 208, letter 2.

29. Chao Meng-fu, letter to Chung-feng Ming-pen, ca. 1313, *Shodō geijutsu,* 7: 209, letter 6.

30. Chao Meng-fu, "Tzu-ching," in his *Sung-hsüeh-chai wen-chi, chüan* 5: 225.

31. *Tso-chuan,* "Hsiang-kung," year 24, in *Tso-chuan chu-shu* (Taipei: Chung-hua shu-chü, 1965), *chüan* 35: 11b–13a.

32. Chao Meng-fu, "Ch'ou T'eng Yeh-yün," in his *Sung-hsüeh-chai wen-chi, chüan* 2: 94–95.

33. "Sung-shan k'ai-mu-miao shih-ch'üeh ming," dated A.D. 113, *Shoseki meihin sōkan* (Tokyo: Nigensha, 1964), vol. 2. On the

function and significance of stelae, see Wu Hung, *Monumentality in Early Chinese Art and Architecture* (Stanford: Stanford University Press, 1995), 222–23.

34. See Chao Meng-fu's description of his visit to an ancient stele at Mount T'ien-kuan, Chekiang. Chao Meng-fu, "Kuei-ku yen," in his *Sung-hsüeh-chai wen-chi, chüan* 5: 203.

35. Yü Chi, "T'i Fu Ming shu-fa ping Li T'ang shan-shui," in *Tao-yüan hsüeh-ku lu, chüan* 11: 12b.

36. Ibid.

37. Chao Meng-fu, "Lun shu," in his *Sung-hsüeh-chai wen-chi, chüan* 5: 192.

38. Chao Meng-fu, "Lan-t'ing shih-san pa," *Shodō geijutsu,* 7: 203.

39. *Record of the Restoration of the Three Gates of the Hsüan-miao Priory* does not bear a date. It is stated in the text, however, that Mou Yen wrote the essay after *Record of the Restoration of the San-ch'ing Hall,* dated 1302, and at the request by Chao Meng-fu's brother Chao Meng-p'an, who died in 1305. In addition, Chao Meng-fu's official title recorded in the text points to the period between 1299 and 1309. Judging from these facts and the calligraphy, Chao probably wrote this work not long after 1302. For a reproduction and more discussion, see *Shodō geijutsu,* 7: pls. 54–65, pp. 195–96; see also Chao Meng-fu, "Wu-hsiung k'uang-chih," in his *Sung-hsüeh-chai wen-chi,* 477–79.

40. Chao Meng-fu, "Hsi-t'ieh yüan-liu," in *Ku-kung li-tai fa-shu ch'üan-chi,* 3: 190.

41. See Hsü Wu-wen, "Kuan-yü Sung-tai shu-fa shih te yen-chiu," in Sun Ch'in-shan et al., eds., *Kuo-chi Sung-tai wen-hua yen-t'ao hui lun-wen chi* (Ch'eng-tu: Ssu-ch'uan ta-hsüeh ch'u-pan-she, 1991), 411–13.

42. Ou-yang Hsiu, *Chi-ku lu pa-wei,* completed ca. 1061, facsimile reprint of 1887 edition (Taipei: Hsin wen-feng ch'u-pan kung-ssu, 1977), *chüan* 4: 16a–18a.

43. The epigraphical studies that flourished throughout the Sung dynasty produced many catalogues of stelae, the major ones including Ou-yang Hsiu's *Chi-ku lu pa-wei,* Ou-yang Fei's *Chi-ku lu mu,* Tseng Kung's *Yüan-feng chih-shih pa-wei,* Chao Ming-ch'eng's *Chin-shih lu,* and Hung K'uo's *Li shih.* See Kuo Ch'i, "Chin pai-nien Sung-tai wen-hua yen-chiu niao-k'an," in Sun et al., eds., *Kuo-chi Sung-tai wen-hua,* 485–86.

44. One of the stele rubbings that Chao Meng-fu collected was that of Ch'in dynasty stone drums. It later entered the T'ien-i-ko library collection and was reproduced in the Ch'ing dynasty. The original was lost in fire. It is now known only through a modern reproduction by the I-yüan Chen-shang-chai of Shanghai. See Kadoi Hiroshi, "Sekikobun Taisan kokuseki," in *Chūgoku hōsho gaido* (Tokyo: Nigensha, 1988), 2: 12–13.

45. Chan Ching-feng, *Chan-shih hsüan-lan pien,* n.d., reprinted in *I-shu shang-chien hsüan-chen* (Taipei: Kuo-li chung-yang t'u-shu-kuan, 1970), 144.

46. Chao made this comment in one of his colophons on the preface. He compared Wang Hsi-chih's calligraphy with that of the Ch'i and Liang calligraphers. Although the Ch'i and Liang

were southern dynasties, the calligraphy was not different from the Northern Wei dynasty's. Stelae and epitaphs from the Southern Dynasties, such as *Stele for Ts'uan Lung-yen, Epitaph for Lü Ch'ao-ching,* and *Eulogy on Burying a Crane,* are sound proof of this phenomenon. For Chao Meng-fu's colophon, see Chao Meng-fu, "Lan-t'ing shih-san pa," 7: 203.

47. In addition to *Stele of Receiving Heavenly Mandate* (*Shou-shan pei*), Shen Fu's only other known work is *Stele of Imperial Hunting* (*Yü-she pei*), which is documented in Cheng Ch'iao's (1104–1160) *T'ung Chih.* It should be cautioned that *Stele of Imperial Hunting* is often confused with a fifth-century Wei stele of the same name. See Chang Yen-sheng, *Shan-pen pei-t'ieh lu* (Peking: Chung-hua shu-chü, 1984), 61; Yang Tsai-ch'un, *Chung-kuo shu-fa kung-chü shou-ts'e* (Peking: Pei-ching t'i-yü hsüeh-yüan, 1987), 223.

48. Chao Meng-fu could not have seen these two epitaphs, which were discovered in the early twentieth century. However, we have reason to believe that he saw similar works, since the Sung scholars recorded in their catalogues many epitaphs and stelae dating from the Northern and Southern Dynasties. For reproduction of the rubbings, see *Shodō zenshū,* n.s. (Tokyo: Heibonsha, 1966), 6: pls. 70–71; and *Wei-pei ta-kuan* (Ho-fei: Huang-shan shu-she, 1989), 369–88.

49. Li Jih-hua, *T'ien-chih-t'ang chi,* preface dated 1637, facsimile reprint (Taipei: Kuo-li chung-yang t'u-shu-kuan, 1971), *chüan* 36: 37b–38a.

50. For reproduction and discussion, see Fong et al., *Images of the Mind,* pls. 285–86, pp. 94–102; Shen C. Y. Fu et al., *Traces of the Brush: Studies in Chinese Calligraphy* (New Haven: Yale University Art Gallery, 1977), 139–40.

51. Fong et al., *Images of the Mind,* 99.

52. Ibid.

53. The content of the epitaph was actually composed not by Chao Meng-fu, but by Liu Kuan on his behalf. See Liu Kuan, *Liu Tai-chih chi,* preface dated 1350, facsimile reprint of 1924 edition (Taipei: I-wen yin-shu-kuan, 1973), *chüan* 10: 2a–4a.

54. Chao Meng-fu, "Pa Wang Hsi-chih Ch'i-yüeh t'ieh," in Wu Sheng, *Ta-kuan lu,* preface dated 1713, 1st ed. (n. p., 1920), *chüan* 1: 17a.

55. Although Chao Meng-fu admired and studied Yen Chen-ch'ing's style, he was aware of its shortcomings. He implied his criticism in his colophon to *Preface to the Orchid Pavilion Collection,* saying, "Recently people have all followed the current practice and preferred to study Yen Chen-ch'ing's style. Yen's style is a great change in calligraphy. People who spend their life learning Yen often cannot digest it and their calligraphy therefore has the defect of being fat and fleshy, which cannot be corrected. This is all because of seeking the name but not substance" (Chao Meng-fu, "Lan-t'ing shih-san pa," 7: 203–4).

56. Chao Meng-fu, "Ch'ih-chien Ta lung-hsing ssu pei-ming feng i-chih chuan," in *Sung-hsüeh-chai wen-chi, chüan* 9: 389.

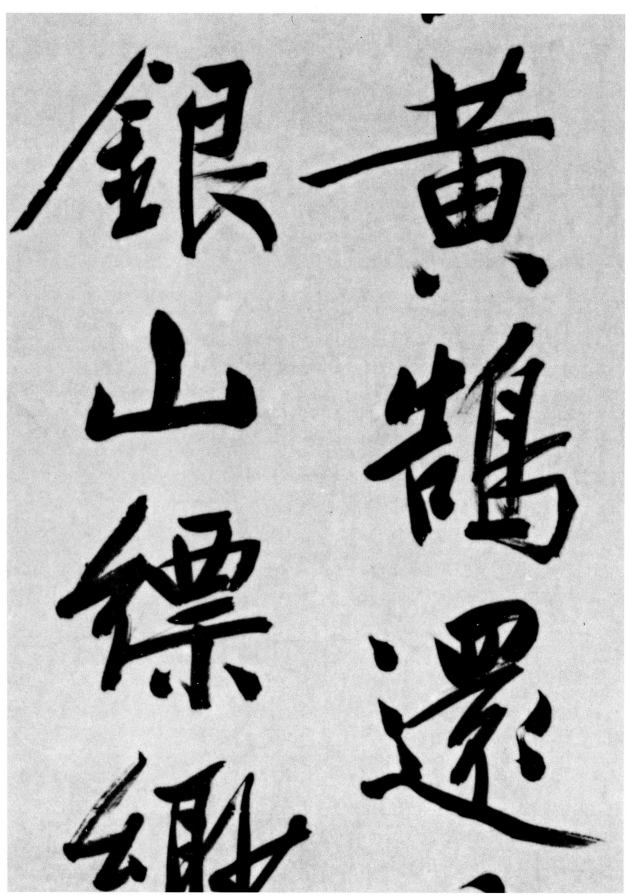

Wen Cheng-ming (1470–1559), *Poem on Lake T'ai-yeh* (cat. no. 27, detail).

Ming Dynasty Soochow and the Golden Age of Literati Culture

CHUAN-HSING HO

During the late fifteenth and sixteenth centuries, the metropolitan region of Soochow was not only one of the most prosperous areas of southern China but also a dominant center for the production of art and literature. Compared to Peking, the imperial capital in the north, Soochow was a relatively liberal center for intellectual activity. In this urban center young scholars could seek out different schools of learning according to their inclinations, while for those seeking success in government office and unable to pursue the ideal of eremitic refinement, the cultural life in Soochow offered an acceptable alternative.[1] In this stimulating environment the Soochow elite visited one another's art collections, toured local scenic spots, and participated in lively debates and artistic exchanges during visits to gardens. In many ways, the scholarly life of Soochow can be considered a microcosm of an idealized literati culture.

Although serving as a government official remained a prestigious goal for educated men, many scholars from Soochow had only brief and often frustrating careers as officials, and preferred to live in retirement, devoting themselves full time to the study and practice of the arts. Not surprisingly, much of the poetry, painting, and calligraphy produced by these men reflected their personal experiences and their interaction with like-minded friends who also participated in the region's rich cultural life.

In the field of painting, Shen Chou (1427–1509) drew inspiration from the individualistic styles of late Yüan literati artists and led the development of painting in Soochow, known as Wu. In the decades after his death, such artists as T'ang Yin (1470–1523), Wen Cheng-ming (1470–1559), Ch'iu Ying (ca. 1494–ca. 1552) and their followers developed a distinct regional style of painting that later became known as the Wu school. Unlike painters working under imperial patronage in Peking,

Nanking, and Hangchow, whose careers were shaped by the demands of their patrons, the Soochow scholar-artists developed modes of painting that expressed their inner thoughts and feelings. Although some depended on painting for their livelihood, their patrons seem to have valued the stylistic independence of these artists.

Soochow in the Ming dynasty was also home to many literary talents. Although they did not become known as a literary school comparable to the Wu school in painting, they nevertheless formed a cohesive group and shared a core of literary ideas. Soochow scholars were able to choose freely from two main currents of Ming literature, Chancellery style (T'ai-ko t'i or Kuan-ko t'i) and archaists (fu-ku p'ai). Versed in ancient styles of poetry and the Confucian classics, they also were keenly interested in novels, collectanea, and Buddhist and Taoist subjects whose disparate influences are often reflected in their poetry, prose, and miscellaneous writings.[2]

The fifteenth and sixteenth centuries also witnessed a florescence of innovative personal styles among Soochow calligraphers. Their innovations contrasted sharply with the practice of calligraphy among scholars recruited for court service in Peking, especially during the late Yüan and the early Ming (ca. 1368–1430). Like their T'ang and Sung predecessors, court calligraphers were obliged to reconcile their personal tastes with the state-sanctioned calligraphic style of Wang Hsi-chih (303–361) prescribed for memorials, official documents, imperial eulogies, and other writings. As practiced by court calligraphers, this ossified tradition came to be known as the Chancellery style and was scorned by later critics.[3] As court patronage of calligraphy waned in the mid-fifteenth century, however, Soochow calligraphers and their individualistic styles rose to prominence.

The relationship between gardens and scholar-officials has a long history in China, and much evidence for it survives in historical records, literature, and painting. Gardens eventually became one of the most important themes in Chinese literati art. In the Ming dynasty, Soochow literati and officials who retired often returned home to private gardens constructed as retreats from the bustle of city life. These became the settings for convivial literary gatherings, in which art in almost every form was created, shared, or appreciated. Since many Soochow literati were skilled in more than one art form, they moved easily among poetry, painting, and calligraphy. Not surprisingly, the gardens themselves often became the subject of (or associated with) their works. Although the Ming gardens of Soochow have long since disappeared, extant art associated with them documents the cultural activities nurtured within their confines.[4]

The Bamboo Residence (*Yu-chu-chü*) owned by Shen Chou was a classic example of a Soochow garden estate and an important monument of contemporary cultural life. From the 1460s to the 1470s this site was Shen Chou's country retreat, serving as the setting for many cultural gatherings. Although it was the subject of poems, essays, and paintings, no physical evidence of the garden remains. Nonetheless, contemporary descriptions present us with a clear picture of Ming garden culture as it was reflected in Shen Chou's

property and in the activities that took place there.[5] Among these descriptions is one written by Hsü Yu-chen (1407–1472), Shen Chou's close friend and a frequent visitor to his Bamboo Residence. In the summer of 1467 Hsü traveled with Liu Chüeh (1410–1472) by boat from Soochow to visit Shen Chou at his estate and to view his art collection. While there, Hsü composed and inscribed a poem on Shen Chou's *Handscroll Painting of the Bamboo Residence (Yu-chu-chü t'u-chüan).*[6] Around this same time, Hsü also inscribed in a free running-cursive script (*hsing-ts'ao*) a handscroll for Shen Chou titled *Song on the Bamboo Residence (Yu-chu-chü ko;* fig. 1).

Hsü Yu-chen was born in the Chi-hsiang district of Soochow but accompanied his family to Peking as a youth. Earning his *chin-shih* degree in 1433, he spent his career as a court official in Peking. Around 1458, following the restoration of Emperor Ying-tsung (r. 1436–49, 1457–64) to the throne, he became Grand Academician of the Hua-kai-tien Hall, which marked the pinnacle of his official career. He soon ran afoul of court politics and was exiled to Yunnan, where he served until finally being granted permission in 1461 to return to his hometown. In retirement Hsü took the sobriquet Recluse by Heavenly Permission (*T'ien-ch'üan chü-shih*) and lived in Soochow until his death at the age of sixty-five.[7] Hsü had few chances to visit Soochow during his career in office, but in the short

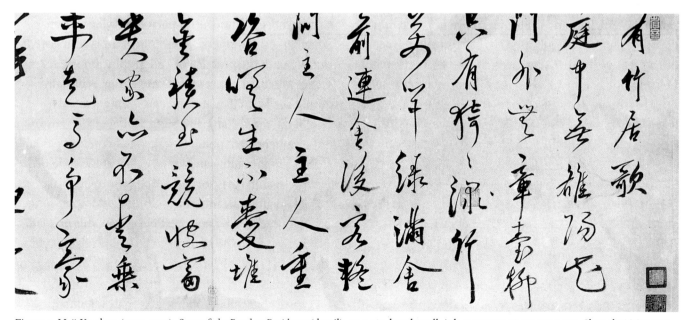

Figure 1. Hsü Yu-chen (1407–1472), *Song of the Bamboo Residence* (detail), ca. 1467, handscroll, ink on paper, 38.3 x 263.8 cm. Shanghai Museum.

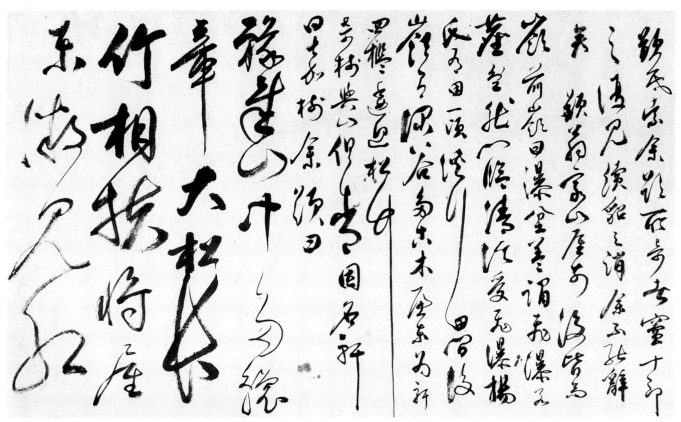

Figure 2. Hsü Yu-chen, *Colophon for Shen Chou's "Painting of Mount Chia"* (detail), ca. 1461, handscroll, ink on paper, 41.2 x 231.0 cm. The Art Museum, Princeton University, bequest of John B. Elliott.

span of his retirement there, he built a close and varied circle of friends. Indeed, it appears that the high level of art and culture in Soochow provided the catalyst to bring out Hsü's creative talents as a calligrapher during the last few years of his life.

Unfortunately, few examples of Hsü's calligraphy survive. The handscroll *Colophon for Shen Chou's "Painting of Mount Chia"* (*T'i Shen Chou Chia-shan t'u*) in running-cursive script (fig. 2) in the Elliott Collection is an important work that bears Hsü's signature. Like his *Song on the Bamboo Residence*, this colophon is a product of Soochow literati garden culture in the early Ming. In it, Hsü recounts how Shen Chou commemorated the seventieth birthday of their mutual friend, a certain Mr. Ch'ung, by painting the scenery around the Ch'ung residence and presenting it to him as a gift. Mr. Ch'ung thereupon asked Hsü to write a colophon for the painting. Although Shen Chou's painting no longer survives, the content of Hsü's colophon provides a glimpse of Ch'ung's estate. Hsü describes a range of hills extending both in front of and behind the residence and a waterfall known as Cascade Range (*P'u-fen ling*). The residence fronted on an area of streams and fields; behind it was a valley with many

old trees. To the east was a winding covered walkway surrounded by pines, bamboo, and various trees. The pavilion there, standing out among the hills, was known as the Studio of Lush Trees (*Chia-shu-hsüan*). To complement his prose description of the estate, Hsü added a poem in seven-character meter and transcribed it in large cursive script.

The simple description of the scenery in Hsü's colophon, unadorned by ornate expressions or classical allusions, may appear unremarkable at first. Hsü's understated literary style was in keeping, however, with that of the garden landscape at Mr. Ch'ung's estate. In contrast to many famous Soochow gardens, the site apparently featured no fantastic rocks or exotic trees or plants, nor did it include any dramatic scenery. Shen Chou's and Hsü's praise of the plain elegance of the garden may actually mirror the ideal of simple naturalness (*p'ing-tan tzu-jan*) that was reflected in the Soochow literati attitude toward painting and life.

Hsü Yu-chen's colophon is signed with his sobriquet Recluse by Heavenly Permission and bears his seals "Senior Retiree by Imperial Permission" (*Tz'u kuei lao-jen*) and "Elder of Heavenly Permission" (*T'ien-ch'üan weng*). The signature and seals indicate that the colophon was

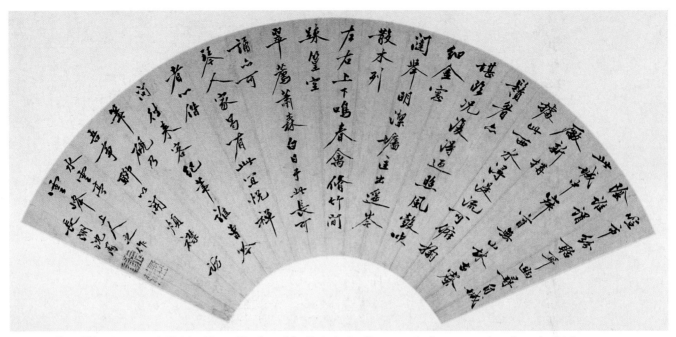

Figure 3. Shen Chou (1427–1509), *Visiting Master Yün-feng of the Shui-yün Pavilion*, ca. 1488, fan mounted as album leaf, ink on paper, 32.0 x 67.0 cm. The Art Museum, Princeton University, bequest of John B. Elliott.

written after he returned to Soochow in 1461, making it more or less contemporary with his *Song on the Bamboo Residence*. However, close examination reveals differences in style between the two works, including some notable variations in the brushwork of similar characters. In general, the strokes in *Song on the Bamboo Residence* tend to be thinner and more tensile, and the brush was applied to the paper slightly more heavily and more hesitantly. Those places where the brush was lifted from the paper show that the strokes were turned back to reveal the tip of the brush. These features tend to recall the draft-cursive script (*chang-ts'ao*) of Sung K'o (1327–1387; cat. no. 18) and the brothers Shen Tu (1357–1434; cat. no. 19) and Shen Ts'an (1379–1453), which was widely practiced in the Soochow–Sung-chiang area during the late Yüan and early Ming.[8]

The brushwork in the Elliott scroll is thicker and rounder. The proportions of the characters vary considerably and the spaces between the lines are somewhat irregular, much in the manner of Chu Yün-ming (1461–1527). Chu was the grandson of Hsü Yu-chen and in his youth was influenced by Hsü's calligraphy. Later, Chu fused that influence with his own interpretation of the styles of Huai-su (ca. 735– ca. 799) and Huang T'ing-chien (1045–1105; cat. no. 6) to form his own distinctively personal style.[9] Thus, although *Colophon for Shen Chou's "Painting of Mount Chia"* bears the signature of Hsü, it may in fact represent the work of a

close follower of Chu Yün-ming paying homage to the style and heritage of Hsü Yu-chen.

Shen Chou's *Visiting Master Yün-feng of the Shui-yün Pavilion (Fang Shui-yün-t'ing Yün-feng shang-jen;* fig. 3) from the Elliott Collection is another product of Soochow garden culture. On this folding fan, Shen Chou inscribed a five-character archaic verse.[10] The poem describes the peaceful scenery of a small temple pavilion in the southern part of the city, a site ideal for literati pursuits such as composing poetry, playing the *ch'in* (zither), and meditating, which typified garden life in Soochow.

This work was done on a folding fan, a format that originated in Japan and Korea and was introduced to China in the Northern Sung. At that time, such fans were often presented as tribute to the Chinese emperor, but it was not until the early fifteenth century, when they were favored by the Yung-lo emperor (r. 1403–24), that they came into common use throughout China. By the latter half of the fifteenth century, the folding fan had become a popular format for calligraphy and painting among literati. This was especially true among Soochow painters and calligraphers, who left behind many such works. Shen Chou was one of the artists instrumental in developing and adapting compositions for this format.[11]

Like his poetry and painting, calligraphy served Shen Chou as a means of personal expression. Perhaps it was for this reason that he rarely discussed

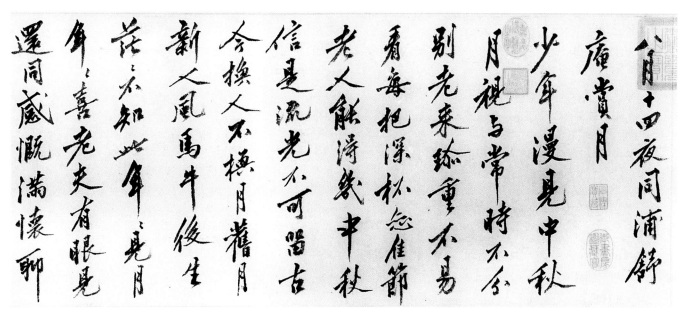

Figure 4. Shen Chou, *Mid-Autumn Poem* (detail), 1489, handscroll, ink on paper, 31.9 x 232 cm. National Palace Museum, Taipei, Taiwan, Republic of China.

theoretical or technical matters concerning calligraphy. His style echoes the running script of the Northern Sung scholar-calligrapher Huang T'ing-chien, especially in exaggerated *p'ieh* (left-falling) and *na* (right-falling) diagonal strokes as well as in the

intentional awkwardness found in the trembling and hesitant "one wave, three crests" (*i-p'o san-che*) manner. Wang Ao (1450–1505), a Soochow scholar who served at court, described Shen Chou's calligraphy as being powerful yet awkward.[12] This style is especially

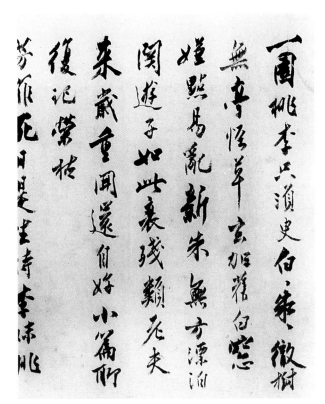

Figure 5. Shen Chou, *Odes and Painting on Fallen Flowers* (detail), ca. 1504, handscroll, ink on paper, 30.5 x 208.3 cm. National Palace Museum, Taipei, Taiwan, Republic of China.

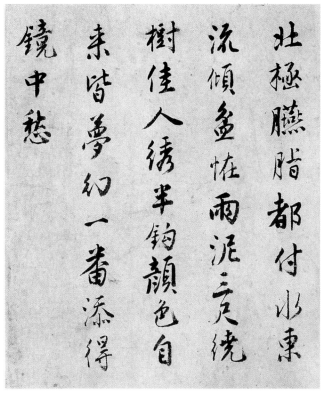

Figure 6. T'ang Yin (1470–1524), *Odes to Fallen Flowers*, ca. 1505 (cat. no. 26, detail).

evident in Shen's works from the 1480s, when he was approximately sixty years of age. An example is the scroll *Mid-Autumn Poem* (*Chung-ch'iu shih;* fig. 4), dated to 1489. Here, vertically elongated characters are balanced by exaggerated diagonal and horizontal strokes leaning dramatically to the left, in an unusual yet confident calligraphic style. The painting on the Elliott fan is dated to 1488 and the calligraphy on the other side appears similar in style to that in *Mid-Autumn Poem*.

DISAPPOINTED SCHOLARS

In the late spring of 1504 Shen Chou fell ill for a month and, upon recovering, noticed that all the blossoms in his garden had withered. Moved by the brevity of their existence, he composed ten poems titled "Odes to Fallen Flowers" (*Lo-hua shih*). These poems inspired Wen Cheng-ming, Hsü Chen-ch'ing (1479–1511), and Lü Ch'ang (1440–1511) to compose their own poems on the same theme. To reciprocate, Shen Chou composed another twenty poems. Shen Chou's handscroll, *Odes and Painting on Fallen Flowers* (*Lo-hua t'u ping shih*; fig. 5), includes transcriptions of the verses as well as a poem added by Wen Cheng-ming in 1507. The fame of these poems among the Soochow literati is attested to by numerous calligraphic copies, including a small-standard script handscroll by Wen Cheng-ming, now in the Soochow Museum, that records the complete set of poems.[13]

The artist and poet T'ang Yin also participated in this ongoing process of literary composition, and his thirty poems on the theme of fallen flowers are recorded in his collected literary works.[14] Twenty-one of these poems are transcribed in T'ang Yin's handscroll *Odes to Fallen Flowers* in the Elliott Collection (fig. 6, cat. no. 26).[15] Like Shen Chou, T'ang used the imagery of fallen blossoms as a metaphor for the vicissitudes of human life. This imagery had special significance in the context of T'ang Yin's own vexed career. In 1504, the year Shen Chou wrote his poems, T'ang Yin had just returned from the metropolitan examinations in Peking, tainted by scandal and abandoned by his wife.[16] The withered blossoms that are the subject of his poems appear to allude to this troubled time in his life. In the second poem about the waning days of spring, images of the setting sun, sounds of a flute,

damaged blossoms, and pouring rain evoke his own sorrows. The final lines read, "All the colors [of spring] appear [before me] as if in a dream; / But they all turn to sorrow [as I look at myself] in the mirror." The fallen spring flowers may well symbolize T'ang Yin himself, whose whole career as a promising young scholar and degree candidate had changed completely in less than one year after he had achieved top honors in the provincial examinations in Nanking. Although he had set out for the final and most important round of examinations in Peking almost certain of achieving success, he was implicated in a cheating scandal, disqualified, and forced to return home with no hope of pursuing a career as an official. His frustrations also seem to lie behind the imagery of another of his poems on the theme of fallen flowers:

Yellow blossom without a master, for whom do
 you glow?
Left here all alone, on this desolate and winding path,
Spending everything you had to adorn yourself,
It comes to naught in these winds of autumn.[17]

Taking a solitary yellow chrysanthemum in late autumn as a symbol of his own state in life, he conveys the frustrated sentiments of a lonely scholar whose dreams of success have been shattered.

Ho Liang-chün (1506–1573), who resided in nearby Sung-chiang, recorded that when T'ang Yin returned to Soochow after his disastrous trip to the capital, he abandoned himself to heavy drinking but continued to paint with great concentration: "He [T'ang Yin] lived in the Wu-ch'ü ward [of Soochow], often sitting in a small building overlooking the street. Those who requested a painting from him would bring wine, which he would drink all day. Although unrestrained in manner, he was very attentive to details."[18] T'ang's devotion to the practice of art also extended to calligraphy, as is clearly evident in the Elliott scroll, in which each stroke is carefully controlled. The flowing rhythm of the brushwork and the relationships between the characters create a sense of energy and harmony throughout the calligraphy. Furthermore, the generously spaced lines invite the reader to pause and reflect on the poetry. As a painter, T'ang understood the aesthetic demands of the art market. Likewise, in calligraphy, he adapted bold elements of the popular style of Yen Chen-ch'ing (709–785), which was associated with Confucian loyalty and upright virtue. In this way, as seen in *Odes to Fallen Flowers*, he was able to

incorporate outwardly elegant and attractive aspects into a solid and stable style of calligraphy to evoke a dignified and refined sense of beauty.

Although Wen Cheng-ming and T'ang Yin were the same age and had been boyhood friends, their temperaments and artistic dispositions could not have been more different. One of the things they did share was their frustration in the pursuit of an official career. T'ang Yin's triumph in the provincial examinations was cut short by scandal, and Wen Cheng-ming, who failed the examinations many times, entered official life only at the age of fifty-four, when upon recommendation he was called to Peking to serve in the Hanlin Academy. In spite of this honor, Wen met with continual setbacks, became disillusioned, and returned to Soochow after only three years.[19] His brief official career was not a waste, however, for it became an important source of inspiration for his art. Although Wen could not aspire to the level of success in art and government service achieved by Northern Sung scholar-officials such as Su Shih (1037–1101) and Huang T'ing-chien, or by his more immediate predecessors from Soochow such as Wu K'uan (1436–1504) and Wang Ao, he led many students and followers to develop a Soochow regional style of art.

Wen Cheng-ming's sojourn in Peking included several notable events. In the spring of 1525, for example, he had the honor of being invited with some colleagues of the Hanlin Academy on a tour of the Western Garden of the imperial-city palace compound. To commemorate this rare opportunity, he composed a set of ten verses titled "Poems on the Western Garden" (Hsi-yüan shih). The ten poems are preserved along with other poems of the same period in the collected writings of Wen Cheng-ming (Fu-t'ien chi). At the end of the chüan, Wen Cheng-ming added the following note:

> In the past, when I envisioned divine palaces and treasuries, they were far in the empyrean, not visible from the realm of mortals. In this period of peace, my colleagues and I had the opportunity to enter the forbidden [imperial Western Garden]. Given a day of leisure to wander inside, this was a rare tour that I may never repeat. In the future, it will be rare to encounter such scenic spots or such moments of beauty. I will soon embark on my return journey to my native region of Chiang-nan [south of the Yangtze]. Now, when I recall my previous journeys [there], I wonder how I can undertake them again [now that I have been to

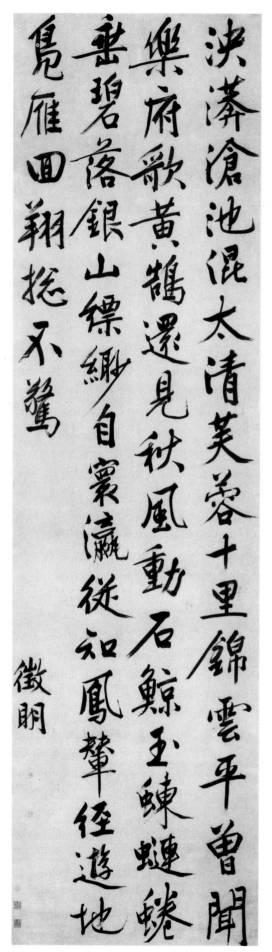

Figure 7. Wen Cheng-ming (1470–1559), *Poem on Lake T'ai-yeh*, undated (cat. no. 27, detail).

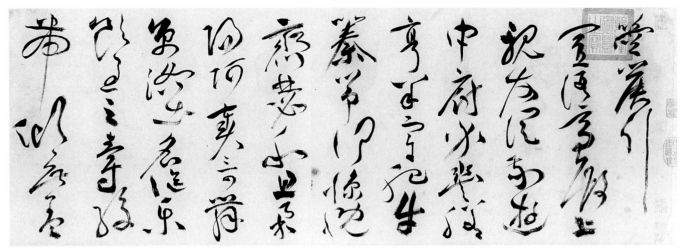

Figure 8. Chu Yün-ming (1461–1527), *Poems by Ts'ao Chih* (detail), ca. 1525, handscroll, ink on paper, 36.2 x 1154.7 cm. National Palace Museum, Taipei, Taiwan, Republic of China.

the Western Garden]. For this reason, I have captured the Western Garden in various poems, so when by chance I open them and read them to "old woodcutters and fishermen" [i.e., fellow scholars] at some later time, it will be almost as if I am actually there again at [the mystical sites of] Kuang-han Moon Palace and Lake T'ai-yeh.[20]

The Western Garden was situated inside the Peking imperial city precinct (*Huang-ch'eng*) and was counted among the city's Eight (sometimes Ten) Scenic Views. Off-limits to almost all, it was deemed a high honor for court officials to be permitted to enter. Wen Cheng-ming's delight in describing in poetry and calligraphy his visit to this site to friends and associates back home in Soochow can only be imagined.

Poem on Lake T'ai-yeh from the Elliott Collection (fig. 7, cat. no. 27) transcribes one of the ten poems from the "Western Garden" series. Writing in large running-script characters, Wen Cheng-ming likens the scenery to that of the land of the immortals, which he enlivens with Han dynasty poetical and mythical allusions.

As an erudite Soochow literatus-calligrapher, Wen Cheng-ming studied the classical tradition of Wang Hsi-chih in writing standard, running, and cursive scripts, but he also followed the example of his teacher Shen Chou in emulating the self-expressive styles of Northern Sung scholar-officials such as Su Shih and Huang T'ing-chien.[21] When he was in Peking, his poems in praise of imperial culture were often written in Huang T'ing-chien's grand, large running-script style, and *Poem on Lake T'ai-yeh* is such an example. He may have written the scroll in Peking not long after visiting the Western Garden, possibly on the spur of

the moment for a friend. This strong brushwork and personal calligraphic manner must have provided a new perspective on calligraphy for his Hanlin colleagues accustomed to the more delicate and decorative Chancellery style at court.

LITERARY MASTERPIECES AND CALLIGRAPHIC INSIGHT

All works of calligraphy rely on texts that convey specific meaning in either prose or poetry. The latter was especially popular among Soochow scholar-calligraphers of the Ming period, who often transcribed texts by poets such as Ts'ao Chih (192–232), T'ao Yüan-ming (T'ao Ch'ien, 365–427), Li Po (701–762), Tu Fu (712–770), and Su Shih. Although these texts were admired for their literary quality, they could also be used by calligraphers as oblique commentaries on their own lives and feelings. As early as the sixth century, the calligrapher and theorist Sun Kuo-t'ing (648?–703?) had already remarked on the influence of textual content on calligraphic expression.[22]

For the scholar-calligraphers of Soochow, who were not confined to the styles of calligraphy or writing required for the civil service examinations, the "untrammeled" qualities thought to reside in certain works of early literature exerted a special fascination. For example, in the handscroll *Poems by Ts'ao Chih* (*Tsa-shu shih chüan;* fig. 8), Chu Yün-ming transcribed the folk song (*yüeh-fu;* lit., "music repository") poetry of Ts'ao Chih in wild cursive script. At the end of the scroll, Chu wrote, "[I know Ts'ao's] spirit from fifteen hundred

years ago, yet who [in the future] will know my calligraphy?" He thus used calligraphy as a medium by which to evoke the emotional sentiment of Ts'ao Chih's poems; yet, the scroll can also stand alone as a brilliant artistic display of Chu Yün-ming's calligraphy.

The ancient poetic form of the folk song originated in the Western Han dynasty and was based on popular verse from the Spring and Autumn period exemplified in *The Book of Poetry* (*Shih ching*). Folk-song poems tend to be relatively simple and emotionally direct. Not restricted by set metric forms or specific rhyme patterns, lines in folk-song poems can vary in length, making this highly flexible genre suitable for giving voice to the poet's sentiments. Reputed to be impetuous and unbridled, Ts'ao Chih was exceptionally talented at this type of verse and became known as one of the most influential masters in the history of the genre. Similar in personality and also tending toward drink and unconventional behavior, the T'ang poet Li Po and others of similar temperament were deeply influenced by Ts'ao's work.[23] For example, Li Po wrote "Pai-ma p'ien," a folk song that imitated the calligraphy of, and was inspired by, a similarly titled piece by Ts'ao Chih. Likewise, Chu Yün-ming used a wild-cursive script to transcribe Ts'ao's "Pai-mai p'ien" in his *Poems by Ts'ao Chih* handscroll.[24]

In some ways, the artistic genius of Chu Yün-ming was similar to that of Ts'ao Chih and Li Po. Through his wild-cursive (*k'uang-ts'ao*) script, Chu was able to convey the intensely expressive qualities of Ts'ao

Chih's poem. Using the same calligraphic style for a handscroll in the Elliott Collection, he transcribed Li Po's "The Arduous Road to Shu," also a folk-song poem, and "Song of the Immortal" (*Huai-hsien ko*) in seven-character ancient verse (fig. 9, cat. no. 25)."The Arduous Road to Shu" is one of Li Po's most famous works and is often found in anthologies of Chinese poetry. It describes the precipitous mountain scenery of Szechwan. At least since the Yüan dynasty, the poem has been interpreted as an account of the escape of Emperor Hsüan-tsung (r. 712–56) to Szechwan following the An Lu-shan Rebellion in 756.[25] Beginning with the opening lines of the verse, Li Po uses dramatic language to convey the dangers of the journey. Expressing amazement at the sight of the sheer cliffs, he writes, "Oh, so high rise the precipitous peaks! / The journey to Shu is as difficult as the ascent to the heavens." Li Po repeats these lines for emphasis at the middle and end of the poem. The poem also speaks of endless peaks twisting and turning like a "stairway to heaven," stone paths carved into the cliffsides, and deep valleys crossed by raging rapids. Along the way Li Po introduces the imagery of craggy trees and the lonely cries of birds to enhance the desolate atmosphere, evoking for the reader the hidden dangers of wild animals lurking in the mountains. The overall effect is direct and emotionally overwhelming, and Li's dramatic language calls to mind the wholly unrestrained nature of wild-cursive script as it appeared in Li Po's time.

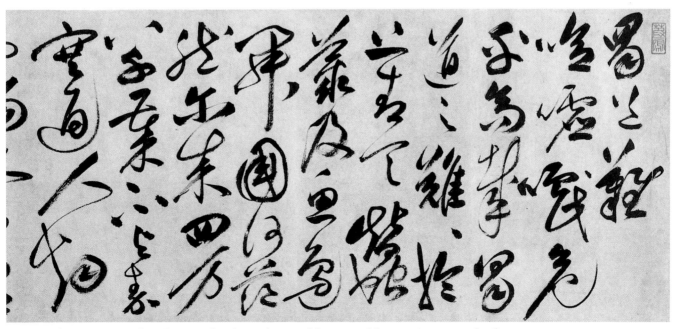

Figure 9. Chu Yün-ming, *"The Arduous Road to Shu" and "Song of the Immortal,"* ca. 1525 (cat. no. 25, detail).

Figure 10. Wang Ch'ung (1494–1533), *The Nine Songs*, 1527 (cat. no. 29, detail).

As in *Poems by Ts'ao Chih,* Chu Yün-ming used wild-cursive script to transcribe Li Po's "Arduous Road to Shu," relying on this highly expressive form of writing to echo the turbulent emotions aroused by Li Po's verse. The most expressive elements of Chu Yün-ming's calligraphy can be seen in his dot and turning strokes. Sometimes small, complex dots are formed by emphasizing the entry stroke to produce a solid body and ending with a quick, light flick of the brush tip to create a spike tail. In such dots Chu combines strong linework with the use of angled brush techniques to emphasize the speed and movement of the brush. Elsewhere in his turning strokes, he used a continuously twisting brush method, displaying a spiraling and revolving vigor. In this handscroll, some brushstrokes are crude and attenuated, demonstrating rapidity and hesitation, while others are agile and thin, displaying an unrestrained speed and freedom. In this way Chu Yün-ming was seemingly able to imitate the irregular and unstructured character of folk-song poems and their authors' expressed intent.

After retiring from official life in 1521, Chu Yün-ming returned home to Soochow and built the Huai-hsing Hall (*Huai-hsing-t'ang*) at the former residence of his grandfather Hsü Yu-chen. There he indulged in a lifestyle similar to his grandfather's, "recording all that he witnessed and experienced while at ease in the tranquil landscape."[26] Reportedly, he frequently invited friends to drink, and soon spent all his savings. This was also, however, a period during which Chu matured as both a scholar and a calligrapher. In the frequent company of friends and drinking companions, he composed calligraphy with increasing freedom and ease, producing many masterpieces in his unique cursive style. It was also at this time that his works began to be highly valued. Not surprisingly, many who associated with him tried to find ways to acquire his calligraphy. In the ninth lunar month of 1525, for instance, he wrote *Nineteen Poems in Ancient Verse* (*Ku-shih shih-chiu shou*) in running-cursive script for Wen Chia (1501–1583), the son of Wen Cheng-ming. On this affair, a later writer recounts that:

When [Chu] Yün-ming met with financial difficulties, he sought to borrow money. For this reason Wen Hsiu-ch'eng [Chia] kept fine silk in his studio. Yün-ming liked to write "Nineteen Poems in Ancient Verse" and obtained a large sum from Wen Chia for this scroll. It is widely felt that Hsiu-ch'eng's acquisition of this calligraphy is a matter of ridicule in the art world.[27]

A colophon Chu Yün-ming wrote for his *Handscroll in Cursive Script (Ts'ao-shu chüan)* reports similar incidents:

> Those who come asking for my calligraphy bring [scrolls] made of many connected sheets, in order to boast to others how many they possess. Over time my interest has seemed to wane as my arm rests here in resentment. How am I to have peace of mind [to do calligraphy]?[28]

Although the circumstances surrounding the production of the Elliott scroll are unclear, perhaps some of the unrestrained wildness of this work can be attributed to such resentment on the part of Chu Yün-ming.

When Soochow calligraphers transcribed literary masterpieces of the past, they often appropriated the texts to allude to circumstances in their own lives. Wang Ch'ung's (1494–1533) *Nine Songs* handscroll in the Elliott Collection (fig. 10, cat. no. 29) is just such an example. Wang Ch'ung was born into a merchant family in Soochow, and, like others from well-to-do backgrounds, he collected art and mingled in literary circles. As a youth, Wang was tutored at home in calligraphy by Wen Cheng-ming, and from 1511 to 1514, he also studied under Ts'ai Yü (d. 1541), a well-known proponent of *fu-ku,* reviving antiquity in literature. Later, he left urban Soochow for the serenity of the Stone Lake region outside the city, immersing himself in teaching and in the study of antiquity. He attempted but failed the civil service examinations eight times between 1506 and 1531.[29] At the peak of his artistic and literary prowess, because of his unrivaled talent, Wang Ch'ung was considered by contemporaries to be the heir to the Soochow tradition of calligraphy as handed down from Shen Chou and Wen Cheng-ming. Unfortunately, due to illness, he passed away at the young age of forty.

The people living in the area lying between the rivers Yüan and Hsiang in the ancient state of Ch'u maintained superstitious religious rites aimed at entertaining the gods with song, music, and dance. In the fourth century B.C., when the high minister and writer Ch'ü Yüan (343–278 B.C.) was exiled to this region, he observed that the verses of "The Nine Songs," a religious drama, were particularly poor, so he composed his own reworked version in eleven sections. In part he wrote "The Nine Songs" to honor the gods, but he also seems to allude in them to his private inner griefs and feelings of resentment.[30] Ch'ü Yüan is best remembered for his virtuous but tragic decision to drown

himself after failing to win the recognition of his ruler, and his "Nine Songs" became a literary monument and a source of inspiration for succeeding generations of both artists and writers.

When Wang Ch'ung, a serious student of ancient literature, wrote his *Nine Songs* handscroll in 1527, he appended an inscription in which he cites explanations of the text's origin and meaning by the Han dynasty scholar Wang I (ca. 89–after 158). In transcribing "The Nine Songs" in the cursive-script style of Wang Hsi-chih, Wang Ch'ung may have been following the precedents of others before him in showing a similar interest in this literary monument, but a colophon by his friend and fellow Soochow artist Ch'en Ch'un (1483–1544; cat. no. 44) suggests that the "The Nine Songs" may have had special meaning for Wang Ch'ung:

> I have often seen "The Nine Songs" of Master Ch'ü [Yüan], transcribed by calligraphers of old and illustrated by painters, who must have been inspired by the content [of his poems]. They must have felt some sympathy for him and used the piece to express their own ideas. Nowadays, we live in peaceful and auspicious times, and he [Wang Ch'ung] is at the peak of his fame. So why should he transcribe such sorrowful and bitter poetry? He must have had something in mind, but only he knows what it is.

Ch'en Ch'un hints that despite the enjoyment of "peaceful times" and the "peak of his fame," Wang Ch'ung may have still longed for success in official life. It also seems possible that Wang Ch'ung, embittered by his repeated failures at the examinations, identified his own fate with that of the rejected statesman Ch'ü Yüan. As a close friend of the calligrapher, Ch'en Ch'un probably understood Wang Ch'ung's feelings as well as anyone, and his colophon should be read as not merely a perfunctory note exchanged between friends but as a message sympathizing with Wang's unstated reasons for transcribing "The Nine Songs."

Despite Wang's early death, he left behind many works of calligraphy. Like Chu Yün-ming, Wang emulated the styles of Wei and Chin masters of the third and fourth centuries, seeking a subtle and simple form of expression. The style of his *Nine Songs* scroll is close to the tradition of Sui and T'ang interpretations of Wang Hsi-chih's cursive script, but Wang Ch'ung did not indulge in connective ligatures between characters

or in excessive, uncontrolled brushwork that exposed the brush tip. Instead, keeping his brush tip centered in each stroke, he maintained the integrity of each stroke, producing a slightly loose or free effect that echoes the expressive quality inherent in calligraphy of the Chin dynasty.

COLLECTING, CONNOISSEURSHIP, AND SOOCHOW CALLIGRAPHY

In the late Yüan many literati were concentrated in the Chiang-nan region in the south. With the turmoil of this period, many works of painting and calligraphy were scattered, often falling into the hands of private Chiang-nan collectors. The early Ming court devoted little attention to acquiring art. The imperial household bestowed works of painting and calligraphy on various princes and, when funds were short, even used paintings and calligraphy from the imperial treasury as payment.[31] As a result, many private individuals had been able to purchase major works of art and to form large collections. By the second half of the fifteenth century, this increase in private art collecting was accompanied by a growing interest in related literati activities, such as composing colophons and inscriptions, recording visits to collections, conducting scholarly research, and printing anthologies of model-book calligraphies (t'ieh).

Abundant documentary evidence and surviving works indicate that many important pieces of calligraphy were gathered in the private collections of the economically and culturally prominent Soochow elite. Local literati, artists, and officials formed closely knit circles of friendship, growing out of relationships stemming from education, place of origin, or kinship, and the collecting and connoisseurship of painting, calligraphy, and antiquities in their collections formed an integral part of their formal and informal gatherings. In addition to being sources of visual pleasure, masterpieces of ancient calligraphy in private collections underwent the scrutiny of connoisseurs. They were thus critically judged, imitated, and copied, and naturally came to have a larger influence on the development of calligraphy than did works that were inaccessible in the imperial court.

Among his circle of acquaintances, Shen Chou came into frequent contact with such connoisseurs and col-

lectors as Liu Chüeh, Ch'en Ch'i (fl. mid-15th century), Wu K'uan, Li Tung-yang (1447–1516), Li Ying-chen (1431–1493), Shih Chien (1434–1493), and Hua Ch'eng (1438–1514). These men emphasized personal character and literary accomplishment expressed in calligraphy and showed a keen interest in the work of Sung scholar-calligraphers. For example, according to *Reflections on Calligraphy and Painting* (*Yü-i pien*), a record of contemporary collecting written by Tu Mu (1458–1525), among eighteen works of calligraphy in Shen Chou's collection, sixteen were by the Four Great Sung Masters—Ts'ai Hsiang (1012–1067), Su Shih, Huang T'ing-chien, and Mi Fu (1052–1107). Tu also listed letters by prominent scholars and officials of both the Northern and Southern Sung.[32] Shen Chou appears to have been particularly interested in *Two Letters* (*Shou-cha erh-t'ieh*) by Lin Pu (967–1028). This album, now in the National Palace Museum in Taipei, is simply two short letters offering fairly ordinary expressions of gratitude. Still, Shen Chou paid special attention to Lin Pu's letters, displaying them for the appreciation of his friends on many occasions between 1475 and 1493. The letters even inspired him to compose his own seven-character regulated verse "Poetic Colophon on Lin Pu's Following [*su*] Tung-p'o's Rhyme" (*Ho Tung-p'o t'i Lin Pu shih yün*), written in 1476. On Lin Pu's calligraphy album Shen impressed his seals, "Precious Antiquity of Shen Chou" (*Shen Chou pao-wan*) and "Painting and Calligraphy of Mr. Shen's Bamboo Villa" (*Wu Shen-shih Yu-chu-chuang t'u-shu*). In his poem, Shen linked Lin Pu's taut, elegant calligraphic style to his noble and incorruptible spirit, thereby seeing the embodiment of the man's character in his calligraphy. Following his poem, Shen inscribed the following note:

> Several years ago I traveled to Hangchow with Liu Wan-an [i.e., Liu Chüeh] and Shih Ming-ku [i.e., Shih Chien]. We first went to pay our respects at the grave of Recluse Lin Ho-ching [i.e., Lin Pu]. To this day, his character remains upright and pure. It is just like seeing him among the mountains and lakes, and now not being able to forget it. Recently, I read a colophon by [Su] Tung-p'o inscribed on a poem written by the Recluse. So marvelous and unattainable, few can truly appreciate it. I have borrowed its tune to compose a poem that I have transcribed on the Recluse's *Two Letters* in my collection as a token of my respect and admiration.

Figure 11. Wu K'uan (1436–1504),
Essays on Calligraphy, undated
(cat. no. 23, detail).

吾衍曰金之篆以古人平常字下古初相筆不過竹上麥毛

便指過畫故篆字肥痩均一轉折等後角也後人以真草

行或細或把以為美茲苃筆意可成體令人以此

筆作篆難于古人尤多羨揚學来能用時器手燈上燒過

庶幾便手篆書多有字中包一二畫如日目字之類者

初一字内畫不与兩頸相連後皆妙之則為尾一法矣

反捲向上派右欠右一筆作章草狀不是擫把字巳闲

口脚孤生氣火矣旅字是四黙與感字是戈邊直

作一筆不是黙未嘗不不字及挑脚藻有一喇右法妙

此甚多器筆其大藥持此注可以親天下之蘭亭矢五字

摸本者流流帶右天五字者摸也

作篆尚婉而通隸必精為蕃貴流而暢章韜橋兩使然

後凜之以平神温之必姸潤鼓以枯勁和以圓雅必視傍通黙

畫之情惰尧姹終之理鏤鑄嬴篆陶鈞草隸一點成一

字之規一字乃鍾扁之遁遠而不犯移而不固喬不常遷遺

不悟疾帶燥方潤時濃遂枯泯規矩于方圓遁鈎繩

于曲直

小篆二世而各筆注李斯方圓廓落李陽冰圓恬姿

武㯋或若名自相異為不守法度圓圈圓黙古文有之

小篆無此口字作三角形不可引用篆注匾者最好用

之蠕㯋匾徐鉉謂非老手莫能到石數文是也

婑徐鉉如隸無蚕脚字下如釵股稍尖錯如其先但字

下為玉筋微小韋崔子玉多用隸法似于不精拖有漢

長洲吳寬為

鶴山賢友書

Shen Chou's close friend Wu K'uan expressed similar views in the inscriptions and colophons he wrote for works of calligraphy. In Wu's appraisal of three of the Four Sung Masters, for example, Mi Fu did not rank very high. In his colophon on Mi's *Copy after Yen Chen-ch'ing's "Letter on the Controversy over Seating Protocol"* (*Lin Yen Lu-kung Cheng-tso-wei t'ieh*), he noted that Mi Fu's calligraphy was "strident and grandiose, but leaned to one side," unlike the work of Yen Chench'ing, characterized by "correctness and purity" that allowed him to be the "best of the ancients."[33] Wu admired the more "reserved and structured" style of Ts'ai Hsiang, whom he ranked first among the Four Sung masters. Wu felt that Huang T'ing-chien's and Mi Fu's styles were "excessively imbalanced and strange," and he thus ranked them below Ts'ai.[34] In his colophon for Ts'ai Hsiang's *In Gratitude for a Gift of Imperial Calligraphy* (*Hsieh-tz'u yü-shu*) handscroll in the collection of Hsü Pu (1428–1499) (presently in the collection of the National Palace Museum, Taipei), Wu again emphasized the connection between Ts'ai's character and his calligraphy, arguing that "the person and calligraphy are the same, and his calligraphy is upright and dignified; such was the case whenever he took up the brush."

Wu K'uan was born into a family involved in the silk business in Soochow and received his *chin-shih* degree in 1472. He then spent over thirty years as an official at the imperial court, where he served in a number of important positions. He was admired and respected for his broad learning and upright character, becoming known as the Confucian Servitor (*Ju-ch'en*). Modest by nature, he adopted the sobriquet Bottlegourd (*P'ao*), likening himself to a useless object in much the same way that Shen Chou adopted the sobriquet Field of Stones (*Shih-t'ien*). Wu even gave his collected writings, which included thirty chapters of poetry and forty of prose, the humble title *Family Collection* (*Chia-ts'ang chi*). His prose was noted for its purity and elegance, and his poetry expressed his emotions with exceptional honesty and directness. Since Wu enjoyed studying the writings of Su Shih and developed a keen understanding of his works, it is not surprising that his calligraphy would be influenced by Su's style.[35]

Like Shen Chou, Wu K'uan (posthumous name, Wen-ting) rarely mentioned issues of technique and theory in his writings about calligraphy, but in his *Essays on Calligraphy,* also known under the title *Brush Traces of Wu K'uan* (*Wen-ting i-mo*), from the Elliott Collection (fig. 11, cat. no. 23) it is clear how seriously he considered these matters. In this small album, Wu transcribed in running and standard scripts selections from earlier essays on calligraphy theory. Among these are excerpts from *On Studying the Ancients* (*Hsüeh-ku pien*) by the calligrapher-theorist Wu Ch'iuyen (1272–1311). This text describes the practice of writing seal script and has been included in collectanea of calligraphy from the Sung onwards. Written for a friend named Ho-shan, the version of the text Wu K'uan transcribed appears in T'ao Tsung-i's (1316–1403) *Essentials of the History of Calligraphy* (*Shu-shih hui-yao*), whose preface is dated 1376.[36] It is possible that parts of Wu K'uan's transcription were executed at different times; this may be the reason that running script is favored in some portions while standard script prevails in others.

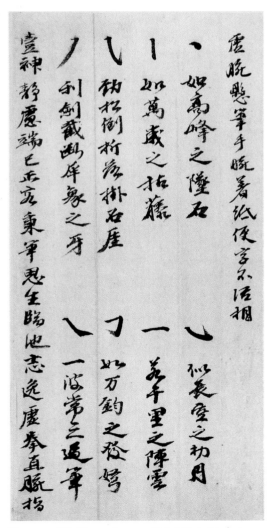

Figure 12. Wu K'uan, *Ou-yang Hsün's Eight Methods,* from *Essays on Calligraphy* (cat. no. 23, detail).

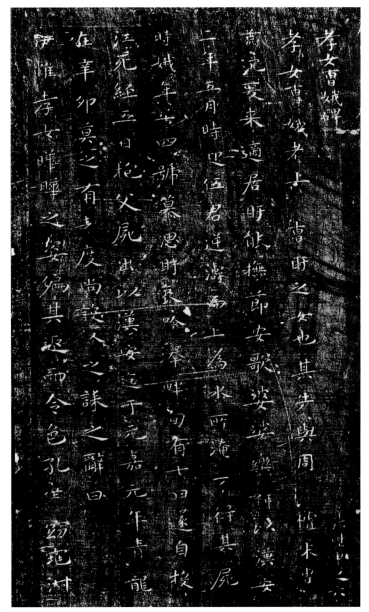

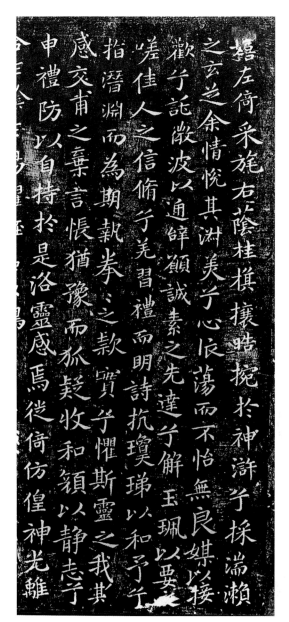

Figure 13. After Wang Hsi-chih (303–361), *Stele for the Filial Daughter Ts'ao O,* rubbing from *Model Calligraphies from the Hall of Lingering Clouds,* engraved 1537–60. National Palace Museum, Taipei, Taiwan, Republic of China.

Figure 14. After Wang Hsien-chih (344–386), *Prose Poem on the Nymph of the Lo River,* rubbing from *Model Calligraphies from the Hall of Lingering Clouds.* National Palace Museum, Taipei, Taiwan, Republic of China.

Since the texts he transcribed deal with calligraphic techniques, Wu was conscious of the value of actually demonstrating them in his own calligraphy. This is apparent in his transcription of *Ou-yang Hsün's Eight Methods (Ou-yang Hsün pa-fa;* fig. 12), which discusses *A Diagram of the Battle Formation of the Brush (Pi-chen t'u),* attributed to Madam Wei (272–349), Wang Hsi-chih's calligraphy teacher.[37] Here, Wu demonstrates each of the basic strokes of standard-script calligraphy described in the text, giving concrete form to verbal metaphors likening these strokes to phenomena in nature such as a stone falling from a cliff or clouds drifting across the sky.

By the first half of the sixteenth century, the earlier, more carefree, impressionistic approach to the appreciation and connoisseurship of art as practiced by Shen Chou and his circle had gradually shifted to one emphasizing critical research and matters of authenticity. During this period, many works in private collections were recorded in scholarly compilations such as Tu Mu's *Reflections on Calligraphy and Painting* of 1522 and a work by Wen Cheng-ming and his sons, *Model Calligraphies from the Hall of Lingering Clouds (T'ing-yün-kuan t'ieh),* a model-book anthology of ancient and modern calligraphy systematically collected between 1537 and 1560. In addition to such compilations, Chu Yün-ming,

Wen Cheng-ming, and others left compilations of their colophons and inscriptions on works of calligraphy and painting, which were often edited by the authors themselves or by their descendants. Although such colophons often follow traditional forms, on works of calligraphy they rarely discuss matters of style. Instead, unlike the earlier impressionistic approach, the focus of these later colophons is on substantive authentication and critical analysis.

The Wen family's *Model Calligraphies from the Hall of Lingering Clouds,* compiled and engraved in model-book form over a period of twenty-four years, was one of the first private publications of a collection of rubbings. One of its biggest differences from such earlier imperial Ming compilations as *Model Calligraphies from the Eastern Hall (Tung-shu-t'ang t'ieh;* 1416) and *Model Calligraphies from the Hall of Treasured Worthies (Pao-*

hsien-t'ang t'ieh; 1496) is that most of the works that were copied into the Wen family model-book were based directly on ink manuscripts from various collections. Ranging in date from the fourth to seventeenth centuries, the copied works were systematically selected for their authenticity and representative nature.[38] Such an extensive project could have been carried out only by skilled connoisseurs who had access to many private collections. Their knowledge of ancient calligraphy surpassed the impressionistic approach of earlier generations and paved the way for the critical research methods of late-Ming and Ch'ing connoisseurship and antiquarianism.

The first part of *Model Calligraphies from the Hall of Lingering Clouds* includes six specimens of Wang Hsi-chih's calligraphy, including *Stele for the Filial Daughter Ts'ao O (Hsiao-nü Ts'ao O pei),* as well as his son Wang

Hsien-chih's (344–388) *Prose Poem on the Nymph of the Lo River* (*Lo-shen fu shih-san hang*), all in small standard script (figs. 13, 14). These works became classic examples of the Wang Hsi-chih tradition after the T'ang dynasty and were studied and copied extensively by Ming calligraphers in Soochow. Their impact is apparent in Wen Cheng-ming's hanging scroll of 1551 written in small standard script and titled *Record of the Pavilion of the Old Drunkard* (*Tsui-weng-t'ing chi;* fig. 15). Wen's colophon for the scroll reads,

> Wang Hsi-chih's *Classic of the Yellow Court* [*Huang-t'ing ching*] in small standard script has the three elements of "tendons" [brushwork], "bones" [composition], and "flesh" [ink], which are difficult for later calligraphers to achieve. . . . His calligraphy also has the "quality of ice and jade, yet it is like an immortal in flight looking down at the immortal's realm in the waves." These aspects are even more difficult to attain. For the past few months, I have placed this set of rubbings at the head of my studio desk and have often opened it for study. Even in sleep, I could not let go of it. As a result, I slowly felt that I finally could begin to grasp Wang Hsi-chih's brush method. However, when I was about to set my brush on the paper, I could not write a word. I have recently read the collected writings of Ou-yang Hsiu [1007–1072] and appreciated his "supple and flowing" style. Because Ou-yang Hsiu came into the possession of Han Yü's [768–824] surviving writings, he ignored sleep and food as he studied them with all his energy, and he eventually became famous for his own writing. Now I wish I could be the same. By studying the remaining works of Wang, I have found inspiration and guidance.

Written when Wen was eighty-one, an established leader in the art world who had long since created his own individual calligraphy style, this passage typifies the antiquarian ideals of the Soochow literati.

Wang Hsi-chih's transcription of *Classic of the Yellow Court* became a model for such later calligraphers as Ou-yang Hsün (557–641), Yü Shih-nan (558–638), and Ch'u Sui-liang (596–658) in the T'ang and Chao Meng-fu (1254–1322) in the Yüan. During the early Ming, copying the *Classic* became commonplace after Chu Yün-ming did so again. Chu copied it so often that there are textual records and surviving examples of his copies for every year of his life from the age of twenty-six to his death at fifty-nine.[39]

Chu Yün-ming was of the opinion that the principle (*li*) of calligraphy had already been perfected between the second and fourth centuries, and that later calligraphers could only try to approach the ideal.[40] When learning calligraphy as a youth, his teachers restricted him to models from the Chin and T'ang periods, and

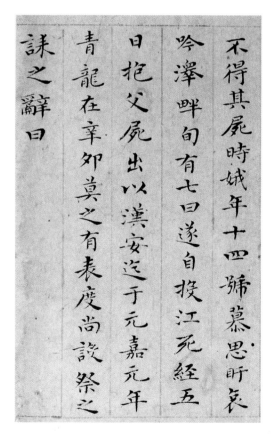
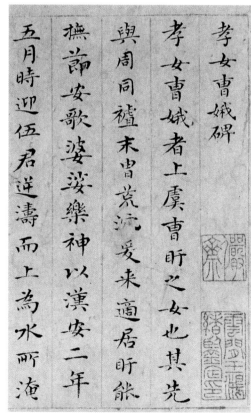

Figure 16. Chu Yün-ming, *"Stele for the Filial Daughter Ts'ao O"* and *"Prose Poem on the Nymph of the Lo River,"* 1507 (cat. no. 24, detail).

Figure 17. Chao Meng-fu (1254–1322), *Story of the Orchid Pavilion Preface* (detail), 1290, handscroll, ink on paper, 26.0 x 217.9 cm. National Palace Museum, Taipei, Taiwan, Republic of China.

Figure 18. Shen Tu (1357–1434), *On Not Giving Up* (detail), 1426, hanging scroll, ink on paper, 104.4 x 29.9 cm. National Palace Museum, Taipei, Taiwan, Republic of China.

he was not permitted to study later examples.[41] As for Wen Cheng-ming, he believed that when he was only twenty-seven his calligraphy was in a pure Chin-T'ang manner, without vulgarity.[42] Another example of Chu Yün-ming's interest in the Wang Hsi-chih tradition is the 1507 album *"Stele for the Filial Daughter Ts'ao O"* and *"Prose Poem on the Nymph of the Lo River,"* written in small standard script, in the Elliott Collection (fig. 16, cat. no. 24).

In the late thirteenth and early fourteenth centuries, the study of Wang Hsi-chih's calligraphy tradition once again revived under the influence of Chao Meng-fu's call for a "return to antiquity" (*fu-ku*). Chao owned a rubbing copy of Wang's *Classic of the Yellow Court,* and his small standard script was largely patterned after Wang's, as seen in Chao's handscroll *Story of the Orchid Pavilion Preface* (*Hsi-t'ieh yüan-liu*; fig. 17), done at the age of thirty-six. In this work, however, Chao's brushwork is much more complicated and ornate than the Wang Hsi-chih model.

In the early Ming, calligraphers summoned to serve as scribes at the imperial court took Wang Hsi-chih's small standard script style as their model. However,

because of stylistic restrictions and the conservative political atmosphere at court, court calligraphy lacked the creative spirit found in Chin writing. The work of the calligrapher Shen Tu, the "Wang Hsi-chih of the Ming," is representative of this court calligraphy, which came to be known as "Chancellery style." In Shen Tu's *On Not Giving Up* (*Pu-tzu-ch'i shuo*) a hanging scroll in small standard script (fig. 18), well-formed characters are written with rounded corners and elegant strokes that expose the brush tip. In the late fifteenth century, this somewhat mannered impersonal style was criticized by Soochow calligraphers who admired the more expressionistic styles of the Sung or the simple refinement of more ancient writing.

In his interpretation of the Wang Hsi-chih tradition of small standard script, displayed in *"Stele for the Filial Daughter Ts'ao O"* and *"Prose Poem on the Nymph of the Lo River,"* Chu Yün-ming attempted to recapture the original archaic appearance of this form, stressing squat compositions in individual characters and uniform, rounded, hidden-tip brushwork, and evoked the essence of Han dynasty clerical script, out of which Wang Hsi-chih's style emerged. Chu wrote that when

Figure 19. Wang Ku-hsiang (1501–1568), *The Thousand Character Essay*, 1541 (cat. no. 30, detail).

one copies from model-books, each stroke and character should be rooted in antiquity and that one should conceal technical skill in favor of simplicity and archaic spirit, an ideal that made his style very different from the court Chancellery style.[43]

The creative consideration of an artistic "return to antiquity" was inherited by a third generation of Soochow calligraphers through the influence of Chu Yün-ming and Wen Cheng-ming. One of these, Wang Ku-hsiang (1501–1568), had the good fortune to study literature and calligraphy under Wen and Chu. Although Wang was born into a well-to-do Soochow family and earned his *chin-shih* degree in 1529, he never achieved high office. In around 1535 he retired from office and returned to his hometown, where he remained for the rest of his life. Refusing subsequent official appointments and spending much of his time with literati friends in Soochow, he became an important member in the circle around Wen Cheng-ming.[44] Wang's debt to Wen Cheng-ming is apparent in the close similarity between Wang's *Thousand Character Essay* handscroll, dated 1541, in the Elliott Collection (fig. 19, cat. no. 30) and Wen Cheng-ming's 1529 album of the same text (fig. 20). This comparison reveals the extent of Wen's influence on Soochow calligraphers of the mid-sixteenth century.

The text of "The Thousand Character Essay" originated in the first half of the sixth century, when Emperor Wu (r. 502–49) of the Liang dynasty, an ardent admirer of Wang Hsi-chih's calligraphy, reportedly ordered the official Chou Hsing-ssu (d. 520), a specialist in writing court documents, to collate surviving fragmentary examples of Wang's calligraphy and compose them into an essay that contained exactly one thousand characters, each used only once. The emperor conferred model-book rubbings of the *Essay* on the various imperial princes to be used for the practice of calligraphy. The earliest surviving calligraphic transcription of the *Essay* is by the sixth-century monk Chih-yung (fl. late 6th–early 7th century), who wrote it in both standard and cursive scripts.[45] In succeeding

Figure 20. Wen Cheng-ming, *The Thousand Character Essay* (detail), 1529, album leaves, ink on paper, each leaf 26.3 x 24.0 cm. National Palace Museum, Taipei, Taiwan, Republic of China.

centuries, because the *Essay* became a standard model for calligraphers, most later versions focused on displaying different script forms and individual styles. Before the Sung, most transcriptions followed Chih-yung's version. Beginning in the Yüan dynasty, calligraphers transcribed it in other scripts as well, including seal, clerical, and draft cursive. Soochow calligraphers of the Ming dynasty made numerous copies of the *Essay*; among surviving examples are copies by Chu Yün-ming, Wen Cheng-ming, Ch'en Ch'un, Wang Ch'ung, and Wen P'eng (1498–1573). Their interpretations differ from those of the Yüan. Instead of treating script styles as the main subject, the Ming versions, written in running or cursive script, placed their emphasis on individual expression. Ch'en Ch'un, in an inscription from his 1535 *"The Thousand Character Essay" in Cursive Script (Ts'ao-shu Ch'ien-tzu wen)*, summarizes the approach of Soochow calligraphers:

> Many have calligraphed "The Thousand Character Essay" in the past. Few, however, did so because they enjoyed it; but rather [most did so] because they needed [to study it]. Since "The Thousand Character Essay" has no repeated characters, the study of calligraphy [should] start here. I, however, do not believe in this. Seeking the form (*hsing*) is not as good as seeking the heart or mind (*hsin*) [of calligraphy]. After all, how can one's mind be limited to only a thousand characters? . . . Though studying these scripts is not without merit, one must still take the ancients as one's master. As for myself, even I need to follow the ancients, so how could others take me as their teacher? Thus, copying this scroll is insufficient as an honor but sufficient for practice. This is something that viewers should keep in mind.[46]

Ch'en Ch'un belonged to the third generation of Soochow calligraphers who followed Shen Chou, Wu

K'uan, Chu Yün-ming, and Wen Cheng-ming in the study of the ancients. Beyond mere imitation, a comprehension of the outward "forms" of ancient models was sought as a basis from which to elevate calligraphy to a new literati aesthetic calling for an expression of the "mind" (*i hsing hsieh hsin*).

In the mid-Ming, during the fifteenth and sixteenth centuries, the development of literati culture in Soochow took on a multifaceted but distinctly regional character. Scholars there built private gardens in order to satisfy their desire for seclusion and to pursue their inner quest for an ideal mode of life that combined intellectual, aesthetic, and spiritual cultivation. The interests and erudition of these scholars were as broad as their talents. Some were successful in official life, while others were not. Lack of official success, however, was not always regretted, as it often cleared the way for even greater efforts in art and scholarship. Soochow scholars were especially interested in expressive forms of literature or those which could help them achieve an imaginative spiritual bond with men of the past. They not only appropriated early texts as subjects for their own art, but also used them as vehicles for the expression of their private feelings. Finally, their activities often centered around the connoisseurship and collecting of art, and the copying of ancient masterpieces. Spanning a period of over one hundred years, the works of calligraphy in the Elliott Collection discussed here embody these varied features of literati life in Soochow during a period that is still remembered as the most culturally brilliant in the long history of this ancient city.

Translated by Donald E. Brix
and Liu I-wei

NOTES

1. Wen C. Fong and James C. Y. Watt, *Possessing the Past: Treasures from the National Palace Museum, Taipei* (New York: The Metropolitan Museum of Art; and Taipei: The National Palace Museum, 1996), 381.

2. On Soochow writers, see Chien Chin-sung, *Ming-tai wen-hsüeh p'i-p'ing yen-chiu* (Taipei: Hsüeh-sheng shu-chü, 1989), 85–183.

3. Fong and Watt, *Possessing the Past*, 369–72. The Chancellery style originally referred to the formal style of writing used at court, but in calligraphy it came to designate small standard script. See Fu Shen, "Mindai no shodan," in Nakata Yūjirō and

Fu Shen, eds., *Ōbei shūzō Chūgoku hōsho meiseikishū* (Tokyo: Chūōkōron-sha, 1981–83), 4: 129–30.

4. Cheng Wen-hui, "Ming-tai yüan-lin shan-shui t'i-hua shih chih yen-chiu," *Kuo-li Cheng-chih ta-hsüeh hsüeh-pao*, 69, *shang* (Sept. 1994): 17–41.

5. Fu Shen, "Shen Chou Yu-chu-chü yü *Tiao-yüeh-t'ing t'u chüan*," in *Chung-kuo i-shu wen-wu t'ao-lun hui lun-wen chi—shu-hua, shang* (Taipei: National Palace Museum, 1992), 377–99.

6. Pien Yung-yü, *Shih-ku-t'ang shu-hua hui-k'ao* (Taipei: Cheng-chung shu-chü, 1958), 4: 413.

7. See Wu K'uan, *P'ao-weng Chia-ts'ang chi*, in *Ying-yin Wen-yüan-ko Ssu-k'u ch'üan-shu* (Taipei: T'ai-wan shang-wu yin-shu-kuan, 1983), vol. 1255, *chüan* 58: 537–41, s.v. "T'ien-ch'üan hsien-sheng Hsü kung hsing-chuang." For a biography of Hsü in English, see Wolfgang Franke, "Hsü Yu-chen," in *Dictionary of Ming Biography* (New York: Columbia University Press, 1976), 2: 612–15.

8. See Chu Hui-liang, *Yün-chien shu-p'ai t'e-chan t'u-lu* (Taipei: National Palace Museum, 1994), 2–3.

9. See Shen C. Y. Fu, "Chu Yün-ming: Defining a Master's Range and Quality," in Shen C. Y. Fu et al., *Traces of the Brush: Studies in Chinese Calligraphy* (New Haven: Yale University Art Gallery, 1977), 205–36; and Ho Chuan-hsing, "Chu Yün-ming chi ch'i shu-fa i-shu," part 2, *Ku-kung hsüeh-shu chi-k'an* 10, no. 1 (1992): 1–60.

10. This poem, with slightly different wording, appears in Shen Chou's literary collection under the title "Water Pavilion at the Pei-ssu Temple" (*Pei-ssu shui-ko*). See *Shih-t'ien hsien-sheng chi*, in *Ming-tai i-shu chia chi hui-k'an*, no. 2 (Taipei: Kuo-li chung-yang t'u-shu kuan, 1968), 1: 144. A poem similar to the literary collection's version is also inscribed at the front of a handscroll by Shen Chou titled *Painting of Peonies* (*Shao-yao t'u*). Reproduced in *Shang-hai po-wu-kuan ts'ang Ming ssu-chia ching-p'in hsüan-chi* (Hong Kong: Ta-yeh kung-ssu, 1996), pl. 34.

11. She Ch'eng, "Shan han shan-mien shu-hua," *Ku-kung wen-wu yüeh-k'an* 16, no. 7 (1984): 13–25.

12. Wang Ao, *Chen-tse chi*, in *Ying-yin Wen-yüan-ko Ssu-k'u ch'üan-shu*, 1256: 18, s.v. "Shih-t'ien hsien-sheng mu-chih."

13. For Shen Chou's poems, see his *Shih-t'ien hsien-sheng chi*, 2: 629–43. For the Wen Cheng-ming scroll in the Soochow Museum, see *Chung-kuo ku-tai shu-hua t'u-mu* (Peking: Wen-wu ch'u-pan-she, 1988), 6: fig. no. 1-044. Another version of this work was in the Hsü Po-chai collection in Hong Kong; see *Chūgoku hosho gaido* (Tokyo: Nigensha, 1989), 50: 44–46.

14. T'ang Yin, *T'ang Po-hu hsien-sheng ch'üan-chi* (Taipei: Hsüeh-sheng shu-chü, 1970), 131–44.

15. The poems of the Elliott scroll were originally in the form of album leaves. In addition to this work, other transcriptions of the poems by T'ang Yin appear in the collection of the Chinese Museum of Art (see *Shu-p'u*, nos. 4 and 5, 1989), as well as versions in the Liaoning Provincial Museum, Shenyang (see *Liao-ning sheng po-wu-kuan ts'ang fa-shu hsüan-chi*, set 2 [Peking: Wen-wu ch'u-pan-she, 1982], vol. 13), and the Ling-yen Temple in Soochow (see *Shodō gurafu*, no. 5 [1980]: 2–31. The latter version closely resembles the Elliott scroll (see Nakata and Fu, *Ōbei, Ming–Ch'ing*, vol. 1: 169–171.

16. Chiang Chao-shen, *Kuan-yü T'ang Yin te yen-chiu* (Taipei: National Palace Museum, 1976), 10–18.

17. *T'ang Po-hu hsien-sheng ch'üan-chi*, 89–90.

18. Ho Liang-chün, *Ssu-yu-chai ts'ung-shuo*, in *Pi-chi hsiao-shuo ta-kuan*, part 15 (Taipei: Hsin-hsing shu-chü, 1977), vol. 7, *chüan* 15: 133.

19. Chiang Chao-shen, *Wen Cheng-ming yü Su-chou hua-t'an* (Taipei: National Palace Museum, 1977), 125–36.

20. Wen Cheng-ming, *Fu-t'ien chi* (Taipei: Kuo-li chung-yang t'u-shu-kuan, 1968), vol. 2, *chüan* 26: 7.

21. Fu Shen, "Mindai no shogaku," in Nakata and Fu, eds., *Ōbei, Ming–Ch'ing*, vol. 1: 148–57.

22. Sun Kuo-t'ing, *Shu-p'u* (687), handscroll in the collection of the National Palace Museum, Taipei. See English translation in Chang Ch'ung-ho and Hans H. Frankel, trans., *Two Chinese Treatises on Chinese Calligraphy* (New Haven and London: Yale University Press, 1995), 10–11

23. Liu Wei-ch'ung, *Li Po p'ing chuan* (Taipei: T'ai-wan shang-wu yin-shu kuan, 1996), 219.

24. Ibid., 221.

25. Hsiao Shih-yün, *Li T'ai-pai chi fen-lei pu-chu*, in *Ying-yin Wen-yüan-ko Ssu-k'u ch'uan-shu*, vol. 1066, *chüan* 3: 482.

26. Wang Chao-yün, *Huang-ming tz'u-lin jen-wu k'ao*, Wan-li reign ed., *chüan* 5: 40b.

27. Ma Tsung-huo, *Shu-lin chi-shih*, in Yang Chia-lo comp. and ed., *I-shu ts'ung-pien* (Taipei: Shih-chieh shu-chü, 1967), set 1, vol. 6, *chüan* 2: 70.

28. Chu Yün-ming, *Chu-shih chi-lüeh* (Taipei: National Central Library, 1971), *hsia*, *chüan* 26: 1641.

29. See Wen Cheng-ming, "Wang Lü-chi mu-chih ming," in his *Fu-t'ien chi*, *chüan* 31: 767–70.

30. Chu Hsi, *Ch'u-tz'u chi-chu*, in *Ying-yin Wen-yüan-ko Ssu-k'u ch'üan-shu*, vol. 1062, *chüan* 2: 315.

31. Shen Te-fu, "Chi-mo ku-wan," in his *Wan-li yeh-huo pien* (Taipei: Wei-wen ch'u-pan-she, 1976), vol. 2, *chüan* 8: 552.

32. Tu Mu, *Yü-i pien*, in Yang Chia-lo, comp. and ed., *I-shu ts'ung-pien*, set 1, vol. 17: 274–76.

33. Wu K'uan, *P'ao-weng Chia-ts'ang chi*, *chüan* 48: 440–41.

34. Ibid., *chüan* 49: 452.

35. See Wang Ao, *Chen-tse chi*, *chüan* 22: 352–54; and *chüan* 13: 272. See also *Dictionary of Ming Biography*, 2: 1487–89, s.v. "Wu K'uan."

36. T'ao Tsung-i, *Shu-shih hui-yao*, in *Ying-yin Wen-yüan-ko Ssu-k'u ch'uan-shu*, vol. 814: 785–91.

37. Chang Yen-yüan, *Fa-shu yao-lu*, in Yang Chia-lo, comp. and ed., *I-shu ts'ung-pien*, set 1, vol. 1, *chüan* 1: 2–3.

38. Jung Keng, *Ts'ung-t'ieh mu* (Taipei: Hua-cheng shu-chü, 1984), 1: 221–53.

39. Ho Chuan-hsing, "Chu Yün-ming chi ch'i shu-fa i-shu," 11–15.

40. Chu Yün-ming, *Chu-shih chi-lüeh*, *hsia*, *chüan* 24, 1521.

41. Ibid., *hsia*, *chüan* 26, 1633.

42. See Wen Cheng-ming's colophon to Chu Yün-ming's, *T'ang Sung ssu chia wen* handscroll in the collection of the Palace Museum, Peking. Reproduced in *Ku-kung po-wu-yüan ts'ang li-tai fa-shu hsüan-chi* (Peking: Wen-wu ch'u-pan-she, 1980), set 1, vol. 19.

43. *Shih-ch'ü pao-chi hsü-pien* (Taipei: National Palace Museum, 1971), 1: 404.

44. Huang Fu-fang, *Huang Fu Ssu-Hsün chi*, in *Ying-yin Wen-yüan-ko Ssu-k'u ch'üan-shu*, vol. 1275, *chüan* 56: 879.

45. She Ch'eng, "Ch'ien-tzu wen: Ku-tai te tzu-t'ieh ho chiao-k'o shu," parts 1 and 2, *Ku-kung wen-wu yüeh-k'an* 1, no. 9 (Dec. 1983): 57–61; and 1, no. 10 (Jan. 1984): 91–95.

46. See Ch'en Ch'un's *"The Thousand Character Essay" in Cursive Script* in the collection of the Tokyo National Museum. Reproduced in *Shoseki meihin sōkan* (Tokyo: Nigensha, 1969), vol. 138.

Wang To (1592–1652), *Calligraphy after Wang Hsi-chih* (cat. no. 33, detail of fig. 2).

The Aesthetics of the Unusual and the Strange in Seventeenth-Century Calligraphy

DORA C. Y. CHING

During the seventeenth century, an interest in both the concept and the visual aesthetics of *ch'i*—"the unusual" and "the strange"—percolated among calligraphers and critics. The term *ch'i* and its compounds occur in a number of descriptions of seventeenth-century calligraphy. For example, Chiang Shao-shu (fl. mid-17th century) called the calligraphy of Chang Jui-t'u (1570–1641) "strange and extraordinary" (*ch'i-i*)[1] and the running (*hsing*) and cursive (*ts'ao*) calligraphy of Ni Yüan-lu (1593–1644) "intriguingly strange" (*li-ch'i*).[2] Two calligraphers, Wang To (1592–1652) and Fu Shan (1607–1684/85), addressed the concept of *ch'i* in their own theoretical writings. In the eighteenth and nineteenth centuries, this preoccupation with *ch'i* as a

descriptive term for seventeenth-century calligraphy continued to grow, and references to *ch'i* abound in the critical literature.[3] Modern scholarship also portrays Chang Jui-t'u, Ni Yüan-lu, Wang To, Fu Shan, and Huang Tao-chou (1585–1646) as "individualists" or "eccentrics" who practiced strange and idiosyncratic calligraphy.[4]

The prickly brushwork of Chang Jui-t'u (fig. 1, cat. no. 32), the sharp but fluid characters of Wang To (fig. 2, cat no. 33), and the scraggly characters of Fu Shan (fig. 3, cat. no. 35) do appear highly unusual, especially when compared with the classical elegance of calligraphy by Tung Ch'i-ch'ang (1555–1636; fig. 4). As it was understood in the seventeenth century, however, *ch'i* cannot be defined purely in terms of visual

Figure 1. Chang Jui-t'u (1570–1641), *Ch'ang-an, the Ancient Capital* (cat. no. 32, detail).

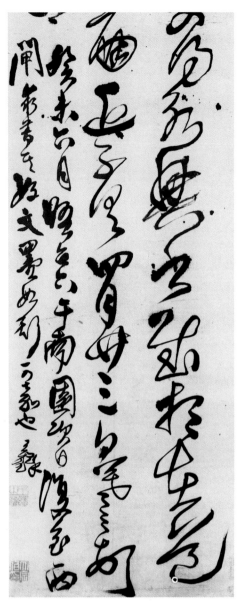

Figure 2. Wang To (1592–1652), *Calligraphy after Wang Hsi-chih* (cat. no. 33, detail).

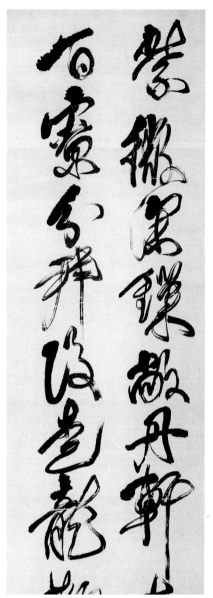

Figure 3. Fu Shan (1607–1684/85), *Poem on the Heavenly Emperor* (cat. no. 35, detail).

effects, particularly since the term was applied to a broad range of styles.

This essay explores the concept of *ch'i*, beginning with a brief review of the successive definitions of the term and then focusing on the aesthetics of *ch'i* in seventeenth-century calligraphy, specifically that of Chang Jui-t'u, Wang To, and Fu Shan. *Ch'i* can be seen to refer above all to the potential for highly individualistic expression that these artists sought in calligraphy. In this context, *ch'i* is translated as "the unusual" and "the strange," two terms that reflect much the same idea with different degrees of intensity. *Ch'i* will also be illuminated by considering its dialectical relationship with the concept of *cheng*—"the normal" or "the orthodox." These seventeenth-century calligraphers'

willful pursuit of "the unusual" and "the strange" in their art can be understood in part as a reaction against prevailing standards.

HISTORICAL DEVELOPMENT OF THE CONCEPT OF *CH'I*

Used in various compounds and translated a number of different ways, the term *ch'i* appeared in criticism of painting and calligraphy well before the seventeenth century. It encompassed a variety of meanings that included but were not limited to "the unusual" and "the strange." In an important early example dating from the late fifth century, Hsieh Ho (fl. ca. 479–502),

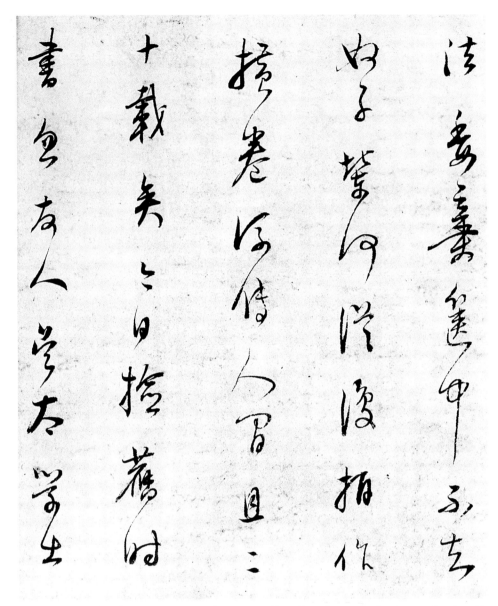

Figure 4. Tung Ch'i-ch'ang (1555–1636), *Theories on Calligraphy and Painting* (detail), 1592, handscroll, ink on paper, two sections, 26.3 x 86.0 cm and 25.0 x 93.5 cm. Palace Museum, Peking. From Wai-kam Ho, ed., *The Century of Tung Ch'i-ch'ang, 1555–1636* (Kansas City, Mo.: Nelson Atkins Museum of Art, 1992), vol. 1, pl. 1; vol. 2, pp. 3–6.

a leading painting critic, used the compound *hsin-ch'i*, "novel and unusual," to describe one artist's innovative and free brushwork.[5] He also called the works of another artist "heroic and unusual" (*ying-ch'i*).[6] In both of these instances, Hsieh Ho used *ch'i* in compounds to comment favorably upon particular qualities in painting.

Critics and theorists from the T'ang and Sung dynasties continued to use the term *ch'i* in various ways. In his *Manual on Calligraphy* (*Shu-p'u*), dated 687, Sun Kuo-t'ing (648?–703?) described the art of calligraphy as "divine and unusual" (*shen-ch'i*), and called the clerical script (*li-shu*) of Chung Yu (151–230) "extraordinary" (*ch'i*).[7] Chang Huai-kuan (fl. ca. 714–760), in one of his many texts on calligraphy, praised the works of Wang

Hsien-chih (344–388) for being "startlingly marvelous" (*ching-ch'i*).[8] In the ninth century the art historian Chang Yen-yüan (ca. 815–ca. 880) coupled *ch'i* with other terms to create compounds that evoke qualities such as "strange and different" (*ch'i-i*)[9] and "noble and unusual" (*kao-ch'i*).[10] In the early twelfth century the critic Tung Yu called the calligraphy of Wang Hsi-chih (303–361) "marvelous" (*ch'i*) and also included *ch'i* in a number of other compounds.[11] Su Shih (1037–1101), Huang T'ing-chien (1045–1105), and Mi Fu (1052–1107), three leading scholar-calligraphers of the northern Sung, similarly used the term *ch'i* in their descriptions of works by famous calligraphers.[12]

In these examples the word *ch'i*, particularly when used in conjunction with other descriptive expressions,

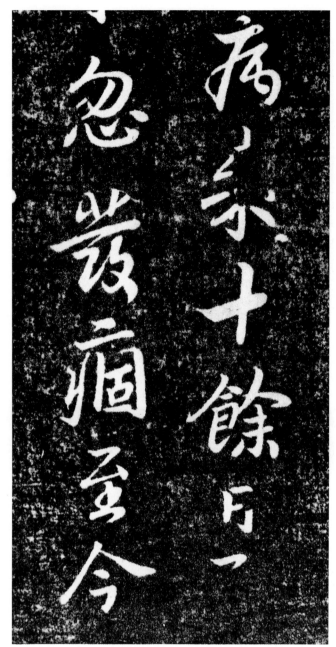

Figure 5. Wang Hsi-chih (303–361), *Letter about Kuan-nu* (detail), K'uai-hsüeh-t'ang rubbing. From *Shodō zenshū*, n.s. (Tokyo: Heibonsha, 1960), 4: pl. 82.

is a chameleon-like term evoking ideas that range from simply "unusual" to "marvelous" to "strange." Nevertheless, what unites these uses is the stress critics and theorists placed on two essential points: *ch'i* as a generally positive attribute and *ch'i* as a description of artistic phenomena that exceeded their expectations or went beyond what they considered normative.

In pointing out "unusual," "extraordinary," or "strange" qualities in painting and calligraphy, critics and theorists implicitly set up a dialectic between *ch'i* and *cheng*. They used the term *ch'i* to indicate features that appeared to deviate from their underlying under-

standing of "the normal" or "the orthodox" (*cheng*). As norms and standards fluctuated over time, so, too, did "the unusual" and "the strange." What remained constant, however, was the opposition between *ch'i* and *cheng*.

Evidence of this dialectic can be found in a number of texts on a variety of media. An early instance of the pairing of *ch'i* and *cheng* occurs in *The Literary Mind and the Carving of Dragons* (*Wen-hsin tiao-lung*) by the literary theorist Liu Hsieh (ca. 465–522). He understood *ch'i* and *cheng* as opposites to be interpreted in light of each other.[13] In describing one of his innovative literary devices, Liu explains that the reversal of "normal" or "orthodox" word order (*cheng*) gives rise to "the unusual" (*ch'i*), a quality he considered desirable.[14] In early painting criticism Chang Yen-yüan used "elegant" and "orthodox" (*ya cheng*) to accord highest praise to a group of artists whom he held up as a standard.[15] In the sixteenth century the critic Ho Liang-chün (1506–1573) clearly used the term *cheng* to denote what he considered to be orthodox models in the tradition of painting.[16] By the late Ming the term *cheng* carried associations of correctness and orthodoxy in literary and painting circles.[17]

In calligraphy criticism the dialectic between *ch'i* and *cheng* occurred on two levels. By the mid- or late Ming, the use of *cheng* paralleled its use in painting and literary criticism and signaled "the normal" and "the orthodox" in a tradition of classical models. On a more specific level, however, when used as a descriptive term applied to individual characters, *cheng* referred to a balanced compositional structure, a standard feature usually considered desirable in the practice of calligraphy. On each level *ch'i* signified the opposite: as a broad concept it indicated a rejection of, or a deliberate effort to transform, traditional models by seeking "the strange," and in its specific sense it described an unbalanced character composition. The writings and the art of certain calligraphers of the seventeenth century reflect this dialectic.

THE METAMORPHOSIS OF *CH'I* IN SEVENTEENTH-CENTURY CALLIGRAPHY

In the early seventeenth century Tung Ch'i-ch'ang, an influential artist, calligrapher, art historian, and official, addressed the concept of *ch'i* in his theoretical

writings on calligraphy. His interpretation of the term, however, reflects a conservative attitude that is consistent with his bias toward *cheng*. Tung strove to establish a tradition of correct models in painting by sorting contemporary and past artists into two stylistic lineages, which he called the Southern and Northern schools by analogy with the two schools of Ch'an (Zen) Buddhism.[18] Promoting the Southern school as the "orthodox" (*cheng*) lineage, he attempted to create standards for critical judgment. Despite his preoccupation with *cheng,* however, he conceded the importance of *ch'i*.

In his comments on *ch'i* in calligraphy, Tung Ch'i-ch'ang adopted a strict interpretation. For Tung, *ch'i* was a descriptive term that referred to a certain kind of character structure. Every character, built up through a series of individual strokes, was a structural unit within an overall composition of many characters; when the internal structure of individual characters appeared off-centered or slanted, Tung described this phenomenon as *ch'i*: "For calligraphers, unbalanced and skewed structure is a manifestation of the quality of strangeness [*ch'i*]."[19]

But Tung, viewing this "strangeness" as a positive quality, accommodated it within the framework of what he considered normal and orthodox. *Ch'i* did not mean complete freedom to construct unbalanced characters without respect to established graphic conventions, nor did it threaten the traditional goal of achieving stability in the overall composition of a word. In describing Wang Hsi-chih's calligraphy in the work *Letter about Kuan-nu (Kuan-nu t'ieh;* fig. 5), Tung wrote that "every character looks as though it is hovering in the air, with a strange [*ch'i*] structure that nonetheless stays upright and balanced [*cheng*]."[20] For instance, in *shih,* the third character in the first column on the right, a vertical stroke tilted toward the right is balanced by a thicker, horizontal stroke, which acts as a counterweight and stabilizes the entire character. What Tung found praiseworthy was Wang's ability to produce an overall effect of balance from characters whose internal structures were not balanced. Implicit in his use of the term *ch'i* to praise Wang Hsi-chih was an understanding that "the strange" did not transgress the bounds of acceptable norms.

Chang Jui-t'u, Wang To, and Fu Shan, three calligraphers who reached maturity during a time when the ideas of Tung Ch'i-ch'ang were widely influential, de-

Figure 6. Chang Jui-t'u, *"Peach Blossom Spring" by T'ao Yüan-ming* (detail), 1615, rubbing in *Kuo-t'ing mo-han,* first leaf of four, 27.4 x 14.0 cm. From Liu Cheng-ch'eng, ed., *Chung-kuo shu-fa ch'üan-chi* (Peking: Jung-pao-chai, 1993), 55: 38.

parted both from his theories and from his calligraphic styles. In the critical writings of these artists, *ch'i* was no longer limited to the narrow function of describing character structure but took on broader meanings that it did not have for Tung.

Chang Jui-t'u was the eldest of this group and a close contemporary of Tung Ch'i-ch'ang. A native of the southern province of Fukien, he traveled the conventional path toward officialdom, passing the provincial examination in 1603 and achieving the prestigious

rank of third place in the metropolitan examination of 1607. This success opened many opportunities for him at court, and over the next two decades he rose from the rank of compiler in the Hanlin Academy to vice-minister of the Board of Rites. Throughout his career as an official he intermittently requested home leave so as to escape politically unstable times at court. In one instance, by staying home for almost two years, he avoided the investigations and political jockeying following the death of the Wan-li emperor in 1620 and that of his successor, the T'ai-ch'ang emperor, who died after only one month on the throne.[21] In 1626, under the patronage of the eunuch Wei Chung-hsien (1568–1627), he was promoted to serve as a member of the Grand Secretariat. Wei admired Chang's calligraphy, and one of Chang's major responsibilities was therefore to write inscriptions for tablets and shrines honoring him. After two years, in 1628, Chang returned to Fukien, pleading ill health, but in 1629, in a purge of all those associated with Wei Chung-hsien ordered by the Ch'ung-chen emperor (r. 1628–44), Chang was stripped of his rank and demoted to the status of a commoner.[22] This ended his official career, and Chang spent the remaining years of his life in Fukien, immersing himself in literary activities and practicing calligraphy until his death in 1641.

In contrast to his official career, which was volatile in the extreme, Chang always enjoyed great success as a calligrapher. One of the Four Masters of the Late Ming—along with Hsing T'ung (1551–1612), Tung Ch'i-ch'ang, and Mi Wan-chung (d. 1628)—he developed a style of calligraphy that elicited much praise. Most critics commented upon his stylistic innovations. Tung Ch'i-ch'ang, as remembered and recorded by Chang in a scroll dated 1637, complimented his unfathomable and outstanding talent in writing small standard script (hsiao-k'ai-shu).[23] A Ch'ing dynasty critic, Liang Yen, remarked upon Chang's squarish, oblique brushstrokes in cursive calligraphy and his ability to transform ancient models completely.[24] Others invoked the term ch'i to characterize Chang's calligraphy.[25]

But what is it exactly about Chang's calligraphy that they defined as "strange"? And did Chang view his own calligraphy as an embodiment of ch'i? Although he does not use the term ch'i in the following passage, he provides a clue as to what he thought it meant:

> The standard calligraphy of Chin dynasty calligraphers is understated and profound, and the beauty of their

calligraphy does not stem from calligraphic techniques. It cannot be achieved through practice and conventional learning. Su Shih said, "Although I do not excel in calligraphy, no one knows calligraphy better than I do. If one can understand the true essence of calligraphy, then one can achieve excellence without laborious practice." If I were given a few years, if I could abandon all that I have already learned, and if I could seek the essence of calligraphy not through conventional training, then I would probably get close to it.[26]

Implicit in Chang's statement is his understanding of the dialectic between ch'i and cheng. He believed that the "essence of calligraphy" could not be realized through the perfection of brush techniques or conventional practice. Nor did the beauty of calligraphy reside in outward forms learned through the emulation of works by past masters. The practice of accumulating technical skill through copying past masters was, in fact, the orthodox (cheng) route to becoming a distinguished calligrapher. Invoking the anti-traditional statement of the northern Sung scholar-calligrapher Su Shih as a precedent, Chang suggested that he could achieve greatness in calligraphy if he could only forget his training and follow his intuition. It is this rejection of tradition that signals his preference for "the unusual" and "the strange" (ch'i) over the orthodox. And indeed despite his thorough training and knowledge of past calligraphic models, he developed a highly individual style that deviated strikingly from conventional norms.

In the eyes of Chiang Shao-shu, a seventeenth-century critic who saw "strangeness" in Chang's calligraphy, Chang was an innovative calligrapher who "developed a new path beyond Chung Yu and Wang Hsi-chih."[27] Drawing inspiration from the small standard script of Chung Yu, Chang invented a personal style of standard script that almost seems a parody of his model. This is apparent in a comparison of Chang's "Peach Blossom Spring" by T'ao Yüan-ming (Hsiao k'ai T'ao Yüan-ming T'ao-hua-yüan chi), a work dated 1615 and preserved in the form of a rubbing (fig. 6), and Chung Yu's Memorial Recommending Chi-chih (Chien Chi-chih piao; fig. 7). Chang exaggerated Chung Yu's scheme of arranging characters in widely separated columns and further highlighted the unusual spacing by crowding the characters together in each column. Although the general shape of his characters and the simplicity of his brushwork reveal his close study of Chung Yu (figs. 8a, b), Chang's characters are oriented vertically,

Figure 7. Chung Yu (151–230), *Memorial Recommending Chi-chih* (detail), rubbing, 25.7 x 13.7 cm. Shodō Hakubutsukan, Tokyo. From *Shodō zenshū*, n.s., 3: pls. 111–12.

whereas Chung's are squat and tend to stretch horizontally. Chang's characters are also more spindly and show sharper brushstrokes, and he often gave them a slight torque by tilting various components within them. For instance, the left side of the radical in Chang's character *tao* leans outward, but it is centered and straight in a comparable character by Chung Yu (figs. 9a, b). This slanted character structure recalls Tung Ch'i-ch'ang's narrow definition of *ch'i,* whereas the combination of these traits—skewed character structure, angular brushwork, and peculiar spacing— reveals Chang's individualism and fits a much broader interpretation of the term *ch'i.*

Many of Chang's artistic idiosyncrasies are evident in the handscroll *Ch'ang-an, the Ancient Capital (Ch'ang-an ku-i;* cat. no. 32), dated 1634 and now in the Elliott Collection. Chang transcribed in cursive calligraphy the lengthy poem "Ch'ang-an, the Ancient Capital" by Lu Chao-lin (fl. 650–669), one of the most famous early T'ang poets. In the poem, Lu Chao-lin pretends to be writing about the Han capital Ch'ang-an, though in fact he is describing the luxury and extravagance of the court of his own period.[28] The poem begins with a description of the hustle and bustle of a vibrant city, but concludes with sobering images of golden stairs and halls of white marble giving way to green pines.

Figure 8a. Chung Yu, *Memorial Recommending Chi-chih* (detail), the characters *pu, shih, kuan.*

Figure 8b. Chang Jui-t'u, *"Peach Blossom Spring" by T'ao Yüan-ming* (detail), the characters *pu, shih, wen.*

Lu expresses disillusionment and a sense of impermanence, conveying nostalgia for better times and suggesting presentiments of a bleak future. Although Chang did not comment upon his choice of this poem for transcription, he may have shared Lu's bitterness and, like Lu, disapproved of the extravagance and decadence of life during his period.

In *Ch'ang-an, the Ancient Capital* the individualistic tendencies Chang revealed in *Peach Blossom Spring* become even more pronounced. Though writing cursive calligraphy, Chang still favored the unusual compositional scheme of widely spaced columns of tightly packed characters that he had developed in his earlier work in standard script. The generous spacing between columns gives an impression of calm, but the tightly compressed characters create a sense of urgency and tension. An upward tilt of the characters and a contrast between thick, ink-laden slanting strokes and thinner, dry ones give his writing movement and vitality; prickly brushwork gives it further energy.

In this scroll Chang eschewed technical virtuosity in brushwork, a quality he viewed as a product of orthodox training and disparaged in the statement translated above. In some characters he reduced the brush movements to the barest essentials. For instance, in the character *lien* (fig. 10, fifth character in the first column on the right), he wrote the radical as a single brushstroke with little manipulation of the brush, making the turns in the stroke as simply as possible. With radically reduced brushwork, unusual compositional schemes, and a professed desire to abandon his classical training, Chang broke away from conven-

tional standards and earned the description of his art as *ch'i.*

Wang To, a younger contemporary of Chang Jui-t'u, not only produced inventive calligraphy but also wrote explicitly about *ch'i.* Like Chang, Wang was an official as well as a renowned calligrapher. A native of Honan Province in central China, he entered government service after passing the metropolitan examination of 1622. From his entry-level position in the Hanlin Academy, he eventually rose to the high rank of minister of rites. After the collapse of the Ming dynasty, he surrendered in 1645 to the Manchus and served as an official under the new dynasty.[29]

Wang had begun practicing calligraphy at an early age and chose for his principal models the work of the fourth-century calligrapher Wang Hsi-chih and his son Wang Hsien-chih.[30] Despite these thoroughly traditional models, however, Wang To's calligraphy was far from conventional.

Figure 9a. Chung Yu, *Memorial Recommending Chi-chih* (detail), the character *chien.*

Figure 9b. Chang Jui-t'u, *"Peach Blossom Spring" by T'ao Yüan-ming* (detail), the character *tao.*

Wang To aspired toward an aesthetic of "the unusual" and "the strange," whose nature he explained as follows:

To be strange [*ch'i*] is only to bring out the true essence completely. It is like excavating an ancient artifact that has never been seen or heard of before from an ancient tomb—it is strange, odd, and shocking—truly bizarre. But what one does not realize is that this ancient artifact had always been in the tomb. Other people have dug two to three feet, or six to seven feet and then have stopped. Today I have dug deep and drawn it out to show to people. I did not dig elsewhere to find the strange.[31]

Wang To conveys his understanding of "the strange" metaphorically. Like an unknown ancient artifact removed from its natural context of an ancient tomb, "the strange" seems bizarre only because it is not recognized as something that was always there. Though hidden and inaccessible to those who do not look for

it, "strangeness" is latent in ordinary things. Wang found it not by digging in places where others had not looked, but only by digging deeper. "The strange" could be found in the most orthodox (*cheng*) of places.

Wang To's definition of *ch'i* represents a striking departure from his predecessors. Tung Ch'i-ch'ang's narrow view essentially limited *ch'i* to a skewed or slanted character structure that miraculously achieved an impression of balance. Chang Jui-t'u considered *ch'i* fundamentally separate and distinct from *cheng* and advocated a rejection of orthodox techniques and training. Wang differed from both, viewing *ch'i* as a hidden core within *cheng*, a strangeness lurking within the commonplace. For Wang, the *ch'i*–*cheng* dialectic was not a clash of opposing forces but a question of unveiling *ch'i*.

Wang To's fascination with *ch'i* and his understanding that "the strange" could be found within the

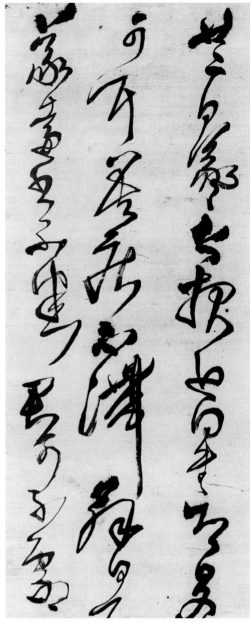

Figure 11. Wang To, *Calligraphy after Wang Hsi-chih* (cat. no. 33, detail).

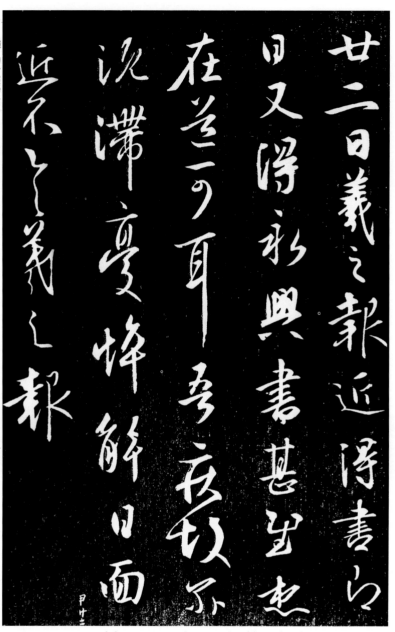

Figure 12. Wang Hsi-chih, *Letter Recently Received,* rubbing, height 26.0 cm. From *Shodō zenshū,* n.s., 4: pl. 62.

familiar meshed well with his deep interest in the classical tradition of Wang Hsi-chih, the most orthodox of all models of calligraphy. *Ch'i* manifests itself in several ways in Wang To's work. Though he based his calligraphy on that of Wang Hsi-chih, Wang To diverged significantly from his model. A tall, narrow hanging scroll in the Elliott Collection, *Calligraphy after Wang Hsi-chih* (fig. 11, cat no. 33), gives the measure of Wang To's artistic license. Written in ink on silk, this hanging scroll is a showy work executed with splendid panache. Thin, ribbon-like brushstrokes merge with thick, ink-saturated strokes, and the characters vary dramatically in size and ink tonality. With its three

columns of large, spiky characters and two half-columns of smaller characters, the composition is a rhythmic dance of swaying columns that opens up space in the center of the scroll only to close it down in the crowded lower left-hand corner.

In his inscription, Wang To recorded the circumstances under which he produced this scroll: "In the sixth month of *kuei-wei* [1643] I met Chao-liu at the Southern Garden. The following day Chao-liu came back to the Western Sluice to entreat me for calligraphy. He loves calligraphy so! Isn't this commendable?" After what was apparently a chance encounter, Chao-liu, a friend identified only by his personal

a. b.

Figures 13a, b. The characters *Hsi-chih*
13a. Wang To, *Calligraphy after Wang Hsi-chih* (cat. no. 33, detail).
13b. Wang Hsi-chih, *Letter Recently Received* (detail).

name, sought out Wang to request some calligraphy. He presumably also presented Wang with the silk on which Wang wrote.

In this scroll, Wang To declared his link to Wang Hsi-chih by choosing two of Wang Hsi-chih's classic model-book letters. But Wang To's transcriptions of these pieces, *Letter Recently Received* (*Chin-te-shu t'ieh*; fig. 12) and *Letter of the 23rd Day of the Fourth Lunar Month* (*Ssu-yüeh nien-san jih t'ieh*),[32] are by no means faithful. He omitted individual characters and even long strings of characters, dropping a total of five characters from the first text and nine from the second. Such haphazard copying rendered the letters unreadable. Prior to the seventeenth century, the standard training in calligraphy had always required that ancient models be copied with strict adherence. Replication of both the text and its calligraphic style was expected. In the seventeenth century, however, calligraphers such as Wang To took a much more liberal view of copying. They experimented with splicing different texts together and took other liberties as a way of realizing their own creative potential.[33] Partially stripped of semantic meaning, the characters functioned as rhythmically linked components in a more purely visual, aesthetic sense. For Wang To, the Wang

Hsi-chih models were more important as visual inspiration than as readable texts.

Besides condensing the Wang Hsi-chih texts, Wang To departed from his model in two other ways. First, he took the format of a small letter from a model-book and magnified it to mural size, transforming Wang Hsi-chih's half-inch characters into characters well over six inches tall. This magnification was strange and daring at the time; Wang To was one of the first to transform an intimate letter into a massive hanging scroll, a format still relatively new in the Ming dynasty but later increasingly popular and widespread. Secondly, Wang To's calligraphy bears scant resemblance to that of the Wang Hsi-chih letters. In *Calligraphy after Wang Hsi-chih*, Wang used cursive calligraphy, even though his models were mainly in running script. His dramatic writing jerks and slashes its way down the silk, whereas Wang Hsi-chih's by comparison is lusciously sedate (see figs. 11 and 12). In the original letters each character is a discrete entity; Wang To's characters merge and dissolve into nearly undecipherable brush-lines. Even at points where his model has the freedom of cursive calligraphy, Wang To's interpretation is more extreme, as evidenced in a comparison of the characters *Hsi-chih* (figs. 13a, b). Wang To's version disintegrates into a series of strokes completely divorced from the model. By creating a work so unlike the Wang Hsi-chih letters he transcribes, Wang To derives something strange from something familiar. His point of departure was Wang Hsi-chih's calligraphy; his radically different result shows the potential for individualism and self-expression latent in even the most traditional of sources.

Wang To also used one-stroke script (*i-pi-shu*) as a method of reformulating works by Wang Hsi-chih and Wang Hsien-chih. Writing one character or several characters with one continuous stroke was a common technique in wild-cursive (*k'uang-ts'ao*) script. The practice also had associations with Taoist trance writing and with the writing of magical talismans, which probably added to its appeal for some calligraphers.[34] Wang To, however, seems to have been mainly interested in the aesthetic possibilities of unusual linkages of characters. At several places in *Calligraphy after Wang Hsi-chih* he wrote several characters in one stroke without lifting his brush from the silk (see fig. 11).

In another hanging scroll written in 1643, *Copying a Letter by Wang Hsien-chih* (*Lin Wang Hsien-chih pao-nu*

Figure 14. Wang To, *Copying a Letter by Wang Hsien-chih*, 1643, hanging scroll, 268.5 x 54.5 cm. From Murakami Mishima, ed., *Ō Taku no shohō* (Tokyo: Nigensha, 1979), pl. 23.

Figure 15a. Detail of figure 14.

Figure 15b. Wang Hsien-chih, *Letter* (detail). From *Ch'un-hua-ko t'ieh* ([Kansu] Lan-chou: Kan-su jen-min ch'u-pan-she, 1988), vol. 2, *chüan* 10: 473–74.

t'ieh; fig. 14), Wang took one-stroke writing to an extreme, connecting so many characters that the entire hanging scroll approaches a single, unbroken brushstroke.[35] The text is a pastiche of phrases from model-book letters by Wang Hsien-chih and Wang Hsi-chih. Wang To began by copying fairly closely the first several characters of a Wang Hsien-chih letter (figs. 15a, b). Yet even the first two characters reveal how quick he was to transform his models. He rearranged the composition by shifting the first character toward the left and compacting its structure, making it squat and giving it heavily inked, rounded loops. The smooth curves of Wang Hsien-chih's characters are replaced by brushlines that arc and bend, sometimes in sharp angles. Wang To continued with a long line of characters in the one-stroke script, and all resemblance to his model disappeared. His calligraphy thwarts any attempt to read it, as the disjointed texts make no sense and the one-stroke writing makes it difficult even to recognize characters—the strange emerges from the familiar.

Fu Shan, a scholar-calligrapher fifteen years younger than Wang To, shared some of Wang's ideas about *ch'i.* A northerner whose family lived near Taiyuan, Shansi, Fu had a classical education, spending his early years in preparation for the civil service examinations and practicing calligraphy and seal carving. The 1640s, however, were traumatic for Fu, owing to his failure in the provincial examination and then to the Manchu conquest of China. In response to the fall of the Ming dynasty, he donned the red robe and yellow cap of a Taoist priest and avoided government service under the foreign regime. He spent the rest of his life composing poetry, writing commentaries on historical texts and essays, practicing and writing about women's health, and writing calligraphy.

Commenting on his training in calligraphy, Fu Shan wrote that he studied all the traditional models, including Chung Yu, Wang Hsi-chih, Wang Hsien-chih, Yen Chen-ch'ing (709–785), and others.[36] He also declared unabashedly of his own writing that he "would rather [it] be awkward, not skillful; ugly, not charming; fragmented, not slick; and spontaneous, not premeditated."[37] His conviction that calligraphy should eschew any classical or orthodox elegance agreed well with his interest in *ch'i.* He wrote,

> There is no clever, ingenious trick to writing calligraphy; there is only the balanced and the clumsy. The

unusual and the strange [*ch'i*] arise from the balanced taken to the extreme, and great cleverness is nothing but clumsiness. If you do not believe this, when you are about to write calligraphy, first form an idea in your mind and think, "I would like to write calligraphy in a certain way." When you have finished writing, the calligraphy will be the complete opposite of your intention. From this you can learn the truth, and you cannot feign this with artifice.[38]

In the concise four-character phrase *cheng chi ch'i sheng,* Fu summed up his definition of *ch'i* as the "extreme form of the balanced." He believed that calligraphy was either "balanced" or "clumsy" and that slick technique would not by itself escape clumsiness. "Balanced" refers to an upright character structure traditionally deemed normative. Fu's use of the term recalls Tung Ch'i-ch'ang, but Tung saw a balanced composition arising miraculously from a "strange" structure; Fu saw strangeness emerging from the balanced. By placing such importance on "the unusual" and "the strange," Fu Shan echoed Wang To. Both men considered *ch'i* a desirable quality that enabled them to go beyond ordinary calligraphic styles to find new sources of creativity, but they described it differently. For Wang To strangeness was hidden in the familiar, for Fu Shan *ch'i* was *cheng* pushed over the edge.

Pursuing *ch'i* by extreme measures, Fu Shan showed a flair for dramatic styles. An accomplished seal carver in his early twenties, he was fascinated by archaic scripts and took to experimenting with antique character forms early in his career. Carving seals introduced him to ancient scripts containing characters that were puzzling and difficult to decipher because they combined archaic forms of familiar components. These forms inspired Fu to invent similarly confusing characters in seal script; his made-up characters intentionally obfuscated meaning.[39] Concocting new character forms by experimenting with ancient scripts gave him an avenue to express his creativity.

A remarkable transcription of the *Lotus Sutra* (fig. 16) executed entirely in seal script (*chuan-shu*) is a testament to Fu Shan's deep interest in the ancient script type. Fu wrote it in 1655, while imprisoned for alleged association with anti-Manchu groups. Incarcerated in the sixth month of 1654 and tortured, he appealed to influential friends in the Ch'ing government, who came to his assistance by testifying on his behalf. A year later he was released.[40] During his imprisonment,

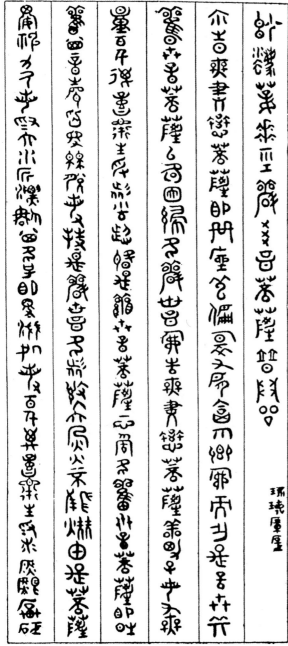

Figure 16. Fu Shan, *"Lotus Sutra" in Seal Script* (detail), 1655, album, measurements unavailable. Private collection.

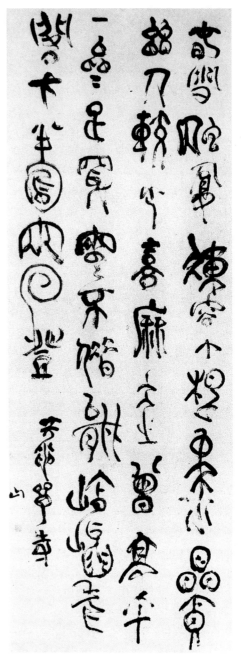

Figure 17. Fu Shan, *Poem to a Ch'an Temple,* hanging scroll, ink on paper, 160.1 x 59.3 cm. Shanghai Museum. From *Chung-kuo ku-tai shu-hua t'u-mu* (Peking: Wen-wu ch'u-pan-she, 1990), vol. 4, no. 1–2427, p. 231.

in an act that was filial and perhaps also religious, Fu copied the Buddhist sutra for his mother. Although seal script had been used before in frontispieces by other calligraphers, Fu's use of the script for his entire text was unprecedented. With painstaking care, he used a centered brush tip to make strong, rounded strokes in imitation of the even, unmodulated lines in ancient bronze inscriptions. He also undermined the readability of the sutra by littering it with strange characters.[41] A religious text is seemingly transformed

into a magical charm by an unreadably archaic script further confused by invented characters.

Fu Shan continued to play with undecipherable scripts in *Poem to a Ch'an Temple (T'ien-lung Ch'an ssu shih;* fig. 17), a hanging scroll of strange ciphers and distorted characters in a style inspired by seal script. Seal script is usually admired for its evenness and solidity, but Fu Shan has made it look like a magic code complete with circles and spirals. As a Taoist priest, he would have been familiar with the secret writing used

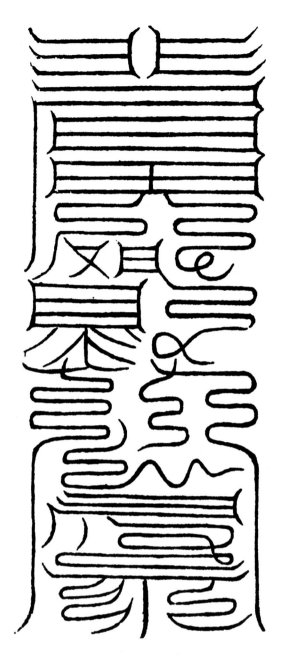

Figure 18. Taoist charm from *The Inner Chapters of the "Pao-p'u-tzu"* (*Pao-p'u tzu, nei-p'ien*) by Ko Hung (283–343), *Ssu-pu pei-yao* edition (Taipei: Chung-hua shu-chü, 1965), *chüan* 17.

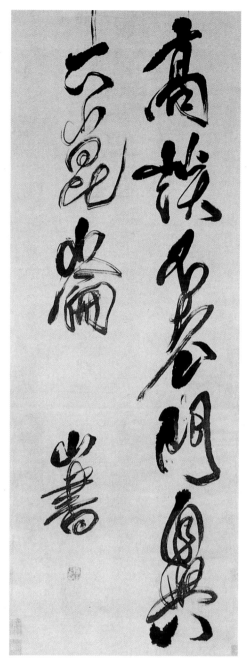

Figure 19. Fu Shan, *Poem on the Heavenly Emperor* (cat. no. 35, detail).

for charms and incantations, and he may have drawn inspiration from Taoist talismans (fig. 18).[42] Fu's eccentric artistic language thus drew not only on obscure ancient scripts but also on contemporary religious esoterica.

Fu Shan's creative tendencies in seal script are equally evident in more conventional script types. In a towering satin hanging scroll measuring over nine feet high, Fu transcribed the poem "The Heavenly Emperor" (cat. no. 35), excerpted from a collection of ninety-eight verses titled *Poems on Wandering Immortals* (*Hsiao-yu hsien shih*). By the minor T'ang poet Ts'ao T'ang (fl. 847–873), the poem reads,

> Within the deeply locked heavenly palace, the Red Pavilion stands open,
> The Heavenly Emperor speaks aloud of the gate to eternal life.
> After the officials bid him farewell,
> Astride dragons and tigers, they descend Mount K'un-lun.[43]

Signing the scroll "written by Shan," Fu transcribed the seven-character-meter poem in two columns of large characters in a mixture of cursive and running scripts. He arranged the characters in a fairly orderly way, so that they basically fit within the imaginary box-grid associated with standard script. The impression of order, however, is deceptive. Some characters appear to be running script in form, but the quick, dramatic manner of their execution takes them close to cursive script. Many, such as *k'un-lun* (fig. 19, second and third characters in the second column from the right), have energetic, chaotic twists and turns, resembling sharp ribbons bending and folding back upon themselves in space. Some brushstrokes are so wet and drippy that the ink bled into the satin, creating ragged edges, while other strokes are so dry they look parched. Even the shapes of some characters appear contorted and misshapen, for instance the character *pu* (fig. 19, third character in the first column). Fu's willful distortions of characters and the dramatic juxtaposition of strokes in dry and wet ink represent some of the devices he used to transform the ordinary into "the unusual" and "the strange."

Ch'i was a concept that helped seventeenth-century calligraphers such as Chang Jui-t'u, Wang To, and Fu Shan transcend traditional methods of practicing calligraphy. Each developed different artistic strategies— Chang's innovative compositional scheme and prickly style, Wang To's transformations of the Wang Hsi-chih models, and Fu Shan's inventive distortions of characters. *Ch'i* was an abstract, even complex, concept that encompassed, or was applied to, all of these diverse reactions to orthodoxy. It embodied a challenge by calligraphers to orthodoxy, a challenge that did not so much reject norms as take them as a point of departure for highly individual experiments. In the art and culture of seventeenth-century calligraphy, the aesthetics of "the unusual" and "the strange" signified that, despite the weight of centuries of traditional historical models, calligraphy could still be a medium for individual expression.

NOTES

1. Chiang Shao-shu, *Wu-sheng-shih shih* (mid-17th century), *chüan* 4: 72, in *Hua-shih ts'ung-shu* (Taipei: Wen-shih-che ch'u-pan-she, 1983), 2: 1030 (hereafter *HSTS*).

2. Ibid., *chüan* 4: 77, in *HSTS* 2: 1035.

3. For references to *ch'i* concerning Chang Jui-t'u, see P'eng Yün-ts'an (1780–1840), comp., *Li-tai hua-shih hui chuan* (Shanghai: Shanghai sao-yeh shan-fang, 1920), *chüan* 10: 13; and Ma Tsung-huo, *Shu-lin tsao-chien* (1936, reprint, Taipei: Shang-wu yin-shu-kuan, 1982), *chüan* 11: 335b. On Fu Shan, see Ch'in Tsu-yung (1825–1884), *T'ung-yin lun-hua*, in Yang Chia-lo, ed., *Ch'ing-jen hua-hsüeh lun-chu* (Taipei: Shih-chieh shu-chü, 1968), 2: 12; and Ma, *Shu-lin tsao-chien*, *chüan* 12: 346b–47.

4. See Shen C. Y. Fu et al., *Traces of the Brush: Studies in Chinese Calligraphy* (New Haven: Yale University Art Gallery, 1977), 94–96, cat. nos. 62, 64, 65, 67; Fu Shen, "Ming mo Ch'ing ch'u te t'ieh-hsüeh feng-shang," in *Ming mo Ch'ing ch'u shu-fa chan* (Taipei: Ho Ch'uang-shih chi-chin-hui, 1996): 9–25; and Cheng P'ei-k'ai, "Ming mo Ch'ing ch'u te wen-hua sheng-t'ai yü shu-fa i-shu," in ibid., 26–34.

5. Hsieh Ho, quoted by Chang Yen-yüan in *Li-tai ming-hua chi* (completed 847), *chüan* 6: 78, in *HSTS* 1: 82.

6. Ibid., *chüan* 7: 85, in *HSTS* 1:89.

7. Sun Kuo-t'ing, *Shu-p'u*, dated 687, illustrated and transcribed in *Ku-kung li-tai fa-shu ch'üan-chi* (1976–79; 3d reprint, Taipei: National Palace Museum, 1988), 1: 84–127, 172–75.

8. Chang Huai-kuan, *Shu-ku*, in Chang Yen-yüan, *Fa-shu yao-lu*, completed ca. 847 (Peking: Jen-min mei-shu ch'u-pan-she, 1984), *chüan* 4: 141.

9. Chang Yen-yüan, *Li-tai ming hua-chi*, *chüan* 9: 115, in *HSTS* 1: 119.

10. Ibid., *chüan* 10: 120, in *HSTS* 1: 124. For additional references to *ch'i* in *Li-tai ming-hua chi*, see *chüan* 7: 91 (*ch'i-wei*); *chüan* 8: 98 (*kao-ch'i*); *chüan* 9: 115 (*ch'üan-ch'i*), in *HSTS* 1.

11. Tung Yu, *Kuang-ch'uan shu-pa*, as cited in Ma Tsung-huo, *Shu-lin tsao-chien*, 55a, 126a, 129b.

12. For references to *ch'i* and its compounds, see Teng Ch'un, *Hua-chi* (ca. 1167), *chüan* 3: 11 (*ch'i-kuai*); *chüan* 3: 13 (*ch'u-ch'i*); *chüan* 5: 37 (*ch'i-i*); and *chüan* 9: 71, in *HSTS* 1. See also *Hsüan-ho hua-p'u* (preface dated 1120), *chüan* 2: 14 (*ch'i-wei*); *chüan* 11: 122 (*ch'i*); and *chüan* 20: 251 (*ch'i-ch'iao*), in *HSTS* 1.

13. Liu Hsieh, *Wen-hsin tiao-lung*, in Chou Chen-fu, ed., *Wen-hsin tiao-lung chu-shih* (Peking: Jen-min wen-hsüeh ch'u-pan-she, 1981), *chüan* 30: 339.

14. Ibid., 340. For an English translation, see Vincent Yu-chung Shih, *The Literary Mind and the Carving of Dragons* (New York: Columbia University Press, 1959), 173.

15. Chang Yen-yüan, *Li-tai ming-hua chi*, *chüan* 1: 15, in *HSTS* 1: 19. For an English translation, see William R. B. Acker, *Some T'ang and Pre-T'ang Texts on Chinese Painting* (Westport, Conn: Hyperion Reprint Edition, 1979), 149.

16. Ho Liang-chün, *Ssu-yu-chai hua-lun*, 36–37, as quoted in Richard Barnhart, "The 'Wild and Heterodox School' of Ming Painting," in Susan Bush and Christian F. Murck, eds., *Theories of the Arts in China* (Princeton: Princeton University Press, 1983), 377.

17. On literature, see Jonathan Chaves, "The Panoply of Images: A Reconsideration of the Literary Theory of the Kung-an School," in Bush and Murck, eds., *Theories of the Arts in China*, 341–64; and also Richard John Lynn, "Alternate Routes to Self-Realization in Ming Theories of Poetry," 317–40, in the same

volume. On painting studies, see James Cahill, *The Compelling Image: Nature and Style in Seventeenth-Century Chinese Painting* (Cambridge, Mass., and London: Harvard University Press, 1982), 94–98. See also Katherine Burnett, "The Landscapes of Wu Bin (c. 1543–c. 1626) and a Seventeenth-Century Discourse of Originality" (Ph.D. diss., University of Michigan, 1995), esp. 90–129.

18. See Wai-kam Ho, ed., *The Century of Tung Ch'i-ch'ang, 1555–1636,* 2 vols. (Kansas City, Mo.: Nelson Atkins Museum of Art, 1992), esp. Celia Carrington Riely, "Tung Ch'i-ch'ang's Life," 1: 385–458; Wai-kam Ho and Dawn Ho Delbanco, "Tung Ch'i-ch'ang's Transcendence of History and Art," 1: 3–42; and Wen C. Fong, "Tung Ch'i-ch'ang and Artistic Renewal," 1: 43–54.

19. Tung Ch'i-ch'ang, *Hua-ch'an-shih sui-pi,* in *I-shu ts'ung-pien ti i chi* (Taipei: Shih-chieh shu-chü, 1962), vol. 28, *chüan* 1: 7. Translation adapted from Xu Bangda, "Tung Ch'i-ch'ang's Calligraphy," trans. Hui-liang Chu, Hans Frankel, and Chang Ch'ung-ho, in Ho, ed., *The Century of Tung Ch'i-ch'ang,* 1: 116.

20. Tung Ch'i-ch'ang, *Hua-ch'an-shih sui-pi, chüan* 1: 24. Translation adapted from Xu Bangda, "Tung Ch'i-ch'ang's Calligraphy," 108. Another citation used to demonstrate Tung's attitude toward *ch'i* is "i ch'i wei cheng," which has been translated, "to use 'the unusual' and 'the strange' to achieve 'the normative' or 'the orthodox.'" See Nelson Wu, "Tung Ch'i-ch'ang: Apathy and Government Fervor in Art," in Arthur F. Wright and Denis Twitchett, eds., *Confucian Personalities* (Stanford: Stanford University Press, 1960), 290; and Ho and Delbanco, "Tung Ch'i-ch'ang's Transcendence in History and Art," 1: 34–35. This phrase, however, refers to the character structure of Wang Hsi-chih's calligraphy and should be translated "to use the slanty to achieve balance." The original text by Tung Ch'i-ch'ang can be found in *Hua-ch'an-shih sui-pi, chüan* 1: 2.

21. Liu Heng, "Chang Jui-t'u ch'i jen ch'i shu," in *Chung-kuo shu-fa ch'üan-chi* (Peking: Jung-pao-chai, 1992), 55: 3.

22. Ibid., 5; *Ming shih* (1974 ed.; reprint, Peking: Chung-hua shu-chü, 1991), *chüan* 306: 7846.

23. Chang Jui-t'u, colophon to *Tu i shih erh shou,* handscroll dated 1637, illustrated in *Shodō zenshū,* n.s. (Tokyo: Heibonsha, 1961), 21: 24.

24. Liu Heng, "Chang Jui-t'u ch'i jen ch'i shu," 15.

25. See note 3.

26. Chang Jui-t'u, "Shu-p'ing shih-p'ing," in *Kuo-t'ing mo-han, chüan* 1, as cited in Liu Heng, "Chang Jui-t'u ch'i jen ch'i shu," 9.

27. Chiang Shao-shu, *Wu-sheng-shih shih, chüan* 4: 72. Chiang also recorded a popular belief that Chang Jui-t'u's calligraphy had talismanic properties, providing protection against fire because Chang was the reincarnation of the water star and his pseudonym was Erh-shui, "Two Water." Nakata Yūjirō suggests that this legend arose as patrons attempted to justify their appreciation of the calligraphy of Chang Jui-t'u, whose reputation had been put into question because of his association with the corrupt eunuch Wei Chung-hsien. See "Ron Chō Zuito," *Shodō zenshū, n.s.,* 21: 18–27.

28. For a transcription of the text, see *Ch'üan T'ang shih* (1960 ed.; reprint, Peking: Chung-hua shu-chü, 1985), *chüan* 41: 518–19. For a complete English translation, see Stephen Owen, *The Poetry of the Early T'ang* (New Haven and London: Yale University Press, 1977), 105–8.

29. For Wang To's biography, see Mingshui Hung, "Wang To," in L. Carrington Goodrich and Chaoying Fang, eds., *Dictionary of Ming Biography, 1368–1644* (New York: Columbia University Press, 1976), 2: 1434–36.

30. Liu Cheng-ch'eng, "Wang To shu-fa p'ing-chuan," in *Chung-kuo shu-fa ch'üan-chi* (Peking: Jung-pao-chai, 1993), 61: 8.

31. Wang To, *Ni-shan-yüan chi* (1653), *chüan* 82: 2b. I am grateful to Qianshen Bai for bringing the Chinese text to my attention.

32. Reproduced in *Shodō zenshū,* n.s., 4: pl. 63.

33. See Hui-liang Chu, "Explorations of Free-Copying: One Aspect of the Development of Calligraphy after Tung Ch'i-ch'ang" (paper presented at the Tung Ch'i-ch'ang International Symposium, The Nelson-Atkins Museum of Art, Kansas City, April 19, 1992); and Qianshen Bai, "Indiscriminate Duplication of Calligraphy, Pictures and Texts in Late Ming and Early Qing" (paper presented at the annual meeting of the Association for Asian Studies, March 16, 1997).

34. See Lothar Ledderose, " Some Taoist Elements in the Calligraphy of the Six Dynasties," *T'oung Pao* 70, nos. 4–5 (1984): 246–78. On magic writing, see also Jonathan Chaves, "The Legacy of Ts'ang Chieh: The Written Word as Magic," *Oriental Art,* n.s., vol. 23, no. 2 (Summer 1977): 200–15.

35. Liu Cheng-ch'eng, "Wang To shu-fa p'ing-chuan," 20–22.

36. See Qianshen Bai, "Fu Shan (1607–1684/85) and the Transformation of Chinese Calligraphy in the Seventeenth Century" (Ph.D. diss., Yale University, 1996), 50–51. For the Chinese text, see Fu Shan, *Fu Shan ch'üan shu* (Taiyuan: Shan-hsi jen-min ch'u-pan-she, 1991), 1: 519–20.

37. Fu Shan, *Fu Shan ch'üan shu,* 1: 50. Translation adapted slightly from Bai, "Fu Shan," 112.

38. Fu Shan, *Fu Shan ch'üan shu,* 1: 511.

39. For a discussion of the vogue of seal carving and inventing strange characters, see Bai, "Fu Shan," 31–47.

40. Ibid., 96–98. See also Fu Shan, *Fu Shan ch'üan shu,* 7: 5159–97.

41. Bai, "Fu Shan," 147.

42. Ibid., 183–84. See also Tseng Yuho, *A History of Chinese Calligraphy* (Hong Kong: Chinese University Press, 1993), 95.

43. There are several discrepancies between Ts'ao T'ang's original poem and Fu Shan's transcription. Most notable is Fu's substitution of the "Pu-lao Gate of Lo-yang" (*pu-lao-men*) in the second line for "gate to eternal life" (*pu-ssu-men*). My translation follows Ts'ao T'ang's poem because Fu Shan's substitution makes little sense. For interpretations of *pu-lao-men,* see *Chung-wen ta tz'u tien* (Taipei: Chung-kuo wen-hua ta-hsüeh, 1973, 1990), 1: 343b. For the original text, see *Ch'üan T'ang shih, chüan* 641: 7351.

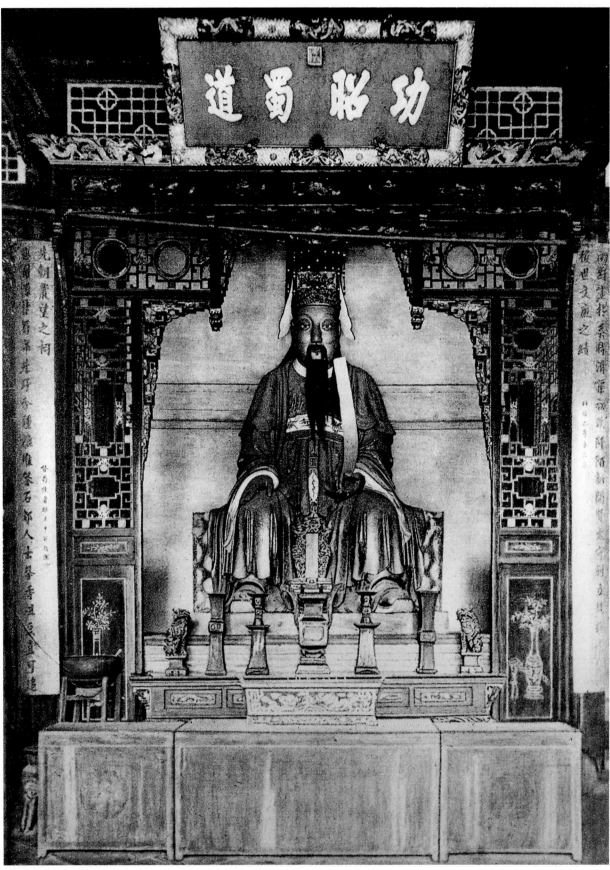

Figure 1. Altar to Li Ping, the Drain God (*Kuan-k'ou shen*), Ch'ing dynasty, Fu-lung-kuan Monastery, Kuan-hsien, Szechwan.
Photo ca. 1906–9, from Ernst Boerschmann, *Picturesque China: Architecture and Landscape, A Journey Through Twelve Provinces*
(London: T. Fisher Unwin, n.d.), pl. 130.

Calligraphic Couplets as Manifestations of Deities and Markers of Buildings

CARY Y. LIU

Calligraphic couplets—commonly referred to as *tui-lien*, *tui-fu*, or *tui-tzu*—originated as markers of spiritual and worldly edifices. From their earliest appearance as a calligraphic format, couplets were linked to ritual and building practices. Flanking a column bay, bracketing a door opening, or forming a triptych with a central scroll, altar, or throne (*chung-t'ang*; figs. 1, 2), couplets marked literal or phenomenal portals and were inseparable from religious and building rites.[1]

Although the terms used to designate them are similar, calligraphic couplets as an artistic format should be clearly differentiated from literary and poetic couplets. Poetic couplets as an oral or written tradition originated early in the history of Chinese literature. The unique graphic-phonetic correspondence in reading and speaking Chinese characters may have naturally led to the pairing of lines of equal length.[2] Such paired lines can be found in works as early as *The Book of Poetry* (*Shih ching*) and *The Songs of Ch'u* (*Ch'u-tz'u*), but couplet writing probably did not become recognized as an independent literary form until the T'ang dynasty, when rules for poetic prosody, antithetical parallelism, and other techniques were fully developed.

Here the term *tui-lien* designates a calligraphic format. While the rules for poetic prosody and parallel structure govern the internal composition of many calligraphic couplets, they account for only a part of the wide range of calligraphic couplet writing. As a visual as well as literary format, calligraphic couplets can be categorized by intended use and function. The terms "column couplets" (*ying-lien*), "door couplets" (*men-lien*), and "spring couplets" (*ch'un-lien*) indicate the location where, or season when, couplets are displayed, while "wedding couplets" (*hsi-lien*), "birthday couplets" (*shou-lien*), and "funerary couplets" (*wan-lien*) demarcate occasions or events. Such designations for couplets, however, fail to impart a sense of the format's origin or to recognize the importance of the central void or passage that couplets frame.

In China the architectural building process is accompanied at almost every step by rituals, and deities are believed to permeate various parts of a building. Too often dismissed as mere superstition, along with geomancy and building magic, such practices are in fact essential to the Chinese conception of architecture. At various times and places, sets of deities and sacrifices have been associated with dwellings. One of the oldest groups is the Five Sacrifices (*Wu-ssu*) listed in *The Book of Rites* (*Li chi*), which specify oblations to the Gods of the Inner Door (*Hu*); Hearth (*Tsao*); Impluvium, or Rain-water Basin (*Chung-liu*); Outer Door (*Men*); and Passages (*Hsing*).[3] Each deity guarded a gateway to a spiritual realm that linked earthly abodes to heaven, earth, ancestors, and the afterlife. The placement of calligraphic couplets at these locations marked these passageways. Today couplets are still found flanking an auspicious image or piece of writing in a central location in many residences (fig. 3). Such practices continue the worship of the Gods of the Hearth or Impluvium and mark the geomantic center of a building (*chung-t'ang* or *chung-kung*), where a family's ancestral altar is often housed.[4] The application of the expression "central hall" (*chung-t'ang*) to a painting or calligraphy scroll hung between couplets in the main hall or behind an altar seems, in part, to derive from this tradition of marking the geomantic center. Guarding the gateway, such couplets offer more than auspicious wishes for fortune and blessing; they also provide protection against harmful demons and spirits that might trespass through the gate. This protective function is better documented for couplets marking the Gods of the Inner and Outer Doors.

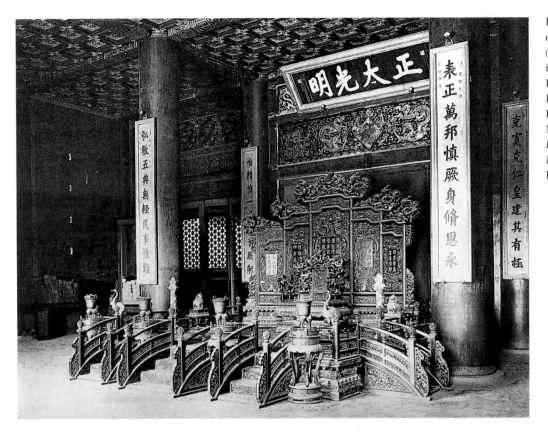

Figure 2. Throne chamber of the Ch'ien-ch'ing-kung (Palace of Heavenly Purity) in the Forbidden City, Peking, Ch'ing dynasty. Photo ca. 1906, from Imperial [Household] Museum of Tokyo, comp., *Photographs of Palace Buildings of Peking* (Tokyo: K. Ogawa, 1906), pl. 67.

At the approach of the Lunar New Year, spring couplets are traditionally placed by house doors with wishes for good fortune in the coming year. Legend has it that in ancient times a beast called the *nien* emerged to devour people on the first day of each year (*nien*). Because the *nien* beast was said to fear the color red, peach-tree-wood and (later) red-paper couplets and tablets were hung by doors as protective devices. In fact, most tales about the earliest recorded couplets concern the apotropaic property of spring couplets.

Figure 3. Calligraphic couplets presented on the occasion of a building's completion and hung symmetrically about a central hanging scroll surmounted by the characters "Auspicious airs fill the main hall." Central room of a modern dwelling in Lan-hsi, Chekiang.

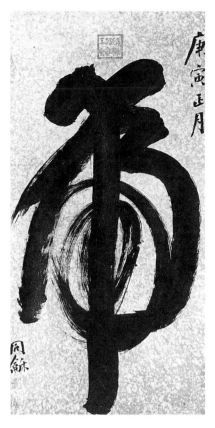

Figure 4. Weng T'ung-ho (1830–1904), *Tiger*, calligraphy in "one-stroke" technique that combines the image of ropes with the word "tiger" (*hu*), Ch'ing dynasty, hanging scroll, ink on mottled orange paper, 132.2 x 61.2 cm. Wango H. C. Weng Collection. From Shen C. Y. Fu et al., *Traces of the Brush: Studies in Chinese Calligraphy* (New Haven: Yale University Art Gallery, 1977), cat. no. 87, p. 123 (illus.).

(934–65). In the year 946, after permitting the court official Hsin Yin-hsün to compose a poem and engrave it as a peach-wood amulet (*t'ao-fu*) to be hung on the inner door of the palace, Meng Ch'ang judged the work to be deficient and composed his own couplet:

> The new year inherits the remaining good fortune;
> The auspicious festival heralds an endless spring.
> [*Hsin-nien na yü ch'ing;*
> *Chia-chieh hao ch'ang ch'un.*]

This story became popularly known, however, only after it was anecdotally recorded in Liang Chang-chü's (1775–1849) *Collected Anecdotes on Column Couplets* (*Ying-lien ts'ung-hua*), which dates to the early nineteenth century.[6] Therefore, the accuracy of calling this the oldest couplet is highly questionable. However, the suggestion that spring couplets originally developed from peach-wood amulets finds textual corroboration in a passage from *The Classic of Mountains and Seas* (*Shan-hai-ching*) recorded in Wang Ch'ung's (A.D. 27–ca. 97) *Disquisitions* (*Lun-heng*) of the Han dynasty.[7] In the passage, a large peach tree stands on the slopes of Mount Tu-shuo in the Eastern Sea. In the tree there is a spirit gate through which demons come and go. Two brothers, Shen Shu and Yü Lü, stand guard by the tree. Using a rope, they capture harmful demons and feed them to a tiger. Accordingly, Wang Ch'ung notes,

Although some anecdotes record examples of spring couplets produced by Wang Hsi-chih (303–361) in the Eastern Chin period,[5] the conventional story about the earliest couplet attributes their invention to Meng Ch'ang (r. 934–65), the ruler of the Later Shu dynasty

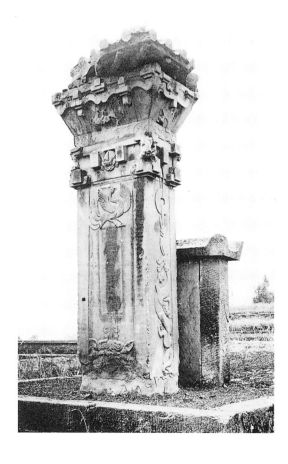

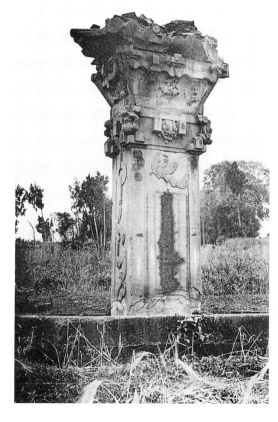

Figures 5a, b. Inscribed tomb pillars of the Han dynasty official Ch'en, 2nd century A.D., Ch'ü County, Szechwan. Southern views. From Victor Segalen, Gilbert de Voisins, and Jean Lartigue, *Mission archéologique en Chine (1914 et 1917)* (Paris: Paul Geuthner, 1923–24), I: pl. 16.

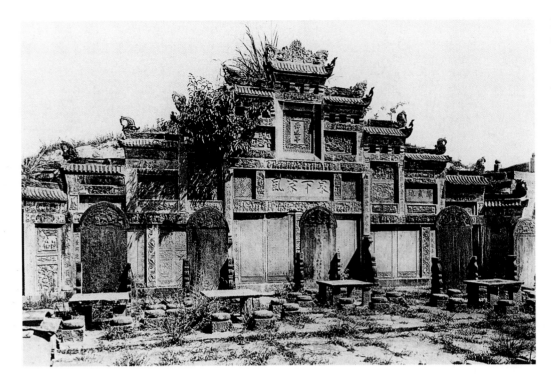

Figure 6. Family tomb, Ya-chou County, Szechwan, Ch'ing dynasty. Photo ca. 1906–9, from Boerschmann, *Picturesque China*, pl. 139.

the Han dynasty emperor erected effigies of the two brothers carved from peach wood in front of his door to ward off evil. Later, images of tigers, ropelike calligraphic amulets written in "one-stroke" (*i-pi-shu*) script (fig. 4),[8] along with peach-wood amulets, were hung by doorways. Paired amulets appear to be the precedent for door couplets. By the Han dynasty there is evidence in a commentary to *The Book of Rites* that the brothers Shen Shu and Yü Lü were already recognized as the Gods of the Door (*Men-shen*); later peach-wood effigies, amulets, and door couplets can be understood as manifestations of these protective guardians of the house and family.[9] The subsequent use of red paper, or even red characters, can be under-

stood as a substitution for peach wood. Some have even suggested that red-paper couplets were used to ward off evil in the Shu region (modern Szechwan) during the Three Kingdoms period.[10]

Other possibly related origins of the calligraphic couplet format may be observed in honorific inscriptions on Han dynasty tomb pillars (*ch'üeh*) and in early representations of deities in which a center image is flanked by columns of calligraphy. Pairs of tomb pillars were sometimes erected marking a central gateway to a sepulcher (figs. 5a, b). On the front and rear faces of some surviving pillars, characters are carved in vertical lines.[11] Such inscriptions usually describe the official titles held by the deceased, and they are possibly the forerunner of later, eulogistic funerary couplets (fig. 6).[12]

An early example of a deity flanked by columns of calligraphy is represented by an excavated ceramic brick from the Eastern Chin period showing the tortoise and snake figure of the Dark Warrior (*Hsüan-wu*), one of the Four Deities (*Ssu-shen*) of the cardinal directions. The deity is shown in relief in a center panel (fig. 7). On either side are vertical strips, each with the same number of inscribed characters. In a second example, reflecting the spread of Buddhism in China, the tripartite format also appears in painted representations of buddhas and Buddhist paradises. In a tenth-century woodblock print recovered from the Tun-huang Caves in Kansu, the image of Kuan-yin, the Bodhisattva of Infinite Compassion, is flanked by lotus

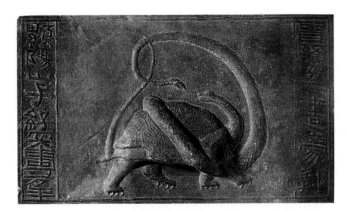

Figure 7. Tomb tile with the figure of the Dark Warrior deity flanked by vertical inscriptions in relief, Eastern Chin dynasty, 398, excavated in 1972 at Chen-chiang, Kiangsu, 31.5 x 18.0 cm. Chen-chiang Municipal Museum. From *Chung-kuo mei-shu ch'üan-chi, tiao-su pien*, vol. 3, *Wei-Chin Nan-Pei ch'ao tiao-su* (Peking: Jen-min mei-shu ch'u-pan-she, 1988), pl. 21.

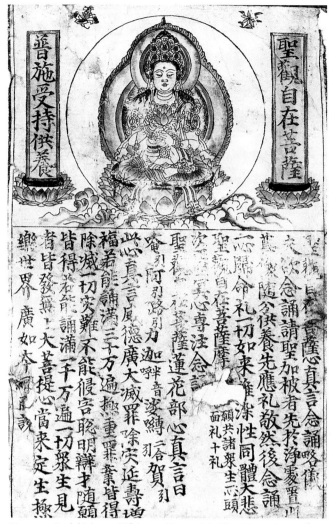

Figure 8. *Avalokitésvara* (Chinese: Kuan-yin), Five Dynasties, 10th century, Tun-huang, Kansu, woodblock print, ink and color on paper, 39.9 x 17.0 cm. British Museum. From Roderick Whitfield, *The Art of Central Asia: The Stein Collection in the British Museum* (Tokyo: Kodansha, 1983), 2: pl. 81.

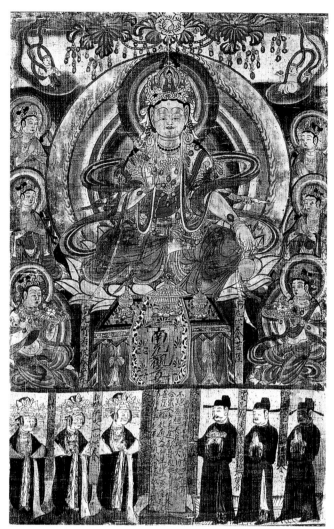

Figure 9. *Avalokitésvara with Donors,* Northern Sung dynasty, 972, Tun-huang, Kansu, hanging scroll, ink and colors on silk, 91.5 x 59.1 cm. British Museum. From Whitfield, *The Art of Central Asia,* 2: pl. 26.

blossoms supporting vertical placards, each bearing six inscribed characters (fig. 8). In the foregoing examples, the flanking calligraphy cannot be considered couplets; instead, they are more aptly called cartouches. While they do not manifest the presence of a deity by themselves—as it was believed that door couplets and spring couplets could—they serve to help identify and support the central images.

In another image of Kuan-yin, dated 972 (fig. 9), also from Tun-huang, the pictorial surface is divided into two areas. The deity and six attendants occupy an upper square zone. In front of the bodhisattva is an altar table with a central cartouche. Lines of calligraphy on equally sized blue strips lie to either side. Below the upper zone, a row of donor figures stand facing into the center, which is occupied by a yellow rectangle containing a calligraphic inscription. To

either side are symmetrically arranged pairs of alternating blue and yellow strips bearing calligraphy that separate the donor images. As in the prior two examples, the paired calligraphy seen in this painting cannot be considered to be couplets; however, it is likely that this basic format of a central altar, or hanging scroll, with flanking calligraphy was the prototype of what later is called the "central hall" (*chung-t'ang;* fig. 10). As suggested earlier, the name "central hall" may actually derive from ritual and geomantic building practices, but this requires further investigation. Here, I offer as conjecture the possibility that in the later development of this prototype, the "central hall" calligraphy or painting scroll becomes a visualization leading to a separate realm. The triptych acts as a framed portal through which one enters in spirit, hope, or imagination.

Figure 10. Diagram of a "central hall" triptych arrangement with couplets flanking a central hanging. From Tseng, *A History of Chinese Calligraphy*, fig. 4.35.

Figure 11. Li Wen-t'ien (1834–1895), *Couplet in Standard-Script Calligraphy*, 1881, pair of hanging scrolls, ink on paper. Collection unknown. See *Christie's New York: Fine Chinese Paintings and Calligraphy* (March 22, 1995), lot. 156. From Christie's Images.

In early examples of the tripartite format, the calligraphy to either side is often displayed with an unequal number of characters. In order to satisfy the format's inherent demand for symmetry, the characters were inscribed in equally sized strips. Already in early examples, as witnessed in the Eastern Chin period tile (fig. 7) and the tenth-century woodblock print (fig. 8) discussed above, a concern for uniform numbers of characters is discernible. This proclivity for symmetrical balance is best illustrated in long calligraphic couplets of two or more columns on each side, for example as seen in a standard-script (*k'ai-shu*) couplet on a temple altar (fig. 1) or one by the calligrapher Li Wen-t'ien (1834–1895; fig. 11). Whereas the right half of the couplet maintains the pattern of reading—from top to bottom, right to left—the left half transgresses this convention for the sake of symmetry—reading from top to bottom, left to right.

This inherent tendency toward external balance and visual symmetry was accompanied by growing internal syntactic and semantic correspondences between the read or spoken lines of a couplet, so that in addition to a *vertical* linear reading of the text, the characters of each line could be related *horizontally* by the rules of poetic prosody, grammatical syntax, morphological roots, phonetic criteria, or content. This had been true of couplet writing in literature and poetry since the T'ang dynasty, but when these compositional rules were first transferred to the couplet format in calligraphy is still in question. If the rudimentary, paired calligraphic cartouches on the two tenth-century Kuan-yin images (figs. 8, 9) are any indication, then the internal syntactic and semantic development of calligraphic couplets, like that ascribed to Meng Ch'ang, may have been at a stage of infancy during the Five Dynasties and early Sung periods. To date, the

oft-cited notion that calligraphic couplets were already widespread in the Sung dynasty cannot be substantiated, owing to the lack of any surviving examples.[13] Such claims may have arisen from a failure to distinguish between literary and calligraphic couplets in recorded documents. We can only speculate that the artistic couplet format was probably in its incipient stages during the Sung period and became recognized as an independent calligraphic format only in the early- to mid-Ming dynasty, from which the earliest known examples survive.[14]

The infancy of brushed couplets in the Sung period should also be weighed against the development of other new calligraphic formats. In the case of hanging scrolls, the earliest extant example devoted solely to calligraphy as its subject is a seven-syllabic quatrain by Wu Chü (fl. ca. late 12th century) now in the National Palace Museum, Taipei, which also dates only to the Southern Sung period.[15] Before this time, large-size calligraphy in a vertical format had usually been limited to monumental writing engraved on stone stelae, pillars, and natural cliff sides. Antiquarian concerns in the Sung engendered an interest in such early artistic models and led to attempts to translate the monumental technique and appearance of large-size carved characters into the self-expressive media of ink and brush: witness Huang T'ing-chien's (1045–1105) fascination with the *Eulogy on Burying a Crane* (*I-ho ming*) cliff carving as reflected in his *Scroll for Chang Ta-t'ung* (cat. no. 6).[16] Such interest in monumental writing may have provided the impetus for experimenting with the couplet and hanging-scroll formats for the art of calligraphy. This process of returning to ancient epigraphic models as a stylistic source for ink and brush calligraphy would later be revisited by artists and scholars in the Ch'ing dynasty.

Other Sung period pieces of calligraphy that have often been confused with couplets include numerous poetic inscriptions on fans and paintings, many written by emperors and empresses (cat. nos. 8 and 9).[17] Such examples written on a single sheet of silk or paper, however, should not be considered calligraphic couplets, because they do not mark a central void or passage; instead, they are more properly classified as poetic or literary couplets. A work attributed to the Neo-Confucian philosopher Chu Hsi (1130–1200) may be an early surviving calligraphic couplet.[18] The text is a variation of lines from *The Book of Poetry* and also

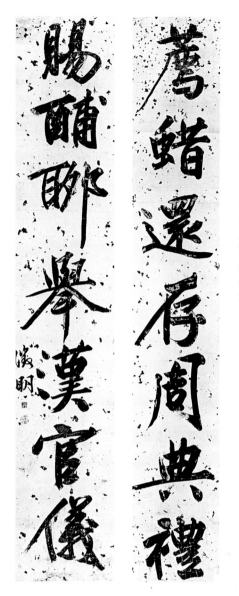

Figure 12a. Wen Cheng-ming (1470–1559), *Couplet*, undated, pair of hanging scrolls, ink on silver-flecked paper, each 155.6 x 30.6 cm. Wango H. C. Weng Collection. From Tseng Yu-ho Ecke, *Chinese Calligraphy* (Philadelphia: Philadelphia Museum of Art and Boston Book and Art Publishers, 1971), cat. no. 48.

Figure 12b. Grammatical analysis of typeset version of figure 12a.

verb	賜	薦
noun	酺	蜡
adv.	聊	還
verb	舉	存
adj.	漢	周
adj.	官	典
noun	儀	禮

appears in abbreviated form on a rubbing of a horizontal placard attributed to Chu Hsi.[19] It is possible that Chu Hsi did compose these lines, but both the couplet and the placard are most likely later fabrications. This is the case for another five-character-verse couplet attributed to Chu Hsi now in the National Palace Museum, Taipei, which is actually a Ch'ing dynasty recombination of fragments spliced together to form a couplet.[20]

Certainly by the early Ming period, what is presently recognized as the calligraphic couplet had fully emerged. Among the earliest surviving couplets from the mid-Ming dynasty is an example signed by the influential artist Wen Cheng-ming (1470–1559; fig. 12a):

To offer sacrifice with cured meat preserves the Chou dynasty canonical ceremony [*li*];
To permit people to drink and dine together is just to mention a Han dynasty official ritual [*i*]. [21]

In this couplet, the horizontal correspondence between the two couplet lines is made explicit. Besides being symmetrically arranged with the same number of characters, each line is written in parallel seven-character prosody, and each corresponding character belongs to the same part of speech (fig. 12b). Moreover, in this couplet the standard vertical reading from top to bottom is "inlaid" (ch'ien-tzu) with a horizontal cross-reading of the bottom two characters, which designate "rites and ceremonies" (li-i), the subject of the couplet.

As an artistic form, calligraphic couplets gained widespread popularity during the Ming and Ch'ing periods. With this development came new audiences and new couplet forms. Scholars, officials, and even emperors took to brushing couplets as tests of wit and artistry. At court, emperors would assign the first or "upper" (shang-lien) line of a couplet intended to mark an occasion or edifice, and the assembled ministers and officials were expected to respond with the completing or "lower" (hsia-lien) line.[22] Calligraphic couplets were also given as gifts, exchanged during literary gatherings and competitions, and hung as decoration. New strategies continued the interplay between vertical and horizontal readings. Couplets could be composed following the rules of poetic structure, could contain inlaid (ch'ien-tzu) cross-readings or palindromes (hui-wen), could be composed from characters selected from other models (chi-lien), or could vary in length, some containing as many as 1,614 characters.[23]

The question of calligraphic presentation should also be considered. Couplets, by their very nature offering protective warnings and decorative display, were often executed with large-size characters to project a more powerful image that implied a greater apotropaic or hortatory efficacy, or to make the writing more legible.[24] For these purposes Wen Cheng-ming modeled his calligraphy on the large-scale brush manner of Huang T'ing-chien (cat. no. 6). This same style was also adopted by Wen Cheng-ming for large hanging scrolls such as his Poem on Lake T'ai-yeh, in the Elliott Collection (cat. no. 27). The newly popular formats of calligraphic couplets and grand public hanging scrolls shared the same artistic problem of trying to adapt traditional brush and ink models to monumental public formats. One result was experimentation in large script calligraphy in the late Ming to early Ch'ing

periods, represented in the Elliott Collection by hanging scrolls by Wang To (1592–1652; cat. no. 33) and Fu Shan (1607–1684/85; cat. no. 35).

In the early Ch'ing period a growing acceptance of the methodological approaches of evidential scholarship (k'ao-cheng hsüeh) inspired many calligraphers to return again to a study of ancient epigraphy engraved on metal and stone.[25] Often relying on Six Dynasties, Han, or earlier engravings and rubbings as paradigms, calligraphers developed brush techniques that evoked effects produced by a cutting stylus, or the weathered appearance of ancient stone engravings. As calligraphic couplets became a major literary and visual form in the early Ch'ing period, these archaistic effects appeared frequently in calligraphic couplets and sometimes became part of the artistic and scholarly dialogue among educated elites, as evidenced by three works in the Elliott Collection by I Ping-shou, Ho Shao-chi, and Li Jui-ch'ing.

The calligrapher and official I Ping-shou (1754–1815)[26] brushed his Couplet on Venerable Officials (cat. no. 40) in clerical-script (li-shu) calligraphy that can be translated literally,

Venerable officials [ts'ang-kuan] and pure scholars are the trees [shu], left and right;

Divine sages [shen-chün] and immortal beings are the flowers [hua], high and low.

The difficulty in translating couplets is demonstrated by the double entendres incorporated at the beginning of each line of this couplet. The binome ts'ang-kuan can be read as "venerable officials" but it also alludes to "hoary pines," which complements "tree" (shu), the last character of the first line. The second line begins with two characters for "divine sages" (shen-chün), but chün also designates chrysanthemum blossoms,[27] which complements "flowers" (hua) at the end. Additionally, shen-chün was also used to refer to "just, capable, and virtuous officials." Because this latter reading appropriately parallels "venerable officials" in the first line, it is likely that I Ping-shou composed this couplet as a gift for a fellow official or a high minister.

Through his studies of Han dynasty epigraphic models such as Stele for Chang Ch'ien (Chang Ch'ien pei), Ritual Vessels Stele (Li-ch'i pei), and Hsi-p'ing Stone

Classics (*Hsi-p'ing shih-ching*), as well as Six Dynasties materials,[28] I Ping-shou developed a unique clerical script using a concealed- or center-tip (*chung-feng*) brush style.[29] The square composition and spacing are modeled after such stone engravings, while the vertically held brush produced bold center-tip strokes with vibrant contours and blunt ends. I Ping-shou's early predilection toward ancient epigraphic models was probably motivated by his early training as a calligrapher under Liu Yung (1719–1804; cat. no. 39) and coincided with his study of the art of seal carving. He may also have been influenced by the patronage he received from supporters of evidential scholarship, such as Chi Yün (1724–1805), compiler-in-chief of *The Comprehensive Library of the Four Treasuries* (*Ssu-k'u ch'üan-shu*), and the official and scholar Chu Kuei (1731–1807), an instructor of the emperor's sons and a chief proofreader in the Four Treasuries Institute (*Ssu-k'u-kuan*).[30] Other influences included his friendships with other calligraphers, antiquarians, and officials known for their "study of metal and stone" (*chin-shih hsüeh*) relics, including Juan Yüan (1764–1849) and Kuei Fu (1736–1805).[31]

In his writings on calligraphy, Juan Yüan was the first to divide calligraphers into Model-book school (*T'ieh-hsüeh*) and Stele school (*Pei-hsüeh*) lineages.[32] From as early as the Sung dynasty, exemplary ink and brush calligraphy had begun to be cut into wood and stone tablets. Reproduced rubbings made from such tablets became the chief model-books used by calligraphers until the eighteenth century. The interest of evidential scholars in returning to pre-Sung models, prior to any perceived corruption by foreign influences (i.e., Buddhism), led calligraphers to seek out new models in Six Dynasties, Han, and earlier engraved bronze vessels and stone stelae. Juan Yüan credits I Ping-shou with being one of the founders of the Stele-school movement in the Ch'ing period.

The clerical-script *Couplet on Transcending Limitations* by the calligrapher, philologist, and official Ho Shao-chi (1799–1873; cat. no. 41)[33] reads,

> The cosmos is unbounded, yet a myriad
> mountains rise;
> The clouds and mist are motionless, yet the eight
> windows[34] are clear.

The artist's inscription at the right edge of the first scroll reveals that this couplet was written with deference to a local official (*fu-t'ai*) named T'ung-hsüan.[35]

As an encouragement to overcome untold challenges and unfathomable obstacles (i.e., mountains and mist), this couplet may have been presented to celebrate an appointment to a new position, or perhaps was simply a gift to an esteemed colleague. This is only one example of numerous couplets executed by Ho Shao-chi, who, in fact, produced so many of them that they became known as "Ho couplets" (*Ho-tui*).

The style of the calligraphy reflects the artist's close study of ancient stone engravings. Ho Shao-chi, the son of a minister at court, began his career as a compiler in the Hanlin Academy in 1839. In the following thirteen years he was involved in several court-sponsored literary compilation projects and at one point served as subeditor (*chiao-li*) in the Wen-yüan-ko (Hall of Cultural Origins) imperial library. Excelling in studies on the Confucian classics and philology, Ho supervised several provincial examinations, but while serving as educational commissioner of Szechwan in 1855, he was dismissed after being accused of submitting imprudent proposals to the throne. Never to return to public office, Ho traveled extensively before settling in the mid-1860s in Soochow, where he was esteemed for his calligraphy.

In his writings about calligraphy, Ho Shao-chi declared allegiance to the Stele school. An expert in ancient inscriptions on metal and stone, Ho often endured hardships in order to tour the original sites of such relics. Early in his career he followed the monumental brush style of Yen Chen-ch'ing (709–785)[36] and other T'ang dynasty calligraphers, but by the 1830s and 1840s he had already begun to incorporate elements of seal script (*chuan-shu*) and clerical script brush styles garnered from copying Six Dynasties, Han, and earlier inscriptions. It is recorded that in as early as 1832 he journeyed south to Chen-chiang to copy the *Eulogy on Burying a Crane* cliff carving and made it a daily practice to copy ancient inscriptions. In his sixties Ho Shao-chi favored copying Han dynasty stelae such as *Ritual Vessels Stele* and *Stele for Chang Ch'ien,* which, according to his grandson, he copied over a hundred times each. The calligraphy of the couplet in the Elliott Collection shows strong stylistic ties to *Stele for Chang Ch'ien*.

Studying such monumental models and inscriptions, Ho synthesized his own brush style using a suspended-arm (*hsüan-pi*) technique. Holding his arm out with the elbow unsupported, his wrist was turned inward to grasp the brush—a stance that Ho likened

Figure 13. Li Jui-ch'ing (1867–1920), *Couplet on Achievements and Virtues,* 1916 (cat. no. 43, details).

to that of an archer about to shoot.[37] Such a technique restricted brush movement, yet produced controlled, tense, powerful strokes that appeared engraved into the surface. Ho Shao-chi described his writing technique as follows: "Whenever I copy [ancient inscriptions], I must suspend my arm with my wrist turned inwards. The energy travels through my body to [my fingers], and then characters can be made. When I am not yet half finished, my clothes are soaking wet with sweat!"[38] In this description, the strength and effort expended in writing with brush and ink were said to be the result of trying to follow the ways of ancient engravers. Here, Ho Shao-chi likens the wielding of a brush on paper or silk to a stylus incising words in stone.

A third couplet in the Elliott Collection, by the scholar and official Li Jui-ch'ing (1867–1920; fig. 13, cat. no. 43),[39] deserves special attention. Li Jui-ch'ing passed his metropolitan examination in 1894 and was assigned for advanced study as a bachelor (*shu-chi-shih*) in the Hanlin Academy. He was later appointed superintendent of education for the Nanking area and in the

early 1900s established China's first Western art painting department at Liang-chiang Normal School (*Liang-chiang shih-fan hsüeh-t'ang*) in Nanking.[40] Participating in the military defense of Nanking in the latter years of the Ch'ing dynasty, Li expressed his willingness to emulate the patriot-martyrs Wen T'ien-hsiang (1236–1283) and Shih K'o-fa (1601–1645).[41] After the collapse of the Ch'ing dynasty in early 1912, Li refused to serve the new regime, donned Taoist attire, and took on the name Ch'ing-tao-jen to show his loyalty to the fallen dynasty.[42] Moving to Shanghai, he earned a living as a professional artist and came to be paired with his close friend Tseng Hsi (1861–1930; cat. no. 42) for their mastery of calligraphy.

Li Jui-ch'ing developed a personal, running-script (*hsing-shu*) style after studying the calligraphy of Huang T'ing-chien. An example can be seen in a colophon (fig. 14) to his 1911 figure painting of a red-robed Maitreya, which is appended to a T'ang sutra handscroll from Tun-huang in the Elliott Collection.[43] Li was best known for infusing his calligraphy with elements of seal and clerical scripts garnered from

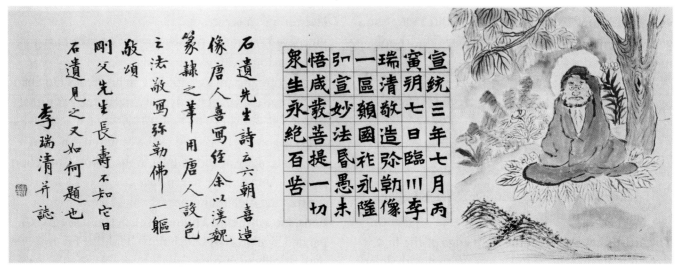

Figure 14. Li Jui-ch'ing, *Image of Red-Robed Maitreya and Colophon to "Transcription of the Mahāprajñāpāramitā Sūtra"* (detail), 1911, handscroll, ink on paper. The Art Museum, Princeton University, bequest of John B. Elliott.

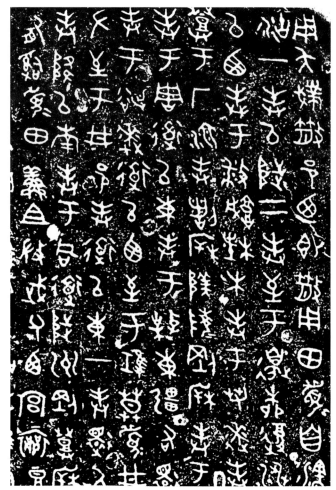

Figure 15. *San Basin* bronze inscription (detail), Western Chou dynasty, rubbing, ink on paper. From *Shodō zenshū*, 3rd ed. (Tokyo: Heibonsha, 1966–69), 1: no. 81.

intense study of ancient bronze and stele inscriptions. As observed in his 1916 *Couplet on Achievements and Virtues* (cat. no. 43), Li developed a large standard-script style characterized by a tightly held brush that was wielded like a stylus to produce tremulous strokes similar to those seen on worn stone engravings. Li Jui-ch'ing argued that all calligraphy originally derived from ancient seal-script writing such as the Western Chou dynasty *San Basin* (*San shih p'an*) bronze inscription (fig. 15).[44] A second great source, Li claimed, was

clerical-script stone engravings such as the Northern Wei *Later Stele for Cheng Wen-kung* (*Cheng Wen-kung hsia pei;* fig. 16).[45] As stated in the artist's inscription on this couplet,[46] the text is composed of words culled from the Han dynasty *Stele for Hsia Ch'eng* (*Hsia Ch'eng pei*),[47] and the standard-script calligraphy is patterned after the *Later Stele for Cheng Wen-kung* (compare figs. 13 and 16); that is to say, it was patterned after seal- and clerical-script archetypes.

What is special about this couplet is the relationship between its literary content and its calligraphic style. Like interlaced horizontal readings involving prosody, syntax, and other criteria between corresponding characters in a couplet's "upper" and "lower" lines, an interplay or cross-reading was established between content and style that served to reinforce the thematic content of the words. The couplet can be translated,

> Recording achievements [*kung*] like the
> *Yen-shan Stone*;
> Enumerating virtues [*te*] like the *Ching-chün Inscription.*

The *Yen-shan Stone* (*Yen-shan shih*) was a clerical-script stone inscription composed by Pan Ku (32–92) and erected atop Mount Yen-jan during the Later Han period to commemorate a victory over the Hsiung-nu in A.D. 89;[48] the *Ching-chün Inscription* (*Ching-chün ming*), from a Han stele dated A.D. 143, listed the virtues of the official Ching Chih (d. 143) and later become a model for clerical-script calligraphy.[49] A horizontal or cross-reading of the second characters in each line underscores the couplet's focus: the recording of meritorious "achievements and virtues" (*kung-te*). Alternatively, due to the importance Li placed on the calligraphic models for this couplet, the subject can also be understood to be the "achievements and virtues" of ancient calligraphy as exemplified in the *Yen-shan Stone* and the *Ching-chün Inscription*. In this way, by basing his own calligraphic style on that of the

Figure 16. Cheng Tao-chao (d. 515), *Later Stele for Cheng Wen-kung* (details), 511, rubbing, ink on paper. From *Shodō geijutsu* (Tokyo: Chūōkō ron-sha, 1970–73), 2: 56, 58.

Figure 17. Auspicious Ming dynasty couplet for new buildings: "For erecting the columns, we are happy to encounter the day of the Yellow Path; / for hoisting the ridge-pole, we just meet the Polar Star." From Klaas Ruitenbeek, *Carpentry and Building in Late Imperial China: A Study of the Fifteenth-Century Carpenter's Manual 'Lu Ban Jing'* (Leiden: E. J. Brill, 1993), 219 (translation); end of *chüan* 2 of Chinese text (illustration).

monuments he wrote about, Li presented his theory for the development of calligraphy from its roots in seal- and clerical-script engravings to its culmination in standard-script forms as embodied in the couplet's calligraphic style.[50]

The increased seriousness and respect attached to couplet writing by the beginning of this century is evidenced by the scholar Ch'en Yin-k'o's (1890–1969) proposal that it replace traditional entrance examination questions as the means for testing the scholarly, moral, and intellectual qualifications of college applicants.[51] Indeed, in one question given on an entry exam at Ch'ing-hua University, examinees were instructed to complete a couplet for which the first line was given.[52]

At the same time, the increased popularity of couplets as gift items, auspicious decorations, and exercises in wit and humor began to dissociate them from their origin as protective amulets and manifestations of deities. As works of art, couplets by master calligraphers began to be hung side by side, displacing the literal

Figure 18a. T'ai-ho-tien (Hall of Supreme Harmony), Ch'ing dynasty, modern interior view, Forbidden City, Peking. From Yu Zhuoyun, gen. ed., *Palaces of the Forbidden City* (New York: Viking Press/Allen Lane, 1984), fig. 40.

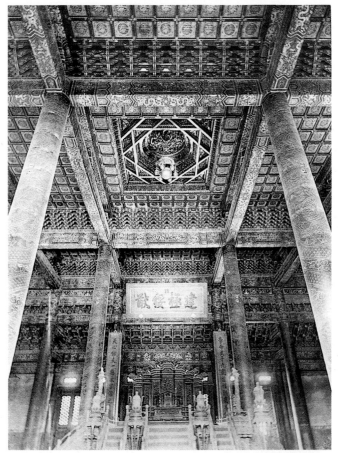

Figure 18b. T'ai-ho-tien, interior view, ca. 1906, showing column couplets and placard about the throne. From Imperial [Household] Museum of Tokyo, comp., *Photographs of Palace Buildings of Peking*, pl. 39.

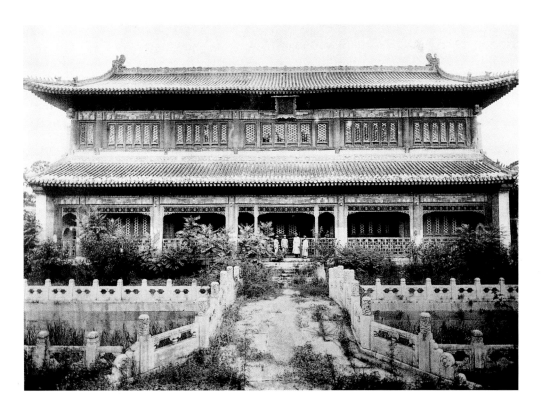

Figure 19. Wen-yüan-ko (Hall of Cultural Origins) library, 1776, south facade, Forbidden City, Peking. Photo ca. 1906, from Imperial [Household] Museum of Tokyo, comp., *Photographs of Palace Buildings of Peking*, pl. 94.

or phenomenal image of the central void. When couplets framed a doorway or were hung on columns framing a bay (*chien*), they literally marked a passage between inner and outer zones. New Year spring couplets framed the outer door of a home as manifestations of the brothers Shen Shu and Yü Lü, guarding the family against evil demons and beasts. Similarly, couplets framing a central painting, calligraphy, or altar image in a "central-hall" arrangement marked a phenomenal passage. Through the viewer's visualiza-

tion, the central image became a transparent screen leading to another realm. Couplets flanking central paintings of Buddhist scenes or immortal lands evoked a passage to paradisiacal realms, while funerary couplets, when placed about an ancestral portrait, called forth a portal to the afterworld. Even those couplets completed by officials in response to an upper line given by the emperor, or by candidates in response to an examination question, symbolically marked a passage. If successful, the examinee was said to pass

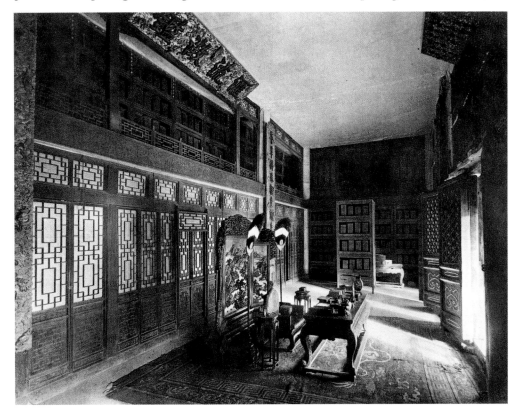

Figure 20. Wen-yüan-ko library, interior view of audience chamber. From *Ku-kung wen-wu yüeh-k'an* 1, no. 2 (1983): 62.

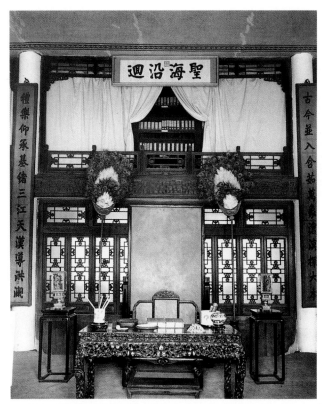

Figure 21. Wen-su-ko library, Ch'ing dynasty, 1782, interior view of audience chamber, Shen-yang, Liaoning. From *Chung-kuo mei-shu ch'üan-chi, chien-chu i-shu pien*, vol. 1, *Kung-tien chien-chu* (Peking: Chung-kuo chien-chu kung-yeh ch'u-pan-she, 1987), pl. 153.

through the Dragon Gate (*Lung-men*) in pursuit of achievement.[53]

History has also acted to isolate calligraphic couplets from their ritual and building contexts. Couplets throughout the Ming and Ch'ing periods retained a close connection to building practices and rituals. As recorded in Ming dynasty editions of *The Classic of Lu Pan* (*Lu Pan ching*), a carpentry manual, couplets and amulets continued to be pasted on columns and beams to mark auspicious days for building.[54] An example is the couplet for erecting the columns and hoisting the ridge-pole (fig. 17).[55] Couplets also came to mark towns, buildings, bridges, temples, and altars. In local gazetteers, travelogues, and records of places, such as Yü Min-chung's (1714–1749) *Examining the Former Tales of Peking* (*Jih-hsia chiu-wen k'ao*),[56] edifices came to be described by their calligraphic couplets and placards. The imperishable power of "words" is epitomized by the fictional Ta-kuan-yüan, a garden described in the eighteenth-century novel *The Dream of the Red Chamber* (*Hung-lou meng*).[57] In the novel, the garden's actual construction is given only passing notice. Instead, attention focuses on the *act* of naming the scenic spots and buildings in the garden sanctuary.

This bestowal of "words" embodies a moment of spontaneity, as important as the first note in music or the first brushstroke in calligraphy and painting. In architecture it is the instant of naming that confers on a building its "imperishable mark of authenticity." Such a mark is often captured in calligraphic couplets in ritual and imperial building.[58]

In Ch'ing imperial palaces, couplets composed and brushed under the name of the emperor marked in words a building's design and "symbology."[59] In many contemporary photographs of palace interiors, the architectural setting is incomplete due to the absence of calligraphy, but in early photos of the T'ai-ho-tien (Hall of Supreme Harmony), a placard hangs over the center bay and couplets flank the imperial throne (figs. 18a, b).

Among the few existing Ch'ing palace halls that retain their original complement of calligraphic accoutrements are the surviving library halls erected during the reign of the Ch'ien-lung emperor (r. 1736–95) to house sets of *The Comprehensive Library of the Four Treasuries*. The Wen-yüan-ko library (figs. 19, 20) in Peking and the Wen-su-ko library (fig. 21) in Shen-yang belong to a group of four northern halls specially built as repositories for this immense anthology of manuscript books (each reproduced in its entirety), which formed the core of the Ch'ing imperial library collection. As such, *The Four Treasuries* represented the sum of knowledge bestowed from heaven—a ritual symbol of the dynasty's legitimacy and ability to rule. The design of the library halls, consequently, came to have special significance.[60]

Dedicatory records composed by the Ch'ien-lung emperor outlined the design symbology of the four northern Four Treasuries libraries. Each library hall represented a step in an upstream journey in search for the origin (*yüan*) of all that is knowable, and together the collected books in each library were likened to a vast sea of knowledge. The water metaphor is further developed by the halls' green-and-black color scheme and the inclusion of a water radical in the central character of the names conferred on the buildings.

The water imagery is also echoed in the calligraphy composed and brushed by the Ch'ien-lung emperor in each hall. A placard suspended over the imperial throne would have been immediately visible upon entering the audience chamber (figs. 20, 21). In the Wen-yüan-ko the central placard reads,

Figure 22. T'ien-an-men (Gate of Heavenly Peace), southwest view, Peking. Modern photo, from *Chung-kuo mei-shu ch'üan-chi, chien-chu i-shu pien*, vol. 1, *Kung-tien chien-chu*, pl. 2.

Converging streams like a pure mirror
 [*Hui liu ch'eng chien*]

And in the Wen-su-ko library it reads,

The sea of wisdom flows back and forth
 [*Sheng hai yen hui*][62]

Here the imagery likens water flowing to the sea to knowledge gathering in a reservoir that reflects cultural wisdom and societal harmony. This symbology is also marked by imperial couplets inside the halls. For example, in the Wen-su-ko library, one pair of column couplets (fig. 21) reads,

The past and present are all encompassed within, the
 countless phenomena and the vast sea [of learning]
 help to search out the true origin;
Rites-and-music uphold the fundamental threads, the
 Three Rivers[63] and Milky Way guide the overflowing
 pool [of knowledge].
[*Ku-chin ping ju han-ju, wan-hsiang ts'ang-ming
 shen ta-pen;*
*Li-yüeh yang ch'eng chi-hsü, san-chiang t'ien-han
 tao hung-lan.*][64]

Many other couplets in the Four Treasuries libraries also reinforce this symbology that characterizes the design and significance of the imperial libraries. In these palace halls, calligraphic couplets help mark the edifice and provide a key to reading and understanding the design of the buildings.

Whether suspended on building columns, door posts, or on a wall to frame a central image, couplets manifest deities or mark aedicules and edifices. The function of calligraphic couplets seems to be connected to their origin as ritual protective markers, and couplets still reflect this purpose even when dressed in modern garb (figs. 22, 23).

Figure 23. Household shrine, featuring photograph of Chairman Mao with a couplet exhorting study of his teachings to build a new China. Ancestral and family photographs are placed on each side at the top. Photo 1964 by René Burri, from W. J. F. Jenner, ed., *China: A Photohistory 1937–1987* (New York: Pantheon Books, 1988), fig. 110.

1. On the terms "literal" and "phenomenal," see Colin Rowe and Robert Slutzky, "Transparency: Literal and Phenomenal," in Colin Rowe, *The Mathematics of the Ideal Villa and Other Essays* (Cambridge, Mass.: MIT Press, 1976), 159–83.

2. The one-to-one correspondence of a single spoken syllable with a single written graph in the Chinese language allows for a unique visual and aural pairing. This does not occur in Japan or Korea, even when Chinese characters are used, and may explain why couplets did not become a popular literary or calligraphic form in those cultures.

3. *Li Chi, Book of Rites,* trans. James Legge, rev. ed. (New York: University Books, 1967), 1: 116; 2: 206–7. See also Cary Y. Liu, "'Heavenly Wells' in Ming Dynasty Huizhou Architecture," *Orientations* 25, no. 1 (1994): 34–35. The God of the Inner Door is also equated with the gate of earth, and the God of the Outer Door with the gate of heaven.

4. On the ritual significance of the *chung-t'ang* and its relationship to calligraphic couplets, see Robert H. van Gulik, *Chinese Pictorial Art,* limited ed. (Rome: Istituto Italiano per il Medio ed Estremo Oriente, 1958), 17–19. See also Klaas Ruitenbeek, *Carpentry and Building in Late Imperial China: A Study of the Fifteenth-Century Carpenter's Manual 'Lu Ban Jing'* (Leiden: E. J. Brill, 1993), 57–59; Ronald G. Knapp, *China's Vernacular Architecture: House Form and Culture* (Honolulu: University of Hawaii Press, 1989), 51–53; and Tseng Yuho, *A History of Chinese Calligraphy* (Hong Kong: Chinese University Press, 1993), 89–93.

5. The story goes that at the approach of the New Year, Wang Hsi-chih brushed a couplet with seven characters in each line. Three times he hung the couplet outside his door, and each time it was stolen. Finally, he hung only the top four characters of each line, reading, "Fortune does not come paired; / Calamity does not go alone." The inauspicious content prevented the abbreviated couplet from being taken. On New Year's morning, Wang put up the remaining characters: "Fortune does not come paired, it arrives today; / Calamity does not go alone, it went last night" (Han Ming-an and Ma Hsiang-lin, eds., *Tui-lien man-hua* [Harbin: Hei-lung-chiang jen-min ch'u-pan-she, 1983], 16–17). The linkage of the Wang family's calligraphy to the writing of amulets and couplets is also due to their use of the "one-stroke" (*i-pi-shu*) brush technique. On this connection, see Ch'en Yin-k'o's "T'ien-shih-tao yü pin-hai ti-yü chih kuan-hsi" (1933), reprinted in his *Ch'en Yin-k'o hsien-sheng lun-wen chi* (Taipei: San-jen-hsing ch'u-pan-she, 1974), 397–402; and Tseng, *A History of Chinese Calligraphy,* 84–87.

6. Liang Chang-chü (1775–1849) et al., comp., *Ying-lien ts'ung-hua fu hsin hua* (Peking: Chung-hua shu-chü, 1987), *chüan* 1: 9. Liang Chang-chü cites Chang T'ang-ying's *Shu t'ao-wu* of the Sung dynasty as a source. For an alternative translation of the couplet, see Ma Meng's introduction in *Chinese Couplets,* translated and annotated by T. C. Lai (Hong Kong: University Book Store, 1969), vii–viii. Another popular tale points to an early Ming origin for the habit of hanging spring couplets. One New Year, the first Ming emperor, Chu Yüan-chang (T'ai-tsu; r. 1368–98), ordered that spring couplets be hung outside the doors of all buildings in the capital city, Nanking. Disguised as a commoner, he went out at night to inspect the city and discovered one house without a couplet. Inquiries revealed that the resident was a pig butcher who could not find anyone to write for him. The emperor personally took up a brush and wrote lines aptly referring to the butcher's profession: "Two arms that cleave open the road to life and death; / One knife that cuts apart the root to being and nonexistence" (*Shuang shou p'i k'ai sheng ssu lu; / I tao ko tuan shih fei ken*). Days later, when the emperor passed by the same location, he noticed that the couplet was again missing. When asked what had happened, the butcher replied that upon discovering that it was the emperor's writing, he felt obligated to hang it in the central hall (*chung-t'ang*), where offerings could be made to engender benefit for the nation in the new year. Again, this tale seems to have been popularized through a Ch'ing dynasty source (Ch'en Hsiang-ku, *Tsan-yün-lou tsa hua* [*Shuo ling* ed.; Taipei: Hsin-hsing shu-chü, 1968], "Ch'un-lien," 9a, b [671]). The authenticity of these tales concerning the origin of spring couplets is appropriately questioned in Chang T'ieh-chün, *Ying-lien-hsüeh ch'uang-lun* (Taipei: Chang T'ieh-chün, 1979), 17–19.

7. Wang Ch'ung, *Lun-heng chu-shih,* ed. by Pei-ching ta-hsüeh li-shih-hsi Lun-heng chu-shih tsu (Peking: Chung-hua shu-chü, 1979), "Luan-lung pien," 917–18; "Ting-kuei," 1283–85.

8. See note 5, above.

9. *Li chi cheng-i* (*Shih-san ching chu-shu* ed.; Peking: Chung-hua shu-chü, 1980), "Yüeh-ling, Meng-ch'un chih yüeh, Ssu hu," 1354.

10. On the apotropaic properties of amulets, ropes, and peach wood and their origins, see Ko Chao-kuang, *Tao-chiao yü Chung-kuo wen-hua* (Shanghai: Shang-hai jen-min ch'u-pan-she, 1987), 97–99. I thank Qianshen Bai for bringing this to my attention. See also Tseng Yuho, *A History of Chinese Calligraphy,* 79–83. On reports regarding the use of red-paper couplets in the Three Kingdoms period, see *Tui-lien man-hua,* 17.

11. For Han tomb pillars with inscribed calligraphy, see rubbings of the official Wang Huan's (*tzu:* Chih-tzu, d. A.D. 105) pillars in Szechwan, illus. in Édouard Chavannes, *Mission archéologique dans la Chine septentrionale* (Paris: E. Leroux, 1909–15), fig. 199, text vol. 1: 256–58. Other examples are the pillars for the official Ch'en seen in photographs in Victor Segalen, Gilbert de Voisins, and Jean Lartigue, *Mission archéologique en Chine (1914 et 1917)* (Paris: Paul Geuthner, 1923–24), 1: pls. 15–17; and *Ssu-ch'uan Han-tai shih-ch'üeh,* eds. Ch'ung-ch'ing shih wen-wu-chü, et al. (Peking: Wen-wu ch'u-pan-she, 1992), 40–41, 128–33.

12. For recorded examples of funerary couplets, see Li Lung, ed., *Chüeh-lien ch'i-wen* (Taipei: Hsing-kuang ch'u-pan-she, 1977), 233–46; and Liang Kung-ch'en, *Ying-lien ssu hua,* in Liang, comp., *Ying-lien ts'ung-hua fu hsin hua),* 364–76. According to Chiang Tsun, ed., *Tui-lien yü i-hua* (Hong Kong: Wen-han ch'u-pan-she, n.d.), 55, funerary couplets developed relatively late. He cites an example recorded in T'ao Tsung-i's *Cho-keng lu* (1366) of the late Yüan dynasty as an early example.

13. Many general studies on the development of couplets make such a claim, including *Tui-lien man-hua,* 16; Ma Meng's introduction in *Chinese Couplets,* viii; and Hsü Pao-hsün, ed., *Ming Ch'ing ying-lien* (Shanghai: Shang-hai shu-hua ch'u-pan-she, 1981), "Ch'ien-yen." There are records of Sung dynasty calligraphic couplets engraved in stone, such as a column couplet by the recluse Ch'en Po (d. 989): "The oceans are the dragon's world; / The clouds are the crane's abode" (Yü Chien-hua, gen. ed., *Chung-kuo mei-shu-chia jen-ming tz'u-tien* [Shanghai: Jen-min mei-shu ch'u-pan-she, 1981], 1034). Though the texts

are attributed to Sung authors, their actual engraving in a couplet format may date to later periods. As discussed below, this was the case for calligraphy by Chu Hsi that was later recombined as a couplet.

14. Extant early- to mid-Ming couplets include examples by Wen Cheng-ming, discussed below (fig. 12); and Wen Ju-yü (1528–1569), reproduced in *Ming Ch'ing ying-lien*, pl. 1. A couplet said to be by Shen Chou is included in Liu Chao, ed., *Ming Ch'ing ying-lien chi-ts'ui* (Hong Kong: Liu Chih-wen and Ts'ai Ch'iao-wei, 1991), 2, but should be examined more carefully.

15. Reproduced in *Ku-kung li-tai fa-shu ch'üan-chi* (Taipei: Kuo-li ku-kung po-wu-yüan, 1979), 30: 9. The beginning of the calligraphic hanging-scroll format may also have coincided with the growing practice of engraving poetic compositions (instead of the customary commemorative texts and memorials) on monumental stone stelae. An example is an ink rubbing of a 1076 stone engraving of a seven-syllabic quatrain by Cheng Wen-pao (953–1013), reproduced in *Chin-shih shu-hua*, gen. no. 21 (April 15, 1935): 1. Engraved in seal script, Cheng's poem may represent a transitional stage between monumental stele inscriptions and the development of calligraphic hanging scrolls.

16. On Sung antiquarian studies and the arts, see Robert E. Harrist, Jr., "The Artist as Antiquarian: Li Gonglin and His Study of Early Chinese Art," *Artibus Asiae* 55 (1995): 237–80. On Huang T'ing-chien's study of ancient models, see cat. no. 6; and Wen C. Fong et al., *Images of the Mind* (Princeton: Princeton University Press, 1984), 76–84.

17. Examples can be found illustrated in Wen C. Fong, *Beyond Representation: Chinese Painting and Calligraphy, 8th–14th Century* (New York: The Metropolitan Museum of Art, 1992), pls. 31–42; and Nakata Yūjirō and Fu Shen, eds., *Ōbei shūzō Chūgoku hō sho meisekishū* (Tokyo: Chūōkōron-sha, 1981–83), 2: nos. 17–33.

18. This couplet is reproduced in Chu Hsi, *Chu-tzu ch'üan-shu* (Taipei: Kuang-hsüeh-she yin-shu-kuan, 1977), 1: front matter.

19. Variation on the lines "The hawks fly up to heaven; / The fishes leap in the deep" (*Yüan fei li t'ien; / Yü yüeh yü yüan*) in *Mao shih cheng-i*, "Ta ya, Han-lu," *chüan* 16c: 515–16; *The Chinese Classics*, trans. James Legge, reprint ed. (Taipei: Southern Materials Center, Inc., 1985), 5: 445. The placard rubbing is reproduced as front matter in Chang Li-wen, *Chu Hsi ssu-hsiang yen-chiu* (Peking: Chung-kuo she-hui k'o-hsüeh ch'u-pan-she, 1981) and is in the collection of the Fu-chien Chien-yang wen-hua kuan.

20. Reproduced in *Lan-ch'ien-shan-kuan fa-shu mu-lu* (Taipei: Kuo-li ku-kung po-wu-yüan pien-chi wei-yüan-hui, 1987), pl. 8.

21. Discussed in Tseng, *A History of Chinese Calligraphy*, 316, fig. 9.42. For the offering of cured meat in Chou ceremonies, see *Chou li chin-chu chin-i*, annotated by Lin Yin (Taipei: Shang-wu yin-shu-kuan, 1972), "T'ien-kung, La-jen," *chüan* 1: 43–44. Han dynasty regulations forbade groups of more than three people to drink and dine together. On the occasion of the Wen-ti emperor's (r. 179–157 B.C.) ascension, people were allowed to drink in groups for five days. See Pan Ku, comp., *Han shu* (Peking: Chung-hua shu-chü, 1962), *chüan* 4: 108 n. 20. Without examining this work, judgment on its authenticity is reserved.

22. Such couplets were "composed in response" (*ying-chih*) to imperial commands. For examples, see Liang comp., *Ying-lien ts'ung-hua fu hsin hua*, 20–31.

23. For recorded examples of palidromic couplets, see P'ei Kuo-ch'ang, ed., *Chung-kuo ying-lien hsüeh* ([Nanking]: Chiang-su ku-chi ch'u-pan-she, 1989), 30–32; for selected-model couplets, see ibid., 60–92; and for long couplets, see ibid., 93–115; and *Chüeh-lien ch'i-wen*, 51–55. Generally, long couplets were often used to mark scenic locations, cities, temples, and towers that afforded ample space for long texts. Towns and buildings even became famous for their couplets, and there are numerous modern, regional compilations of couplets, such as Wang Ts'un-hsin and Wang Jen-ch'ing, *Chung-kuo ming-sheng ku-chi tui-lien hsüan chu* (Chi-lin: Chi-lin jen-min ch'u-pan-she, 1984); and Ts'ao Lin-ti, *Su-chou yüan-lin pien-o ying-lien chien-shang* (Peking: Hua-hsia ch'u-pan-she, 1991).

24. On the problem of image size as a function of value and visibility, and image scale as a function of relative size, see Meyer Schapiro, "On Some Problems in the Semiotics of Visual Art: Field and Vehicle in Image-Signs," reprinted in his *Theory and Philosophy of Art: Style, Artist, and Society* (New York: George Braziller, 1994), 22–24.

25. See Sha Meng-hai, "Ch'ing-tai shu-fa kai-shuo," in *Chung-kuo mei-shu ch'üan-chi: Shu-fa chuan-k'o pien*, 6, *Ch'ing-tai shu-fa* (Shanghai: Shang-hai shu-hua ch'u-pan-she, 1989), front pp. 1–5; and Benjamin Elman, *From Philosophy to Philology: Intellectual and Social Aspects of Change in Late Imperial China* (Cambridge, Mass.: Council on East Asian Studies, Harvard University, 1984), 28, 191–97.

26. For I Ping-shou's biography, see Chao Erh-hsün et al., comps., *Ch'ing shih kao* (Taipei: Hung-she ch'u-pan-she, 1981 [unacknowledged reprint of Peking: Chung-hua shu-chü ed.]), *chüan* 478: 13047–48; and Chin K'ai-ch'eng and Wang Yüeh-ch'uan, eds., *Chung-kuo shu-fa wen-hua ta-kuan* (Peking: Pei-ching ta-hsüeh ch'u-pan-she, 1995), 598–99.

27. *Chung-wen ta tz'u-tien*, ed. Chung-wen ta tz'u-tien pien-tsuan wei-yüan-hui (Taipei: Hua-kang ch'u-pan pu, 1973), nos. 3395.3.14, 3395.3.26.

28. A rubbing of the A.D. 186 *Stele for Chang Ch'ien* is reproduced in *Shoseki meihin sōkan* (Tokyo: Nigensha, 1958–), case 3; and *Shodō zenshū*, n.s. (Tokyo: Heibonsha, 1958), 2: nos. 120–21. A close copy of part of this stele by I Ping-shou is in the Szechwan Provincial Museum, Ch'eng-tu; see *Chung-kuo mei-shu ch'üan-chi: Shu-fa chuan-k'o pien*, 6: no. 147. *Ritual Vessels Stele* was completed in the reign of emperor Huan-ti (r. 147–67); a rubbing is reproduced in Iijima Shunkei, ed., *Ippi itchō Chūgoku-hi hōchō seika* (Tokyo: Tōkyō shoseki, 1984), fascicle 3. *The Hsi-p'ing Stone Classics* were finished in A.D. 183 and erected at the National University (*T'ai-hsüeh*) in the capital, Loyang, where they were meant to serve as the orthodox version of the Confucian classics. On *The Hsi-p'ing Stone Classics*, see Chin and Wang, eds., *Chung-kuo shu-fa wen-hua ta-kuan*, 463–64.

29. On I Ping-shou's calligraphy, see Chin and Wang, eds., *Chung-kuo shu-fa wen-hua ta-kuan*, 599–603; Léon Long-yien Chang and Peter Miller, *Four Thousand Years of Chinese Calligraphy* (Chicago: University of Chicago Press, 1990), 106–10; Hsü Kuo-p'ing, "I Ping-shou ti li-shu lien," *Tzu-chin-ch'eng*, gen. no. 73, no. 6 (1992): 32; and collected articles and plates in *Sho-hin* 67 (1956): 1–56.

30. The Ch'ing *Comprehensive Library of the Four Treasuries* imperial library was the largest compilation ever produced in dynastic China and represents one of the greatest undertakings in evi-

dentiary scholarship. On the library compilation, see Kuo Po-kung, *Ssu-k'u ch'üan-shu tsuan-hsiu k'ao* (Shanghai: Kuo-li Pei-p'ing yen-chiu-yüan shih-hsüeh yen-chiu-hui, 1937); Huang Ai-p'ing, *Ssu-k'u ch'üan-shu tsuan-hsiu yen-chiu* (Peking: Chung-kuo jen-min ta-hsüeh ch'u-pan-she, 1989); and Cary Y. Liu, "The Ch'ing Dynasty Wen-yüan-ko Imperial Library: Architecture and the Ordering of Knowledge" (Ph.D. diss., Princeton University, 1997), 42–82. Chi Yün actually considered I Ping-shou as a pupil and also employed him to teach his grandson. Chu Kuei was the younger brother of Chu Yün (1729–1781) who had submitted the initial proposals for the *Comprehensive Library of the Four Treasuries* compilation project. On their respective biographies, see Arthur W. Hummel, ed., *Eminent Chinese of the Ch'ing Period* (hereafter *ECCP*; 1943; reprint ed., Taipei: Ch'eng-wen ch'u-pan-she, 1975), 120–23 and 185–86. See also Chin and Wang, eds., *Chung-kuo shu-fa wen-hua ta-kuan*, 598.

31. For Juan Yüan's biography, see Chao et al., comps., *Ch'ing shih kao, chüan* 370: 11421–24; A. Vissière, "Biographie de Jouàn Yuàn: Homme d'Etat, lettré et mathématicien," *T'oung Pao*, ser. 2 (1904): 561–96; and *ECCP*, 399–402. Kuei Fu's skills at clerical-script calligraphy and seal carving were influenced by evidentiary studies, such as his *Historical Review of the Stone Classics* (*Li-tai shih-ching lüeh*).

32. Juan Yüan, *Yen-ching-shih chi* (*Ts'ung-shu chi-ch'eng chien-pien* ed.; Taipei: T'ai-wan shang-wu yin-shu-kuan, 1965–66), *San chi* supplement, "Nan pei shu p'ai lun," *chüan* 1: 553–57; and "Pei-pei nan-t'ieh lun," *chüan* 1: 557–59.

33. For Ho Shao-chi's biography, see Chao et al., comps., *Ch'ing shih kao, chüan* 487: 13436–37; and *ECCP*, 287–88. For his writings about calligraphy, see Ts'ui Erh-p'ing, comp. and annot., *Ming Ch'ing shu-fa lun wen-hsüan* (Shanghai: Shang-hai shu-tien, 1994), 833–58. On his calligraphy, see Chin and Wang, eds., *Chung-kuo shu-fa wen-hua ta-kuan*, 603–8; and Tseng Yu-ho Ecke, *Chinese Calligraphy* (Philadelphia: The Philadelphia Museum of Art and Boston Book and Art Publishers, 1971), no. 96.

34. The "eight windows" (*pa ch'uang*) refer to those of the ideal Ming-t'ang hall. See Pan Ku (32–92), *Pai-hu t'ung* (*Pai-pu ts'ung-shu chi-ch'eng* ed.; Taipei: I-wen yin-shu-kuan, 1968), "Pi-yung," *chüan* 2b: 10b–11a.

35. Possibly the official Chu Feng-piao (d. 1874). For a list of persons with T'ung-hsüan as their style (or courtesy) name, see Yang T'ing-fu et al., eds., *Ch'ing-jen shih-ming pieh-ch'eng tzu-hao so-yin* (Shanghai: Shang-hai ku-chi ch'u-pan-she, 1988), 1: 381.

36. It is recorded that Ho Shao-chi made an outline tracing (*shuang-kou*) of a rare Sung rubbing of Yen Chen-ch'ing's *Chung-i-t'ang Yen t'ieh* (cited in Chin and Wang, eds., *Chung-kuo shu-fa wen-hua ta-kuan*, 604). Ho's tracing in the form of an album of fifty-seven leaves is partly illustrated in *Christie's New York: Fine Chinese Paintings and Calligraphy*, March 27, 1996: lot 162.

37. Ho Shao-chi, "Yüan-pi weng," poem cited in Chin and Wang, eds., *Chung-kuo shu-fa wen-hua ta-kuan*, 607–8. This apelike positioning of the arms also formed the basis for Ho's style name, Old Ape (Yüan-sou) (Ecke, *Chinese Calligraphy*, no. 96). More research is needed on how and when Ho adopted this writing technique and whether he used it for all script styles, as is sometimes claimed. In Robert Hatfield Ellsworth, *Later Chinese Painting and Calligraphy, 1800–1950* (New York: Random House, 1987), 1: 275, it is noted that Ho adopted this technique after suffering a stroke, but no sources are cited. The year Ho began using the style name Old Ape may indicate the starting date.

38. Ho Shao-chi, "Pa Wei Chang Hei nü mu-chih t'a-pen," cited in Chin and Wang, eds., *Chung-kuo shu-fa wen-hua ta-kuan*, 608.

39. For Li Jui-ch'ing's biography, see Wang Chao-yung, comp., *Pei-chuan chi san pien,* reprint ed. (Hong Kong: Ta-tung t'u-shu, 1978), *chüan* 21: 1245–55; and Chao et al., comps., *Ch'ing shih kao, chüan* 486: 13437. For biographic references, see Chou Chün-fu, ed., *Ch'ing-tai chuan-chi ts'ung-k'an so-yin* (Taipei: Ming-wen shu-chü, 1986), 1119–20.

40. Michael Sullivan, *Art and Artists of Twentieth Century China* (Berkeley: University of California Press, 1996), 19, 25.

41. On Wen T'ien-hsiang, see Herbert Franke, ed., *Sung Biographies* (Wiesbaden: Franz Steiner, 1976), 1187–1201. On Shih K'o-fa, see *ECCP*, 651–52; and Lynn A. Struve, ed. and trans., *Voices from the Ming-Qing Cataclysm: China in Tiger's Jaws* (New Haven: Yale University Press, 1993), 29–32.

42. As a loyalist, Li Jui-ch'ing may have had an affinity for artists such as Shih-t'ao (1642–1707) and Pa-ta-shan-jen (1626–1705), who had found themselves in similar circumstances after a change of dynasty. On his interest in these artists, see Liu Chao-chia, "Ch'ing-tao-jen chuan," in Wang, comp., *Pei-chuan chi san pien,* 1253. Chang Ta-ch'ien, who bragged about having been Li's student for less than a year before Li's death, notes that Li had encouraged his own interest in Shih-t'ao and Pa-ta-shan-jen. See Chu-tsing Li, *Trends in Modern Chinese Painting* (Ascona: Artibus Asiae Publishers, 1979), 99–100, 103; and Shen C. Y. Fu, *Challenging the Past: The Paintings of Chang Dai-chien* (Washington, D.C.: Arthur M. Sackler Gallery, Smithsonian Institution; Seattle: University of Washington Press, 1991), 23, 90.

43. The sutra calligraphy is discussed and partly illustrated in Frederick W. Mote, Chu Hung-lam, et al., *Calligraphy and the East Asian Book, Gest Library Journal* 2, no. 2 (Spring 1988): 58–59, 60.

44. Li Jui-ch'ing, "Pa tzu lin San shih p'an ch'üan wen," in idem, *Ch'ing-tao-jen i-chi* (N.p.: Chung-hua shu-chü, 1939), "I kao," 28b–29a. A rubbing of the *San Basin* inscription is reproduced in *Shodō zenshū*, n.s., 1: nos. 80–81. Li followed this bronze inscription as a calligraphy model in many works, as is evident in a 1916 hanging scroll produced in the same month as this couplet (*In Celebration: Works of Art from the Collections of Princeton Alumni and Friends of The Art Museum, Princeton University* [Princeton: The Art Museum, Princeton University, 1997], cat. no. 34).

45. This stele is dated 511. Also known as the *Stele for Cheng Hsi* (*Cheng Hsi pei*), it is said to have been written by Cheng Hsi's son Cheng Tao-chao (d. 515). There are earlier and later stelae of the same text with minor variations. The later stele engraving has larger characters and is better preserved. It was repopularized in the Ch'ing period by Juan Yüan and Pao Shih-ch'en (1775–1855) as a calligraphy model. Reproduced in Iijima, ed., *Ippi itchō Chūgoku-hi hōchō seika*, fascicle 10; *Shodō geijutsu* (Tokyo: Chūōkōron-sha, 1971–73), 2: pls. 41–69; and in *Shodō zenshū*, n.s., 6: nos. 6–9.

46. The artist's inscription reads, "Gathered from the *Stele for Hsia Ch'eng*, and using the brush manner of Mr. Chung-yüeh's *Later Stele for Cheng Wen-kung.*"

47. The *Stele for Hsia Ch'eng* dates to the Eastern Han period. Raised in A.D. 170 in what is now the Yung-nien area, Hopei,

the actual stone has long been lost, although a version recut in 1543 survives. This recutting has thirteen columns of thirty-five characters each. Most extant rubbings are from this stone. The stele text concerns the official Hsia Ch'eng (*tzu*: Chung-yen, d. 170). For more on this stele, see Lang Shao-chün et al., eds., *Chung-kuo shu-hua chien-shang tz'u-tien* (Peking: Chung-kuo ch'ing-nien ch'u-pan-she, 1988), 1256–57. A portion of a rubbing is reproduced and transcribed in *Shodō zenshū*, old series (Tokyo: Heibonsha, 1930), 2: nos. 166–71.

48. On this incident, see Fan Yeh et al., comps., *Hou-Han shu* (Peking: Chung-hua shu-chü, 1965), *chüan* 4: 168–69; 23: 814–17 (transcription included). On the A.D. 89 campaign, see also *The Cambridge History of China,* vol. 1, Denis Twitchett and Michael Loewe, eds., *The Ch'in and Han Empires, 221 B.C.–A.D. 220* (Cambridge: Cambridge University Press, 1986), 268. A rubbing of the inscription is reproduced in *Pei-ching t'u-shu-kuan ts'ang Chung-kuo li-tai shih-k'o t'a-pen hui-pien,* ed. Pei-ching t'u-shu-kuan chin-shih tsu (Cheng-chou: Chung-chou ku-chi ch'u-pan-she, 1989–1991), 1: pl. 29.

49. *Ching-chün Inscription,* also known as *Stele for Ching-chün* (*Ching-chün pei*). Reproduced in *Pei-ching t'u-shu-kuan ts'ang Chung-kuo li-tai shih-k'o t'a-pen hui-pien,* 1: pls. 91–92; and *Shodō zenshū,* n.s., 2: nos. 78–9. The stele's full title, written at the top in seal-script characters, is *Han ku I-chou t'ai-shou Pei-hai hsiang Ching-chün ming.* Originally located in Chi-chou, Jen-ch'eng County, it was relocated to the prefectural school in Chi-ning, Shan-tung. The main body of the stele text is written in clerical script in seventeen columns of thirty-seven characters each, and the writing retains a seal-script influence.

50. See Li Jui-ch'ing's various writings on calligraphy in Ts'ui, comp., *Ming Ch'ing shu-fa lun wen-hsüan,* 1065–1105; and in Li's collected writings, *Ch'ing-tao-jen i-chi.*

51. Ch'en Yin-k'o, "Yü Liu Wen-tien chiao-shou lun kuo-wen shih-t'i shu," *Hsüeh heng,* no. 79 (1933), reprint pagination, 10991–98. Also reprinted in Ch'en Yin-ko, *Ch'en Yin-k'o hsien-sheng ch'üan-chi* (Taipei: Chiu-ssu ch'u-pan yu-hsien kung-ssu, 1977), 1367–73.

52. See Chiang Tsun, ed., *Tui-lien yü i-hua,* 133.

53. The Dragon Gate is located between Ho-chin County, Shansi, and Han-ch'eng County, Shensi, along the Yellow River. This landmark is composed of two sharp peaks rising on either side of perilous rapids to form a natural gate. Legend has it that Yü excavated this site during his river conservation work, and that ordinary fish cannot swim upstream beyond this point. The few that can become dragons. The Dragon Gate, consequently, is seen as a transcendental point, or bridge, between the ordinary and extraordinary, or earthly and heavenly realms. It is for this reason that the name Dragon Gate is used for the main gate of examination compounds. See *Shang shu cheng-i* (*Shih-san ching chu-shu* ed.; Peking: Chung-hua shu-chü, 1980), "Yü kung," *chüan* 6: 150; trans. in *The Chinese Classics,* trans. Legge, 3: 127. See also Lai Ssu-hsing (*chin-shih* degree, 1607), *Ch'a-an hsiao ch'eng* (Taipei: Hsüeh-sheng shu-chü, 1971), "Lung-men," *chüan* 4: 20b–21b.

54. Ruitenbeek, *Carpentry and Building,* 157–58, 290–91, 295, 303, 305, 308–11.

55. Recorded in *Secret Charms and Magical Devices* (*Mi-chüeh hsien-chi*), a late-Ming supplement to a ca.-16th-century version of *The Classic of Lu Pan.* See Ruitenbeek, *Carpentry and Building,* 290–91; and the figure at the end of *chüan* 2 of the Chinese text.

56. Yü Min-chung et al., comps., *Jih-hsia chiu-wen k'ao* (Peking: Pei-ching ku-chi ch'u-pan-she, 1983).

57. Cao Xueqin [Ts'ao Hsüeh-ch'in], *The Story of the Stone* [*Dream of the Red Chamber*], trans. David Hawkes, vol. 1, *The Golden Days* (Harmondsworth: Penguin Books, 1973), chaps. 16–17.

58. Liu, "Ch'ing Dynasty Wen-yüan-ko Imperial Library," 269–81.

59. Symbology is the study or interpretation of a system of symbols. Elsewhere I have proposed that although the Western-based Vitruvian categories of form, function, and structure may be useful analytical tools, they are nevertheless inadequate for understanding Chinese architecture. Analysis of a building's symbology—including decoration, name, numerology, geomancy, calligraphy, ritual layout, and design models—is an additional lens through which to view Chinese architecture (Liu, "Ch'ing Dynasty Wen-yüan-ko Imperial Library," 7, 269–83).

60. On the design and symbology of the Wen-yüan-ko and other *Four Treasuries* library halls, see Liu, "Ch'ing Dynasty Wen-yüan-ko Imperial Library."

61. See Ch'ing-kuei (1735–1816), *Kuo-ch'ao kung-shih hsü-pien* (Peking: Ku-kung po-wu-yüan t'u-shu-kuan, 1932), *chüan* 53: 5a; Yü et al., comps., *Jih-hsia chiu-wen k'ao, chüan* 12: 165–66; and Kuo Po-kung, *Ssu-k'u ch'üan-shu tsuan-hsiu k'ao,* 176.

62. Kuo Po-kung, *Ssu-k'u ch'üan-shu tsuan-hsiu k'ao,* 184. A photograph of the placard is reproduced in *Chung-kuo mei-shu ch'üan-chi, chien-chu i-shu pien,* vol. 1, *Kung-tien chien-chu,* ed., Chung-kuo mei-shu ch'üan-chi pien-chi wei-yüan-hui, (Peking: Chung-kuo chien-chu kung-yeh ch'u-pan-she, 1987), pl. 153.

63. The term "Three Rivers" (*San-chiang*) is found in *The Book of Documents* (*Shang shu cheng-i,* "Yü kung," *chüan* 6: 148): "The three Kiang entered (into the sea). The marsh of Chen was settled" (*San-chiang chi ju, Chen-tse ti ting*); as translated in Bernard Karlgren, "Book of Documents," *Bulletin of the Museum of Far Eastern Antiquities,* no. 22 (1950): 14. It is variously interpreted and can no longer be understood with any certainty. On discussion and commentary of its possible meaning, see Wang Ying-lin (1223–1296), *Hsiao-hsüeh kan-chu* (*Pai-pu ts'ung-shu chi-ch'eng* ed.; Taipei: I-wen yin-shu-kuan, 1966), *chüan* 2: 9b–3a; and *Chinese Classics,* trans. Legge, 3: 108–10. Important to the allusion in this imperial couplet is the flowing of water down to the sea. In *The Book of Documents,* the routing of the Three Rivers to the sea allowed regions to become inhabitable and governable.

64. Recorded in Wang and Wang, *Chung-kuo ming-sheng ku-chi tui-lien hsüan chu,* 62–63. The characters *ju han-ju* are incorrectly transcribed in Kuo Po-kung, *Ssu-k'u ch'üan-shu tsuan-hsiu k'ao,* 184.

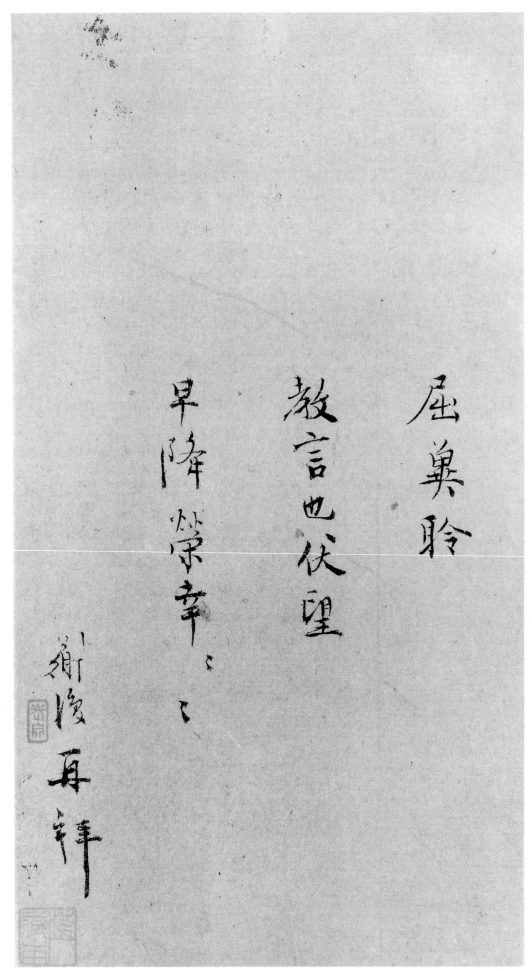

Ch'en Ch'un (1483–1544), *Letter to Wen Cheng-ming* (cat. no. 44, detail).

Chinese Letters: Private Words Made Public

QIANSHEN BAI

I n many cultures private letters have been col-
lected and published, chiefly because of their his-
torical value and literary style, or because of the
fame of their authors. As early as the Western
Han dynasty, letters were collected in China, primarily
as samples of outstanding calligraphy. Letters also
were copied and made into rubbings, which became
objects of aesthetic appreciation in their own right
and models to be imitated by calligraphers. Through
these processes, texts intended for a private readership
became known among a large audience. This essay
examines some of the ways in which personal letters
were written, collected, duplicated, and circulated, as
well as their function in Chinese culture. It also consid-
ers how scripts were selected for writing letters and
how calligraphic styles, formats of writing, and even
stationery conveyed meanings within what might be
termed the culture of letter writing in China.[1]

AN INTRODUCTION TO THE ART
OF THE CHINESE LETTER

The earliest extant personal letters from China were
written on wooden sticks dated to the Ch'in dynasty.
Excavated from the tombs at Shui-hu-ti, Hupei, in
1975 (fig. 1),[2] these early letters are designated by the
term *ch'ih-tu*, "letter on foot-long wood or bamboo
tablets." This became the most common term for let-
ters and was used even after they were written on
other materials.[3]

It is beyond question that the Han dynasty was a
turning point in the history of Chinese calligraphy and
letter writing. In a story about Liu Mu (fl. 1st century),
a cousin of Emperor Ming-ti of Han (r. 57–75), a pas-
sage reads, "[Liu Mu] was good at calligraphy; his con-
temporaries took him as a standard and followed his
model. When Liu was on his deathbed the emperor
sent an express courier by horse to ask him to write
ten letters in draft cursive script."[4]

How could an emperor ask someone on his death-
bed to write ten letters, if not driven by love of callig-
raphy? The biography does not tell us to whom these
letters were written; it is likely that the emperor was
the only intended recipient. The primary, perhaps
only, reason the emperor asked Liu Mu to write letters
in draft-cursive (*chang-ts'ao*) script was that this form
of calligraphy commonly used in letter writing had
recently become a new vehicle for artistic expression
among aristocrats. Thus, in addition to their useful-
ness as written communication, letters came to be
appreciated and collected as works of calligraphy.

The story of Liu Mu took place during a period of
increasing interest among nobles in collecting calligra-
phy. The biography of Ch'en Tsun (fl. Hsin period,
A.D. 9–24) in *The History of the Later Han* (*Hou Han shu*)
notes that Ch'en Tsun "was a born calligrapher. When
he wrote letters, their recipients always kept them and
stored them away, because they viewed them as some-
thing magnificent."[5]

In the following centuries, especially in the dynas-
ties ruling south China, calligraphy was elevated to
the most important form of fine art among the elite.
According to Yü Ho (fl. 465–471), a calligraphy critic of
the Liu Sung dynasty (420–479), displaying calligraphy
was one of the entertainments at aristocratic gather-
ings. He writes, "Huan Hsüan [369–404] loved calligra-
phy. Whenever he held feasts, he would show guests
his collection of calligraphy."[6] Anecdotal evidence
suggests that many of the works Huan Hsüan col-
lected were letters.

In this cultural milieu, calligraphers sometimes
even asked the recipients of their letters to preserve
them. A story about Wang Hsien-chih (344–388) states,
"Wang Hsien-chih once wrote a letter of ten or so
pages to Emperor Chien-wen (r. 371). At the end he
wrote, 'My calligraphy in this letter is quite good. I
wish it to be kept and stored away.'"[7] Although there
were no galleries and museums in the modern sense
for collecting and displaying works of art, letters

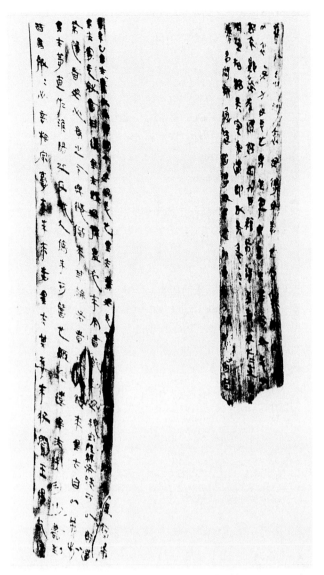

Figure 1. Two Ch'in dynasty letters on wood tablets, excavated at Shui-hu-ti, Hupei, 1975. From *Yün-meng Shui-hu-ti Ch'in-mu* (Peking: Wen-wu ch'u-pan-she, 1981), pls. 167, 168.

became a vehicle to show off one's calligraphy and were showcases for a calligrapher's achievement.

Another anecdote by Yü Ho describes how aristocrats used letter writing to compete with one another in calligraphy:

Hsieh An [320–385], who excelled in calligraphy, had no high opinion of Wang Hsien-chih's calligraphy. When Wang Hsien-chih wrote a letter in excellent calligraphy to Hsieh An, he thought Hsieh would appreciate it. But Hsieh An wrote his reply on the back of Wang Hsien-chih's letter and returned it.[8]

This anecdote demonstrates the calligraphic competitiveness among aristocrats in letter writing. By returning Wang Hsien-chih's letter, Hsieh An implicitly but clearly suggested that the calligraphy was not worth

saving. It can be imagined how insulting this behavior would be during a period in which the value of a writer's calligraphy was judged by whether his letters were collected by their recipients, circulated, and appreciated among the elite.

As personal letters became collectible objects, they passed through different hands. For instance, the letter to Emperor Chien-wen by Wang Hsien-chih discussed above later entered the collection of Huan Hsüan.[9] This and similar accounts of letter collecting show that aristocratic writers clearly understood that letters in good calligraphy were likely to be circulated and appreciated in settings such as the gatherings of aristocrats hosted by Huan Hsüan. A keen awareness that letters were collectible led to a conscious effort to make their literary style and the calligraphy in which they were written the objects of aesthetic appreciation. In this sense, private letters had achieved a public audience, leading to the seemingly contradictory phenomenon of "private letters for public consumption." The notion of "public" used here should be carefully defined. Because of a strictly hierarchical social system in effect during Wang Hsi-chih's (303–361) time, the public for these letters was rather limited. As a token of the cultural supremacy of the aristocrats, letters were shown only to those who were regarded as "men of letters." The new calligraphic style of Wang Hsi-chih and his son Wang Hsien-chih, as a recent study by Hua Jen-te suggests, circulated only among those northern nobles who fled to the south. Not only did common people have no access to these letters, but native southern aristocrats were hardly able to attain them.[10]

A careful examination of the surviving copies of letters by early masters reveals that their texts deal mostly with purely private matters, such as reporting one's health to a friend, expressing happiness or grief, or offering gifts. Because the calligraphy of these letters made them collectible objects, we may say that while their texts were intended for private readers, their calligraphy was aimed at a public audience who would inevitably read them in very different contexts.

A classical tradition based on the calligraphy of Wang Hsi-chih and Wang Hsien-chih, especially the former, was finally established after a long formative period in the Southern Dynasties through the efforts of Emperor T'ai-tsung (r. 626–49) of the T'ang dynasty.[11] As a passionate collector of calligraphy, Emperor

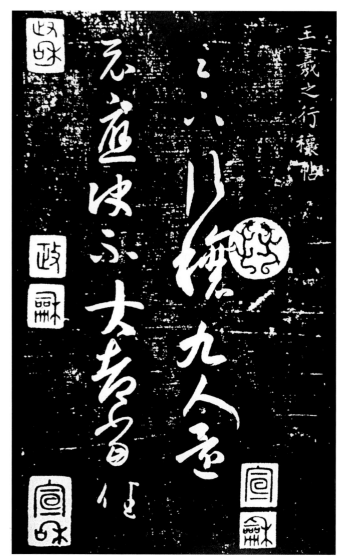

Figure 2. Wang Hsi-chih (303–361), *Ritual to Pray for Good Harvest,* facsimile of rubbing. The Art Museum, Princeton University.

warfare in the centuries prior to the T'ang, many works by Wang Hsi-chih and other masters were destroyed or lost.

The production of copies of works by Wang Hsi-chih and other masters became crucial to both the practice and connoisseurship of calligraphy.[14] In the T'ang dynasty, an institution responsible for copying calligraphy was established at the imperial court. Copies of masterpieces were made and sometimes given to princes and senior officials as imperial favors. The copy of Wang Hsi-chih's *Ritual to Pray for Good Harvest,* now in the Elliott Collection, is an ideal example of a T'ang copy (cat. no. 2).[15] Widely believed by scholars to be a tracing copy of Wang Hsi-chih's original calligraphy, the strokes in this work are rounded and vigorous, retaining the archaic flavor of clerical script (*li-shu*). The copy of *Ritual* consists of fifteen characters, but according to the transcription in Chang Yen-yüan's *Essentials of Calligraphy,* the complete text of the letter had thirty-two characters, including two damaged characters and Wang Hsi-chih's signature; the text transcribed by Chang is also slightly different from that of the Elliott copy. For instance, in Chang Yen-yüan's text, the third character in the second line is *k'uai* ("fast," or "happy") rather than *chüeh* ("decide," or "definitely"), which appears in the Elliott version.[16]

There are several possible reasons for these differences. First, the Elliott copy may present only part of the letter recorded in *Records of Wang Hsi-chih's Calligraphy,* and the textual differences may be the result of an error of transcription or printing. A second possibility is that the Elliott version was originally a complete copy of the letter, the last part of which was damaged and cut off when the letter was remounted during the reign of Sung emperor Hui-tsung (r. 1100–1126). It is also possible that there was more than one tracing copy of the letter. The textual differences may have arisen during the copying process. As Ch'i Kung notes, T'ang copyists sometimes miscopied Wang Hsi-chih's works.[17] We also should not exclude the possibility that the Elliott letter is based on another T'ang copy or on the original but damaged *Ritual to Pray for Good Harvest.* Whatever their origins, tracing copies of works by Wang Hsi-chih and other masters made them accessible to a wide audience.[18]

Reproductions of early calligraphy proliferated during the Sung dynasty. At the command of Emperor T'ai-tsung (r. 976–97), the courtier Wang Chu compiled

T'ai-tsung used his imperial power and resources to purchase Wang Hsi-chih's works, leaving few in private hands.[12] During the T'ang, letters by the Two Wangs and other masters were not only objects of appreciation but also models imitated by both students and mature calligraphers. From *Index of Wang Hsi-chih's Calligraphy (Yu-chün shu-mu)* by Ch'u Sui-liang (596–658) and *Records of Wang Hsi-chih's Calligraphy (Yu-chün shu-chi),* transcribed in Chang Yen-yüan's (ca. 815–ca. 880) *Essentials of Calligraphy (Fa-shu yao-lu),* we know that by the T'ang dynasty the overwhelming majority of Wang Hsi-chih's extant works were letters.[13] The surprisingly large quantity of personal letters among extant early calligraphic works demonstrates the role played by letter writing in calligraphy's early stages of development. But owing to frequent

Figure 3. Covered verandah in the Garden of the Unsuccessful Politician (*Cho-cheng yüan*), Soochow. From Laurence G. Liu, *Chinese Architecture* (New York: Rizzoli International Publications, Inc., 1989).

about 419 works of calligraphy by some one hundred writers into ten volumes which were then engraved on wooden blocks in 992. Rubbings of the engravings were distributed by the emperor as imperial favors to his senior officials. This project was later known as *Model Calligraphies from the Imperial Archives of the Ch'un-hua Era (Ch'un-hua-pi-ko fa-t'ieh)*. The works in this anthology are predominantly letters, especially personal letters; others are ancient classics, poems, critiques of and colophons to calligraphic works, and sections of stele inscriptions.[19] They, together with the letters, were called *fa-t'ieh*. Interestingly, the term *t'ieh*, one of whose original meanings is "short letter," came to mean "model-book"—a single rubbing or collection of engraved calligraphic models intended for the study of calligraphy.[20] *T'ieh* and *fa-t'ieh* then became special terms for a calligraphy model-book. The broadened connotation of *t'ieh* demonstrates that letter writing was one of the driving forces behind the development of Chinese calligraphy.

In the Southern Sung dynasty, a new type of model-book began to feature works, most of which were letters, by contemporary calligraphers. *Model-book from Feng-shan Villa (Feng-shu fa-t'ieh)*, compiled by Tseng Hung-fu during the Chia-hsi and Ch'un-yu reigns (1237–53), was traditionally believed to be the first model-book of this kind.[21]

Fa-t'ieh usually were engraved on horizontally arranged rectangular wood or stone tablets, from which rubbings were made. This became a conven-

tional method of calligraphy reproduction until photography and modern printing were introduced into China. Numerous *fa-t'ieh* were produced in the Sung and succeeding dynasties.[22] Through the dissemination of these model-books, reproductions of ancient masterpieces, such as *Ritual to Pray for Good Harvest*, became widely available to Chinese literati (fig. 2). Through this process, letters by master calligraphers reached an ever larger readership.

While imperial collectors and private scholars in the Sung dynasty were enthusiastic about model-books, it was in this period that contemporary letters were first engraved on stelae. In 1203 eight letters by Lu Yu (1125–1210) to a Buddhist monk were carved on the back of a stele in a temple in Chin-hua, Chekiang.[23] The inscription on the front of the stele is an essay commemorating the renovation of the temple. For centuries stelae functioned mainly as memorial monuments erected in public places such as temples and cemeteries. But now monks and pilgrims could view letters of poets and scholars in a public place.

Carvings of calligraphy, which almost without exception included letters by ancient masters, were sometimes sponsored by local officials. A case in point is *Calligraphies from the Pao-hsien Hall (Pao-hsien-t'ang fa-t'ieh)*. Comprising many letters by Wang Hsi-chih and other ancient masters, this model-book was originally engraved by a Ming prince in Shansi in the ninth year of the Hung-chih reign period (1496). By the early Ch'ing dynasty, most of the stones used to print this

anthology had been lost. When Tai Meng-hsiung (d. 1680) served as the magistrate of Yang-ch'ü, a county near modern Taiyuan, he collected the old stones and hired people to reengrave the lost ones using the original rubbings as a guide. He also donated a building to house the newly engraved stones, which were later moved into the Chin-yang Academy and now are in Shuang-t'a Temple in Taiyuan.[24]

Not only can engraved letters be found in public places such as Buddhist temples and government-sponsored academies, but also in private gardens. The walls of many famous gardens in Chiang-nan (south China), such as Li Garden in Wu-hsi and Wang-shih Garden, Cho-cheng Garden, and Ch'ü Garden in Soo-chow feature stone tablets engraved with calligraphy (fig. 3). The question of when engraved calligraphy was first installed in private gardens demands further investigation,[25] but by the Ch'ing dynasty this practice had become quite fashionable among literati. As a part of the scenery of literati gardens, calligraphic works were like permanent installations in the art museums and galleries of today. Although located in private gardens, engraved letters were likely seen by people other than the garden owners on such occasions as literary gatherings. Once again, private letters were publicly viewed.

Literati gardens provided a new context for reading and viewing engraved letters. Ideally, works for these locations were essays or poems, such as Wang Hsi-chih's *Preface to the Orchid Pavilion Collection (Lan-t'ing chi hsü)*, that reflect their settings. But many letters recounted personal affairs inappropriate to gardens. Often they reported everyday activities that were far from elegant, such as the illness of the author or his relatives. Would guests at a literary gathering in a garden, drinking tea and wine, or composing poems, have been disturbed by Wang Hsi-chih's reports of illness? Did they feel pleasure reading about the sufferings of others in a peaceful, elegant garden? Were they interested in the letters because they afforded a peek into the private life of a celebrated calligrapher? I assume that in most cases viewers concentrated on the calligraphy and did not enter deeply into the messages of these letters, maintaining a psychological distance from their literal contents.

When letters were engraved in a garden, their original content diminished in importance, and new meanings were created by a new context. Once the engraved calligraphy was installed on a wall, it became part of the visual rhetoric of the garden. Reading was subordinated to viewing. Consequently, the rareness of letters and the craftsmanship of their engraving became more important than their texts. In addition to being able to view beautiful writing, the owners of such gardens benefitted from the possession and exhibition of superior calligraphy, which, even in engraved form, helped demonstrate high social and cultural status.

Reproductions of letters in China may have had a profound impact on the literati attitude toward letter writing. Some prominent calligraphers seemed to believe that since personal letters were likely to be publicized in model-books, they should write them to appeal directly to public audiences. A set of four hanging scrolls now in the Chin-tz'u Museum in Taiyuan by Fu Shan (1607–1684/85), a Ming loyalist scholar and artist from Shansi, is an interesting innovation in the history of Chinese letter writing (fig. 4). Fu Shan's self-description as "the seventy-eight-year-old man Fu Chen-shan" (Fu Shan's Taoist name) dates this work to 1684, the last year of his life.

The text is a short but beautiful essay written for a friend, Ch'ien-ch'i, whom Fu Shan praised for having an aloof personality and for maintaining harmonious relationships with his brothers. At the end of the text Fu Shan wrote, "I got up early this morning to write this work in front of the Small Pavilion of Apricots as a substitute for a letter [to Ch'ien-ch'i]." Many past masterpieces of calligraphy were written in epistle format usually no larger than eight by eleven inches. But Fu Shan wrote a set of four huge hanging scrolls (each more than six feet high) as a letter. Bold and ink-saturated, the vigorous brushwork commands the viewer's attention.

Although Fu Shan's set of four hanging scrolls was a personal gift for a close friend, its format displayed certain public features. The huge size of the work and its scroll form made it suitable for displaying in a central hall where the owner met his friends and guests. Displayed as a famous calligrapher's work, personal letters in this unusual format served a new function, demonstrating the cultural sophistication of the owner.

Artists of the twentieth century continued to create letters in unusual formats. As unconventional as Fu Shan's four hanging scrolls is a letter written on a hanging scroll of figure painting by Fu Pao-shih

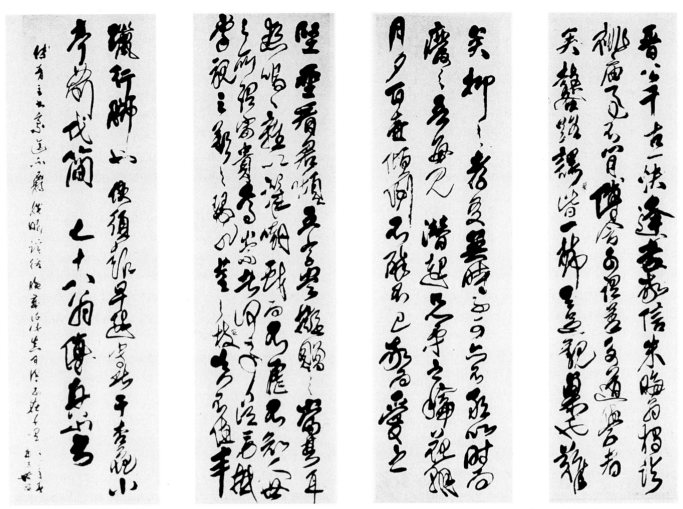

Figure 4. Fu Shan (1607–1684), *A Set of Hanging Scrolls as a Letter to Ch'ien-ch'i*, 1684, ink on silk, 200.1 x 51.7 cm. Shansi Chin-tz'u Museum, Taiyuan. From *Fu Shan shu-fa* (Taiyuan: Shan-hsi jen-min ch'u-pan-she, 1987), 1–2.

(1904–1965; fig. 5). Usually, after executing a painting, a Chinese painter likes to inscribe a few lines indicating its date of execution, to whom the work is dedicated, on what occasion it was made, and other information. Fu Pao-shih's painting depicts "Three Laughers by Tiger Stream" (*Hu-hsi san-hsiao*), a famous story praising the harmonious relationships among Confucianism, Taoism, and Buddhism. Rather than inscribing something relevant to this story, in the position where a painter normally would write an inscription, Fu Pao-shih wrote a letter:

> My respected brother Shang-i: I have not written to you for months. I hope everything is fine for you. Last week Mrs. Ssu-t'u came here from Mountain City [Ch'ung-ch'ing] and passed on your words. I was very delighted to hear from you. I have not gone out my door for three months this summer. At the beginning of this time, I worked on my manuscript. More recently, I have painted frequently and have accumu-

lated a large number of paintings. I regret that I have not had the opportunity to discuss them with you. Now I use this work to express my thoughts to you. The autumn wind is whistling. I wish you would take good care of yourself. With all the best, Pao-shih presents. After the tenth day of the tenth month of the year of *k'uei-wei* [1943]. For your amusement.

An eminent painter, Fu Pao-shih clearly knew that his painting and letter would be mounted and hung on a wall. Because both artist and recipient were willing to allow the scroll to be displayed and viewed by others, this personal letter, although hung in private quarters, became accessible to a public audience. For this reason, both Fu Shan's set of four hanging scrolls for his friend Ch'ien-ch'i and Fu Pao-shih's painting with a letter as an inscription are not truly private. Since the original intention behind writing these two letters was that they be displayed, we may term them "private letters for public consumption."

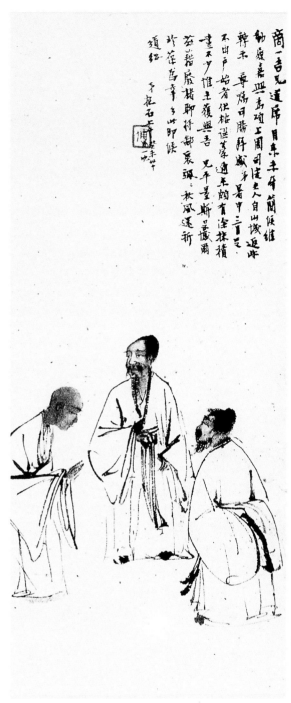

Figure 5. Fu Pao-shih (1904–1965), *A Letter to Wang Shang-i on a Figure Painting,* 1943, ink and color on paper, 45.4 x 19 cm. Collection of Ch'ü Kuei-liu, Hong Kong. From *Han Mo: A Magazine of Chinese Brush Art,* no. 10 (1990).

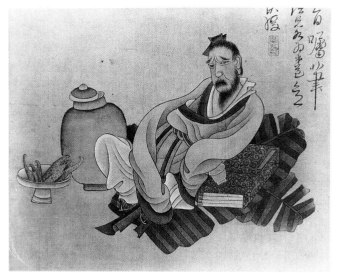

Figure 6. Ch'en Hung-shou (1598–1652), *A Letter to Chang Ping-tsu on an Album Leaf with Self Portrait,* ca. 1633, ink and colors on silk, 26.4 x 23.3 cm. The Metropolitan Museum of Art, New York, promised gift of Mr. and Mrs. Wan-go Weng.

Fu Pao-shih, however, was not the first painter who inscribed a personal letter on a painting. We can find precedent in a painting by the famous late Ming figure painter Ch'en Hung-shou (1598–1652). On an album leaf of a figure painting dating from around 1633, Ch'en depicted a dejected scholar knotting his eyebrows while leaning on a case of books beside a huge wine jar (fig. 6). Some scholars argue that this is a self-

portrait of the artist.[26] The inscription to the right of the figure is actually a letter Ch'en Hung-shou wrote to his friend Chang P'ing-tsu (fl. 1633).[27] In the letter, Ch'en expressed his worry and fear about the growing crises the nation faced: the military threat of the Manchus in the northern border areas and robberies by the outlaw bands that menaced his hometown. Judging from the placement of the inscription, it is clear that Ch'en Hung-shou painted the figure first and then wrote the letter. Chang P'ing-tsu must certainly have been delighted that his friend, a leading figure painter of his time, wrote to him on such unusual "stationery."

We have so far discussed how personal letters were made public, how they moved from a private to a public domain. Did Chinese calligraphers ever write letters intended only for the eyes of a single recipient? Without doubt, the answer must be yes. But it is likely that letters of this kind were destroyed rather than gathered in collections.[28] There are extant, however, letters whose authors tried without success to prevent their entry into the public domain. Among these is a handscroll of eighteen letters that Fu Shan wrote to his friend Wei I-ao (ca. 1620–1694), a Chinese official in the Ch'ing government (fig. 7).[29] We know from these letters that during the difficult period of dynastic transition, Wei I-ao gave Fu Shan all manner of help when the former served as a local official in Shansi. In 1652 Fu Shan even asked Wei I-ao for a tax exemption on his land:

Figure 7. Fu Shan, *A Letter to Wei I-ao*, ca. 1652, section of a handscroll, ink on paper, dimensions unavailable. Yip Shing Yiu Collection, Hong Kong.

My family is originally from Hsin-chou; at present we still own a few *mu* of poor land there. . . . They have not been taxed for eighty years as a registered household. But now the treacherous officials put them into the tax category "Real Grain." I am bombarded with complaints from my clansmen there. My two brothers are burdened with taking care of this matter, and their bitterness cannot be expressed by words. I am going to

submit a report to the government and ask to have the case transferred to the prefecture in which I am now living and to have the property made tax exempt as before. Is this possible? If so, I still do not know how to process it. I hope you can advise me in person. I am ready to live in abject poverty, but this concerns the living of my family, so I cannot leave the matter unsettled. I just heard that the Bureau of Agriculture is investigating famine. Would this present an opportunity for pursuing it?[30]

It seems that Fu Shan felt ashamed to ask the Ch'ing government to exempt his land from taxation, even though he was obliged to do so by the burden of feeding his family. Hence at the end of the letter, he added, "After reading this, please burn it immediately; do not keep it. Be sure of that!" Furthermore, most letters in this handscroll end with the character *shen,* "be careful," indicating that Fu Shan wanted these letters to be kept strictly private. But Wei I-ao treasured Fu Shan's calligraphy so much that he did not honor Fu's request, preserving these important historical documents because of their calligraphic value.[31]

In most societies, celebrities enjoy less privacy than do common people, and letters by the famous have always been collected and published by contemporary and later admirers. Not only did Chinese literati recognize the likelihood that their letters would be collected, but many self-consciously kept copies of their letters and compiled them in anthologies.[32] Those who did so knew that their readership would not be limited to a single person or family members or friends, but would eventually expand to include a broad audience. In many Chinese literary anthologies, one or more chapters are devoted to a genre called *shu,* letters. Letters concerning sensitive matters had to be handled with discretion. Authors would certainly not include in anthologies letters that might bring them trouble or hurt their public images. For instance, *Jung-t'ai chi,* an anthology of works by the famous late Ming calligrapher and painter Tung Ch'i-ch'ang (1555–1636), was published about 1630, when Tung was still alive. Although Tung liked to preserve his own writings, not a single letter is included in this work. Celia Carrington Riely convincingly demonstrates that Tung was cautious during a period in which political strife put everyone in a dangerous situation. He had received four imperial patents awarding him honorary titles, including one granted during a period when the

Figure 8. Attributed to So Ching (239–303), *Model Letters for Each Month* (detail), rubbing. From *Shōdo zenshū*, n.s. (Tokyo: Heibonsha, 1965), 3: 117.

notorious eunuch Wei Chung-hsien (1568–1627) was in power, but Tung never mentioned these in his correspondence.[33] It seems that, since any connection with the eunuch clique might have caused political trouble, Tung simply excluded all of his letters from his anthology. Meanwhile, his fame in calligraphy caused many of his letters in private hands to be preserved and later carved into model-books of famous calligraphy. In the Elliott Collection there is a letter by Tung Ch'i-ch'ang in his gracious, fluent running-and-cursive script (cat. 45). This letter, whose recipient is unknown, recommends a friend to some officials. Although it was excluded from Tung's anthology, its calligraphic value ensured the survival of Tung's original calligraphy.

THE DECORUM OF LETTER WRITING

Manuals known as *shu-i* were an important part of the history of Chinese letter writing.[34] A literal translation of *shu-i* is "letter-writing manual," a compendium of letters that could be used as models. But this translation conceals the social and moral connotations of these texts. In classical Chinese, *i* refers to ceremonies, manners, rites, customs, rules, and standards. Combined with the word *li* in the compound *i-li*, "ceremonies and rites," it refers to a concept central to Chinese culture. In some cases, the connotations of these two characters overlap and are thus interchangeable. The prefaces of a few extant copies of T'ang *shu-i* begin with the statement "When there is *li* among human beings, there is peace. When there is no *li* among human beings, dangers come."[35] Like *i*, *li* has multiple meanings. As the French scholar Joseph Marie Callery stated when he summarized the use of *li* in classical Chinese,

> As far as possible, I have translated *li* by the word "rite," whose meaning has the greatest range; but it must be acknowledged that according to the circumstances in which it is employed it can signify ceremonial, ceremonies, ceremonial practices, etiquette, politeness, urbanity, courtesy, honesty, good manners, respect, good education, good breeding, the proprieties, convention, *savoir-vivre*, decency, personal dignity, moral conduct, social order, social duties, social laws, rights, morality, laws of hierarchy, sacrifice, mores, and customs.[36]

Wu Hung comments on Callery's definition of *li* in his study of early Chinese ritual art: "Callery's list is by no means a compact definition, but it does make clear two major aspects of human lives to which the concept of *li* is applied: ceremonies and related practices, and social conventions—primarily those of law, morality, and propriety—that govern the working of society at large."[37] By asserting the significance of *li*, the T'ang *shu-i* prefaces convey the unmistakable message that *shu-i* teach not only letter writing, but also behavior that conforms to traditional social mores and norms.

According to *History of the Sui Dynasty (Sui shu)*, the history of letter-writing manuals can be traced to the Eastern Han.[38] The earliest one extant is *Model Letters for Each Month (Yüeh-i t'ieh)*, attributed to the famous Western Chin calligrapher So Ching (239–303; fig. 8). This manual is a guide to terms that should be used in each of the twelve months when writing letters to friends. Although most scholars believe that its

Figure 9. A section of *Classical Manual of Letter Writing* (*Shu-i ching*), by Tu Yu-chin (fl. 713–755), T'ang dynasty. From Chou I-liang and Chao Ho-p'ing, *T'ang Wu-tai shu-i yen-chiu* (Peking: Chung-kuo she-hui k'o-hsüeh ch'u-pan-she, 1995), pl. 2.

calligraphy indicates it is a T'ang copy, the text could date to the Western Chin.[39] According to some records, Wang Hsi-chih wrote a similar letter manual.[40] In the Southern and Northern Dynasties, more manuals were produced. In addition to comprehensive guides to letter writing, there were specialized manuals made for specific social groups such as monks, women, and government officials.[41] What intrigues us is that among the eleven letter-writing manuals recorded in the *Sui shu*, five of the ten for laymen (another for monks was written by a monk) were written by members of the Wang and Hsieh families, which had also produced the most famous calligraphers of the Eastern Chin and Southern Dynasties.[42] Letters by these two groups of aristocrats must have become common models for both calligraphic and literary style. Numerous *shu-i* were produced in succeeding dynasties.

A great number of *shu-i* from the T'ang dynasty have come to light since the discovery of the Caves of the Thousand Buddhas in Tun-huang. In recent years, scholars have explored the close relationships between *shu-i* and aspects of social life in the period from the T'ang through the Five Dynasties.[43] For example, the *fu-t'u*, or diagram of mourning responsibilities, is included as an important part of *shu-i* (fig. 9). This diagram clarifies the length of mourning periods based on the reader's *tsu* (patrilineage) and his obligations to other family members. It also specifies the forms of address and other terminology to be used when writing to family members.[44] Its inclusion further demonstrates a firm link between letter writing and *li*, and the important social function of *shu-i*. T'ang *shu-i*, the earliest extant examples that include the *fu-t'u* diagram, established a convention for many subsequent manuals.[45]

Letter writing as a major vehicle of communication touched almost all aspects of social life, and it is small wonder that the *shu-i* gradually developed into a kind of social and moral guide. The most famous surviving Sung letter-writing manual is by the high-ranking official Ssu-ma Kuang (1019–1086). Although it is titled *Shu-i*, only the first of its ten chapters concerns letter writing. The rest of the text addresses various ceremonies.[46] Finally, the Yüan dynasty produced the lengthy fifty-one-*chüan Newly Compiled Selections of Letters for Brief Classification of Matters and Essays* (*Hsin-pien shih-wen lei-yao ch'i-cha ch'ing-ch'ien*), another early example of the *shu-i*'s expanding scope, published by the Liu family in Chien-an, Fukien, in 1324. Although the title of this book refers to letter writing, its contents cover

such nonepistolary activities as etiquette, including banquet seating and model eulogies by the ancients. It provides a great quantity of model letters for a variety of social occasions, including letters accepting and declining invitations. In line with its pragmatism, this book includes seven chapters of *huo-t'ao-men,* "adaptable conventions in verbal exchanges," options that readers may apply to varying conversational circumstances.[47] In the Ming dynasty a book of this type, rather than using a title associated with letter writing, acquired one more properly reflective of its contents, *Household Encyclopedia (Wan-pao ch'üan-shu).*[48] Even so, a letter-writing manual was always an important part of an encyclopedia, and, almost without exception, it was included in the same section as the diagram of mourning responsibilities.

A few questions surface from this brief survey of *shu-i.* Who read them? How broad was the readership and circulation? Although there are no extant textual accounts of the actual use of *shu-i* in everyday life, we can draw some conclusions based on the information we have. As mentioned above, Wang Hsi-chih himself wrote a *shu-i.* During the Six Dynasties, both the calligraphic and literary style of letters by aristocratic writers were widely imitated, and *shu-i* must have had a considerable readership among all those with a vital interest in rhetorical courtesies.[49]

The fact that in the T'ang dynasty many *shu-i* were composed by senior officials demonstrates the importance of these texts. That over one hundred copies of *shu-i* transcribed in rather poor calligraphy were found in Tun-huang, an area far from political and cultural centers, confirms the broad circulation of these materials in the T'ang dynasty. Chao Ho-p'ing points out that various *shu-i* were in fact used as children's textbooks in the Tun-huang area and were widely copied.[50]

As printing technology advanced after the Sung dynasty, many *shu-i* were printed, and some of the most popular were reprinted in different editions. For instance, there are many surviving editions of *Newly Compiled Complete Collection of Letters for Classification of Matters and Essays (Hsin-pien shih-wen lei-chü han-mo ta-ch'üan),* including many preserved in Korea and Japan, where the book was very popular and reprinted quite early.[51]

There is also the question of the degree to which the models given in *shu-i* were actually followed in personal correspondence. These manuals were not, of course, the only way to learn letter writing. People followed the examples of senior family members or learned from letters by others, including letters compiled in publications such as literary anthologies and collections of letters.[52] Even so, a comparison of the standards set by letter-writing manuals and the forms used in actual letters should reveal how close the relationship was between the two; distinctions could reflect changes in social customs.

Among the specifications found in *shu-i,* the most common are rules of spacing known as *p'ing-ch'üeh.* *P'ing,* "level," refers to the practice of starting a new line every time the recipient's name or a direct reference to him occurs, even though the previous line may still have space for more characters. This ensures that the recipient's name is always at the head of a line. *Ch'üeh,* "blank," refers to the one or two blank spaces left before the recipient's name instead of starting a new line with it. These rules of respectful spacing were strictly required in correspondence between government offices, and personal letters sometimes followed them as well.[53]

These rules can be traced back to Wang Hsi-chih's *Letter to My Aunt (I-mu t'ieh)* of the Eastern Chin dynasty (fig. 10). In this letter, when Wang mentioned his aunt he started a new line even though the second line (from the right) had space for more characters. Such conventions are even more apparent in Mi Fu's (1052–1107) letter *Hasty Reply before Guests* in the Elliott Collection (cat. no. 7c). Rapidly written in running script (*hsing-shu*), this letter comprises nine lines, but the third has only one character because the recipient's name has been moved to a place of honor at the head of the fourth line. This format, together with Mi Fu's untrammeled brushwork, enhances the graphic vividness of the work.

Similar to the *p'ing* and *ch'üeh* conventions is that of *t'ai-t'ou,* elevation of the recipient's name to one (or sometimes more than one) character space above the upper margin of a letter. This format, originally used for the terms "emperor" and "empress" or for references to the monarchy, later was used for any recipient's name. Examples can be found in a number of letters in the Elliott Collection. For instance, in his letter to Kao Shih-ch'i (1645–1703), when Li T'ien-fu (1635–1699), a courtier who served the K'ang-hsi emperor (r. 1662–1722), mentioned the emperor (*Shang*) and matters related to him or the name of the recipient,

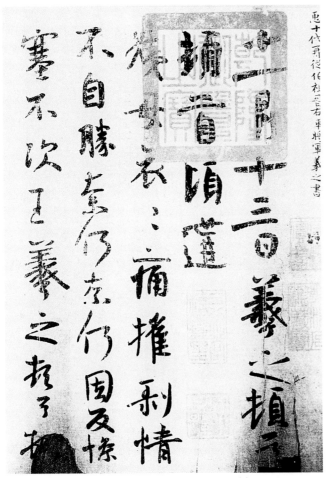

Figure 10. Wang Hsi-chih, *Letter to My Aunt,* T'ang tracing copy, ink on paper. Liaoning Provincial Museum, Shenyang. From *Chung-kuo mei-shu chüan-chi: Shu-fa chuan-k'o pien* (Peking: Jen-min mei-shu ch'u-pan-she, 1986), 2: 72.

he followed this convention without exception (cat. no. 47). The characters referring to the emperor and related matters are placed slightly higher than Kao's name to further honor the emperor. A letter written by Chin Jen-jui (1608–1661), a famous late Ming–early Ch'ing literary critic, is also in this format (cat. no. 46). The recipient was Mao-ch'ing, whom Chin Jen-jui called Chang, an honorific form of address used for an old person. Whenever Chin used this term, he raised the character above the upper margin. However, because this letter has only eight lines, of which "Chang" heads five, the repetitions deprive Chin's writing of the variation of form thought to be essential to good calligraphy. Here, observing social norms was more important than achieving graphic beauty.

Chinese is replete with complicated kinship terms. Equally complex were *ch'eng-wei* (forms of address) applied to all members of society.[54] The use of appropriate terms for oneself and the recipient of a letter

was regarded as part of *li.* In addition to various forms of address in letter writing, the writer also attached an honorific term that could function as a personal pronoun. The forms of address and the honorific terms used in a letter were governed by the relationship between the writer and the recipient and by their gender and social status. Most *shu-i* pay great attention to these matters.

In the Elliott Collection is a group of letters by the famous Yüan calligrapher Chao Meng-fu (1254–1322) and members of his family (cat. no. 12). The most interesting of these, attributed to Chao's wife, Kuan Tao-sheng (1262–1319), is believed by most scholars to be from Chao's own hand.[55] Why Chao ghostwrote letters for his wife is a puzzle, since she was a well-educated calligrapher and painter. Because the letter is signed as if from Kuan, the terms of self-reference for the writer and of address to the recipient accord with the way in which she wrote letters. In this sense, the letter reads as if it were from Kuan's hand.

The letter responds to a female relative who we know was of Kuan's grandmother's generation because Kuan called her T'ai-fu-jen, Grandmother. The letter, which speaks of domestic trivia, was sent with a gift of winter bamboo shoots and cabbage. At the very beginning, Kuan writes that she "presents this letter to the front of Grandmother's dressing table." The Chinese term for "front of the dressing table," *chuang-ch'ien,* is used in addressing a senior female family member. This term was recommended in *Newly Compiled Selections of Letters,*[56] and the ghost-written letter demonstrates its use.

One term in Kuan Tao-sheng's letter departs from the recommendations of the manual. At the end of her letter, Kuan repeats the phrase "Tao-sheng kuei-fu," (Tao-sheng kneels and replies), which she had used at the beginning. Writers usually expressed respect or humility with the character *pai,* "bow," which Kuan had used in a letter to a Buddhist master, Chung-feng Ming-pen (1263–1323).[57] Yet in the letter to her relative, she instead used *kuei,* "kneel."[58] According to *Newly Compiled Selections of Letters,* there was no requirement that women use "kneel" to show their respect when writing to senior family members. Kuan Tao-sheng's usage may indicate a change in social custom not reflected in the letter-writing manual.

The format of Kuan's letter is also of interest. Near the right edge of the paper are three lines of charac-

ters. The first reads, "An-shu pai-shang" (This letter of peace is presented with a bow of greeting). Next is the eight-character line "Tsun ch'in-chia t'ai-fu-jen chuang-ch'ien" (To my respected grandmother of related family). Between but lower than these two lines, Kuan Tao-sheng signed her personal name with the two characters chin-feng, "respectfully sealed." After the letter is rolled up, these three lines remain outside, serving as the equivalent of an address on an envelope. The first line was also used for writing the "cover," or outside surface of a type of letter called p'ing-an chia-shu, "letter reporting that the family is safe and healthy." Ssu-ma Kuang, the famous Sung literary figure, explained the reason for writing "safe and healthy" on the "cover" when one writes to grandparents or parents: "Those who have just received a letter from a family member feel at once both happy and worried [because they do not know whether it reports good news or bad]. For this reason, [the words] 'safe and healthy,' should not be absent. It will make the recipients happy immediately. This became a convention for writing double covers for family letters."[59]

This practice is mentioned in an anecdote about Hu Yüan, who studied on Mount T'ai during the Sung dynasty. He was a diligent student, and to avoid distractions, whenever he received a letter with the characters p'ing-an on the cover, he would throw it into a mountain stream without reading it.[60] That this convention was continued in the Yüan is shown by the family letter from Kuan Tao-sheng discussed above. In fact, this convention is recorded in Newly Compiled Selections of Letters.[61] It may also explain why so many personal letters reporting illness can be found dating from premodern China; it appears that the chief function of the chia-shu, or "letter to family members," was to report the status of a family's health.[62]

In China the family was traditionally regarded as the heart of society, and to be a filial child was one of the most important of all human social obligations. Through writing letters to family members, and through observing widely sanctioned conventions for their composition, writers helped to maintain social stability and to perpetuate a hierarchical system that governed everyday life. Although correspondence among family members belongs to the domain of private life, the importance of letters is apparent from the contents of shu-i and from the very public circulation of these manuals.

SCRIPTS AND LETTER PAPER

Other aspects of letter writing, such as the scripts and paper used, can also convey meaning. The type of script chosen for writing a letter is governed by the occasion on which it is written, the content of the letter, and the relationship between the writer and the recipient.

Standard script (k'ai-shu) is used for serious, formal occasions. The Yüan letter-writing manual quoted earlier clearly states that letters to one's grandparents and parents should be written in standard script on good paper.[63] These rules sometimes also applied to correspondence between students and teachers. In the Elliott Collection of Chinese letters, one (cat. no. 44) by the gifted calligrapher and painter Ch'en Ch'un (1483–1544) to his teacher Wen Cheng-ming (1470–1559) reads,

> The Student Ch'en Tao-fu bows and respectfully presents to Mr. Heng[-shan], my respected teacher: Your student Tao-fu will have his fifth son marry Ms. Hsüeh. I have selected the sixteenth day of the fourth month as auspicious. I dare to prepare some fruits and vegetables [for this occasion] and hope I will be able to listen to your teaching at that time. I humbly request that you come early. It will be an honor if you can come as early as possible. Tao-fu bows once again.

Ch'en Ch'un was famous for his wild-cursive (k'uang-ts'ao) calligraphy, yet in this invitation to his teacher he wrote carefully in small standard script, as dictated by social convention.

Scripts other than running, cursive (ts'ao), and standard were seldom used in letters. But by virtue of their rarity, letters in seal (chuan) and clerical scripts can be indicative of the cultural milieu in which they were produced. In the Ch'ing dynasty, paleography and chin-shih hsüeh, "the study of ancient metal and stone [artifacts]," established new approaches to the study of epigraphs and gave new importance to this discipline. Consequently, seal and clerical scripts used in the inscriptions on ancient stelae became the showcase scripts for scholars and calligraphers who attempted to show that they were aware of current intellectual trends.[64] It was in this intellectual setting that letters sometimes were written in clerical and seal scripts.

Yü Yüeh (1821–1907), a famous scholar of the late Ch'ing, excelled in seal and clerical scripts, especially the latter. His deep interest in clerical script, as Fu

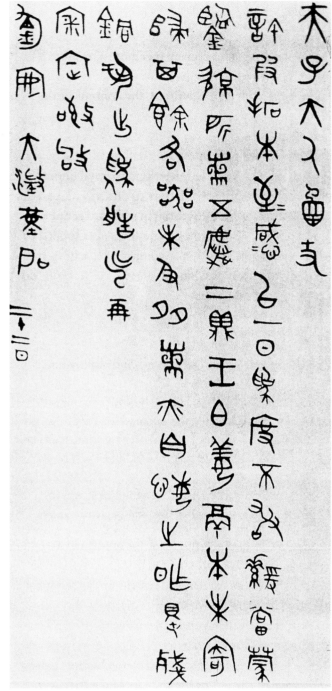

Figure 11. Wu Ta-ch'eng (1835–1902), *A Letter to P'an Tsu-yin in Seal Script,* ink on paper, 24.5 x 12.2 cm. Former collection of P'an Ching-cheng. From *Chung-kuo mei-shu ch'üan-chi: Shu-fa chuan-k'o pien,* vol. 6, *Ch'ing-tai shu-fa* (Shanghai: Shang-hai shu-hua ch'u-pan-she, 1989), 197.

round, and the brushwork is solid but rough, in imitation of the forms of ancient stone inscriptions. Known as an etymologist, Yü also employed unusual character forms that had been out of use for millennia. For instance, the third character in the sixth line from the right, *chia,* "borrow," is written without the customary *jen* radical on the left. The fourth character in line 12, *ch'ou,* "ugly," is rendered in its ancient form, which is quite different from its normal modern appearance.

In the Elliott Collection we also find a letter in small seal script from Tai Wang (1837–1873) to his friend Chung-i (cat. no. 54). This letter contains some 230 characters. Writing a letter of this length in small seal script is significantly more time consuming than writing in running or cursive script.

An extreme case of the use of archaic script can be found in Wu Ta-ch'eng's (1835–1902) letters. As the foremost paleographer of his time, Wu sometimes wrote letters in *chin-wen,* "bronze script," or "script found on metal objects," a subtype of seal script difficult for even well-educated people to read (fig. 11). Although letters composed in this script displayed Wu's education, they were an extremely inefficient form of communication; most of his extant letters, like the one in the Elliott Collection (cat. no. 55), were written in running and standard scripts. Nevertheless, the unprecedented number of letters in clerical and seal scripts written in the Ch'ing dynasty by scholars such as Wu Ta-ch'eng demonstrates how the selection of scripts for letters was sometimes conditioned by broad intellectual trends.

Specific calligraphic styles were sometimes deemed desirable in certain historical periods. According to *Principal Guides for Government Officials (Huan-hsiang yao-tse),* a Ch'ing letter-writing manual designed chiefly for government officials, the styles of Chao Meng-fu and Tung Ch'i-ch'ang were fashionable among government officials:

> Recently, among the calligraphic styles for correspondence between officials, the styles of Chao Meng-fu and Tung Ch'i-ch'ang have been regarded as the most prized. Even Wang Hsi-chih's style is ranked second. The styles of Yen Chen-ch'ing [709–785], Liu Kung-ch'üan [778–865], Ou-yang Hsün [557–641], and Su Shih [1037–1101] are not considered desirable in this kind of letter.[66]

It seems no accident that the calligraphic styles of Chao Meng-fu and Tung Ch'i-ch'ang were trendy among government officials. Tung Ch'i-ch'ang's style

Shen points out, "was actually a function of his broader commitment to *chin-shih hsüeh* in general and to philology and etymology in particular."[65] Yü's strong preference for clerical script was evident in his correspondence and daily writing, such as a letter in the Elliott Collection (cat. no. 53). Yü tried to capture with this script the archaic flavor of the clerical inscriptions on Han stelae. The character structures are short and

Figure 12. Wu Fa-hsiang (b. 1578), a page from *The Wisteria Studio Album of Stationery Decorated with Ancient and Modern Designs,* 1626, woodblock-printed book, ink and colors. Shanghai Museum. From James C. Y. Watt and Chu-tsing Li, eds., *The Chinese Scholar's Studio: Artistic Life in the Late Ming Period* (New York: The Asia Society Galleries, 1987), pl. 27.

was prized among the courtiers of the K'ang-hsi reign and Chao's style was treasured by the Ch'ien-lung emperor (r. 1736–95). Although epigraphic Stele-school calligraphy entered its heyday after the Ch'ien-lung reign, a separate court style of calligraphy endured throughout the Ch'ing, and many officials modeled their calligraphic style after imperial taste.

Letter paper is another item that should be discussed in our study of the letter-writing culture of traditional China,[67] where paper itself was invented. The use of ornamental paper for letter writing can be traced to as early as the period of Wang Hsi-chih, when, as we have seen, letter writing was regarded as an important way to display one's calligraphy.[68] Although we know from written records that letter paper with multicolored pictures was developed before the Sung dynasty, pre-Sung letters on ornamental paper unfortunately have not survived. Extant

letters from the Sung show that during this period decorated papers (papers with designs) were used for letters,[69] but this type of stationery did not become fashionable until the late Ming and early Ch'ing.

The seventeenth century witnessed a blossoming of the manufacture of multicolored ornamental letter paper. A surviving album of letter paper titled *The Wisteria Studio Album of Stationery Decorated with Ancient and Modern Designs (Lo Hsüan pien-ku chien p'u)*, printed in 1626, is the earliest ornamental-paper album (fig. 12). It consists of sixteen thematic sections comprising a total of 178 images. The papers display exquisite designs produced through complicated printing techniques.[70] Another famous example is *The Ten Bamboo Studio Decorative Paper Album (Shih-chu chai chien-p'u)*, published by Hu Cheng-yen (fl. 1582–1672) in about 1644.[71] Subsequently, ornamental paper became more commonly used for letter writing. Most examples in the Elliott Collection were written in the Ch'ing dynasty during or after the K'ang-hsi reign. These include letters by Wang Shih-chen (1634–1711; cat. no. 48) and Hang Shih-chün (1696–1773; cat. no. 49), the two leading literary figures of the K'ang-hsi and Yung-cheng reigns (1662–1735).

Although decorative letter paper was readily available for purchase, since the K'ang-hsi reign there was a growing interest among Chinese literati in making their own paper,[72] which many liked to present as gifts. The letter paper of Yao Nai (1731–1815), a prominent scholar, bears the inscription "Made by Wen-yüan of the Hsü-pai [Void and White] Studio." Two letters, one by Wang Hsüeh-chin (1748–1804; cat. no. 50) and the other by Ch'in En-fu (1760–1843; cat. no. 51), in the Elliott Collection have inscriptions reading "Hsü-pai Studio." It is possible that Wang and Ch'in obtained these sheets from Yao Nai, although the designs are not identical. Exchanging letter paper became a new social activity among literati and scholars,[73] and writing on stationery made by famous literary figures demonstrated discriminating taste.

Also in the Elliott Collection are several letters by Liu Ming-ch'uan (1836–1896; cat. no. 52), a famous general of the Ch'ing dynasty. The letter papers bear beautifully printed designs of I-hsing teapots in various shapes. Although Liu presumably liked the stationery he purchased or commissioned, and although the literati painting style of the teapot design creates a mood of leisure, the content of one letter is about

Figure 13. Chiang Piao (1860–1899), *A Letter to Sheng Hsüan-huai* [1844–1916], ink on paper, dimensions unavailable. Hong Kong Chinese University Gallery. From Chan Sin-wai and Wang Erh-min, comps., *Chin-tai ming-jen shou-cha ching-hsüan* (Hong Kong: Chinese University Press, 1992).

military affairs. It shows us that the letter writer did not choose stationery to complement the content of his letter, but just wrote on whatever favorite paper was at hand, thus revealing his private interests in a public context.

Chinese scholars and intellectuals became increasingly aware of the outside world following the Opium War (1839–42), and many of them were eager for Western knowledge. Their enthusiasm was reflected even in the manufacture of letter paper. A letter by Chiang Piao (1860–1899), a famous late-Ch'ing reformer who studied at the Bureau of Foreign Languages (*T'ung-wen-chü*), written to Sheng Hsüan-huai (1844–1916), a scholar and publisher, epitomizes this change (fig. 13). In the center of the letter paper is the printed image of a globe. To the lower left of the globe, Chiang Piao printed sixteen characters that read, "In the late spring month of the year *ting-yu* [1897], Chiang Chien-hsia [Chiang's courtesy name] made this letter paper, 'Communication and Transportation within the World.'"[74] Three years after China's defeat in the Sino-Japanese War forced the Ch'ing government to cede Taiwan to Japan, a sense of crisis was strong among the Chinese elite, who had begun to realize the inadequacy of traditional learning. Written on paper printed with a globe, Chiang's letter, no matter how private its content, was tied to widely shared public concerns of his day.

Chiang Piao's letter signaled the coming of a new era. As China struggled for modernization, letter writing and collecting underwent a significant historical change in the twentieth century. Pen and pencil replaced the brush as everyday writing tools; telephone, e-mail, and electronic communication have further reduced its use. The civil service examination system, in which calligraphy played an important role, was replaced by a modern educational system. And as the vernacular language became standard for everyday written usage, use of classical Chinese waned in traditional letter writing. Stationery became highly standardized, usually with a printed title on a piece of plain white paper. As fewer letter writers used the calligraphy brush to write in classical Chinese on beautifully printed stationery, the collecting of letters for their calligraphic value also declined. As Liang Shih-ch'iu (1902–1987), a modern essayist, commented on this phenomenon, "I have never had an interest in collecting letters. . . . Since the brush was gradually replaced [by pen and pencil], letters that are worth collecting have become fewer and fewer. This is because the beauty of a letter lies in its calligraphy, writing style, and interest; lacking these, it will be defective."[75]

Collecting letters by contemporary celebrities continues in the modern era, but it is scarcely for their

merit as calligraphy. It is unlikely that modern letters will be made into model-books, engraved on stones, or installed in temples and gardens. In the new cultural and material environment, collecting letters as works of calligraphy becomes part of a past collected only in our memory.

Notes

I am grateful to many friends who provided support and read versions of this article and gave me constructive suggestions, especially Liu Heng, Matthew Flannery, Kathryn Lowry, and Robert E. Harrist, Jr.

1. Two articles published in recent years reflect current scholarship on the calligraphy of Chinese letters: "Ch'ien-t'an ch'ih-tu yü ch'ih-tu shu-fa," in Liu Heng, *Li-tai ch'ih-tu shu-fa* (Peking: Chih-shih ch'u-pan-she, 1992), 1–10; Chu Hui-liang, "Sung-tai ts'e-yeh chung chih ch'ih-tu shu-fa," in *Sung-tai shu-hua ts'e-yeh ming-p'in t'e-chan* (Taipei: National Palace Museum, 1995), 10–20.

2. With regard to the format and content of these two letters, see *Yün-meng Shui-hu-ti Ch'in-mu* (Peking: Wen-wu ch'u-pan-she, 1981), 25–26.

3. There were many terms for letters in traditional China, such as *ch'i-shu, shu, cha, chien,* and *han.* Some were used only for certain kinds of letters. The numerous and complicated terms for letters are indicative of the well-developed letter-writing culture. See "Ch'ien-t'an ch'ih-tu yü ch'ih-tu shu-fa," 1.

4. Fan Yeh et al., comps., *Hou Han shu* (Peking: Chung-hua shu-chü, 1965), 12: 557. Translation adapted from Lothar Ledderose, *Mi Fu and the Classical Tradition of Chinese Calligraphy* (Princeton: Princeton University Press, 1979), 30.

5. Pan Ku, comp., *Han shu* (Peking: Chung-hua shu-chü, 1970), 8: 3711. Translation by Lothar Ledderose, *Mi Fu,* 30.

6. Yü Ho, "Lun-shu piao," in Huang Chien, ed., *Li-tai shu-fa lun-wen-hsüan* (Shanghai: Shang-hai shu-hua ch'u-pan-she, 1979), I: 54.

7. Ibid., 54.

8. Ibid., 55.

9. Yü Ho, "Lun-shu piao," I: 54.

10. See Hua Jen-te, "Lun Tung-Chin mu-chih chien-chi Lan-t'ing lun-pien," *Ku-kung hsüeh-shu chi-k'an* 13, no. 1 (Oct. 1995): 41.

11. For a discussion of the formation of this tradition, see Ledderose, *Mi Fu;* and Stephen J. Goldberg, "Court Calligraphy in the Early T'ang Dynasty" (Ph.D. diss., University of Michigan, 1981).

12. Emperor T'ai-tsung's project of collecting Wang Hsi-chih's calligraphy started at the very beginning of his reign (Wu P'ing-i, "Hsü-shih fa-shu chi," in Chang Yen-yüan, ed., *Fa-shu yao-lu,* in Lu Fu-sheng et al., eds., *Chung-kuo shu-hua ch'üan-shu* [Shanghai: Shang-hai shu-hua ch'u-pan-she, 1993], 45), and it culminated in its thirteenth year (639). It turned out, as the famous T'ang calligraphy critic Chang Huai-kuan (fl. ca. 714–760) put it, that "all of his [Wang Hsi-chih's] masterpieces came into [the imperial household collection] from everywhere" (Chang Huai-kuan, "Erh Wang teng shu lu," in Chang Yen-yüan ed., *Fa-shu yao-lu,* 61).

13. See Ch'u Sui-liang, "Chin Yu-chün Wang Hsi-chih shu-mu," and Chang Yen-yüan, "Yu-chün shu-chi," in Chang Yen-yüan, ed., *Fa-shu yao-lu,* I: 48–51; 99–118.

14. On the importance of the term "copy" in Chinese calligraphy and its various uses in the T'ang dynasty, see Ledderose, *Mi Fu,* 33–44.

15. For a detailed discussion of this work and tracing practices in the T'ang dynasty, see Shen C. Y. Fu et al., *Traces of the Brush: Studies in Chinese Calligraphy* (New Haven: Yale University Art Gallery, 1977), 5–8.

16. Due to their brevity and the obscurity of the contexts of many Chin letters, the meaning of the message conveyed in many of these letters remains unknown to modern readers.

17. Ch'i Kung, "T'ang-mo Wan-sui t'ung-t'ien t'ieh shu-hou," in Liu T'ao, ed., *Wang Hsi-chih, Wang Hsien-chih,* in the series *Chung-kuo shu-fa ch'üan-chi* (Peking: Jung-pao-chai, 1991), 18: 29. The evidence Ch'i Kung offers is that, in the famous T'ang copy of Wang Hsi-chih's *Erh hsieh t'ieh,* the character *ch'eng* (carry) is copied as *yung* (chant) in the first column.

18. Although tracing copies of ancient masterpieces enlarged the audience of these works, only a very limited number of people had access to these reproduced works.

19. For instance, the first work attributed to Emperor Chang (r. 76–88) of the Later Han in *chüan* 1 is a mixture of excerpts from *The Classic of Ten Thousand Characters.* Other nonletter works in this collection include Emperor T'ang T'ai-tsung's rhymed prose in *chüan* 1, an admonition by Kao Piao (fl. 150) from *The History of the Later Han* attributed to Huang Hsiang (fl. ca. 220–279) in *chüan* 2, Hsiao Tzu-yün's (492–553) transcription of sections of *Chuang-tzu* and *Lieh-tzu* in small standard script in *chüan* 4, Ou-yang Hsün's (557–641) colophon in *chüan* 4, and the monk Chih-kuo's (ca. 605–617) calligraphic criticism in *chüan* 5. The content of the first few pieces in *chüan* 5 attributed to the legendary or ancient figures Ts'ang Chieh, Hsia Yü (ca. 21st century B.C.), Confucius (551–479 B.C.), and Li Ssu (284–208 B.C.) indicates that they were unlikely to have been letters. It is also possible that the engravings of these works in the *Ch'un-hua-ko fa-t'ieh* were based on rubbings rather than on ink-written works. Judging from its literary style, the piece attributed to Li Ssu is very likely an excerpt from a stele. Later, the Northern Sung scholar Huang Po-ssu (1079–1118) pointed out that this work is in fact a part of the stele inscribed by the T'ang calligrapher Li Yang-ping (ca. 759–780?), believed to be a follower of Li Ssu's calligraphic style in small seal script (Huang Po-ssu, *Tung-kuan yü-lun,* in Lu Fu-sheng et al., eds., *Chung-kuo shu-hua ch'üan-shu,* I: 484).

20. For a thorough discussion of model-book production in the Sung dynasty, see Amy McNair, "The Engraved Model-Letters Compendia of the Song Dynasty," *Journal of the American Oriental Society* 114, no. 2 (April–June 1994): 209–25.

21. Amy McNair points out that the *Li-chih-lou t'ieh,* a publication of the famous poet Lu Yu's (1125–1210) family collection of letters, probably included works of only the Sung, because of its alternate name *Sung fa-t'ieh* (ibid., 224).

22. For information on model-books produced in imperial China, see Jung Keng, *Ts'ung-t'ieh mu,* 4 vols. (Hong Kong: Chung-hua shu-chü, 1980–86); Wang Chuang-hung, *T'ieh-hsüeh chu-yao* (Shanghai: Shang-hai shu-hua ch'u-pan-she, 1987).

23. Yeh Ch'ang-chih, *Yü shih*, commentary by Ko Chang-ssu (Peking: Chung-hua shu-chü, 1994), 209.

24. For more information on this *fa-t'ieh*, see Jung Keng, *Ts'ung-t'ieh mu*, 1: 194–214.

25. It seems that this practice started fairly early. According to Su Shih (1037–1101), his friend Sun Chüeh (1028–1090) built the Pavilion of Excellent Calligraphy at his residence so that visitors could walk around and view engraved calligraphic works (Su Shih, "Mo-miao-t'ing chi," in Li Fu-shun, ed., *Tung-p'o lun shu-hua shih-liao* [Shanghai: Shang-hai jen-min mei-shu ch'u-pan-she, 1988], 90).

26. See James Cahill, *The Compelling Image: Nature and Style in Seventeenth-Century Chinese Painting* (Cambridge, Mass., and London: Harvard University Press, 1982), 107–10.

27. P'ing-tsu was the courtesy name of the receiver, whose given name is unknown. Chang P'ing-tsu was the brother of the famous late-Ming essayist Chang Tai (1597–ca. 1680), whom Ch'en also mentioned in the letter. The author is grateful to Wan-go H. C. Weng, who provided this information in his correspondence of December 29, 1996.

28. Fu Mei (1628–1684), the son of Fu Shan, mentioned in a letter to his friend Tai T'ing-shih (1618–1692) that at Tai's request, he had burned the letter Tai wrote to him (Fu Shan, *Fu Shan ch'üan-shu* [Taiyuan: Shan-hsi jen-min ch'u-pan-she, 1991], 7: 4902).

29. These letters are now in the collection of Yip Shing Yiu in Hong Kong. For a study of Fu Shan's relationship with Wei I-ao and a transcription of these letters, see Qianshen Bai, "Fu Shan yü Wei I-ao: Ch'ing-ch'u Ming i-min yü shih-ch'ing Han-tzu kuan-yüan kuan-hsi te ko-an yen-chiu," *Kuo-li T'ai-wan ta-hsüeh mei-shu-shih yen-chiu chi-k'an* 3 (March 1995): 95–139. See also Qianshen Bai, "Fu Shan (1607–1684/85) and the Transformation of Chinese Calligraphy in the Seventeenth Century" (Ph.D. diss., Yale University, 1996), 82–110.

30. This letter is undated. According to *The History of the Ch'ing Dynasty (Ch'ing-shih kao)*, in response to the famine of 1652, the Ch'ing government suspended the tax on crops ([Peking: Chung-hua shu-chü, 1976–77], 1: 130–31). I thus tentatively date this letter to 1652.

31. As an eminent calligrapher in early Ch'ing, Fu Shan produced calligraphy that was valuable to collectors. Wang Yü-yu (fl. 1644–1670), a friend of Fu Shan, says in a letter to a friend, "Ch'ing-chu's [Fu Shan's courtesy name] calligraphy catches the calligraphy of Chung Yu [151–230] and Wang Hsi-chih. Obtaining one character from him is like getting gold" (Wang Yü-yu, "Chien K'ung Kung-hsiang," in *Wu-kung Shan-jen chi* [printed in the K'ang-hsi reign, 1662–1722], *chüan* 12).

32. The long tradition of compiling letters into literary anthologies can be traced to Hsiao T'ung's (501–531) *Selections of Refined Literature (Wen hsüan)*, which includes compilations of famous letters in *chüan* 41, 42, and 43 (Peking: Chung-hua shu-chü, 1977), 2: 573–613.

33. Celia Carrington Riely, "Tung Ch'i-ch'ang's Copies of Three Imperial Patents (*kao-ch'ih*) Granting Him Prestige Titles (*san-kuan*) in the Liaoning, Shanghai, and Peking Palace Museums," paper presented at the International Symposium on the History of Chinese Calligraphy, Ch'ang-shu, China, Sept. 17, 1994.

34. For a discussion of the history of Chinese letter-writing manuals, see Chou I-liang, "Shu-i yüan-liu k'ao," in *Li-shih yen-chiu*, no. 5 (1990): 95–103.

35. See Chou I-liang and Chao Ho-p'ing, *T'ang Wu-tai shu-i yen-chiu* (Peking: Chung-kuo she-hui k'o-hsüeh ch'u-pan-she, 1995), 179.

36. Quoted in *Li Chi, Book of Rites*, trans. James Legge (New York: University Books, 1967), 1: 11.

37. Wu Hung, *Monumentality in Early Chinese Art and Architecture* (Stanford: Stanford University Press, 1995), 20.

38. See Wei Cheng et al., *Sui shu* (Peking: Chung-hua shu-chü, 1973), 4: 942.

39. Chou and Chao, *T'ang Wu-tai shu-i yen-chiu*, 1.

40. Hsü Chien et al., *Ch'u-hsüeh chi* (Peking: Chung-hua shu-chü, 1962), 1: 63–64.

41. See Wei Cheng et al., *Sui shu*, 4: 971.

42. Ibid.

43. An excellent study of Tun-huang *shu-i* by Chou I-liang and Chao Ho-p'ing is included in their newly published book *T'ang Wu-tai shu-i yen-chiu*. The discussion of *shu-i* here benefits greatly from their thorough and original research. A discussion of T'ang *shu-i* in English may be found in Patricia Ebrey, "T'ang Guide to Verbal Etiquette," *Harvard Journal of Asiatic Studies* 45 (1985): 581–613.

44. Mourning customs are discussed in detail in such Confucian classics as *I li* (Ceremonies and Rites) and *Li chi* (Book of Rites). For modern scholarship on this system and its legal basis, see T'ung-tsu Ch'u, *Law and Society in Traditional China* (Paris: Mouton & Co., 1965), 15–20.

45. Letter-writing manuals such as *Newly Compiled Selections of Letters for Brief Classification of Matters and Essays* of the Yüan and *Principal Guides for Government Officials* of the Ch'ing, which are discussed later in this essay, contain diagrams of mourning responsibilities. Ssu-ma Kuang's *Shu-i*, also discussed below, does not provide a diagram, but discusses mourning customs in detail.

46. In Ssu-ma Kuang's *Shu-i*, *chüan* 2 is about ceremonies of adulthood; *chüan* 3 and 4 deal with wedding ceremonies; and *chüan* 5–10 discuss mourning ceremonies.

47. For a brief discussion of this book, see Chou I-liang, "Shu-i yüan-liu k'ao," in Chou I-liang and Chao Ho-p'ing, *T'ang Wu-tai shu-i yen-chiu*, 97. Another Yüan title, *Newly Compiled Complete Collection of Letters for Classification of Matters and Essays* by Liu Ying-li from Chien-yang, Fukien, is probably based to a great degree on *shu-i* compiled in the Sung dynasty. The largest version of this work consists of 194 chapters. *The Newly Compiled Selections of Letters for Brief Classification of Matters and Essays* is likely a shortened version of this work.

48. On Ming *shu-i* and letter writing, see Kathryn Lowry, "Writing and Reading Personal Letters in the Late Ming" (paper presented at the annual meeting of the Association for Asian Studies, Chicago, March 16, 1997).

49. The importance of rhetoric in the Southern Dynasties is evident in Liu I-ch'ing's famous *A New Account of Tales of the World, (Shih-shuo hsin-yü)*, the second chapter of which is about language and rhetoric.

50. Chao Ho-p'ing, "Tun-huang hsieh-pen shu-i lüeh-lun," in Chou I-liang and Chao Ho-p'ing, *T'ang Wu-tai shu-i yen-chiu*, 35–36.

51. See note 47. I am very grateful to Sören Edgren, an expert on Chinese rare books, who provided this information by correspondence in December 1996.

52. In her study of the correspondence among educated women in seventeenth-century China, Ellen Widmer points out that

"the publishing of letter collections began in earnest toward the end of the sixteenth century. Some concentrated on a single individual, and some gathered samples from many individuals. They were sold as models of good writing or as entertainment. Presumably this new type of publication was part of a wave of popular, private publishing" ("The Epistolary World of Female Talent in Seventeenth-Century China," *Late Imperial China* 10, no. 2 [Dec. 1989]: 4).

53. Some *shu-i* require that personal letters use the *p'ing-ch'üeh* format. See Chao Ho-p'ing, "Tun-huang hsieh-pen shu-i lüeh-lun," in *T'ang Wu-tai shu-i yen-chiu*, 8.

54. A thirty-two *chüan* reference book on complicated forms of address was compiled in the Ch'ing dynasty (Liang Chang-chü, *Ch'eng-wei lu* [Changsha: Yüeh-lu ch'u-pan-she, 1991]).

55. See Chiang I-han, "A Study of Six Letters from Chao Meng-fu's Family," *Ku-kung chi-k'an* 11, no. 4 (1977): 34–37; Wang Lien-ch'i, "Chao Meng-fu wei chi tai-pi," *Tzu-chin-ch'eng* 23, no. 1 (1984): 42–43.

56. *Hsin-pien shih-wen lei-yao ch'i-cha ch'ing-ch'ien* (reprint, Tokyo: Koten Kenkyūkai, 1963), 17.

57. This letter is in the collection of the National Palace Museum, Taipei. For a discussion of the use of *pai* in letter writting, see *Hsin-pien shih-wen lei-yao ch'i-cha ch'ing-ch'ien*, 34–35.

58. In her letters to other senior female family members Kuan Tao-sheng also used "kneel" rather than "bow." See two such letters discussed in Wang Lien-ch'i, "Chao Meng-fu wei chi tai-pi," *Tzu-chin-ch'eng* 23, no. 1 (1984): 42–43.

59. Ssu-ma Kuang, *Shu-i (Hsüeh-chin t'ao-yüan* ed.), *chüan* 1: 9b.

60. Quoted from Chou I-liang and Chao Ho-p'ing, *T'ang Wu-tai shu-i yen-chiu*, 60.

61. *Hsin-pien shih-wen lei-yao ch'i-cha ch'ing-ch'ien*, 365.

62. Many recorded letters and extant T'ang copies of letters by Wang Hsi-chih to his friends also reported on the health of the writer. Liu T'ao argues that this phenomenon was closely related to the prevalence of *fu-shih* (taking Taoist pills) among nobles during Wang Hsi-chih's time. Nobles liked to discuss the negative symptoms of this addiction (Liu T'ao, ed., *Wang Hsi-chih, Wang Hsien-chih, chüan* 1: 8–9). This may have influenced later letter writing, since Wang Hsi-chih's letters became standard calligraphic models. When Wang's style was studied, his phrases may also have been imitated.

63. *Hsin-pien shih-wen lei-yao ch'i-cha ch'ing-ch'ien*, 365.

64. The shift of intellectual orientation in the early Ch'ing has been discussed by Benjamin A. Elman in *From Philosophy to Philology: Intellectual and Social Aspects of Change in Late Imperial China* (Cambridge, Mass.: Council on East Asian Studies, Harvard University, 1990). For a study of the formation of the Stele school of calligraphy in the early Ch'ing, see Qianshen Bai, "Fu Shan (1607–84/85) and the Transformation of Chinese Calligraphy in the Seventeenth Century."

65. Fu et al., *Traces of the Brush*, 60.

66. Huan-hsiang Lao-jen, *Huan-hsiang yao-tse* (Taipei: Lao-ku wen-hua shih-yeh kung-ssu, n.d.), 1b.

67. For a lucid and comprehensive introduction to Chinese letter papers, see Chan Sin-wai and Wang Erh-min's introduction to *Chin-tai ming-jen shu-cha ching hsüan* (Letters of Prominent Figures in Modern China) (Hong Kong: Chinese University Press, 1992).

68. For a general account of various kinds of Chinese ornamental letter paper and their history, see Tsien Tsuen-hsuin, *Paper and Printing*, in Joseph Needham, ed., *Science and Civilisation in China* (Cambridge: Cambridge University Press, 1985), vol. 5, part 1: 91–96.

69. See Chu Hui-liang, "Sung-tai ts'e-yeh chung chih ch'ih-tu shu-fa," p. 11 and pl. 19.

70. For a discussion of this album, see Wang Qingzheng, "The Arts of Ming Woodblock-Printed Images and Decorated Papers," in James C. Y. Watt and Chu-tsing Li, eds., *The Chinese Scholar's Studio: Artistic Life in the Late Ming Period* (New York: The Asia Society Galleries, 1987), 57–60, 161. For recent research on this album and late Ming letter paper, see Suzanne Wright, "Social Identity and Visual Communication in Woodblock-Print Letter Papers of the Late Ming Dynasty" (Ph.D. diss., Stanford University, forthcoming).

71. For a discussion of this work, see Ma Meng-ching, "Wan-Ming Chin-ling 'Shih-chu chai shu-hua-p'u' 'Shih-chu chai chien-pu' yen-chiu" (master's thesis, Taiwan University, 1994).

72. See Chan Sin-wai and Wang Erh-min's introduction to *Chin-tai ming-jen shu-cha ching hsüan*.

73. This is discussed in ibid.

74. Many other late-Ch'ing reformers printed the globe on their stationery. See ibid., 18.

75. Liang Shih-ch'iu, *K'an-yün chi* (Taipei: Chi-wen Press, 1974), Preface, 3.

Bibliography

Acker, William R. B. *Some T'ang and Pre-T'ang Texts on Chinese Painting*. 2 vols. Leiden: E. J. Brill, 1954, 1974.

An Ch'i. *Mo-yüan hui-kuan* (Notes on Painting and Calligraphy I Chanced to See). Preface dated 1742. In *I-shu ts'ung-pien*, part 1, vol. 17. Reprint, Taipei: Shih-chieh shu-chü, 1981.

An Ssu-yüan ts'ang shan-pen pei t'ieh hsüan (The Chunhuage tie and Rare Rubbings from the Collection of Robert Hatfield Ellsworth). Peking: Wen-wu ch'u-pan-she, 1996.

Bai Qianshen, "Ch'ing-ch'u chin-shih hsüeh te fu-hsing tui Pa-ta-shan-jen wan-nien shu-feng te ying-hsiang" (The Influence of the Revival of the Study of Bronze and Stone Inscriptions in the Early Ch'ing on the Late Calligraphy of Pa-ta-shan-jen). *Ku-kung hsüeh-shu chi-k'an* (Palace Museum Research Quarterly) 12, no. 3 (1995): 89–124.

———. "Fu Shan (1607–1684/85) and the Transformation of Chinese Calligraphy in the Seventeenth Century." Ph.D. diss., Yale University, 1996.

———. "Fu Shan yü Wei I-ao: Ch'ing-ch'u Ming i-min yü shih-ch'ing Han-tzu kuan-yüan kuan-hsi te ko-an yen-chiu" (Fu Shan [1607–1684/85] and Wei I-ao [ca. 1620–1694]: A Case Study of the Relationship between Ming Loyalists and the Chinese Officials in the Ch'ing Government). *Kuo-li T'ai-wan ta-hsüeh mei-shu-shih yen-chiu chi-k'an* (Taiwan University Journal of Art History) 3 (1996): 95–140.

———. "Kuan-yü Ming-mo Ch'ing-ch'u shu-fa-shih te i-hsieh ssu-k'ao: I Fu Shan wei-li" (Reflections on Some Issues in Late Ming and Early Ch'ing Calligraphy: The Case of Fu Shan). *Shu-fa yen-chiu* (Researches on Calligraphy), no. 2 (1998): 25–54.

———. "The Irony of Copying the Elite: A Preliminary Study of the Poetry, Calligraphy, and Painting on Seventeenth Century Jingdezhen Porcelains." *Oriental Art* 41, no. 3 (Autumn 1995): 10–21.

———. "Shih-ch'i shih-chi liu-shih ch'i-shih nien-tai Shan-hsi te hsüeh-shu-ch'üan tui Fu Shan hsüeh-shu yü shu-fa te ying-hsiang" (The Shan-hsi Intellectual Community in the 1660–70s and Fu Shan's Late Scholarship and Calligraphy). *Kuo-li T'ai-wan ta-hsüeh mei-shu-shih yen-chiu chi-k'an* 5 (1998): 183–217.

Barnhart, Richard M. "Chinese Calligraphy: The Inner World of the Brush." *The Metropolitan Museum of Art Bulletin* 30, no. 5 (April/May 1972): 230–41.

———. "Chinese Calligraphy and Painting: The Jeannette Shambaugh Elliott Collection at Princeton." *Record of The Art Museum, Princeton University* 38, no. 2 (1979).

———. *Li Kung-lin's "Classic of Filial Piety."* With essays by Robert E. Harrist, Jr. and Hui-liang J. Chu. New York: The Metropolitan Museum of Art, 1993.

———. "Wei Fu-jen's *Pi-chen T'u* and the Early Texts on Calligraphy." *Archives of the Chinese Art Society of America* 18 (1964): 13–25.

———. "The 'Wild and Heterodox School' of Ming Painting." In Bush and Murck, eds., *Theories of the Arts in China*, 365–96.

———, et al. *The Jade Studio: Masterpieces of Ming and Qing Painting and Calligraphy from the Wong Nan-p'ing Collection*. New Haven: Yale University Art Gallery, 1994.

Baxandall, Michael. *Patterns of Intention: On the Historical Explanation of Pictures*. New Haven: Yale University Press, 1985.

Bickford, Maggie, et al. *Bones of Jade, Soul of Ice: The Flowering Plum in Chinese Art*. Exhib. cat. New Haven: Yale University Art Gallery, 1985.

———. *Ink Plum: The Making of a Chinese Scholar-Painting Genre*. Cambridge: Cambridge University Press, 1996.

Billeter, Jean François. *The Chinese Art of Writing*. Trans. Jean-Marie Clarke and Michael Taylor. Geneva: Skira, 1990.

Bodde, Derk. "The Chinese Language as a Factor in Chinese Cultural Continuity." 1942; reprinted in idem, *Essays on Chinese Civilization*, 43–44. Princeton: Princeton University Press, 1981.

Bol, Peter. *"This Culture of Ours": Intellectual Transitions in T'ang and Sung China*. Stanford: Stanford University Press, 1992.

Boltz, William G. "Early Chinese Writing." *World Archaeology* 17, no. 3 (Feb. 1986): 420–36.

———. "Notes on the Authenticity of the So Tan Manuscript of the *Lao-tzu*." *Bulletin of the School of Oriental and African Studies, University of London* 59, no. 3 (1996): 508–15.

———. *The Origin and Early Development of the Chinese Writing System*. American Oriental Series 78. New Haven: American Oriental Society, 1994.

Bourassa, Jon Rawlings. "The Life and Work of the Literati Painter Yao Shou." Ph.D. diss., Washington University, 1978.

Bush, Susan. *The Chinese Literati on Painting: Su Shih (1037–1101) to Tung Ch'i-ch'ang (1555–1636)*. Harvard-Yenching Institute Studies 27. 2d ed. Cambridge, Mass.: Harvard University Press, 1978.

Bush, Susan, and Christian F. Murck, eds. *Theories of the Arts in China*. Princeton: Princeton University Press, 1983.

Bush, Susan, and Hsio-yen Shih, comps. and eds. *Early Chinese Texts on Painting*. Cambridge, Mass.: Harvard University Press, 1985.

Cahill, James. *The Compelling Image: Nature and Style in Seventeenth-Century Chinese Painting*. Cambridge, Mass., and London: Harvard University Press, 1982.

The Cambridge History of China. Vol. 1, *The Ch'in and Han Empires, 221 B.C.–A.D. 220*, ed. Denis Twitchett and Michael Loewe, 1986; vol. 3, *Sui and T'ang China, 589–906, Part 1*, ed. Denis Twitchett, 1979; vol. 6, *Alien Regimes and Border States, 907–1358*, ed. Herbert Franke and Denis Twitchett, 1994; vol. 7, *The Ming Dynasty, 1368–1644, Part 1*, ed. Frederick W. Mote and Denis Twitchett, 1988; vol. 8, *The Ming Dynasty, 1368–1644, Part 2*, 1998; vol. 10, *Late Ch'ing, 1800–1911, Part 1*, ed. John K. Fairbank and Kwang-ching Liu, 1978; vol. 11, *Late Ch'ing, 1800–1911, Part 2*, ed. John K. Fairbank and Kwang-ching Liu, 1980. Cambridge: Cambridge University Press.

Chan Sin-wai (Ch'en Shan-wei) and Wang Erh-min, comps. *Chin-tai ming-jen shu-cha ching hsüan* (Letters of Prominent Figures in Modern China). Hong Kong: Chinese University Press, 1992.

Chang Chih-tao. *Hsi-ching Pei-lin* (Stele Forest of Sian). Sian: Chung-hua shu-chü ta shou, 1935.

Chang Ch'ing-chih. "Ch'ien-ku tsui-jen i seng shu—T'an Huai-su ts'ao-shu *Tzu-hsü t'ieh*" (The Calligraphy of a Drunken Monk—Huai-su's *Autobiography* in Cursive Script). *Ku-kung wen-wu yüeh-k'an* (National Palace Museum Monthly of Chinese Art) 1, no. 11 (1984): 14–29.

Chang, Ch'ung-ho, and Hans H. Frankel, trans. *Two Chinese Treatises on Calligraphy*. New Haven and London: Yale University Press, 1995.

Chang, Cornelius. "A Revaluation of the Development of Hsing-shu Style in the Fourth Century A.D." *Ku-kung chi-k'an* (National Palace Museum Quarterly) 2, no. 2 (Winter 1976): 19–41.

Chang Huai-kuan. *Shu-tuan* (Critical Reviews on Calligraphy). 727. In Chang Yen-yüan, *Fa-shu yao-lu, chüan 7–9*.

Chang Kuang-pin. *Chung-hua shu-fa shih* (A History of Chinese Calligraphy). Taipei: T'ai-wan shang-wu yin-shu-kuan, 1981.

———. "Ts'ung Wang Yu-chün shu *Yüeh I lun* ch'uan-yen pien Sung-jen mo Ch'u ts'e" (Interpolations of the Various Calligraphic Versions of the *Yüeh I Lun*.) *Ku-kung chi-k'an* 14, no. 4 (Summer 1980): 41–62.

———. *Yüan-ch'ao shu-hua-shih yen-chiu lun-chi* (Collection of Essays on the History of Yüan Dynasty Calligraphy and Painting). Taipei: National Palace Museum, 1979.

———. *Yüan ssu ta-chia* (Four Great Masters of the Yüan). Taipei: National Palace Museum, 1975.

Chang, Léon Lung-yien. *La Calligraphie Chinoise, un art à quatre dimensions*. Paris: Le Club français du livre, 1971.

———, and Peter Miller. *Four Thousand Years of Chinese Calligraphy*. Chicago and London: University of Chicago Press, 1990.

Chang Yen-yüan. *Fa-shu yao-lu* (Essentials of Calligraphy). Completed ca. 847. Peking: Jen-min mei-shu ch'u-pan-she, 1984.

———. *Li-tai ming-hua chi* (Record of Famous Paintings in Successive Dynasties). Completed 847. In *Hua-shih ts'ung-shu*, vol. 1.

Chao Meng-fu (1254–1322). *Sung-hsüeh-chai wen-chi* (Collected Works of the Sung-hsüeh Studio). In *Li-tai hua-chia shih-wen chi* (A Collection of Poetry and Prose Writings by Painters), vol. 3. Taipei: Hsüeh-sheng shu-chü, 1970.

Character and Context in Chinese Calligraphy. Eds. Cary Y. Liu, Dora C. Y. Ching, and Judith G. Smith. Papers prepared for an international symposium organized by The Art Museum, Princeton University, and held in March 1999 in conjunction with the exhibition "The Embodied Image: Chinese Calligraphy from the John B. Elliott Collection." Princeton: The Art Museum, Princeton University, 1999.

Chaves, Jonathan. "The Legacy of Ts'ang Chieh: The Written Word as Magic." *Oriental Art*, n.s. 23, no. 2 (Summer 1977): 200–215.

———. "The Panoply of Images: A Reconsideration of the Literary Theory of the Kung-an School." In Bush and Murck, eds., *Theories of the Arts in China*, 341–64.

Ch'en Kao-hua, ed. *Sung Liao Chin hua-chia shih-liao* (Historical Source Materials on the Painters of the Sung, Liao, and Chin Dynasties). Peking: Wen-wu ch'u-pan-she, 1984.

———. *Yüan-tai hua-chia shih-liao* (Historical Source Materials on the Painters of the Yüan Dynasty). Shanghai: Shang-hai jen-min mei-shu ch'u-pan-she, 1980.

Ch'en Pao-chen and Chu Hung-lam. "The Impact of Chao Meng-fu (1254–1322) in Late Yüan and Ming." In Mote and Chu et al., *Calligraphy and the East Asian Book*, 111–32.

Ch'en Yin-k'o. "T'ien-shih-tao yü pin-hai ti-yü chih kuan-hsi" (The Cult of the Heavenly Master and Its Relation to Coastal China). *Kuo-li chung-yang yen-chiu-yüan li-shih yü-yen yen-chiu-so chi-k'an* (Bulletin of the Institute of History and Philology, Academia Sinica) 3 (1933): 439–66.

Ch'en Yüan. *Tun-huang chieh-yü lu* (Catalogue of Scrolls from Tun-huang in the National Library of Peking). 6 vols. Peking: Academia Sinica, Institute of History and Philology, 1931.

Cheng Chin-fa. "Mi Fu Shu-ssu t'ieh" (Mi Fu's Calligraphy on Shu Silk). Master's thesis, National Taiwan University, Taipei, 1974.

Cheng, François. *Chinese Poetic Writing*. Trans. Donald A. Riggs and Jerome P. Seaton. Bloomington: Indiana University Press, 1982.

Cheng Kuang-jung. "T'ai-ko t'i ho Kuan-ko-t'i" (The Chancellery Style and the Court Style of Calligraphy). *Wen-wu* (Cultural Relics), no. 4 (1979): 79–80.

Cheung Kwong-yue. "Recent Archaeological Evidence Relating to the Origin of Chinese Characters." In David N. Keightley, ed., *The Origins of Chinese Civilization*, 323–91. Berkeley: University of California Press, 1983.

Ch'i Kung (see also Qi Gong). *Ch'i Kung ts'ung-kao* (Collected Essays by Ch'i Kung). Peking: Chung-hua shu-chü, 1981.

———. "*Chi-chiu P'ien* ch'uan-pen k'ao (A Study of *Chi-chiu P'ien*)." In *Ch'i Kung ts'ung-kao*, 1–25.

———. "Lun Huai-su *Tzu-hsü t'ieh* mo-chi pen" (Discussion on Huai-su's *Autobiographical Essay*, Ink Version). *Wen-wu*, no. 12 (1983): 76–83.

———. "Sun Kuo-t'ing *Shu-p'u* k'ao" (A Study of Sung Kuo-t'ing's *Shu-p'u*). *Wen-wu*, no. 2 (1964): 19–33.

———. "T'ang Yin's Poetry, Painting, and Calligraphy in Light of Critical Biographical Events." In Murck and Fong, eds., *Words and Images,* 459–86.

Chiang Chao-shen. "The Identity of Yang Mei-tzu and the Paintings of Ma Yüan." *National Palace Museum Bulletin* 2, no. 2 (May 1967): 1–14; 2, no. 3 (July 1967): 8–14.

———. *Kuan-yü T'ang Yin te yen-chiu* (A Study of T'ang Yin). Taipei: National Palace Museum, 1976.

———. *Wen Cheng-ming yü Su-chou hua-t'an* (Wen Cheng-ming and Soochow Painting). Taipei: National Palace Museum, 1977.

Chiang Ch'eng-ch'ing. *Chung-kuo shu-fa ssu-hsiang shih* (Intellectual History of Chinese Calligraphy), in the series *Chung-kuo shu-hsüeh ts'ung-shu.* Changsha: Hu-nan mei-shu ch'u-pan-she, 1994.

———. *Shu-fa wen-hua ts'ung-t'an* (A Discussion of Calligraphy and Culture). Hangchow: Che-chiang mei-shu hsüeh-yüan ch'u-pan-she, 1992.

Chiang I-han. "Chao Meng-fu shu *Hu-chou Miao-yen ssu chüan*" (*Record of the Miao-yen Monastery,* a Calligraphic Handscroll by Chao Meng-fu). *Ku-kung chi-k'an* 10, no. 3 (Spring 1976): 59–81.

———. "Chao-shih i men ho cha yen-chiu" (A Study of Six Letters by Chao Meng-fu's Family). *Ku-kung chi-k'an* 11, no. 4 (1977): 23–50, pls. 1–12; English trans., 33–37.

———. "P'u-lin-ssu-tun ta-hsüeh mei-shu-kuan ts'ang Wang Yang-ming san-cha chüan" (Three Letters by Wang Yang-ming in The Art Museum, Princeton University). *Ming-pao yüeh-k'an* (Ming-pao Monthly) 10, no. 1 (Jan. 1975): 58–65.

———. *Yüan-tai K'uei-chang-ko chi K'uei-chang jen-wu* (The Yüan Dynasty Hall of Literature and Personnel). Taipei: Lien-ching ch'u-pan-she, 1981.

Chiang Shao-shu. *Wu-sheng-shih shih* (Painting History). Mid-17th century. In *Hua-shih ts'ung-shu,* 2: 949–1099.

Chiang Wen-kuang. *Chung-kuo shu-fa shih* (History of Chinese Calligraphy). Taipei: Wen-chin ch'u-pan-she, 1993.

Chiang Yee. *Chinese Calligraphy: An Introduction to Its Aesthetics and Technique.* 3d rev. ed. Cambridge, Mass.: Harvard University Press, 1979.

Chin K'ai-ch'eng. "T'an Huai-su te ts'ao-shu" (A Discussion of Huai-su's Cursive Script). *Wen-wu,* no. 2 (1979): 15–18.

Chin Wang Hsi-chih chih mo-chi (Calligraphy of Wang Hsi-chih). Taipei: National Palace Museum, 1968.

Chou I-liang and Chao Ho-p'ing. *T'ang Wu-tai shu-i yen-chiu* (A Study of Model Letters of the T'ang and Five Dynasties). Peking: Chung-kuo she-hui k'o-hsüeh ch'u-pan-she, 1995.

Chu, Hui-liang. "The Chung Yu (A.D. 151–230) Tradition: A Pivotal Development in Sung Calligraphy." Ph.D. diss., Princeton University, 1990.

———. "Imperial Calligraphy of the Southern Sung." In Murck and Fong, eds., *Words and Images,* 289–312.

———. "Nan-Sung huang-shih shu-fa (Southern Sung Imperial Calligraphy). *Ku-kung hsüeh-shu chi-k'an* 2, no. 4 (Summer 1985): 17–52.

———. "Sung-tai ts'e-yeh chung chih ch'ih-tu shu-fa" (The Calligraphy of Letters on Sung Dynasty Album Leaves). In *Sung-tai shu-hua ts'e-yeh ming-p'in t'e-ch'an* (Famous Album Leaves of the Sung Dynasty), 10–20. Taipei: National Palace Museum, 1995.

———. *Yün-chien shu-p'ai t'e-chan t'u-lu* (A Special Exhibition of the Calligraphy of the Yün-chien School). Taipei: National Palace Museum, 1994.

Chu Jen-fu (Zhu Renfu). *Chung-kuo ku-tai shu-fa shih* (History of Ancient Chinese Calligraphy). Peking: Pei-ching ta-hsüeh ch'u-pan-she, 1992.

Ch'u Sui-liang. *Chin Yu-chün Wang Hsi-chih shu-mu* (List of Calligraphic Works by Wang Hsi-chih, General of the Army of the Right of the Chin Dynasty). In Chang Yen-yüan, *Fa-shu yao-lu.* In *P'ei-wen-chai shu-hua p'u.*

Ch'üan T'ang shih (Complete Poems of the T'ang Dynasty). Comp. P'eng Ting-ch'iu et al. 1960. 25 vols. Reprint, Peking: Chung-hua shu-chü, 1985, vol. 41.

Chūgoku hosho gaido (Guide to Chinese Calligraphy). Tokyo: Nigensha, 1987– .

Ch'un-hua-ko t'ieh (Model Calligraphies from the Imperial Archives of the Ch'un-hua Era). 994; Ming dynasty rubbing. Ed. and comp. Ch'in Ming-chih and Hsü Tsu-fan. Lan-chou: Kan-su jen-min ch'u-pan-she, 1988.

Chung-kuo ku-tai shu-hua t'u-mu (Illustrated Catalogue of Selected Works of Ancient Chinese Painting and Calligraphy). Vols. 1– . Peking: Wen-wu ch'u-pan-she, 1986– .

Chung-kuo mei-shu ch'üan-chi: Shu-fa chuan-k'o pien (Comprehensive Collection of Chinese Art: Calligraphy and Stone Stelae). Ed. Chung-kuo mei-shu ch'üan-chi pien-chi wei-yüan-hui. Vols. 1–4, Peking: Jen-min mei-shu ch'u-pan-she; vols. 5–7, Shanghai: Shang-hai shu-hua ch'u-pan-she, 1986–89.

Chung-kuo shu-fa ch'üan-chi (Comprehensive Collection of Chinese Calligraphy). Ed. Liu Cheng-ch'eng. Vols. 1– . Peking: Jung-pao-chai, 1992– .

Chung-kuo shu-fa kuo-chi hsüeh-shu yen-t'ao-hui: Chi-nien Yen Chen-ch'ing shih-shih i-ch'ien-er-pai nien (The International Seminar on Chinese Calligraphy in Memory of Yen Chen-ch'ing's 1200th Posthumous Anniversary). Taipei: Council for Cultural Planning and Development, Executive Yüan, R.O.C., 1987.

Chung-kuo shu-fa wen-hua ta-kuan (An Overview of the Culture of Chinese Calligraphy). Ed. Chin K'ai-ch'eng and Wang Yüeh-ch'uan. Peking: Pei-ching ta-hsüeh ch'u-pan-she, 1995.

Chung-yang yen-chiu-yüan li-shih yü-yen yen-chiu-so ts'ang li-tai mu-chih ming t'a-p'ien mu-lu (Catalogue of Rubbings of Epitaphs in the Collection of the Institute of History and Philology, Academia Sinica). Comp. Mao Han-kuang et al. Taipei: Chung-yang yen-chiu-yüan li-shih yü-yen yen-chiu-so (Institute of History and Philology, Academia Sinica), 1985.

Cleaves, Francis W. "The 'Fifteen Palace Poems' by K'o Chiu-ssu." *Harvard Journal of Asiatic Studies* 20, no. 3/4 (1957): 391–479.

Clunas, Craig. *Superfluous Things: Material Culture and Social Status in Early Modern China*. Urbana and Chicago: University of Illinois Press, 1991.

Crawford, John M., L. C. S. Sickman, and Pierpont Morgan Library. *Chinese Calligraphy and Painting in the Collection of John M. Crawford, Jr.* New York: Pierpont Morgan Library, 1962.

David, Percival, trans. *Chinese Connoisseurship: The Ko Ku Yao Lu*. New York and Washington: Praeger Publishers, 1971.

de Bary, William Theodore, et al. *Self and Society in Ming Thought*. New York: Columbia University Press, 1970.

Ebrey, Patricia. "T'ang Guide to Verbal Etiquette." *Harvard Journal of Asiatic Studies* 45, no. 2 (Dec. 1985): 581–613.

Ecke, Tseng Yu-ho (see also Tseng Yuho). *Chinese Calligraphy*. Exhib. cat. Philadelphia: Philadelphia Museum of Art; and Boston: Boston Book and Art Publishers, 1971.

Edwards, Richard. *The Art of Wen Cheng-ming (1470–1559)*. Ann Arbor: University of Michigan Museum of Art, 1976.

Egan, Ronald C. *The Literary Works of Ou-yang Hsiu (1007–72)*. Cambridge: Cambridge University Press, 1984.

Eight Dynasties of Chinese Painting: The Collections of the Nelson Gallery–Atkins Museum, Kansas City, and The Cleveland Museum of Art. Exhib. cat. Cleveland: The Cleveland Museum of Art, 1980.

Ellsworth, Robert Hatfield. *Later Chinese Painting and Calligraphy, 1800–1950*. 3 vols. New York: Random House, 1987.

Farrer, Anne. *The Brush Dances & the Ink Sings: Chinese Paintings and Calligraphy from the British Museum*. London: South Bank Centre, Hayward Gallery, 1990.

Fong, Wen C. *Beyond Representation: Chinese Painting and Calligraphy, 8th–14th Century*. New York: The Metropolitan Museum of Art; and New Haven and London: Yale University Press, 1992.

———. "Modern Art Criticism and Chinese Painting History." In Ching-i Tu, ed., *Tradition and Creativity: Essays on East Asian Civilization: Proceedings of the Lecture Series on East Asian Civilization*, 98–108. New Brunswick: Rutgers, State University of New Jersey, 1987.

———. "The Wang Hsi-chih Tradition and Its Relationship to T'ang and Sung Calligraphy." In *Chung-kuo shu-fa kuo-chi hsüeh-shu yen-t'ao-hui*, 249–66.

———, ed. *The Great Bronze Age of China: An Exhibition from the People's Republic of China*. Exhib. cat. New York: The Metropolitan Museum of Art, 1980.

Fong, Wen C., and James C. Y. Watt. *Possessing the Past: Treasures from the National Palace Museum, Taipei*. New York: The Metropolitan Museum of Art; and Taipei: National Palace Museum, 1996.

Fong, Wen C., et al. *Images of the Mind: Selections from the Edward L. Elliott Family and John B. Elliott Collections of Chinese Calligraphy and Painting at The Art Museum, Princeton University*. Exhib. cat. Princeton: The Art Museum, Princeton University, 1984.

Fontein, Jan, and Money L. Hickman. *Zen Painting and Calligraphy: An Exhibition of Works of Art Lent by Temples, Private Collectors, and Public and Private Museums in Japan*. Exhib. cat. Boston: Museum of Fine Arts, 1970.

Fontein, Jan, and Wu Tung. *Unearthing China's Past*. Boston: Museum of Fine Arts, 1973.

The Freer Gallery of Art. Comp. The Freer Gallery of Art. Vol. 1, *China*. Tokyo: Kodansha, 1972.

Fu, Marilyn Wong (M. W. Gleysteen) . "Hsien-yü Shu's Calligraphy and His 'Admonitions' Scroll of 1299." Ph.D. diss., Princeton University, 1983.

———. "The Impact of the Reunification: Northern Elements in the Life and Art of Hsien-yü Shu (1257?–1302) and Their Relation to Early Yüan Literati Culture." In John D. Langlois, ed., *China under Mongol Rule*, 371–433. Princeton: Princeton University Press, 1981.

Fu Shan. *Fu Shan ch'üan-shu* (The Complete Works of Fu Shan). 7 vols. Taiyuan: Shan-hsi jen-min ch'u-pan-she, 1991.

Fu, Shen C. Y. (Fu Shen). "Chang Chi-chih ho t'a-te chung-k'ai" (Chang Chi-chih [1186–1266]: The Last Great Calligrapher of the Sung and His Medium-regular Script). *Ku-kung chi-k'an* 10, no. 4 (Summer 1976): 43–65; English trans., 21–39.

———. "Huang T'ing-chien's Calligraphy and His *Scroll for Chang Ta-t'ung*: A Masterpiece Written in Exile." Ph.D. diss., Princeton University, 1976.

———. "Huang T'ing-chien's Cursive Script and Its Influence." In Murck and Fong, eds., *Words and Images*, 107–22.

———. "Mindai no shodan." In Nakata and Fu, *Ōbei shūzō Chūgoku hōsho meisekishū, Ming–Ch'ing*, vol. 1: 129–30.

———. "Ming mo Ch'ing ch'u te t'ieh-hsüeh feng-shang" (The Prevailing Tastes in the Study of Model-books in the Late Ming and Early Ch'ing). In *Ming mo Ch'ing ch'u shu-fa chan* (An Exhibition of Late Ming and Early Ch'ing Calligraphy), 9–25. Taipei: Ho Ch'uang-shih chi-chin-hui, 1996.

———. "Shen Chou Yu-chu-chü yü *Tiao-yüeh-t'ing t'u chüan*" (Shen Chou's Bamboo Dwelling and the Handscroll Painting *Pavilion for Fishing the Moonlight*). In *Chung-kuo i-shu wen-wu t'ao-lun-hui lun-wen-chi—Shu-hua, shang* (Proceedings of the International Colloquium on Chinese Art History, 1991—Painting and Calligraphy, part 1), 377–99. Taipei: National Palace Museum, 1992.

———. *Shu-shih yü shu-chi: Fu Shen lun-wen chi* (Essays on the History of Chinese Calligraphy: T'ang though Yüan). Taipei: Kuo-li li-shih po-wu-kuan, 1996.

———. *Yüan-tai huang-shih shu-hua shou-ts'ang shih-lüeh* (A Brief History of the Yüan Imperial Collections of Calligraphy and Painting). Taipei: National Palace Museum, 1981. Reprint of a four-part article first published in *Ku-kung chi-k'an* 13, nos. 1–4 (1978–79).

———, et al. *Traces of the Brush: Studies in Chinese Calligraphy*. New Haven: Yale University Art Gallery, 1977.

Fu, Shen, Glenn D. Lowry, and Ann Yonemura. *From Concept to Context: Approaches to Asian and Islamic Calligraphy*. Washington, D.C.: Freer Gallery, Smithsonian Institution, 1986.

Fujiwara, S. "Shofu-kaigi" (Corrections to the 'Shu-p'u'). *Shohin* (Calligraphy), gen. no. 30 (1952): 52–57.

Fung Yu-lan. *A History of Chinese Philosophy.* Trans. Derk Bodde. 2d ed. 2 vols. Princeton: Princeton University Press, 1952–1953.

Fushimi Chūkei. *Sho no rekishi Chūgoku hen* (History of Chinese Calligraphy). Tokyo: Nigensha, 1963.

Goepper, Roger. "Methods for a Formal Analysis of Chinese Calligraphy, Taking Sun Kuo-t'ing's *Shu-p'u* as an Example." In *Proceedings of the International Colloquium on Chinese Art History, 1991. Painting and Calligraphy,* part 2, 599–626. Taipei: National Palace Museum, 1992.

———. *Shu-p'u, der Traktat zur Schriftkunst der Sun Kuo-t'ing.* Wiesbaden: Franz Steiner, 1974.

Goldberg, Stephen J. "Court Calligraphy of the Early T'ang Dynasty." *Artibus Asiae* 49, no. 3/4 (1988–89): 189–237.

Goodrich, L. Carrington, and Chaoying Fang, eds. *Dictionary of Ming Biography, 1368–1644.* 2 vols. New York: Columbia University Press, 1976.

Han Ming-an and Ma Hsiang-lin, eds. *Tui-lien man-hua.* Harbin: Hei-lung-chiang jen-min ch'u-pan-she, 1983.

Hansen, Chad. *Language and Logic in Ancient China.* Ann Arbor: University of Michigan Press, 1983.

Harrist, Robert E., Jr. "The Artist as Antiquarian: Li Gonglin and His Study of Early Chinese Art." *Artibus Asiae* 55 (1995): 237–80.

———. "Ch'ien Hsüan's *Pear Blossoms:* The Tradition of Flower Painting and Poetry from Sung to Yüan." *Metropolitan Museum of Art Journal* 22 (1987): 53–70.

———. "Eulogy on Burying a Crane: A Ruined Inscription and Its Restoration." *Oriental Art* 44, no. 3 (Autumn 1998), 2–10.

———. "Watching the Clouds Rise: A Tang Dynasty Couplet and Its Illustration in Song Painting." *Cleveland Museum of Art Bulletin* 78, no. 7 (Nov. 1991), 301–23.

Hay, John (Han Chuang). "Hsiao I Gets the Lan-t'ing Manuscript by a Confidence Trick." Parts 1 and 2. *National Palace Museum Bulletin* 5, no. 3 (July–Aug. 1971): 1–7; and 5, no. 6 (Jan.–Feb. 1971): 1–17.

———. "The Human Body as a Microcosmic Source of Macrocosmic Values in Calligraphy." In Bush and Murck, *Theories of the Arts in China,* 74–102.

Henricks, Robert G., trans. *Lao-tzu Tao-te ching: A New Translation Based on the Recently Discovered Ma-wang-tui Texts.* New York: Ballantine Books, 1989.

Hirotzu Unsen. *Chō Zuito no shohō* (The Calligraphy of Chang Jui-t'u). 2 vols. Tokyo: Nigensha, 1981.

Ho Chuan-hsing. "Chang Pi chi ch'i *Tsa-shu chüan*" (Chang Pi and His *Handscroll of Miscellaneous Calligraphy*). *Ku-kung wen-wu yüeh-k'an* 7, no. 6 (1989): 112–17.

———. "Chu Yün-ming chi ch'i shu-fa i-shu" (Chu Yün-ming and His Calligraphy). Parts 1 and 2. *Ku-kung hsüeh-shu chi-k'an* 9, no. 4 (Summer 1992): 13–35; and 10, no. 1 (Autumn 1992): 1–60.

———. "Huai-su *Tzu-hsü t'ieh* tsai Ming-tai te liu-ch'uan yü ying-hsiang" (Huai-su's Calligraphy *Autobiography:* Its Passage and Influence in the Ming Dynasty). In *Proceedings of the International Colloquium on Chinese Art History, 1991. Painting and Calligraphy,* part 2, 661–85. Taipei: National Palace Museum, 1992.

———. "P'u Hsin-yü yü Ch'ing-tai kung-t'ing shu-fa" (P'u Hsin-yü and Ch'ing Dynasty Court Calligraphy). In *Chang Ta-ch'ien P'u Hsin-yü shih shu-hua-hsüeh shu t'ao-lun-hui lun-wen-chi* (Proceedings of the Conference on the Calligraphy and Painting of Chang Dai-chien and P'u Hsin-yü), 427–66. Taipei: National Palace Museum, 1994.

———. "The Revival of Calligraphy in the Early Northern Sung." In Maxwell K. Hearn and Judith K. Smith, eds., *Arts of the Sung and Yüan,* 59–85. New York: The Metropolitan Museum of Art, 1996.

———. "Tung Ch'i-ch'ang yü Mi Fu te shu-chi" (Tung Ch'i-ch'ang and the Calligraphic Works of Mi Fu). *I-shu-hsüeh* (Study of the Arts) 4 (1990): 193–222.

Ho, Wai-kam, ed. *The Century of Tung Ch'i-ch'ang, 1555–1636.* 2 vols. Exhib. cat. Kansas City, Mo.: Nelson-Atkins Museum of Art, 1992.

Hsü, Ginger Cheng-chi. "Zheng Xie's Price List: Painting as a Source of Income in Yangzhou." In Ju-hsi Chou and Claudia Brown, eds., *Chinese Painting under the Qianlong Emperor: The Symposium Papers in Two Parts,* part 2, 261–71. Tempe: Arizona State University, 1988.

Hsü Pang-ta (see also Xu Bangda). "Nan Sung ti-hou t'i-hua shih-shu k'ao-pien" (A Study of Inscriptions on Paintings Written by Southern Sung Empresses). *Wen-wu,* no. 6 (1981): 52–64.

Hsüan-ho hua-p'u (The Hsüan-ho Painting Catalogue). Ca. 1120. In *Hua-shih ts'ung-shu,* vol. 2.

Hsüan-ho shu-p'u (The Hsüan-ho Calligraphy Catalogue). Ca. 1120. In *Hsüeh-chin t'ao-yüan,* vol. 159. Taipei: I-wen yin-shu-kuan, 1965.

Hu, Philip K., and Yiling Mao, *Shanghai Library Treasures: Historical Rubbings and Letters.* Exhib. cat. New York: Queens Library Gallery, [1998].

Hua Hsia. *Chen-shang-chai t'ieh* (Model Calligraphies from the Chen-shang Studio). 1522.

Hua Jen-te (Hua Rende). "Lun Tung-Chin mu-chih chien-chi Lan-t'ing lun-pien." *Ku-kung hsüeh-shu chi-k'an* 13, no. 1 (Oct. 1995): 27–62. Translation: "Eastern Jin Epitaphic Stones—With Some Notes on the 'Lanting Xu' Debate." *Early Medieval China* 3 (1997): 30–88.

Hua-shih ts'ung-shu (Compendium of Painting Histories). Comp. Yü An-lan. Shanghai: Jen-min mei-shu ch'u-pan-she, 1963. Reprint, Taipei: Wen-shih-che ch'u-pan-she, 1974.

Huang Chien, ed. *Li-tai shu-fa lun-wen hsüan* (A Selection of Essays on Chinese Calligraphy). 2 vols. Shanghai: Shang-hai shu-hua ch'u-pan-she, 1979).

Huang T'ing-chien (1045–1105). *Huang Shan-ku shih ch'üan-chi* (Comprehensive Collection of Poems by Huang T'ing-chien). 1899. Reprint, Shanghai: Chu-i-t'ang shu-chü, 1919.

———. *Shan-ku t'i-pa* (Colophons by Huang T'ing-chien). 12th century. *I-shu ts'ung-pien* ed.

Hummel, Arthur W, ed. *Eminent Chinese of the Ch'ing Period.* Washington, D.C.: U.S. Government Printing Office, 1943.

I-shu ts'ung-pien (Collected Works on Chinese Art). Comp. and ed. Yang Chia-lo. 36 vols. 1962. Reprint, Taipei: Shih-chieh shu-chü, 1967.

The International Seminar on Chinese Calligraphy in Memory of Yen Chen-ch'ing's 1200th Posthumous Anniversary. See *Chung-kuo shu-fa kuo-chi hsüeh-shu yen-t'ao-hui.*

Jao Tsung-i. "Wu Chien-heng erh nien So Tan hsieh pen *Tao-te ching* ts'an chüan k'ao cheng" (The So Tan Manuscript Fragment of the *Tao-te ching*, A.D. 270). *Journal of Oriental Studies* 2, no. 1 (1955): 1–68; English abstract, 68–71.

Jen Yu-wen. "Ch'en Hsien-chang's 'Philosophy of the Natural.'" In de Bary et al., *Self and Society in Ming Thought,* 53–92.

Jung Keng. *Ts'ung-t'ieh mu* (Catalogue of Model Calligraphies). 4 vols. Hong Kong: Chung-hua shu-chü, 1980–86.

Kahn, Harold. "A Matter of Taste: The Monumental and Exotic in the Qianlong Reign." In Chou Ju-hsi and Claudia Brown, eds., *The Elegant Brush: Chinese Painting under the Qianlong Emperor, 1735–1795,* 288–302. Phoenix: Phoenix Art Museum, 1985.

Kao, Yu-kung. "Chinese Lyric Aesthetics." In Murck and Fong, eds., *Words and Images,* 47–90.

Knapp, Ronald G. *China's Vernacular Architecture: House Form and Culture.* Honolulu: University of Hawaii Press, 1989.

Ko-ku yao-lu. See David, Percival, trans.

Kraus, Richard Curt. *Brushes with Power: Modern Politics and the Chinese Art of Calligraphy.* Berkeley, Los Angeles, Oxford: University of California Press, 1991.

Ku-kung fa-shu hsüan-ts'ui (Masterpieces of Chinese Calligraphy in the National Palace Museum). 2 vols. Taipei: National Palace Museum, 1970.

Ku-kung li-tai fa-shu ch'üan-chi (Comprehensive Collection of Chinese Calligraphy in the National Palace Museum). 30 vols. Taipei: National Palace Museum, 1976–79.

Ku-kung po-wu-yüan ts'ang li-tai fa-shu hsüan-chi (Selected Works of Chinese Calligraphy in the Palace Museum). 20 vols. Peking: Wen-wu ch'u-pan-she, 1963.

Ku-kung shu-hua-lu (The National Palace Museum Catalogue of Calligraphy and Painting). 4 vols. 1956; rev. ed., Taipei: National Palace Museum, 1965.

K'uai-hsüeh-t'ang fa-shu (Model Calligraphies from the K'uai-hsüeh Studio). Ed. Feng Ch'üan. Preface 1779.

Kuo Mo-jo (Guo Moruo). "Yu Wang Hsieh mu-chih te ch'u-t'u lun tao *Lan-t'ing hsü* te chen-wei" (A Discussion of the Authenticity of the *Orchid Pavilion Preface* Based on the Newly Discovered Epitaph of Wang Hsieh). *Wen-wu,* no. 6 (1965): 1–33.

Kuo Shao-yü. *Chung-kuo wen-hsüeh p'i-p'ing shih* (History of Chinese Literary Criticism). Shanghai: Chung-hua shu-chü, 1961.

Lawton, Thomas. "The Mo-yüan hui-kuan by An Ch'i." In *Ch'ing chu Chiang Fu-ts'ung hsien-sheng ch'i-shih sui lun-wen chi* (Symposium in Honor of Dr. Chiang Fu-ts'ung on His Seventieth Birthday), 13–35. Taipei: National Palace Museum, 1969.

Ledderose, Lothar. "An Approach to Chinese Calligraphy." *National Palace Museum Bulletin* 7, no. 1 (1972): 1–14.

———. "Chinese Calligraphy: Its Aesthetic Dimension and Social Function." *Orientations* 17, no. 10 (Oct. 1986): 35–50.

———. *Mi Fu and the Classical Tradition of Chinese Calligraphy.* Princeton: Princeton University Press, 1979.

———. "Mi Fu yü Wang Hsien-chih" (Mi Fu and Wang Hsien-chih). *Ku-kung chi-k'an* 7, no. 2 (1972): 71–84.

———. "Some Taoist Elements in the Calligraphy of the Six Dynasties." *T'oung Pao* 70, nos. 4–5. (1984): 246–78.

Lee Hui-shu. "Art and Imperial Images at the Late Sung Court." In Maxwell K. Hearn and Judith G. Smith, eds., *Arts of the Sung and Yüan,* 249–69. New York: The Metropolitan Museum of Art, 1996.

———. "The Domain of Empress Yang (1162–1233): Art, Gender and Politics at the Late Southern Song Court." Ph.D. diss., Yale University, 1994.

Lee, Sherman E., and Wai-kam Ho. *Chinese Art under the Mongols: The Yüan Dynasty (1279–1368).* Exhib. cat. Cleveland: The Cleveland Museum of Art, 1968.

Leys, Simon. "One More Art." *New York Review of Books,* April 18, 1996, 28–31.

Li Chi, Book of Rites. Trans. James Legge. Rev. ed. 2 vols. New York: University Books, 1967.

Li Fu-shun, ed. *Tung-p'o lun shu-hua shih-liao* (Historical Source Materials on Su Shih's Comments on Calligraphy and Painting). Shanghai: Shang-hai jen-min mei-shu ch'u-pan-she, 1988.

Liao-ning sheng po-wu-kuan ts'ang fa-shu hsüan-chi (A Selection of Calligraphy from the Liaoning Provincial Museum). 20 vols. Peking: Wen-wu ch'u-pan-she, 1982.

Lin, Shuen-fu. "Chiang K'uei's Treatise on Poetry and Calligraphy." In Bush and Murck, eds., *Theories of the Arts in China,* 293–316.

———. *Transformation of the Chinese Lyrical Tradition: Chiang K'uei and Southern Sung Tz'u Poetry.* Princeton: Princeton University Press, 1978.

Little, Stephen. "Chinese Calligraphy." *Bulletin of the Cleveland Museum of Art* 74, no. 9 (Nov. 1987): 372–403.

Liu, Cary Y. "The Ch'ing Dynasty Wen-yüan-ko Imperial Library: Architecture and the Ordering of Knowledge." Ph.D. diss., Princeton University, 1997.

———. "'Heavenly Wells' in Ming Dynasty Huizhou Architecture." *Orientations* 25, no. 1 (1994): 28–36.

———. "The Yüan Dynasty Capital, Ta-tu: Imperial Building Program and Bureaucracy." *T'oung Pao* 78 (1992): 264–301.

Liu Cheng-ch'eng, ed. *Wang To.* Vols. 61 and 62 in the series *Chung-kuo shu-fa ch'üan-chi.* Peking: Jung-pao-chai, 1993.

Liu Heng. *Li-tai ch'ih-tu shu-fa* (The Calligraphy of Letters from Imperial China). Peking: Chih-shih ch'u-pan-she, 1992.

———. "Ling-lüeh ku-fa sheng hsin-ch'i—T'an Chang Jui-t'u te shu-fa i-shu" (Innovations Arising from Tradition: A Discussion of Chang Jui-t'u's Calligraphy). *Chung-kuo shu-fa* (Chinese Calligraphy), no. 2 (1987): 35–37.

Liu Hsieh. *Wen-hsin tiao-lung* (The Literary Mind and the Carving of Dragons). In Chou Chen-fu, ed., *Wen-hsin tiao-lung chu-shih.* Peking: Jen-min wen-hsüeh ch'u-pan-she, 1981. *See also* Shih, Vincent Yu-chung, trans.

Liu, James J. Y. *The Art of Chinese Poetry.* Chicago and London: University of Chicago Press, 1962.

Liu, James T. C. *Reform in Sung China: Wang An-shih (1021–1086) and His New Politics.* Harvard East Asian Studies 3. Cambridge, Mass.: Harvard University Press, 1959.

Liu Shih. "Huang T'ing-chien tsai Si-ch'uan ch'uang-tso te san chien shu-fa tso-p'in chien-hsi" (Huang T'ing-chien's Calligraphy from his Szechwan Exile). *Si-ch'uan wen-wu* (Cultural Relics from Szechwan), no. 6 (1988): 38–40.

Liu T'ao, ed. *Wang Hsi-chih, Wang Hsien-chih.* Vols. 18 and 19 in the series *Chung-kuo shu-fa ch'üan-chi.* Peking: Jung-pao-chai, 1991.

Lovell, Hin-cheung. *An Annotated Bibliography of Chinese Painting Catalogues and Related Texts.* Michigan Papers in Chinese Studies 16. Ann Arbor: Center for Chinese Studies, University of Michigan, 1973.

Lu Fu-sheng. *Shu-fa sheng-t'ai lun* (Theoretical Discourses on Chinese Calligraphy). Hangchow: Che-chiang mei-shu hsüeh-yüan ch'u-pan-she, 1992.

Ma Kuo-ch'üan, ed. *Shu-p'u i-chu* (Translation and Annotations of Sun Kuo-t'ing's *Shu-p'u*). Shanghai: Shang-hai shu-hua ch'u-pan-she, 1980.

Ma Tsung-huo, ed. *Shu-lin chi-shih* (Records of Calligraphers). Peking: Wen-wu ch'u-pan-she, 1984.

———. *Shu-lin tsao-chien* (Critiques on Calligraphy). 1936. Reprint, Taipei: Shang-wu yin-shu-kuan, 1982.

McNair, Amy. "Engraved Calligraphy in China: Recension and Reception." *Art Bulletin* 77, no. 1 (March 1995): 106–14.

———. "The Engraved Model-Letters Compendia of the Song Dynasty." *Journal of the Americal Oriental Society* 114, no. 2 (April-June 1994): 209–25.

———. "Public Values in Calligraphy and Orthography in the Tang Dynasty." *Monumenta Serica* 43 (1995): 263–78.

———. "Su Shih's Copy of the *Letter on the Controversy over Seating Protocol.*" *Archives of Asian Art* 43 (1990): 38–48.

———. *The Upright Brush: Yan Zhenqing's Calligraphy and Song Literati Politics.* Honolulu: University of Hawaii Press, 1998.

Mei-shu ts'ung-shu (Compilation of Books on Fine Art). Comp. Teng Shih and Huang Pin-hung, 1912–36. Reprint, Peking: Kuo-chi wen-hua ch'u-pan-she, 1993.

Mi Fu. *Hai-yüeh ming-yen* (Famous Sayings of Mi Fu). In *I-shu ts'ung-pien,* vol. 2.

———. *Hai-yüeh t'i-pa* (Colophons by Mi Fu). In *I-shu ts'ung-pien,* part 1, vol. 22.

———. *Pao Chin ying-kuang chi* (Collections of Treasuring the Chin and the Brilliant Lights). Taipei: Hsüeh-sheng shu-chü, 1971.

———. *Pao-chang tai-fang lu* (Catalogue of Treasured Calligraphies). In *I-shu ts'ung-pien,* part 1, vol. 2.

———. *Shu shih* (History of Calligraphy). In *I-shu ts'ung-pien,* vol. 2.

Mo Chia-liang (Harold Mok). "Chung-kuo i-shu-shih yen-chiu fang-fa chü yü—Lun K'ang Yu-wei 'T'ien-ch'ing lien'" (A Case Study in Methodology of Chinese Art History: K'ang Yu-wei's "T'ien-ch'ing lien") *Mei-shu chiao-yü* (Art Education), 1997: 77–80.

———. "Ming-tai chung-ch'i shu-fa—Pei-Sung ch'uan-t'ung te hui-kuei" (Calligraphy of the Mid Ming Period—A Return to Northern Sung Traditions). *Chung-kuo wen-wu shih-chieh* (Art of China) 116 (April 1995): 76–86.

———. "Sung-tai k'uang-ts'ao te pien-ko" (The Changes in Wild-Cursive Calligraphy of the Sung Dynasty). In *1997 nien shu-fa lun-wen hsüan-chi* (Collected Essays on Calligraphy, 1997), 1–21. Taipei: T'ai-pei Hsing-cheng-yüan wen-hua chien-she wei-yüan-hui, Chung-hua min-kuo shu-fa chiao-yü hsüeh-hui, 1998.

Mok, Harold (Mo Chia-liang). "New Approaches in the Study of Southern Song Calligraphy." Paper presented at "New Studies in Chinese Art and Antiquities: An International Symposium," November 23, 1996, Art Museum and Friends of the Art Museum, The Chinese University of Hong Kong.

———. "Zhao Mengjian and Southern Song Calligraphy." D. Phil. thesis, University of Oxford, 1993.

Mote, Frederick W. "The Oldest Chinese Book at Princeton." *Gest Library Journal* 1, no. 1 (Winter 1986): 34–44.

———, and Hung-lam Chu et al. *Calligraphy and the East Asian Book. Gest Library Journal* 2, no. 2 (Spring 1988). Special catalogue issue.

Murck, Alfreda, and Wen C. Fong, eds. *Words and Images: Chinese Poetry, Calligraphy, and Painting.* New York and Princeton: The Metropolitan Museum of Art and Princeton University Press, 1991.

Murck, Christian F. "Chu Yün-ming (1461–1527) and Cultural Commitment in Su-chou." Ph.D. diss., Princeton University, 1978.

———, ed. *Artists and Traditions: Uses of the Past in Chinese Culture.* Princeton: The Art Museum, Princeton University, 1976.

Murray, Julia K. *Ma Hezhi and the Illustration of the Book of Odes.* Cambridge and New York: Cambridge University Press, 1993.

Nakamura Shigeo. *Chūgoku garon no tenkai: Shin Tō Sō no hen* (An Explanation of Chinese Painting Theory: Chin, T'ang, and Sung). Kyoto: Nakayama bunkadō, 1965.

Nakata Yūjirō. *Bei Futsu* (Mi Fu). 2 vols. Tokyo: Nigensha, 1982.

———. "Calligraphic Styles and Poetry Handscrolls: Mi Fu's *Sailing on the Wu River.*" In Murck and Fong, eds., *Words and Images,* 91–106.

———. *Chinese Calligraphy: A History of the Art of China*. Trans. Jeffrey Hunter. New York, Tokyo, Kyoto: Weatherhill and Tankosha, 1982.

———. *Chūgoku no shohinron* (Discussion of the Grading of Chinese Calligraphy). In idem, *Chūgoku shoron shu* (Collected Essays on Chinese Calligraphy). Tokyo: Nigensha, 1971.

———, ed. *Chūgoku shoron taikei* (Compendium of Essays on Chinese Calligraphy). 18 vols. Tokyo: Nigensha, 1977–92.

———. "Hōsho daibatsu no reikishi" (The History of Colophons). In Nakata and Fu, eds., *Ōbei shūzō Chūgoku hōsho meisekishū*, 1: 115–22.

———. "Mindai no hōjō" (Model Calligraphies of the Ming Dynasty). In *Shodō zenshū*, n. s., 17: 19–27.

———. *Ō Gishi no chūshin to suru hōjō no kenkyū* (A Study of the Calligraphy of Wang Hsi-chih). Tokyo: Nigensha, 1970.

——— and Fu Shen, eds. *Ōbei shūzō Chūgoku hōsho meisekishū* (Masterpieces of Chinese Calligraphy in American and European Collections). 6 vols. Tokyo: Chūōkōron-sha, 1981–83.

Nivison, David S. "A Neo-Confucian Visionary: Ou-yang Hsiu." In James T. C. Liu and Peter J. Golas, eds., *Change in Sung China: Innovation or Tradition?* Lexington, Mass.: D. C. Heath, 1969.

Ou-yang Hsün. *Ou-yang Shuai-keng shu san-shih-liu fa* (Thirty-six Methods of Calligraphy Taught by Ou-yang Hsün). In *P'ei-wen-chai shu-hua-p'u, chüan* 3: 41–46.

Owen, Stephen, ed. and trans. *An Anthology of Chinese Literature*. New York: Norton and Co., 1996.

———. *Readings in Chinese Literary Thought*. Cambridge, Mass.: Harvard University Press, 1992.

Pei-ch'ao mo-yai k'o-ching yen-chiu (A Study of Cliff Carvings of Sūtras of the Northern Dynasties). Comp. Chung-kuo shu-fa hsieh-hui Shan-tung fen-hui and Shan-tung shih-k'o i-shu po-wu-kuan. Chi-nan: Ch'i-lu shu-she, 1991.

P'ei Kuo-ch'ang, ed. *Chung-kuo ying-lien hsüeh* (A Study of Chinese Couplets). Nanking: Chiang-su ku-chi ch'u-pan-she, 1989.

P'ei-wen-chai shu-hua-p'u (Encyclopedic Compilation of Writings on Calligraphy and Painting of the P'ei-wen Studio). Comp. Wang Yüan-ch'i et al. Peking, 1708. Reprint, Taipei: Hsin-hsing shu-chü yu-hsien kung-ssu, 1972.

Pelliot, Paul. "Le Ts'ien Tseu Wen ou 'Livre des Milles Mots.'" *T'oung Pao* 24 (1926): 179–214.

Pien Yung-yü, comp. *Shih-ku-t'ang shu-hua hui-k'ao* (Compilation of Writings on Calligraphy and Painting from the Shih-ku Hall). Preface dated 1682. Reprint of the 1921 facsimile, Taipei: Cheng-chung shu-chü, 1958.

Powers, Martin J. "Discourses of Representation in Tenth-and-Eleventh-Century China." In *The Art of Interpretation*. Papers in Art History from the Pennsylvania State University 8. University Park: Pennsylvania State University, 1995.

Proser, Adriana G. "Moral Characters: Calligraphy and Bureaucracy in Han China (206 B.C.E.–C.E. 220)." Ph.D. diss., Columbia University, 1995.

Qi Gong (see also Ch'i Kung). "The Relationships between Poetry, Calligraphy, and Painting." In Murck and Fong, eds., *Words and Images*, 11–20.

Riely, Celia Carrington. "Tung Ch'i-ch'ang's Life (1555–1636)." In Wai-kam Ho, ed., *The Century of Tung Ch'i-ch'ang*, 2: 387–457.

Ruitenbeek, Klaas. *Carpentry and Building in Late Imperial China: A Study of the Fifteenth-Century Carpenter's Manual 'Lu Ban Jing.'* Leiden: E. J. Brill, 1993.

San-hsi-t'ang fa-t'ieh (Model Calligraphies from the Hall of Three Rarities [Selected from the Imperial Collection of the Ch'ien-lung Emperor, Supervised by Liang shih-cheng, 1747–55]). 36 vols. Reprint, Shanghai: Chung-hua t'u-shu-kuan, 1909?

Seiran hirin shodō geijutsu (The Calligraphy of the Forest of Stelae in Hsi-an). Tokyo: Kodansha, 1979.

Shan-hsi li-tai pei-shih hsüan-chi (A Selection of Stone Stelae in Shensi). Sian: Shan-hsi jen-min ch'u-pan-she, 1979.

Shan-tung-sheng po-wu-kuan. "Fa-chüeh Chu Tan mu chi-shih" (A Discovery of the Tomb of Chu Tan). *Wen-wu*, no. 5 (1972): 2–8.

Shang-hai po-wu-kuan. *Shang-hai po-wu-kuan ts'ang li-tai fa-shu hsüan-chi* (A Selection of Calligraphy in the Collection of the Shanghai Museum). 20 vols. Peking: Wen-wu ch'u-pan-she, 1964.

She Cheng. "*Ch'ien-tzu wen*: Ku-tai te tzu-t'ieh ho chiao-k'o shu" (The *Thousand Character Essay*: A Model of Calligraphy and Textbook in Ancient China). Parts 1 and 2, *Ku-kung wen-wu yüeh-k'an* 1, no. 9 (Dec. 1983): 57–61; and 1, no. 10 (Jan. 1984): 91–95.

———. "Ts'ung ko-jen feng-ko lai t'an-t'ai i chien wei Su Shih shu-fa" (Examination of a Forgery after Su Shih's Calligraphy from the Perspective of Individual Style). In *Proceedings of the International Colloquium on Chinese Art History, 1991. Painting and Calligraphy*, part 2: 627–60. Taipei: National Palace Museum, 1992.

Shih-ch'ü pao-chi ch'u-pien (Treasured Boxes of the Stony Moat [Catalogue of Painting and Calligraphy in the Ch'ien-lung Imperial Collection]). Comp. Chang Chao et al. 2 vols. 1745. Facsimile reprint of an original manuscript copy, Taipei: National Palace Museum, 1971.

Shih-ch'ü pao-chi hsü pien (Sequel to *Shih-ch'ü pao-chi*). Comp. Wang Chieh et al. 7 vols. 1793. Facsimile reprint, Taipei: National Palace Museum, 1971.

Shih-ch'ü pao-chi san-pien (*Shih-ch'ü pao-chi*, part 3). Comp. Hu Ching et al. 10 vols. 1817. Facsimile reprint, Taipei: National Palace Museum, 1971.

Shih, Shou-chien. "The Eremitic Landscapes of Ch'ien Hsüan (ca. 1235–before 1307)." Ph.D. diss., Princeton University, 1984.

———. *Feng-ko yü shih-pien: Chung-kuo hui-hua shih lun-chi* (Style and Historical Changes: Essays on the History of Chinese Painting). Taipei: Yün-ch'en wen-hua, 1996.

Shih, Vincent Yu-chung, trans. *The Literary Mind and the Carving of Dragons by Liu Hsieh*. New York: Columbia University Press, 1959.

Shimizu, Yoshiaki. "Transmission and Transformation, Chinese Calligraphy and Japanese Calligraphy." In J. Thomas Rimer, ed., *Multiple Meanings: The Written Word in Japan—Past, Present, Future*. Washington, D.C.: Library of Congress, 1986.

Shodō geijutsu (The Art of Chinese and Japanese Calligraphy). 24 vols. Tokyo: Chūōkōron-sha, 1970–73.

Shodō zenshū (Compilation of Chinese and Japanese Calligraphy). Ed. Kanda Kiichirō, Shimonaka Kunihiko, et al. New series. 28 vols. Tokyo: Heibonsha, 1954–68.

Shodō zenshū (Compilation of Chinese and Japanese Calligraphy). Ed. Shimonaka Yasaburō et al. Old series. 27 vols. Tokyo: Heibonsha, 1930–32.

Shoseki meihin sōkan (Series of Masterpieces of Calligraphy). 208 vols. Tokyo: Nigensha, 1958–90.

Sickman, Laurence. *Chinese Calligraphy and Painting in the Collection of John M. Crawford, Jr.* New York: Pierpont Morgan Library, 1962.

Ssu-k'u ch'üan-shu (Comprehensive Library of the Four Treasuries). See *Ying-yin Wen-yüan-ko Ssu-k'u ch'üan-shu*.

Sturman, Peter C. "Calligraphy." In Howard Rogers, gen. ed., *5000 Years of Innovation and Transformation in the Arts*, 159–70. New York: The Solomon R. Guggenheim Foundation; and Peking: Art Exhibitors, 1998.

———. (Shih Man). "K'o-chin hsiao-tao te Mi Yu-jen—Lun ch'i tui fu-ch'in Mi Fu shu chi te sou-chi chi Mi Fu shu-chi tui Kao-tsung ch'ao-t'ing te ying-hsiang" (Mi Yu-jen as Filial Son—Notes on the Collection of Mi Fu's Calligraphy and Its Influence at Sung Kao-tsung's Court). *Ku-kung hsüeh-shu chi-k'an* 9, no. 4 (July 1992): 89–126.

———. *Mi Fu: Style and the Art of Calligraphy in Northern Song China*. New Haven: Yale University Press, 1997.

———. "Mi Youren and the Inherited Literati Tradition." Ph.D. diss., Yale University, 1989.

———. "The 'Thousand Character Essay' Attributed to Huaisu and the Tradition of Kuangcao Calligraphy." *Orientations* 25, no. 4 (April 1994): 38–46.

Su Shih. *Tung-p'o t'i-pa* (Colophons by Su Shih). In *I-shu ts'ung-pien*, vol. 22. Taipei: Shih-chieh shu-chü, 1962.

Sugimura Kunikiho. "Sho no seisei to hyōron" (The Development and Criticism of Calligraphy). *Tokyo kenkyū* (Tokyo Research) 25, no. 2 (Sept. 1966): 35–65.

Sullivan, Michael. *The Three Perfections: Chinese Painting, Poetry, and Calligraphy*. The Walter Neurath Memorial Lectures. London: Thames and Hudson, 1974.

Sun Kuo-t'ing. *Shu-p'u* (Manual on Calligraphy). 687. In *Shoseki meihin sōkan*, no. 25.

Sun Ta-yü. "On the Fine Art of Chinese Calligraphy." *T'ien Hsia Monthly* (Sept. 1935): 192–207.

Suzuki Kei, comp. *Chūgoku kaiga sōgō zuroku* (Comprehensive Illustrated Catalogue of Chinese Paintings). 5 vols. Tokyo: University of Tokyo Press, 1982–83.

Szathmary, Arthur. "Symbolic and Aesthetic Expression in Painting." *Journal of Aesthetics and Art Criticism* 8, no. 1 (Sept. 1954): 86–96.

Tao-te ching. See Henricks, Robert G., trans.

T'ao Tsung-i. *Shu-shih hui-yao* (Essential References on Calligraphy). In *Ying-yin Wen-yüan-ko Ssu-k'u ch'üan-shu*, 814: 785–91.

Teng Ch'un. *Hua-chi* (A Continuation of the History of Painting). Preface dated 1167. In *Hua-shih ts'ung-shu*, vol. 1.

Tokiwa Daijo and Sekino Tadashi. *Shina bunka shiseki* (The Culture of Chinese Calligraphy). 12 vols. Tokyo: Hozokan, 1939–41.

Ts'ai Yung, attributed to. *Yün Pi-lun shu* (A Discourse on the Use of the Brush). Late 2d century. In *P'ei-wen chai shu-hua-p'u* (Encyclopedic Compilation of Writings on Calligraphy and Painting of the P'ei-wen Studio), comp. Wang Yüan-ch'i et al., vol. 5, no. 1. Peking, 1708. Reprint, Taipei: Hsin-hsing shu-chü yu-hsien kung-ssu, 1972.

Tseng Yuho (See also Tseng Yu-ho Ecke). *A History of Chinese Calligraphy*. Hong Kong: Chinese University Press, 1993.

Ts'ui Erh-p'ing, comp. and annot. *Ming Ch'ing shu-fa lun wen-hsüan* (Collection of Essays on Chinese Calligraphy of the Ming and Ch'ing Dynasties). Shanghai: Shang-hai shu-tien, 1994.

Ts'ui Erh-p'ing, ed. *Li-tai shu-fa lun-wen hsüan hsü-pien* (Sequel to *A Collection of Essays on Chinese Calligraphy*). Shanghai: Shang-hai shu-hua ch'u-pan-she, 1993.

Tsung Tien. *K'o Chiu-ssu shih-liao* (Historical Source Materials on K'o Chiu-ssu). Shanghai: Shang-hai jen-min mei-shu ch'u-pan-she, 1985.

Tung Ch'i-ch'ang. *Hua-ch'an-shih sui-pi* (Miscellaneous Notes of the Hua-ch'an Studio). In *I-shu ts'ung-pien* (Collected Works on Chinese Art). Taipei: Shih-chieh shu-chü, 1962.

———. *Jung-t'ai chi* (The Collected Works of Tung Ch'i-ch'ang). Preface dated 1630. 4 vols. Reprint, Taipei: Kuo-li chung-yang t'u-shu-kuan, 1968.

Tung Tso-pin. *Chia-ku hsüeh wu-shih nien*. Taipei: Ta-lu tsa-chih, 1955. Translation: *Fifty Years of Studies in Oracle Inscription*. Tokyo: Centre for East Asian Cultural Studies. 1964.

Tung Yu. *Kuang-ch'uan shu-pa* (Colophons on Calligraphy by Tung Yu). 12th century. In *Ts'ung-shu chi-ch'eng ch'u-pien* (Encyclopaedic Compendium). Shanghai: Shang-wu yin-shu-kuan, 1936.

van Gulik, Robert H. *Chinese Pictorial Art as Viewed by the Connoisseur*. Rome: Instituto Italiano per il Medio ed Estremo Oriente, 1958.

Vandier-Nicolas, Nicole. *Le Houa-che de Mi Fou*. Paris: Presses Universitaires de France, 1964.

Wang Fang-yu. "Li-tai chang-ts'ao te fa-chan" and Eng. trans. "The Historical Development of Chang-ts'ao." In *Chung-kuo shu-fa kuo-chi hsüeh-shu yen-t'ao-hui*, 211–48.

Wang K'o-yü. *Shan-hu wang ming hua t'i-pa* and *Shan-hu wang fa-shu t'i-pa* (Postscripts on Famous Calligraphy and Painting). 1643. 16 vols. Reprint, Peking: Wen-wu ch'u-pan-she, 1992.

Wang Lien-ch'i. "Chao Meng-fu lin-pa *Lan-t'ing-hsü* k'ao" (A Study of Chao Meng-fu's Copy of and Colophons on the *Orchid Pavilion Preface*). Parts 1 and 2. *Ku-kung po-wu-yüan yüan-k'an* (Palace Museum Journal) 1 (1985): 36–47; 2 (1985): 60–70.

———. "Chao Meng-fu wei ch'i tai-pi" (Chao Meng-fu as Calligrapher for his wife). *Tzu-chin-ch'eng* (Forbidden City) 23, no. 1 (1984): 42–43.

Wang Nan-p'ing, ed. *Ming Ch'ing shu-hua hsüan-chi* (Selection of Calligraphy and Painting of the Ming and Ch'ing Dynasties). Hong Kong: Nan-hua yin-shua yu-hsien kung-ssu, 1975.

Wang Qingzheng. "The Arts of Ming Woodblock-Printed Images and Decorated Papers." In Watt and Li, eds., *The Chinese Scholar's Studio*, 56–61.

Wang To. *Ni-shan-yüan chi* (Collected Writings of Wang To). 1653.

Wang Yün. *Shu-hua mu-lu* (Catalogue of Calligraphy and Painting). Preface dated 1276. In Yang Chia-lo, *Shu-hua lu* (Catalogue of Calligraphy and Painting). In *Chung-kuo hsüeh-shu ming-chu* (Reprints of Famous Works on Chinese Learning). Taipei: Shih-chieh shu-chü, 1968–71. Also in *Mei-shu ts'ung-shu* (Compilation of Books on Fine Art), vol. 18, IV/6. Taipei: Kuang-wen shu-chü, 1963.

Watt, James C. Y. and Chu-tsing Li, eds. *The Chinese Scholar's Studio: Artistic Life in the Late Ming Period*. Exhib. cat. New York: The Asia Society Galleries, 1987.

Wei Heng. "Ssu t'i shu-shih" (History of the Four Script Types). In Huang Chien, ed., *Li-tai shu-fa lun-wen hsüan* (Collection of Essays on Chinese Calligraphy), 1: 11–17. Shanghai: Shang-hai shu-hua ch'u-pan-she, 1979.

Wen Chia. *Ch'ien-shan-t'ang shu-hua chi* (The Record of Calligraphy and Paintings in the Ch'ien-shan Studio). Preface dated 1569. In *Mei-shu ts'ung-shu* (Compilation of Books on Fine Art), vol. 8, II/6. Taipei: Kuang-wen shu-chü, 1963.

Weng, Wango. *Chinese Painting and Calligraphy: A Pictorial Survey*. New York: Dover Publications, Inc., 1978.

———, and Yang Boda. *The Palace Museum: Treasure of the Forbidden City*. New York: Harry N. Abrams, 1982.

Willetts, William. *Chinese Calligraphy: Its History and Aesthetic Motivation*. Oxford: Oxford University Press, 1981.

Wixted, John Timothy. "The Nature of Evaluation in the 'Shih-p'in' (Gradings of Poets) by Chung Hung (A.D. 469–518)." In Bush and Murck, eds., *Theories of the Arts in China*, 225–64.

Wo Hsing-hua. *Tun-huang shu-fa i-shu* (Calligraphy at Tun-huang). Shanghai: Shang-hai jen-min ch'u-pan-she, 1994.

Wong, Kwan S. *Masterpieces of Sung and Yüan Dynasty Calligraphy from the John M. Crawford Jr. Collection*. Exhib. cat. New York: China House Gallery, 1981.

Wong-Gleysteen, Marilyn. "Calligraphy and Painting: Some Sung and Post-Sung Parallels in North and South—A Reassessment of the Chiang-nan Tradition." In Murck and Fong, eds., *Words and Images*, 141–72.

Wright, Suzanne. "Social Identity and Visual Communication in Woodblock-Print Letter Papers of the Late Ming Dynasty." Ph.D. diss., Stanford University, forthcoming.

Wu, Nelson. "Tung Ch'i-ch'ang: Apathy and Government Fervor in Art." In Arthur F. Wright and Denis Twitchett, eds., *Confucian Personalities*, 260–93. Stanford: Stanford University Press, 1960.

Xu Bangda (see also Hsü Pang-ta). "Tung Ch'i-ch'ang's Calligraphy." In Wai-kam Ho, ed., *The Century of Tung Chi-ch'ang, 1555–1636*, 1: 105–32.

Xue Yongnian (Hsüeh Yung-nien). "Declining the Morning Blossom and Inspiring the Evening Bud: The Theory and Practice of Tung Ch'i-ch'ang's Calligraphy." In *Proceedings of the Tung Ch'i-ch'ang International Symposium*. Kansas City, Mo.: Nelson Atkins Museum of Art, 1991.

Yang Chia-lo, ed. *Ch'ing jen shu-hsüeh lun-chu* (Theories of Calligraphy from the Ch'ing Dynasty). 1962. Reprint, Taipei: Shih-chieh shu-chü, 1966.

———. *Ming jen shu-hsüeh lun-chu* (Theories of Calligraphy from the Ming Dynasty). 1962. Reprint, Taipei: Shih-chieh shu-chü, 1966.

———. *Sung Yüan jen shu-hsüeh lun-chu* (Theories of Calligraphy from the Sung and Yüan Dynasties). 1962. Reprint, Taipei: Shih-chieh shu-chü, 1972.

———. *T'ang jen shu-hsüeh lun-chu* (Theories of Calligraphy from the T'ang Dynasty). 1962. Reprint, Taipei: Shih-chieh shu-chü, 1972.

Yang Hsin. *Ku-lai neng-shu jen-min* (Gathering of Capable Calligraphers' Names Since Ancient Times). In Huang Chien, ed., *Li-tai shu-fa lun-wen hsüan*, 1: 47.

Yang Jen-k'ai and Hsüeh Yung-nien. *Chung-kuo shu hua* (Chinese Painting and Calligraphy). 1st ed. Shanghai: Shang-hai ku-chi ch'u-pan-she, 1990.

Yang Renkai (see also Yang Jen-k'ai). "Masterpieces by Three Calligraphers: Huang T'ing-chien, Yeh-lü Ch'u-ts'ai, and Chao Meng-fu." In Murck and Fong, eds., *Words and Images*, 21–44.

Yin Sun, ed. *Chung-kuo shu-fa-shih t'u-lu* (Illustrated History of Chinese Calligraphy). Shanghai: Shang-hai shu-hua ch'u-pan-she, 1989.

Ying-yin Wen-yüan-ko Ssu-k'u ch'üan-shu (Facsimile reproduction of the Wen-yüan-ko Hall *Comprehensive Library of the Four Treasuries*). Comp. 1782. 1500 vols. Reproduced facsimile reprint, Taipei: Shang-wu yin-shu-kuan, 1983–86.

Yü An-lan, comp. *Hua-shih ts'ung-shu* (Compendium of Painting Histories). 10 vols. Shanghai: Jen-min mei-shu ch'u-pan-she, 1963. Reprint, Taipei: Wen-shih-che ch'u-pan-she, 1974.

Yü Chien-hua, ed. *Chung-kuo hua-lun lei-pien* (Classified Compilation of Writings on Chinese Painting Theories). Hong Kong: Chung-hua shu-chü, 1973.

Yü Chien-wu. *Shu-p'in* (Gradings of Calligraphers). 6th century. In Chang Yen-yüan, *Fa-shu yao-lu* (*I-shu ts'ung-pien* ed.) 2: 26–32.

Yü Ho. *Lun-shu piao* (A Memorial on Calligraphy). In Huang Chien, ed., *Li-tai shu-fa lun-wen hsüan,* 1: 50–54.

Yü Shao-sung. *Shu-hua shu lu chieh-t'i* (Annotated Bibliography of Books on Chinese Calligraphy and Painting). Peiping: Kuo-li Pei-p'ing t'u-shu-kuan, 1932.

Yü Ying-shih. "Individualism and the Neo-Taoist Movement in Wei-Chin China." In Donald J. Munro, ed., *Individualism and Holism: Studies in Confucian and Taoist Values,* 121–55. Ann Arbor: Center for Chinese Studies, University of Michigan, 1985.

Zhang Yiguo. *Brushed Voices: Calligraphy in Contemporary China.* Exhib. cat. New York: Miriam and Ira D. Wallach Art Gallery, Columbia University, 1998.

The John B. Elliott Collection of Chinese Calligraphy and Painting, The Art Museum, Princeton University

All works are arranged in chronological order and, unless noted, are the bequest of John B. Elliott.

So Tan (ca. 250–ca. 325), Wu Kingdom
Tao-te ching, chapters 51–81, dated 270
Handscroll (fragment), ink on sutra paper
Calligraphy, 30.8 x 208.2 cm; colophons, 30.8 x 524.4 cm
1998-116 (cat. no. 1)

Wang Hsi-chih (303–361), Eastern Chin dynasty
Ritual to Pray for Good Harvest (Hsing-jang t'ieh),
T'ang dynasty tracing copy
Letter mounted as a handscroll, ink on *ying-huang* paper
Calligraphy, letter alone, 24.4 x 8.9 cm;
entire scroll, 30.0 x 372.0 cm
1998-140 (cat. no. 2)

Wang Hsi-chih (303–361), Eastern Chin dynasty
Ritual to Pray for Good Harvest (Hsing-jang t'ieh), 1962 copies
Pair of handscrolls
 a. Photomechanical facsimile reproduction
 b. Ink rubbing on paper
1998-50 a–b

Ching K'o (fl. ca. 650–83), T'ang dynasty
Epitaph for the Layman Wang, dated 658
Album of 15 leaves, ink rubbing on paper
Calligraphy, 9 leaves, each leaf, 19.5 x 9.4 cm;
colophons, 6 leaves
1998-139 (cat. no. 3)

Anonymous (7th century), T'ang dynasty
Mahāprajñāpāramitā Sūtra (Ta-pan-jo po-lo-mi-to ching),
chapter 329, dated 674
Handscroll, ink on sutra paper
Calligraphy, 25.7 x 701.3 cm
 Front illustration:
 Anonymous
 Image of Samantabhadra
 Ink and colors on paper
 25.7 x 21.7 cm
1998-109 (cat. no. 4)

Chung Shao-ching (fl. early 8th century),
T'ang dynasty, attributed
Sammatiya-nikāya Treatise (San-mi-ti-pu-lun)

Handscroll, ink on sutra paper
Calligraphy, 22.3 x 560.8 cm; colophons, 28.4 x 170.3 cm
 Front illustration:
 Li Kung-lin (ca. 1041–1106),
 Northern Sung dynasty, attributed
 Sixteen Lohans, 14th century
 Ink on paper, 29.9 x 201.3 cm
1998-120 a–b

Anonymous (8th–9th century), T'ang dynasty *Mahāprajñā-pāramitā Sūtra (Mo-ho po-jo p'o-lo-mi ching)*, chapters 73–74
Pair of handscrolls, ink on sutra paper
 a. Frontispiece, 26.9 x 81.0 cm;
 calligraphy, 27.3 x 92.6 cm; colophons
 b. Frontispiece, 19.3 x 17.9 cm;
 calligraphy, 27.7 x 418.5 cm; colophons, 27.7 x 237.5 cm
1998-123 a–b

Anonymous (9th century), T'ang dynasty
Dhāraṇī Pillar Inscribed with Buddhas and the "Uṣṇīṣa-vijaya Dhāraṇī" (Fo-ting tsun-sheng to-lo-ni ching), dated 878
 a. Inscribed stone pillar
 Height 124.5, base diameter 27.9 cm
 b. Ink rubbing on paper, 98.1 x 92.2 cm
Gift of James J. Freeman in honor of John B. Elliott
1995-115 a–b (cat. no. 5)

Huang T'ing-chien (1045–1105), Northern Sung dynasty
Scroll for Chang Ta-t'ung, dated 1100
Handscroll, ink on paper
Calligraphy, 34.1 x 552.9 cm
Gift of John B. Elliott
1992-22 (cat. no. 6)

Mi Fu (1052–1107) , Northern Sung dynasty
Three Letters, ca. 1093–94
Album of 3 leaves, ink on paper
 Calligraphy
 a. *Abundant Harvest*
 31.7 x 33.0 cm
 b. *Escaping Summer Heat*
 30.9 x 40.6 cm
 c. *Hasty Reply before Guests*
 31.7 x 39.7 cm
1998-51 a–c (cat. no. 7)

Emperor Kao-tsung (1107–1187, reigned 1127–62),
Southern Sung dynasty
Quatrain on an Autumn Fan
Fan mounted as an album leaf, ink on silk
Calligraphy, 24.6 x 23.3 cm
1998-75 a (cat. no. 8)

Yang Mei-tzu (Empress Yang, 1162–1232),
Southern Sung dynasty
Quatrain on Autumn
Album leaf, ink on silk
Calligraphy, 25.4 x 27.4 cm
1998-75 b (cat. no. 9)

Anonymous (12th or early 13th century),
Southern Sung dynasty
White-Robed Kuan-yin on a Rock,
with a 1208 inscription by Shih-ch'iao K'o-hsüan
Hanging scroll, ink on silk
Painting, 77.5 x 37.0 cm
1998-143

Chang Chi-chih (1186–1266), Southern Sung dynasty
Diamond Sutra (Chin-kang ching), dated 1246
Album of 128 leaves and 54 leaves of colophons, ink on paper
Calligraphy, each leaf, 29.1 x 13.4 cm
1998-52 (cat. no. 10)

Chao Meng-fu (1254–1322), Yüan dynasty
Record of the Miao-yen Monastery
(Hu-chou Miao-yen-ssu chi), ca. 1309–1310
Handscroll, ink on paper
Calligraphy, 34.2 x 364.5 cm; colophons, 34.2 x 206.7 cm
1998-53 (cat. no. 11)

Chao Meng-fu (1254–1322) et al.
Collected Letters of the Chao Meng-fu Family
Six letters mounted as a handscroll, ink on paper
 Calligraphy
 a. Chao Meng-fu
 Letter to Chung-feng Ming-pen, dated 1321
 29.5 x 50.2 cm
 b. Chao Meng-fu
 Letter to Shu Chi-po, after 1310
 27.7 x 49.6 cm
 c. Kuan Tao-sheng (1262–1319; wife), author;
 Chao Meng-fu (1254–1322), calligrapher
 Letter to a Relative, after 1310
 29.0 x 49.7 cm
 d. Chao Yung (1290–ca. 1362; son)
 Letter to Kao Su, after 1330
 32.6 x 61.8 cm
 e. Chao Yung
 Letter to Kao Su, after 1330
 30.0 x 51.9 cm
 f. Chao Yu-hsi (fl. late 13th–early 14th century; daughter)
 Letter to Ch'iang Wen-shih, dated 1319
 28.3 x 42.4 cm
 1998-54 a–f (cat. no. 12)

Chao Meng-fu (1254–1322), Yüan dynasty
Quatrain in Running Script
Oval fan mounted as an album leaf, ink on silk
Calligraphy, 26.6 x 21.8 cm
1998-75 c

Chao Meng-fu (1254–1322), Yüan dynasty, attributed
Nymph of the Lo River (Lo-shen fu)
Handscroll, ink on paper
Calligraphy, 25.8 x 234.5 cm
1998-118

Anonymous (13th–14th century), Yüan dynasty
Palace by a Lake
Hanging scroll, ink on silk
Painting, 36.0 x 31.9 cm
1998-121

Chang Yen (fl. early 14th century), Yüan dynasty
On Viewing Calligraphy by Su Shih, after 1303
Album leaf, ink on silk
Calligraphy, 28.0 x 26.8 cm
1998-75 d

Wang Ying-kao (unknown), Yüan dynasty
Poem on Chao Meng-fu's Calligraphy
Album leaf, ink on paper
Calligraphy, 35.8 x 26.8 cm
1998-75 e

Hsien-yü Shu (ca. 1257–1302), Yüan dynasty
Admonitions to the Imperial Censors (Yü-shih chen), dated 1299
Handscroll, ink on paper
Calligraphy, 50.1 x 409.6 cm
1998-49 (cat. no. 13)

Hsien-yü Shu (ca. 1257–1302), Yüan dynasty, copy
Copy of Hsien-yü Shu's "Admonitions to the Imperial Censors"
(Yü-shih chen kou-mo pen), 20th-century copy
Handscroll, ink on paper
Calligraphy, 49.5 x 761.3 cm
1998-105

K'o Chiu-ssu (1290–1343), Yüan dynasty
Palace Poems (Shang-ching kung-tz'u)
Handscroll, ink on paper
Calligraphy, 30.5 x 53.0 cm
1998-55 (cat. no. 14)

K'ang-li Nao-nao (1295–1345), Yüan dynasty
Biography of a Carpenter (Tzu-jen chuan), dated 1331
Handscroll, ink on paper
Calligraphy, 27.8 x 281.0 cm
Gift of John B. Elliott in honor of Lucy L. Lo
1985-11 (cat. no. 15)

Yü Ho (1307–1382), Yüan dynasty
Essay on Yüeh I (Yüeh I lun), dated 1360
Handscroll, ink on paper
Calligraphy, 24.7 x 68.5 cm
1998-76 (cat. no. 16)

Wang Feng (1319–1388), Yüan dynasty; and
Huang T'ien (unknown), Ming dynasty
Colophons to Chao Meng-fu's "T'ien-ma t'u"
Album leaf, ink on paper
Calligraphy, 29.3 x 38.0 cm
1998-75 f

Anonymous (14th century), late Yüan to early Ming dynasty
Pear Blossoms and Bird (Li-hua shan-ch'üeh), ca. 1300
Hanging scroll, ink and color on paper
Painting, 91.5 x 30.7 cm
1998-108

Huang T'ien (unknown), Ming dynasty
See Wang Feng (1319–1388), Yüan dynasty; and
Huang T'ien, *Colophons to Chao Meng-fu's "T'ien-ma t'u"*
(q.v., 1998-75 f)

Sung K'o (1327–1387), Ming dynasty
"T'ao Ch'ien's Poems" and "Bamboo and Rocks"
(T'ao Yüan-ming shih, Chu-shih hsiao-ching), dated 1370
Handscroll, ink on paper
Calligraphy, 25.9 x 627.9 cm; painting, 25.9 x 151.0 cm
1998-106

Sung K'o (1327–1387), Ming dynasty
Transcription of Sun Kuo-t'ing's "Manual on Calligraphy," ca. 1370
Album of 14 leaves, ink on yellow-tinted paper
Calligraphy, each leaf, 20.3 x 12.4 cm
1998-124 (cat. no. 18)

Sung K'o (1327–1387), Ming dynasty
Calligraphy
Album leaf, ink on gold-tinted paper
Calligraphy, 34.8 x 35.4 cm
1998-75 g

Shen Tu (1357–1434), Ming dynasty
Proverbs by Chu Hsi (Chu Wen-kung ko-yen)
Album leaf, ink on paper
Calligraphy, 29.4 x 44.1 cm
1998-75 h

Shen Tu (1357–1434), Ming dynasty
See also Shen Ts'an (1379–1453) and Shen Tu, *Collected Poems*
(q.v., 1998-57)

Shen Ts'an (1379–1453) and Shen Tu (1357–1434), Ming dynasty
Collected Poems
Handscroll, ink on paper
Calligraphy, Shen Ts'an, 28.0 x 152.4 cm; Shen Tu, 25.9 x 86.1 cm
1998-57 (cat. no. 19)

Hsia Heng (ca. 1392–1464), Ming dynasty
Two Poems in Clerical Script
Album leaf, ink on ruled paper
Calligraphy, 30.1 x 30.0 cm
1998-75 i

Hsü Yu-chen (1407–1472), Ming dynasty
Colophon for Shen Chou's "Painting of Mount Chia," ca. 1461

Handscroll, ink on paper
Calligraphy, 41.2 x 231.0 cm
1998-142

Yao Shou (1423–1495), Ming dynasty
Poems about Banana Plants, dated 1489
Handscroll, ink on paper
Calligraphy, 30.5 x 781.8 cm
1998-59 (cat. no. 20)

Chang Pi (1425–1487), Ming dynasty
Poem by Wang Wei
Hanging scroll, ink on paper
Calligraphy, 155.4 x 61.5 cm
1998-115 (cat. no. 21)

Shen Chou (1427–1509), Ming dynasty
Visiting Master Yün-feng of the Shui-yün Pavilion
(Fang Shui-yün-t'ing Yün-feng shang-jen), dated 1488
Two folding fans mounted as album leaves, ink on paper
 a. Painting, 31.5 x 67.0 cm
 b. Calligraphy, 32.0 x 67.0 cm
1998-101 a–b

Shen Chou (1427–1509), Ming dynasty
Farewell at a Spring River (Ch'un-chiang sung pieh), dated 1499
Handscroll, ink and color on paper
Painting, 26.0 x 152.3 cm; colophons, 26.9 x 122.5 cm
1998-94

Ch'en Hsien-chang (1428–1500), Ming dynasty
Writing about Plum Blossoms while Ill
(Mei-hua ping-chung tso), dated 1492
Handscroll, ink on paper
Calligraphy, 30.5 x 897.4 cm
Gift of John B. Elliott
1980-43 (cat. no. 22)

Ch'en Hsien-chang (1428–1500), Ming dynasty
Jade-Crown Peak among Clearing Clouds (Yü-mien ch'ing-yün)
Album leaf, ink on paper
Calligraphy, 24.2 x 26.8 cm
1998-75 j

Wu K'uan (1436–1504), Ming dynasty
Essays on Calligraphy
Album of 12 leaves, ink on paper
Calligraphy, each leaf, 28.7 x 14.4 cm
1998-60 (cat. no. 23)

Anonymous (15th century), Ming dynasty
Searching for Demons on Mount Kuan-k'ou
(Kuan-k'ou sou-shan t'u), ca. 1500
Handscroll, ink on silk
Frontispiece, 49.7 x 117.0 cm; painting, 48.4 x 935.9 cm;
colophons, 48.7 x 98.3.0 cm
Gift of John B. Elliott
1982-97

Shih Chung (Hsü Tuan-pen; fl. 1437–ca. 1520), Ming dynasty
Bare Trees and Rocks (K'u-mu shih t'u), 1506
Hanging scroll, ink on paper
Painting, 80.5 x 30.7 cm
Gift of John B. Elliott
1982-98

Chu Yün-ming (1461–1527), Ming dynasty
"Stele for the Filial Daughter Ts'ao O" and
"Prose Poem on the Nymph of the Lo River"
(Hsiao-nü Ts'ao O pei, Lo-shen fu), dated 1507
Album of 13 leaves, ink on paper
Calligraphy, each leaf, 17.1 x 10.6 cm
1998-117 (cat. no. 24)

Chu Yün-ming (1461–1527), Ming dynasty
Flowers of the Seasons, dated 1519
Handscroll, ink on paper
Calligraphy, 45.5 x 1586.5 cm
1998-61

Chu Yün-ming (1461–1527), Ming dynasty
"The Arduous Road to Shu" and "Song of the Immortal"
(Shu tao nan, Huai hsien ko)
Handscroll, ink on paper
Frontispiece by P'u Ju (1896–1963), 29.3 x 92.5 cm;
calligraphy, 29.4 x 510.6 cm
Museum purchase, gift of the Mercer Trust
for the John B. Elliott Collection
1998-148 (cat. no. 25)

Chu Yün-ming (1461–1527)
Epitaph for Madam Han (Tu-ch'a-yüan yu-fu-tu-yü-shih Mao kung
ch'i ch'ien-feng ju-jen Han shih mu-chih-ming), after 1524
Album of 56 leaves, ink on silk strips mounted as an album
Frontispiece of 4 leaves; title of 10 leaves; calligraphy of 22
leaves, each leaf, 26.0 x 12.9 cm; colophons of 20 leaves
1998-141

T'ang Yin (1470–1524), Ming dynasty
Odes to Fallen Flowers (Lo-hua shih), ca. 1505
Album leaves mounted as a handscroll, ink on paper
Calligraphy, 25.1 x 649.2 cm
1998-102 (cat. no. 26)

Wen Cheng-ming (1470–1559), Ming dynasty
Poem on Lake T'ai-yeh
Hanging scroll, ink on paper
Calligraphy, 344.0 x 96.4 cm
1998-98 (cat. no. 27)

Wen Cheng-ming (1470–1559), Ming dynasty, attributed
Collected Poems in Running-Cursive Script
Handscroll (fragment), ink on Sung dynasty sutra paper
Calligraphy, 27.7 x 274.4 cm
1998-122

Wang Shou-jen (Wang Yang-ming, 1472–1529), Ming dynasty
Letters to Cheng Pang-jui, ca. 1523–25
Handscroll, ink on paper

Painting, 24.3 x 43.0 cm; calligraphy, 24.0 x 292.8 cm
Gift of Mrs. Edward L. Elliott
1979-95 (cat. no. 28)

Ch'en Ch'un (1483–1544), Ming dynasty
Narcissus and Plum Blossoms (Mei-hua shui-hsien t'u)
Hanging scroll, ink on paper
Painting, 70.2 x 33.1 cm
1998-97

Wang Ch'ung (1494–1533), Ming dynasty
The Nine Songs (Chiu ko), dated 1527
Handscroll, ink on paper
Calligraphy, 29.1 x 479.0 cm
1998-58 (cat. no. 29)

Wang Ku-hsiang (1501–1568), Ming dynasty
The Thousand Character Essay (Ch'ien-tzu wen), dated 1541
Handscroll, ink on paper
Calligraphy, 23.5 x 329.0 cm
1998-110 (cat. no. 30)

Yang Chi-sheng (1516–1555), Ming dynasty
Poem by Chao Yen-chao
Hanging scroll, ink on paper
Calligraphy, 164.3 x 45.7 cm
1998-66 (cat. no. 31)

Sheng Shih-t'ai (16th century), Ming dynasty
Manuscript of Poems, dated 1559
Album of 23 leaves and 3 leaves of colophons, ink on paper
Calligraphy, each leaf, ca. 30.7 x ca. 17.5 cm
1998-72

Mo Shih-lung (1539–1587), Ming dynasty
Letters (Shou cha)
Handscroll, ink on paper
Calligraphy, 18.8 x 319.8 cm
1998-104

Tung Ch'i-ch'ang (1555–1636), Ming dynasty
Calligraphy in the Styles of the Four Sung Masters
(Fang Su Huang Mi Ts'ai hsing-shu)
Handscroll, ink on paper
Calligraphy, 55.0 x 933.5 cm
1998-114

Tung Ch'i-ch'ang (1555–1636), Ming dynasty
Manuscript
Handscroll, ink on paper
Calligraphy, 25.9 x 367.8 cm
1998-95

Tung Ch'i-ch'ang (1555–1636), Ming dynasty, attributed
"Kuei-t'ien fu" by Chang P'ing-tzu
Handscroll, ink on paper
Calligraphy, 31.9 x 646.2 cm
1998-103

Tung Ch'i-ch'ang (1555–1636), Ming dynasty, attributed
"Prose Poem on Promenading in the Back Garden" and

Transcription of the "Tso-yu-ming" by Hu Huan (993–1059)
Album of 15 leaves with 8 leaves of colophons, ink on paper
Calligraphy, each leaf, 18.8 x 11.1 cm
1998-127

Chang Jui-t'u (1570–1641), Ming dynasty
Ch'ang-an, the Ancient Capital (Ch'ang-an ku-i), dated 1634
Handscroll, ink on paper
Calligraphy, 28.2 x 466.5 cm
1998-100 (cat. no. 32)

Chang Hung (1580–after 1650), Ming dynasty
Landscape Album of Ten Leaves
(Shan-shui ts'e shih cheng), dated 1625
Album of 10 leaves, ink and colors on paper
Painting, each leaf, 30.0 x 30.7 cm
Gift of John B. Elliott
1983-42 a–j

Huang Tao-chou (1585–1646), Ming dynasty
Trees and Bamboo by a Stream (Lin chu hsi liu), dated 1641
Handscroll, ink on paper
Painting, 28.4 x 171.8 cm
1998-68

Huang Tao-chou (1585–1646), Ming dynasty
Poems in a Classical Mode (Ni-ku shih), dated 1645
Handscroll, ink on paper
Calligraphy, 34.6 x 324.5 cm
1998-107

Huang Tao-chou (1585–1646) and Ni Yüan-lu (1593–1644),
Ming dynasty
Letters and Commentary
Two albums, ink on paper
 Calligraphy
 a. Frontispiece, 4 leaves
 Ni Yüan-lu, *Letters* (attributed), 24 leaves
 Each leaf, 26.1 x 11.9 cm
 Huang Tao-chou, *On Calligraphy* (1631), 6 leaves
 Each leaf, 24.7 x 14.0 cm
 b. Ni Yüan-lu, *Letters*, 10 leaves (partial copy of 1998-92 a)
 Each leaf, 25.0 x 10.0 cm
 Huang Tao-chou, *Letter*, 3 double leaves
 Each leaf, 27.9 x ca. 24.0 cm
1998-92 a–b

Lan Ying (1585–ca. 1664), Ming dynasty
Landscape in the Style of Huang Kung-wang
(Fang Huang Tzu-chiu Fu-ch'un chüan), dated 1624
Handscroll, ink and pale colors on gold-flecked paper
Painting, 28.0 x 623.4 cm; colophons, 28.0 x 124.0 cm
Gift of John B. Elliott
1976-41

Wang To (1592–1652), Ming dynasty
Calligraphy after Wang Hsi-chih, dated 1643
Hanging scroll, ink on silk
Calligraphy, 246.0 x 52.0 cm
1998-144 (cat. no. 33)

Ni Yüan-lu (1593–1644), Ming dynasty
Rock Bound (Shih chiao t'u), dated 1640
Album of 10 leaves, ink and colors on silk (satin);
with a frontispiece, ink and paper
Painting, size varies: 20.8 to 21.2 x 19.9 to 20.0 cm
1998-70

Ni Yüan-lu (1593–1644), Ming dynasty
See also Huang Tao-chou (1585–1646) and
Ni Yüan-lu (1594–1644), *Letters and Commentary*
(q.v., 1998-92)

Ch'en Hung-shou (1598–1652), late Ming to early Ch'ing dynasty
Poem on Wandering in the Mountains
Hanging scroll, ink on paper
Calligraphy, 114.6 x 32.0 cm
Gift of John B. Elliott
1971-1 (cat. no. 34)

Tu Ta-shou (fl. early 17th century), Ming dynasty
Tuan-ch'i Ink Manual (Tuan-ch'i yen-p'u), transcription
On Appreciating Inkstones (P'in yen t'u), painting
Handscroll, ink and color on paper
Frontispiece, 27.5 x 100.5 cm; painting and calligraphy,
27.5 x 195.9 cm
1998-93

Fu Shan (1607–1684/85), late Ming to early Ch'ing dynasty
Poem on the Heavenly Emperor, ca. 1670s
Hanging scroll, ink on silk (satin)
Calligraphy, 284.5 x 47.1 cm
1998-99 (cat. no. 35)

Fu Shan (1607–1684/85), late Ming to early Ch'ing dynasty
Transcription of "Tso-chuan"
Album of 18 leaves, black and red ink on paper
Calligraphy, each leaf, ca. 35.0 x 15.2 cm
1998-128

Cha Shih-piao (1615–1698), Ch'ing dynasty
Poem on Greenwood Shade and Azure Mountains
Hanging scroll, ink on paper
Calligraphy, 139.5 x 52.1 cm
1998-112 (cat. no. 36)

Sung Lo (1634–1713), Ch'ing dynasty
Landscape in the Style of Ni Tsan (Fang Ni Tsan shan-shui)
Hanging scroll, ink on silk
Painting, 128.8 x 51.4 cm
1998-145

Shih-t'ao (Yüan-chi, 1642–1707), Ch'ing dynasty
An Ancient House under Tall Pine Trees
(Ch'ang-sung lao-wu), ca. 1700
Hanging scroll, ink on paper
Painting, 184.8 x 88.3 cm
Gift of John B. Elliott
1984-48

Chiang Shih-chieh (1647–1709), Ch'ing dynasty
Letters (Chiang Shih-chieh shou-cha)

Album of 7 leaves with 1 leaf of colophons
Calligraphy, height 28.5 cm, each leaf varies in width
1998-71

Lu Wei (17th–18th century), Ch'ing dynasty
Landscape, dated 1710
Hanging scroll, ink and color on paper
Painting, 142.0 x 40.4 cm
Gift of John B. Elliott
1970-309

Kao Feng-han (1683–1748/49), Ch'ing dynasty
In Wind and Snow, dated the twelfth lunar month of 1737
Album of 10 double leaves, ink and color on paper
Calligraphy and painting, each double leaf, 24.1 x 28.7 cm
1998-111 (cat. no. 37)

Chin Nung (1687–1764), Ch'ing dynasty
Appreciating Bamboo
Hanging scroll, ink on paper
Calligraphy, 116.0 x 49.5 cm
1998-113 (cat. no. 38)

Chin Nung (1687–1764), Ch'ing dynasty
Ink Plum (Mo-mei)
Hanging scroll, ink on paper
Painting, 98.0 x 47.5 cm
1998-147

Chin Nung (1687–1764), Ch'ing dynasty, attributed
Treatise on the Plough (Lei-ssu ching)
Hanging scroll, ink on silk
Calligraphy, 126.3 x 37.2 cm
1998-119

Huang Shen (1687–ca. 1768), Ch'ing dynasty
Figures, Flowers, and Insects (Jen-wu hua-hui ts'ao-ch'ung ts'e)
Album of 8 leaves, ink and pale color on paper
Painting, each leaf, ca. 23.2 x 32.3 cm
Gift of John B. Elliott
1976-43 a–h

Li Shan (1711–after 1754), Ch'ing dynasty
Flowers and Birds (Hua-niao ts'e), dated 1731
Album of 12 leaves, ink and color on paper
Painting, each leaf, ca. 28.9 x 38.8 cm
Gift of John B. Elliott
1976-42 a–l

Liu Yung (1719–1804), Ch'ing dynasty
Quotations on Canonical Texts
Hanging scroll, ink on paper
Calligraphy, 175.2 x 45.3 cm
1998-69 (cat. no. 39)

Weng Fang-kang (1733–1818), Ch'ing dynasty
On Su Shih's Calligraphy, dated 1809
Handscroll, ink on paper
Calligraphy, 31.4 x 596.3 cm
 Front rubbing:
 Su Shih, *Chang Tzu-hou t'ieh*

Ink rubbing on paper
 Calligraphy, 31.4 x 99.6 cm
1998-96

Ch'ien Feng (1740–1795), Ch'ing dynasty
Couplet for Feng-t'ing
Pair of hanging scrolls, ink on decorated paper
Calligraphy, each scroll, 178.6 x 28.7 cm
1998-62 a–b

I Ping-shou (1754–1815), Ch'ing dynasty
Couplet on Venerable Officials, dated 1813
Pair of hanging scrolls, ink on gold-flecked paper
Calligraphy, each scroll, 162.7 x 32.9 cm
1998-64 a–b (cat. no. 40)

Ho Shao-chi (1799–1873), Ch'ing dynasty
Couplet on Transcending Limitations
Pair of hanging scrolls, ink on paper
Calligraphy, each scroll, 153.5 x 36.1 cm
1998-63 a–b (cat. no. 41)

Chao Chih-ch'ien (1829–1884), Ch'ing dynasty
On Calligraphy
Four hanging scrolls (framed), ink on paper
Calligraphy, each scroll, 134.5 x 32.0 cm
1998-130 a–d

Wu Ch'ang-shuo (1844–1927), Ch'ing dynasty to modern
Calligraphic Couplet in Clerical Script, dated 1920
Pair of hanging scrolls, ink on paper
Calligraphy, each scroll, 134.3 x 33.3 cm
1998-133 a–b

Wu Ch'ang-shuo (1844–1927), Ch'ing dynasty to modern
Plums and Daffodils (Mei-hua shui-hsien), dated 1923
Hanging scroll, ink and color on paper
Painting, 137.0 x 34.0 cm
1998-146

Shen Tseng-chih (1851–1922), Ch'ing dynasty to modern
"On Brush Technique" by Pao Shih-ch'en
Hanging scroll, ink on paper
Calligraphy, 123.8 x 48.3 cm
1998–126

Tseng Hsi (1861–1930), Ch'ing dynasty to modern
Calligraphy after Chung Yu
Four hanging scrolls, ink on paper
Calligraphy, each scroll, 150.3 x 39.8 cm
1998-67 a–d (cat. no. 42)

Huang Pin-hung (1864–1955), Ch'ing dynasty to modern
Couplet on Jade Phoenixes and Gold Horses, dated 1946
Pair of hanging scrolls, ink on paper
Calligraphy, each scroll, 140.5 x 25.6 cm
1998-125 a–b

Li Jui-ch'ing (1867–1920), Ch'ing dynasty to modern
Red-Robed Maitreya, colophon to T'ang dynasty sutra scroll, dated 1911

See Anonymous (8th–9th century), T'ang dynasty,
Mahāprajñāpāramitā Sūtra
(q.v., 1998-123 b)

Li Jui-ch'ing (1867–1920), Ch'ing dynasty to modern
Couplet on Achievements and Virtues, dated 1916
Pair of hanging scrolls, ink on paper
Calligraphy, each scroll, 148.5 x 39.8 cm
1998-65 a–b (cat. no. 43)

Chu Ch'i-chan (b. 1892), modern
Poem on Mountain Orchids, dated 1978
Hanging scroll, ink on paper
Calligraphy, 128.6 x 33.9 cm
1998-137

Feng Tzu-k'ai (1898–1975), modern
Illustrations of Children and Two Letters
Album of 11 leaves, ink on paper
Painting, each leaf, 25.0 x 17.2 cm
1998-132

Lin San-chih (b. 1898), modern
Two Poems on Lake Mo-ch'ou
Hanging scroll, ink on paper
Calligraphy, 103.3 x 33.4 cm
1998-138

Lin Feng-mien (b. 1900), modern
Boats Moored on a Riverbank
Framed scroll, ink and colors on paper
Painting, ca. 65.3 x 65.3 cm
1998-134

Lu Yen-shao (b. 1909), modern
Calligraphy in Running Script, 1977
Hanging scroll, ink on paper
Calligraphy, 136.3 x 65.3 cm
1998-136

Shih Lu (1919–1982), modern
Hibiscus, dated 1971
Hanging scroll, ink and color on paper
Painting, 172.2 x 96.5 cm
1998-131

Shih Lu (1919–1982), modern
Calligraphy in Running Script
Hanging scroll, ink on paper
Calligraphy, 138.2 x 68.4 cm
1998-129

Liu Kuo-sung (b. 1932), modern
Full Moon, dated 1971
Five hanging scrolls, ink and colors on paper
 Painting
 a. 152.7 x 76.0 cm
 b–d. 152.7 x 75.1 cm
 e. 152.7 x 75.5 cm
1998-135 a–e

APPENDIX:
COLLECTED CHINESE LETTERS

Calligraphic Album of Sung, Yüan, and Ming Dynasties
(San-ch'ao i-han)
Album of 10 leaves, ink on paper or silk
Size varies; 11 artists:
 Emperor Kao-tsung (1107–1187, r. 1127–62)
 Yang Mei-tzu (Empress Yang, 1162–1232)
 Chao Meng-fu (1254–1322)
 Chang Yen (fl. early 14th century)
 Wang Ying-kao (Yüan dynasty)
 Wang Feng (1319–1388)
 Sung K'o (1327–1387)
 Shen Tu (1357–1434)
 Hsia Heng (ca. 1392–1464)
 Ch'en Hsien-chang (1428–1500)
 Huang T'ien (Ming dynasty)
1998-75 a–j

Poems and Letters by Ch'an Monks (Yüan Ming ku-te)
Album of 12 leaves, ink on paper
Size varies; 14 artists:
 Chih-na (1078–1157; cat. no. 17a)
 Ta-hsin (1284–1344; cat. no. 17b)
 Liang-ch'i (fl. early 14th century)
 Jen-i (Yüan dynasty)
 Fan-ch'i (1296–1370)
 K'o-ch'i (1309–1391)
 Huai-wei (1317–1375)
 Tsung-lo (1318–1391)
 Lai-fu (1319–1391)
 Tao-yen (Yao Kuang-hsiao, 1335–1418; cat. no. 17d)
 I-chien (d. after 1392; cat. no. 17c)
 P'u-chuang (1347–1403)
 Shou-jen (fl. late 14th century)
 Te-ch'ing (1546–1623)
1998-56 a–l

Ming Dynasty Letters (Ming hsien shou-cha chi ts'e)
Album of 19 leaves, ink on paper
Size varies, one colophon leaf; 3 artists:
 Wang Ju-hsün (1551–1610)
 Chu Yen-hsi (fl. early 17th century)
 Hsü Ch'i (Ming dynasty)
1998-73 a–s

Ming Dynasty Letters (Ming jen shou-cha)
Album of 32 leaves and frontispiece, ink on paper
Size varies; 20 artists:
 Sung Lien (1310–1381)
 Nieh Ta-nien (1402–1456)
 Hsü Yu-chen (1407–1472)
 Chang Pi (1425–1487)
 Wu K'uan (1436–1504)
 Li Tung-yang (1447–1516)
 Chu Yün-ming (1461–1527)
 Wen Cheng-ming (1470–1559)

Ts'ai Yü (d. 1541)
Lü Nan (1479–1542)
Ch'en Ch'un (1483–1544; cat. no. 44)
Wen P'eng (1489–1573)
Wang Shou (*chin-shih* degree, 1526)
Wang Ch'ung (1494–1533)
Wen Chia (1501–1583)
P'eng Nien (1505–1566)
Chang Feng-i (1527–1613)
Chü Chieh (ca. 1531–1585)
Hsü Ch'u (fl. mid 16th century)
Lu Chia-shu (1619–1689)
1998-77 a–ff

Ming Dynasty Letters
Album of 37 leaves, ink on paper
Size varies; 22 artists:
Li Ying-chen (1431–1493)
Wang Ao (1450–1524)
Ch'en I (1469–1538)
Hsia Yen (1482–1548)
Ch'en Liu (1506–1575)
Huang Chi-shui (1509–1574)
Fan Wei-i (1510–1584)
Yü Yün-wen (1513–1579)
Wen Jen-ch'üan (*chin-shih* degree, 1525)
Wang Shih-chen (1526–1590)
Chan Ching-feng (fl. 1567–1598)
Wang Chih-teng (1535–1612)
Lou Chien (1567–1631)
Tso Kuang-tou (1575–1625)
Sung Chüeh (1576–1632)
Huang Tao-chou (1585–1646)
Ni Yüan-lu (1593–1644)
Sheng Mao-yeh (fl. 1607–1637)
Chu Chia-cheng (1602–1684)
Chin K'an (d. 1703)
Unidentified (2)
1998-78 a–kk

Ming Dynasty Letters
Album of 39 leaves, ink on paper
Size varies; 22 artists:
Chang Pang-ch'i (fl. late 15th–early 16th century)
K'ou T'ien-hsü (fl. early 16th century)
Li Ch'un-fang (1511–1585)
Feng Pin (fl. mid 16th century)
Sun Ts'ung-lung (fl. late 16th century)
Tung Ch'i-ch'ang (1555–1636; cat. no. 45)
Ch'en Chi-ju (1558–1636)
Huang Hui (*chin-shih* degree, 1589)
Wen Chen-meng (1574–1636)
Li Liu-fang (1575–1629)
Mi Wan-chung (fl. 1595–1628)
Fan Yün-lin (*chin-shih* degree, 1595)
Wang Ssu-jen (*chin-shih* degree, 1595)
Ch'en Hsün (*chin-shih* degree, 1601)

Wen Chen-heng (1585–1645)
Chin Sheng (1598–1645)
Ku Meng-yu (1599–1660)
Chiang Kai (fl. late 16th–early 17th century)
T'u Lung (fl. late 16th–early 17th century)
Chang Cheng-i (Ming dynasty)
Han Ching (Ming dynasty)
Unidentified
1998-79 a–mm

Ming Dynasty Letters
Album of 38 leaves, ink on paper
Size varies; 21 artists:
Yang Hsün-chi (1458–1546)
Tu Mu (1459–1525)
T'ien I-heng (1524–ca. 1574)
Chiao Hung (1540–1620)
Huang Ju-heng (1558–1626)
Li Jih-hua (1565–1635)
Yü Ch'un-hsi (*chin-shih* degree, 1583)
Ma Shih-ying (1591–ca. 1646)
Ch'en Yüan-su (fl. late 16th century)
Li Teng (fl. late 16th century)
Ch'en Meng (fl. late 16th–early 17th century)
Ch'eng Cheng-k'uei (1604–1676)
Kuang Lu (1604–1650)
Chu Chih-fan (*chin-shih* degree, 1619)
Chu Yüan (1614–1645)
Wu Pen-t'ai (*chin-shih* degree, 1634)
Hsü Kuang-tso (fl. early 17th century)
Hou Chi-tseng (Ming dynasty)
Li Tan-teng (Ming dynasty)
Unidentified (2)
1998-80 a–ll

Ming and Ch'ing Dynasty Letters
Album of 34 leaves, ink on paper
Size varies; 20 artists:
Ch'en Ch'un (1483–1544)
Ch'eng Wen-te (1497–1559)
Hsiang Yüan-ch'i (fl. mid–late 16th century)
Chang Hsiao-ssu (fl. late 16th–early 17th century)
Shen Sheng-ch'i (*chin-shih* degree, 1607)
Ch'eng Sui (1602–ca. 1690)
Ts'ao Yung (1613–1685)
Kung Ting-tzu (1616–1673)
Lü Liu-liang (1629–1683)
Shih K'o-fa (1629–1654)
Tu Shou-ch'ang (fl. mid–late 17th century)
P'eng Sun-yü (1631–1700)
Li T'ien-fu (1635–1699; cat. no. 47)
T'ien Wen (1635–1704)
Ch'en T'ing-ching (1639–1710)
Shih Ta-ch'eng (17th century)
Wang Fu (unknown)
Wen Han (unknown)
Unidentified (3)
1998-81 a–hh

Ming and Ch'ing Dynasty Letters
Album of 33 leaves, ink on paper
Size varies; 21 artists:
 Chou Shih (fl. early 16th century)
 Yüan Chieh-huan (*chin-shih* degree, 1592)
 Wang To (1592–1652)
 Wu Shan-t'ao (1609–1690)
 Li Yü (1611–ca. 1680)
 Cha Shih-piao (1615–1698)
 Wei Hsi (1624–1680)
 Yen Tiao-yü (fl. early–mid 17th century)
 Sung Ts'ao (fl. mid–late 17th century)
 Fei Mi (1625–1701)
 Chu Ta (1626–1705)
 Yün Shou-p'ing (1633–1690)
 P'eng P'eng (1637–1704)
 Wan Ssu-t'ung (1638–1702)
 Wu Chih-chen (1640–1717)
 Shih-t'ao (1642–1707)
 Ti I (fl. late 17th century)
 Hsü Jun (unknown)
 Ku Yün-lung (unknown)
 Wu Yü (unknown)
 Unidentified
1998-82 a–gg

Ming and Ch'ing Dynasty Letters
Album of 59 leaves, ink on paper
Size varies; 23 artists:
 Wang Shu (1668–1743)
 Ying-lien (1707–1783)
 Liu Yung (1719–1804)
 Feng Min-ch'ang (1747–1806)
 Juan Yüan (1764–1849)
 Wu Jung-kuang (1773–1843)
 T'ang I-fen (1778–1853)
 Chang Wei-ping (1780–1859)
 Liu Pin-hua (*chin-shih* degree, 1801)
 Ho Shao-chi (1799–1873)
 Tseng Wang-yen (*chin-shih* degree, 1822)
 Yang Hsien (1819–1896)
 Ho Shao-ching (*chü-jen* degree, 1839)
 Ch'en Yü (Ch'ing dynasty)
 Unidentified (9)
1998-88 a–ggg

Ming and Ch'ing Dynasty Letters
Album of 70 leaves, ink on paper
Size varies; 48 artists:
 Hsü Fang (1622–1694)
 Ch'in En-fu (1760–1843; cat. no. 51)
 Wu Ping-yung (18th century)
 Yang Han (*hao* Hsi-k'o chü-hsih, 1812–1879)
 Chang Chao-chin? (*ming* T'ao, Ch'ing dynasty)
 Shou-yüeh (*tzu* Hsin-yin, Ch'ing dynasty)
 Chan Chih (unknown)
 Chu Chün (unknown)

 Lin Yü-yü (unknown)
 Sheng Wen-yüan (unknown)
 Unidentified (38)
1998-91 a–rrr

Ming and Ch'ing Dynasty Letters
Album of 56 leaves, ink on paper
Size varies; 22 artists:
 Wu Yün (d. 1375)
 Kao Feng-han (1683–1748/49; cat. no. 37)
 Wang Ch'i-sun (1755–1818)
 Wang Yin-chih (1766–1834)
 Yao Yüan-chih (1773–1852)
 Ch'eng En-tse (1785–1837)
 Ch'en Chi-ch'ang (*chin-shih* degree, 1810)
 Chu Tz'u-ch'i (1807–1881)
 Li Tsung-hsi (fl. 1821–1851)
 Chang Yü-chao (1823–1894)
 Chao Chih-ch'ien (1829–1884)
 P'an Tsu-yin (1830–1890)
 Li Wen-t'ien (1834–1895)
 Wu Ta-ch'eng (1835–1902; cat. no. 55)
 Chang Chih-tung (1837–1909)
 Tai Wang (1837–1873; cat. no. 54)
 P'an Ting-hsin (*chü-jen* degree, 1849, d. 1888)
 Li Ho-nien (*chin-shih* degree, 1854, d. 1890)
 Sun Yü-wen (*chin-shih* degree, 1856, d. 1899)
 Lo An-hsien (fl. late 19th century)
 Chung Te-hsiang (Ch'ing dynasty)
 Unidentified (1)
1998-86 a–ddd

Ming and Ch'ing Dynasty Paintings, Calligraphy, and Colophons
Album of 9 double leaves, ink (and colors) on paper
Size varies; 6 artists:
 Tung Ch'i-ch'ang (1555–1536), attributed
 Kuo Ting-ching (17th century)
 Chang Wei-yin (fl. ca. 1700)
 Tai Ssu-wang (fl. ca. 1700)
 Ch'ien Chi-po (unknown)
 Unidentified
1998-74 a–i

Ch'ing Dynasty Letters
Album of 25 leaves, ink on paper
Size varies; 20 artists:
 Chin Jen-jui (1608–1661; cat. no. 46)
 Mao Hsiang (1611–1693)
 Sung Wan (1614–1673)
 Yen Hang (1617–1678)
 Ta Chung-kuang (1623–1692)
 Wang Shih-lu (1626–1673)
 Fang Heng-hsien (*chin-shih* degree, 1647)
 Fu Mei (1628–1683)
 Chu I-tsun (1629–1709)
 Ch'en Kung-yin (1631–1700)
 Wang Shih-chen (1634–1711; cat. no. 48)

Ku Pao-wen (*chin-shih* degree, 1655)
Han T'an (1637–1704)
Yeh Yang-liu (1642–1688)
P'an Lei (1646–1708)
Yang Chung-na (1649–1719)
Kao Hsiao-pen (fl. mid 17th century)
Wu Ch'i-yüan (fl. mid–late 17th century)
Yao Shih-yü (fl. late 17th–early 18th centuries)
Ch'en Hsi-tseng (fl. mid–late 18th century)
1998-83 a–y

Ch'ing Dynasty Letters
Album of 54 leaves, ink on paper
Size varies; 20 artists:
 Wang Hung-hsü (1645–1723)
 Ch'en I-hsi (1648–1709)
 Chang Chao (1691–1745)
 Hang Shih-chün (1696–1773; cat. no. 49)
 Ch'a Li (1716–1783)
 Hsieh Yung (1719–1795)
 Wu Hsien (1733–1813)
 Shen P'ei-sheng (1734–1813)
 Tung Kao (1740–1818)
 Li Chien (1749–1799)
 Chang Fu (*chin-shih* degree, 1774, d. 1821)
 Hsien Lan-sheng (1760–1831)
 Ch'en Shou-ch'i (1771–1834)
 Shan Mao-ch'ien (fl. mid 19th century)
 Ch'en Kuang-chien (Ch'ing dynasty)
 Ch'en Shu-hua (Ch'ing dynasty)
 Shih Shan-ch'ang (Ch'ing dynasty)
 Tai Tien-chiang (Ch'ing dynasty)
 Wei Chin-hsi (Ch'ing dynasty)
 Unidentified
1998-84 a–bbb

Ch'ing Dynasty Letters
Album of 56 leaves, ink on paper
Size varies; 19 artists:
 Chiang Heng (1672–1743)
 Chin Nung (1687–1764)
 Liang Shih-cheng (1697–1763)
 Hung Liang-chi (1746–1809)
 Sung Pao-ch'un (1748–ca. 1817)
 I Ping-shou (1754–1815)
 Chiang Hsiang-ch'ih (*chin-shih* degree, 1790)
 Kuo Shang-hsien (1785–1832)
 Ch'i-ying (d. 1858)
 Tai Hsi (1801–1860)
 Ch'en Li (1810–1882)
 Yang I-sun (1812–1881)
 Shen Kuei-fen (1817–1881)
 Ho Ching (fl. mid 19th century)
 Ch'en P'u (*chin-shih* degree, 1844 or 1851)
 Weng T'ung-ho (1830–1904)
 Ch'iu Chiu-hua (Ch'ing dynasty)

Liu San-shan (Ch'ing dynasty)
Unidentified
1998-85 a–ddd

Ch'ing Dynasty Letters
Album of 54 leaves, ink on paper
Size varies; 21 artists:
 Li Shih-cho (ca. 1690–1770)
 Liang T'ung-shu (1723–1815)
 Yao Nai (1732–1815)
 Weng Fang-kang (1733–1818)
 Ch'u T'ing-chang (*chin-shih* degree, 1763)
 Wu Hsi-ch'i (1746–1818)
 T'ieh-pao (1752–1824)
 Yung-hsing (Prince Ch'eng, 1752–1823)
 Po Jung (1769–1842)
 Ho Ling-han (1772–1840)
 Yen Po-tao (fl. late 18th–early 19th centuries)
 Hsü Tsung-kan (1796–1866)
 Ch'en Chieh-ch'i (1813–1884)
 Feng Yü-chi (*chin-shih* degree, 1841)
 Yang I (fl. 1862–1894)
 Hu Yü-fen (d. 1906)
 I-ch'in (Ch'ing dynasty)
 P'eng Ts'ai-ch'ou (Ch'ing dynasty)
 Unidentified (3)
1998-87 a–bbb

Ch'ing Dynasty Letters
Album of 39 leaves, ink on paper
Size varies, 16 artists:
 Chou Tsai-chün (b. 1640)
 Lu Kuang-hsü (fl. late 17th century)
 Chang Ta-shou (fl. 1662–1722)
 Li K'ai (fl. late 17th–early 18th century)
 Yin-hsi (Prince Shen, 1711–1758)
 Wu Hsi-ch'i (1746–1818)
 Shih Yün-yü (1756–1837)
 Ch'en Hung-shou (1768–1822)
 Sun Erh-chün (1770–1832)
 Ch'eng Chung-fu (fl. 1796–1850)
 Ch'en Hsi (Ch'ing dynasty)
 Chu Erh-mai (Ch'ing dynasty)
 Hu Chüeh? (Ch'ing dynasty)
 Yang Han (Ch'ing dynasty)
 Unidentified (2)
1998-89 a–mm

Ch'ing Dynasty Letters
Album of 72 leaves, ink on paper
Size varies; 31 artists:
 P'eng Yü-lin (1619–1692)
 Sung Lo (Sung Lao, 1634–1713)
 Wang Hsüeh-chin (1748–1804; cat. no. 50)
 Wen Ju-kua (1755–1821)
 Wu Nai (1755–1821)
 Wu Sung-liang (1766–1834)

Liu Feng-kao (*chin-shih* degree, 1789)
Wang Shou-ho (*chin-shih* degree, 1796)
Lo Ping-chang (1792–1867)
Tseng Kuo-fan (1811–1872)
Wan Ch'ing-li (*chin-shih* degree, 1840)
Chou Chia-mei (fl. 1850–1874)
Shen Pao-chen (1820–1879)
Ting Pao-chen (1820–1886)
Yü Yüeh (1821–1907; cat. no. 53)
Mao K'uei (*chü-jen* degree, 1866)
Jen Tao-jung (1823–1906)
Ni Wen-wei (*chin-shih* degree, 1852)
Liu Ming-ch'uan (1836–1896; cat. no. 52)
Shen Tseng-chih (1851–1922)
K'ang Yu-wei (1858–1927)
Liang Ting-fen (1859–1919)
Yü Yu-jen (1879–1964)
Ch'en T'ai-sun (Ch'ing dynasty)
Li Ming-ch'ih (Ch'ing dynasty)
Wang Chen (Ch'ing dynasty)
Wang Wen-hsieh (Ch'ing dynasty)
Wu Hsing-lan (Ch'ing dynasty)
Unidentified (3)
1998-90 a–ttt

Glossary-Index

Index compiled by Robert J. Palmer
Chinese glossary compiled by David T. Liu

Note: Alphabetization of this index is word by word, with hyphens counting as blank spaces. Apostrophes and other diacritical marks are ignored in the alphabetization. Calligraphers are paired with works according to ordinary or accepted attributions. Page numbers for illustrations are in **boldface.**

pu 不
pu-hsiu 不朽, 307
P'u Ju 溥儒 (1896–1963), 160
P'u-fen ling 瀑垒嶺 (Cascade Range)
Pu-tzu-ch'i shuo 不自棄説. *See: On Not Giving Up*
pu-yüan 不遠
publications on social and cultural issues of calligraphy, 26*n35*

Quatrain (Kao-tsung), 283–84, **283**, 299*n14*
Quatrain on an Autumn Fan (Kao-tsung), 107, 114, **115**, 282, 283, 285, 285
Quatrain on Autumn (Yang Mei-tzu), 107, 116, 117, 282, 286–88, 289
"Quest for the Imperishable: Chao Meng-fu's Calligraphy for Stele Inscriptions, A" (Sun), 302–19
Quotations on Canonical Texts (Liu Yung), 187, 194, **195**

radicals, xviii
Reading a Stele (Kuo Hsi), 9, **9**
reading aloud of calligraphy, 8
"Reading Chinese Calligraphy" (Harrist), xix, 2–27
Recluse by Heavenly Permission (*t'ien-ch'üan chü-shih* 天全居士), 322, 323
Record of Mount Mao (*Mao-shan chih* 茅山志; Chang Yü), **58**
Record of the Altar of the Immortal of Mount Ma-ku (*Ma-ku hsien-t'an chi* 麻姑仙壇記; Yen Chen-ch'ing), xviin, 46, 270
Record of the Collection of Antiquities (*Chi-ku lu* 集古錄; Ou-yang Hsiu), 309–10
Record of the Fu-shen Priory at Hangchow (*Hang-chou Fu-shen-kuan chi* 杭州福神觀記; Chao Meng-fu), 308–9
Record of the Miao-yen Monastery (*Hu-chou Miao-yen ssu chi* 湖州妙嚴寺記; Chao Meng-fu), 10, **28**, 55–57, **55–57**, 122, 124–25, **124–25**, 236, 237, **238**, **247**, 302, **312**, 313, **313**, **314**
Record of the Pao-yün Monastery in Sung-chiang (*Sung-chiang Pao-yün ssu chi*; Chao Meng-fu), 237
Record of the Pavilion of the Old Drunkard (*Tsui-weng-t'ing chi* 醉翁亭記; Wen Cheng-ming), 336, **337**
Record of the Restoration of the San-ch'ing Hall of the Hsüan-miao Priory (*Hsüan-miao-kuan ch'ung-hsiu San-ch'ing-tien chi* 玄妙觀重修三清殿記; Chao Meng-fu), 308

Record of the Restoration of the Three Gates of the Hsüan-miao Priory (*Hsüan-miao kuan ch'ung-hsiu san-men chi* 玄妙觀重修三門記; Chao Meng-fu), 237, **237**, **305**, 308–9, **310**, 311, **311**, **312**, 313–15, **315**, 319*n39*
Record of the Sacred Teaching. See: Preface to the Sacred Teaching
Record of the Three Kingdoms, The (*San-kuo chih* 三國志), 90
Record of the To-pao Pagoda (*To-pao-t'a pei* 多寶塔碑; Yen Chen-ch'ing), 9, **288**
Records of Spectacles Seen by Chan Ching-feng (*Chan-shih hsüan-lan pien* 詹氏玄覽編), **310**
red, to ward off evil, 362, 364
Reflections on Calligraphy and Painting (*Yü-i pien* 寓意編; Tu Mu), 332, 335
"Remembering My Old Friend" by Li Po (*Li Po I chiu-yu* 李白憶舊遊; Huang T'ing-chien), **266**, 267
representation, 30
 Chinese development of, 58–62, **59–62**
 Greek development of, 59
 historicity substituted for, 62
"Responding to an Imperial Order: Two Poems on the Suburban Sacrifice" (*Ying chih fu chiao-ssu ta-tien ch'ing erh shou* 應制賦郊祀大典慶成二首; K'o Chiu-ssu), 292
revivalists, 67, 68, 235. *See also: fu-ku*
"Rhapsody on the Capital of Shu" (Yang Hsiung), 245
"Rhapsody on the Three Capitals" (Tso Ssu), 245
Riely, Celia Carrington, 388
Ritual to Pray for Good Harvest (*Hsing-jang t'ieh* 行穰帖; Wang Hsi-chih), 23, 39, 40, 92–93, **93**, 186, **240**, 241–59, **242–43**, **255**, 383, 384
 colophons on, **22–23**, 23–24, **74–75**, 76, 92, 145, **242–43**, 253
 T'ang copy of, 383
Ritual Vessels Stele (*Li-ch'i pei* 禮器碑), 9, **30**, 187, 196, 368, 369
River Diagram (*Ho-t'u* 河圖), 198
Rosenbaum, Allen, xiv
 "Foreword," ix–x
Rosenblum, Richard, xiii
Rowley, George, ix, xi
rubbings
 collections of
 by Chao Meng-fu, of Wei stelae, 310
 Ch'ien-lung emperor's, 92, 186, 256
 Hua Hsia's, 70
 Hui-tsung's, 251
 in Ming dynasty, 253
 in Sung dynasty, 258*n39*

by T'ang T'ai-tsung of Wang Hsi-chih's works, 96, 240
 Wen Cheng-ming's, 158, 335–37, **335**
 Wu T'ing's, **252**, 254, 256
 corrupted versions of, 270
 of engravings, 207, 256
 as lacking authenticity, 232, 254
 model books (*t'ieh*) of, 194, 202, 332, 339, 384
 as models of calligraphy, 11
running script. *See: hsing-shu*

Sage of Calligraphy, 34, 231
Samantabhadra, 100
samsara (cycle of rebirth), 306
San Basin (*San shih p'an* 散氏盤) bronze inscription, 371, **371**
san-chiang chi ju, chen-tse ti ting 三江既入, 震澤底定, 379*n63*
San-chieh chiao 三階教. *See* Three Stages
San-hsi-t'ang 三希堂 (Hall of the Three Rarities), 186, **254**, 255–56
San-kuo chih 三國志 (*The Record of the Three Kingdoms*), 90
satin, *Poem on the Heavenly Emperor* (Fu Shan) on, **78**, 79, 182, **183**, **344**, 357–58, **357**, 359*n43*
Schapiro, Meyer, 32
scholar-amateur, definition of, 124
scholar officials, 164
 in late Northern Sung, 47–52, 69
 in Yüan dynasty, 53, 69, 122
 See also literati
School of the Mind (*Hsin-hsüeh* 心學), 66–68
School of the Principle (*Li-hsüeh* 理學), 67
script styles.
 See: tzu-t'i
Scroll for Chang Ta-t'ung (Huang Ting-chien), xi, **2**, 47–48, **48**, 108–9, **108–9**, 164, 261, **262–63**, 264–65, 274, 275, **275**, 367
 translation of, 276–77
sculpture, Buddhist, 59, **59**
seal script. *See: chuan-shu*
Second Prose Poem on the Red Cliff by Su Shih (*Hou Ch'ih-pi fu* 後赤壁賦; Chu Yün-ming), 12–15, **13**
Second Prose Poem on the Red Cliff by Su Shih (Wen Cheng-ming), 12–15, **12**
"Self-Admonishment" (*Tzu-ching* 自警; Chao Meng-fu), 306–7
self-expression
 literati promotion of, in calligraphy, 232
 Mi Fu on naturalness as, 273
 in Ming dynasty, 66

446

Photography Credits

Qianshen Bai, Boston University
Bai—figs. 1, 3, 4, 5, 7, 8, 9, 10, 11, 12, 13; Ching—fig. 16; Fong—fig. 65

John Blazejewski, Princeton University
Fong—fig. 50; Harrist (A Letter)—fig. 13; Harrist (Reading)—fig. 14; Harrist (Two Perfections)—fig. 2; Liu—figs. 17, 20, 21, 23; Scripts—fig. 1; Sun—fig. 17a; Xu—figs. 4, 7, 8, 9, 11b

Christie's Images, New York
Liu—fig. 11

H. David Connelly, Department of Art and Archaeology, Princeton University
Ching—figs. 4, 5, 6, 7, 8a, 8b, 9a, 9b, 12, 13b, 14, 15a–b, 17, 18; Fong—figs. 1, 2, 4, 5, 6, 9a–c, 10, 13, 15a, 16, 17, 18, 19, 20, 21, 22, 24a–e, 26, 27, 29, 31, 34, 36b, 37b, 38b, 39b, 41, 42, 45, 50, 58, 63; Harrist (A Letter)—2, 3, 5, 10, 11, 12, 17; Harrist (Reading)—4, 5, 7, 9, 10, 12, 13, 16, 17, 18, 19; Harrist (Two Perfections)—figs. 1a, 1b, 3, 7, 8, 9, 15, 16, 18; Liu—figs. 1, 2, 4, 5, 6, 7, 8, 9, 10, 12, 15, 16, 18, 19, 22; Scripts—figs. 2, 3, 4, 5, 6; Sun—figs. 1, 2, 5, 6, 7, 8, 9, 10, 11, 13b, 14b, 15, 16, 17, 18, 19, 20, 21, 22, 23; Xu—fig. 10

Freer Gallery of Art, Smithsonian Institution
Fong—fig. 44

Gest Oriental Library, Princeton University
Fong—fig. 54

Ronald C. Knapp, State University of New York, New Paltz
Liu—fig. 3

Amy McNair, University of Kansas
McNair—figs. 1, 2, 4a, 5, 6b, 7, 8, 10, 11b, 12

The Metropolitan Museum of Art, New York
Bai—fig. 6; Fong—figs. 3, 11, 28, 30a–b, 43, 49, 52, 59, 66; Harrist (A Letter)—figs. 8, 16; Harrist (Reading)—fig. 2; Harrist (Two Perfections)—fig. 4; Xu—figs. 5, 6

Museum of Fine Arts, Boston
Harrist (Reading)—fig. 8

National Palace Museum, Taipei, Taiwan, Republic of China
Fong—figs. 7, 8a–b, 14, 15b, 23, 33, 46, 47, 48; Harrist (A Letter)—figs. 4, 14, 15; Harrist (Reading)—figs. 3, 6, 20; Harrist (Two Perfections)—figs. 6, 11, 13; Ho—figs. 4, 5, 8, 13, 14, 15, 17, 18, 20; McNair—figs. 3, 13, 14a; Xu—fig. 3

Freer Gallery of Art, Smithsonian Institution
Fong—fig. 44

Royal Ontario Museum, Toronto
Fong—fig. 43

Everett H. Scott, Class of 1977
Foreword—frontispiece

Shanghai Museum, China
Ho—fig. 1

University of Michigan Museum of Art, Ann Arbor
Harrist (A Letter)—fig. 9

Bruce M. White, Caldwell, New Jersey
Bai—fig. 2; catalogue cover; catalogue frontispiece; cat. nos. 1–55; Ching—figs. 1, 2, 3, 10, 11, 13a, 19; Fong—frontispiece, figs. 12, 25, 32, 35, 36a, 37a, 38a, 39a, 40a–b, 51, 53, 55, 56, 57, 60, 61, 62, 64, 67, 68, 69, 70; Harrist (A Letter)—figs. 1, 6, 7, 18; Harrist (Reading)—frontispiece, figs. 1, 11, 15, 21; Harrist (Two Perfections)—figs. 5, 10, 12, 14, 17, 18; Ho—figs. 2, 3, 6, 7, 9, 10, 11, 12, 16, 19; Liu—figs. 13, 14; McNair—figs. 4b, 6a, 9, 11a, 14b; Sun—figs. 12, 13a, 14a; Xu—figs. 1, 2a–c, 11a

Alison Speckman, Princeton, New Jersey, printed some of the black-and-white figure illustrations.

利矣圍城而害不加於百姓此
邇矣舉國不謀其功除暴不以
登然天下矣邁全德以率列國則
武之事矣樂生方恢大綱以縱二
信以待其弊使即墨莒人顧仇其
戎賴我猶親善守之智無所施
在得仁即墨大夫之義也任窮則
周之道也開彌廣之路以待田單